Pollock and After

Pollock and After: The Critical Debate brings together key writings on debates about Abstract Expressionism and Modernist art history. It is an essential resource for understanding post-war American art and culture. The second edition has been fully revised and updated in response to new critical approaches to post-war American art. It includes nine new articles and a substantial overview essay by Francis Frascina.

Articles are grouped into three parts, each with an introduction by Francis Frascina. Part One includes two foundational articles by the influential Modernist critic, Clement Greenberg, and represents the debate about Greenberg's work, with contributions by T. J. Clarke and Michael Fried. Part Two focuses on revisionist writers, who questioned established ideas about Modernist art history, examining the relationship between Abstract Expressionism and the politics of McCarthyism and the Cold War.

The third part, which is new to the volume, is devoted to recent developments of revisionist critiques. Contributors explore the work of Greenberg's contemporaries, the relationship between critical and commercial responces to Abstract Expressionism, and perceptions of cultural value in the 1940s and 1950s, and challenge assumptions about ethnicity, gender and sexuality in the construction of the 'post-war American artist'.

Francis Frascina is John Raven Professor of Visual Arts at Keele University. He is the author of *Art, Politics and Dissent: Aspects of the Art Left in Sixties America* (1999), co-author of *Modernism in Dispute: Art Since the Forties* (1993) and co-editor of influential anthologies, including *Art in Modern Culture: An Anthology of Critical Texts* (1992).

Pollock and After

The Critical Debate

Second Edition

Edited by

Francis Frascina

London and New York

First published 1985 by Harper & Row Ltd
Reprinted by Paul Chapman Publishing Ltd

This edition first published 2000
by Routledge
2 Park Square, Milton Park, Abingdon, Oxon, OX14 4RN

Simultaneously published in the USA and Canada
by Routledge
270 Madison Avenue, New York, NY 10016

Reprinted 2006, 2007, 2008, 2009, 2010

Routledge is an imprint of the Taylor & Francis Group, an informa business

© 1985, 2000 Francis Frascina for selection and editorial matter.
Individual chapters © 2000 the contributors

Typeset in Perpetua and Bell Gothic by RefineCatch Ltd
Printed and bound in Great Britain by
the MPG Books Group

British Library Cataloguing in Publication Data
A catalogue record for this book is available from the British Library

Library of Congress Cataloging in Publication Data
A catalog record for this book has been requested

ISBN 0–415–22866–2 (hbk)
ISBN 0–415–22867–0 (pbk)

ISBN 978–0–415–22866–4 (hbk)
ISBN 978–0–415–22867–1 (pbk)

Contents

Acknowledgements

1. Clement Greenberg, 'Avant-Garde and Kitsch', in *Partisan Review*, vol. 6, no. 5, Fall 1939. © 1961, 1989 by Clement Greenberg.

2. Clement Greenberg, 'Towards a Newer Laocoon, in *Partisan Review*, vol. 7, no. 4, July–August 1940. © 1986 by Clement Greenberg.

3. T. J. Clark, 'Clement Greenberg's Theory of Art' in *Critical Inquiry*, September 1982, vol. 9, no. 1 (The University of Chicago Press 1982), pp. 139–156. Reprinted by permission of The University of Chicago Press.

4. Michael Fried, 'How Modernism Works: A Response to T. J. Clark' in *Critical Inquiry*, September 1982, vol. 9, no. 1 (The University of Chicago Press 1982), pp. 217–234. Reprinted by permission of The University of Chicago Press.

5. T. J. Clark, 'Arguments About Modernism: A Reply to Michael Fried' in W. J. T. Mitchell (ed.) *The Politics of Interpretation* (Chicago & London: The University of Chicago Press 1983), pp. 239–248. Reprinted by permission of The University of Chicago Press.

6. Max Kozloff, 'American Painting During the Cold War' in *Artforum* vol. 11, no. 9, May 1973, pp. 43–54. © Artforum.

7. Eva Cockroft, 'Abstract Expressionism, Weapon of the Cold War' in *Artforum* vol. 12, no. 10, June 1974, pp. 43–54. © Artforum.

8. Jane de Hart Matthews, 'Art and Politics in Cold War America' in *The American Historical Review*, vol. 81, February–December 1976, pp. 762–787.

9. David and Cecile Shapiro, 'Abstract Expressionism: the Politics of Apolitical Painting' in Jack Salzman (ed.) *Prospects 3*, 1977, pp. 175–214. © David and Cecile Shapiro. Reprinted by permission of the authors.

10. Serge Guilbaut, 'The New Adventures of the Avant-Garde in America' in October 15, Winter 1980, pp. 61–78. Reprinted by permission of the author.

11. Fred Orton and Griselda Pollock, 'Avant-Gardes and Partisans Reviewed' in *Art History* vol. 3, no. 3, September 1981, pp. 305–327. Reprinted by permission of the authors.

12. David Craven, 'Abstract Expressionsim, Automatism and the Age of Automotion' in *Art History* Vol. 13, No. 3 (March 1990) pp. 72–103. © Association of Art Historians.

13. Fred Orton, 'Action, Revolution and Painting' in *Oxford Art Journal*, vol. 14, no. 2, 1992, pp. 3–17. Reprinted by permission of the author.

14. Dierdre Robson, 'The Market for Abstract Expressionism: the Time Lag Between Critical and Commercial Acceptance' in *Archives of American Art Journal*, vol. 25, no. 3, 1985, pp. 19–23. Reprinted by permission of the author. Dierdre Robson is an independent lecturer in London. This article was drawn upon her PhD research on the market for modern art in New York at University College London (1988). The results of this research as a whole have been published in rewritten form as *Prestige, Profit and Pleasure: The Market for Modern Art in New York in the 1940s and 1950s* (1995).

15. Michael Kimmelman, 'Revisiting the Revisionists: the Modern, Its Critics, and the Cold War' in *The Museum of Modern Art at Mid-Century, At Home and Abroad*, No. 59 (New York: MOMA 1994) pp. 38–55. Reprinted by permission of the author.

16. Anne Gibson, from *Abstract Expressionism: Other Politics* (New Haven & London, Yale University Press, 1997), pp. xix-xxxviii. Reprinted by permission of Yale University Press.

17. Anna C. Chave, 'Pollock and Krasner: Script and Postscript' in *Res* 24, Autumn 1993, pp. 95–111. © Anna Chave. Reprinted by permission of the author.

18. Michael Leja, from *Reframing Abstract Expressionism: Subjectivity and Painting in the 1940s* (New Haven & London, Yale University Press, 1993), pp. 253–268, 363–4. Reprinted by permission of Yale University Press.

19. Rosalind E. Krauss, from *The Optical Unconscious* (Cambridge, MIT Press, 1993), pp. 244–48 and 321–22. Reprinted by permission of MIT Press.

Preface

Pollock and After: the Critical Debate was first published in 1985 by Harper and Row, which became Paul Chapman Publishing. When Sage took over Paul Chapman Publishing, I discovered, in 1998, that *Pollock and After* was no longer in print. Thanks to the interest shown by Rebecca Barden, Senior Editor at Routledge, *Pollock and After* is now available in a revised form and with a new overview essay: 'Looking Forward, Looking Back: 1985–1999'.

The Introductions to Parts One and Two remain basically the same as they appeared in 1985, including the notes, save for minor corrections. Please consult and cross-reference the notes to 'Looking Forward, Looking Back: 1985–1999' for updates on publications and relevant debates.

The note reference systems for each of the edited texts from the 1985 edition have been retained, as have the note reference systems for each of the additions to the edited texts in this edition.

Where texts have been edited, excised material is indicated thus [. . .]. Reference to chapters printed in this book is made thus [00].

Francis Frascina

LOOKING FORWARD, LOOKING BACK: 1985–1999

Pollock and After: the Critical Debate: conditions of production (1985)

The first edition of *Pollock and After: the Critical Debate* was the product of a particular historical moment in the mid 1980s. That decade, the pinnacle of an era of cultural and historical amnesia,[1] was characterized by, on the one hand, the ideological agendas of Thatcherism in the United Kingdom and Reaganism in the United States[2] and, on the other hand, a reinvigorated 'citadel culture' within many academic institutions. The phrase 'citadel culture' was used by O. K. Werckmeister in his book of the same name published in 1991. He argued that, during the time span of the historic changes in the industrial societies from 1968 to the conservative political turn of the early 1980s, many Left-wing intellectuals, who had risen to influence in the academic institutions and the public culture of these societies, revised the aims of their work:

> They retracted their unfulfilled claims to political practice, be it through radical democratic reforms or through a cultural revolution, and began to justify their resigned accommodation to existing political conditions as a refinement of thought, particularly as they were at liberty to pursue thought as long as they stuck to their academic enclaves . . . intellectual activity was defined as a self-feeding process of reading and writing, printing and reviewing, commentary and critique. The 'text' became the surrogate of reality.[3]

In 1985, *Pollock and After* was intended to address not only those aspects of this process, to be found in art criticism and art history, but also an amnesia about the period since the 1940s. Addressing the latter involved the inclusion of a number

of articles, published in the 1970s and 1980s, which began to interrogate both a prevailing institutionalized Modernist narrative and the conditions of the practice of art and of criticism before and after McCarthyism. The first of these articles by Max Kozloff, 'American Painting During the Cold War' [Chapter 6], appeared in *Artforum*, in 1973,[4] at a time when both Nixon's Presidential term and the United States involvement in Vietnam were drawing to ignoble ends. Nixon's hawkish anti-Communism and defense of the military involvement in Indo-China have their deep roots in the early Cold War from the late 1940s onwards. Kozloff's article was a contribution to the wider phenomenon of revisionist histories of the post-1945 'settlement' produced by participants in the variety of radical and counter-cultural movements that gained force in the late 1960s and early 1970s. In a modest way, *Pollock and After* was a further contribution to such histories.

A few years after the anthology was published, I was asked by one of the authors why so many British historians were 'obsessed' with art and criticism during the Cold War. It took me a while to understand that this question could only be asked by an American for whom the 'past,' since the 1950s, was both a loaded and contradictory reality and a densely embedded series of 'texts.' The latter exists as a pervasive element in the collective narratives of official memory in the United States, for which the constant flying of the flag in all locations acts as a metaphor, and in the structures of denial amongst the various strands of intellectuals for whom McCarthyism is a haunting legacy.[5] The relationship between denial and legacy can be pictured by remembering the early repressive political and cultural interests of Nixon and Reagan, cemented during McCarthyism, and their return as reactionary Presidents first with Nixon in the late 1960s and early 1970s, terminated by 'Watergate,' and then with Reagan for two terms in the 1980s.[6]

In 1999, planning a revised edition of *Pollock and After*, I sit in Duke University, North Carolina, where Nixon graduated third in his class at the Duke School of Law in 1937.[7] When Nixon died in 1994 there returned haunting reminders of the situation in 1974, with his resignation prompted by the threat of impeachment and the revelations in the Pentagon Papers. These were also reminders of the situation two decades earlier still, the early 1950s, when the relationships between art, culture and politics were in particular tension and Nixon's reputation as an anti-Communist was made on the back of the Alger Hiss case.[8] In 1974 *Artforum* published Eva Cockcroft's 'Abstract Expressionism Weapon of the Cold War' [Chapter 7],[9] which sought to take up questions raised by Kozloff's article from 1973. Cockcroft made a startling case for viewing art and culture in the 1950s as a major concern of the State and State agencies. In retrospect, we can now see that it would have been very difficult to make such a case *and get published* in major art journals before the early 1970s even though, for example, the undercover role of the Central Intelligence Agency (CIA) in cultural organizations and institutions had been revealed in the 1960s. In April 1966 *The New York Times* ran a series of five articles on the purposes and methods of the CIA.[10] The third of these articles, 27 April 1966, began to detail false-front organizations and the secret transfer of CIA funds to, for example, the State Department or to the United States Information Agency (USIA) which 'may help finance a scholarly inquiry and publication. Or the agency may channel research money through founda-

tions – legitimate ones or dummy fronts.'[11] *The New York Times* cited, amongst others, the CIA's funding of the anti-Communist organization of liberal intellectuals the Congress for Cultural Freedom, *Encounter* magazine, 'several American book publishers,' the Massachusetts Institute of Technology's Center of International Studies, and a foreign-aid project in South Vietnam run by Michigan State University. During 1966 and 1967 journals from *Frontier* to *Ramparts* ran articles questioning the role of the CIA.[12] In 1967, Thomas Braden, former supervisor of cultural activities at the CIA, published his notorious 'I'm Glad the CIA is Immoral' and in 1968 Christopher Lasch extended the analysis.[13]

The then editor of *Artforum*, Philip Leider was not only politically aware because of his involvement in anti-war protests but also he would have heard of CIA undercover activity from a variety of sources such as Walter Hopps, whom he knew when *Artforum* was based above the Ferus Gallery in Los Angeles. Hopps had founded Ferus with Ed Kienholz in 1957 and by the early 1960s was running it with Irving Blum. In 1962 he moved to the Pasadena Museum of Art, Los Angeles, as curator and then acting Director. In 1965 Hopps, representing the Pasadena Museum of Art, organized the USIA's exhibition at the VIII Bienal de São Paulo where there were numerous CIA operatives under cultural affairs cover.[14] However, little of such awareness made it to the published pages of *Artforum* during the 1960s. It was only in September 1970, after a year of staggering events – including revelations about My Lai, Altamont, police killings of Black Panthers, the US bombing of Cambodia, deaths of students most famously at Kent State – that *Artforum* explicitly asked questions about artists and politics.[15]

Given that *Artforum* was a center for a particular paradigm of Modernist debates for so long, it may seem paradoxical that the journal published articles by Kozloff and Hauptmann, in 1973, and Cockcroft, 1974, as it had published Peter Plagen's incisive 'Los Angeles: The Ecology of Evil,' in 1972.[16] Part of the reason for the appearance of these articles was the changed political and cultural situation brought about by the anti-Vietnam war and the Civil Rights movements.[17] Belatedly, the force of these movements was acknowledged by elements of the art institutions. Specifically, too, there was a shift in priorities at *Artforum* from the end of 1971 with Philip Leider being replaced as editor by John Coplans.[18] Throughout the previous decade, Leider had uncomfortably combined commitments to an art world agenda with those related to radical anti-war activities.[19]

It is clear that the period is characterized by such contradictions and paradoxes. For example Walter Hopps, involved in bohemian and leftist groupings in Los Angeles in the late 1950s and early 1960s, recalled, in 1990, the strains of responding to the variety of USIA, CIA undercover and State Department representatives in the 1960s. His conclusion was that Kozloff's views on the USIA's use of the new American painting in Cold War propaganda was not quite right: his impression was that agencies such as the USIA did not care what kind of art was used as long as it was made in the United States and, crucially, not linked to Communism in any way.[20] The implication is that the ideological importance of particular American values was more crucial than a specific form of art or group of artists. The main factors on the agenda were to ensure a high global profile for the United States, its anti-Communist values, and a

selected range of its traditions of representation. As long as there was continual exposure of such values and selections, the art involved could be Abstract Expressionism or American Primitives or American Folk Art or various mixtures. *Pollock and After* collected texts that had brought such contradictions and paradoxes to historical attention in the 1970s. As with all publications, subsequent researchers have queried some of the emphases and details of these texts. However, it is clear that the issues, debates and relationships uttered by these authors in the 1970s and early 1980s are still fought over in the 1990s. One reason for this is that, despite the Freedom of Information Act, full details of CIA and FBI activities in promoting or curtailing cultural activities are still to be fully revealed.[21]

Another emphasis of *Pollock and After* was a critical examination of the writings of Clement Greenberg. In the early 1980s the influence and status of Greenberg's writings published in journals such as *Partisan Review* and *The Nation* in 1939 and the 1940s [Chapters 1 and 2] were being reviewed and re-evaluated, not least in the context of the different conditions of the 1930s and of the 1950s in the United States. After *Pollock and After* was published, four volumes of Greenberg's collected writings appeared[22] enabling further scrutiny of his texts and his career from a variety of perspectives.[23] There have been suggestions that the art-historical left has been obsessed with Greenberg or with the influence of his ideas. Such suggestions often miss the point about such historians' interests in Greenberg's agency and what his work and ideas represent ideologically; they also misunderstand the work of historians of leftist intellectuals, particularly those in New York from the 1930s onwards.[24] Further, it is important to consider the politics and cultural demarcations of Greenberg's writings, as argued by Annette Cox,[25] not least in the transforming conditions of the United States in the 1950s. Texts such as Greenberg's 'The Plight of Our Culture,' 1953,[26] and 'American Stereotypes', 1956,[27] are politicized interventions that underpin his writings of the 1950s and 1960s as well as his actions.[28] It is clear, too, that Greenberg's writings and the publications by his Modernist acolytes from the 1960s onwards, are indebted to a belief in the authoritative judgments of aesthetic value, which are steeped in unquestioned assumptions about gender and the euro-centric cultural tradition. When it comes to the 1960s they are also inseparable from a defensive cultural pessimism about the production of high art within capitalism. This is to link Greenberg's criticism, paradoxically, to the writings of Theodor Adorno.[29] I say paradoxically because whilst Greenberg's criticism can be indexed to Adorno's views about the politics of autonomous art, to be found in 'Commitment' 1962,[30] Greenberg's writings on art and politics bear many of the characteristics, identified by Adorno and others, of the authoritarian personality. Adorno had been a member of the research team that published *The Authoritarian Personality* in 1950.[31] This was a time when Adorno was still resident in the United States, to which he fled as an exile from Nazism, returning to Germany in 1953.[32] During the 1940s Adorno formed a positive personal view of Greenberg that can be gleaned from his reply, dated 19 February 1962, to the managing editor of The University of Chicago Press. Adorno wrote: 'I know Clement Greenberg very well from my American time and I think exceedingly high of him. His opinion on [Walter] Benjamin, without any doubt, will not only agree with my own but will also carry great objective weight.'[33]

We have to speculate on why Adorno wrote such flattering remarks when he would have been aware of Greenberg's mixed political legacy especially during the 1950s.[34] One possible reason is a mutual bond with what in the United States is referred to as the Old Left, with its roots in debates and commitments of the 1930s. A later episode in Adorno's life lends support to such a possible reading: his response, in the late 1960s, to the student movement in Germany (its 'New Left'), particularly a clash in 1969, and his uncomfortable correspondence and differences with his old Frankfurt School radical Herbert Marcuse. Marcuse, a Professor in California, was an important figure to many of the New Left in the United States whilst Adorno, a Professor in Frankfurt, was in conflict with revolutionary students in his University.[35] Adorno was not alone in feeling the pressure of critique and historical contingency. But it was not with Greenberg that he shared such pressures, rather with Meyer Schapiro. Schapiro from the same generation as Adorno and Greenberg, and whose writings would have been in the first section of *Pollock and After* if he had given permission, was also uncomfortably in disagreement with a generation of radicals during 1969–1970: those in the Art Workers Coalition, New York. For details of this disagreement, readers will have to read one of the 'legacies' of *Pollock and After*.[36]

Legacies

Much has happened within art history and criticism in the fifteen years since the first edition of *Pollock and After* in 1985.[37] My intention here is to characterize only some of those developments as they relate to the central concerns of texts collected in that anthology.[38] Developments related to the relationship between the social histories of art and feminist analyses have been discussed by, for example, authors included in *Pollock and After*: Fred Orton and Griselda Pollock in the introduction to their own collected essays and articles entitled *Avant-Gardes and Partisans Reviewed*, published in 1996.[39] Other art historians have argued that the texts produced in the 1970s are based on overly reductive relationships between art, culture and politics in the 1950s and 1960s, or that such relationships are the fictitious clichéd obsessions of left-wing intellectuals stuck in the 1960s. With reference to accounts of Abstract Expressionism such counter-revisions centered initially on responses to Serge Guilbaut's book *How New York Stole the Idea of Modern Art: Abstract Expressionism, Freedom, and the Cold War*, published in 1983.[40] The reactions were predicted in an early positive review by Patricia Hills in which she concludes: 'there will be those who will want to read Guilbaut's book in complete disbelief, holding to the credo that the history of art has nothing to do with politics, nothing to do with nationalism or with propaganda.'[41] Hills was right, though she probably did not expect the critical reaction to be extended to earlier texts from the 1970s. Within the Academy examples of critical reaction predicted by Hills are Irving Sandler's 'Introduction' to the selected writings of Alfred H. Barr Jr, published in 1986, and Stephen Polcari's 'Statement' as a joint editor of a special issue of the *Art Journal* devoted to Abstract Expressionism in 1988.[42] Out of this particular process of reaction I want to identify

two entwined strands of critical development, with parallel ones to be discussed subsequently.

The first strand is what I call the reaction of the institutionalized academe, particularly in the United States, with its focus on the canonical certainties of Museums and Galleries. Although these have been subject to protests and written critiques since the late 1960s, few have radically changed their central cultural concerns. For example, the Museum of Modern Art (MoMA) has continued to develop the museum's production of classic catalogues as defining moments in the paradigmatic discipline of modern art history and criticism. A recent phenomenon has been larger publishing ventures redefining and re-defending the source of official history.[43] The 'catalogue' has spawned the symposia publication[44] and the 'studies' series with MoMA competing with other institutions particularly European enterprises such as the Pompidou Centre in Paris.[45] In the counter-revisionist decade of the 1990s, the fourth and fifth of MoMA's 'Studies in Modern Art' have been devoted to reinvesting in positive representations of itself, its activities and major figures in its history.[46] Essays by Michael Kimmelman, in particular, Lynn Zelevansky and Helen Franc attempt to redress the critiques of MoMA, its touring exhibitions and the International Programme and Council as connected in various ways to Cold War ideology.[47] In 'Revisiting the Revisionists: The Modern, Its Critics and the Cold War' [Chapter 15], Kimmelman seeks to rebut the substance of critical texts that have appeared from the early 1970s to the early 1990s. He ranges from Cockcroft's critique of MoMA to T. J. Clark's 'In Defense of Abstract Expressionism' published in *October*, Summer 1994.[48] Significantly, Clark has continued, since the early 1980s, to develop arguments in his 'Clement Greenberg's Theory of Art' (in *Pollock and After* [Chapter 3]) which started out as a paper, 'More on the Differences Between Comrade Greenberg and Ourselves' delivered at a conference organized by Serge Guilbaut at Vancouver in 1981.[49] Greenberg presented 'To Cope With Decadence' and both papers produced a highly charged interchange.[50]

The second strand of critical development has been from within constituencies that sought to consolidate and to extend the type of analyses provided by Kozloff, Cockcroft, Hauptman, Jane de Hart Mathews and others from the seventies, and those by Guilbaut and others from the early 1980s. Early examples of the latter include significant re-evaluations of art and culture in post-war America such as Annette Cox's book *Art-as-Politics: The Abstract Expressionist Avant-Garde and Society*, 1982,[51] and Phyllis Rosenweig's *The Fifties: Aspects of Painting in New York*, a Smithsonian catalogue from 1980.[52] Within such a development there are books such as Erika Doss's, *Benton, Pollock, and the Politics of Modernism: from Regionalism to Abstract Expressionism*, 1991,[53] and texts that discuss the State's involvement in art and politics during the 1940s, as in the 'Advancing American Art' exhibition of 1946.[54] Out of this development we can identify critiques, produced in the 1990s, which began to re-evaluate earlier texts that were important to leftist constituencies. For example, Michael Leja in *Reframing Abstract Expressionism: Subjectivity and Painting in the 1940s*, published in 1993 [Chapter 18], is clear about how and why he is indebted to, but departs from, the Cockcroft to Guilbaut revisionism.[55] Similarly, Daniel Belgrad in *The Culture of Spontaneity: Improvisation and the Arts in American Society, 1940–1960*, 1998, offers an interdisciplinary development of and departure from both

Guilbaut's and Leja's approaches.[56] Perhaps the most insistent critique, from the left, is that made by David Craven in a series of publications, which began in a review article for *Art History* in 1985[57] and, to date, culminates in his *Abstract Expressionism as Cultural Critique: Dissent During the McCarthy Period,* 1999. In the latter he states:

> Significantly, the social history of art as applied to Abstract Expression-ism has been plagued, if not undermined, both by an inability to orches-trate an immanent critique and by an evident capacity to understand the failings of any dominant-ideology thesis. For all their undeniable and sometimes considerable merits, these studies often result in a form of left-wing populism laced with moralizing indignation. It is precisely because the social historians of art (whether Eva Cockcroft and Serge Guilbaut or T. J. Clark and Michael Leja) have so successfully forced other scholars to deal with the relationship between Abstract Expressionism and power that we must also admit that they have largely failed to address adequately the decentered and contradictory nature of this power relationship.[58]

No doubt Craven's strongly held views will, in turn, produce a variety of responses from both the academic right and academic left. The risk is that the academic right will inflate Craven's claims about 'failure' and see his critical engagement as symp-tomatic of factional fighting amongst social historians of art bidding for academic space within a citadel culture.

There have been other parallel developments, to which Craven has contributed, one of which has been a re-consideration of the relationship between criticism, for example the writings of Harold Rosenberg and Meyer Schapiro, and the early Cold War. For instance, Craven considers the work of Meyer Schapiro from the 1950s in 'Abstract Expressionism, Automatism and the Age of Automation', 1990,[59] [Chapter 12] and the special issue of *The Oxford Art Journal* devoted to Schapiro develops a deeper understanding of his importance to the social history of art since the 1930s.[60] Similarly, Fred Orton has sought to re-assert the historical importance of Harold Rosenberg's writings as 'necessary but insufficient' in understanding the period[61] [Chapter 13] and to re-consider the contradictions of the relationships between art, culture and the Cold War.[62] In relation to the latter there have been several publica-tions that have revealed the ideological character of the normalized claim that the baton of avant-gardism passed from 'Paris' to 'New York' in the period from the occupation of France by the Nazis and Vichy to the announcement of the Marshall Plan. Many of these have discussed the situation in France,[63] though Serge Guilbaut has also considered the relationship between France and the USA.[64]

A parallel strand of development has been the long neglected analysis of gender and ethnicity with reference to the 1940s and 1950s. Ann Eden Gibson's *Abstract Expressionism: Other Politics,* 1997,[65] [Chapter 16] provides important discussions of both gender and ethnicity. Gibson's essays on Norman Lewis also consider the relation-ships between African-American artists and Abstract Expressionism[66] and, in 1992, David Craven sought to redress the normal omission of Lewis's work from exhibitions of Abstract Expressionism by requesting that two of his paintings outside of the Tate

Gallery holdings be included in the exhibition 'Myth-Making: Abstract Expressionist Painting from the United States,' Tate Gallery Liverpool, 1991.[67] Other essays, such as Judith Wilson's on Hale Woodruff, have sought to reveal the selective exclusions of dominant histories as have catalogues at, for example, The Studio Museum in Harlem, New York, and Kenkeleba Gallery, New York, particularly those involving Ann Eden Gibson.[68] Anne Wagner's 'Lee Krasner as L.K.,' 1989, has been a highly influential discussion of gender identity.[69] Further examples are Anna Chave's 'Pollock and Krasner: Script and Postscript,' 1993,[70] [Chapter 17] and Griselda Pollock's 'Killing Men and Dying Women: A Woman's Touch in the Cold Zone of American Painting in the 1950s,' 1996.[71] Ellen Landau's work on Lee Krasner also importantly reminds us of the dominance of institutionalized attention to men in Abstract Expressionism.[72] The constructions of masculinity and of Abstract Expressionist personae have been addressed, directly or indirectly, by, for example, Michael Leja, Caroline Jones, Amelia Jones and Andrew Perchuk.[73] Ethnicity and the discourses of/on Abstract Expressionism have been considered by, amongst others, David Craven, W. Jackson Rushing, Lisa Bloom and Daniel Belgrad.[74]

A further area of investigation has been the institutional networks of galleries, dealers and collectors for whom the notion of the modern has a particular status where sublimated desire and investment portfolios meet. Whilst it is possible to piece together the relationships between the art market and the critical reception of art in the post-War consumerist boom in the United States from a variety of sources, a major focus for researchers has to be the invaluable work of Deirdre Robson on the art market in New York in the 1940s and 1950s.[75] [Chapter 14] Other important information on the art market and galleries has been published by Karl Meyer, Diane Crane and Steven Naifeh.[76]

Alongside such developments there have been publications by a social formation centered around the journal *October*, founded in 1976, and in particular Rosalind Krauss.[77] From the paradigmatic centre of this formation, texts especially those by Yves-Alain Bois, Benjamin Buchloh, Hal Foster, and Rosalind Krauss have been produced for *October*, for spin-offs such as 'October Books' and for the satellite sites of conferences, symposia and journals.[78] Although these have ranged across the whole terrain of the twentieth century, one of the major concerns has been to preserve a selective tradition of art and criticism since the Second World War. For Krauss, two central figures are Jackson Pollock and Clement Greenberg. Pollock has to be read, as Picasso has to be read, through a 'structure of oppositions' in which the theories of Wölfflin and Saussure are hybridized to mobilize acerbic critiques of anything, or anyone, *other*.[79] Krauss's view of Greenberg, a formative mentor,[80] is ambivalent for which the necessary but insufficient explanation relates to both the social and psychic spaces of 'Greenberg and the Group' in the sixties and to the public split between the two of them over Greenberg's controversial decision to order the stripping of paint from a number of David Smith's sculptures after the death of the artist. Greenberg was an executor of the Smith estate (Smith died in 1965) and Krauss's doctoral dissertation at Harvard University was a catalogue raisonné of Smith's sculptures. The public exchange between them, begun in 1974 with publications about Greenberg's act, was finally bitter on the letters page of *Art in America*, 1978.[81] In 1985, at the start of

The Originality of the Avant-Garde and Other Modernist Myths, Krauss claims that practically everything in her book stands in contradiction to what she calls the 'histori-cist' position represented by Greenberg's *Art and Culture*, published in 1961. Written in the decade after her public split from Greenberg, Krauss embraces the 'method' the 'discourse' of 'structuralism, with its later poststructuralist modifications, the analytic methods of which produced a radical inversion of the position on which *Art and Culture* depended.'[82] Arguably, the collection of essays in *The Originality of the Avant-Garde* was an attempt to provide a paradigmatic 'text' for the 1980s as Krauss, Michael Fried and others around *Artforum* had regarded Greenberg's *Art and Culture* for the 1960s.[83] Several years later, Krauss produced *The Optical Unconscious*[84] in which 'Six' is an extended essay on 'Greenberg' and 'Pollock' [Chapter 19] mixing several genres of writing not least that of personal memory and diary description.[85]

'America takes command': MoMA, the Whitney and rehabilitation

Has anything changed, since the publication of *Pollock and After*, within institutional accounts of the period since the 1940s? The answer is mixed. From the perspectives of the place and time of writing this essay, December 1999, there is evidence of a reinvigorated rehabilitation of many assumptions and evaluations rooted in the com-plexities of the early Cold War. For example, in 1999, the Whitney Museum of Ameri-can Art, New York, held its two-part exhibition entitled *The American Century: Art and Culture 1900–2000*. Part II of the exhibition, 1950–2000 (26 September 1999 to 13 February 2000), opened with the words: 'America Takes Command 1950–1960.' Both the overall title of the two-part exhibition and the opening headline to Part II evoke a rhetoric and a certainty about the possession of culture to be found in the 1950s and 1960s;[86] one that is re-claimed a decade after the collapse of both the Berlin Wall, 1989, and of the eastern bloc communist regimes.[87] The Whitney's con-fidence in who possesses the 'art and culture' of the twentieth century is consistent with shared contemporary assumptions. For instance, on the front cover of *The New York Times Magazine*, 28 November 1999, the lead feature is advertised: 'The Rehabilitation of Joe McCarthy' with the article, inside, entitled 'Cold War Without End' by Jacob Weisberg.[88] The article traces some of the effects of the CIA's release of the so-called Venona documents in 1995–6.[89] These were National Security Agen-cy's decoded Soviet encrypted diplomatic messages from 1939–1957. Counter-revisionists claim that the Venona documents not only confirm the guilt of Julius and Ethel Rosenberg, both executed in 1953, and of Alger Hiss but also that Senator McCarthy's Un-American Activities Committee basically 'got it right' about the Communist menace within the USA.[90] Not surprisingly, such claims are still debated and contested,[91] as is the overt and covert role of United States Government agencies, such as the CIA, from the 1940s onwards.

However, institutionalized confidence in the century being essentially 'American' is not without its embarrassments. In October 1999 more revelations about Nixon were published with the release of a batch of conversations secretly taped by the President, from February to July 1971, at the time that the Pentagon papers were

published by *The New York Times*.[92] He is heard to demand that no one in the White House provide any information to the newspaper's Washington Bureau, then headed by Max Frankel whom Nixon is heard to describe as: 'that damned Jew Frankel . . . he's bad, you know. Don't give him anything.' Nixon then turned the conversation to people targeted in anti-Communist investigations during the 1940s and 1950s: 'The only two non-Jews in the Communist conspiracy,' he says 'were Chambers and Hiss. Many felt Hiss was. He could have been half, but he was not by religion . . . Every other one was a Jew. And it raised hell with us.'[93] One of the consequences of such prejudice and paranoia during the early Cold War years of the 1950s in America was that thousands of federal civil servants were either dismissed or resigned while under investigation, hundreds of teachers were dismissed and hundreds black listed in the film industry, television and radio. People were arrested for deportation because of their politics and hundreds of scientists and university teachers lost their jobs.[94] Within a set of struggles in the late 1990s over the meaning of the early Cold War, the Whitney's drive to invest in a particular cultural and political imperative, that of 'America Takes Command', is, arguably, to re-subscribe to a dominant selective tradition, to conserve a particular legacy.

We should ask, too, whose 'America' is being claimed in the Whitney's phrase, and is it significantly different from 'America' in the 1950s? To ask such a question has become unavoidable to all except those for whom the nation state is defined by a set of unquestioned assumptions about what and who constitutes the United States of America. What constituency, which groups, which individuals? Consider just one individual, marked by difference, from 1999. An African–American woman, in her mid thirties, from Greensboro, North Carolina who is not a keen supporter of Jesse Helms, the Republican Senator representing North Carolina, whose reactionary reputation includes attacking the National Endowment for the Arts (NEA) as part of the so-called 'Culture Wars' during the late 1980s and early 1990s.[95] Sen. Helms does not represent her America but she learned early on that many official representatives and representations had constructed a history of another America. That is an America in which, for instance, the experiences of her family had been erased from the normalized accounts of South Carolina rice plantations reliant in the eighteenth and nineteenth centuries on slavery. Most plantations, like the one her ancestors from West Africa had been sold into, are now tourist attractions where the realities and records of black slaves have become marginalized if not obscured. As a teenager, she realized that only in the 'African–American' sections of libraries, archives and books stores are such realities and records represented. She sought out texts and sites that re-claimed the tangled and contradictory memories of denied histories; she was currently reading Victoria Bynum's *Unruly Women: The Politics of Social and Sexual Control in the Old South* and a friend had given her a copy of James Loewen's *Lies Across America: What Our Historic Sites get Wrong*.[96] Twenty years earlier in Greensboro, as a teenager with her parents, she had been amongst the dozens of spectators and television camera crews who had witnessed the murder of four white and one black anti-Ku Klux Klan demonstrators by members of the Klan and the American Nazi Party on 3 November 1979. As a student at Howard University, Washington, D.C. she had read about the artist and activist Jimmie Durham and the FBI's manipulation, in 1974, of

his text prepared for the Euro-American members of the Native American Support Committee (NASC).[97] Partly because of her formative experiences, she had also become involved in the case of Leonard Pelitier, a Native American activist who was imprisoned in 1977 for the 1975 shoot out between the FBI and the American Indian Movement (AIM) in which two federal agents and an Indian man were killed. Four years later documents released under a Freedom of Information Act suit proved his innocence and the FBI's use of a Counter Intelligence Programme (COINTELPRO) set up in the 1960s to destroy any organization deemed by the Government, FBI or CIA to be politically or socially dissident. The AIM was one, the Black Panthers another. In 1999 she attends protests in Washington D.C. to seek the release of Pelitier, who is still in prison, and visits the Corcoran Gallery to see an exhibition she first saw in the Studio Museum in Harlem: *To Conserve a Legacy: American Art from Historically Black Colleges and Universities.*[98] The legacy in this exhibition, including that of her own university, is not a conspicuous part of the legacies that structure the Whitney's *American Century* Exhibition. In Part Two the representation of post–1945 American art and culture is one in which Jackson Pollock is placed as a symbolic 'eye of the needle' for subsequent cultural developments of the 1950s and 1960s.

Whilst visiting *To Conserve a Legacy*, she recalled recently seeing an exhibition at the Weatherspoon Gallery, the University of North Carolina, in her home town of Greensboro: *Looking Forward, Looking Black.*[99] The exhibition included works by, for example, Kara Walker, Renée Cox, Glen Ligon, Carrie Mae Weems, and Lyle Ashton Harris, which engage with the cultural critiques of racial stereotypes in the United States.[100] Though critical of some of the arguments made in the catalogue she is glad to have seen such works and their contemporary place in that 'legacy' of 'American Art' represented by *To Conserve a Legacy*. She thought of these powerful images in relation to her own research and teaching and returned to New York where, before returning to her university department, she had time to work in the Schomburg Center for Research in Black Culture, New York Public Library and in the Archives of American Art, New York branch. The Whitney's 'American Century' is still on her mind not least because there is so much in her mind that the exhibition marginalizes and erases. She reads the reviews of the major three part re-hang of the Museum of Modern Art, New York entitled *MoMA 2000*. MoMA has for decades, most famously since the publication of the 'Barr Diagram' in 1936, represented a particular and highly influential history of modern art often criticized for the grounds of its selectivity and emphases on euro-centric male assumptions. Referred to as the 'Kremlin of Modernism' MoMA's gallery displays have constructed a narrative of modern art in which the baton of European modernism is passed from Paris to New York around the time of the Second World War.[101] Perhaps there has been a radical change in this canonical narrative? Before visiting MoMA to see for herself, a friend lends her a copy of the three brochures and the new 'catalogue' publication *ModernStarts: People, Places, Things,* all of which accompany the first of the three exhibitions.[102] The first brochure, *People,* describes the entrance, on the second floor, to this initial part of *MoMA 2000*. This entrance dedicated to Alfred H. Barr Jnr has been the conventional start of the museum's labyrinth and narrative overseen for years by Cézanne's *The Bather,* c.1885. The description and the two works of art newly chosen by MoMA to hail the

viewing subject make, she thought, implicit historical, political and gendered claims: Aristide Maillol's *The River*, 1938–43, and Barnett Newman's *Vir Heroicus Sublimis*, 1950–51. Maillol's sculpture of a horizontal naked woman cast in the dead weight of poisonous lead is, the brochure claims, a 'metaphor' of the 'natural world.' It is, too, within MoMA's conventions a symbol of French culture at a time of danger or decline under Hitler and Vichy. By contrast, Newman's enormous composition, with its evocation of the 'heroic sublime' is, as the brochure reminds the reader, a metaphor of 'masculinity' and 'verticality.' Within MoMA it is also a cultural symbol of the United States after 1945. Juxtaposed at the entrance, these two works evoke a famous claim made by Greenberg in 1948: 'the main premises of Western art have at last migrated to the United States, along with the center of gravity of industrial production and political power.'[103]

In *ModernStarts: People, Places, Things* she reads the museum's claim to be providing 'an unconventional guide to the beginnings of modernism,' identified as the period 1880–1920 and based on the 'old organization of genres, or traditionally standardized types or classes of subject matter, which – before modernism upset things – were organized into a hierarchy that began with figure compositions and portraits, continued with landscapes, and ended with still lives. Hence People, Places, Things.'[104] But this explanation seems odd for, as she recalls from an art history class she studied as part of her undergraduate degree, it was 'History Painting' that was at the pinnacle of the conventional hierarchy of genres. And the strangely unhistorical phrase 'before modernism upset things' sounded to her consistent with Alfred Barr's phrases, from 1936, for describing the development of abstract art in the early twentieth century: Barr claimed that the so-called 'more adventurous and original artists had grown bored with painting facts' and 'by a common and powerful impulse they were driven to abandon the imitation of natural appearance.'[105] There were more signs that there was no actual radical rethink of the canon and of MoMAs unquestioned belief in its authority. Was this just a re-packaging of MoMA as text? She reads John Elderfield's confident assertion that 'the period 1880–1920, to which this project is devoted, is when the "modern" starts, when modern art starts.'[106] Though she is glad to read his reference to 'multiple histories', she is dismayed to see an unquestioned belief in the 'modern' as synonymous with the institutional hegemony of the Museum of Modern Art, New York:

> We assert that the 'modern' starts in the period 1880–1920. We do so because this project draws solely upon the collection of The Museum of Modern Art. The Museum, founded in 1929, first devoted itself to the art of the preceding fifty years, which means that its collection, in the main, begins around 1880. The present exhibition is the first of three that examines its collection, in equal chronological divisions – 1880–1920; 1920–1960; and 1960–2000. Thus, the precise period when the modern starts is something we have taken as given, and do not argue for it here.[107]

Although Elderfield states that 'far too much' has been written about the most famous MoMA narrative, the diagram which was on the cover of *Cubism and Abstract Art*, 1936, little of the theorization and canonization begun by Barr and elaborated by

subsequent curators and directors appears to have been revised. Elaboration is even evident in Elderfield's discussion of Malevich's *Analytical Chart,* c.1925, which represents the artist's view of the development from nineteenth-century academic conventions to Suprematist compositions (one of Malevich's own) via Cézanne and Cubism. Malevich's *Chart* is described as 'an early, biased, hindsight . . . very selective view of the period . . . And yet it does capture the big shift from figural language to figural composition . . . [to] the pictorial field.'[108] The latter phrase stimulates her recollections, from her courses on 'Theorizing Modernism,' that Elderfield had been a Greenbergian in his formative years and early publications in *Artforum.* Further, she detects strong gender assumptions in Elderfield's notions of 'the artist' and of 'the beholder'. She particularly focused on Elderfield's use of 'his', 'he' and 'us':

> . . . one of the most important innovations of this period was the internalization of represented, narrative subject matter within the form of the execution, which effectively relocated the narrative component of a painting to its representation in the perception of the beholder. The artist thus challenges the beholder to encourage his participation, and elicits ever more from the beholder when he holds us by the intricate power of a narratable content. Only, that is now deep within the enacted form of the image – in the shaping of the lines, the composition, and the color – as within the writing of words.[109]

Historically, she quickly indexed these claims to Greenberg's 'Modernist Painting,' 1961, and to Michael Fried's notion of the beholder in 'Art and Objecthood', 1967.[110] As for the gendered (and she thought, ethnic and classed) presumptions about the 'artist', the 'beholder' and undifferentiated beholders as a collectivized 'us', she drew upon a number of writers on the gaze. As an African–American woman recently re-reading Franz Fanon, she was acutely aware of the colonizing character of the language of erasure of the 'other' in *ModernStarts: People, Places, Things.* Intellectually, historically, emotionally, psychically, she felt no different after visiting MoMA to see the enactment in the modes and selections of display. At the entrance to *People,* Maillol's supine sculpture of a naked woman as 'river' is located, whether consciously or not, as a symbol of a feminine 'fall' and 'decline' of Paris after 1939. It is placed so that viewers gaze beyond to Newman's Abstract Expressionist 'heroic sublime', used here as a symbol of the proposed masculine power of the United States as cultural haven of one version of modernism. She thought again of what Greenberg dared to claim in the 'Decline of Cubism' in 1948[111] and of the two double-page spreads, on 'Jackson Pollock' and 'Arms for Europe' in *Life* magazine in August 1949.[112] She concluded that nothing much had changed between then and now.

Pollock and After: revisions

There was a strong temptation to reprint *Pollock and After* as it was. However, I decided that this option was problematic, not least the relevance of an anthology from

1985 for a changed audience. A full revision was not possible, either, without completely rethinking the book. Therefore, I made some strategic decisions. First, it was important to retain the historical aspects of the collection: to represent a particular politicized moment in the 1970s when a review of the history of art and criticism since the 1940s was gaining strong momentum. The case study, and I stress that it was one case study, in Part Two of the original anthology was 'Abstract Expressionism.' I have retained that example. There were important parallels during the 1970s in the production of texts by individuals and collectives that analyzed and debated representations and misrepresentations with reference to gender and race. These were not specifically about, for example, 'Abstract Expressionism' but rather constituted a series of interventions, using other cases of the relationships between power, selectivity, institutions, marginalization and language. Clearly, these are vital to a full understanding of the period since the mid-1960s. *Pollock and After* only aimed in 1985, and again now, to consider *aspects* of such an understanding.

There are some art historians who would urge a pruning of Part Two on the grounds that such texts have done their work or that the story of the 'depoliticization' of post-war American art is no longer news. I would argue that both views are mistaken. First, these texts are important not only for understanding debates about the post-war period but also they reveal much about aspects of the history of art criticism and art history in the 1970s and 1980s. Second, was there a 'depoliticization' amongst artists and critics? This is still much debated and contested not least because of the evidence of the politics of the Abstract Expressionist artists and their interpreters in the context of the 1950s. There also needs to be careful analysis of claims for 'depoliticization' or of the claimed separation of art and politics as themselves political claims. Third, these texts are still much quoted, read, referred too and sought. I have, therefore left Part Two intact save for the addition of an edited version of Jane de Hart Mathews influential article [Chapter 8] for which there was no space in the first edition.

A second decision was to readdress a problem I had to confront with the first edition. In the early 1980s Meyer Schapiro declined permission to reprint texts that he had written in the 1930s. In order to characterize the origins of debate and controversy I wished to include both the writings of Clement Greenberg and those by Schapiro particularly his 'The Social Bases of Art', 1936, and 'Nature of Abstract Art,' 1937. To try to incorporate them in a new edition raised more problems. There are practicalities of space. There are arguments about the importance of other writers and texts. Further there are the shifts, changes and contradictions in both Greenberg's and Schapiro's writings particularly in the changed political priorities of the 1950s. To include a range of texts from the late 1930s to the 1950s would be to make *Pollock and After* more of an anthology of contemporary publications and to make it a much larger volume. In order to draw readers' attention to debates about the place and position of Schapiro's and Rosenberg's writings I have included articles, in Part Three, by David Craven and Fred Orton respectively [Chapter 12 and 13].

A third decision was to change completely the content of Part Three. The main reason was to create space for publications since the mid-1980s that have developed, expanded and critiqued texts addressing the relationship between art, criticism and the Cold War in the USA. The texts contained in this revised edition represent

exemplary strands of the debates and they are presented in a thematic order. The first two texts discuss the writings of Schapiro (by Craven) and Rosenberg (by Orton). The next two consider aspects of the art market and institutions, particularly MoMA, in relation to the arguments put forward in revisionist texts. These are by A. Deirdre Robson on the time lag between art market and critical responses to the Abstract Expressionists, and by Michael Kimmelman on MoMA [Chapters 14 and 15]. The third pair of texts, by Anne Eden Gibson and Anna C. Chave, consider fundamental issues of gender and ethnicity in relation to Abstract Expressionism [Chapters 16 and 17]. Lastly, there are two differing texts on masculinity and the authorial voice with extracts from larger works by Michael Leja and Rosalind E. Krauss, both of whom are concerned with identity and Abstract Expressionism [Chapters 18 and 19].

Notes

1 A phrase used in July 1999 by an anonymous reader, from the United States, of the first edition of *Pollock and After: the Critical Debate*, London and New York, Harper and Row, 1985.

2 I will cite just two examples of reactionary cultural interventions during these political regimes where there was a systematic attack on trades unions, previous progressive legislation and what was described as the 'legacy of the Sixties.' In 1982, the first issue of *The New Criterion*, New York, opened with a statement by the editors (including Hilton Kramer) attacking recent analyses of the relationships between art and politics including teaching in universities and the publications of T. J. Clark, Dore Ashton, Lucy Lippard and Fred Orton and Griselda Pollock. The editors asserted that the so-called 'leftward turn' was 'the aftermath of the insidious assault on mind that was one of the most repulsive features of the radical movement of the Sixties,' vol. I, no. I, September 1982, p. 2. See, too, further instances such as Hilton Kramer, 'T. J. Clark and the Marxist Critique of Modern Painting,' *The New Criterion*, vol. 3, no. 7, March 1985, pp. 1–8. *The New Criterion* was a site for reactionary critiques that contributed to the attacks on the National Endowment for the Arts in the late 1980s (see latter). Parallel assaults can be observed in the United Kingdom particularly on courses in universities. These can be traced back to a right wing publication Julius Gould, *The Attack on Higher Education: Marxist and Radical Penetration*, London, Institute for the Study of Conflict, September 1977, and to the election of the Thatcher Government in 1979. By 1985 several courses in higher education had been subjected to a series of allegations. For example see Richard Hoggart's 'What Price Self-Government?' *Universities Quarterly*, vol. 39, no. 4, Autumn, 1985, pp. 290–93. In this special issue dealing with the government's recent Green Paper on Higher Education, Hoggart alludes to Sir Keith Joseph's (Secretary of State at the Department of Education and Science) sympathy towards Thatcherite complaints about 'left-wing bias' in universities (Hoggart, as Principal of Goldsmiths College University of London, was aware of instances of such complaints to the DES including one about Goldsmiths). In 1985 in the same week as a lengthy anonymous politicized complaint about an Open University course (A315 *Modern Art and Modernism: Manet to Pollock*) was delivered to the Open University from the DES, George Walden, Under Secretary at the DES and responsible for Higher Education published, in *The Spectator*, an attack on the social

history of art including T. J. Clark's work and the Open University course materials (Clark had also been the external assessor for the course): 'Painting and Politics,' *The Spectator*, 13 July 1985, pp. 28–9. An example of Walden's rhetoric is as follows: 'Letting the ideologues loose on painting is dangerous enough; giving them "new interpretative tools" as well is lethal. Semiotics in the hands of a leftist art critic are like computers at the fingers of sociologists: whole new permutations of misconceptions become possible' (p. 28). In contrast, Walden praised a number of writers including Roger Fry and Clement Greenberg. It is instructive to compare Walden's views (and those of *The New Criterion*) with those to be found in the 1980s in *The Salisbury Review* (a Conservative political journal), edited by Roger Scruton, and *Modern Painters*, edited by Peter Fuller (Fuller also wrote for *The Salisbury Review*). The complaint about A315 claimed that the course was 'revolutionary and subversive . . . with the ultimate objective as the destruction of the *democratic parliamentary* system.' After a lengthy investigation by a Pro-Vice Chancellor of the University, the complaint was demonstrated to be misconceived. However, in the culture of Thatcherite threats, it had a dissuasive effect detailed by Francis Beckett, 'Academics watch their backs,' *Independent*, 15 September 1988. As we now know, the 'Gould project' had government followers. See, for example, disclosure of the government's covert attack on the high profile Peace Studies Department at Bradford University at the height of the 1980s CND campaign (Martin Wainwright, 'Thatcher War on Peace Studies,' *Guardian*, 16 October 1993, p. 9). Also: Stephen Bates, '[John] Major Targets Left Ideas in Schools,' *Guardian*, 29 June 1992, p. 7.

3 O. K. Werckmeister, *Citadel Culture*, Chicago and London, The University of Chicago Press, 1991, pp. 28–9. See, too: Edward Said, 'Opponents, Audiences, Constituencies and Community,' in Hal Foster (ed.) *The Anti-Aesthetic: Essays on Postmodern Culture*, Port Townsend, Washington, Bay Press, 1983 (reprinted in Britain as *Postmodern Culture*, London, Pluto Press, 1985); Frank Lentricchia, *After the New Criticism*, Chicago and London, The University of Chicago Press and Athlone Press, 1980; J. G. Merquoir, *From Prague to Paris: A Critique of Structuralist and Post-Structuralist Thought*, London, Verso, 1986; Terry Eagleton, *The Ideology of the Aesthetic*, Oxford and Cambridge, Blackwell, 1990.

4 Max Kozloff, 'American Painting During the Cold War,' *Artforum*, vol. 11, no. 9, May 1973, pp. 43–54.

5 On the politics of remembering see Meta Mendel-Reys, *Reclaiming Democracy: The Sixties in Politics and Memory*, New York and London, Routledge, 1995, and Marita Sturken, *Tangled Memories: The Vietnam War, the Aids Epidemic, and the Politics of Remembering*, Berkeley, Los Angeles and London, University of California Press, 1997.

6 On this see 'Researching Alternative Histories of the Art Left' and 'Culture Wars and the American Left' in Francis Frascina, *Art, Politics and Dissent: Aspects of the Art Left in Sixties America*, Manchester and New York, Manchester University Press, 1999, pp. 1–14, 209–234.

7 Nixon was president of the student body at Duke. The university later declined the gift of his Presidential Library.

8 In October 1999 Nixon and the late 1940s were again evoked with the release of previously unpublished documents from the Hiss case. In December 1998 scholars petitioned for records in the case to be unsealed. Following a court order (13 May 1999), in October 1999 the Justice Department released documents, totalling about 4,200 pages, including 51 pages of the transcripts of Nixon's speech, 13 December 1948, before a Federal grand

jury in New York which was investigating the case against Alger Hiss. The transcripts reveal that in his speech to the court Nixon, then a young member of the House Committee on Un-American Activities (HUAC), subtly 'built a case that sought to leave the jurors with no alternative but to indict Hiss.' Two days after Nixon's speech Hiss was indicted ('Nixon Lobbied Grand Jury to Indict Hiss in Espionage Case, Transcripts Reveal,' *The New York Times*, 12 October 1999, p. A25). In the context of rabid anti-Communism Nixon's speech, his role generally in the Hiss case and his activities on the HUAC catapulted his career. See Nixon's confirmation of such a view and the effect of the Hiss case on Nixon in shaping his 'attitude to the war in Vietnam' (essentially an anti-Communist domino theory) in his 'Lessons of the Alger Hiss Case,' *The New York Times*, 8 January, 1986. For Nixon's interest in American values, art and the activities of Rep. Dondero in the 1950s see Frascina, op. cit., pp. 222–23.

9 Eva Cockcroft, 'Abstract Expressionism: Weapon of the Cold War,' *Artforum*, vol. 11, no. 10, June 1974, pp. 39–41.

10 *The New York Times*, 25, 26, 27, 28, 29 April 1966. Also see 'The C.I.A. and How it Grew,' *The New York Times*, 18 April 1965, Section 4, E5.

11 'CIA Is Spying From 100 Miles Up; Satellites Probe Secrets of the Soviet Union,' *The New York Times*, 27 April 1966, p. 28.

12 For example see: Bertrand Russell, 'A Communication,' *Frontier*, vol. 17, no. 4, February 1966, pp. 26–7; Sol Stern, 'NSA and the CIA,' *Ramparts*, vol. 5, no. 9, March 1967, pp. 29–38 (and Michael Wood, 'An Epilogue . . . ' and Marcus Raskin, ' . . . And A Judgment,' pp. 38–9).

13 Thomas Braden, 'I'm Glad the CIA is Immoral,' *Saturday Evening Post*, 20 May 1967, pp. 10–14. Christopher Lasch, 'The Cultural Cold War: a Short History of the Congress for Cultural Freedom' in Barton J. Bernstein (ed.) *Towards a New Past: Dissenting Essays in American History*, New York, Pantheon Books, 1968, pp. 322–59. For a recent study see Frances Stoner Saunders, *Who Paid The Piper: The CIA and the Cultural Cold War*, London, Granta Books, 1999. Saunder's book is useful but does not engage with a number of texts and issues. One that relates to the CIA, the United States and the United Kingdom is the 'Unknown Political Prisoner Episode.' On this see Robert Burstow, 'Butler's Competition Project for a Monument to *The Unknown Political Prisoner*: Abstraction and Cold War Politics,' *Art History*, vol. 12, no. 4, December 1989, pp. 472–96 and Robert Burstow, 'The Limits of Modernist Art as a "Weapon of the Cold War": Reassessing the Unknown Patron of the Monument to the Unknown Political Prisoner, *Oxford Art Journal*, vol. 20, no. 1, 1997, pp. 68–80.

14 See *Walter Hopps: Pasadena Art Museum*, Walter Hopps interviewed by Joanne L. Ratner (Department of Special Collections, Oral History Programme, University Research Library, UCLA, 1990) especially pp. 80–93. Generally see ' "We Dissent": the Artists' Protest Committee and representations in/of Los Angeles', Frascina, op. cit., especially pp. 41–43.

15 'The Artist and Politics: a Symposium,' *Artforum*, vol. 9, no. 1, September 1970, pp. 35–9.

16 Peter Plagens, 'Los Angeles: the Ecology of Evil,' *Artforum*, vol. 11, no. 4, December 1972, pp. 67–76; William Hauptman, 'The Suppression of Art in the McCarthy Decade,' *Artforum* vol. 11, no. 2, October 1973, pp. 48–52.

17 Though some art historians have suggested that these articles were more a reaction or

response to Irving Sandler, *Abstract Expressionism: The Triumph of American Painting*, New York, Praeger, 1970.

18 Coplans had been the Associate Editor (Los Angeles) of *Artforum* since the 1960s.

19 On Leider and *Artforum* see Frascina, op. cit., especially pp. 82–87, 137–49.

20 *Walter Hopps: Pasadena Art Museum*, op. cit., p. 86.

21 For an example of persistence see David Craven, 'New Documents: The Unpublished F.B.I. Files on Ad Reinhardt, Mark Rothko, and Adolph Gottlieb,' in David Thistlewood (ed.) *American Abstract Expressionism*, Liverpool, Liverpool University Press and the Tate Gallery Liverpool, 1993, pp. 41–52, and Craven, 'The FBI Files on the New York School,' chapter 3 of *Abstract Expressionism as Cultural Critique: Dissent During the McCarthy Period*, Cambridge, Cambridge University Press, 1999. Artists, especially those who were also politically active, have obtained copies of some of their FBI files. Typically, pages in these documents are characterized by lines and lines of blacked out details (on the grounds of 'National Security') with only the artist's name left untouched.

22 Clement Greenberg, *The Collected Essays and Criticism*, edited by John O'Brian, Chicago and London, The University of Chicago Press: Volume 1 *Perceptions and Judgments, 1939–1944*, 1986; Volume 2 *Arrogant Purpose, 1945–1949*, 1986; Volume 3 *Affirmations and Refusals, 1950–1956*, 1993; Volume 4 *Modernism with a Vengeance, 1957–1969*, 1993.

23 These have included Kay Larson, 'The Dictatorship of Clement Greenberg,' *Artforum*, summer 1987, vol. 25, no. 10, pp. 76–79; Susan Noyes Platt, 'Clement Greenberg and the 1930s: A New Perspective on His Criticism,' *Art Criticism*, 1989, vol. 5, no. 3, pp. 47–64; Robert Storr, 'No Joy in Mudville: Greenberg's Modernism Then and Now,' in Kirk Varnedoe and Adam Gopnik (eds) *Modern Art and Popular Culture: Readings in High and Low*, New York, Abrams, 1990, pp. 161–190; Thierry de Duve, 'The Monochrome and the Blank Canvas,' in Serge Guilbaut (ed.) *Reconstructing Modernism: Art in New York, Paris and Montreal*, Cambridge and London, The MIT Press, 1990, pp. 244–310; David Craven, 'Clement Greenberg and the "Triumph" of Western Art,' *Third Text*, 25, Winter 1993–94, pp. 3–9; Nancy Jachec, 'Modernism, Enlightenment Values, and Clement Greenberg,' *Oxford Art Journal*, vol. 21, no. 2, 1998, pp. 121–132.

24 For example: Terry A. Cooney, *The Rise of the New York Intellectuals: Partisan Review and its Circle*, Madison, University of Wisconsin Press, 1986; Alan Wald, *The New York Intellectuals: The Rise and Fall of the Anti-Stalinist Left from the 1930s to the 1980s*, Chapel Hill and London, University of North Carolina Press, 1987; Maurice Isserman, *If I had a Hammer: The Death of the Old Left and the Birth of the New Left*, Urbana and Chicago, University of Illinois Press, 1993; Hugh Wilford, *The New York Intellectuals: From Vanguard to Institution*, Manchester and New York, Manchester University Press, 1995.

25 See the chapter 'The Facts of Culture: The Art Criticism of Clement Greenberg,' Annette Cox, *Art-as-Politics: The Abstract Expressionist Avant-Garde and Society*, Ann Arbor, UMI Research Press, 1982.

26 'The Plight of Our Culture': Part I ('Industrialism and Class Mobility'), *Commentary*, vol. 15, June 1953, pp. 558–66; Part II ('Work and Leisure Under Industrialism'), *Commentary*, vol. 15, August 1953, pp. 54–62.

27 *Commentary*, vol. 22, October 1956, pp. 379–81.

28 On this see my 'The Politics of Representation,' Chapter 2 of Paul Wood, Francis Frascina, Jonathan Harris, Charles Harrison, *Modernism in Dispute: Art Since the*

Forties, New Haven and London, Yale University Press, 1994, especially pp. 142–145, and my *Art, Politics and Dissent*, op. cit., especially pp. 142–146.

29　For example see: my 'Greenberg and the Politics of Modernism,' *Art Monthly* 111, November 1987, pp. 6–11; Ian McClean, 'Modernism and Marxism, Greenberg and Adorno,' *Australian Journal of Art*, vol. 7, 1988, pp 97–111; Peter Osborne, 'Aesthetic Autonomy and the Crisis of Theory: Greenberg, Adorno, and the Problem of Postmodernism in the Visual Arts', *New Formations*, 9, Winter 1989, pp. 31–50; Jay Bernstein, 'The Death of Sensuous Particulars: Adorno and Abstract Expressionism', *Radical Philosophy*, No 76, March/April 1996, pp. 7–18. Nancy Jachec, 'Adorno, Greenberg and Modernist Politics,' *Telos*, no. 110, Winter 1998, pp. 105–118.

30　First published in *Die Neue Rundschau*, 1962; English translation by Francis McDonagh in *Aesthetics and Politics*, London, New Left Books, 1977, pp. 177–95.

31　Theodor Adorno et al., *The Authoritarian Personality*, New York, Harper, 1950. On Greenberg and the authoritarian personality see Frascina, 'Frascina on Greenberg,' *Art Monthly* 178, July–August, 1994, pp. 18–19.

32　On Adorno's view of the United States see his 'Scientific Experiences of a European Scholar in America,' in D. Fleming and B. Bailyn (eds) *The Intellectual Migration: Europe and America, 1930–1960*, Cambridge, Mass., The Belknap Press of Harvard University Press, 1969.

33　Letter from Adorno to Maurice English, 19 February 1962, in the Greenberg Papers, Archives of American Art, Smithsonian Institution, Washington D.C.

34　For Greenberg's attempts to expose his former colleagues on *The Nation* as Communist sympathizers and Rep. Dondero's use of these claims in the Congressional record see Annette Cox, *Art-as-Politics*, op. cit., for example p. 142.

35　See Esther Leslie, 'The Frankfurt School and the Student Movement' and Theodor Adorno and Herbert Marcuse, 'Correspondence on the Student Revolutionaries,' *New Left Review* 233, January–February, 1999, pp. 118–136.

36　See 'My Lai, *Guernica*, MoMA and the Art Left, New York, 1969–70,' in Frascina, *Art, Politics and Dissent*, op. cit., 160–208.

37　With reference to Abstract Expressionism see subsequent footnotes, and anthologies such as: Michael Auping (ed.) *Abstract Expressionism: The Critical Developments*, New York, Abrams, 1987; and David Shapiro and Cecile Shapiro (eds) *Abstract Expressionism: A Critical Record*, Cambridge, Cambridge University Press, 1990.

38　To do anything other would be to enter into a completely new project.

39　Manchester and New York, Manchester University Press, 1996.

40　Chicago and London, The University of Chicago Press, 1983.

41　*Archives of American Art Journal*, vol. 24, no. 1, 1984, p. 28.

42　*Defining Modern Art: Selected Writings of Alfred H. Barr Jr.*, edited by Irving Sandler and Amy Newman with an introduction by Irving Sandler (see Sandler's 'Introduction,' especially pp. 42–47); Stephen Polcari, 'Abstract Expressionism: "New and Improved",' special issue of *Art Journal* on 'New Myths for Old: Redefining Abstract Expressionism' (Guest Editors: Ann Gibson and Stephen Polcari) vol. 47, no. 3, Fall 1988, pp. 174–180. See, too, Polcari, *Abstract Expressionism and the Modern Experience*, Cambridge, Cambridge University Press, 1991.

43　On paradigms, Alfred Barr's *Cubism and Abstract Art*, 1936, and the early theorizing of modern art see the introduction to Part One of the first edition of *Pollock and After* [pp. 29–47].

44 One example is *Picasso and Braque: A Symposium*, New York, MoMA, 1992, following and legitimating the exhibition *Picasso and Braque: Pioneering Cubism*, 1989, at MoMA, which had its own hefty catalogue. For a critique of the methods and approaches in the symposium see Patricia Leighten, 'Cubist Anachronisms: Ahistoricity, Cryptoformalism, and Business-as-Usual in New York,' *Oxford Art Journal*, vol. 17, no. 2, 1994, pp. 91–102. The massive Jackson Pollock retrospective at MoMA, which opened in 1998, also had an enormous catalogue and we await the publication of the symposium papers and discussions.

45 See MoMA's 'Studies in Modern Art' series, a publishing vehicle for the Museum's Research and Scholarly Publications Programme. On the Pompidou Centre [Beaubourg] and its early catalogues see: 'Beaubourg: the Containing of Culture in France' by the Cultural Affairs Committee of the Parti Socialist Unifé, *Studio International*, vol. 194, no. 988, 1/1978, pp. 27–36.

46 *The Museum of Modern Art at Mid-Century, At Home and Abroad*, 'Studies in Modern Art 4,' New York, MoMA, 1994; *The Museum of Modern Art at Mid-Century, Continuity and Change*, 'Studies in Modern Art 5', New York, MoMA, 1995. In particular, Michael Kimmelman's 'Revisiting the Revisionists: The Modern, Its Critics and the Cold War' attempts to rebut the substance of critical texts that have appeared since the late 1960s, in 'Studies in Modern Art 4,' pp. 38–55.

47 All in 'Studies in Modern Art 4.'

48 T. J. Clark, 'In Defense of Abstract Expressionism,' *October* 69, Summer 1994, pp. 23–48. This essay should be placed in the context of T. J. Clark, 'Jackson Pollock's Abstraction', in Serge Guilbaut (ed.) *Reconstructing Modernism*, op. cit., pp. 172–238; and T. J. Clark, 'The Unhappy Consciousness' and 'In Defense of Abstract Expressionism' Chapters 6 and 7 of his *Farewell to an Idea: Episodes from a History of Modernism*, New Haven and London, Yale University Press, 1999.

49 In Benjamin H. D Buchloh, Serge Guilbaut, and David Solkin (eds) *Modernism and Modernity: The Vancouver Conference Papers*, Halifax, Nova Scotia, The Press of the Nova Scotia College of Art and Design, 1983, pp. 169–187.

50 Ibid., pp. 161–164 and pp. 165–168, 188–193.

51 Ann Arbor, UMI Research Press, 1982.

52 Washington D.C., Hirshhorn Museum and Sculpture Garden, Smithsonian Institution Press, 1980.

53 Chicago and London, The University of Chicago Press. 1991. See, too, Bradford Collins, '*Life* Magazine and the Abstract Expressionists, 1948–51,' *Art Bulletin*, vol. 73, no. 2, June 1991, pp. 283–308.

54 See, for example, Susan Sivard, 'The State Department "Advancing American Art" Exhibition of 1946 and the Advance of Modern Art,' *Arts Magazine*, vol. 58, no. 8, April 1984, pp. 92–99, and Taylor D. Littleton and Maltby Sykes, *Advancing American Art: Painting, Politics, and Cultural Confrontation at Mid-Century*, Tuscaloosa and London, The University of Alabama Press, 1989.

55 New Haven and Yale, Yale University Press, 1993. See, too, Leja's conference paper 'Slow Learners: The Challenges of Using Art for Cold War Cultural Diplomacy', 1998, forthcoming as part of the proceedings of a conference on Cold War Culture, Zagreb, 1998, and his earlier related paper given at the 'Cold War Culture' conference, University College London, October 1994.

56 Daniel Belgrad, *The Culture of Spontaneity: Improvisation and the Arts in American*

Society, 1940–1960, 1998, Chicago and London, The University of Chicago Press, 1998.

57 'The Disappropriation of Abstract Expressionism,' a review of books by William Seitz, Annette Cox and Serge Guilbaut, *Art History,* vol. 8, no. 4, December 1985, pp. 499–515. This issue also contained Adrian Rifkin's notorious review of T. J. Clark's *The Painting of Modern Life: Paris in the Art of Manet and His Followers,* 1985, 'Marx' Clarkism,' pp. 488–495. There is a case to be made for historically locating the effects from 1985 onwards of internal divisions within leftists writing about art and politics (something only begun in the 'Conclusion' to my *Art, Politics and Dissent:* see for example the sub-section 'Wall Street *culture'* pp. 213–15).

58 Craven, 1999, op. cit., p. 39–40.

59 *Art History,* vol. 13, no. 1, March 1990, pp. 72–103. See the response by Nancy Jachec, 'The Space Between Art and Political Action: Abstract Expressionism and Ethical Choice in Post War America,' *The Oxford Art Journal,* vol. 14, no. 2, 1991, pp. 18–29.

60 *The Oxford Art Journal,* vol. 17, no. 1, 1994 (guest edited by Craven).

61 Fred Orton, 'Action, Revolution and Painting,' *The Oxford Art Journal,* vol. 14, no. 2, 1991, pp. 3–17.

62 Fred Orton, 'Footnote One: the Idea of the Cold War,' in David Thistlewood (ed.) op. cit., pp. 179–192 (see, too, essays by Anfam, Craven, Gibson, Harris, Jachec and Rosenweig).

63 For example: Laurence Bertrand Dorléac, *Histoire de l'art, Paris 1940–1944: ordre national – traditions et modernités,* Paris, Publications de la Sorbonne, 1986; *L'Art en Europe: les anneés décisives 1945–1953,* Musée d'Art Moderne de Saint-Etiènne, Editions Skira, 1987; Michèle C. Cone, *Artists Under Vichy: A Case of Prejudice and Persecution,* Princeton, Princeton University Press, 1992; publications by Sarah Wilson such as 'Fernand Léger Art and Politics 1935–1955' in *Fernand Léger: The Later Years,* London, Whitechapel Art Gallery, 1987, pp. 55–75.

64 Serge Guilbaut, 'Postwar Painting Games: the Raw and the Slick,' in Serge Guilbaut (ed.) *Reconstructing Modernism: Art in New York, Paris and Montreal,* op. cit., pp. 30–79. Also, see my 'The Politics of Representation,' Chapter 2 of Paul Wood, Francis Frascina, Jonathan Harris, Charles Harrison, *Modernism in Dispute: Art Since the Forties,* op. cit., pp. 77–169, and my 'L'Art en Europe at Saint-Etiènne,' *Art Monthly,* 116, May 1988, pp. 17–20.

65 New Haven and London, Yale University Press, 1997.

66 See Ann Eden Gibson, 'Norman Lewis in the Forties,' *Norman Lewis: From the Harlem Renaissance to Abstraction,* New York, Kenkeleba Gallery, 1989, slightly modified in Thistlewood (ed.) op. cit., pp. 53–76; and the important publication Ann Eden Gibson et al., *The Search For Freedom: African American Abstract Painting, 1945–1975,* New York, Kenkeleba Gallery, 1991.

67 See David Craven, 'Myth-Making in the McCarthy Period,' in Penelope Curtis (ed.) *Myth-Making: Abstract Expressionist Painting from the United States,* Liverpool, Tate Gallery Liverpool, 1992.

68 Judith Wilson, ' "Go Back and Retrieve It": Hale Woodruff, Afro-American Modernist' in *Selected Essays: Art and Artists from the Harlem Renaissance to the 1980s,* Atlanta, National Black Arts Festival, 1988, pp. 41–49. Mary Schmidt Campbell (ed.) *Tradition and Conflict: Images of a Turbulent Decade, 1963–73,* New York, The Studio Museum in Harlem, 1985; Ann Eden Gibson et al., *The Search For Freedom,* op. cit.

69 Anne Wagner, 'Lee Krasner as L.K.' *Representations* 25, Winter 1989, pp. 42–57. See too: Anne Wagner, 'Krasner's Presence, Pollock's Absence,' in Whitney Chadwick, and

Isabelle de Courtivon (eds) *Significant Others: Creativity and Intimate Partnership*, London and New York, Thames and Hudson, 1993, pp. 223–43; Anne Wagner, *Three Artists (Three Women): Modernism and the Art of Hesse, Krasner and O'Keeffe*, Los Angeles and London, University of California Press, 1996.

70 Anna C. Chave, 'Pollock and Krasner: Script and Postscript,' *Res*, 24, Autumn 1993, pp. 95–111.

71 Griselda Pollock, 'Killing Men and Dying Women' in Fred Orton and Griselda Pollock, *Avant-Gardes and Partisans Reviewed*, Manchester, Manchester University Press, 1996, pp. 219–94.

72 Ellen G. Landau, *Lee Krasner: a Catalogue Raisonné*, New York, Abrams, 1995.

73 Michael Leja, *Reframing Abstract Expressionism: Subjectivity and Painting in the 1940s*, op. cit.; Caroline Jones, 'Finishing School: John Cage and the Abstract Expressionist Ego,' *Critical Inquiry*, vol. 19, no. 4, Summer 1993, pp. 628–625; Andrew Perchuk, 'Pollock and Postwar Masculinity,' Andrew Perchuk and Helaine Posner (eds) *The Masculine Masquerade; Masculinity and Representation*, Cambridge and London, The MIT Press, 1995, pp. 31–42; Michael Leja, 'Barnett Newman's Solo Tango,' *Critical Inquiry*, vol. 21, no. 3, Spring 1995, pp. 556–80; Caroline Jones, *Machine in the Studio: Constructing the Postwar American Artist*, Chicago, 1996; Amelia Jones, *Body Art/ Performing the Subject*, Minneapolis and London, University of Minnesota Press, 1998.

74 David Craven, 'Abstract Expressionism and Third World Art: A Post-Colonial Approach to "American" Art,' *The Oxford Art Journal*, Vol. 17, no. 7, 1991, pp. 44–66; David Craven, 'Clement Greenberg and the "Triumph" of Western Art' *Third Text*, 25, Winter 1993–4, pp. 3–9; W. Jackson Rushing, *Native American Art and the New York Avant-Garde, A History of Cultural Primitivism*, Austin, University of Texas Press, 1995; Lisa Bloom, 'Ghosts of Ethnicity: Rethinking Art Discourses of the 1940s and 1980s', *Socialist Review*, vol. 24, nos 1–2, 1995, pp. 129–63; Belgrad, op. cit.

75 A. Deirdre Robson, 'The Market for Abstract Expressionism; The Time Lag Between Critical and Commercial Acceptance,' *Archives of American Art Journal*, vol. 25, no. 3, 1985, pp. 19–23; A. Deirdre Robson, 'The Avant-Garde and the On-Guard: Some Influences of the Potential Market for the First Generation Abstract Expressionists in the 1940s and 1950s,' *Art Journal*, vol. 47, no. 3, Fall 1988, pp. 215–21; A. Deirdre Robson, *Prestige, Profit, and Pleasure: The Market for Modern Art in New York in the 1940s and 1950s*, New York and London, Garland Publishing, 1995.

76 See for example the statistics and tables in Diane Crane, *The Transformation of the Avant-Garde: The New York Art World, 1940–1985*, Chicago and London, The University of Chicago Press, 1987. Also Karl E. Meyer, *The Art Museum: Power, Money, Ethics*, New York, William Morrow and Company, 1979; Steven Naifeh, *Culture Making: Money, Success, and the New York Art World*, Princeton, Princeton Undergraduate Studies in History: 2, The History Department of Princeton University, 1976. Much of the latter informed the discussion of the role of the art market in Steven Naifeh and Gregory White Smith, *Jackson Pollock: An American Saga*, New York, Clarkson N. Potter, 1989.

77 There is a temptation to echo Barbara Reise and say 'Krauss and the Group'. See Barbara Reise, 'Greenberg and The Group: A Retrospective View,' *Studio International*, vol. 175, no. 901, May 1968, pp. 254–57 (Part 1) and vol. 175, no. 902, June 1968, pp. 314–16 (Part 2). Reprinted in Francis Frascina and Jonathan Harris (eds), *Art in Modern Culture*, London, Phaidon, 1992, pp. 252–263. Krauss was part of the 'group' around Greenberg in the 1960s.

78 See: Annette Michelson, Rosalind Krauss, Douglas Crimp, Joan Copjec (eds) *October: The First Decade, 1976–1986,* Cambridge and London, The MIT Press, 1987 and Krauss et al., (eds) *October: The Second Decade, 1976–1986,* Cambridge and London, The MIT Press, 1997.

79 For example see: Rosalind E. Krauss, 'Re-Presenting Picasso,' *Art in America,* December 1980, pp. 90–6. Rosalind E. Krauss, 'Life with Picasso: Sketchbook No. 92,' in Arnold Glimcher and Marc Glimcher (eds), *Je suis le cahier: The Sketchbooks of Picasso,* London, Royal Academy of Arts and Thames and Hudson, 1986. Rosalind E. Krauss, 'The Motivation of the Sign,' in *Picasso and Braque: A Symposium,* New York, The Museum of Modern Art, 1992. Rosalind E. Krauss, 'Contra Carmean: The Abstract Pollock,' *Art in America,* Summer 1982, pp. 123–131,155. Rosalind E. Krauss, *The Originality of the Avant-Garde and Other Modernist Myths,* Cambridge and London, The MIT Press, 1985.

80 See for instance: Rosalind E. Krauss, 'A View of Modernism,' *Artforum,* vol. 11, no. 1, 1972, pp. 48–51.

81 See 'Issues and Commentary' and Rosalind E. Krauss, 'Changing the Work of David Smith,' *Art in America,* September–October 1974, pp. 30–34; Hilton Kramer 'Altering of Smith Work Stirs Dispute', *The New York Times,* 13 September, 1974, p. 28; 'Arrogant Intrusion,' *Time,* 30 September, 1974, p. 49; 'Alter Ego,' *Newsweek,* 7 October 1974, p. 61; 'Letters' page (Letter from Joseph Henderson and reply by Krauss), *Art in America,* March-April 1975, p. 136; 'Letters' page (Letter from Greenberg and replies by Diane Upright Headley and by Krauss), *Art in America,* March–April 1978.

82 'Introduction,' *The Originality of the Avant-Garde and Other Modernist Myths,* op. cit., p. 2.

83 See my 'Picasso's Art: A Biographic Fact?' *Art History,* vol. 10, no. 3, 1987, pp. 401–415.

84 *The Optical Unconscious,* An October Book, Cambridge and London, The MIT Press, 1993.

85 Pp. 243–329. The descriptions of Greenberg evoke the bitterness of the final interchanges in the 'Letters' page, *Art in America,* March–April 1978. For a brief but revealing view of Krauss's critique of Greenberg (and Fried) in *The Optical Unconscious* see: Michael Fried, *Art and Objecthood: Essays and Reviews,* Chicago and London, The University of Chicago Press, 1998, p. 58, note 25.

86 Clement Greenberg even published an article titled 'America Takes the Lead 1945–1965,' *Art in America,* August–September 1965, pp. 108–129.

87 This coincides, too, with a rehabilitation of Reagan as the simple moralist, though hardly intellectually articulate President, who achieved the 'end' of the Cold War by forcing the financial bankruptcy of the Soviet Union through a capitalist driven military escalation.

88 *The New York Times Magazine,* 28 November, 1999, pp. 116–123, 155–158.

89 Robert Louis Benson and Michael Warner (eds) *Venona: Soviet Espionage and The American Response 1939–1957,* Washington, D.C., National Security Agency, Central Intelligence Agency, 1996; for all of the released documents see NSA Web Site: http://www.nsa.gov:8080/docs/venona; John Earl Haynes and Harvey Klehr, *Venona: Decoding Soviet Espionage in America,* New Haven and London, Yale University Press, 1999.

90 See for example: Ronald Radosh, 'The Venona Files,' *The New Republic,* 7 August 1995, pp. 25–27; Eric Breindel, 'Hiss's Guilt,' *The New Republic,* 15 April 1996, pp. 18–20.

91 See the response to Weisberg's 'Cold War Without End' from Victor Navasky, publisher of *The Nation, The New York Times,* 19 December 1999, Section 6, p. 18; also Maurice

Isserman, 'They Led Two Lives' *The New York Times*, 9 May 1999, p. 34; Nelson Lichtenstein, 'Commentary', *Los Angeles Times*, 9 November, 1998, p. 5.

92 Irving Molotsky, '1971 Tapes, Nixon Is Heard Blaming Jews for Communist Plots,' *The New York Times*, 7 October 1999, p. A21.

93 Ibid.

94 See, for example, David Caute, *The Great Fear: The Anti-Communist Purge Under Truman and Eisenhower*, London, Secker and Warburg, 1978.

95 See Richard Bolton (ed.) *Culture Wars: Documents from the Recent Controversies in the Arts*, New York, The New Press, 1992, and Brian Wallis, Marianne Weems, and Philip Yenawine (eds) *Art Matters: How the Culture Wars Changed America*, New York, The New Press, 1999.

96 Victoria Bynum, *Unruly Women: The Politics of Social and Sexual Control in the Old South*, Chapel Hill and London, The University of North Carolina Press, 1992; James Loewen, *Lies Across America: What Our Historic Sites Get Wrong*, New York, The New Press, 1999.

97 See his 'American Indian Culture: Traditionalism and Spiritualism in a Revolutionary Struggle,' 1974, first distributed and altered by the FBI in an attempt to discredit Durham. Re-circulated in its original form in 1977 and included in Jimmie Durham, *A Certain Lack of Coherence: Writing on Art and Cultural Politics*, London, Kala Press, 1993, pp. 1–22.

98 Richard J. Powell and Jock Reynolds (eds) *To Conserve a Legacy: American Art from Historically Black Colleges and Universities*, Cambridge, The MIT Press, 1999. Travelling to eight venues the exhibition was at the Corcoran Gallery of Art from 20 November, 1999 to 31 January, 2000.

99 29 August–31 October, exhibition catalogue: Jo Anna Isaak (ed.) *Looking Forward, Looking Black*, Geneva, New York, Hobart and William Smith Colleges Press, 1999.

100 Some of these artists are represented within the Whitney's show but as accommodations within a grand narrative that their works actually critique.

101 See Kirk Varnedoe's use of this phrase and of his discussion of the culmination of MoMA's gallery displays with Abstract Expressionism in Frascina, 'The Politics of Representation,' loc. cit., p. 77.

102 The brochures dedicated to the three staggered openings (one on each floor of the museum) of this first part of the three-part *MoMA 2000* are titled *People* (7 October 1999–1 February 2000), *Places* (28 October 1999–14 March 2000) and *Things* (21 November 1999–14 March 2000). The 'catalogue' (one of three publications) is: John Elderfield, Peter Reed, Mary Chan, Maria del Carmen Gonzàlez (eds) *ModernStarts: People, Places, Things*, New York, The Museum of Modern Art, 1999.

103 'The Decline of Cubism,' *Partisan Review*, vol. 15, no. 3, March 1948, p. 369. Further, on the walls flanking the entrance and as part of the *People* installation is an enormous work by Sol LeWitt, an artist from the United States: *On black walls, all two-part combinations of white arcs from corners and sides, and white straight, not straight, and broken lines*, 1975.

104 John Elderfield, 'Making ModernStarts,' *ModernStarts*, op. cit, p. 27.

105 Alfred H. Barr Jnr., 'Introduction,' *Cubism and Abstract Art*, New York, The Museum of Modern Art, 1936, p. 11.

106 Elderfield, loc. cit., p. 18.

107 Ibid., p. 18–19.

108 Elderfield, 'Representing People: the Story and the Sensation' in *ModernStarts*, op. cit., p. 48.

109 Ibid., p. 47.

110 Clement Greenberg, 'Modernist Painting,' 1961, Radio Broadcast Lecture 14 of *The Voice of America Forum Lectures: the Visual Arts*, reprinted, as spoken, in the paperback edition of all 18 Lectures, Washington D.C., United States Information Agency, 1965, pp. 105–11. After its broadcast, 'Modernist Painting' was published in *Arts Yearbook* 4, 1961, pp. 101–8. It appeared in revised form in *Art and Literature* 4, Spring 1965, pp. 193–201, and then in Gregory Battcock (ed.) *The New Art: A Critical Anthology*, New York, E. P. Dutton, 1966, pp. 100–110. Michael Fried, 'Art and Objecthood,' *Artforum*, vol. 5, no. 10, June 1967, pp. 12–23; also slightly revised in Gregory Battcock (ed.) *Minimal Art: A Critical Anthology*, New York, E. P. Dutton, 1968, reprinted with an introduction by Anne Wagner, University of California Press, Berkeley and Los Angeles, 1995. See, too Michael Fried, *Art and Objecthood: Essays and Reviews*, op. cit.

111 That 'the main premises of Western art have at last migrated to the United States, along with the center of gravity of industrial production and political power' in 'The Decline of Cubism', loc. cit., p. 369.

112 'Jackson Pollock: Is he the greatest living painter in the United States?' *Life*, 8 August 1949, pp. 42–3 and 'Arms for Europe: The top brass of the U.S. comes up with a program to defend Europe with revitalized European armies,' *Life*, 8 August 1949, pp. 26–7. See Frascina, 'The Politics of Representation,' loc. cit., especially pp. 124–128.

PART ONE

The critical debate and its origins

Introduction (1985)

During the 1970s and the 1980s there have been several critiques of conventional art history and major debates on the methods and procedures of art historians and art critics concerned with the 'modern period'. Informed by the interests and analytical tools of other disciplines, certain historians and critics began to consider questions and issues raised some time ago but submerged in the 1950s and 1960s by the dominance of Modernist critical theory and history. The sorts of questions and issues raised would not seem novel to *some* art historians of earlier art or to other types of historians who had been working in the post-war period. However, to many practitioners of Modernism, and to those who received their education from a generation, or two, of teachers and academics steeped in the Modernist tradition, conventional art history and criticism seemed authoritative and 'objective'; it formed the consensus.

For those concerned with art, art criticism and art history produced since the mid-thirties, the questions and issues can be seen to fall into separable but *not* mutually exclusive areas. One is general and philosophical, the other is specific and political. The first area centres on questions of 'historical interpretation' and the 'interested writing of history,' on which Karl Popper has written.[1] Are the judgements of art historians and critics 'completely objective' or 'absolutely compelling'?; if no history is disinterested are the interpretations and evaluations of art historians and critics not so much knowledge but ideological desiderata, wishes and ideals which the author would like to be realized? Arnold Hauser has written in his more robust work on the philosophy of art history on these issues:

> Are [such] interpretations correct or incorrect? Is one more correct than another? Is a later interpretation always more correct than an earlier? Or has the temporal sequence of judgments in this case nothing whatever to do with progress, with any progressive discovery of truth? Is relativism in

art history inevitable and unobjectionable? Or have we in the last resort to do with assertions that are not to be distinguished as true or false, but to some quite different criteria, such as the degree of relevance of the connections pointed out, or the extent of the deepening and enrichment of our aesthetic experience which may result? It certainly seems clear that the course not merely of art, but of art history also – that is, not only of the practice but also of the interpretation of art – is subject to the laws of something like Alfred Weber's 'cultural development,' which is not a strictly progressive movement, unlike the continuous process of cumulative achievement which he terms 'civilization'.[2]

Are the evaluations and revaluations of art history governed by ideology or by logic? What are the criteria for distinguishing between a truthful statement about a painting and an ideological one? These are not simple issues. Nor is the distinction which can be seen to follow from Hauser's comments. The historian of art needs to be concerned with a consciously defined history of how and why works of art were produced *and* a history of the ideas and ideological formations that produced the most characteristic, or conventional, histories.

Also central to this area is debate on the concept of representation: works of art as representations – whether or not resemblance to the 'real' world was of interest to their producers – and works of history and explanation as representations. Writing in 1937, partly as a response to the work of Alfred H. Barr Jr, *Cubism and Abstract Art*, published in 1936,[3] Meyer Schapiro made the following important points, explicitly on representation in art and implicitly on representation in art history. They still hold for recent debates.

> The logical opposition of realistic and abstract art by which Barr explains the more recent change rests on two assumptions about the nature of painting, common in writing on abstract art – that representation is a passive mirroring of things and therefore essentially non-artistic, and that abstract art, on the other hand, is a purely esthetic activity, unconditioned by objects and based on its own internal laws . . .
>
> These views are thoroughly one-sided and rest on a mistaken idea of what a representation is. There is no passive, 'photographic' representation in the sense described; the scientific elements of representation in older art – perspective, anatomy, light and shade – are ordering principles and expressive means as well as devices of rendering. All rendering of objects, no matter how exact they seem, even photographs, proceed from values, methods and viewpoints which somehow shape the image and often determine its contents. On the other hand, there is no 'pure art', unconditioned by experience; all fantasy and formal construction, even the random scribbling of the hand, are shaped by experience and by non-esthetic concerns.[4]

As Schapiro implies, painting is a practice of representation. Artists work within

changing systems and codes, as do practitioners of other disciplines. These systems and codes are the means by which people represent some kind of *cognition* of their world. Individual works of art, therefore, do not provide transparent illusions of 'reality,' or of the 'world,' but constitute determined and produced allusions to it. Such allusions are specific combinations of the formal and thematic elements of a picture and may be seen as an expression of the way people relate their lives to the conditions of their existence. This is to regard paintings as produced images of, ideas about, and positions on the world; as forms of ideology which represent systems of ideas, values and beliefs. And it should be realized that as mediated, or worked, representations of reality, they are not self-evident or transparent.

It can also be argued that art history is a practice of representation. In painting, particular signifying systems, codes and expressive means are used; in art history, or art criticism, the system is language with all its power. Thus, to gain any knowledge of a specific society or of its history requires that we understand its systems of representation, though neither the signifying systems nor that which is signified should be considered as reducible to simplistic models — both are complex. For the practice of art or the practice of art history entails a process of transforming given and inherited raw materials — the socially determined signifying systems of practices and institutions — into a definite product. The transformation is a *practice* — using social/ intellectual labour within the constraints and expressive and productive possibilities of socially determined means of production ('ordering principles and expressive means as well as devices of rendering'). This is to acknowledge that whatever is perceived as reality or is offered as history should not necessarily be considered as innocent, disinterested, self-evident or transparent.

The second area where questions and issues have been raised is in the consideration of the nature of the ideological formation which has produced the most dominant history of modern art in general, and of post-war American art in particular. The critical theory we now call 'Modernism' was elaborated at the same time that Abstract Expressionism was produced and ratified. Its influence on art history, art criticism and other forms of explanation has been as great as the 'art boom', to use Greenberg's phrase, in art dealing and curatorship since the late 1940s. The dominance of Modernism, the massive growth in entrepreneurial dealership, the status and function of museums in the mould of the Museum of Modern Art New York, the idea and reality of the 'Cold War,' the role of imperialist ideology in the formation of a particular social matrix and culture in America and its perceived allies; these have been the sorts of connections made by those seeking a critique of conventional art history and criticism. The breadth of these connections may be seen as consistent with a claim for Modernism made in 1961 by Clement Greenberg, the most competent exponent of this convention. He asserted that: 'Modernism includes more than art and literature. By now it covers almost the whole of what is truly alive in our culture.'[5] He went on, in this classic statement, to explain that:

> The essence of Modernism lies, as I see it, in the use of the characteristic methods of a discipline to criticize the discipline itself, not in order to

subvert it, but in order to entrench it more firmly in its area of competence.

[. . .] Realistic, naturalistic art had dissembled the medium, using art to conceal art; Modernism used art to call attention to art. The limitations that constitute the medium of painting – the flat surface, the shape of the support, the properties of the pigment – were treated by the Old Masters as negative factors that could be acknowledged only implicitly or indirectly. Under Modernism these same limitations came to be regarded as positive factors, that were to be acknowledged openly. Manet's became the first Modernist pictures by virtue of the frankness with which they declared the surfaces on which they were painted [. . .]

It was the stressing of the ineluctable flatness of the surface that remained, however, more fundamental than anything else to the processes by which pictorial art criticized and defined itself under Modernism [. . .] Because flatness was the only condition painting shared with no other art, Modernist painting orientated itself to flatness as it did to nothing else.[6]

As an art critic, art theorist and commentator on social and political issues, Greenberg belongs to the intelligentsia, which Noam Chomsky identifies as a social class in a 'society like ours'.[7] As professionals, members of this class see their job as the analysis and presentation of some picture of social reality. As Chomsky says, 'by virtue of their analyses and interpretations, they serve as mediators between the social facts and the mass of the population: they create the ideological justification for social practice.'[8] He goes on to suggest that to compare the work of specialists in contemporary affairs, their interpretations, with 'the events,' the 'world of fact,' often reveals a 'great and fairly systematic divergence'. The critiques of Modernism during the 1970s and 1980s were started, in part, by those who recognized a systematic divergence between Modernists' explanation, interpretation and history of art, and more materialist representations of 'events' and the 'world of fact.' This can be said to have happened in two major areas. The first was effected by work produced on the nineteenth century by T. J. Clark with the publication of two of his books in 1973: *The Absolute Bourgeois: Artists and Politics in France, 1848–1851* and *Image of the People: Gustave Courbet and the 1848 Revolution.*[9] The second was the appearance of articles which questioned the Modernist explanation of, and influence on, art from the late 1940s onwards. Some of these are collected in Part Two of this anthology.

Chomsky suggests that the explanation of systematic divergences needs to take into account the class position of the intelligentsia:

With a little industry and application, anyone who is willing to extricate himself from the system of shared ideology and propaganda will readily see through the modes of distortion developed by substantial segments of the intelligentsia. Everybody is capable of doing that. If such an analysis is often carried out poorly, that is because, quite commonly, social and political analysis is produced to defend special interests rather than to account for the actual events.[10]

The last sentence of Chomsky's quote is a salutary warning to those interested in the 'social history of art'. He may, however, also underestimate the difficulty of the project. It is certainly true that many critiques of Modernism have been poorly argued and inadequately theorized. One reason for this is the danger of special interest leading to reductionism or reflectionism: works of art, or of art history, or of art criticism 'reflecting' ideologies, social relations or wider histories; history as 'background' to that which is produced; the determinist argument of economic base causing an auto-matic response in superstructural forms.[11] However, there are problems facing his-torians who view conventional Modernism as a 'set of ideas' or as an 'ideology'. As Kolakowski writes, the problem facing the 'historian of ideas'

> . . . does not consist in comparing the 'essence' of a particular idea with its practical 'existence' in terms of social movements. The question is rather how, and as the result of what circumstances, the original idea came to serve as a rallying-point for so many different and mutually hostile forces; or what were the ambiguities and conflicting tendencies in the idea itself which led to its developing as it did?[12]

And for those historians who view mainstream Modernism as part of the system of shared ideology which is inextricable from American imperialism in the post-war period (examples will be found in Part Two), Chomsky makes a series of points:

> The resources of imperialist ideology are quite vast. It tolerates – indeed encourages – a variety of forms of opposition . . . It is permissible to criti-cize the lapses of the intellectuals and of government advisers, and even to accuse them of an abstract desire for 'domination,' again a socially neutral category, not linked in any way to concrete social and economic structures. But to relate that abstract 'desire for domination' to the employment of force by the United States government in order to preserve a certain sys-tem of world order, specifically, to ensure that the countries of the world remain open insofar as possible to exploitation by U.S.-based corporations – that is extremely impolite, that is to argue in an unacceptable way.[13]

Art history, art criticism and art itself may seem marginal in the context of the principles that 'guide US foreign policy, and its concern to create a global economic order that conforms to the needs of the US economy and its masters.'[14] Yet, for many critics of Modernism who see that theory as a misrepresentation of the causal condi-tions of Abstract Expressionism and as ideologically dominating the critical debate on art since the 1950s, it is deeply embedded in the strategies and rhetoric of the Cold War. For them, the history of the ideas and ideological formations that produced the most characteristic, or conventional, history of art in the post-war period is a history intersected by the forces and resources of the 'imperialist ideology.'

There is a good case for seeing the major debates of the 1970s and 1980s as having their roots in the 1930s and 1940s in the USA, where Modernism became elaborated

and entrenched in subsequent decades. Certainly many of the texts in this anthology discuss the historical and theoretical significance of two essays by Clement Greenberg written for *Partisan Review* when it was an important forum for Marxist debate in the late 1930s and early 1940s. These two essays, 'Avant-Garde and Kitsch' (1939) and 'Towards a Newer Laocoon' (1940),[15] are as much concerned with culture as they are with forms of art in bourgeois society. So too is Meyer Schapiro's 'Nature of Abstract Art' published in *Marxist Quarterly* in 1937.[16] The text by Serge Guilbaut [Chapter 10] considers the contribution made by this essay not only to our understanding of debates in the 1930s but also to the competences of those interested in early critiques of the shifts and developments in the tradition of Modernism. Schapiro's point of departure was Alfred H. Barr Jr's *Cubism and Abstract Art*, published by the Museum of Modern Art as the guide to and catalogue of the exhibition, of the same name, held by the museum in the spring of 1936. On the jacket of Barr's book appeared a diagram of lines of influence in modern art. This diagram represents a discernible shift in the premises for the discussion of modern art and its history. Implicitly or explicitly Barr's model, a linear and intentionalist flow diagram, informs much subsequent conventional history and explanation of modern art. That is not to say that there were no sources or critical traditions on which Barr drew. He would have been aware of the tradition we now recognize as forming the basis of Modernism: certain *aspects* of criticism by Zola and other late nineteenth-century critics, and by Denis, Fry, Bell, Wilenski, etc.[17] Though it is fair to say, I think, that Barr's position was *particular*.

As the director of a new and prestigious museum, established in 1929 and funded by the financially élite families of East Coast entrepreneurial capitalism,[18] Barr wished to organize major retrospective exhibitions of modern art. As a scholar, he also wished to write well-researched art history. In 1926, he had been appointed Assistant Professor of Art History at Wellesley College, where he taught the first college course to be devoted exclusively to twentieth-century art history. Painting since the *Fauves* and the Cubists had received little *systematic* attention of a similar intellectual and historical seriousness as works of art produced in, say, Mediaeval and Renaissance Europe had by, in particular, German academics. Barr's ambition was to provide explanations of modern art which were as scholarly as academic work on earlier art; he was, therefore, researching in an area ripe for authoritative and pioneering 'history.' But first he had to be clear about what he was constructing a history *of*.

Barr was active when explanations as seemingly diverse as those by Worringer, Fry, Bahr, Cheney, Breton and Trotsky were available.[19] It should also be remembered that Barr had travelled in Europe, including Soviet Russia where he had met artists and writers concerned with debates on Russian Formalism. For Barr such explanations would have shown the failure of modern criticism *systematically* to account for the range of modern art and modern art practices. Many of the debates were historically specific, as were the art works discussed. However, one function of a museum, and therefore of its director, is to collect elements of different cultures – at best to represent their relevant cognitive systems and social beliefs, but at worst to construct curatorial histories – histories which may have more to do with the ideals and projected status of the representatives of the institution and its apologists within a particular society than they do with adequate historical representation.

As an art historian *and* exhibition organizer, Barr needed to establish a coherent explanation of diverse productions in modern art. He split up his explanation into two complementary parts. One was represented by 'Cubism and Abstract Art,' the other by the exhibition 'Fantastic Art, Dada and Surrealism' held in the Museum of Modern Art in late 1936. As with the former this was a substantial pioneering exhibition with an accompanying catalogue in which Barr explained that, unlike the rational and abstract tendencies displayed in the earlier show, these works represented human interest in the irrational, the spontaneous, the enigmatic and the dreamlike – art which was defined as romantic, often figurative and naturalistic. With these two shows Barr constructed what appeared to be a dialectic in modern art; a dialectic of exhaustion and reaction between styles which emanated from Cubism. This 'style,' represented as the largest and most influential in Barr's 'flow diagram,' is seen as having been caused by selected aspects of late nineteenth-century French art.

Barr's general thesis rests on two major premises. First, he makes the intellectual error of distinguishing between 'representational' and 'non-representational' art. As Schapiro suggested in 1937, this is a mistaken distinction. *All* works of art represent or signify, something. For Barr 'representation' is associated with art that appears to be concerned with the world of 'facts,' or with what more theoretically robust authors have called 'resemblance'.[20] Yet, any informed consideration of art produced at different times and in different cultures will confirm that there is a wide range of ways in which a picture represents its subject or theme or conveys knowledge. Often combinations of symbols and signifiers convey shifting or ambiguous meanings which may not appear consistent with what a picture *resembles*. If representations are constructed from conventions, references, symbols, and signifiers then the characteristics of an art work in which there is little evident concern with resemblance may still *represent* something or be symbolic. Plainly without knowledge of the conventions implicit in abstract works references or symbols may be difficult to 'read' or to 'translate.' However, as it is essential to Modernist aesthetics for the history of modern art to be one stressing a move toward autonomy, and disinterestedness they characterize abstract art, as 'non-representational.' They are blind to considering pictorial representations as actively constructed from conventions available as the resources of a culture or sub-culture. Hence, with Cubism, Barr sees an exhaustion of 'representational' art and an inevitable move to what he identifies as the two major trends in the twentieth century.

Second, he sees art as essentially explainable in terms of certain formal interests. He identifies what appear to be formal similarities between works produced in different cultures and circumstances; formal similarity is used as a key for unlocking historical complexity. He constructs a systematic model which seeks to explain diversity, to provide a history which is essentially *historicist* – a retrospective curatorial validation for certain forms of 'Non-Geometric Abstract Art' and 'Geometric Abstract Art.' This 'history' and explanation of modern art, which Barr developed and elaborated in further catalogues and publications, became enormously influential despite criticism such as that by Meyer Schapiro in 1937:

> . . . if the book is largely an account of historical movements, Barr's conception of abstract art remains essentially unhistorical. He gives us, it is

true, the dates of every stage in the various movements, as if to enable us to plot a curve, or to follow the emergence of the art year by year, but no connection is drawn between the art and the conditions of the moment. He excludes as irrelevant to its history the nature of the society in which it arose, except as an incidental obstructing or accelerating atmospheric factor. The history of modern art is presented as an internal, immanent process among the artists; abstract art arises because, as the author says, representational art had been exhausted. Out of boredom with 'painting facts,' the artists turned to abstract art as a pure esthetic activity. 'By a common and powerful impulse they were driven to abandon the imitation of natural appearance' just as the artists of the fifteenth century 'were moved by a passion for imitating nature.' The modern change, however, was 'the logical and inevitable conclusion toward which art was moving'.[21]

Barr's emphasis on the theory of exhaustion and reaction reduces history, as Schapiro observes, to the 'pattern of popular ideas on changes in fashion.' Yet despite such dissent, Barr's critical model seemed to offer a plausible 'explanation'. He relegated problematic issues such as that of 'realism' in Cubism by emphasizing one aspect of Picasso's and Braque's interests, namely formal and technical radicalism, as though it was the motive force of their practice. To give priority to formal concerns provided Barr with a critical model which not only allowed him to discuss particular paintings in scholarly detail, but also to construct a systematic history of modern art, in which developments appeared self-winding and independent of extrapictorial forces. And, more importantly, it could be both elaborated and extended to account for 'new developments'. Here is Barr in 1939, developing the vocabulary and conceptual framework of his model:

> Les Demoiselles d'Avignon is the masterpiece of Picasso's Negro period, but it may also be called the first cubist picture for the breaking up of natural forms, whether figures, still-life or drapery, into a semi-abstract all over pattern of tilting shifting planes is already cubism; cubism in a rudimentary stage, it is true, but closer to the developed early cubism of 1909 than are most of the intervening 'Negro' works. Les Demoiselles is a transitional picture, a laboratory, or, better, a battlefield of trial and experiment; but it is also a work of formidable, dynamic power unsurpassed in European art of its time. Together with Matisse's Joie de vivre of the same year it marks the beginning of a new period in the history of modern art.[22]

We can get a better idea of the implications of Barr's critical model by seeing it as a paradigm, in a similar way to that proposed by Thomas S. Kuhn, the historian of science. In 1962 Kuhn published an influential book, The Structure of Scientific Revolutions,[23] the general thesis of which is useful for art history. Kuhn argues that change or 'progress' in scientific theory consists of shifts in paradigms; it is not a

linear series of revolutions, or a disinterested development of knowledge. A paradigm is a model by which the practitioners of any discipline, for our purposes art historians and critics, define *their* field of problems, a 'field' is that which any group of practitioners needs to circumscribe in order to do any productive *work*. The paradigm may be 'metaphysical,' based on 'values', 'beliefs' or an organizing principle governing perception itself; it may be 'sociological' as a set of intellectual, verbal, behavioural or institutional *habits*; it may be dominated by a 'classic' or hegemonic work. Importantly, Kuhn's sociological notion of a paradigm means that the paradigm can function *prior to theory*. I am not suggesting that art criticism, art history or art practice is the *same* as the procedures, interests and demands of scientific research. Rather, that to apply Kuhn's general model of scientific change to explain change in art criticism and art history helps us to understand the nature and success of Modernist criticism and history, particularly that which has dominated post-war debates on art.

> What then is the nature of the more professional and esoteric research that a group's [i.e. art critics/historians] reception of a single paradigm permits? If the paradigm represents work that has been done once and for all; what further problems does it leave the united group to resolve?
>
> [. . .] we must recognize how very limited in both scope and precision a paradigm can be at the time of its first appearance. Paradigms gain their status because they are more successful than their competitors in solving a few problems that the group of practitioners has come to recognize as acute. To be more successful is not, however, to be either completely successful with a single problem or notably successful with any large number. The success of a paradigm . . . is at the start largely a promise of success discoverable in selected and still incomplete examples. Normal [art history/criticism] . . . consists in the actualization of that promise, an actualization achieved by extending the knowledge of those facts [i.e. about characteristics of works of art] that the paradigm displays as particularly revealing, by increasing the extent of the match between those facts and the paradigm's predictions, and by further articulations of the paradigm itself.[24]

According to Kuhn, a new paradigm becomes dominant when, in comparison with its competitors, it promises to explain selected and seemingly incompatible examples which the old paradigm cannot. Within the new model certain 'facts' are selected as particularly revealing. By successfully matching those 'facts' against the paradigm's predictions the paradigm can be elaborated.

For Barr the existing paradigm for modern art history and art criticism would have been under stress because it could not *systematically* account for modern developments. (In Kuhnian terms the situation before Barr may even be characterized as *pre*-paradigmatic.) So, by emphasizing formal characteristics of paintings as especially revealing, he could construct a particular history of modern art. His paradigm could be not only elaborated and *theorized* but also extended to account for new paintings. Clement Greenberg had a major influence on both these kinds of

development. He refined and elaborated Barr's explanation and history of modern art in his gradual emphasis on 'modern specialization' and the rigours of formalism; his 1958 essay on Cubist 'Collage,'[25] is an example of his sophisticated analysis of particular works, while his 1961 essay, 'Modernist Painting',[26] provides the theoretical rationalizations. Greenberg is also the major figure in the extension of the paradigm to account for new developments in terms of its formal predictions. He could account for Abstract Expressionism in general, and Jackson Pollock in particular, within the paradigm's narrowly circumscribed set of problems. An introduction to the conditions in which Greenberg's criticism developed and shifted within the paradigm's 'resources' and 'tolerances of opposition' can be found at the beginning of Part Two.

Schapiro's early critique of Barr's model is powerful in both its historical and theoretical arguments. Yet the paradigm took off because it seemed to solve problems within the practice of *criticism* itself. By defining the 'field,' the 'model' of problems for criticism, it misrepresented the problems for modern art *practices*. As Kuhn says, the success of a paradigm does not mean that it is *true*:

> . . . one of the things . . . [an artistic or art historical/critical] community acquires with a paradigm is a criterion for choosing problems that, while the paradigm is taken for granted, can be assumed to have solutions. To a great extent these are the only problems that the community will admit as . . . [artistic, art historical or art critical] or encourage its members to undertake. Other problems, including many that had previously been standard, are rejected as metaphysical, as the concern of another discipline, or sometimes as just too problematic to be worth the time. A paradigm can, for that matter, even insulate the community from those socially important problems that are not reducible to the puzzle form, because they cannot be stated in terms of the conceptual and instrumental tools the paradigm supplies.[27]

By 1961 the paradigm was well entrenched; it had been elaborated and refined to account for the history of art since Manet and had seemed to account for new and seemingly incompatible examples. Pollock's work of the 1940s and particularly his 'drip paintings,' were explained in terms of an extension of Barr's model; Pollock was characterized as essentially taking on the formal and technical problems of both the 'abstract and rational' trend and the 'surrealist and irrational,' which also included aspects of expressionism. His art, therefore, could be explained in terms of a synthesis of styles which itself established a new heading in the extended model. His art could also be seen not only as a 'reaction' to previous styles but also as an 'exhaustion' of them. Greenberg's writings during the 1950s and 1960s are conventionally regarded as exhibiting his 'art for art's sake' and 'modern specialization' theories, as demonstrated in 'Modernist Painting.' However, as the Kuhnian notion of paradigm suggests, the critical theory refined in 'Modernist Painting' had its roots in Greenberg's criticism of the late 1930s, when the community of art critics had acquired Barr's paradigm. Here is Greenberg in 1939:

Picasso, Braque, Mondrian, Miró, Kandinsky, Brancusi, even Klee, Matisse and Cézanne, derive their chief inspiration from the medium they work in. The excitement of their art seems to lie most of all in its pure preoccupation with the invention and arrangement of spaces, surfaces, shapes, colours etc., to the exclusion of whatever is not necessarily implicated in these factors.[28]

and in 1940,

The arts lie safe now, each within its 'legitimate' boundaries, and free trade has been replaced by autarchy. Purity in art consists in the acceptance, willing acceptance, of the limitations of the medium of the specific art . . .

It is by virtue of its medium that each art is unique and strictly itself. To restore the identity of an art the opacity of its medium must be emphasized.[29]

These two essays, included in Part One of this anthology, contain elements recognizable in the critical debates on Pollock and his legacy. Yet, they also contribute to the debates on culture and society which preoccupied Marxists during the 1930s and 1940s. As T. J. Clark notes, when Greenberg reprinted 'Avant-Garde and Kitsch' as the opening collection of critical essays, *Art and Culture* (1961), he made 'no attempt to tone down its mordant hostility to capitalism'.[30] Greenberg offered a critique of bourgeois culture under capitalism from the nineteenth century to the late 1930s. For him the contemporary era was one in which there seemed to be little possibility of a critical art, only 'an academicism in which the really important issues are left untouched because they involve controversy, and in which creative activity dwindles to virtuosity in the small details of form . . . '.[31] And he concluded this essay with a view which *seems* incompatible with his later elaboration of formalism: 'Capitalism in decline finds that whatever of quality it is still capable of producing becomes almost invariably a threat to its own existence . . . Here, as in every other question today, it becomes necessary to quote Marx word for word . . . Today we look to socialism *simply* for the preservation of whatever living culture we have right now.'[32]

'Towards a Newer Laocoon' is a defence of abstract art without the same attention to a social and cultural critique. And even though the content of both essays has provided some of the origins of current debates about Modernism, and about art practice, art history and art criticism since Pollock, they are essentially within the same paradigm. This is clear if we compare them to the essays by Meyer Schapiro from the late 1930s, particularly 'The Social Bases of Art' (1936) and 'Nature of Abstract Art' (1937).[33] As permission for their inclusion in this anthology could not be obtained from the author, it is necessary to quote from them at length.

Much recent debate on Pollock and after has centred on 'the social history of art'. And if, as I argue, there is a good case for seeing the origins of conventional post-war Modernism rooted in the 1930s then there is as strong a case for examining early critiques from Marxists of the same period.

'The Social Bases of Art' provides us with a more lucid and more historically informed analysis of art and culture from ca. 1850 to the 1930s than much else on offer at the time. It also discusses many of the issues which concern those historians and critics active in debates on art practice, art historical practice and critical practice since Pollock. It starts with a clear awareness of what has been called the 'relative autonomy' of art:

> When we speak in this paper of the social bases of art we do not mean to reduce art to economics or sociology or politics. Art has its own conditions which distinguish it from other activities. It operates with its own special materials and according to general psychological laws. But from these physical and psychological factors we could not understand the great diversity of art, why there is one style at one time, another style a generation later, why in certain cultures there is little change for hundreds of years, in other cultures not only a mobility from year to year but various styles at the same moment, although physical and psychological factors are the same . . . [34]

Schapiro goes on to identify 'the common character' which unites the art of individuals at any one time and place: it is as members of a society,

> . . . with its special traditions, its common means and purposes, prior to themselves, that individuals learn to paint, speak and act in the current manner. And it is in terms of changes in their immediate common world that individuals are impelled together to modify their no longer adequate conceptions. [35]

Schapiro is here arguing from within a particular aspect of the Marxist tradition. Leon Trotsky had written that a 'work of art, should in the first place, be judged by its own law, that is, by the law of art,'[36] therein lies its 'relative autonomy' (the specific phrase is attributed by some to French Marxists of the 1960s and 1970s, particularly to Althusser).[37] However, we need to explain why and how a 'given tendency in art has originated in a given period of history; in other words, who it was who made a demand for such an artistic form and not for another, and why.'[38] The answer for Trotsky lay within the materialist conception of history, according to which the *ultimately* determining element in history is the production and reproduction of real life. Engels wrote in 1894:

> Political, juridical, philosophical, religious, literary, artistic, etc., development is based on economic development. But all these react upon one another and also upon the economic basis. It is not that the economic situation is *cause, solely active*, while everything else is only passive effect. There is, rather, interaction on the basis of economic necessity, which *ultimately* always asserts itself . . . So it is not, as people try here and there conveniently to imagine, that the economic situation produces an

automatic effect. No. Men make their history themselves, only they do so in a given environment, which conditions it, and on the basis of actual relations already existing, among which the economic relations, however much they may be influenced by the other – the political and ideological – relations, are still ultimately the decisive ones, forming the keynote which runs through them and alone leads to understanding.[39]

This letter restates a similar position made clear in an earlier one to J. Bloch where Engels stated that 'the economic situation is the basis, but the various elements of the superstructure . . . also exercise their influence upon the course of the historical struggles and in many cases preponderate in determining their *form*'.[40] That is to say that art, as a superstructural form, is produced from all kinds of causes – *as are* art history and art criticism. The interaction or the relationship between the two sets of causes is often inadequately discussed. Importantly, as Engels states, elements of the superstructure have a relative autonomy, so it is clear, for example, that ideas can be determinants on modes of production and activities, and have a revolutionary potential. Yet, although ideas, beliefs and forms of representation may not be subject to exhaustive causal explanation by reference to 'the material conditions of life' – they have some life of their own – ultimately social and economic relations are the decisive influences. Schapiro argues

> If modern art seems to have no social necessity, it is because the social has been narrowly identified with the collective as the anti-individual, and with repressive institutions and beliefs, like the church or the state or morality, to which most individuals submit. But even those activities in which the individual seems to be unconstrained and purely egotistic depend upon socially organized relationships. Private property, individual competitive business enterprise or sexual freedom, far from constituting non-social relationships, presuppose specific, historically developed forms of society.
>
> . . . if we examine attentively the objects a modern artist paints and the psychological attitudes evident in the choice of these objects and their forms, we will see how intimately his art is tied to the life of modern society.
>
> . . . elements drawn from the professional surroundings and activity of the artist; situations in which we are consumers and spectators; objects which we confront intimately, but passively or accidentally, or manipulate idly and in isolation – these are typical subjects of modern painting.
>
> . . . The preponderance of objects drawn from a personal and artistic world does not mean that pictures are now more pure than in the past, more completely works of art. It means simply that the personal and aesthetic contexts of secular life now condition the formal character of art . . .[41]

Schapiro's account of modern art is consistent with a materialist conception of

history. He considers what works of art in the modern period may be seen as representations *of*, and offers a history and explanation which address similar social concerns to those which exercised Greenberg in 'Avant-Garde and Kitsch' only three years later. Schapiro recognized, as had Barr at the same period, that the existing paradigm for the explanation of modern art could not systematically account for the range of its forms, practices and justifications – whether by artists or contemporary critics. 'The Social Bases of Art' is obviously also the result of an informed consideration of what a history of modern art should be a history *of*. Barr's consideration led to a different construction, to the formation of what we now call the Modernist paradigm. If Schapiro also provides the criterion for selecting problems, that is a paradigm, it was conspicuously unsuccessful in the light of Modernism's subsequent ideological dominance.

In retrospect, though, critics of Modernism see Schapiro's texts of 1936 and 1937 as demonstrating some of the historical resources for a revision of the dominant paradigm. This is particularly so as there are areas of agreement in the social analysis underlying both these texts and Greenberg's 'Avant-Garde and Kitsch;' yet they come to different conclusions. As Thomas Crow observes:

> Both see the commodification of culture as the negation of the real thing, that is, the rich and coherent symbolic dimension of collective life in earlier times; both see beneath the apparent variety and allure of the modern urban spectacle only the 'ruthless and perverse' laws of capital; both posit modernist art as a direct response to that condition, one which will remain in force until a new, socialist society is achieved.[42]

This last point may be open to debate where Greenberg is concerned, though on a quick reading it would be difficult to identify the author of the following:

> The conception of art as purely aesthetic and individual . . . in its most advanced form . . . is typical of the *rentier* leisure class in modern capitalist society, and is most intensely developed in centers like Paris, which have a large *rentier* group and considerable luxury industries. Here the individual is no longer engaged in a struggle to attain wealth; he has no direct relation to work, machinery, competition; he is simply a consumer, not a producer.[43]

It is Schapiro, not Greenberg; perhaps it is the emphasis on 'producer' which distinguishes the text as incompatible with the notion of 'purity' as strong in Greenberg's essays of 1939 and 1940 as is his hostility to capitalism. Further examination reveals fundamental difference in each author's view of 'mass culture'. For Greenberg, as with Adorno, there is a strong sense of moral judgement underlying his concept of 'kitsch' and his emphasis on formal 'purity in art,' representing the preservation of a living Western culture. This prevents him from making an *historical* analysis of the avant-garde's engagement with particular subjects and images from urban leisure and 'mass culture.' Fundamentally, I think this is because even in his early essays, as impressive

as they are, there is a concern with the notion of 'quality' (the *disinterested* discrimin-
ations of value) which is inseparable from the other aspects of the Modernist para-
digm, even in its unelaborated form. Hence, it is Schapiro who carries through his
materialist concept of history to claim that:

> The social origins of such forms of modern art do not in themselves permit
> one to judge this art as good or bad; they simply throw light upon some
> aspects of their character and enable us to see more clearly that the ideas
> of modern artists, far from describing eternal and necessary conditions of
> art, are simply the results of recent history. In recognizing the dependence
> of his situation and attitudes on the character of modern society, the artist
> acquires the courage to change things, to act on his society and for himself
> in an effective manner.
>
> . . . An individual art in a society where human beings do not feel them-
> selves to be most individual when they are inert, dreaming, passive, tor-
> mented or uncontrolled, would be very different from modern art. And in a
> society where all men can be free individuals, individuality must lose its
> exclusiveness and its ruthless and perverse character.[44]

An analysis of the reasons why the Barr paradigm became so successfully elabor-
ated and internalized within the seemingly incompatible social analysis of early
'Trotskyist' Greenberg cannot be dealt with here. Some of the reasons are covered in
the next section of this anthology but a full account will be covered elsewhere. How-
ever, recalling Chomsky's comments on the 'intelligentsia' as a 'social class,' we can
see from Schapiro's own essay that the production of a successful form of criticism
may be seen as a form of 'ideological justification for social practice':

> Of course, only a small part of this [*rentier*] class is interested in painting,
> and only a tiny proportion cultivates the more advanced modern art . . .
> the common character of this class affects to some degree the tastes of its
> most cultivated members. We may observe that these consist mainly of
> young people with inherited incomes, who finally make art their chief
> interest, either as artists and decorators, or as collectors, dealers, museum
> officials, writers on art and travellers. Active businessmen and wealthy
> professionals who occasionally support this art tend to value the collecting
> of art as a higher activity than their own daily work.[45]

I do not wish to suggest that Schapiro's writings of the 1930s are somehow revealed
as more ideologically sound than the early work of Greenberg or Barr.[46] Rather they
shed light on the context of the 1930s debates which, in many respects, are similar to
the ones that occupy us now. To be consistent we need to examine the social, intel-
lectual and political conditions of the late 1930s in order to begin to explain the extent
of the differences between their respective analyses, histories; their writings as forms
of representation. However, it would be disingenuous not to admit that Schapiro's

texts, despite their weaknesses in certain areas, have a powerful explanatory force, particularly in the context of art history in the 1930s. It is a pity that they could not be included in this anthology.

Schapiro's texts, especially 'Nature of Abstract Art,' also owe their strength to the fact that they address Modernist heroes – they do not *avoid* them. As T. J. Clark states in Chapter 5:

> . . . the critique of modernism will not proceed by demotion of heroes, but by having heroism come to be less and less the heart of the matter. We should not be trying to puncture holes in the modernist canon (we shall anyway usually fail at that) but rather to have canon replaced by other, more intricate, more particular orders and relations. Naturally, new kinds of value judgement will result from this: certain works of art will come to seem more important, others less interesting than before; but above all the *ground* of valuation will shift.[47]

It is clear that one of the major debates within the 'history of modern art' concerns the art critic's and art historian's function as a disseminator, or 'mediator' of 'truth,' of 'knowledge,' of 'history,' of 'ideology.' In an interview held in June 1981, which formed the basis for a television programme, 'Greenberg on Art Criticism' for the Open University course *Modern Art and Modernism: Manet to Pollock*, Greenberg distances himself from recent work produced by younger academics:

> . . . you young ones, you think there's always more there than there is. You have to write out the rest . . . the value judgements come *first*. You young ones, you want to fill in, fill in the pages . . . You want to think, and there's nothing wrong with that, but cut, cut . . .[48]

By 'cut' Greenberg means 'edit out' all that which is not relevant to value judgements and aesthetic questions. For Greenberg historians such as T. J. Clark and others represented in this anthology 'want to fill in, fill in the pages'. By this he means burrowing into the past, dishing up facts, even if presented in a well-substantiated and theorized way. He said something similar to Charles Harrison in an interview published in *Art Monthly* in 1984,[49] though Harrison would *not* characterize himself as a 'social historian of art.' Here, though, there are the grounds for a debate on the work to be done by art historians and art critics concerned with a critique of Modernism: as it can be seen as a misrepresentation of the possible cognitive and historical meanings of art, and of how and why works of art are *produced* in particular causal conditions; as a dominant post-war ideology in which debate on Pollock and later artists was contained within the insulated paradigm. This last point can be illustrated by the seemingly substantial debate between the 'abstractionists' and 'literalists' in the 1960s on the 'legacy of Pollock.'[50] Michael Fried, further elaborating Greenberg, most clearly expressed the 'abstractionist' case, while Don Judd and Robert Morris favoured the 'literalist.' For those locked within the Modernist critical paradigm such a debate may seem, in the context of 'modern specialization' etc., to be interesting, productive and a contribution

to human knowledge. Others may consider the debate as doctrinal squabbles, as the paradigm's tolerance and indeed as encouragement of a variety of forms of opposition – albeit 'opposition' as defined by the criterion of problems for the group of practitioners.

For Harrison and members of Art & Language, Modernism and the 'social history of art' need, and have needed, one another in order to justify their existence. For them also the 'Left' has 'failed' systematically to counter the cultural and theoretical claims of the former.[51] Whether or not both these observations are true, they see a major project to be a consideration of what a clash of Modernism – its emphasis on aesthetic judgement, on 'intuition,' on autonomy, on 'quality' – and the social history of art – its historical materialism – will bring to an art history and an art criticism informed by the rigours of scientific inquiry and the legacy of British philosophy which follows in the tradition of philosophical rationalism. For other critics of Modernism, historical materialism has no truck with 'intuition' unless it is considered as the historical product of bourgeois individualism. For them, Modernism as a critical theory has all the dangers of closure on inquiry, ideologically determined, that characterizes the considerable limits of a paradigm, as considered by Thomas Kuhn. And as an account of modern art it is rank bad history; Modernism is an ideology which systematically misrepresents the real relations between the meaning of art and its practices and how and why works of art are and were *produced*.

What at least needs to be recognized is that there are jobs of work to be done. Rigorous engagement with theoretical problems is one, the practice and continual testing of the social history of art – historical materialism – is another. The continual testing, though, requires that critiques are based on an adequate characterization and defensible criticism of the work produced by other historical materialists. The *historian* of art needs to be concerned with a consciously defined history of how and why works of art were, and are, produced *and* a history of the ideas and ideological formations that produced the most characteristic, or paradigmatic, histories.

Notes

1 See *The Poverty of Historicism*, London, Routledge & Kegan Paul, 1957. An important extract, 'Situational Logic in History. Historical Interpretation,' is reprinted in *Modern Art and Modernism: A Critical Anthology*, edited by Francis Frascina and Charles Harrison, London, Harper & Row, 1982, pp. 11–13.

2 'The Sociological Approach: The Concept of Ideology in the History of Art,' *The Philosophy of Art History*, London, Routledge & Kegan Paul, 1959. This quote from the edited reprint in Frascina and Harrison, op. cit., p. 237. See also Frederick Antal's essays published under the title of *Classicism and Romanticism*, London, Routledge & Kegan Paul, 1966.

3 Published by The Museum of Modern Art, New York.

4 'Nature of Abstract Art', *Marxist Quarterly*, vol. 1, no. 1, January–March 1937, pp. 77–98; this quote from the essay is reprinted in Schapiro, *Modern Art: 19th and 20th Centuries*, pp. 85–6, London, Chatto and Windus, 1978.

5 Greenberg, 'Modernist Painting,' 1961, Radio Broadcast Lecture 14 of *The Voice of America Forum Lectures: the Visual Arts*, reprinted, as spoken, in the paperback edition of all 18 Lectures, Washington D.C., United States Information Agency, 1965, pp. 105–11. (After its broadcast, 'Modernist Painting' was published in *Arts Yearbook* 4, 1961, pp. 101–8. It appeared in revised form in *Art and Literature*, 4, Spring 1965, pp. 193–201, and then in Gregory Battcock (ed.) *The New Art: A Critical Anthology*, New York, E. P. Dutton, 1966, pp. 100–110.)

6 Ibid., pp. 105–6.

7 'Politics' in *Language and Responsibility*, based on conversations with Mitsou Ronat, Sussex, The Harvester Press, 1979, p. 4.

8 Ibid.

9 Both published by Thames and Hudson.

10 Op cit., p. 4.

11 For a discussion of these 'taboos' see T. J. Clark's 'On the Social History of Art,' *Image of the People*, op. cit., pp. 9–20; edited reprint in Frascina and Harrison, op. cit, pp. 249–258.

12 Leszek Kolakowski, *Main Currents of Marxism: Its Origins, Growth and Dissolution*, Vol. 1, *The Founders*, translated from the Polish by P. S. Falla, Oxford, Oxford University Press, 1981, p. 3.

13 Op. cit., pp. 40–41.

14 Ibid., p. 41. He goes on: 'I'm referring, for example, to the crucial documentation contained in the *Pentagon Papers*, covering the late 1940s and early 1950s when the basic policies were clearly set, or the documents on global planning for the post war period produced in the early 1940s by the War–Peace Studies groups of the Council on Foreign Relations, to mention only two significant examples.'

15 See Chapters 1 and 2.

16 See note 4.

17 For a representative selection of texts see Frascina and Harrison, op. cit. For a further discussion of the origins of, typical debates within, and resources for a critique of Modernism, see the Open University course A315 *Modern Art and Modernism: Manet to Pollock*, Milton Keynes, The Open University Press, 1983.

18 See Russell Lynes, *Good Old Modern: An Intimate Portrait of the Museum of Modern Art*, New York, Atheneum, 1973.

19 See Frascina and Harrison, op. cit.

20 See, for example, M. Baldwin, C. Harrison, M. Ramsden, 'Art History, Art Criticism and Explanation' *Art History*, vol. 4, no. 4, December, 1981, pp. 432–456 and other work by Art & Language.

21 Loc. cit., p. 79.

22 *Picasso: Forty Years of his Art*, New York, The Museum of Modern Art, 1939, p. 60. See also Barr's *Picasso: Fifty Years of his Art*, New York, The Museum of Modern Art, 1946, p. 56.

23 The University of Chicago Press, Chicago. See also the second enlarged edition, 1970, from which all quotations are taken. Important also for this discussion is Margaret Masterman, 'The Nature of a Paradigm' in *Criticism and the Growth of Knowledge*, ed. I. Lakatos and A. Musgrave, Cambridge University Press, Cambridge, 1970, pp. 59–89.

24 Ibid., pp. 23–24.

25 First published as 'The pasted-paper revolution,' *Art News*, vol. 57, September 1958, pp.

46–49 and p. 60. See reprint in Frascina and Harrison, op. cit., pp. 105–108. Revised and expanded it appeared as 'Collage' in Greenberg's *Art and Culture: Critical Essays*, Boston, Beacon Press, 1961.

26 See note 5.

27 Kuhn, op. cit., p. 37.

28 'Avant-Garde and Kitsch,' p. 37 *[50]*. See Chapter 1 for full reference.

29 'Towards a Newer Laocoon,' p. 305 *[66]*. See Chapter 2 for full reference.

30 'Clement Greenberg's Theory of Art,' p. 139 *[71]*. See Chapter 3 for full reference.

31 Op. cit., p. 35 *[49]*.

32 Ibid., pp. 48–49 *[58]*.

33 The former: the *First American Artists' Congress Against War and Fascism*, New York, 1936, pp. 31–37. Reprinted in *Social Realism: Art as a Weapon*, edited and introduced by David Shapiro, New York, Frederick Ungar Publishing Co., 1973, pp. 118–127 from which all quotations are taken. The latter: see note 4.

34 Loc. cit., p. 118.

35 Ibid.

36 *Literature and Revolution*, translated by Rose Strunsky, Ann Arbor Paperbacks, The University of Michigan Press, 1960, p. 178. This was written in the summers of 1922 and 1923, first appearing in English translation in 1925.

37 See Louis Althusser, *For Marx*, Harmondsworth, Penguin, 1969; French original, 1966.

38 Trotsky, op. cit., p. 178.

39 Friedrich Engels to W. Borgius, 25 January 1894, in Karl Marx and Friedrich Engels, *Selected Works*, vol. III, London, Lawrence and Wishart, pp. 502–503.

40 Engels to J. Bloch, 21–22 September 1890, *Selected Works*, vol. III, p. 487.

41 'The Social Bases of Art,' loc. cit., pp. 120–123.

42 'Modernism and Mass Culture in the Visual Arts,' in Benjamin Buchloh, Serge Guilbaut and David Solkin (eds) *Modernism and Modernity: The Vancouver Conference Papers*, Halifax, Nova Scotia, The Press of Nova Scotia College of Art and Design, 1983, p. 227.

43 'The Social Bases of Art,' loc. cit., p. 123.

44 Ibid., pp. 126–127.

45 Ibid., p. 124.

46 For an analysis of Schapiro's career and interests see O. K. Werckmeister's review of Schapiro's *Romanesque Art, Art Quarterly*, new series 11, Spring 1979, pp. 211–218.

47 See 'Arguments about Modernism,' Chapter 5, pp. 104–105.

48 Television Programme 29, see note 17.

49 April 1984, No. 75, p. 6.

50 For a sample of Michael Fried taking issue with the 'literalists' see his 'Art and Object-hood,' *Artforum*, vol. 5, no. 10, June 1967, pp. 12–23 revised reprint in *Minimal Art: A Critical Anthology*, edited by Gregory Battcock, New York, 1968. And for a résumé of the rival positions see Philip Leider, 'Abstraction and Literalism: Reflections on Stella at the Modern', *Artforum*, vol. 8, no. 8, April 1970, pp. 44–51.

51 See the Introduction to Charles Harrison and Fred Orton (eds) *Modernism, Criticism, Realism*, London and New York, Harper & Row, 1984.

Clement Greenberg

AVANT-GARDE AND KITSCH

ONE AND THE SAME civilization produces simultaneously two such different things as a poem by T. S. Eliot and a Tin Pan Alley song, or a painting by Braque and a *Saturday Evening Post* cover. All four are on the order of culture, and ostensibly, parts of the same culture and products of the same society. Here, however, their connection seems to end. A poem by Eliot and a poem by Eddie Guest – what perspective of culture is large enough to enable us to situate them in an enlightening relation to each other? Does the fact that a disparity such as this within the frame of a single cultural tradition, is and has been taken for granted – does this fact indicate that the disparity is a part of the natural order of things? Or is it something entirely new, and particular to our age?

The answer involves more than an investigation in aesthetics. It appears to me that it is necessary to examine more closely and with more originality than hitherto the relationship between aesthetic experience as met by the specific – not generalized – individual, and the social and historical contexts in which that experience takes place. What is brought to light will answer, in addition to the question posed above, other and perhaps more important ones.

I

A society, as it becomes less and less able, in the course of its development, to justify the inevitability of its particular forms, breaks up the accepted notions upon which artists and writers must depend in large part for communication with their audiences. It becomes difficult to assume anything. All the verities involved by religion, authority, tradition, style, are thrown into question, and the writer or artist is no longer able to estimate the response of his audience to the symbols and references

Source: 'Avant-Garde and Kitsch', *Partisan Review*, vol 6, no. 5, Fall 1939, pp. 34–49. Copyright © 1961 by Clement Greenberg. Reprinted by permission of Beacon Press.

with which he works. In the past such a state of affairs has usually resolved itself into a motionless Alexandrianism, an academicism in which the really important issues are left untouched because they involve controversy, and in which creative activity dwindles to virtuosity in the small details of form, all larger questions being decided by the precedent of the old masters. The same themes are mechanically varied in a hundred different works, and yet nothing new is produced: Statius, mandarin verse, Roman sculpture, Beaux Arts painting, neo-republican architecture.

It is among the hopeful signs in the midst of the decay of our present society that we – some of us – have been unwilling to accept this last phase for our own culture. In seeking to go beyond Alexandrianism, a part of Western bourgeois society has produced something unheard of heretofore: avant-garde culture. A superior consciousness of history – more precisely, the appearance of a new kind of criticism of society, an historical criticism – made this possible. This criticism has not confronted our present society with timeless utopias, but has soberly examined in the terms of history and of cause and effect the antecedents, justifications and functions of the forms that lie at the heart of every society. Thus our present bourgeois social order was shown to be, not an eternal, 'natural' condition of life, but simply the latest term in a succession of social orders. New perspectives of this kind, becoming a part of the advanced intellectual conscience of the fifth and sixth decades of the nineteenth century, soon were absorbed by artists and poets, even if unconsciously for the most part. It was no accident, therefore, that the birth of the avant-garde coincided chronologically – and geographically too – with the first bold development of scientific revolutionary thought in Europe.

True, the first settlers of Bohemia – which was then identical with the avant-garde – turned out soon to be demonstratively uninterested in politics. Nevertheless, without the circulation of revolutionary ideas in the air about them, they would never have been able to isolate their concept of the 'bourgeois' in order to define what they were *not*. Nor, without the moral aid of revolutionary political attitudes would they have had the courage to assert themselves as aggressively as they did against the prevailing standards of society. Courage indeed was needed for this, because the avant-garde's emigration from bourgeois society to Bohemia meant also an emigration from the markets of capitalism, upon which artists and writers had been thrown by the falling away of aristocratic patronage. (Ostensibly, at least, it meant this – meant starving in a garret – although, as will be shown later, the avant-garde remained attached to bourgeois society precisely because it needed its money.)

Yet it is true that once the avant-garde had succeeded in 'detaching' itself from society, it proceeded to turn around and repudiate revolutionary politics as well as bourgeois. The revolution was left inside society, a part of that welter of ideological struggle which art and poetry find so unpropitious as soon as it begins to involve those 'precious,' axiomatic beliefs upon which culture thus far has had to rest. Hence it was developed that the true and most important function of the avant-garde was not to 'experiment,' but to find a path along which it would be possible to keep culture *moving* in the midst of ideological confusion and violence. Retiring from public altogether, the avant-grade poet or artist sought to maintain the high level of his art by both narrowing and raising it to the expression of an absolute in which all relativities and contradictions would be either resolved or beside the point.

'Art for art's sake' and 'pure poetry' appear, and subject matter or content becomes something to be avoided like a plague.

It has been in search of the absolute that the avant-garde has arrived at 'abstract' or 'non-objective' art – and poetry, too. The avant-garde poet or artist tries in effect to imitate God by creating something valid solely on its own terms in the way nature itself is valid, in the way a landscape – not its picture – is aesthetically valid; something *given*, increate, independent of meanings, similars, or originals. Content is to be dissolved so completely into form that the work of art or literature cannot be reduced in whole or in part to anything not itself.

But the absolute is absolute, and the poet or artist, being what he is, cherishes certain relative values more than others. The very values in the name of which he invokes the absolute are relative values, the values of aesthetics. And so he turns out to be imitating, not God – and here I use 'imitate' in its Aristotelian sense – but the disciplines and processes of art and literature themselves. This is the genesis of the 'abstract.'[1] In turning his attention away from subject-matter or common experience, the poet or artist turns it in upon the medium of his own craft. The non-representational or 'abstract,' if it is to have aesthetic validity, cannot be arbitrary and accidental, but must stem from obedience to some worthy constraint or original. This constraint, once the world of common, extraverted experience has been renounced, can only be found in the very processes or disciplines by which art and literature have already imitated the former. These themselves become the subject matter of art and literature. If, to continue with Aristotle, all art and literature are imitation, then what we have here is the imitation of imitating. To quote Yeats:

> Nor is there singing school but studying
> Monuments of its own magnificence.

Picasso, Braque, Mondrian, Miró, Kandinsky, Brancusi, even Klee, Matisse and Cézanne, derive their chief inspiration from the medium they work in.[2] The excitement of their art seems to lie most of all in its pure preoccupation with the invention and arrangement of spaces, surfaces, shapes, colors, etc., to the exclusion of whatever is not necessarily implicated in these factors. The attention of poets like Rimbaud, Mallarmé, Valéry, Eluard, Pound, Hart Crane, Stevens, even Rilke and Yeats, appears to be centered on the effort to create poetry and on the 'moments' themselves of poetic conversion rather than on experience to be converted into poetry. Of course, this cannot exclude other preoccupations in their work, for poetry must deal with words, and words must communicate. Certain poets, such as Mallarmé and Valéry,[3] are more radical in this respect than others – leaving aside those poets who have tried to compose poetry in pure sound alone. However, if it were easier to define poetry, modern poetry would be much more 'pure' and 'abstract.' . . . As for the other fields of literature – the definition of avant-grade aesthetics advanced here is no Procrustean bed. But aside from the fact that most of our best contemporary novelists have gone to school with the avant-grade, it is significant that Gide's most ambitious book is a novel about the writing of a novel, and that Joyce's *Ulysses* and *Finnegan's Wake* seem to be above all, as one French critic says, the reduction of experience to expression for the sake of expression, the expression mattering more than what is being expressed.

That avant-garde culture is the imitation of imitat*ing* – the fact itself – calls for neither approval nor disapproval. It is true that this culture contains within itself some of the very Alexandrianism it seeks to overcome. The lines quoted from Yeats above referred to Byzantium, which is very close to Alexandria; and in a sense this imitation of imitat*ing* is a superior sort of Alexandrianism. But there is one most important difference; the avant-garde moves, while Alexandrianism stands still. And this, precisely, is what justifies the avant-garde's methods and makes them necessary. The necessity lies in the fact that by no other means is it possible today to create art and literature of a high order. To quarrel with necessity by throwing about terms like 'formalism,' purism,' 'ivory tower' and so forth is either dull or dishonest. This is not to say, however, that it is to the *social* advantage of the avant-garde that it is what it is. Quite the opposite.

The avant-garde's specialization of itself, the fact that its best artists are artists' artists, its best poets, poets' poets, has estranged a great many of those who were capable formerly of enjoying and appreciating ambitious art and literature, but who are now unwilling or unable to acquire an initiation into their craft secrets. The masses have always remained more or less indifferent to culture in the process of development. But today such culture is being abandoned by those to whom it actually belongs – our ruling class. For it is to the latter that the avant-garde belongs. No culture can develop without a social basis, without a source of stable income. And in the case of the avant-garde this was provided by an elite among the ruling class of that society from which it assumed itself to be cut off, but to which it has always remained attached by an umbilical cord of gold. The paradox is real. And now this elite is rapidly shrinking. Since the avant-garde forms the only living culture we now have, the survival in the near future of culture in general is thus threatened.

We must not be deceived by superficial phenomena and local successes. Picasso's shows still draw crowds, and T. S. Eliot is taught in the universities; the dealers in modernist art are still in business, and the publishers still publish some 'difficult' poetry. But the avant-garde itself, already sensing the danger, is becoming more and more timid every day that passes. Academicism and commercialism are appearing in the strangest places. This can mean only one thing that the avant-garde is becoming unsure of the audience it depends on – the rich and the cultivated.

Is it the nature itself of avant-garde culture that is alone responsible for the danger it finds itself in? Or is that only a dangerous liability? Are there other, and perhaps more important, factors involved?

II

Where there is an avant-garde, generally we also find a rearguard. True enough – simultaneously with the entrance of the avant-garde, a second new cultural phenomenon appeared in the industrial West: that thing to which the Germans give the wonderful name of *Kitsch*: popular, commercial art and literature with their chromeotypes, magazine covers, illustrations, ads, slick and pulp fiction, comics, Tin Pan Alley music, tap dancing, Hollywood movies, etc., etc. For some reason this gigantic apparition has always been taken for granted. It is time we looked into its whys and wherefores.

Kitsch is a product of the industrial revolution which urbanized the masses of Western Europe and America and established what is called universal literacy.

Previous to this the only market for formal culture, as distinguished from folk culture, had been among those who in addition to being able to read and write could command the leisure and comfort that always goes hand in hand with cultivation of some sort. This until then had been inextricably associated with literacy. But with the introduction of universal literacy, the ability to read and write became almost a minor skill like driving a car, and it no longer served to distinguish an individual's cultural inclinations, since it was no longer the exclusive concomitant of refined tastes. The peasants who settled in the cities as proletariat and petty bourgeois learned to read and write for the sake of efficiency, but they did not win the leisure and comfort necessary for the enjoyment of the city's traditional culture. Losing, nevertheless, their taste for the folk culture whose background was the countryside, and discovering a new capacity for boredom at the same time, the new urban masses set up a pressure on society to provide them with a kind of culture fit for their own consumption. To fill the demand of the new market a new commodity was devised: ersatz culture, kitsch, destined for those who, insensible to the values of genuine culture, are hungry nevertheless for the diversion that only culture of some sort can provide.

Kitsch, using for raw material the debased and academicized simulacra of genuine culture, welcomes and cultivates this insensibility. It is the source of its profits. Kitsch is mechanical and operates by formulas. Kitsch is vicarious experience and faked sensations. Kitsch changes according to style, but remains always the same. Kitsch is the epitome of all that is spurious in the life of our times. Kitsch pretends to demand nothing of its customers except their money – not even their time.

The pre-condition for kitsch, a condition without which kitsch would be impossible, is the availability close at hand of a fully matured cultural tradition, whose discoveries, acquisitions and perfected self-consciousness kitsch can take advantage of for its own ends. It borrows from it devices, tricks, strategems, rules of thumb, themes, converts them into a system and discards the rest. It draws its life blood, so to speak, from this reservoir of accumulated experience. This is what is really meant when it is said that the popular art and literature of today were once the daring, esoteric art and literature of yesterday. Of course, no such thing is true. What is meant is that when enough time has elapsed the new is looted for new 'twists,' which are then watered down and served up as kitsch. Self-evidently, all kitsch is academic, and conversely, all that's academic is kitsch. For what is called the academic as such no longer has an independent existence, but has become the stuffed-shirt 'front' for kitsch. The methods of industrialism displace the handicrafts.

Because it can be turned out mechanically, kitsch has become an integral part of our productive system in a way in which true culture could never be except accidentally. It has been capitalized at a tremendous investment which must show commensurate returns; it is compelled to extend as well as to keep its markets. While it is essentially its own salesman, a great sales apparatus has nevertheless been created for it, which brings pressure to bear on every member of society. Traps are laid even in those areas, so to speak, that are the preserves of genuine culture. It is not enough today, in a country like ours, to have an inclination towards the latter, one must have a true passion for it that will give him the power to resist the faked

article that surrounds and presses in on him from the moment he is old enough to look at the funny papers. Kitsch is deceptive. It has many different levels, and some of them are high enough to be dangerous to the naive seeker of true light. A magazine like the *New Yorker*, which is fundamentally high-class kitsch for the luxury trade, converts and waters down a great deal of avant-garde material for its own uses. Nor is every single item of kitsch altogether worthless. Now and then it produces something of merit, something that has an authentic folk flavor, and these accidental and isolated instances have fooled people who should know better.

Kitsch's enormous profits are a source of temptation to the avant-garde itself, and its members have not always resisted this temptation. Ambitious writers and artists will modify their work under the pressure of kitsch, if they do not succumb to it entirely. And then those puzzling border-line cases appear, such as the popular novelist, Simenon, in France, and Steinbeck in this country. The net result is always to the detriment of true culture, in any case.

Kitsch has not been confined to the cities in which it was born, but has flowed out over the countryside, wiping out folk culture. Nor has it shown any regard for geographical and national-cultural boundaries. Another mass product of Western industrialism, it has gone on a triumphal tour of the world, crowding out and defacing native cultures in one colonial country after another, so that it is now by way of becoming a universal culture, the first universal culture ever beheld. Today the Chinaman, no less than the South American Indian, the Hindu, no less than the Polynesian, have come to prefer to the products of their native art magazine covers, rotogravure sections and calendar girls. How is this virulence of kitsch, this irresistible attractiveness, to be explained? Naturally, machine-made kitsch can undersell the native handmade article, and the prestige of the West also helps, but why is kitsch a so much more profitable export article than Rembrandt? One, after all, can be reproduced as cheaply as the other.

In his last article on the Soviet cinema in the *Partisan Review*, Dwight Macdonald points out that kitsch has in the last ten years become the dominant culture in Soviet Russia. For this he blames the political regime – not only for the fact that kitsch is the official culture, but also that it is actually the dominant, most popular culture; and he quotes the following from Kurt London's *The Seven Soviet Arts*: ' . . . the attitude of the masses both to the old and new art styles probably remains essentially dependent on the nature of the education afforded them by their respective states.' Macdonald goes on to say: Why after all should ignorant peasants prefer Repin (a leading exponent of Russian academic kitsch in painting) to Picasso, whose abstract technique is at least as relevant to their own primitive folk art as is the former's realistic style? No, if the masses crowd into the Tretyakov (Moscow's museum of contemporary Russian art: kitsch) it is largely because 'they have been conditioned to shun "formalism" and to admire "socialist realism".'

In the first place it is not a question of a choice between merely the old and merely the new, as London seems to think – but of a choice between the bad, up-to-date old and the genuinely new. The alternative to Picasso is not Michelangelo, but kitsch. In the second place, neither in backward Russia nor in the advanced West do the masses prefer kitsch simply because their governments condition them towards it. Where state educational systems take the trouble to mention art, we are told to respect the old masters, not kitsch; and yet we go and hang Maxfield Parrish or his

equivalent on our walls, instead of Rembrandt and Michelangelo. Moreover, as Macdonald himself points out, around 1925 when the Soviet regime was encouraging avant-garde cinema, the Russian masses continued to prefer Hollywood movies. No, 'conditioning' does not explain the potency of kitsch . . .

All values are human values, relative values, in art as well as elsewhere. Yet there does seem to have been more or less of a general agreement among the cultivated of mankind over the ages as to what is good art and what bad. Taste has varied, but not beyond certain limits: contemporary connoisseurs agree with eighteenth century Japanese that Hokusai was one of the greatest artists of his time; we even agree with the ancient Egyptians that Third and Fourth Dynasty art was the most worthy of being selected as their paragon by those who came after. We may have come to prefer Giotto to Raphael, but we still do not deny that Raphael was one of the best painters of his *time*. There has been an agreement then, and this agreement rests, I believe, on a fairly constant distinction made between those values only to be found in art and the values which can be found elsewhere. Kitsch, by virtue of rationalized technique that draws on science and industry, has erased this distinction in practice.

Let us see for example what happens when an ignorant Russian peasant such as Macdonald mentions stands with hypothetical freedom of choice before two paintings, one by Picasso, the other by Repin. In the first he sees, let us say, a play of lines, colors and spaces that represent a woman. The abstract technique – to accept Macdonald's supposition, which I am inclined to doubt – reminds him somewhat of the icons he has left behind him in the village, and he feels the attraction of the familiar. We will even suppose that he faintly surmises some of the great art values the cultivated find in Picasso. He turns next to Repin's picture and sees a battle scene. The technique is not so familiar – as technique. But that weighs very little with the peasant, for he suddenly discovers values in Repin's picture which seem far superior to the values he has been accustomed to finding in icon art; and the unfamiliar technique itself is one of the sources of those values: the values of the vividly recognizable, the miraculous and the sympathetic. In Repin's picture the peasant recognizes and sees things in the way in which he recognizes and sees things outside of pictures – there is no discontinuity between art and life, no need to accept a convention and say to oneself, that icon represents Jesus because it intends to represent Jesus, even if it does not remind me very much of a man. That Repin can paint so realistically that identifications are self-evident immediately and without any effort on the part of the spectator – that is miraculous. The peasant is also pleased by the wealth of self-evident meanings which he finds in the picture: 'it tells a story.' Picasso and the icons are so austere and barren in comparison. What is more, Repin heightens reality and makes it dramatic: sunset, exploding shells, running and falling men. There is no longer any question of Picasso or icons. Repin is what the peasant wants, and nothing else but Repin. It is lucky, however, for Repin that the peasant is protected from the products of American capitalism, for he would not stand a chance next to a *Saturday Evening Post* cover by Norman Rockwell.

Ultimately, it can be said that the cultivated spectator derives the same values from Picasso that the peasant gets from Repin, since what the latter enjoys in Repin is somehow art too, on however low a scale, and he is sent to look at pictures by the same instincts that send the cultivated spectator. But the ultimate values which the

cultivated spectator derives from Picasso are derived at a second remove, as the result of reflection upon the immediate impression left by the plastic values. It is only then that the recognizable, the miraculous and the sympathetic enter. They are not immediately or externally present in Picasso's painting, but must be projected into it by the spectator sensitive enough to react sufficiently to plastic qualities. They belong to the 'reflected' effect. In Repin, on the other hand, the 'reflected' effect has already been included in the picture, ready for the spectator's unreflective enjoyment.[4] Where Picasso paints *cause*, Repin paints *effect*. Repin pre-digests art for the spectator and spares him effort, provides him with a short cut to the pleasure of art that detours what is necessarily difficult in genuine art. Repin, or kitsch, is synthetic art.

The same point can be made with respect to kitsch literature: it provides vicarious experience for the insensitive with far greater immediacy than serious fiction can hope to do. And Eddie Guest and the *Indian Love Lyrics* are more poetic than T. S. Eliot and Shakespeare.

III

If the avant-garde imitates the processes of art, kitsch, we now see, imitates its effects. The neatness of this antithesis is more than contrived; it corresponds to and defines the tremendous interval that separates from each other two such simultaneous cultural phenomena as the avant-garde and kitsch. This interval, too great to be closed by all the infinite gradations of popularized 'modernism' and 'modernistic' kitsch, corresponds in turn to a social interval, a social interval that has always existed in formal culture as elsewhere in civilized society, and whose two termini converge and diverge in fixed relation to the increasing or decreasing stability of the given society. There has always been on one side the minority of the powerful – and therefore the cultivated – and on the other the great mass of the exploited and poor – and therefore the ignorant. Formal culture has always belonged to the first, while the last have had to content themselves with folk or rudimentary culture, or kitsch.

In a stable society which functions well enough to hold in solution the contradictions between its classes the cultural dichotomy becomes somewhat blurred. The axioms of the few are shared by the many; the latter believe superstitiously what the former believe soberly. And at such moments in history the masses are able to feel wonder and admiration for the culture, on no matter how high a plane, of its masters. This applies at least to plastic culture, which is accessible to all.

In the Middle Ages the plastic artist paid lip service at least to the lowest common denominators of experience. This even remained true to some extent until the seventeenth century. There was available for imitation a universally valid conceptual reality, whose order the artist could not tamper with. The subject matter of art was prescribed by those who commissioned works of art, which were not created, as in bourgeois society, on speculation. Precisely because his content was determined in advance, the artist was free to concentrate on his medium. He needed not to be philosopher or visionary, but simply artificer. As long as there was general agreement as to what were the worthiest subjects for art, the artist was relieved of the necessity to be original and inventive in his 'matter' and could devote all his

energy to formal problems. For him the medium became, privately, professionally, the content of his art, even as today his medium is the public content of the abstract painter's art – with that difference, however, that the medieval artist had to suppress his professional preoccupation in public – had always to suppress and subordinate the personal and professional in the finished, official work of art. If, as an ordinary member of the Christian community, he felt some personal emotion about his subject matter, this only contributed to the enrichment of the work's public meaning. Only with the Renaissance do the inflections of the personal become legitimate, still to be kept, however, within the limits of the simply and universally recognizable. And only with Rembrandt do 'lonely' artists begin to appear, lonely in their art.

But even during the Renaissance, and as long as Western art was endeavoring to perfect its technique, victories in this realm could only be signalized by success in realistic imitation, since there was no other objective criterion at hand. Thus the masses could still find in the art of their masters objects of admiration and wonder. Even the bird who pecked at the fruit in Zeuxes' picture could applaud.

It is a platitude that art becomes caviar to the general when the reality it imitates no longer corresponds even roughly to the reality recognized by the general. Even then, however, the resentment the common man may feel is silenced by the awe in which he stands of the patrons of this art. Only when he becomes dissatisfied with the social order they administer does he begin to criticize their culture. Then the plebeian finds courage for the first time to voice his opinions openly. Every man, from Tammany aldermen to Austrian house-painters, finds that he is entitled to his opinion. Most often this resentment towards culture is to be found where the dissatisfaction with society is a reactionary dissatisfaction which expresses itself in revivalism and puritanism, and latest of all, in fascism. Here revolvers and torches begin to be mentioned in the same breath as culture. In the name of godliness or the blood's health, in the name of simple ways and solid virtues, the statue-smashing commences.

IV

Returning to our Russian peasant for the moment, let us suppose that after he has chosen Repin in preference to Picasso, the state's educational apparatus comes along and tells him that he is wrong, that he should have chosen Picasso – and shows him why. It is quite possible for the Soviet state to do this. But things being as they are in Russia – and everywhere else – the peasant soon finds that the necessity of working hard all day for his living and the rude, uncomfortable circumstances in which he lives do not allow him enough leisure, energy and comfort to train for the enjoyment of Picasso. This needs, after all, a considerable amount of 'conditioning.' Superior culture is one of the most artificial of all human creations, and the peasant finds no 'natural' urgency within himself that will drive him towards Picasso in spite of all difficulties. In the end the peasant will go back to kitsch when he feels like looking at pictures, for he can enjoy kitsch without effort. The state is helpless in this matter and remains so as long as the problems of production have not been solved in a socialist sense. The same holds true, of course, for capitalist countries and makes all talk of art for the masses there nothing but demagogy.[5]

Where today a political regime establishes an official cultural policy, it is for the sake of demagogy. If kitsch is the official tendency of culture in Germany, Italy and Russia, it is not because their respective governments are controlled by philistines, but because kitsch is the culture of the masses in these countries, as it is everywhere else. The encouragement of kitsch is merely another of the inexpensive ways in which totalitarian regimes seek to ingratiate themselves with their subjects. Since these regimes cannot raise the cultural level of the massess – even if they wanted to – by anything short of a surrender to international socialism, they will flatter the masses by bringing all culture down to their level. It is for this reason that the avant-garde is outlawed, and not so much because a superior culture is inherently a more critical culture. (Whether or not the avant-garde could possibly flourish under a totalitarian regime is not pertinent to the question at this point.) As matter of fact, the main trouble with avant-garde art and literature, from the point of view of Fascists and Stalinists, is not that they are too critical, but that they are too 'innocent,' that it is too difficult to inject effective propaganda into them, that kitsch is more pliable to this end. Kitsch keeps a dictator in closer contact with the 'soul' of the people. Should the official culture be one superior to the general mass-level, there would be a danger of isolation.

Nevertheless, if the masses were conceivably to ask for avant-garde art and literature, Hitler, Mussolini and Stalin would not hesitate long in attempting to satisfy such a demand. Hitler is a bitter enemy of the avant-garde, both on doctrinal and personal grounds, yet this did not prevent Goebbels in 1932–33 from strenuously courting avant-garde artists and writers. When Gottfried Benn, an Expressionist poet, came over to the Nazis he was welcomed with a great fanfare, although at that very moment Hitler was denouncing Expressionism as *Kulturbolschewismus*. This was at a time when the Nazis felt that the prestige which the avant-garde enjoyed among the cultivated German public could be of advantage to them, and practical considerations of this nature, the Nazis being the skilful politicians they are, have always taken precedence over Hitler's personal inclinations. Later the Nazis realized that it was more practical to accede to the wishes of the masses in matters of culture than to those of their paymasters; the latter, when it came to a question of preserving power, were as willing to sacrifice their culture as they were their moral principles, while the former, precisely because power was being withheld from them, had to be cozened in every other way possible. It was necessary to promote on a much more grandiose style than in the democracies the illusion that the masses actually rule. The literature and art they enjoy and understand were to be proclaimed the only true art and literature and any other kind was to be suppressed. Under these circumstances people like Gottfried Benn, no matter how ardently they support Hitler, become a liability; and we hear no more of them in Nazi Germany.

We can see then that although from one point of view the personal philistinism of Hitler and Stalin is not accidental to the political roles they play, from another point of view it is only an incidentally contributory factor in determining the culture policies of their respective regimes. Their personal philistinism simply adds brutality and double-darkness to policies they would be forced to support anyhow by the pressure of all their other policies – even were they, personally, devotees of avant-garde culture. What the acceptance of the isolation of the Russian Revolution forces Stalin to do, Hitler is compelled to do by his acceptance of the contradictions

of capitalism and his efforts to freeze them. As for Mussolini — his case is a perfect example of the *disponibilité* of a realist in these matters. For years he bent a benevolent eye on the Futurists and built modernistic railroad stations and government-owned apartment houses. One can still see in the suburbs of Rome more modernistic apartments than almost anywhere else in the world. Perhaps Fascism wanted to show its up-to-datedness, to conceal the fact that it was a retrogression; perhaps it wanted to conform to the tastes of the wealthy élite it served. At any rate Mussolini seems to have realized lately that it would be more useful to him to please the cultural tastes of the Italian masses than those of their masters. The masses must be provided with objects of admiration and wonder; the latter can dispense with them. And so we find Mussolini announcing a 'new Imperial style.' Marinetti, Chirico, et al. are sent into the outer darkness, and the new railroad station in Rome will not be modernistic. That Mussolini was late in coming to this only illustrates again the relative hesitancy with which Italian fascism has drawn the necessary implications of its role . . .

Capitalism in decline finds that whatever of quality it is still capable of producing becomes almost invariably a threat to its own existence. Advances in culture no less than advances in science and industry corrode the very society under whose aegis they are made possible. Here, as in every other question today, it becomes necessary to quote Marx word for word. Today we no longer look towards socialism for a new culture — as inevitably as one will appear, once we do have socialism. Today we look to socialism *simply* for the preservation of whatever living culture we have right now.

Notes

1 The example of music, which has long been an abstract art, and which avant-garde poetry has tried so much to emulate, is interesting. Music, Aristotle said curiously enough, is the most imitative and vivid of all arts because it imitates its original — the state of the soul — with the greatest immediacy. Today this strikes us as the exact opposite of the truth, because no art seems to us to have less reference to something outside itself than music. However, aside from the fact that in a sense Aristotle may still be right, it must be explained that ancient Greek music was closely associated with poetry, and depended upon its character as an accessory to verse to make its imitative meaning clear. Plato, speaking of music, says: 'For when there are no words, it is very difficult to recognize the meaning of the harmony and rhythm, or to see that any worthy object is imitated by them.' As far as we know, all music originally served such an accessory function. Once, however, it was abandoned, music was forced to withdraw into itself to find a constraint or original. This is found in the various means of its own composition and performance.

2 I owe this formulation to a remark made by Hans Hofmann, the art teacher, in one of his lectures. From the point of view of this formulation, Surrealism in plastic art is a reactionary tendency which is attempting to restore 'outside' subject matter. The chief concern of a painter like Dali is to represent the processes and concepts of his consciousness, not the processes of his medium.

3 See Valéry's remarks about his own poetry.

4 T. S. Eliot said something to the same effect in accounting for the short-comings of
 English Romantic poetry. Indeed the Romantics can be considered the original
 sinners whose guilt kitsch inherited. They showed kitsch how. What does Keats
 write about mainly, if not the effect of poetry upon himself?

5 It will be objected that such art for the masses as folk art was developed under
 rudimentary conditions of production – and that a good deal of folk art is on a high
 level. Yes, it is – but folk art is not Athene, and it's Athene whom we want: formal
 culture with its infinity of aspects, its luxuriance, its large comprehension. Besides,
 we are now told that most of what we consider good in folk culture is the static
 survival of dead formal, aristocratic, cultures. Our old English ballads, for instance,
 were not created by the 'folk,' but by the post-feudal squirearchy of the English
 countryside, to survive in the mouths of the folk long after those for whom the
 ballads were composed had gone on to other forms of literature . . . Unfortunately,
 until the machine-age, culture was the exclusive prerogative of a society that lived
 by the labor of serfs or slaves. They were the real symbols of culture. For one man to
 spend time and energy creating or listening to poetry meant that another man had
 to produce enough to keep himself alive and the former in comfort. In Africa today
 we find that the culture of slave-owning tribes is generally much superior to that of
 the tribes that possess no slaves.

(Editor's note: When this text appeared in the author's *Art and Culture: Critical Essays* (Beacon
Press, 1961), Greenberg included the following note when the volume was reprinted:
P.S. To my dismay I learned years after this saw print that Repin never painted a battle scene;
he wasn't that kind of painter. I had attributed some one else's picture to him. That showed
my provincialism with regard to Russian art in the nineteenth century. [1972])

Clement Greenberg

TOWARDS A NEWER LAOCOON

THE DOGMATISM AND INTRANSIGENCE of the 'non-objective' or 'abstract' purists of painting today cannot be dismissed as symptoms merely of a cultist attitude towards art. Purists make extravagant claims for art, because usually they value it much more than any one else does. For the same reason they are much more solicitous about it. A great deal of purism is the translation of an extreme solicitude, an anxiousness as to the fate of art, a concern for its identity. We must respect this. When the purist insists upon excluding 'literature' and subject matter from plastic art, now and in the future, the most we can charge him with off-hand is an unhistorical attitude. It is quite easy to show that abstract art like every other cultural phenomenon reflects the social and other circumstances of the age in which its creators live, and that there is nothing inside art itself, disconnected from history, which compels it to go in one direction or another. But it is not so easy to reject the purist's assertion that the best of contemporary plastic art is abstract. Here the purist does not have to support his position with metaphysical pretentions. And when he insists on doing so, those of us who admit the merits of abstract art without accepting its claims in full must offer our own explanation for its present supremacy.

Discussion as to purity in art and, bound up with it, the attempts to establish the differences between the various arts are not idle. There has been, is, and will be, such a thing as a confusion of the arts. From the point of view of the artist engrossed in the problems of his medium and indifferent to the efforts of theorists to explain abstract art *completely*, purism is the terminus of a salutory reaction against the mistakes of painting and sculpture in the past several centuries which were due to such a confusion.

Source: 'Towards a Newer Laocoon', *Partisan Review*, July–August, 1940, vol. 7, no. 4, pp. 296–310. © Clement Greenberg. This material has been slightly revised by the author. Most revisions are to punctuation.

I

There can be, I believe, such a thing as a dominant art form; this was what literature had become in Europe by the 17th century. (Not that the ascendancy of a particular art always coincides with its greatest productions. In point of achievement, music was the greatest art of this period.) By the middle of the 17th century the pictorial arts had been relegated almost everywhere into the hands of the courts, where they eventually degenerated into relatively trivial interior decoration. The most creative class in society, the rising mercantile bourgeoisie, impelled perhaps by the iconoclasm of the Reformation (Pascal's Jansenist contempt for painting is a symptom) and by the relative cheapness and mobility of the physical medium after the invention of printing, had turned most of its creative and acquisitive energy towards literature.

Now, when it happens that a single art is given the dominant role, it becomes the prototype of all art: the others try to shed their proper characters and imitate its effects. The dominant art in turn tries itself to absorb the functions of the others. A confusion of the arts results, by which the subservient ones are perverted and distorted; they are forced to deny their own nature in an effort to attain the effects of the dominant art. However, the subservient arts can only be mishandled in this way when they have reached such a degree of technical facility as to enable them to pretend to conceal their *mediums*. In other words, the artist must have gained such power over his material as to annihilate it seemingly in favor of *illusion*. Music was saved from the fate of the pictorial arts in the 17th and 18th centuries by its comparatively rudimentary technique and the relative shortness of its development as a formal art. Aside from the fact that in its nature it is the art furthest removed from imitation, the possibilities of music had not been explored sufficiently to enable it to strive for illusionist effects.

But painting and sculpture, the arts of illusion par excellence, had by that time achieved such facility as to make them infinitely susceptible to the temptation to emulate the effects, not only of illusion, but of other arts. Not only could painting imitate sculpture, and sculpture, painting, but both could attempt to reproduce the effects of literature. And it was for the effects of literature that 17th and 18th century painting strained most of all. Literature, for a number of reasons, had won the upper hand, and the plastic arts – especially in the form of easel painting and statuary – tried to win admission to its domain. Although this does not account completely for the decline of those arts during this period, it seems to have been the form of that decline. Decline it was, compared to what had taken place in Italy, Flanders, Spain and Germany the century before. Good artists, it is true, continue to appear – I do not have to exaggerate the depression to make my point – but not good *schools* of art, not good followers. The circumstances surrounding the appearance of the individual great artists seem to make them almost all exceptions; we think of them as great artists 'in spite of.' There is a scarcity of distinguished small talents. And the very level of greatness sinks by comparison to the work of the past.

In general, painting and sculpture in the hands of the lesser talents – and this is what tells the story – become nothing more than ghosts and 'stooges' of literature. All emphasis is taken away from the medium and transferred to subject matter. It is no longer a question even of realistic imitation, since that is taken for granted, but of the artist's ability to interpret subject matter for poetic effects and so forth.

We ourselves, even today, are too close to literature to appreciate its status as a dominant art. Perhaps an example of the converse will make clearer what I mean. In China, I believe, painting and sculpture became in the course of the development of culture the dominant arts. There we see poetry given a role subordinate to them, and consequently assuming their limitations: the poem confines itself to the single moment of painting and to an emphasis upon visual details. The Chinese even require visual delight from the handwriting in which the poem is set down. And by comparison to their pictorial and decorative arts doesn't the later poetry of the Chinese seem rather thin and monotonous?

Lessing, in his *Laokoon* written in the 1760s, recognized the presence of a practical as well as a theoretical confusion of the arts. But he saw its ill effects exclusively in terms of literature, and his opinions on plastic art only exemplify the typical misconceptions of his age. He attacked the descriptive verse of poets like James Thomson as an invasion of the domain of landscape painting, but all he could find to say about painting's invasion of poetry was to object to allegorical pictures which required an explanation, and to paintings like Titian's 'Prodigal Son,' which incorporate 'two necessarily separate points of time in one and the same picture.'

II

The Romantic Revival or Revolution seemed at first to offer some hope for painting, but by the time it departed the scene, the confusion of the arts had become worse. The Romantic theory of art was that the artist feels something and passes on this feeling – not the situation or thing which stimulated it – to his audience. To preserve the immediacy of the feeling it was even more necessary than before, when art was imitation rather than communication, to suppress the role of the medium. The medium was a regrettable if necessary physical obstacle between the artist and his audience, which in some ideal state would disappear entirely to leave the experience of the spectator or reader identical with that of the artist. In spite of the fact that music considered as an art of pure feeling, was beginning to win almost equal esteem, this attitude represents a final triumph for poetry. All feeling for the arts as métiers, crafts, disciplines – of which some sense had survived until the 18th century – was lost. The arts came to be regarded as nothing more or less than so many powers of the personality. Shelley expressed this best when in his *Defense of Poetry* he exalted poetry above the other arts because its medium came closest, as Bosanquet puts it, to being no medium at all. In practice this aesthetic encouraged that particular and widespread form of artistic dishonesty which consists in the attempt to escape from the problems of the medium of one art by taking refuge in the effects of another. Painting is the most susceptible to evasions of this sort, and painting suffered most at the hands of the Romantics.

At first it did not seem so. As a result of the triumph of the burghers and of their appropriation of all the arts a fresh current of creative energy was released into every field. If the Romantic revolution in painting was at first more a revolution in subject matter than in anything else, abandoning the oratorical and frivolous literature of 18th century painting in search of a more original, more powerful, more sincere literary content, it also brought with it a greater boldness in pictorial means.

Delacroix, Géricault, even Ingres, were enterprising enough to find new form for the new content they introduced. But the net result of their efforts was to make the incubus of literature in painting even deadlier for the lesser talents who followed them. The worst manifestations of literary and sentimental painting had already begun to appear in the painting of the late 18th century – especially in England, where a revival which produced some of the best English painting was equally efficacious in speeding up the process of degeneration. Now the schools of Ingres and Delacroix joined with those of Morland and Greuze and Vigée-Lebrun to become the official painting of the 19th century. There have been academies before, but for the first time we have academicism. Painting enjoyed a revival of activity in 19th century France such as had not been seen since the 16th century, and academicism could produce such good painters as Corot and Theodore Rousseau, and even Daumier – yet in spite of this the academicians sank painting to a level that was in some respects an all-time low. The name of this low is Vernet, Gérôme, Leighton, Watts, Moreau, Böcklin, the Pre-Raphaelites, etc., etc. That some of these painters had real talent only made their influence the more pernicious. It took talent – among other things – to lead art that far astray. Bourgeois society gave these talents a prescription, and they filled it – with talent.

It was not realistic imitation in itself that did the damage so much as realistic illusion in the service of sentimental and declamatory literature. Perhaps the two go hand in hand. To judge from Western and Graeco-Roman art, it seems so. Yet it is true of Western painting that in so far as it has been the creation of a rationalist and scientifically-minded city culture, it has always had a bias towards a realism that tries to achieve illusion by overpowering the medium, and is more interested in exploiting the practical meanings of objects than in savoring their appearance.

III

Romanticism was the last great tendency flowing *directly* from bourgeois society that was able to inspire and stimulate the profoundly responsible artist – the artist conscious of certain inflexible obligations to the standards of his craft. By 1848 Romanticism had exhausted itself. After that the impulse, although indeed it had to originate in bourgeois society, could only come in the guise of a denial of that society, as a turning away from it. It was not to be an about-face towards a new society, but an emigration to a Bohemia which was to be art's sanctuary from capitalism. It was to be the task of the avant-garde to perform in opposition to bourgeois society the function of finding new and adequate cultural forms for the expression of that same society, without at the same time succumbing to its ideological divisions and its refusal to permit the arts to be their own justification. The avant-garde, both child and negation of Romanticism, becomes the embodiment of art's instinct of self-preservation. It is interested in, and feels itself responsible to, only the values of art; and, given society as it is, has an organic sense of what is good and what is bad for art.

As the first and most important item upon its agenda, the avant-garde saw the necessity of an escape from ideas, which were infecting the arts with the ideological struggles of society. Ideas came to mean subject matter in general. (Subject matter

as distinguished from content: in the sense that every work of art must have content, but that subject matter is something the artist does or does not have in mind when he is actually at work.) This meant a new and greater emphasis upon form, and it also involved the assertion of the arts as independent vocations, disciplines and crafts, absolutely autonomous, and entitled to respect for their own sakes, and not merely as vessels of communication. It was the signal for a revolt against the dominance of literature, which was subject matter at its most oppressive.

The avant-garde has pursued, and still pursues, several variants, whose chronological order is by no means clear, but can be best traced in painting, which as the chief victim of literature brought the problem into sharpest focus. (Forces stemming from outside art play a much larger part than I have room to acknowledge here. And I must perforce be rather schematic and abstract, since I am interested more in tracing large outlines than in accounting for and gathering in all particular manifestations.)

By the second third of the 19th century academic painting had degenerated from the pictorial to the picturesque. Everything depends on the anecdote or the message. The painted picture occurs in blank, indeterminate space; it just happens to be on a square of canvas and inside a frame. It might just as well have been breathed on air or formed out of plasma. It tries to be something you imagine rather than see – or else a bas-relief or a statue. Everything contributes to the denial of the medium, as if the artist were ashamed to admit that he had actually painted his picture instead of dreaming it forth.

This state of affairs could not be overcome at one stroke. The campaign for the redemption of painting was to be one of comparatively slow attrition at first. Nineteenth century painting made its first break with literature when in the person of the Communard, Courbet, it fled from spirit to matter. Courbet, the first real avant-garde painter, tried to reduce his art to immediate sense data by painting only what the eye could see as a machine unaided by the mind. He took for his subject matter prosaic contemporary life. As avant-gardists so often do, he tried to demolish official bourgeois art by turning it inside out. By driving something as far as it will go you often get back to where it started. A new flatness begins to appear in Courbet's painting, and an equally new attention to every inch of the canvas, regardless of its relation to the 'centers of interest.' (Zola, the Goncourts and poets like Verhaeren were Courbet's correlatives in literature. They too were 'experimental'; they too were trying to get rid of ideas and 'literature,' that is, to establish their art on a more stable basis than the crumbling bourgeois oecumene.) If the avant-garde seems unwilling to claim naturalism for itself it is because the tendency failed too often to achieve the objectivity it professed, i.e. it succumbed to 'ideas.'

Impressionism, reasoning beyond Courbet in its pursuit of materialist objectivity, abandoned common sense experience and sought to emulate the detachment of science, imagining that thereby it would get at the very essence of painting as well as of visual experience. It was becoming important to determine the essential elements of each of the arts. Impressionist painting becomes more an exercise in color vibrations than representation of nature. Manet meanwhile, closer to Courbet, was attacking subject matter on its own terrain by including it in his pictures and exterminating it then and there. His insolent indifference to his subject, which in itself was often striking, and his flat color-modeling were as revolutionary as

Impressionist technique proper. Like the Impressionists he saw the problems of painting as first and foremost problems of the medium, and he called the spectator's attention to this.

IV

The second variant of the avant-garde's development is concurrent in time with the first. It is easy to recognize this variant, but rather difficult to expose its motivation. Tendencies go in opposite directions, and cross-purposes meet. But tying everything together is the fact that in the end cross-purposes indeed do meet. There is a common effort in each of the arts to expand the expressive resources of the medium, not in order to express ideas and notions, but to express with greater immediacy sensations, the irreduceable elements of experience. Along this path it seemed as though the avant-garde in its attempt to escape from 'literature' had set out to treble the confusion of the arts by having them imitate every other art except literature.' (By this time literature had had its opprobrious sense expanded to include everything the avant-garde objected to in official bourgeois culture.) Each art would demonstrate its powers by capturing the effects of its sister arts or by taking a sister art for its subject. Since art was the only validity left, what better subject was there for each art than the procedures and effects of some other art? Impressionist painting, with its progressions and rhythmic suffusions of color, with its moods and atmospheres, was arriving at effects to which the Impressionists themselves gave the terms of Romantic music. Painting, however, was the least affected by this new confusion. Poetry and music were its chief victims. Poetry – for it too had to escape from 'literature' – was imitating the effects of painting and sculpture (Gautier, the Parnassians, and later the Imagists) and, of course, those of music (Poe had narrowed 'true' poetry down to the lyric). Music, in flight from the undisciplined, bottomless sentimentality of the Romantics, was striving to describe and narrate (program music). That music at this point imitates literature would seem to spoil my thesis. But music imitates painting as much as it does poetry when it becomes representational; and besides, it seems to me that Debussy used the program more as a pretext for experiment than as an end in itself. In the same way that the Impressionist painters were trying to get at the structure beneath the color, Debussy was trying to get at the 'sound underneath the note.'

Aside from what was going on inside music, music as an art in itself began at this time to occupy a very important position in relation to the other arts. Because of its 'absolute' nature, its remoteness from imitation, its almost complete absorption in the very physical quality of its medium, as well as because of its resources of suggestion, music had come to replace poetry as the paragon art. It was the art which the other avant-garde arts envied most, and whose effects they tried hardest to imitate. Thus it was the principal agent of the new confusion of the arts. What attracted the avant-garde to music as much as its power to suggest was, as I have said, its nature as an art of immediate sensation. When Verlaine said, 'De la musique avant toute chose,' he was not only asking poetry to be more suggestive – suggestiveness, after all, was a poetic ideal foisted upon music – but also to affect the reader or listener with more immediate and more powerful sensations.

But only when the avant-garde's interest in music led it to consider music as a *method* of art rather than as a kind of effect did the avant-garde find what it was looking for. It was when it was discovered that the advantage of music lay chiefly in the fact that it was an 'abstract' art, an art of 'pure form.' It was such because it was incapable, objectively, of communicating anything else than a sensation, and because this sensation could not be conceived in any other terms than those of the sense through which it entered consciousness. An imitative painting can be described in terms of non-visual identities, a piece of music cannot, whether it attempts to imitate or not. The effects of music are the effects, essentially, of pure form; those of painting and poetry are too often incidental to the formal natures of these arts. Only by accepting the example of music and defining each of the other arts solely in the terms of the sense or faculty which perceived its effects and by excluding from each art whatever is intelligible in the terms of any other sense or faculty would the non-musical arts attain the 'purity' and self-sufficiency which they desired; which they desired, that is, in so far as they were avant-garde. The emphasis, therefore, was to be on the physical, the sensorial. 'Literature's' corrupting influence is only felt when the senses are neglected. The latest confusion of the arts was the result of a mistaken conception of music as the only immediately sensuous art. But the other arts can also be sensuous, if only they will look to music, not to ape its effects, but to borrow its principles as a 'pure' art, as an art which is abstract because it is almost nothing else except sensuous.'

V

Guiding themselves, whether consciously or unconsciously, by a notion of purity derived from the example of music, the avant-garde arts have in the last fifty years achieved a 'purity' and a radical de-limitation of their fields of activity for which there is no previous example in the history of culture. The arts lie safe now, each within its 'legitimate' boundaries, and free trade has been replaced by autarchy. Purity in art consists in the acceptance, willing acceptance, of the limitations of the medium of the specific art. To prove that their concept of purity is something more than a bias in taste, painters point to Oriental, primitive and children's art as instances of the universality and naturalness and objectivity of their ideal of purity. Composers and poets, although to a much lesser extent, may justify their efforts to attain purity by referring to the same precedents. Dissonance is present in early and non-Western music, 'unintelligibility' in folk poetry. The issue is, of course, focussed most sharply in the plastic arts, for they, in their non-decorative function, have been the most closely associated with imitation, and it is in their case that the ideal of the pure and the abstract has met the most resistance.

The arts, then, have been hunted back to their mediums, and there they have been isolated, concentrated and defined. It is by virtue of its medium that each art is unique and strictly itself. To restore the identity of an art the opacity of its medium must be emphasized. For the visual arts the medium is discovered to be physical; hence pure painting and pure sculpture seek above all else to affect the spectator physically. In poetry, which, as I have said, had also to escape from 'literature' or subject matter for its salvation from society, it is decided that the medium is

essentially psychological and sub- or supra-logical. The poem is to aim at the general consciousness of the reader, not simply his intelligence.

It would be well to consider 'pure' poetry for a moment, before going on to painting. The theory of poetry as incantation, hypnosis or drug – as psychological agent then – goes back to Poe, and eventually to Coleridge and Edmund Burke with their efforts to locate the enjoyment of poetry in the 'Fancy' or 'Imagination.' Mallarmé, however, was the first to base a consistent practice of poetry upon it. Sound, he decided, is only an auxiliary of poetry, not the medium itself; and besides, most poetry is now read, not recited: the sound of words is a part of their meaning, not the vessel of it. To deliver poetry from the subject and to give full play to its true affective power it is necessary to free words from logic. The medium of poetry is isolated in the power of the word to evoke associations and to connote. Poetry subsists no longer in the relations between words as meanings, but in the relations between words as personalities composed of sound, history and possibilities of meaning. Grammatical logic is retained only in so far as it is necessary to set these personalities in motion, for unrelated words are static when read and not recited aloud. Tentative efforts are made to discard metric form and rhyme, because they are regarded as too local and determinate, too much attached to specific times and places and social conventions to pertain to the essence of poetry. There are experiments in poetic prose. But as in the case of music, it was found that formal structure was indispensable, that some such structure was integral to the medium of poetry as an aspect of its resistance . . . The poem still offers possibilities of meaning – but only possibilities. Should any of them be too precisely realized, the poem would lose the greatest part of its efficacy, which is to agitate the consciousness with infinite possibilities by approaching the brink of meaning and yet never falling over it. The poet writes, not so much to *express*, as to create a thing which will operate upon the reader's consciousness to produce the emotion of poetry. The content of the poem is what it does to the reader, not what it communicates. The emotion of the reader derives from the poem as a unique object – pretendedly – and not from referents outside the poem. This is 'pure' poetry as ambitious contemporary poets try to define it by the example of their work. Obviously, it is an impossible ideal, yet one which most of the best poetry of that last fifty years has tried to reach, whether it is poetry about nothing or poetry about the plight of contemporary society.

It is easier to isolate the medium in the case of the plastic arts, and consequently avant-garde painting and sculpture can be said to have attained a much more radical 'purity' than avant-garde poetry. Painting and sculpture can become more completely nothing but what they do; like functional architecture and the machine, they *look* what they *do*. The picture or statue exhausts itself in the visual sensation it produces. There is nothing to identify, connect or think about, but everything to feel. 'Pure' poetry strives for infinite suggestion, 'pure' plastic art for the minimum. If the poem, as Valéry claims, is a machine to produce the emotion of poetry, the painting and statue are machines to produce the emotion of 'plastic sight.' The purely plastic or abstract qualities of the work of art are the only ones that count. Emphasize the medium and its difficulties, and at once the purely plastic, the proper, values of visual art come to the fore. Overpower the medium to the point where all sense of its resistance disappears, and the adventitious uses of art become more important.

The history of avant-garde painting is that of a progressive surrender to the resistance of its medium; which resistance consists chiefly in the flat picture plane's denial of efforts to 'hole through' it for realistic perspectival space. In making this surrender, painting not only got rid of imitation – and with it, 'literature' – but also of realistic imitation's corollary confusion between painting and sculpture. (Sculpture, on its side, emphasizes the resistance of its material to the efforts of the artist to ply it into shapes uncharacteristic of stone, metal, wood, etc.) Painting abandons chiaroscuro and shaded modelling. Brush strokes are often defined for their own sake. The motto of the Renaissance artist, *Ars est artem celare*, is exchanged for *Ars est artem demonstrare*. Primary colors, the 'instinctive,' easy colors, replace tones and tonality. Line, which is one of the most abstract elements in painting since it is never found in nature as the definition of contour, returns to oil painting as the third color between two other color areas. Under the influence of the rectangular shape of the canvas, forms tend to become geometrical – and simplified, because simplification is also a part of the instinctive accommodation to the medium. But most important of all, the picture plane itself grows shallower and shallower, flattening out and pressing together the fictive planes of depth until they meet as one upon the real and material plane which is the actual surface of the canvas; where they lie side by side or interlocked or transparently imposed upon each other. Where the painter still tries to indicate real objects their shapes flatten and spread in the dense, two-dimensional atmosphere. A vibrating tension is set up as the objects struggle to maintain their volume against the tendency of the real picture plane to re-assert its material flatness and crush them to silhouettes. In a further stage realistic space cracks and splinters into flat planes which come forward, parallel to the plane surface. Sometimes this advance to the surface is accelerated by inserting a piece of printed paper, or by painting a segment of wood or texture *trompe l'oeil*, or by drawing exactly printed letters, and placing them so that they destroy the partial illusion of depth by slamming the various planes together. Thus the artist deliberately emphasizes the illusoriness of the illusions which he pretends to create. Sometimes these elements are used in an effort to preserve an illusion of depth by being placed on the nearest plane in order to drive the others back. But the result is an optical illusion, not a realistic one, and only emphasizes further the impenetrability of the plane surface.

The destruction of realistic pictorial space, and with it, that of the object, was accomplished by means of the travesty that was cubism. The cubist painter eliminated color because, consciously or unconsciously, he was parodying, in order to destroy, the academic methods of achieving volume and depth, which are shading and perspective, and as such have little to do with color in the common sense of the word. The cubist used these same methods to break the canvas into a multiplicity of subtle recessive planes, which seem to shift and fade into infinite depths and yet insist on returning to the surface of the canvas. As we gaze as at a cubist painting of the last phase we witness the birth and death of three-dimensional pictorial space.

And as in painting the pristine flatness of the stretched canvas constantly struggles to overcome every other element, so in sculpture the stone figure appears to be on the point of relapsing into the original monolith, and the cast seems to narrow and smooth itself back to the original molten stream from which it was poured, or tries to remember the texture and plasticity of the clay in which it was first worked out.

Sculpture hovers finally on the verge of 'pure' architecture, and painting, having been pushed up from fictive depths, is forced through the surface of the canvas to emerge on the other side in the form of paper, cloth, cement and actual objects of wood and other materials pasted, glued or nailed to what was originally the transparent picture plane, which the painter no longer dares to puncture – or if he does, it is only to dare. Artists like Hans Arp, who begin as painters, escape eventually from the prison of the single plane by painting on wood or plaster and using molds or carpentry to raise and lower planes. They go, in other words, from painting to colored bas-relief, and finally – so far must they fly in order to return to three-dimensionality without at the same time risking illusion – they become sculptors and create objects in the round, through which they can free their feelings for movement and direction from the increasing ascetic geometry of pure painting. (Except in the case of Arp and one or two others, the sculpture of most of these metamorphosed painters is rather unsculptural, stemming as it does from the discipline of painting. It uses color, fragile and intricate shapes and a variety of materials. It is construction, fabrication.)

The French and Spanish in Paris brought painting to the point of the pure abstraction, but it remained, with a few exceptions, for the Dutch, Germans, English and Americans to realize it. It is in their hands that abstract purism has been consolidated into a school, dogma and credo. By 1939 the center of abstract painting had shifted to London, while in Paris the younger generation of French and Spanish painters had reacted against abstract purity and turned back to a confusion of literature with painting as extreme as any of the past. These young orthodox Surrealists are not to be identified, however, with such pseudo- or mock Surrealists of the previous generation as Miró, Klee and Arp, whose work, despite its apparent intention, has only contributed to the further deployment of abstract painting pure and simple. Indeed, a good many of the artists – if not the majority – who contributed importantly to the development of modern painting came to it with the desire to exploit the break with imitative realism for a more powerful expressiveness, but so inexorable was the logic of the development that in the end their work constituted but another step towards abstract art, and a further sterilization of the expressive factors. This has been true, whether the artist was Van Gogh, Picasso or Klee. All roads led to the same place.

VI

I find that I have offered no other explanation for the present superiority of abstract art than its historical justification. So what I have written has turned out to be an historical apology for abstract art. To argue from any other basis would require more space than is at my disposal, and would involve an entrance into the politics of taste – to use Venturi's phrase – from which there is no exit – on paper. My own experience of art has forced me to accept most of the standards of taste from which abstract art has derived, but I do not maintain that they are the only valid standards through eternity. I find them simply the most valid ones at this given moment. I have no doubt that they will be replaced in the future by other standards, which will be perhaps more inclusive than any possible now. And even now they do not exclude all

other possible criteria. I am still able to enjoy a Rembrandt more for its expressive qualities than for its achievement of abstract values – as rich as it may be in them.

It suffices to say that there is nothing in the nature of abstract art which compels it to be so. The imperative comes from history, from the age in conjunction with a particular moment reached in a particular tradition of art. This conjunction holds the artist in a vise from which at the present moment he can escape only by surrendering his ambition and returning to a stale past. This is the difficulty for those who are dissatisfied with abstract art, feeling that it is too decorative or too arid and 'inhuman,' and who desire a return to representation and literature in plastic art. Abstract art cannot be disposed of by a simple-minded evasion. Or by negation. We can only dispose of abstract art by assimilating it, by fighting our way through it. Where to? I do not know. Yet it seems to me that the wish to return to the imitation of nature in art has been given no more justification than the desire of certain partisans of abstract art to legislate it into permanency.

Notes

1 This is the confusion of the arts for which Babbitt made Romanticism responsible.
2 The ideas about music which Pater expresses in *The School of Giorgione* reflect this transition from the musical to the abstract better than does any single work of art.

T. J. Clark

CLEMENT GREENBERG'S THEORY
OF ART

IN THE ISSUE OF *Partisan Review* for Fall 1939 appeared an article by Clement Greenberg entitled 'Avant-Garde and Kitsch.' It was followed four issues later, in July–August 1940, by another wide-ranging essay on modern art, 'Towards a Newer Laocoon.'' These two articles, I believe, stake out the ground for Greenberg's later practice as a critic and set down the main lines of a theory and history of culture since 1850 – since, shall we say, Courbet and Baudelaire. Greenberg reprinted 'Avant-Garde and Kitsch,' making no attempt to tone down its mordant hostility to capitalism, as the opening item of his collection of critical essays, *Art and Culture*, in 1961. 'Towards a Newer Laocoon' was not reprinted, perhaps because the author felt that its arguments were made more effectively in some of his later, more particular pieces included in *Art and Culture* – the essays on 'Collage' or 'Cézanne,' for example, or the brief paragraphs on 'Abstract, Representational, and So Forth.' I am not sure that the author was right to omit the piece: it is noble, lucid, and extraordinarily balanced, it seems to me, in its defense of abstract art and avant-garde culture; and certainly its arguments are taken up directly, sometimes almost verbatim, in the more famous theoretical study which appeared in *Art and Literature* (Spring 1965) with the balder title 'Modernist Painting.'*

The essays of 1939 and 1940 argue already for what were to become Greenberg's main preoccupations and commitments as a critic. And the arguments adduced, as the author himself admits at the end of 'Towards a Newer Laocoon,' are largely historical. 'I find,' Greenberg writes there, 'that I have offered no other explanation for the present superiority of abstract art than its historical justification. So what I have written has turned out to be an historical apology for abstract art'

' First published as a 'Voice of America' pamphlet in *Arts Yearbook*, 4, 1961, pp. 101–108 (Ed.).

Source: 'Clement Greenberg's Theory of Art', *Critical Inquiry*, September 1982, vol. 9, no. 1, pp. 139–156. © T. J. Clark. This was a special issue of the journal entitled *The Politics of Interpretation*, based on a symposium of the same name sponsored by *Critical Inquiry*, and held at the University of Chicago's Center for Continuing Education, October 30th–November 1st 1981. T. J. Clark was a speaker at that conference.

('NL,' p. 310) *[71]*. The author's proffered half-surprise at having thus 'turned out' to be composing an apology in the historical manner should not of course be taken literally. For it was historical consciousness, Greenberg had argued in 'Avant-Garde and Kitsch,' which was the key to the avant-garde's achievement – its ability, that is, to salvage something from the collapse of the bourgeois cultural order. 'A part of Western bourgeois society,' Greenberg writes, 'has produced something unheard of heretofore: – avant-garde culture. A superior consciousness of history – more precisely, the appearance of a new kind of criticism of society, an historical criticism – made this possible . . . It was no accident, therefore, that the birth of the avant-garde coincided chronologically – and geographically, too – with the first bold development of scientific revolutionary thought in Europe' ('AK,' p. 35) *[49]*. By this last he means, need I say it, preeminently the thought of Marx, to whom the reader is grimly directed at the end of the essay, after a miserable and just description of fascism's skill at providing 'art for the people,' with the words: 'Here, as in every other question today, it becomes necessary to quote Marx word for word. Today we no longer look toward socialism for a new culture – as inevitably as one will appear, once we do have socialism: Today we look to socialism *simply* for the preservation of whatever living culture we have right now' ('AK,' p. 49) *[58]*.

It is not intended as some sort of revelation on my part that Greenberg's cultural theory was originally Marxist in its stresses and, indeed, in its attitude to what constituted explanation in such matters. I point out the Marxist and historical mode of proceeding as emphatically as I do partly because it may make my own procedure later in this paper seem a little less arbitrary. For I shall fall to arguing in the end with these essays' Marxism and their history, and I want it understood that I think that to do so *is* to take issue with their strengths and their main drift.

But I have to admit there are difficulties here. The essays in question are quite brief. They are, I think, extremely well written: it was not for nothing that *Partisan Review* described Clement Greenberg, when he first contributed to the journal early in 1939, as 'a young writer who works in the New York customs house' – fine, redolent avant-garde pedigree, that! The language of these articles is forceful and easy, always straightforward, blessedly free from Marxist conundrums. Yet the price paid for such lucidity, here as so often, is a degree of inexplicitness – a certain amount of elegant skirting round the difficult issues, where one might otherwise be obliged to call out the ponderous armory of Marx's concepts and somewhat spoil the flow of the prose from one firm statement to another. The Marxism, in other words, is quite largely implicit; it is stated on occasion, with brittle and pugnacious finality, *as* the essays' frame of reference, but it remains to the reader to determine just how it works in the history and theory presented – what that history and theory depend on, in the way of Marxist assumptions about class and capital or even base and superstructure. That is what I intend to do in this paper: to interpret and extrapolate from the texts, even at the risk of making their Marxism declare itself more stridently than the 'young writer' seems to have wished. And I should admit straight away that there are several points in what follows where I am genuinely uncertain as to whether I am diverging from Greenberg's argument or explaining it more fully. This does not worry me overmuch, as long as we are alerted to the special danger in this case, dealing with such transparent yet guarded prose, and as long as we can agree that the project in general – pressing home a Marxist reading

of texts which situate themselves within the Marxist tradition – is a reasonable one.[2]

I should therefore add a word or two to conjure up the connotations of 'Marxism' for a writer in 1939 in *Partisan Review*. I do not need to labor the point, I hope, that there *was* a considerable and various Marxist culture in New York at this time; it was not robust, not profound, but not frivolous or flimsy either, in the way of England in the same years; and it is worth spelling out how well the pages of *Partisan Review* in 1939 and 1940 mirrored its distinction and variety and its sense of impending doom. The issue in which the 'Newer Laocoon' was published began with an embattled article by Dwight MacDonald entitled 'National Defense: The Case for Socialism,' whose two parts were headed 'Death of a World' and 'What Must We Do to Be Saved?' The article was a preliminary to the 'Ten Propositions on the War' which MacDonald and Greenberg were to sign jointly a year later, in which they argued – still in the bleak days of 1941 – for revolutionary abstention from a war between capitalist nation-states. It was a bleak time, then, in which Marxist convictions were often found hard to sustain, but still a time characterized by a certain energy and openness of Marxist thought, even in its moment of doubt. MacDonald had just finished a series of articles – an excellent series, written from an anti-Stalinist point of view – on Soviet cinema and its public. (It is one main point of reference in the closing sections of 'Avant-Garde and Kitsch.') Edmund Wilson in Fall 1938 could be seen pouring scorn on 'The Marxist Dialectic,' in the same issue as André Breton and Diego Rivera's 'Manifesto: Towards a Free Revolutionary Art.' Philip Rahv pieced out 'The Twilight of the Thirties' or 'What Is Living and What Is Dead' in Marxism. Victor Serge's *Ville Conquise* was published, partly, in translation. Meyer Schapiro took issue with *To the Finland Station*, and Bertram Wolfe reviewed Boris Souvarine's great book on Stalin.

And so on. The point is simply that this *was* a Marxist culture – a hectic and shallow-rooted one, in many ways, but one which deserved the name. Its appetite for European culture – for French art and poetry in particular – is striking and discriminate, especially compared with later New York French enthusiasms. This was the time when Lionel Abel was translating Lautréamont, and Delmore Schwartz, *A Season in Hell*. The pages of *Partisan Review* had Wallace Stevens alongside Trotsky, Paul Eluard next to Allen Tate, 'East Coker' – I am scrupulous here – following 'Marx and Lenin as Scapegoats.' No doubt the glamour of all this is misleading; but at least we can say, all reservations made, that a comparable roster of names and titles from any later period would look desultory by contrast, and rightly so.

Greenberg's first contribution to the magazine, in early 1939, was a review of Bertolt Brecht's *Penny for the Poor*, the novel taken from *The Threepenny Opera*. In it he discussed, sternly but with sympathy, the 'nerve-wracking' formal monotony which derived, so he thought, from Brecht's effort to write a parable – a *consistent* fiction – of life under capitalism. In the same issue as 'Avant-Garde and Kitsch' there appeared an account of an interview which Greenberg had had, the previous year, with Ignazio Silone. The interviewer's questions told the tale of his commitments without possibility of mistake: 'What, in the light of their relations to political parties,' he asked, 'do you think should be the role of revolutionary writers in the present situation?'; and then, 'When you speak of liberty, do you mean *socialist*

liberty?'; and then, 'Have you read Trotsky's pamphlet, *Their Morals and Ours?* What do you think of it?'[3]

I am aware of the absurdity of paying more heed to Greenberg's questions than to Silone's grand replies; but you see the point of all this for anyone trying in the end to read between the lines of the 'Newer Laocoon.' And I hope that when, in a little while, I use the phrase 'Eliotic Trotskyism' to describe Greenberg's stance, it will seem less forced a coinage. Perhaps one should even add Brecht to Eliot and Trotsky here, since it seems that the example of Brecht was especially vivid for Greenberg in the years around 1940, representing as he did a difficult, powerful counterexample to all the critic wished to see as the main line of avant-garde activity: standing for active engagement in ideological struggle, not detachment from it, and suggesting that such struggle was not necessarily incompatible with work on the *medium* of theatre, making that medium explicit and opaque in the best avant-garde manner. (It is a pity that Greenberg, as far as I know, wrote only about Brecht's novels and poetry.[4] Doubtless he would have had critical things to say also about Brecht's epic theatre, but the nature of his criticism – and especially his discussion of the tension between formal concentration and political purpose – might well have told us a great deal about the grounds of his ultimate settling for 'purity' as the only feasible artistic ideal.)

All this has been by way of historical preliminary: if we are to read Greenberg's essay of 1939 and 1940, it is necessary, I think, to bear this history in mind.

Let me begin my reading proper, then, by stating in summary form what I take to be the arguments of 'Avant-Garde and Kitsch' and the 'Newer Laocoon.' They are, as I have said, historical explanations of the course of avant-garde art since the mid-nineteenth century. They are seized with the strangeness of the avant-garde moment – that moment in which 'a part of Western bourgeois society . . . produced something unheard of heretofore'; seized with its strangeness and not especially optimistic as to its chances of survival in the face of an ongoing breakdown of bourgeois civilization. For that *is* the context in which an avant-garde culture comes to be: it is a peculiar, indeed unique, reaction to a far from unprecedented cultural situation – to put it bluntly, the decadence of a society, the familiar weariness and confusion of a culture in its death throes. 'Avant-Garde and Kitsch' is explicit on this: Western society in the nineteenth century reached that fatal phase in which, like Alexandrian Greece or late Mandarin China, it became 'less and less able . . . to justify the inevitability of its particular forms' and thus to keep alive 'the accepted notions upon which artists and writers must depend in large part for communication with their audiences' ('AK,' p. 34) *[48]*. Such a situation is usually fatal to seriousness in art. At the end of a culture, when all the verities of religion, authority, tradition, and style – all the ideological cement of society, in other words – are either disputed or doubted or believed in for convenience' sake and not held to *entail* anything much – at such a moment 'the writer or artist is no longer able to estimate the response of his audience to the symbols and references with which he works.' In the past that had meant an art which therefore left the really important issues to one side and contented itself with 'virtuosity in the small details of form, all larger questions being [mechanically, listlessly] decided by the precedent of the old masters' ('AK,' pp. 34–35) *[49]*.

Clearly, says Greenberg, there has been a 'decay of our present society' – the

words are his — which corresponds in many ways to all these gloomy precedents. What is new is the course of art in this situation. No doubt bourgeois culture is in crisis, more and more unable since Marx 'to justify the inevitability of its particular forms'; but it has spawned, half in opposition to itself, half at its service, a peculiar and durable artistic tradition — the one we call modernist and which Greenberg then called, using its own label, avant-garde. 'It was to be the task of the avant-garde to perform in opposition to bourgeois society the function of finding new and adequate cultural forms for the expression of that same society, without at the same time succumbing to its ideological divisions and its refusal to permit the arts to be their own justification' ('NL,' p. 301) [63].

There are several stresses here worth distinguishing. First, the avant-garde is 'part of Western bourgeois society' and yet in some important way estranged from it: needing, as Greenberg phrases it, the revolutionary gloss put on the very 'concept of the "bourgeois" in order to define what they were not' ('AK,' p. 35) [49] but at the same time performing the function of finding forms 'for the expression' of bourgeois society and tied to it 'by an umbilical cord of gold.' Here is the crucial passage: 'it is to the [ruling class] that the avant-garde belongs. No culture can develop without a social basis, without a source of stable income. [We might immediately protest at this point at what seems to be the text's outlandish economism: 'social basis' is one thing, 'source of income' another, the sentence seems to elide them. But let it pass for the moment.] In the case of the avant-garde this [social basis] was provided by an élite among the ruling class of that society from which it assumed itself to be cut off, but to which it has always remained attached by an umbilical cord of gold' ('AK,' p. 38) [51].

That is the first stress: the contradictory belonging-together-in-opposition of the avant-garde and its bourgeoisie; and the sense — the pressing and anxious sense — of that connection-in-difference being attenuated, being on the point of severance. For 'culture is being abandoned by those to whom it actually belongs — our ruling class' ('AK,' p. 38) [51]: the avant-garde, in its specialization and estrangement, had always been a sign of that abandonment, and now it seemed as if the breach was close to final.

Second, the avant-garde is a way to protect art from 'ideological divisions.' 'Ideological confusion and violence' are the enemies of artistic force and concentration: art seeks a space of its own apart from them, apart from the endless uncertainty of meanings in capitalist society ('AK,' p. 36) [49]. It is plain how this connects with my previous wondering about Greenberg on Brecht, and I shall not press the point here, except to say that there is a special and refutable move being made in the argument: to compare the conditions in which, in late capitalism, the meanings of the ruling class are actively disputed with those in which, in Hellenistic Egypt, say, established meanings stultified and became subject to skepticism — this is to compare the utterly unlike. It is to put side by side a time of economic and cultural dissolution — an epoch of weariness and unconcern — and one of articulated and fierce class struggle. Capital may be uncertain of its values, but it is not weary; the bourgeoisie may have no beliefs worth the name, but they will not admit as much: they are hypocrites, not skeptics. And the avant-garde, I shall argue, has regularly and rightly seen an *advantage* for art in the particular conditions of 'ideological confusion and violence' under capital; it has wished to take part in the

general, untidy work of negation and has seen no necessary contradiction (rather the contrary) between doing so and coming to terms once again with its 'medium.'

But I shall return to this later. It is enough for now to point to this second stress, and to the third: the idea that one chief purpose of the avant-garde was to oppose bourgeois society's 'refusal to permit the arts to be their own justification.' This is the stress which leads on to the more familiar – and trenchant – arguments of the essays in question, which I shall indicate even more briefly: the description of the ersatz art produced for mass consumption by the ruling classes of late capitalism as part of their vile stage management of democracy, their pretending – it becomes perfunctory of late – 'that the masses actually rule'; and the subtle account of the main strands in the avant-garde's history and the way they have all conspired to narrow and raise art 'to the expression of an absolute' ('AK,' p. 36) *[49]*. The pursuit has been purity, whatever the detours and self-deceptions. 'The arts lie safe now, each within its "legitimate" boundaries, and free trade has been replaced by autarchy. Purity in art consists in the acceptance . . . of the limitations of the medium . . . The arts, then, have been hunted back [the wording is odd and pondered] to their mediums, and there they have been isolated, concentrated and defined' ('NL,' p. 305) *[66]*. The logic is ineluctable, it 'holds the artist in a vise,' and time and again it overrides the most impure and ill-advised intentions:

> A good many of the artists – if not the majority – who contributed importantly to the development of modern painting came to it with the desire to exploit the break with imitative realism for a more powerful expressiveness, but so inexorable was the logic of the development that in the end their work constituted but another step towards abstract art, and a further sterilization of the expressive factors. This has been true, whether the artist was Van Gogh, Picasso or Klee. All roads led to the same place. ['NL,' pp. 309–10] *[69]*.

This is enough of summary. I do not want now, whatever the temptation, to pitch in with questions about specific cases (Is that *true* of van Gogh? What is the balance in collage between medium and illusion? etc.) Greenberg's argument of course provokes such questions, as arguments should do, but I want to restrict myself, if I can, to describing its general logic, inexorable or not, choosing my examples for their bearing on the author's overall gist.

Let me go back to the start of 'Avant-Garde and Kitsch.' It seems to be an unstated assumption of that article – and an entirely reasonable one, I believe – that there once was a time, before the avant-garde, when the bourgeoisie, like any normal ruling class, possessed a culture and an art which were directly and recognizably its own. And indeed we know what is meant by the claim: we know what it means, whatever the provisos and equivocations, to call Chardin and Hogarth bourgeois painters or Samuel Richardson and Daniel Defoe novelists of the middle class. We can move forward a century and still be confident in calling Balzac and Stendhal likewise, or Constable and Géricault. Of course there are degrees of difference and dissociation always – Balzac's politics, Géricault's alienation, Chardin's royal clientele – but the bourgeoisie, we can say, in some strong sense *possessed* this art: the art enacted, clarified, and criticized the class's experiences, its appearance and values;

it responded to its demands and assumptions. There was a distinctive bourgeois culture; this art is part of our evidence for just such an assertion.

But it is clear also that from the later nineteenth century on, the distinctiveness and coherence of that bourgeois identity began to fade. 'Fade' is too weak and passive a word, I think. I should say that the bourgeoisie was obliged to dismantle its focused identity, as part of the price it paid for maintaining social control. As part of its struggle for power over other classes, subordinate and voiceless in the social order but not placated, it was forced to dissolve its claim to culture – and in particular forced to revoke the claim, which is palpable in Géricault or Stendhal, say, to take up and dominate and preserve the absolutes of aristocracy, the values of the class it displaced. 'It's Athene whom we want,' Greenberg blurts out in a footnote once, 'formal culture with its infinity of aspects, its luxuriance, its large comprehension' ('AK,' p. 49 n. 5) [59]. Add to those qualities intransigence, intensity and risk in the life of the emotions, fierce regard for honour and desire for accurate self-consciousness, disdain for the commonplace, rage for order, insistence that the world cohere: these are, are they not, the qualities we tend to associate with art itself, at its highest moments in the Western tradition. But they are specifically feudal ruling-class superlatives: they are the ones the bourgeoisie believed they had inherited and the ones they chose to abandon because they became, in the class struggles after 1870, a cultural liability.

Hence what Greenberg calls kitsch. Kitsch is the sign of a bourgeoisie contriving to lose its identity, forfeiting the inconvenient absolutes of *Le Rouge et le noir* or *The Oath of the Horatii*. It is an art and a culture of instant assimilation, of abject reconciliation to the everyday, of avoidance of difficulty, pretence to indifference, equality before the image of capital.

Modernism is born in reaction to this state of affairs. And you will see, I hope, the peculiar difficulty here. There had once been, let me say again, a bourgeois identity and a classic nineteenth-century bourgeois culture. But as the bourgeoisie built itself the forms of mass society and thereby entrenched its power, it devised a massified pseudoart and pseudoculture and destroyed its *own* cultural forms – they had been, remember, a long time maturing, in the centuries of patient accommodation to and difference from aristocratic or absolutist rule. Now, Greenberg says, I think rightly, that some kind of connection exists between this bourgeoisie and the art of the avant-garde. The avant-garde is engaged in finding forms for the expression of bourgeois society: that is the phrase again from the 'Newer Laocoon.' But what could this mean, exactly, in the age of bourgeois decomposition so eloquently described in 'Avant-Garde and Kitsch'? It seems that modernism is being proposed as bourgeois art in the absence of a bourgeoisie or, more accurately, as aristocratic art in the age when the bourgeoisie abandons its claims to aristocracy. And how will art keep aristocracy alive? By keeping *itself* alive, as the remaining vessel of the aristocratic account of experience and its modes; by preserving its own means, its media; by proclaiming those means and media *as* its values, as meanings in themselves.

This is, I think, the crux of the argument. It seems to me that Greenberg is aware of the paradox involved in his avant-garde preserving *bourgeoisie*, in its highest and severest forms, for a bourgeoisie which, in the sense so proposed, no longer existed. He points to the paradox, but he believes the solution to it has proved to be,

in practice, the density and resistance of artistic values per se. They are the reposi-
tory, as it were, of affect and intelligence that once inhered in a complex form of life
but do so no longer, they are the concrete form of intensity and self-consciousness,
the only one left, and therefore the form to be preserved at all costs and somehow
kept apart from the surrounding desolation.

It is a serious and grim picture of culture under capitalism, and the measure of
its bitterness and perplexity seems to me still justified. Eliotic Trotskyism, I called it
previously; the cadencies shifting line by line from 'Socialism or Barbarism' to
'Shakespeare and the Stoicism of Seneca.' (And was Greenberg a reader of *Scrutiny*, I
wonder? It was widely read in New York at this time, I believe.)[5] From his Eliotic
stronghold he perceives, and surely with reason, that much of the great art of the
previous century, including some which had declared itself avant-garde and anti-
bourgeois, had depended on the patronage and mental appetites of a certain fraction
of the middle class. It had in some sense *belonged* to a bourgeois intelligentsia – to a
fraction of the class which was self-consciously 'progressive' in its tastes and atti-
tudes and often allied to the cause not just of artistic experiment but of social and
political reform. And it is surely also true that in late capitalism this independent,
critical and progressive intelligentsia was put to death by its own class. For late
capitalism – by which I mean the order emerging from the Great Depression – is a
period of cultural uniformity: a leveling-down, a squeezing-out of previous bour-
geois élites, a narrowing of distance between class and class *and* between fractions of
the same class. In this case, the distance largely disappears between bourgeois
intelligentsia and unintelligentsia: by our own time one might say it is normally
impossible to distinguish one from the other.

(And lest this be taken as merely flippant, let me add that the kind of distance I
have in mind – and distance here does not mean detachment but precisely an active,
uncomfortable difference from the class one belongs to – is that between Walter
Lippmann's salon, say, and the American middle class of its day; or that between the
circle around Léon Gambetta and the general ambience of Ordre Moral. This last is
especially to the purpose, since its consequences for culture were so vivid: one has
only to remember the achievement of Antonin Proust in his brief tenure of the
Direction des Beaux-Arts or Georges Clemenceau's patronage of and friendship
with Claude Monet.)[6]

This description of culture is suitably grim, as I say, and finds its proper echoes
in Eliot, Trotsky, F. R. Leavis, and Brecht. And yet – and here at last I modulate into
criticism – there seem to me things badly wrong with its final view of art and artistic
value. I shall offer three, or perhaps four, kinds of criticism of the view: first, I shall
point to the difficulties involved in the very notion of art itself becoming an
independent source of value; second, I shall disagree with one of the central elem-
ents in Greenberg's account of that value, his reading of 'medium' in avant-garde
art; and third, I shall try to recast his sketch of modernism's formal logic in order to
include aspects of avant-garde practice which he overlooks or belittles but which I
believe are bound up with those he sees as paramount. What I shall point to here –
not to make a mystery of it – are *practices of negation** in modernist art which seem to
me the very form of the practices of purity (the recognitions and enactments of
medium) which Greenberg extols. Finally, I shall suggest some ways in which the
previous three criticisms are connected: in particular, the relation between those

practices of negation and the business of bourgeois artists making do without a bourgeoisie. I shall be brief, and the criticisms may seem schematic. But my hope is that because they are anyway simple objections to points in an argument where it appears palpably weak, they will, schematic or not, seem quite reasonable.

The first disagreement could be introduced by asking the following (Wittgensteinian) question: What would it be *like*, exactly, for art to possess its own values? Not just to have, in other words, a set of distinctive effects and procedures but to have them somehow be, or provide, the standards by which the effects and procedures are held to be of worth? I may as well say at once that there seem, on the face of it, some insuperable logical difficulties here, and they may well stand in the way of ever providing a coherent reply to the Wittgensteinian question. But I much prefer to give — or to sketch — a kind of *historical* answer to the question, in which the point of asking it in the first place might be made more clear.

Let us concede that Greenberg may be roughly right when he says in 'Avant-Garde and Kitsch' that 'a fairly constant distinction' has been made by 'the cultivated of mankind over the ages' 'between those values only to be found in art and the values which can be found elsewhere' ('AK,' p. 42) *[54]*. But let us ask how that distinction was actually made — made and maintained, as an active opposition — in practice, in the first heyday of the art called avant-garde. For the sake of vividness, we might choose the case of the young speculator Dupuy, whom Camille Pissarro described in 1890 as 'mon meilleur amateur' and who killed himself the same year, to Pissarro's chagrin, because he believed he was faced with bankruptcy. One's picture of such a patron is necessarily speculative in its turn, but what I want to suggest is nothing very debatable. It seems clear from the evidence that Dupuy was someone capable of savouring the *separateness* of art, its irreducible difficulties and appeal. That was what presumably won him Pissarro's respect and led him to buy the most problematic art of his day. (This at a time, remember, when Pissarro's regular patrons, and dealers, had quietly sloped off in search of something less odd.) But I would suggest that he also saw — and in some sense insisted on — a kind of

' Author's note, 1984: This phrase in my essay seems to have given rise to some misunderstanding, among those who approved of it as much as those who thought it a dreadful slur. Let me offer a further brief explanation. By 'practice of negation' I meant some form of decisive innovation, in method or materials or imagery, whereby a previously established set of skills or frame of reference — skills and references which up till then had been taken as essential to art-making of any seriousness — are deliberately avoided or travestied, in such a way as to imply that only *by* such incompetence or obscurity will genuine picturing get done.

For example: — The various attacks on centred and legible composition, from the *Burial at Ornans* onwards. The distortion or reversal of perspective space. The refusal of simple equivalences between particular aspects of a representation and aspects of the thing represented: the Impressionists' broken handling, Cézanne's discarding of the usual indicators of different surface textures, the Fauves' mismatching of color on canvas with color in the world out there. Deliberate displays of painterly awkwardness, or facility in kinds of painting that were not supposed to be worth perfecting. Primitivisms of all shapes and sizes. The use of degenerate or trivial or 'inartistic' materials. Denial of full conscious control over the artefact; automatic or aleatory ways of doing things. A taste for the margins and vestiges of social life; a wish to celebrate the 'insignificant' or disreputable in modernity. The rejection or parody of painting's narrative conventions. The false reproduction of painting's established *genres* (Manet was a past master at this). The parody of previous powerful styles (Abstract Expressionism in the hands of Johns or Lichtenstein). And so on.

consonance between the experience and value that art had to offer and those that belonged to his everyday life. The consonance did not need to be direct and, indeed, could not be. Dupuy was not in the market for animated pictures of the Stock Exchange — the kind he could have got from Jean Béraud — or even for scenes à la Degas in which he might have been offered back, dramatically, the shifts and upsets of life in the big city. He purchased landscapes instead and seems to have had a taste for those painted in the neo-impressionist manner — painted, that is, in a way which tried to be tight, discreet, and uniform, done with a disabused orderliness, seemingly scientific, certainly analytic. And all of these qualities, we might guess, he savoured and required as the signs of art's detachment.

Yet surely we must also say that his openness to such qualities, his ability to understand them, was founded in a sense he had of some play between those qualities occurring in art and the same occurring in life — occurring in his life, not on the face of it a happy one, but one at the cutting edge of capitalism still. And when we remember what capitalism *was* in 1890, we are surely better able to understand why Dupuy invested in Georges Seurat. For this was a capital still confident in its powers, if shaken; and not merely confident, but scrupulous: still in active dialogue with science; still producing distinctive rhetorics and modes of appraising experience; still conscious of its own values — the tests of rationality, the power born of observation and control; still, if you wish, believing in the commodity as a (perplexing) form of freedom.

You see my point, I hope. I believe it was the interplay of these values and the values of art which made the distinction between them an active and possible one — made it a distinction at all, as opposed to a rigid and absolute disjunction. In the case of Dupuy, there was difference-yet-consonance between the values which made for the bourgeois' sense of himself in practical life and those he required from avant-garde painting. The facts of art and the facts of capital were in active tension. They were still negotiating with each other, they could still, at moments, in particular cases like Dupuy's, contrive to put each other's categories in doubt.

This, it seems to me, is what is meant by 'a fairly constant distinction [being] made between those values only to be found an art and the values which can be found elsewhere.' It is a negotiated distinction, with the critic of Diderot's or Baudelaire's or Félix Fénéon's type the active agent of the settlement. For critics like these, and in the art they typically address, it is true that the values a painting offers are discovered, time and again and with vehemence, as different and irreducible. And we understand the point of Fénéon's insistence; but we are the more impressed by it precisely because the values are found to be different as part of a real cultural dialectic, by which I mean that they are visibly under pressure, in the text, from the demands and valuations made by the ruling class in the business of ruling — the meanings it makes and disseminates, the kinds of order it proposes as its own. It is this pressure — and the way it is enacted in the patronage relation or in the artist's imagining of his or her public — which keeps the values of art from becoming a merely academic canon.

I hope it is clear how this account of artistic standards — and particularly of the ways in which art's separateness as a social practice is secured — would call into question Greenberg's hope that art could become a provider of value in its own right. Yet I think I can call that belief in question more effectively simply by looking

at one or another of the facts of art which Greenberg takes to have become a value, in some sense: let me look, for simplicity's sake, at the notorious fact of 'flatness.' Now it is certainly true that the literal flatness of the picture surface was recovered at regular intervals as a striking fact by painters after Courbet. But I think that the question we should ask in this case is *why* that simple, empirical presence went on being interesting for art. How could a fact of effect or procedure stand in for value in this way? What was it that made it vivid?

The answer is not far to seek. I think we can say that the fact of flatness was vivid and tractable – as it was in the art of Cézanne, for example, or that of Matisse – because it was made to stand for something: some particular and resistant set of qualities, taking its place in an articulated account of experience. The richness of the avant-garde, as a set of contexts for art in the years between 1860 and 1918, say, might thus be redescribed in terms of its ability to give flatness such complex and compatible values – values which necessarily derived from elsewhere than art. It could stand, that flatness, as an analogue of the 'popular' – something therefore conceived as plain, workmanlike, and emphatic. Or it could signify 'modernity,' with flatness meant to conjure up the mere two dimensions of posters, labels, fashion prints, and photographs. Equally, unbrokenness of surface could be seen – by Cézanne, for example – as standing for the truth of *seeing*, the actual form of our knowledge of things. And that very claim was repeatedly felt, by artist and audience, to be some kind of aggression on the latter: flatness appeared as a barrier to the ordinary bourgeois' wish to enter a picture and dream, to have it be a space apart from life in which the mind would be free to make its own connections.

My point is simply that flatness in its heyday *was* these various meanings and valuations; they were its substance, so to speak; they were what it was seen *as*. Their particularity was what made it vivid – made it a matter to be painted over again. Flatness was therefore in play – as an irreducible, technical 'fact' of painting – with all of these totalizations, all of these attempts to make it a metaphor. Of course in a sense it resisted the metaphors, and the painters we most admire insisted also on it as an awkward, empirical quiddity; but the 'also' is the key word here: there was no fact without the metaphor, no medium without its being the vehicle of a complex act of meaning.

This leads me directly to my third criticism of Greenberg's account. It could be broached most forcefully, I think, by asking the question: How does the medium most often *appear* in modernist art? If we accept (as we ought to, I feel) that avant-garde painting, poetry, and music are characterized by an insistence on medium, then what kind of insistence has it been, usually? My answer would be – it is hardly an original one – that the medium has appeared most characteristically as the site of negation and estrangement.

The very way that modernist art has insisted on its medium has been by negating that medium's ordinary consistency – by pulling it apart, emptying it, producing gaps and silences, making it stand as the opposite of sense or continuity, having matter be the synonym for resistance. (And why, after all, should matter be 'resistant'? It is a modernist piety with a fairly dim ontology appended.) Modernism would have its medium be *absence* of some sort – absence of finish or coherence, indeterminacy, a ground which is called on to swallow up distinctions.

These are familiar avant-garde strategies; and I am not for a moment suggesting

that Greenberg does not recognize their part in the art he admires. Yet he is notoriously uneasy with them and prepared to declare them extrinsic to the real business of art in our time – the business of each art 'determin[ing], through the operations peculiar to itself, the effects peculiar and exclusive to itself.'[7] It is Greenberg's disdain for the rhetoric of negation which underlies, one supposes, the ruefulness of his description of Jackson Pollock as, after all, a 'Gothic' whose art harked back to Faulkner and Melville in its 'violence, exasperation and stridency.'[8] It is certainly the same disdain which determines his verdict on Dada, which is only important, he feels, as a complaisant topic for journalism about the modern crisis (or the shock of the new). And one does know what he means by the charge; one does feel the fire of his sarcasm, in 1947, when, in the middle of dealing well with Pollock's unlikely achievement, he writes: 'In the face of current events, painting feels, apparently, that it must be more than itself: that it must be epic poetry, it must be theatre, it must be an atomic bomb, it must be the rights of Man. But the greatest painter of our time, Matisse, preeminently demonstrated the sincerity and penetration that go with the kind of greatness particular to twentieth century painting by saying that he wanted his art to be an armchair for the tired business man.'[9]

It is splendid, it is salutary, it is congenial. Yet surely in the end it will not quite do as description. Surely it is part of modernism's problem – even Matisse's – that the tired businessman be so weary and vacant and so little interested in art as his armchair. It is this situation – this lack of an adequate ruling class to address – which goes largely to explain modernism's negative cast.

I think that finally my differences with Greenberg centre on this one. I do not believe that the practices of negation which Greenberg seeks to declare mere *noise* on the modernist message can be thus demoted. They are simply inseparable from the work of self-definition which he takes to be central: inseparable in the case of Pollock, for certain, or Miró or Picasso or, for that matter, Matisse. Modernism is certainly that art which insists on its medium and says that meaning can henceforth only be found in *practice*. But the practice in question is extraordinary and desperate: it presents itself as a work of interminable and absolute decomposition, a work which is always pushing 'medium' to its limits – to its ending – to the point where it breaks or evaporates or turns back into mere unworked material. That is the form in which medium is retrieved or reinvented: the fact of Art, in modernism, *is* the fact of negation.

I believe that this description imposes itself: that it is the only one which can include Mallarmé alongside Rimbaud, Schoenberg alongside Webern, or (dare I say it?) Duchamp beside the Monet of the *Nymphéas*. And surely that dance of negation has to do with the social facts I have spent most of my time rehearsing – the decline of ruling-class élites, the absence of a 'social base' for artistic production, the paradox involved in making bourgeois art in the absence of a bourgeoisie. Negation is the sign inside art of this wider decomposition: it is an attempt to *capture* the lack of consistent and repeatable meanings in the culture – to capture the lack and make it over into form.

I should make the extent of this, my last disagreement with Greenberg, clear. The extent is small but definite. It is not, of course, that Greenberg fails to recognize the rootlessness and isolation of the avant-garde; his writing is full of the recognition, and he knows as well as anyone the miseries inherent in such a loss of place.

But he does believe – the vehemence of the belief is what is most impressive in his writing – that art can substitute *itself* for the values capitalism has made valueless. A refusal to share that belief – and that is finally what I am urging – would have its basis in the following three observations. First, to repeat, negation is inscribed in the very practice of modernism, as the form in which art appears to itself as a value. Second, that negativity does not appear as a practice which guarantees meaning or opens out a space for free play and fantasy – in the manner of the joke, for example, or even of irony – but, rather, negation appears as an absolute and all-encompassing fact, something which once begun is cumulative and uncontrollable; a fact which swallows meaning altogether. The road leads back and back to the black square, the hardly differentiated field of sound, the infinitely flimsy skein of spectral colour, speech stuttering and petering out into etceteras or excuses. ('I am obliged to believe that these are statements having to do with a world, . . . but you, the reader, need not . . . And I and You, oh well . . . The poem offers a way out of itself, hereabouts . . . But do not take it, wholly . . . ' And so on.) On the other side of negation is always emptiness: that is a message which modernism never tires of repeating and a territory into which it regularly strays. We have an art in which ambiguity becomes infinite, which is on the verge of proposing – and does propose – an Other which is comfortably ineffable, a vacuity, a vagueness, a mere mysticism of sight.[10]

There is a way – and this again is something which happens *within* modernism or at its limits – in which that empty negation is in turn negated. And that brings me back finally to the most basic of Greenberg's assumptions; it brings me back to the essays on Brecht. For there is an art – a modernist art – which has challenged the notion that art stands only to suffer from the fact that now all meanings are disputable. There is an art – Brecht's is only the most doctrinaire example – which says that we live not simply in a period of cultural decline, when meanings have become muddy and stale, but rather in a period when one set of meanings – those of the cultivated classes – is fitfully contested by those who stand to gain from their collapse. There is a difference, in other words, between Alexandrianism and class struggle. The twentieth century has elements of both situations about it, and that is why Greenberg's description, based on the Alexandrian analogy, applies as well as it does. But the end of the bourgeoisie is not, or will not be, like the end of Ptolemy's patriciate. And the end of its art will be likewise unprecedented. It will involve, and has involved, the kinds of inward turning that Greenberg has described so compellingly. But it will also involve – and has involved, as part of the practice of modernism – a search for another place in the social order. Art wants to address someone, it wants something precise and extended to do; it wants *resistance*, it needs criteria; it will take risks in order to find them, including the risk of its own dissolution.[11] Greenberg is surely entitled to judge that risk too great and, even more, to be impatient with the pretense of risk so dear to one fringe of modernist art and its patrons – all that stuff about blurring the boundaries between art and life and the patter about art being 'revolutionary.' Entitled he is; but not in my opinion right. The risk is large and the patter odious; but the alternative, I believe, is on the whole worse. It is what we have, as the present form of modernism: an art whose object is nothing but itself, which never tires of discovering that that self is pure as only pure negativity can be, and which offers its audience that nothing, tirelessly and, I

concede, adequately made over into form. A verdict on such an art is not a matter of taste – for who could fail to admire, very often, its refinement and ingenuity – but involves a judgment, still, of cultural possibility. Thus while it seems to me right to expect little from the life and art of late capitalism, I still draw back from believing that the best one can hope for from art, even in *extremis*, is its own singular and perfect disembodiment.

Notes

1 See Clement Greenberg, 'Avant-Garde and Kitsch,' *Partisan Review* 6 (Fall 1939): 34–49 [see Chapter 1], and 'Towards a Newer Laocoon,' *Partisan Review* 7 (July–August 1940): 296–310 [see Chapter 2]; all further references to these essays, abbreviated 'AK' and 'NL' respectively, will be included in the text.

2 This carelessness distinguishes the present paper from two recent studies of Greenberg's early writings, Serge Guilbaut's 'The New Adventures of the Avant-Garde in America,' *October* 15 (Winter 1980) [see Chapter 10], and Fred Orton and Griselda Pollock's '*Avant-Gardes* and Partisans Reviewed,' *Art History* 3 (September 1981) [see Chapter 11]. I am indebted to both these essays and am sure that their strictures on the superficiality – not to say the opportunism – of Greenberg's Marxism are largely right. (Certainly Mr. Greenberg would not now disagree with them.) But I am nonetheless interested in the challenge offered to most Marxist, and non-Marxist, accounts of modern history by what I take to be a justified, though extreme, pessimism as to the nature of established culture since 1870. That pessimism is characteristic, I suppose, of what Marxists call an ultraleftist point of view. I believe, as I say, that a version of some such view is correct and would therefore wish to treat Greenberg's theory *as if* it were a decently elaborated Marxism of an ultraleftist kind, one which issues in certain mistaken views (which I criticize) but which need not so issue and which might still provide, cleansed of those errors, a good vantage for a history of our culture.

3 Greenberg, 'An Interview with Ignazio Silone,' *Partisan Review* 6 (Fall 1939): 23, 25, 27.

4 See Greenberg, 'Bertolt Brecht's Poetry' (1941), *Art and Culture* (Boston, 1961).

5 Mr. Greenberg informs me the answer here is yes and points out that he even once had an exchange with F. R. Leavis, in *Commentary*, on Kafka – one which, he says, 'I did not come out of too well!' ('How Good Is Kafka?,' *Commentary* 19 (June 1955).

6 I think this state of affairs lies at the root of those ills of present-day Marxist criticism to which Edward Said refers in 'Opponents, Audiences, Constituencies, and Community.' [*Critical Inquiry*, September 1982, vol. 9, no. 1, pp. 1–26.] In the years around 1910, for example, it was possible for Marxist intellectuals to identify a worthwhile enemy within the ranks of the academy – there was a group of progressive bourgeois intellectuals whose thought and action had some real effect in the polity. That state of things was fortunate in two regards. It enabled middle-class Marxist intellectuals to attain to some kind of lucidity about the limits of their own enterprise – to see themselves as bourgeois, lacking roots in the main earth of class struggle. It meant they did not spend much of their time indulging in what I regard as the mainly futile breast-beating represented so characteristically by Terry Eagleton's bathetic question, which Said quotes: '"How is a Marxist-structuralist

analysis of a minor novel of Balzac to help shake the foundations of capitalism?"'
(p. 15). Those earlier Marxists did not need this rhetoric, this gasping after class
positions which they did not occupy, because there was an actual job for them to do,
one with a measure of importance, after all – the business of opposing the ideolo-
gies of a bourgeois élite and of pointing to the falsity of the seeming contest
between that élite and the ordinary, power-wielding mass of the class. (I am think-
ing here, e.g., of the simple, historical *ground* to Georg Lukács' battle with positiv-
ism in science, Kantianism in ethics, and Weberianism in politics. It was the evident
link between that circuit of ideas and an actual, cunning practice of social reform
that gave Lukács' essays their intensity and also their sense of not having to apolo-
gize for intellectual work.) I believe it is the absence of any such bourgeois intelli-
gentsia, goading and supplying the class it belongs to – the absence, in other words,
of a bourgeoisie worth attacking in the realm of cultural production – that lies
behind the quandary of Eagleton et al. And let me be clear: the quandary seems to
me at least worth being in, which is more than I can say for most other academic
dilemmas. I just now applied the adjective 'bathetic' to Eagleton's question, and
perhaps it will have seemed a dismissive choice of word. But bathos implies an
attempt at elevation and a descent from it; and of the general run of contemporary
criticism – the warring solipsisms and scientisms, the exercises in spot-the-
discourse or discard-the-referent – I think one can fairly say that it runs no such
risk. Its tone is ludicrously secure.

7 Greenberg, 'Modernist Painting,' *Art and Literature* 4 (Spring 1965): 194.
8 Greenberg, 'The Present Prospects of American Painting and Sculpture,' *Horizon* 16
 (October 1947): 26.
9 Greenberg, 'Art,' *Nation* 8 (March 1947): 284.
10 The editor of *Critical Inquiry* suggested that I say a little more about the negative cast
 I ascribe to modernism and give an example or two. Too many examples crowd to
 mind, and I ought to avoid the more glamorous, since what I am referring to is an
 aspect or *moment* of modernist art, most often mixed up with other purposes or
 techniques, though often, I would argue, dominating them. Nevertheless a phrase
 from Leavis' *New Bearings* occurs, in which the critic describes T. S. Eliot's 'effort to
 express formlessness itself as form,' and the lines (among others) which that phrase
 applies to: 'Shape without form, shade without colour,/Paralysed force, gesture
 without motion.' Yet we would do best to descend from these obvious heights and,
 if glamor is what is wanted, contemplate Ad Reinhardt's description of his own
 black painting in 1962:

> A square (neutral, shapeless) canvas, five feet wide, five feet high, as
> high as a man, as wide as a man's outstretched arms (not large, not
> small, sizeless), trisected (no composition), one horizontal form nega-
> ting one vertical form (formless, no top, no bottom, directionless),
> three (more or less) dark (lightless) non-contrasting (colorless) colors,
> brushwork brushed out to remove brushwork, a matt, flat, free-hand
> painted surface (glossless, textureless, non-linear, no hard-edge, no
> soft-edge) which does not reflect its surroundings – a pure, abstract,
> non-objective, timeless, spaceless, changeless, relationless, disinter-
> ested painting – an object that is self-conscious (no unconsciousness),
> ideal transcendent, aware of no thing but art (absolutely no anti-art).
> [*Art, USA, Now* (New York, 1963), p. 269]

This pretends to be ironical, of course, and the art it gives rise to is negligible now, I dare say, even by received modernist standards; but the passage only puts into words a kind of attitude and practice which is by no means eccentric since Baudelaire and which has often issued in art of peculiar forcefulness and gravity.

11 This is not to smuggle in a demand for realism again by the back door, or at least, not one posed in the traditional manner. The weakness or absence I have pointed to in modern art does not derive, I think, from a lack of grounding in 'seeing' (for example) or a set of realist protocols to go with that; rather, it derives from its lack of grounding in some (any) specific practice of representation, which would be linked in turn to other social practices – embedded in them, constrained by them. The question is not, therefore, whether modern art should be figurative or abstract, rooted in empirical commitments or not so rooted, but whether art is now provided with sufficient constraints of any kind – notions of appropriateness, tests of vividness, demands which bring with them measures of importance or priority. Without constraints, representation of any articulateness and salience cannot take place. (One might ask if the constraints which modernism declares to be its own and sufficient – those of the medium or of an individual's emotions and sense of inner truth – are binding or indeed coherent; or, to be harsh, if the areas of practice which it points to as the *sites* of such constraint – medium, emotion, even 'language' [sacred cow] – are existents at all, in the way that is claimed for them.)

Michael Fried

HOW MODERNISM WORKS
A response to T. J. Clark

IN THE REMARKS THAT follow, I challenge the interpretation of modern-
ism put forward in T. J. Clark's provocative essay, 'Clement Greenberg's Theory
of Art.' As will become clear, my aim in doing so is not to defend Greenberg against
Clark's strictures. On the contrary, although my own writings on recent abstract art
are deeply indebted to the example of Greenberg's practical criticism (I consider
him the foremost critic of new painting and sculpture of our time), I shall suggest
that Clark's reading of modernism shares certain erroneous assumptions with
Greenberg's, on which indeed it depends. I shall then go on to rehearse an alterna-
tive conception of the modernist enterprise that I believe makes better sense of the
phenomena in question than does either of theirs, and, in an attempt to clinch my
case, I shall conclude by looking briefly at an interesting phase in the work of the
contemporary English sculptor Anthony Caro, whose achievement since 1960 I take
to be canonical for modernism generally.

I

At the center of Clark's essay is the claim that the practices of modernism in the arts
are fundamentally practices of negation. This claim is false.

Not that there is nothing at all to the view he espouses. In the first place, there is
a (Gramscian?) sense in which a given cultural expression may be thought of as
occupying a social space that might otherwise be occupied by another and, therefore,
as bearing a relation to that other that might loosely be characterized as one of
negation. Furthermore, particular modernist developments in the arts have often
involved a negative 'moment' in which certain formal and expressive possibilities

Source: 'How Modernism Works: A Response to T. J. Clark', *Critical Inquiry*, September 1982,
vol. 9, no. 1, pp. 217–234. © 1982 The University of Chicago. All rights reserved. Michael Fried
was the respondent to T. J. Clark at the conference where Chapter 3 was delivered.

were implicitly or indeed explicitly repudiated in favor of certain others, as when, for example, Edouard Manet in the early 1860s rejected both dramatic mise-en-scène and traditional sculptural modelling as vehicles of pictorial coherence, or as when Caro almost a century later came to feel the inadequacy to a dawning vision of sculptural possibility of the techniques of modelling and casting in which he had been trained.[1]

It is also true that entire episodes in the history of modern art – Dada, for example, or the career of Marcel Duchamp – can be construed as largely negative in motivation, and it is part of Clark's critique that Greenberg gives those episodes short shrift, treating them, Clark says, as mere noise on the surface of the modernist message. But Clark goes far beyond these observations to insist that 'negation is inscribed in the very practice of modernism, as the form in which art appears to itself as a value,' or, as he more baldly puts it, 'the fact of Art, in modernism, *is* the fact of negation' (p. 154) *[82]*. And these claims, to the extent that I find them intelligible, seem to me mistaken.

Now it is a curious feature of Clark's essay that he provides no specific examples for his central argument. Instead, he merely cites the names Mallarmé, Rimbaud, Schoenberg, Webern, Duchamp, and Monet (of the *Nymphéas*), and in footnote 10, added, we are told, at the request of the editor, he quotes (irrelevantly in my view) a phrase of F. R. Leavis' on two lines by T. S. Eliot, along with a description by Ad Reinhardt – a distinctly minor figure who cannot be taken as representative of modernism – of his own black paintings. (The latter are evidently the 'black square' to which, Clark asserts, 'the road leads back and back' – except it doesn't [p. 154] *[83]*.)

How are we to understand this refusal to discuss specific cases? In an obvious sense, it makes Clark's position difficult to rebut: one is continually tempted to imagine what he would say about particular works of art – Manet's *Déjeuner sur l'herbe*, or Cézanne's *Gulf of Marseilles Seen from L'Estaque*, or Matisse's *Blue Nude*, or Picasso's *Ma Jolie*, or Jackson Pollock's *Lavender Mist*, or David Smith's *Zig IV*, or Caro's *Prairie* – and then to argue against those invented descriptions. I found myself doing this again and again in preliminary drafts of this response until I realized that it was pointless. For the burden of proof is Clark's, the obligation is his, to establish by analyzing one or more indisputably major works of modernist art (I offer him the short list I have just assembled) that negation functions in those works as the radical and all devouring principle he claims it is. And here it is worth stipulating that it will not be enough to say of Manet's *Déjeuner* (I'm anticipating Clark again) that it represents a situation or an action that is psychologically and narratively unintelligible; not enough because it would still be possible to argue, as I would wish to argue, that unintelligibility in Manet, far from being a value in its own right as mere negation of meaning, is in the service of aims and aspirations that have in view a new and profound and, for want of a better word, positive conception of the enterprise of painting.[2] I would make the same sort of argument about the violation of ordinary spatial logic in Cézanne, or the distorted drawing and bizarre color in Matisse, or the near dissolution of sculptural form in Picasso, or the embracing of abstraction and the exploration of new means of picture-making in Pollock, or the use of industrial materials and techniques in Smith and Caro. In all these instances of 'mainstream' modernism – a notion Clark is bound to reject as reinstituting the very distinction he wishes to collapse – there is at most a negative 'moment,' the significance of

which can only be understood (and the form of that understanding can only be historical, which is to say, provisional or at any rate not final) in terms of a relation to a more encompassing and fundamental set of positive values, conventions, sources of conviction.[3] If Clark disagrees with this, and I'm sure he does, let him accept the challenge and offer examples that prove his point. Otherwise his sweeping generalizations lack all force.

II

Clark's essay stages itself as a critique of Greenberg's theory of modernism; yet the gist of Clark's argument, his equation of modernism with negation, involves a largely uncritical acceptance of Greenberg's account of how modernism works.

The story Greenberg tells is this.[4] Starting around the middle of the nineteenth century, the major arts, threatened for the first time with being assimilated to mere entertainment, discovered that they could save themselves from that depressing fate 'only by demonstrating that the kind of experience they provided was valuable in its own right and not to be obtained from any other kind of activity.' (The crucial figure in painting is Manet, whose decisive canvases belong to the early 1860s.)

> Each art, it turned out, had to effect this demonstration on its own account. What had to be exhibited and made explicit was that which was unique and irreducible not only in art in general but also in each particular art. Each art had to determine, through the operations peculiar to itself, the effects peculiar and exclusive to itself. By doing this, each art would, to be sure, narrow its area of competence, but at the same time it would make its possession of this area all the more secure.
>
> It quickly emerged that the unique and proper area of competence of each art coincided with all that was unique to the nature of its medium. The task of self-criticism became to eliminate from the effects of each art any and every effect that might conceivably be borrowed from or by the medium of every other art. Thereby each art would be rendered 'pure,' and in its 'purity' find the guarantee of its standards of quality as well as of its independence. 'Purity' meant self-definition, and the enterprise of self-criticism in the arts became one of self-definition with a vengeance.[5]

As described by Greenberg, the enterprise in question involved testing a wide range of norms and conventions in order to determine which were inessential, and therefore to be discarded, and which on the contrary constituted the timeless and unchanging essence of the art of painting. (Greenberg doesn't use either of the last two adjectives, but both are implicit in his argument.) By the early 1960s, the results of this century-long project, Greenberg's famous modernist 'reduction,' appeared to be in:

> It has been established by now, it would seem, that the irreducibility of pictorial art consists in but two constitutive conventions or norms:

flatness and the delimitation of flatness. In other words, the observance of merely these two norms is enough to create an object which can be experienced as a picture: thus a stretched or tacked-up canvas already exists as a picture – though not necessarily as a *successful* one.[6]

Greenberg may have been somewhat uneasy with this conclusion; at any rate, he goes on to state that Barnett Newman, Mark Rothko, and Clyfford Still, three of the most advanced painters of the postwar period, 'have swung the self-criticism of Modernist painting in a new direction by dint simply of continuing it in its old one. The question now asked in their art is no longer what constitutes art, or the art of painting, as such, but what constitutes *good* art as such. What is the ultimate source of value or quality in art?' (The answer he gives, or finds their art to give, is 'conception.')[7] But here, too, the governing notion is one of reduction to an essence, to an absolute and unchanging core that in effect has been there all along and which the evolution of modernist painting has progressively laid bare.

I don't say that Clark swallows Greenberg whole. In particular he refuses to accept the proposition that with the advent of modernism art becomes or is revealed to be 'a provider of value in its own right' (p. 151) *[80]*, arguing instead that modernist art has always reflected the values of modern society (more on this presently). But I do suggest that Clark's insistence that modernism proceeds by ever more extreme and dire acts of negation is simply another version of the idea that it has evolved by a process of radical reduction – by casting off, negating, one norm or convention after another in search of the bare minimum that can suffice. Indeed I believe that it is because Clark accepts Greenberg's reductionist and essentialist conception of the modernist enterprise that he is led to characterize the medium in modernism as 'the site of negation and estrangement' – as pushed continually 'to the point where it breaks or evaporates or turns back into mere unworked material' – and to assert that in modernism 'negation appears as an absolute and all-encompassing fact, something which once begun is cumulative and uncontrollable' (pp. 152, 153–4, 154) *[81,82,83]*. From this perspective, Clark's attitude towards the developments to which he alludes is less important than the assumptions under-lying his interpretation of those developments. His attitude, of course, is the reverse of Greenberg's, but his assumptions derive directly from Greenberg's schema.

III

As long ago as 1966–67 I took issue with what I called a reductionist conception of modernism. In an essay on a group of paintings by Frank Stella, I wrote:

> I take a reductionist conception of modernist painting to mean this: that painting roughly since Manet is seen as a kind of cognitive enterprise in which a certain quality (e.g., literalness), set of norms (e.g., flatness and the delimiting of flatness), or core of problems (e.g., how to acknowl-edge the literal character of the support) is progressively revealed as constituting the *essence* of painting – and, by implication, as having done so all along. This seems to me gravely mistaken, not on the grounds that

modernist painting is *not* a cognitive enterprise, but because it radically misconstrues the *kind* of cognitive enterprise modernist painting is. What the modernist painter can be said to discover in his work – what can be said to be revealed to him in it – is not the irreducible essence of *all* painting, but rather that which, at the present moment in painting's history, is capable of convincing him that it can stand comparison with the painting of both the modernist and the pre-modernist past whose quality seems to him beyond question.[8]

And in another essay written later that year I quoted Greenberg's remarks about a tacked-up canvas already existing as a picture though not necessarily as a successful one and commented:

> It is not quite enough to say that a bare canvas tacked to a wall is not 'necessarily' a successful picture; it would, I think, be more accurate to say that it is not *conceivably* one. It may be countered that future circumstances might be such as to *make* it a successful painting; but I would argue that, for that to happen, the enterprise of painting would have to change so drastically that nothing more than the name would remain . . . Moreover, seeing something as a painting in the sense that one sees the tacked-up canvas as a painting, and being convinced that a particular work can stand comparison with the painting of the past whose quality is not in doubt, are altogether different experiences: it is, I want to say, as though unless something compels conviction as to its quality it is no more than trivially or nominally a painting . . . This is not to say that painting *has no* essence; it *is* to claim that essence – i.e., that which compels conviction – is largely determined by, and therefore changes continually in response to, the vital work of the recent past. *The essence of painting is not something irreducible.* Rather, the task of the modernist painter is to discover those conventions which, at a given moment, alone are capable of establishing his work's identity as painting.[9]

My aim in quoting these passages is not to spare myself the trouble of formulating afresh the thoughts they express but rather to show that a sharply critical but emphatically pro-modernist reading of Greenberg's reductionism and essentialism has been available for some considerable time. And my aim in showing *this* is not to suggest that Clark ought to have felt obliged to come to grips with or at least to acknowledge that reading (though I tend to think he should have) so much as to underscore his dependence on Greenberg's theory of modernism, even perhaps his solidarity with Greenberg in the face of certain criticisms of the latter's ideas. In any case, I hope it is evident that the conception of modernism adumbrated in the passages just quoted is consistent with the arguments I have already mounted against Clark's essay. The following observations will help spell this out.

1. The less inclined we are to accept the view that modernism proceeds by discarding inessential conventions in pursuit of a timeless constitutive core, the more improbable we are bound to find the claim that negation in modernism is 'cumulative and uncontrollable,' that (to quote Clark in full) 'the road leads back

and back to the black square, the hardly differentiated field of sound, the infinitely flimsy skein of spectral colour, speech stuttering and petering out into etceteras and excuses' (p. 154) *[83]*. There is no road, if by that one means a track laid down in advance and ending in a predetermined destination, which is to say that there are no theoretical grounds for believing (or inclining to believe) that the evolution of modernist painting or sculpture or any other art will be from greater to lesser complexity, from differentiation to nondifferentiation, from articulateness to inarticulateness, and so on. (Nor are there theoretical grounds for believing the reverse.) Of course, it may simply be the case that some such evolution has occurred, but that is precisely what I dispute. Try understanding the history of Impressionism in those terms, or the art of Picasso and Braque between 1906 and 1914, or the emergence in the past seventy years of a tradition of constructed sculpture culminating in Smith and Caro, or the sequence of recent modernist painters Pollock – Helen Frankenthaler – Morris Louis – Kenneth Noland – Jules Olitski – Larry Poons (more challenges to Clark). My point here, however, is not that Clark's account of modernism belies the facts so much as that it is captive to an idea of how modernism works that all but screens the facts from view.

2. To the extent that we acknowledge the need for a putative work of modernist art to sustain comparison with previous work whose quality or level, for the moment anyway, is not in doubt, we repudiate the notion that what at bottom is at stake in modernism is a project of negation. For it is plainly not the case that the art of the old masters – the ultimate term of comparison – can usefully be seen as negative in essence: and implicit in my account is the claim that the deepest impulse or master convention of what I earlier called 'mainstream' modernism has never been to overthrow or supersede or otherwise break with the premodernist past but rather to attempt to equal its highest achievements, under new and difficult conditions that from the first were recognized by a few writers and artists as stacking the deck against the likelihood of success.[10] (For Baudelaire in 1846, those conditions included the disappearance of the great schools of painting that in the past had sustained relatively minor talents and, more broadly, the advent of an extreme form of individualism that in effect threw the modern artist solely on his personal resources and thereby ensured that only the most gifted and impassioned natures could hope to create lasting art.)[11] Here too, of course, someone might wish to argue that the various measures and strategies by which the modernist arts have sought to measure up to the great works of the past have been cumulatively and overwhelmingly negative in import. But this would require serious discussion of specific works, careers, movements, and so on, and once again I would bet heavily against the persuasiveness of the result.

3. The interpretation of modernism that I have been propounding implies a view of the relation of the artistic enterprise to the wider culture in which it is situated that differs from both Greenberg's and Clark's. According to Greenberg, modernism gets started at least partly in response to sociopolitical developments, but once under way its evolution is autonomous and in the long run even predetermined.[12] According to Clark, on the other hand, artistic modernism must be understood as something like a reflection of the incoherence and contradictoriness of modern capitalist society. In his words, 'Negation is the sign inside art of this wider decomposition: it is an attempt to *capture* the lack of consistent and

repeatable meanings in the culture – to capture the lack and make it over into form' (p. 154) *[82]*.

Now it may seem that my own views on this topic are closer to Greenberg's than to Clark's, and in a sense they are. I find Clark's thumbnail analysis of the sociopolitical content of modernism both crude and demeaning, quite apart from the absurdity of the idea that this culture or any culture can be said to lack 'consistent and repeatable meanings.' What on earth can he be thinking of? Furthermore, the modernist artist – say, the modernist painter – is represented in my account as primarily responsible to an exalted conception or at any rate to an exacting practice of the enterprise of painting. And this, in addition to perhaps striking some readers as elitist and inhumane (their problem, not mine),[13] may appear to commit me to a view of art and society as mutually exclusive, forever sealed off from one another without possibility of interpenetration or even communication. But this would be wrong: in the first place because my argument expressly denies the existence of a distinct *realm* of the pictorial – of a body of suprahistorical, non-context-specific, in that sense 'formalist,' concerns that define the proper aims and limits of the art of painting – maintaining on the contrary that modernist painting, in its constantly renewed effort to discover what it must be, is forever driven 'outside' itself, compelled to place in jeopardy its very identity by engaging with what it is not. (The task of understanding modernism politically is itself misunderstood if it is thought of as constructing a bridge over an abyss.)[14] And in the second place because my emphasis on the utterly crucial role played in modernism by conviction or its absence invites inquiry into what might be called the politics of conviction, that is to say, the countless ways in which a person's deepest beliefs about art and even about the quality of specific works of art have been influenced, sometimes to the point of having been decisively shaped, by institutional factors that, traced to their limits, merge imperceptibly with the culture at large. In a particular instance this may result in the undermining of certain beliefs and their replacement by others (a state of no belief is impossible). But it doesn't follow merely from the recognition of influence, even powerful influence, that the original beliefs are not to be trusted. A host of institutional factors must have collaborated long ago to incline me to take Manet seriously; but I can no more imagine giving up my conviction about the greatness of his art than I can imagine losing interest in painting altogether. (Both events could happen and perhaps will, but if they do I will scarcely be the same person. Some convictions are part of one's identity.)

4. To repeat: my insistence that the modernist painter seeks to discover not the irreducible essence of all painting but rather those conventions which, at a particular moment in the history of the art, are capable of establishing his work's nontrivial identity as painting leaves wide open (in principle though not in actuality) the question of what, should he prove successful, those conventions will turn out to be. The most that follows from my account, and I agree that it is by no means negligible, is that those conventions will bear a perspicuous relation to conventions operative in the most significant work of the recent past, though here it is necessary to add (the relation of perspicuousness consists precisely in this) that significant new work will inevitably transform our understanding of those prior conventions and moreover will invest the prior works themselves with a generative importance (and isn't that to say with a measure of value or quality?) that until that moment they may not have

had. Thus the evolution since the early 1950s of what is often called color-field painting has entailed a continual reinterpretation of Pollock's allover drip paintings of 1947–50 as well as an ever more authoritative identification of those pictures as the fountainhead of an entire tradition of modernist painting.[15]

So intensely perspectival and indeed so circular a view of the modernist enterprise – both the meaning and the value of the present are conceived as underwritten by a relation to a past that is continually being revised and reevaluated by the present – has close affinities with modern antifoundationalist thought both in philosophy proper and in theory of interpretation. (Recent discussions of Wittgenstein's treatment in the *Philosophical Investigations* of 'following a rule,' with its problematizing of how we 'go on in the same way' – e.g., making objects capable of eliciting conviction as paintings – are pertinent here.) But what I want to emphasize at this juncture is that insofar as the practice I have just described involves something like radical self-criticism, the nature of that self-criticism is altogether different from what Greenberg means by the term; and insofar as the process in question may be figured as a version of the dialectic, it throws into relief just how *un*dialectical Clark's reading of modernism is.[16]

IV

Toward the close of his essay, Clark writes that the end (in the sense of death) of the art of the bourgeoisie will involve, in fact has already involved (he is thinking of Brecht), 'a search for another place in the social order.' He continues: 'Art wants to address someone, it wants something precise and extended to do; it wants *resistance*, it needs criteria; it will take risks in order to find them, including the risk of its own dissolution' (p. 155) *[83]*. And in a footnote to this he adds:

> This is not to smuggle in a demand for realism again by the back door, or at least, not one posed in the traditional manner. The weakness or absence I have pointed to in modern art does not derive, I think, from a lack of grounding in 'seeing' (for example) or a set of realist protocols to go with that; rather, it derives from its lack of grounding in some (any) specific practice of representation, which would be linked in turn to other social practices – embedded in them, constrained by them. The question is not, therefore, whether modern art should be figurative or abstract, rooted in empirical commitments or not so rooted, *but whether art is now provided with sufficient constraints of any kind* – notions of appropriateness, tests of vividness, demands which bring with them measures of importance or priority. Without constraints, representation of any articulateness and salience cannot take place. [Pp. 155–56 n. 11; my emphasis] *[86]*

Here as elsewhere Clark's argument is unpersuasive. For one thing, to personify art itself as 'wanting' to do certain things that are now not being done is palpably absurd. (Need I add that it is also alien to a materialist view of the subject?) For another, Clark's use of notions like resistance and criteria is obscure. Is it his

considered view that in modernist art literally anything goes? Does he simply dismiss the insistence by Greenberg and others on the need to distinguish between the large mass of ostensibly difficult and advanced but in fact routine and meretricious work – the product, according to those critics, of an ingratiating and empty avant-gardism – and the far smaller and often less obviously extreme body of work that really matters, that can survive comparison with what at that juncture they take to be the significant art of the past?[17] True, the distinction is not enforced by appeal to objective criteria – but are those what Clark is asking for? Does he think, against Kant and Wittgenstein, that such criteria have a role to play in the arts? In any case, despite his disclaimers, the whole passage bears witness to an uneasiness with abstract art that makes Clark a dubious guide to the events of the past century or more.

My strongest objection to his remarks, however, is that they fail to recognize not just the magnitude of the achievement of modernist painters and sculptors I admire but also, more to the point, the formative importance in their art of what can only be called constraints. I shall conclude with a brief example.

In 1966 Caro, who had been making abstract sculptures in welded steel since 1960, became interested in making *small* sculptures – pieces that would extend no more than a foot or two in any dimension and thus would tend to be placed on a table or other convenient locus for small portable objects rather than directly on the ground, the compulsory (i.e., the only right) siting for his abstract pieces until that moment.[18] Now it may seem that this ought not to have presented a problem: Why not simply make small (i.e., tabletop) versions of the larger sculptures that normally would have been placed on the bare ground, and let it go at that? But the fact of the matter is that such a solution was unacceptable to Caro, by which I mean that even without giving it a try he knew with perfect certainty that it would not do, that it was incapable of providing the basis for proceeding that he sought, But why?

Here I want to say, because it failed to respond to the *depth of Caro's need* for something, call it a convention,[19] that would articulate smallness in a manner consistent with the prior logic of his art, that would be faithful to his commitment to a particular mode of thinking, feeling, and willing sculpture, in short that would not run counter to his acceptance (but that is too contractual a term: his internalization, his appropriation) of a particular set of constraints, the initial and at first only partial unearthing of which roughly six years before had been instrumental in his sudden emergence as a major artist (itself a characteristically modernist phenomenon).[20] I associate those constraints with a radical notion of *abstractness*, which I contrast not with *figurativeness*, an uninteresting opposition, but rather with *literalness*, in the present context a compelling one.[21] Reformulated in these terms, the problem of smallness that Caro found so challenging may be phrased quite simply. How was he to go about making pieces whose modest dimensions would strike the viewer not as a contingent, quantitative, in that sense merely literal fact about them but rather as a crucial aspect of their identity as abstract works of art – as internal to their 'form,' as part of their very essence as works of sculpture? To put this another way, by what means was he to make small sculptures that could not be seen, that would effectively defeat being perceived, either as models for or as reduced versions of larger ones? In obvious respects, the task he faced involved departing from norms that had been operative in his art up to that time. More importantly, however, his task was one of remaining responsible to a particular vision of his art

(may we not lift a phrase from Clark and say to a particular vision of 'cultural possibility'?) according to which a sculpture's scale – indeed all its features that matter, including its mode of self-presentation – must be secured abstractly, made part of its essence, in order to convince the viewer (in the first instance the sculptor) of their necessity or at any rate their lack of arbitrariness.

Caro's solution to this problem involved two distinct steps, the first of which soon proved dispensable. First, he incorporated handles of various sorts in a number of pieces in an attempt to key the 'feel' of each work to that of graspable and manipulable objects. The chief precedent for this was Picasso's *Glass of Absinthe* (1914), a small painted bronze sculpture that incorporates a real silver sugar strainer. (Recognizable handles disappear from Caro's art around 1968.) Second, as in *Table Piece XXII* of 1967, Caro ran at least one element in every piece *below* the level of the tabletop or other elevated plane surface on which it was to be placed. This had the effect of precluding the transposition of the sculpture, in fact or in imagination, to the ground – of making the placement of the sculpture on (i.e., partly off) the tabletop a matter not of arbitrary choice but of structural necessity. And it at once turned out that tabling or precluding grounding the sculptures in this way was tantamount to establishing their smallness in terms that are not a function of actual size. More precisely, the distinction between tabling and grounding, determined as it is by the sculptures themselves, makes itself felt as equivalent to a qualitative as opposed to quantitative, essential as opposed to contingent, or abstract as opposed to literal difference in scale. (Not only did the abstract smallness of the table sculptures later prove compatible with surprising largeness of actual size; it soon became apparent that a certain minimum size, on the order of feet rather than inches, was required for their tabling to be experienced in these terms.)[22]

Caro's table sculptures thus embody a sense of scale for which there is no obvious precedent in earlier sculpture. And although it seems clear that our conviction on this score relates intimately to the fact that in everyday life smallish objects of the sort we grasp, manipulate, and shift casually from place to place tend to be found on tables, within easy reach, rather than on the ground, it is also true that we encounter nothing quite like the abstract smallness of Caro's table sculptures in our ordinary dealings with the world. From this point of view, an ontological one, the table sculptures are endlessly fascinating. And the source of that fascination could not have less to do with everything Clark means by negation, decomposition, absence, emptiness – the entire battery of concepts by means of which he tries to evoke the futility of modernism as he sees it.

A further glance at *Table Piece XXII* and I am done. The sculpture consists of three primary elements – a section of curved, broad-diameter pipe, a longer section of straight, narrow-diameter pipe, and a handle – welded together in a configuration, a structure of relations, that subtly, abstractly, asserts not only the disparateness but also the separateness of the two sections of pipe. (The pipe sections strike us as above all *disjoined* from one another by the handle that runs between them.) And one consequence of this is that, far from being tempted to reach out and grasp the handle, we sense as if subliminally that we are being invited to take hold of a gap, a spacing, and we draw back. In short, the everyday, literal function of a handle is here eclipsed by *this* handle's abstract function of enforcing a separation and thereby

attuning us all the more finely to apprehending *Table Piece XXII* abstractly rather than literally, as a work of art and not, or not merely, a physical object. A Marxist critic might wish to say that this last distinction and indeed my larger advocacy of abstractness versus literalness are epitomes of bourgeois ideology. But he would have to grant that my analysis of Caro's table sculptures could hardly be further from Clark's fantasy of the medium in modernism reverting to the state of 'mere unworked material.'

Finally, beyond and embracing the considerations I have so far invoked, the convincingness of *Table Piece XXII* as art depends on something that defies exhaustive analysis, namely, the sheer rightness of *all* the relevant relation at work in it, including the appropriateness of its color, a metallic gray-green, to everything else. Intuition of that rightness is the critic's first responsibility as well as his immediate reward, and if Clark shared more than a fraction of that intuition, about this Caro or any Caro, or any Smith, Pollock, Frankenthaler, Louis, Noland, Olitski, or Poons, not to mention the antecedent masters whose painting and sculptures, continually reinterpreted, stand behind theirs, his understanding of the politics of modernism would be altogether different from what it is.

Notes

1 Clark writes in his n. 10 (p. 154) *[85]* that 'what I am referring to is an *aspect* or *moment* of modernist art, most often mixed up with other purposes or techniques, though often, I would argue, dominating them.' This introduces a hint of qualification, almost of moderation, that can be found nowhere else in his essay. The present response addresses the hard, unqualified position taken by his essay as a whole, which stands virtually as it was read aloud at the 'Politics of Interpretation' conference in Chicago. Perhaps I ought to add, inasmuch as my assessment of his views on modernism will be severe, that I think highly of his studies of French art during the Second Republic, *Image of the People* (Princeton, N.J., 1973) and *The Absolute Bourgeois* (Princeton, N.J., 1973).

2 I associate those aims and aspirations with the search for a new and more perspicuous mode of pictorial unity as well as with the desire to achieve a specific relation between painting and beholder (two aspects of the same undertaking). This is not the place for a detailed discussion of these matters, but I will simply note that the unintelligibility of the action or situation promotes an effect of *instantaneousness*, not of the action itself so much as of one's perception of the scene, the painting, as a whole. For more on Manet's aims in the first half of the 1860s, see my 'Manet's Sources: Aspects of His Art, 1859–1865,' *Artforum* 7 (March 1969): 28–82. In that essay I suggest that the *Déjeuner* combines elements of several genres of painting (e.g., landscape, portraiture, still life) and that this too is to be understood in terms of Manet's pursuit of a more radical and comprehensive mode of unification than was provided by the pictorial culture of his day.

3 On the distinction between 'mainstream' modernism and its shadow, the phenomenon Greenberg calls avant-gard*is*m, see n. 17 below.

4 My presentation of Greenberg's theory of modernism is based chiefly on two of his later essays, 'Modernist Painting' (1961), in *The New Art: A Critical Anthology*, ed. Gregory Battcock (New York, 1966), pp. 100–110, and 'After Abstract

Expressionism' (1962), in *New York Painting and Sculpture: 1940–1970*, ed. Henry
Geldzahler (New York, 1969), pp. 360–71.

5 Greenberg, 'Modernist Painting,' p. 102.

6 Greenberg, 'After Abstract Expressionism,' p. 369.

7 Ibid. Greenberg spells out what he means by 'conception' when he says of
Newman's paintings: 'The onlooker who says his child could paint a Newman may
be right, but Newman would have to be there to tell the child *exactly* what to do'
(p. 370).

8 Fried, 'Shape as Form: Frank Stella's New Paintings' (1966), in *New York Painting
and Sculpture*, p. 422.

9 Fried, 'Art and Objecthood' (1967), in *Minimal Art: A Critical Anthology*, ed.
Battcock (New York, 1968), pp. 123–24 n. 4 (with a few minor changes). The
Wittgensteinian view of essence and convention propounded in these passages and
indeed the basic conception of the modernist enterprise outlined in them were
worked out during a period of close intellectual comradeship with Stanley Cavell;
see, e.g., Cavell, 'The Availability of Wittgenstein's Later Philosophy,' 'Music Dis-
composed,' and 'A Matter of Meaning It,' *Must We Mean What We Say?* (New York,
1969), as well as his *The Claim of Reason: Wittgenstein, Skepticism, Morality, and Tragedy*
(New York, 1979), esp. pp. 86–125. For a highly intelligent, at once sympathetic
and deconstructive, reading of my account of modernism, see Stephen Melville,
'Notes on the Reemergence of Allegory, the Forgetting of Modernism, the Neces-
sity of Rhetoric, and the Conditions of Publicity in Art and Criticism,' *October* 19
(Winter 1981): 55–92.

10 That the historical mission of modernism has been to preserve the standards of
the high art of the past is one of Greenberg's major themes. The closing words of
'Modernist Painting' are these: 'Nothing could be further from the authentic art
of our time than the idea of a rupture of continuity. Art is, among many other
things, continuity. Without the past of art, and without the need and compulsion to
maintain past standards of excellence, such a thing as Modernist art would be
impossible' (p. 110).

11 See Charles Baudelaire, 'The Salon of 1846,' *Art in Paris 1845–1862: Salons and Other
Exhibitions*, trans. and ed. Jonathan Mayne (Ithaca, N.Y., 1981), pp. 115–16. What
the great schools chiefly provided to artists belonging to them was 'faith' or, as
Baudelaire shrewdly goes on to say, 'the impossibility of doubt' (p. 115). In the
same vein, Baudelaire writes of Delacroix more than a decade later. 'He is as great
as the old masters, in a country and a century in which the old masters would not
have been able to survive' ('The Salon of 1859,' p. 168).

12 Let me emphasize that I am speaking here of the implications of his theoretical
essays (or of primarily theoretical passages in essays like 'After Abstract Expression-
ism'); as a practical critic, Greenberg is at pains to eliminate all suggestion of
predetermination and in fact would surely claim that he wished to do so in his
theoretical writings as well. As we have seen, however, the terms of his analysis –
reduction to an essence – make such a suggestion unavoidable.

13 I say that it is their problem because it is based on unexamined assumptions or
simply wishful thinking about what art (and life) should be like. This is perhaps the
place to mention that in a lecture at a conference on art criticism and social theory
held at Blacksburg, Virginia (9–11 October 1981), Donald Kuspit of the State
University of New York at Stony Brook (author of a study of Greenberg) character-
ized my views on modernism as 'authoritarian' and even as 'fascistic.' These are

hard words. Presumably what justifies them is my insistence that some art is better than other art and my claim to know, to be able to tell, which is which. (Sometimes, of course, what I am able to tell is that previously I was wrong.) But what would be the use of a critic who regarded all art as equally indifferent, or who claimed not to be able to distinguish good from bad, or who considered all such questions beside the point? Moreover, my emphasis on the primacy of conviction means precisely that the reader of my criticism is barred from being persuaded, simply by reading me, of the rightness (or wrongness) of the judgments I make; rather, he *must* test those judgments against his firsthand experience of the works in question if he is to arrive at a view of the matter that is truly his. Is this authoritarianism? Fascism? Only, it seems to me, if we are prepared to characterize in those terms the assertion that while 'the doors of the temple stand open, night and day, before every man, and the oracles of this truth cease never, it is guarded by one stern condition; this namely; It is an intuition. It cannot be received at second hand' (Ralph Waldo Emerson, 'The Divinity School Address,' *Nature, Addresses, and Lectures*, ed. Robert E. Spiller and Alfred R. Ferguson [Cambridge, Mass., 1979], p. 80).

14 Early in his essay, Clark cites Bertolt Brecht as a modern artist for whom 'active engagement in ideological struggle . . . was not necessarily incompatible with work on the *medium* of theatre, making that medium explicit and opaque in the best avant-garde manner' (p. 143), and again toward the end he mentions Brecht with approval. This is true as far as it goes, but it fails to consider the possibility that it was precisely Brecht's prior concern with problems and issues relating to what might be called the inescapable theatricality of the theatrical arts that enabled him to make an engagement in ideological struggle *count* artistically. Brecht himself describes his discovery of Marx as that of an ideal audience: 'When I read Marx's *Capital* I understood my plays . . . It wasn't of course that I found I had unconsciously written a whole pile of Marxist plays; but this man Marx was the only spectator for my plays I'd ever come across' (*Brecht on Theater*, trans. and ed. John Willett [New York, 1964], pp. 23–24). (A similar line of argument might be pursued in connection with Godard.) The question as regards modernist painting and sculpture is therefore whether the present state of those arts is such as to facilitate an analogous development. I think the answer is no, but not because of any fact of *closure*.

15 See, e.g., my *Morris Louis* (New York, 1970), pp. 13–22 and passim.

16 Two further ramifications of my account of modernism should at least be mentioned. First, it implies that the conviction of quality or value is always elicited by putative paintings and sculptures and not by putative works of art as such. The way I put this in 'Art and Objecthood' was to claim that 'the concepts of quality and value – and to the extent that these are central to art, the concept of art itself – are meaningful . . . only *within* the individual arts. What lies *between* the arts is theater' (p. 142). (See n. 18 below, and cf. Greenberg, 'Intermedia,' *Arts* 56 [October 1981]: 92–93.) Second, the situation of the critic is analogous to that of the modernist artist in that criticism has no neutral, context-free, in that sense suprahistorical, descriptive categories at its disposal (not even, or especially not, 'painting' and 'sculpture') but rather must seek to elicit the conviction that the concepts it finds itself motivated to deploy actually illuminate the works under discussion. Moreover, as the context changes, largely as the result of subsequent artistic developments, even the concepts in widest use will require modification. For example, during the past fifteen or twenty years the concept 'flatness' that at least since the late

nineteenth century had been indispensable to the construal of modernist painting has lost much of its urgency; which is not to say that ambitious painting in our time has been freed from the demand that it come to terms with issues of *surface* – if anything the pressure there is more intense than before. Larry Poons' recent 'pour' paintings incorporating bits and pieces of polyurethane, shown at the Emmerich Gallery in New York in April 1982, are a case in point.

17 In a lecture delivered at the University of Sydney in 1968, Greenberg distinguishes between the authentic avant-garde, which he sees as dedicated to preserving the values of the high art of the past, and the 'popular' avant-garde – the invention of Duchamp and Dada – which he characterizes as seeking to evade the issue of quality altogether (see Greenberg, 'Avant-Garde Attitudes: New Art in the Sixties,' The John Power Lecture in Contemporary Art, 17 May 1968 [Sydney, 1969], pp. 10–11). (One recurrent tactic of evasion has been to raise the pseudoquestion of art as such.) In that lecture too Greenberg notes the emergence in the 1960s of what he calls 'novelty' art, in which the 'easiness' of the work – its failure to offer a significant challenge to advanced taste – 'is . . . knowingly, aggressively, extravagantly masked by the guises of the difficult' (p. 12). And in a subsequent essay, Greenberg substitutes the pejorative term 'avant-gardism' for that of the 'popular' avant-garde ('Counter Avant-Garde,' *Art International* 15 [May 1971]: 16–19).

In my 'Art and Objecthood' I argue that the best contemporary painting and sculpture seek an ideal of self-sufficiency and what I call 'presentness' whereas much seemingly advanced recent work is essentially *theatrical*, depending for its effects of 'presence' on the staging, the conspicuous manipulation, of its relation to an audience. (In the years since 'Art and Objecthood' was written, the theatrical has assumed a host of new guises and has acquired a new name: post-modernism.) Recently Melville has challenged the hardness of this distinction, arguing, for example, that the desire to defeat the theatrical can find satisfaction only in a theatrical space, or at any rate in circumstances that cannot wholly escape the conditions of theater (I make this point in my writings on pre-modernist art), and going on to claim that today 'the field we call 'painting' includes, and cannot now be defined without reference to, its violations and excesses – performance work in particular' ('Notes,' p. 80). In this connection he cites figures such as Rauschenberg and Acconci, whose endeavors I continue to see as trivial. But the fact that I am unimpressed by his exemplary artists by no means deflects the force of his general argument, which compels an awareness that, as he puts it, neatly paraphrasing me on Diderot, the art of painting is inescapably addressed to an audience that must be gathered (see p. 87). On the other hand, as Melville is aware, the impossibility of a pure or absolute mode of antitheatricality by no means implies that I am mistaken in my assessment of the best work of our time or even, by and large, in the terms in which I have described it. (Effects of presentness can still amount to grace.)

On theatricality as an issue for pre-modernist art, see my *Absorption and Theatricality: Painting and Beholder in the Age of Diderot* (Berkeley, 1980); 'Thomas Couture and the Theatricalization of Action in Nineteenth-Century French Painting,' *Artforum* 8 (June 1970): 36–46; 'The Beholder in Courbet: His Early Self-Portraits and Their Place in His Art,' *Glyph* 4 (1978): 85–129; 'Representing Representation: On the Central Group in Courbet's *Studio*,' in *Allegory and Representation: Selected Papers from The English Institute, 1979–80*, ed. Stephen J. Greenblatt (Baltimore, 1981), pp. 94–127, rpt. in *Art in America* 69 (September 1981): 127–33, 168–73; and 'Painter into Painting: On Courbet's *After Dinner at Ornans* and *Stonebreakers*,' *Critical Inquiry*

8 (Summer 1982): 619–49. Theatricality in Manet is discussed in my 'Manet's Sources,' pp. 69–74.

18 On Caro, see, e.g., my introduction to the exhibition catalog, *Anthony Caro*, Hayward Gallery, London, 1969; Richard Whelan et al., *Anthony Caro* (Baltimore, 1974); and William Rubin, *Anthony Caro* (New York, 1975). The Whelan book contains additional texts by Greenberg, John Russell, Phyllis Tuchman, and myself. The following discussion of Caro's table sculptures is based on my essay in the catalog to the travelling exhibition, *Anthony Caro: Table Sculptures, 1966–77*, British Council, 1977–78 (rpt. in *Art* 51 [March 1977]: 94–97).

19 'It is as if this expressed the essence of form. – I say, however: if you talk about *essence* –, you are merely noting a convention. But here one would like to retort: there is no greater difference than that between a proposition about the depth of the essence and one about – a mere convention. But what if I reply: to the *depth* that we see in the essence there corresponds the *deep* need for the convention' (Ludwig Wittgenstein, *Remarks on the Foundations of Mathematics*, ed. G. H. Von Wright, R. Rhees, and G. E. M. Anscombe, trans. Anscombe [Oxford, 1956], p. 23e).

20 See my discussion of Louis' 'breakthrough' to major achievement in *Morris Louis*, pp. 10–13.

21 The opposition between abstractness and literalness is developed in my essays 'Shape as Form' and 'Art and Objecthood,' as well as in two short reviews, 'Two Sculptures by Anthony Caro' and 'Caro's Abstractness,' both available in Whelan et al., *Anthony Caro*, pp. 95–101 and 103–10; see also in this collection Greenberg's remarks on Caro's abstractness or 'radical unlikeness to nature' ('Anthony Caro,' pp. 87–93, esp. p. 88).

22 Between 1966 and 1974, Caro made roughly two hundred table sculptures of this type. Around 1974–75, however, he began making table sculptures that no longer dipped below the level of the tabletop, without loss of quality. It is as though by then Caro had acquired a mastery of what might be called table scale that enabled him to give up anchoring the pieces to the tabletop and nevertheless to establish abstractly the specificity of their dimensions and mode of presentation. (On the other hand, many of these pieces also 'work' on the ground and in that sense are presentationally looser than the earlier pieces.)

T. J. Clark

ARGUMENTS ABOUT MODERNISM
A Reply to Michael Fried

1 The argument about negation

I THINK THAT THE thesis of my paper Michael Fried chooses mainly to attack – namely, that there is a strong negative cast to modernism, one that characterizes it as an episode in art – is, if banal, pretty well supported by the evidence. Attempts to contradict it always end up seeming strained and over-ingenious (which is not always the case with refutations of the commonplace). Fried's attempts seem to me no exception and not much better in their present form than in the previous ones he wonders I did not mention.

But obviously I should have been clearer about what I took the argument to *be*; that I was not allows Fried to run rings round various imaginary opponents. First of all, it is hardly likely that I should agree with the later Clement Greenberg on some version of essentialism, for example, 'that modernism proceeds by discarding in-essential conventions in pursuit of a timeless constitutive core' (p. 228) *[91]*. To the extent that Fried's self-quotations are disputes with some such notion – and I cannot see that they are much more – I can cordially agree with them and pass on. My argument is about historical cases and how best to interpret them, or how best to interpret the overall sequence they make.

Of course it was a large part of my case in the paper that the same was true of Greenberg's argument in its original form. Both the articles of 1939–40 in *Partisan Review*, 'Avant-Garde and Kitsch' and 'Towards a Newer Laocoon,' depended on a picture – quite a powerful picture, I still think – of the social circumstances of late capitalism, and the discussion of medium in 'Towards a Newer Laocoon' was largely free of the a priori reasoning characteristic of Greenberg later in his career. Fried is evidently very little interested in the Trotskyite writer of 1939–40. I can

Source: 'Arguments about Modernism: A Reply to Michael Fried' in W. J. T. Mitchell (Ed.) *The Politics of Interpretation*, The University of Chicago Press, Chicago and London, 1983, pp. 239–248. © T. J. Clark.

see why. But if he wants to pass judgement on how much or how little of Greenberg I have swallowed, it might help to get clear which Greenberg we are talking about.

Hereabouts another misunderstanding seems to creep in. For to say of a series of artworks that they show modernist art proceeding by leaps and bounds of negation is not to say that these negations result continually in *nothing*, or next to nothing, or even that modernism is habitually nay-saying or nihilistic. It is not to make the claim – which I would find as absurd as Fried does – that modernism has left behind it no complex account of experience and its modes, or no viable work on the means and materials of representation. Of course it has. The argument is rather (1) that it should strike us as important that these accounts depended on such a 'casting off of norms and conventions,' one which in the end included most of the kinds of descriptive work which had previously given art its *raison d'être*, and (2) that this process progressively tended to overwhelm modernist practice and become a peculiar end in itself, or at least to obscure all others. So that the 'new conception of the enterprise of painting' became, in my view, more and more etiolated and self-obsessed.'

Thus to describe Pollock's *Lavender Mist* – it would take, of course, quite a long discussion of its peculiar place in the sequence of Pollock's drip canvases – as representing a delectable *impasse* of painting, from which its author sought to escape, months later, by means of a desperate backtrack to figuration – this would not be to call the picture empty or insubstantial but to point to the unrepeatable, incorrigible nature of its wholeness. (The account could be supported by reference to the artist's own doubts and hesitations about abstraction, for which there is a remarkable and poignant body of evidence; for this kind of reason and others, Fried's remarks about my 'uneasiness with abstract art' making me 'a dubious guide to the events of the past century' [p. 230] *[95]* have an anachronistic ring.) Or to place Picasso's *Ma Jolie* in a series of pictures from 1909 onward in which the female body seems pulled out of shape or dispersed by the very act of representing it, to say that painting itself is seen here as a form of doleful violence against the nude, to point to the grim and obvious irony of the picture's title, inscribed as it is on the scaffold of monochrome shards – none of this would be to say that there *is* no body in *Ma Jolie* but rather that painting here seems obliged to push toward an area in which every vestige of integrity or sensual presence is done to death – every vestige but that of 'paint itself,' put on with such delicate, sober virtuosity – in the belief, apparently, that only there would some genuine grasp of the body be possible.' Fried and I may disagree in either case about whether the grasp or the wholeness is achieved; but I simply want us to be struck again by the violence with which the normal repertoire of likeness is annihilated and to wonder if any other ground for representation had been secured, or could possibly be secured, in the process.

Why is it, I wonder, that modernist critics (Fried is typical here), when they encounter a history of modernism in which its masterpieces are not all pictured as triumphant openings on to fullness and positivity, are so ready to characterize that history as merely hostile, telling a story of 'futility' and waste? Part of the problem may simply be this: for me a strategy of negation and refusal is not an unreasonable response to bourgeois civilization since 1871, and indeed it is the ruthlessness of negation which lies at the root of what I admire – certainly what I feel is still usable – in modern art. The line of wit is replaced by the line of dissolution: there is no

modernism to speak of, as far as I am concerned, apart from *Mauvais Sang* and *Ecce Homo*, from *The Cloud in Trousers* and the *Dictionnaire des idées reçues*, from the black square (Malevich's not Ad Reinhardt's) and the *Wooden Horse*. 'I consider *The Cloud in Trousers* a catechism for modern art,' said its author, V. Mayakovsky. 'It is in four parts, with four rallying cries: "Down with your Love!"; "Down with your Art!"; "Down with your Social Order!"; "Down with your Religion!"'[3] 'Voilà les forces qui se sont déployées,' as an old book has it, 'pour introduire dans les consciences des hommes un peu de la moississure des valeurs pourissantes.'[4] The problem remains, however, whether art on its own has anything to offer *but* the spectacle of decomposition.

I find myself swapping lists of favourite works. This is a pity. For let it be said that no decent historical account of modern art can be framed solely round a selected set of its 'masterpieces.' (Though if a contrary account can only be managed by excluding those masterpieces or admitting them all as exceptions, that account is equally in trouble.)[5] I think that my reading of modernism could make various sense of the works Fried cites and put them in contact with a host of others that are now declared, by modernist fiat not by any process of historical enquiry, to be irrelevant to them. To take the example Fried mentions: I still find it striking that modernist writers so confidently outlaw the real impulse of Dada and early Surrealism from their account of twentieth-century art, while giving such weight to artists – like Arp or Miró or Pollock – who were profoundly affected by it. Nor is the problem solved, I think, by claiming that what Pollock and Miró took from the Surrealists, by some miracle of probity, was a set of techniques which they quickly cleansed and turned to higher purpose, rather than a whole strategy of release, exacerbation, emptying, and self-splitting. Some such description might just apply to Arp's way with his masters, but that it does is the key to his limitations as an artist. It is what puts him outside the 'modern tradition,' if such a contradiction in terms is conceivable.

These points could be pursued further. It is particularly in its treatment of the period between 1910 and 1930 that modernist art history is inadequate, because it is faced most dramatically there with the break-up of its received tradition, the end of Parisian hegemony over the arts, and the emergence of a set of competing art practices in which the limits and autonomy of art are at stake. The question is not whether one approves of or dislikes Marcel Duchamp, who in any case is largely the entrepreneur of 'anti-art' attitudes in the period, giving them commodity form. The question is how one should deal with the whole decentering of art after 1917. A history which has nothing to say about the November Group and the Russian Productivists, about VKhUTEMAS and *Der Ventilator*, while lavishing attention on the dispirited efforts of Matisse and Kandinsky in the same decade, should flinch, I would have thought, from too confident a trading of examples.*

* Author's note, 1984: Since this sentence was written, the Guggenheim Museum has put on its irrefutable show, *Kandinsky: Russian and Bauhaus Years*. No doubt an exhibition of Matisse in the 1920s could be arranged that would leave me looking similarly silly. In the knockabout of argument one tends to lose hold of the main point: that the critique of modernism will not proceed by demotion of heroes, but by having heroism come to be less and less the heart of the matter. We should not be trying to puncture holes in the modernist canon (we shall anyway usually fail at that) but rather to have canon replaced by other, more intricate, more particular

2 The argument about consistent meanings

This can be dealt with briefly. I am surprised that Fried finds the idea that modern culture lacks 'consistent and repeatable meanings' absurd. I used the phrase as a shorthand for *patterns* of meaning, systems of belief and instantiation, by which a culture fixes – and opens to refutation – some complex account of its central experiences and purposes. The word 'consistent' was meant to suggest both coherence and substance – a power to convince, a seeming depth. The word 'repeatable' has that pattern of belief surviving through time, dealing with new evidence without coming apart, becoming something like a tradition or a mythology.

The idea that modern culture is characterized by the absence of such forms of knowledge goes back at least as far as the Jena school or the English writers of the same period and does not seem to me absurd then or later. It has certainly been an important idea for modernist art. To adopt Fried's own tactic for a moment, I should be interested to hear a plausible account of *Bouvard et Pécuchet*, say, or *The Trial* or *The Waste Land* (no minor figures now) which did not take such doubts and uncertainties to be somewhere near the heart of things.

As for Fried's further claim that it makes no sense to picture *any* culture as lacking 'consistent and repeatable meanings,' I recommend a good read of social anthropology – say, the literature on cargo cults.

3 The argument about cases

My answer to Fried is bound to be as inconclusive as responses-to-replies-to-rejoinders normally are, because really there is so little common ground between us on which to argue. This comes out most clearly in Fried's exultant pointing to cases and his certainty that in doing so he poses a serious challenge to my main account.

The reader is entitled to feel a bit baffled. So Fried finds my analyses crude and demeaning, and I find his fulsome and aggrandizing. Apart from the usual academic *corrida*, what does this exchange of courtesies amount to? I do not think it turns on contrary intuitions of Anthony Caro; intuitions about Caro (and so forth) do not seem to me tests of anything very important. Of course their not seeming so derives in a sense from judgements of Caro's work, but these derive from other (primary) interests and commitments. The point at issue is this, I think: Fried is interested in preserving a certain set of practices and sensibilities (let's call them those of 'art' or 'sculpture'); the set is specific; at the heart of it I detect a form of pristine

orders and relations. Naturally, new kinds of value judgement will result from this: certain works of art will come to seem more important, others less interesting than before; but above all the *ground* of valuation will shift. At the moment our sorting is all *ex cathedra*: history proceeds by random exclusions and inclusions: we have a way, for example, of admitting (late in the day) that Diego Rivera was one of the greatest Cubist painters, but no way of reworking our view of his Social Realism in that light; we want Tatlin, but only bits of him; Derain, but not after 1910; Hopper but not Benton; Futurism minus the Fascism; El Lissitsky but not in his Stalinist mode. This is a mess. And the mess affects our account of the heroes, I think: the breathless, repetitive, fawning quality of so much writing on modern art is the result, it seems to me, of our not having a history in which even the masterpieces might make sense.

experience had by an individual in front of an object, an 'intuition of rightness' if you like. The relation of this experience to the normal identities and relations of history is obscure, but the language of Fried's actual descriptions, here and elsewhere, suggests that it somehow abrogates them and opens on to a ground or plenitude of knowledge which is normally closed to us. Caro's sculpture provides such experiences (Fried says); the experience seems valuable (to him). And no doubt it does and is; or rather, since there is no rational ground *for* doubt, let's talk about something else – for instance, about why one person should be interested in preserving this kind of experience and the talk that goes with it and another be interested in its destruction.

Let me put the point another way. I take it that many of Fried's disagreements with me centre or depend on a version of the priority-of-perception thesis. Differences on this subject seem to me largely unresolvable, because behind them lie commitments and interests which are not susceptible of proof or disproof; but nonetheless I shall have my brief say. The priority-of-perception thesis in criticism owes its appeal, surely, to its uncontroversial insistence on the special nature of artistic statements, its reminding us that we are very often dealing with complex and self-conscious cases of description or enunciation, ones which admit the odd materiality of the means they employ. Art is a practice – or at least can be a practice, in certain historical circumstances – in which the mismatching of beliefs and instances can be recognised and played with. Thus artistic statements are likely to be specially demanding on the viewer or reader's attention.

The priority-of-perception thesis therefore insists on close reading, quite properly I think. The mistake it makes is in its notion of what close reading *is*: the question being whether it is an exclusive and intensive focusing, a bracketing of knowledge, a giving-over of consciousness to its object, or whether successful reading is a mobilization of complex assumptions, commitments, and skills, in which the object is always being seen against (as *part* of) a ground of interest and argument. I certainly think the latter is the case. In the critics whose close reading I most admire (and my preferences are not eccentric; I have in mind T. S. Eliot or F. R. Leavis, or for that matter Diderot and Coleridge), objects are attended to as instances of a certain history. They are construed from a political point of view. And these perspectives and commitments are present in the reading, shaping and informing it; they are what gives it precision and substance; the writing of the reading admits as much. The same is true of Greenberg's criticism, or was true in its active and fruitful first period from 1939 to 1948. Again, this was one of the things I tried to suggest in my paper, but perhaps I should state more clearly here that it seems to me Greenberg's best years as a critic were these, when his readings were still openly worked by wider historical concerns and partisanship. Why these were eventually abandoned, and why he retreated to a notoriously intransigent version of the primacy-of-perception thesis, is another story. The Cold War and McCarthyism are not our subject at present.

4

One of the reasons I cannot see Caro's or Jules Olitski's work very well any longer is that I have become more aware over time of the ground of interests and arguments

it serves – and that, woodenly. I find them so uncongenial and boring that I cannot now perceive anything much. (I don't intuit the work's rightness: Is that it? I think I'm still capable of noticing that a Caro is small, but I fail to see why I should take facts of this kind very seriously. And as to accepting them as *constraints*, in the sense I gave the word! . . .) This will seem critical gain to some and loss to others; doubtless the real hardliners will want to say that I never could have genuinely *seen* in the first place if I am thrown off track thus easily by ideology. My hard line in return would be that 'seeing' in such statements seems to me nothing – I mean that more or less literally – but the instrumentation of a different ideology.

There is a danger that all this talk of interests and arguments will seem obscure, and rather than have it remain so I shall spell out what I mean quite crudely (no doubt demeaningly too). The bourgeoisie has a small but considerable interest, I believe, in preserving a certain myth of the aesthetic consciousness, one where a transcendental ego is given something appropriate to contemplate in a situation essentially detached from the pressures and deformities of history. The interest is considerable because the class in question has few other areas (since the decline of the sacred) in which its account of consciousness and freedom can be at all compellingly phrased.

It is not enough, in this connection, for Fried to deny that he posits 'a distinct *realm* of the pictorial,' since his critical practice so insistently reinstates one; in the same sentence we find him saying that painting's engagement 'with what it is not,' though inevitable, 'place[s] in jeopardy its very identity' (p. 226) *[93]*. But why on earth should it? And isn't an account of painting which sees it as *gaining* its various identities through engagement with what it is not automatically foreclosed by Fried's formulations? Won't he rule out my account of Picasso, say, on the ground that it does not grasp how separate and sustaining the 'enterprise of painting' was for the artist in question? In critical practice, isn't *any* account of modern art's engagement with what it is not dismissed as being beside the great ontological point? And when it comes to ontology, all the nods to Merleau-Ponty cannot save Fried's prose from sounding like old-time religion.

One is reminded, if I too can quote from a founding text, of the climax of 'Art and Objecthood' (1967), where Fried draws a distinction between the theatrical, literalist modes of the sculpture he dislikes – preeminently Morris' and Judd's – and the 'presentness' of a Caro, its being at every moment 'wholly manifest.' 'It is this continuous and entire presentness, amounting, as it were, to the perpetual creation of itself, that one experiences as a kind of *instantaneousness*: as though if only one were infinitely more acute, a single infinitely brief instant would be long enough to see everything, to experience the work in all its depth and fullness, to be forever convinced by it.' The essay concludes famously: 'More generally, however, I have wanted to call attention to the utter pervasiveness – the virtual universality – of the sensibility or mode of being which I have characterized as corrupted or perverted by theater. We are all literalists most or all of our lives. Presentness is grace.'[6]

I do not mean to insinuate, finally, that a religious point of view is indefensible in criticism; how could I, with Eliot as reminder? It may even be that a religious perspective is the only possible one from which a cogent defence of modernism in its recent guise can be mounted. But the view is not defended here, it seems to me, just noised abroad in an odd manner; and that is its usual status in such writing.[7] If on

the contrary a defence *were* offered, arguments about modernism, other than the name-calling kind, would be made much easier.

Notes

1 The core of this argument is commonplace, as I say; in no sense is it Greenberg's special property, still less mine. For a more elegant and emphatic phrasing of it, apropos the nineteenth-century invention of 'literature,' see Michel Foucault's *Les Mots et les choses* (Paris, 1966), p. 313:

> De la révolte romantique contre un discours immobilisé dans sa cérémonie, jusqu'à la découverte mallarméenne du mot en son pouvoir impuissant, on voit bien quelle fut, au XIXe siècle, la fonction de la littérature par rapport au mode d'ètre moderne du langage. Sur le fond de ce jeu essentiel, le reste est effet: la littérature se distingue de plus en plus du discours d'idées, et s'enferme dans une intransitivité radicale; elle se détache de toutes les valeurs qui pouvaient à l'âge classique le faire circuler (le goût, le plaisir, le naturel, le vrai), et elle fait naître dans son propre espace tout ce qui peut en assurer la dénégation ludique (le scandaleux, le laid, l'impossible); elle rompt avec toute définition de 'genres' comme formes ajustées à un ordre de représentations, et devient pure et simple manifestation d'un langage qui n'a pour loi que d'affirmer − contre tous les autres discours − son existence escarpée: elle n'a plus alors qu'à se recourber dans un perpétuel retour sur soi.

I am not suggesting, by the way, that Foucault sees no advantages in this round of negation and intransitivity − any more than I do.

2 Interested readers might like to compare *Ma Jolie* with the further extremes of reduction and schematization of the female body in several canvases done some months before, in spring 1911, e.g., *La Mandoliniste* (P. Daix, *Le Cubisme de Picasso*, no. 390), *La Violiniste* (393), *Tête* (395), *Soldat et fille* (394), and the ultimate *Tête de jeune fille* (376; the title is firmly accredited). In comparison *Ma Jolie* does represent a return to a less desolate and rebarbative mode, but only in comparison.

In other paintings by Picasso from this time the presence of a guitar or mandolin gives rise to a play of analogy − it may anyway strike us as perfunctory − between the shape of the instrument and that of the woman. *Ma Jolie* is apparently playing a zither, and its rectilinear form does not allow even this much of metaphor.

3 V. Mayakovsky, foreword to the second edition of his *Cloud in Trousers* as cited in his *Bedbug and Selected Poetry* (New York, 1960), p. 306.

4 R. Vaneigem, *Traité de savoir-vivre à l'usage des jeunes générations* (Paris, 1967), p. 182.

5 Since so much of Michael Fried's argument turns on my reluctance to address particular works of modern art and discuss their negations in detail, I suppose I have to state the obvious here: I do not admit to any such reluctance, and of course I agree that detailed study of particular instances − pictures and their circumstances − is part of the business of understanding modernism. (Readers can now judge for themselves whether my *The Painting of Modern Life: Paris in the Art of Manet and His Followers* (New York and London, 1985) does that job or not.)

6 Fried, 'Art and Objecthood,' *Artforum* 5 (Summer 1967): 22, 23.

7 There is a curious twofold structure to Fried's writing at this point and others like it, which again seems to me typical of a certain discourse on the arts. The metaphysical buzzwords – 'presentness,' 'perpetual creation of itself,' 'infinitely,' 'depth and fullness,' 'forever convinced,' 'grace,' etc. – seem to provide the ground on which the more persistent, not to say strident, appeals to 'intuition' rest. But what is it in the text that gives the metaphysics substance apart from the category, 'intuition,' which it appears to validate? The intuition *is* the religion – not a very satisfactory one, I should imagine, and certainly unlike Eliot's or Coleridge's. For in their kind of criticism, religious commitments are articulated in the form of full-fledged histories. It is clear that these writers possess a test of truth which to their minds exceeds the historical and puts the mere sequence of human events in question; but nonetheless that perspective *constructs* a history – not just a sequence of 'great works' – in which art takes a special, subordinate place. (Consider the duties performed by descriptions of Shakespeare in *Biographia Literaria*, or the nature of the close reading of *Rameau's Nephew* offered by Hegel in the *Phenomenology*.) There is an essay to be written on when and how the religious attitude in criticism declines from this complex building and questioning of the past into a set of merely metaphysical episodes in an earthbound, present-bound discussion of cases.

History: representation and misrepresentation – the case of abstract expressionism

Revisionism in the 1970s and early 1980s

Introduction (1985)

Since the early 1970s the agenda for debate on art produced in the United States from the WPA[1] onwards has been revised. The appearance of Max Kozloff's 'American Painting During the Cold War' (Chapter 6) in 1973 initiated a number of articles and books which placed together 'Abstract Expressionism' with such concepts as the 'Cold War,' 'Art and Politics,' 'American Power,' 'Suppression' and 'Freedom.'[2] Such juxtapositions were not those generally made by art critics and art historians during the 1950s and 1960s, a time when Greenberg conspicuously refined his 'modern specialization'[3] and when the norms for scholarly work were still those which had been set by the books of Alfred Barr and John Rewald.[4] In these decades explanations of Pollock's works and those produced by other 'Abstract Expressionists' mostly stressed not only *formal* similarities and connections with particular examples of European art but also with the Americans' 'development beyond.'[5] A typical example is the four-part article 'Jackson Pollock and the Modern Tradition' by William Rubin, published in *Artforum* between February and May 1967.[6] In it Rubin attempted to make formal links between characteristics of Pollock's paintings and those by: the Impressionists; particular works by Matisse and Mondrian; Picasso's 'Analytic' Cubist works and the legacy of Cubism; and finally the automatism of Surrealism. By concentrating on similarities in formal or technical *appearances*, Rubin constructed an historicist validation for Pollock's works while relegating the meanings of both European and American paintings as *representations* produced in distinct historical, ideological conditions. His article can be seen as a further elaboration of the then successful Modernist paradigm of art historical and art critical interpretation.

An earlier and more 'notorious' text is Michael Fried's *Three American Painters: Kenneth Noland, Jules Olitski, Frank Stella* of 1965.[7] In pursuit of a refined formal criticism Fried is interested in making 'convincing discriminations of value among the works of a particular artist.' He claims that:

For twenty years or more almost all the best new painting and sculpture has been done in America; notably the work of artists such as de Kooning, Frankenthaler, Gorky, Gottlieb, Hofmann, Kline, Louis, Motherwell, Newman, Pollock, Rothko, Smith and Still – apart from those in the present exhibition – to name only some of the best.

. . . the development over the past hundred years of what Greenberg calls 'modernist' painting must be considered, because the work of the artists mentioned above represents, in an important sense, the extension in this country of a kind of painting that began in France with the work of Edouard Manet . . .

Roughly speaking, the history of painting from Manet through Synthetic Cubism and Matisse may be characterized in terms of the gradual withdrawal of painting from the task of representing reality – or of reality from the power of painting to represent it – in favor of an increasing preoccupation with problems intrinsic to painting itself . . . in this century it often happens that those paintings that are most full of explicit human content can be faulted on formal grounds – Picasso's *Guernica* is perhaps the most conspicuous example – in comparison with others virtually devoid of such content. (It must be granted that this says something about the limitations of formal criticism as well as about its strengths. Though precisely *what* it is taken to say will depend on one's feelings about *Guernica*, etc.)[8]

Within the parentheses Fried comes clean about what is gained and what may be lost by the application of formal criticism. In a footnote he also acknowledges that even with Manet, Modernism only offers an interpretation; for Fried it is more able than any other approach to throw light upon Manet's work but,

What one takes to be the salient features of his situation is open to argument; an uncharacteristically subtle Marxist could, I think, make a good case for focussing on the economic and political situation in France after 1848.[9]

If this is possible for Manet then what one takes to be the salient features of Pollock's situation is also open to argument. There may be a good case for focussing on the economic and political situation in America from the mid-thirties onwards. However, for Fried, approaches other than formalist ones are essentially procedures for *reading in* the 'content' of paintings in an arbitrary and illogical way. Modernism defines its interests within containable and, in its terms, testable limits. In Fried's contribution to the Modernist critical tradition he provides 'explanation' for paintings and their changes in terms of a discussion of particular complex relationships between traditions, artistic sources, aspects of contemporary consciousness and art criticism. Most other social, political and cultural causal conditions or influences are excluded as being beyond the limits of usefulness or appropriateness. So, explanation of Pollock's work goes like this:

> In a painting such as *Number One* [1948] there is only a pictorial field so homogeneous, overall and devoid both of recognizable objects and of abstract shapes that I want to call it *optical*, to distinguish it from the structured, essentially tactile pictorial field of previous modernist painting from Cubism to de Kooning and even Hans Hofmann. Pollock's field is optical because it addresses itself to eyesight alone. The materiality of his pigment is rendered sheerly visual, and the result is a new kind of space – if it still makes sense to call it space – in which conditions of seeing prevail rather than one in which objects exist, flat shapes are juxtaposed or physical events transpire.[10]

The outlined figure on the left of *Number One 1948*, or the series of Pollock's hand prints which appear top right of the painting, are of little or no interest to Fried.

In the 1970s and 1980s a number of articles appeared which questioned the Modernist account of American art since the 1930s, particularly the emphasis on stylistic analysis and the conventional presentation of Abstract Expressionism as the epitome of 'individualism,' creative freedom and revolutionary avantgardism.[11] This revision of historical interpretation is represented here by a selection of such texts.

The views and interests of these authors differ greatly from those which inform the approach of Greenberg, Fried, Rubin and Sandler – the most competent exponents of Modernist criticism and history. A major area of difference concerns their respective criteria of *relevance*. The 'revisionists' of the 1970s and 1980s regard as relevant to the explanation and interpretation of works of art and their conditions of production issues and concerns similar to those discussed by social, political and cultural historians of the period from Roosevelt's 'New Deal' to the Vietnam War, historians and commentators such as Joyce and Gabriel Kolko, Christopher Lasch, Richard M. Freeland and Noam Chomsky.[12]

Early essays such as those by Kozloff and Cockcroft began to pose questions hitherto neglected by art historians and art critics, whom we now link with the Modernist tradition of interpretation and explanation. Basically they queried the conventional history of linear artistic progression which explained Abstract Expressionism as a development within an essentially autonomous discipline. The Modernist arguments are well rehearsed and fundamentally propose that Abstract Expressionism, along with Cubism which is seen as its underlying formal influence,[13] is 'socially autonomous' because it is supposedly disengaged from the demands of signifying realistic intent or meaning; it is 'technically autonomous' because it is characterized as an art concerned primarily with purely formal compositions and 'experiments'; and it is 'conceptually autonomous' because the aim of the works is to evoke concerns confined to a notion of the artist's conceptualized vision, which is 'pure' and 'disinterested,' and to communicate the 'essentials' of experience through the expressive use of form, colour, surface and the means for the illusion of shallow space/depth and 'relative flatness.' This explanation of Abstract Expressionism was refined retrospectively. It was produced in specific ideological circumstances in

which issues of a social, cultural, political or economic nature – other than those compatible with Cold War rhetoric – were deemed as irrelevant to the experience, and hence to the explanation, of the 'work itself.' The 'work itself' and the beholder's experience of it are, it is argued, separable from the work's conditions of production and reception and from whatever determinants there may be upon the nature of the beholder's 'experience.'

Greenberg still argued in the 1980s that discriminations of 'value' are the only questions left open to the modern critic.[14] The concept of 'intuition' is the main area of investigation; aesthetics becomes a subject akin to the supposedly insulated problems of those scientific investigations pursued for the academic demands of the special-ism.[15] Greenberg has not always held these views. Some of the 'revisionists' consider why Greenberg, and many other intellectuals of his generation, moved from Leftist,[16] if not Trotskyist, positions in the late 1930s and early 1940s to rabid anti-Communism during the 1950s onwards. As many of the essays in this anthology testify, Greenberg was associated with a 'Marxist culture' of sorts in New York while writing for *Partisan Review* in the late thirties and early forties. From the late forties onwards he became a leading anti-Communist liberal:

> As an editor of *Commentary* from 1945 to 1957, he helped shape the anti-Soviet attitudes of his fellow conservative intellectuals.
>
> In one of the more bizarre convergences in American history, Dondero, the man who found a Communist conspiracy behind modernist painting, endorsed Greenberg's campaign against liberals with alleged pro-Soviet sympathies. This strange alliance took place in 1951 during a controversy over Communist infiltration of political news magazines. An anti-Communist group, the American Committee for Cultural Freedom, led this effort to expose Soviet sympathizers on the staff of the *Nation*. Once a contributor to this journal, Greenberg made the first public charges against his former editors. Delighted with Greenberg's accusations, Dondero immediately reprinted them in the *Congressional Record*.[17]

Congressman George A. Dondero from Michigan is famous for his speech 'Modern Art Shackled to Communism' (1949).[18] For him modern artists of the '-isms' threate-ned American culture and the American way of life because the 'doctrine of "-isms" is Communist-inspired and Communist-connected.' While Greenberg was championing Abstract Expressionism as the most advanced form of painting encapsulating 'the main premises of Western art' because it was detached from representing political and social issues and engaged in going 'beyond' the formal aspects of Cubism, Dondero attacked Cubism as a potential instrument and weapon of American destruction, aiming 'to destroy by designed disorder.' As Christopher Lasch points out,

> Especially in the fifties, American intellectuals, on a scale that is only beginning to be understood, lent themselves to purposes having nothing to do with the values they professed – purposes, indeed, that were diametric-ally opposed to them.[19]

The Kuhnian notion of a successful paradigm can offer an explanation of the *form* of anti-Marxism in a particular discipline during this period. However, it does not provide *reasons why* anti-Marxism came about during the 1940s and 1950s.

At the most basic level the question posed by the 'revisionists' as represented by the Chapters in this section is: notwithstanding the relative autonomy of art, do Modernist explanations provide historically adequate and theoretically defensible reasons for separating consideration of the *appearance* of Abstract Expressionist works from consideration of them as *produced* things; the material and ideological conditions in which, and out of which, they were made and received? These conditions are represented for these authors by the nature and substance of contemporary debates and ideological forms. Hence their concern is not with, say, documenting the formal links between European and Abstract Expressionist paintings which happen to *appear* similar but with considering the question: what sort of world was it in which 'drip paintings' were produced as a cogent form of representation? This leads to the consideration of those issues from the 1930s to the 1950s which are regarded as uninformative within the Modernist paradigm. Some of these issues include: the cultural implications of the fall of Paris into the hands of the German army; debates and allegiances within 'artistic' and 'literary' sub-groups for whom the threats of Fascism could only be withstood by Communism; contemporary discussions of the New World as the only place where 'modern culture' could be safeguarded; the move from US isolationism to internationalism in the 1940s with all its imperialist implications embodied in the Marshall Plan; the US world role as perceived by its ruling class and as represented by the atomic explosions at Hiroshima and Nagasaki and the tests at the Bikini atoll; post-war entrenchment of a 'New Liberalism' and McCarthyite anti-Communism replacing pre-war dialogues on the axis which coupled 'New Deal' politics and Trotskyism. Such issues necessarily need to be located within debates on 'outdated' Regionalism, on Social Realism and on the expressive potential for a mural art in the 1940s which evoked a 'subject' purged of Social Realism, part of the discredited allegiances of the 1930s, and the 'subjective,' a notion which painters 'borrowed' from European Surrealism.

As is indicated by material in the chapters by Kozloff, the Shapiros and Guilbaut, while many artists in the USA in the early 1940s rejected Stalinist and Popular Front aesthetics, they nonetheless sought a political engagement. In the catalogue to the third annual exhibition, which included Gottlieb and Rothko, of the Federation of American Painters and Sculptors, established in 1940 after the Trotskyists seceded from the American Artists' Congress because it became associated with a pro-Stalinist 'line,' there was a proclamation of aims:

> At our inception three years ago we stated 'We condemn artistic nationalism which negates the world tradition of art at the base of modern art movements.' Historic events which have since taken place have eminently confirmed this. Today America is faced with the responsibility either to salvage and develop, or to frustrate western creative capacity . . . Since no one can remain untouched by the impact of the present world upheaval, it is inevitable that values in every field of human endeavour will be affected.

> As a nation we are being forced to outgrow our narrow political isolation-
> ism. Now that America is recognized as the center where art and artists of
> all the world must meet, it is time for us to accept cultural values on a truly
> global plane.[20]

For those painters aware of the competences established by European artists the problem was how to achieve an art which avoided the traps of 'social' and 'realist' propaganda, an art independent of political affiliations of the 1930s, but which was rooted in contemporary experience and its representations. Abstract Expressionist paintings were produced out of conversations and practices in which a major concern was the *means* by which artists could represent their experience as members of an historically specific *avant-garde*. As Orton and Pollock point out, in Chapter 11, the late 1930s and early 1940s in New York are characterized by the establishment of a new discursive framework

> . . . that enabled some of the artists and intellectuals who gathered there
> to construct an identity for themselves which was simultaneously an
> opposition to, and extension of, available American and European tradi-
> tions. It provided them with the consciousness of a role and function
> through which they could engage with, and disengage from, the current
> social turmoil and ideological crisis.[21]

In an article for *Partisan Review*, 'The Situation at the Moment,' in January 1948, Greenberg described the problem in terms of private and social, cabinet picture and mural, artist and audience,

> Thus, while the painter's relation to his art has become more private than
> ever before because of a shrinking appreciation on the public's part, the
> architectural and presumably social location for which he destines his
> product has become, in inverse ratio, more public. This is the paradox, the
> contradiction, in the master-current of painting.[22]

For these artists their work had to address the 'social turmoil and ideological crisis' as perceived by New York-based painters, intellectuals and critics; their *representations* must not be merely fictions. Important, therefore, was the possibility for 'realism,' albeit framed in a confusion of notions of the 'social' and the 'subjective,' which was regarded as crucial as any practical and critical understanding of 'art itself'; or what more theoretically robust authors have meant by the 'relative autonomy' of art as a superstructural form.[23]

For artists of Pollock's generation greater access to Picasso's and Braque's Cubism confirmed the establishment of a new paradigm in art *practice*. For those artists who saw themselves as *avant-garde*, the Renaissance convention of illusionism had been replaced as the most successful form of pictorial representation. In its place was Cubism's assertion of an explicit dialectic between the *means* of representation and an expressive imagery or signifying system. Significantly, for consideration of

critical debates in the late 1930s and early 1940s, authors such as Trotsky and Benjamin had argued that *part* of art's search for 'truth' is its fidelity to its 'own laws' – rules and principles.[24] Both argued that for art to take part actively and consciously in the pursuit of knowledge and revolution, art practice and political practice have to combine. For Trotsky, art as a revolutionary force must be bound to the society in which it is produced but not constrained by society's forces from pursuing a development of its own principles. By doing so it has the potential for providing a critical lead, in as much as it has a liberating role in culture and consciousness. Benjamin too declared in 'The Author as Producer' (1934) that:

> . . . technical progress is for the author as producer the foundation of his political progress. In other words: only by transcending the specialization in the process of production which, in the bourgeois view, constitutes its order, is this production made politically valuable; and the limits imposed by specialization must be breached jointly by both the productive forces that they were set up to divide . . . A political tendency is the necessary, never the sufficient condition of the organizing function of a work. This further requires a directing, instructing stance on the part of the writer. And today this is to be demanded more than ever before. *An author who teaches writers nothing, teaches no one.*[25]

Trotsky and Benjamin are instructive not least for drawing attention to the necessity for any adequate history of art – here of Abstract Expressionism – to map out and account for those forces which moulded the consciousness of the artists and defenders (critics, curators, ideologists of various professions) responsible for its production and ratification. Recent work by historians of Abstract Expressionism such as Guilbaut and Cox has shown that the resources for what I characterize as 'realism' were not disinterested developments 'beyond' the technical and formal specialisms or competences of European styles. Artists' and critics' consciousness may be characterized in part by examination of the nature of their statements. These show that a major resource for their art was a concern with 'alienation.'[26] So notions of 'alienation', 'anxiety' and 'metaphysics of despair' were current not only in the writings of artists and critics (in Greenberg's and in Rosenberg's 'existentialism') but also in more public forms of print. Here is Greenberg in 1947 and 1948:

> In painting today such an urban art can be derived only from Cubism. Significantly and peculiarly, the most powerful painter in contemporary America, and the only one who promises to be a major one is a Gothic, morbid, and extreme disciple of Picasso's Cubism and Miro's post-Cubism, tinctured also with Kandinsky and Surrealist inspiration. His name is Jackson Pollock . . .

> For all its Gothic quality, Pollock's art is still an attempt to cope with urban life; it dwells entirely in the lonely jungle of immediate sensations, impulses and notions, therefore is positivist, concrete. Yet its Gothic-ness, its paranoia and resentment narrow it; large though it may be in ambition

– large enough to contain inconsistencies, ugliness, blind spots and mon-
otonous passages – it nevertheless lacks breadth.[27]

Balance, largeness, precision, enlightenment, contempt for nature in all its
particularity – that is the great and absent art of our age.

The task facing culture in America is to create a *milieu* that will produce
such an art – and literature – and free us (at last!) from the obsession with
extreme situations and states of mind. We have had enough of the wild
artist – he has by now been converted into one of the standard self-
protective myths of our society: if art is wild it must be irrelevant.[28]

Their isolation is inconceivable, crushing, unbroken, damning. That any-
one can produce art on a respectable level in this situation is highly
improbable. What can fifty do against a hundred and forty million?[29]

In the face of current events painting feels, apparently, that it must be
more that itself: it must be epic poetry, it must be theatre, it must be
rhetoric, it must be an atomic bomb, it must be the Rights of Man. But the
greatest painter of our time, Matisse, preeminently demonstrated the sin-
cerity and penetration that go with the kind of greatness particular to
twentieth century painting by saying that he wanted his art to be an
armchair for the tired businessman.[30]

Isolation, or rather the alienation that is its cause, is the truth – isolation,
alienation, naked and revealed unto itself, is the condition under which the
true reality of our age is experienced. And the experience of this true
reality is indispensable to any ambitious art.[31]

These texts require careful analysis and the appropriate context but they at least
suggest, as recent scholarly work reveals, that the informed reader will see the *history*
of the years in which Pollock's drip paintings were produced as incompatible with
either the hagiographical accounts or with the Modernism of Michael Fried where
'opticality' and 'positive/negative figuration' characterize a self-protective critical
paradigm. Greenberg's criticism of the 1940s testifies to the inadequacy of an
emphasis on formal 'specialization' alone. His own criticism from these years is
historically misrepresented by the refined formalism of later Modernism – including
his own writings from the 1950s onwards which seek to relegate the importance of his
pre-1948 work.

The strength of Greenberg's and of some of Fried's criticism and history, par-
ticularly from the 1960s, is, so some would argue, that they attend to the objectively
observable characteristics of Abstract Expressionist works described. They are sys-
tematically restricted by strong criteria of formal and technical *relevance*. The
information and discussions represented by the texts in this section are thus ruled
out as worthy but irrelevant to the discussion of quality. We may regard it as
defensible to claim, as is again and again rehearsed by Greenberg, that the art critic
– if not the art historian – should be true to his or her responses and be open to the
'intuition of quality', however unlikely the source of that intuition may be. However,

such a position needs to be treated sceptically insofar as it can be demonstrated as historically determined and insofar as no concept of quality can be truly disinterested.

Greenberg is reluctant to receive praise or even much respect for his pre-1948 work. Yet, that is where his criticism testifies to the difficulty of characterizing art and its practices in the modern period and particularly in an era of developed capitalism. In an attempt to sustain a critical practice in such a socioeconomic system there are social, political, moral, artistic and intellectual contradictions. It is the same for art practice. Historians such as those included here are interested in these contradictions rather than in seeking to replicate the seamless and insulated accounts of conventional Modernism.

Greenberg is of course aware of the material which recent history of the period emphasizes. However, as is clear from interviews and publications, he has well-marshalled defences against any attempts to expose those contradictions which existed in his writings and interests of the late thirties and the forties. Sometimes, though, he acknowledges the importance of history to those who find themselves unwittingly entertained by *his* desire to talk of a safely defined and socially insulated area of aesthetics. When revising an article, 'New York Painting Only Yesterday', from *Art News* in 1957, for his collected essays *Art and Culture* (1961), Greenberg added a parenthesis

> Abstract art was the main issue among the painters I knew then [the late 1930s]; radical politics was on many people's minds but for them Social Realism was as dead as the American Scene. (Though that is not all, by far, that there was to politics in art in those years; someday it will have to be told how 'anti-Stalinism,' which started out more or less as 'Trotskyism,' turned into art for art's sake, and thereby cleared the way, heroically, for what was to come.)[32]

This is quoted by some of the authors included here for it has been their aim to account for the transformation to which Greenberg refers. For him 'art for art's sake' became entrenched after 1948. Significantly, for those interested in a materialist history, Greenberg wrote in 'The Decline of Cubism' in *Partisan Review* in March of that year on a twofold transformation:

> If artists as great as Picasso, Braque and Léger have declined so griev-ously, it can only be because the general social premises that used to guarantee their functioning have disappeared in Europe. And when one sees, on the other hand, how much the level of American art has risen in the last five years, with the emergence of new talents so full of energy, and content as Arshile Gorky, Jackson Pollock, David Smith . . . then the conclusion forces itself, much to our own surprise, that the main premises of Western art have at last migrated to the United States, along with the center of gravity of industrial production and political power.[33]

This correlation between artistic issues and economic and political conditions is seen as historically significant by those interested in accounting for the development of modern art in terms other than autonomous with respect to social and economic forces. As with much of Greenberg's criticism there are complex issues underlying what appears to be a simple but daring claim in 'The Decline of Cubism.' He openly challenges the supremacy of Parisian art, announcing the decline in power and importance of Cubist-derived works produced in Europe. For him the cultural supremacy of European art had been replaced by the works of Americans who are seen as having revitalized the 'main premises' of Western art. Painters who were later labelled 'Abstract Expressionists' were seen as having assumed the mantle of the international avant-garde. Yet Greenberg, as in 'Avant-Garde and Kitsch' in 1939, is still conscious of art's relationship with 'general social premises'; that the history and changes in art practice are somehow implicated in the histories and forces of 'industrial production and political power.' In 1939 it may be that his analysis of bourgeois culture and of capitalism was more adequately theorized although, as authors such as Guilbaut and Orton and Pollock suggest, there may be a degree of superficiality and opportunism to Greenberg's Marxism. For the 'revisionists' attempts to account for Greenberg's characterization of contemporary art lead them to consider the relationships which the critic himself suggests: were the causal conditions for the practice of art and of criticism in these years solely related to the specialism, or were wider issues, values and beliefs – and the economic structures which produce and sustain them – determining factors?

Certainly, however wary we must be in citing them as rigorously informative, artists' statements give support to the project that recent art historians have undertaken: they do not always fit the Modernist rationalization. What are we to make of Pollock's statement from 1950?

> Modern art to me is nothing more than the expression of contemporary aims of the age that we're living in . . .
>
> My opinion is that new needs need new techniques. And the modern artists have found new ways and new means of making their statements. It seems to me that the modern painter cannot express this age, the airplane, the atom bomb, the radio, in the old forms of the Renaissance or of any other past culture. Each age finds its own technique.[34]

It has surely been demonstrated that Abstract Expressionism was produced out of a desire to produce art which was competent in European terms, but how can it be accounted for as expressive of contemporary times – how do we account for particular works as *representations*?

The essays in this section represent main points in the history of debates and controversies about the status and conditions of the production and the ratification of Abstract Expressionist paintings. They are presented in chronological order and have been edited to remove unnecessary overlap or substantial quotations from the two essays by Clement Greenberg included in Part One. The debate began with articles which considered issues concerned with the ratification of Abstract Expressionism.

They are thus focused on the fifties and to some extent the sixties. Kozloff's article posed the question:

> ... if we seem to have explored everything about this art technically, we have not yet asked sufficiently well what past interests have made it so official.[35]

Himself an early apologist for the Modernist characterization of Abstract Expressionism, Kozloff suggests a new context for the consideration of American painting since 1945, that of 'American political ideology, national self images, and even the history of the country' – 'the burgeoning claims of American world hegemony.'[36] Subsequent articles concentrated on these aspects of the Cold War rather than on the forties: Kozloff raises some issues but he is aware of the then lack of historical work on the period. After quoting Clyfford Still, speaking of the artist's role in the 1940s, he writes: 'How one might relate such an overwrought mood to the prevailing fear of atomic destruction is a baffling and disturbing question.'[37] It is a question which interests Guilbaut particularly, and to some extent the Shapiros, though the latter historians are as concerned with defending the interests of Social Realism, 'art as a weapon.' All of the texts, though, are a response to the art-historical myth making of institutions such as the Museum of Modern Art, New York, in the 1950s and 1960s, and by articles in influential American journals such as *Artforum* in the 1960s. When editorial emphases of that journal shifted in the 1970s, articles which implicitly criticized its Modernist stance of the decade before were published. And as an indication of the depth of revisions in interpretations of the art produced during and since the 1940s and of the types of historical work being done by Americans, there is the substantial exhibition *Realism and Realities: The Other Side of American Painting 1940–1960* held in 1982 in the USA (Rutgers University Art Gallery; Montgomery Museum of Fine Arts; and the Art Gallery, University of Maryland).[38]

Clearly major debates and revisions centre on the interpretation of: the causal conditions and status of the range of paintings produced in the 1940s and 1950s (and to some extent here with the 1960s); the social, cultural and artistic conditions in which painters such as Pollock produced their work; the critical entrenchment of Abstract Expressionism in the 1950s and the possible interests of the agents of that entrenchment; the origins and characteristics of Modernist criticism, particularly that offered by Barr in the 1930s and 1940s, by Greenberg from the later 1930s onwards and by later critics/historians such as Fried and Rubin in the 1960s and 1970s.

For the two articles which more closely address the 1940s, those by the Shapiros and by Guilbaut, a major aim is to take up Greenberg's challenge: 'someday it will have to be told how "anti-Stalinism," which started out more or less as "Trotskyism," turned into art for art's sake.'[39] In the 1930s Pollock was a Communist of sorts, interested in Social Realist mural art and Regionalism. By the mid-1940s he, along with many other radicals, found such commitments of the thirties inappropriate to contemporary reality. Their dilemmas are vividly represented by Dwight MacDonald's discussion of the 'impossible alternatives' which faced the radicals and Trotskyists of

the 1930s in post-1945 America.[40] What was responsible for these changes, dilemmas and impossible alternatives?

> I intend to paint large movable pictures which will function between the easel and mural. I have set a precedent in this genre in a large painting for Miss Peggy Guggenheim which was installed in her house and was later shown in the 'Large-Scale Paintings' show at the Museum of Modern Art. It is at present on loan at Yale University.
>
> I believe the easel picture to be a dying form, and the tendency of modern feeling is towards the wall picture or mural. I believe the time is not yet ripe for a *full* transition from easel to mural. The pictures I contemplate painting would constitute a halfway state, and an attempt to point the direction of the future, without arriving there completely.[41]

This is Pollock from 1947. His statement suggests, for some historians, that it is necessary to account for artists' wishes to draw on the public potential for, and ideo-logical power of, large-scale mural art – the legacy of the thirties – but in a way which expressed their 'unconscious,' 'Gothicness,' 'alienation,' 'morbidness,' 'metaphysics of despair' or whatever term is used. Did they emphasize the 'subjective' in the format of Social Realist mural art of the 1930s in order to make a 'critical statement'? As we have seen, explicit Social Realism, or any art which appeared obviously associated with a particular tendency had been discredited for the politically interested avant-garde because of its links with the failure of Communism and the Popular Front to withstand European Fascism. By painting large-scale 'abstract' works artists in the forties can also be seen to have been interested in a public convention and so to be demonstrating their rejection of the small-scale precious art object – the traditional consumable commodity of the bourgeoisie. This is to see Greenberg's 'Crisis of the Easel Picture'[42] in terms other than formalist, and to consider the possible social meaning of Pollock's belief that 'the time is not yet ripe for a *full* transition from easel to mural.'

The work done by Guilbaut, by the Shapiros and by other historians not repre-sented here contributes to our understanding of the social, political, cultural and artistic conditions not only of the production of Abstract Expressionism but also of the elaboration of Modernist critical theory and its role in the ratification of Abstract Expressionism in ways which misrepresented its causal conditions. Orton and Pollock analyse the context in which Greenberg's early writings had the 'effect of clearing a space' in a specific ideological terrain. In doing so they claim that Greenberg offered a 'special sense of group identity for some painters' and defined 'a function for a specific kind of painting' – Abstract Expressionism.

Modernism may be seen as the ideology of particular class interests and insti-tutional structures in the USA. These interests and structures are in part considered in this section, but it is primarily those texts by Kozloff, Cockcroft and the later part of the Schapiros' text which consider the 1950s when the Museum of Modern Art (MOMA), New York, adopted a promotion and ratification of Abstract Expressionism. Though it needs to be acknowledged that the material used and the arguments pro-

posed are of a provisional nature. Not only were these essays produced in a critical climate which encouraged the critique of Modernism in terms either of innuendo or of reductionism, but also they reveal that competent art-historical work as rigorous as that by social or political historians needed to be done. Examples such as work by Cox, de Hart Mathews, Guilbaut, Orton and Pollock have improved the competences of historians of art since the thirties. However, much still needs to be done.

Recent work on the 1930s and 1950s has been a prerequisite for anyone wishing to develop the schematic analyses of Kozloff and Cockcroft, and particularly the reductionism of the latter. This is not only so as to produce cogent history but also because we need to understand the role and power of such institutions as MOMA in order better to understand our own culture and history. For a good case can be argued that the histories of MOMA, as an institution, of contemporary art and of its Modernist history were intersected by other histories – the histories, for example, of class fraction and of imperialism. Almost as a ratification of Greenberg's claim in 'The Decline of Cubism' (1948), MOMA was involved in the 1950s in exporting Abstract Expressionism to Europe *and* in bringing it back home to New York, to MOMA, not only as 'the triumph of American painting' but also as the manifestation of *the* avant-garde form. This needed to be seen as the most recent, up-to-date and securely mapped position of the historically identifiable avant-garde 'mainstream' of modern art. For Greenberg the 'central' position of Abstract Expressionism was secured by the 'logic of Modernism', a self-fulfilling, and self-criticizing formal and aesthetic development. Between 1939 and 1961 Greenberg radically altered his view of 'relative autonomy'; by 1961 the crucial adjective had been stripped away. For the 'revisionists' the 'logic of Modernism' appears as the ideal projection of art representing the needs, desires, pleasures, aspirations and self-images of the literate hereditary bourgeoisie.

There are problems in the projects tackled by those who are interested in critiques of Modernist histories and forms of explanation. A major one is the discussion of particular paintings, especially the characteristics of certain Pollocks. The problem is how to show that the wider issues discussed by these historians uncover meaning for and in Pollock's work. This general problem is discussed by T. J. Clark in Chapters 3 and 5. To produce a cogent social history of art with respect to nineteenth-century artists and art practices is one thing, but to do the same with paintings seemingly devoid of explicit conventional subject matter or imagery is fraught with more pitfalls. Arguments which discuss 'resistance' and 'critical art' with respect to a drip painting need to be substantiated not only by strong evidence but also by adequate theory. The task is an extremely *difficult* one, not least because the language of description and explanation of Abstract Expressionism is so dominated by Modernist terms and references. Modest but well-theorized historical work needs to be produced.

Despite the limitations of some of the texts in this section they do chart a history of sorts – a history of resistance to Modernist dogma and ideology; a resistance which needs to address Modernism's strengths as an ideological force and as a theory which emphasizes the discipline of *relevance*. Yet, there is much material here which Modernists find extremely uncomfortable – as also in the books by Cox and by Guilbaut – and which extends the debates and competences of those critics of conventional Modernism who wish to establish a cogent historical materialist account of modern art. We

can learn from these articles by arguing with their premises, details and mis-conceptions. Unlike further elaborations of Modernism which close off inquiry, they can be seen to open up debate and contribute to our knowledge of the conditions in which artists such as Pollock and critics such as Greenberg produced forms of representation in the modern period, in an era of developed capitalism.

Notes

1 The Works Progress Administration (WPA), later called the Work Projects Administra-tion, was part of President Roosevelt's 'New Deal' which aimed to stimulate national recovery and to provide a programme of work for those made unemployed as a result of the 'Great Depression.' Between 1935 and 1942 eight-and-a-half million people had worked on the WPA – one out of five able-bodied workers. The WPA's Federal Art Project (FAP) was started in 1935. It lasted until July 1943, and one of the main reasons for its winding up was recurrent criticism from conservatives in Congress who attacked what they called 'socialism' in the WPA. In fact the Dies Committee, which was similar to the anti-Communist McCarthy Committee of the Cold War, questioned members of Federal Project Number One about radical and Communist affiliations. The whole period of the WPA's life was fraught with such difficulties. Pollock joined the FAP's mural division (where some 2,566 murals were produced) in 1935 and in 1936 moved to the easel division (where 108,099 works were produced). His allegiances at this time were to artists associated with the Mexican muralists (Orozco, Rivera, Siqueros) and with Communism, though his polit-ics were probably an untheorized affiliation with the 'left' – a common position in the 1930s. The history and details of this whole period are complex politically, socially and culturally. The standard works are those by Francis V. O'Connor, *Federal Support for the Visual Arts: The New Deal and Now,* Greenwich, Conn., New York Graphic Society 2nd ed., 1971, and *Arts for the Millions: Essays from the 1930s by Artists and Administrators of the W.P.A. Federal Art Project,* Greenwich, Conn. New York Graphic Society 1973. Also see Greta Berman, *The Lost Years, Mural Painting in N.Y. City under the W.P.A. Federal Art Project 1935–1943,* Columbia University PhD, 1975; Garland Press, 1978.

2 The main articles are: Max Kozloff, 'American Painting During the Cold War,' *Artforum,* vol. 11, no. 9, May 1973, pp. 43–54 (see Chapter 6); William Hauptman, 'The Suppres-sion of Art in the McCarthy Decade,' *Artforum,* vol. 12, no. 2, October 1973, pp. 48–52; Eva Cockcroft, 'Abstract Expressionism, Weapon of the Cold War,' *Artforum,* vol. 12, no. 10, June 1974, pp. 39–41 (see Chapter 7); John Tagg, 'American Power and American Painting: The Development of Vanguard Painting in the United States since 1945,' *Praxis,* 1975, pp. 59–79; Jane de Hart Mathews, 'Art and Politics in Cold War America,' *American Historical Review,* vol. 81, October 1976, pp. 762–787 (see Chapter 8); Victor Burgin, 'Modernism in the *Work* of Art,' *Twentieth Century Studies,* December 1976, no. 15/16, pp. 34–55; David and Cecile Shapiro, 'Abstract Expressionism: The Politics of Apolitical Painting,' *Prospects,* 3, 1977, pp. 175–214 (see Chapter 9); Serge Guilbaut, 'Création et développement d'une Avant-Garde; New York 1946–1951,' *Histoire et cri-tique des arts,* 'Les Avant-Gardes,' July 1978, pp. 29–48; Serge Guilbaut, 'The New Adventures of the Avant-Garde in America,' *October,* 15, Winter 1980, pp. 61–78 (see Chapter 10); Fred Orton and Griselda Pollock, '*Avant-Gardes* and Partisans Reviewed,' *Art History,* vol. 4, no. 3, September 1981, pp. 303–327 (see Chapter 11); Frances K.

Pohl, 'An American in Venice: Ben Shahn and American Foreign Policy at the 1954 Venice Biennale,' *Art History*, vol. 4, no. 1, March 1981, pp. 80–113; T. J. Clark, 'Clement Greenberg's Theory of Art,' *Critical Inquiry*, September 1982, vol. 9, no. 1, pp. 139–156 (see Chapter 3). Two major books are: Annette Cox, *Art-as-Politics: The Abstract Expressionist Avant-Garde and Society*, Ann Arbor, Michigan, UMI Research Press, 1982; Serge Guilbaut, *How New York Stole the Idea of Modern Art: Abstract Expressionism, Freedom, and the Cold War*, translated by Arthur Goldhammer, Chicago and London, The University of Chicago Press, 1983.

3 For a selection of his essays see Clement Greenberg, *Art and Culture: Critical Essays*, Boston, Beacon Press, 1961. See also Greenberg, 'Modernist Painting,' 1961, Radio Broadcast Lecture 14 of *The Voice of America Forum Lectures: the Visual Arts*, reprinted, as spoken, in the paperback edition of all 18 Lectures, Washington D.C., United States Information Agency, 1965, pp. 105–11. (After its broadcast, 'Modernist Painting' was published in *Arts Yearbook* 4, 1961, pp. 101–8. It appeared in revised form in *Art and Literature*, 4, Spring 1965, pp. 193–201, and then in Gregory Battcock (ed.) *The New Art: A Critical Anthology*, New York, E. P. Dutton, 1966, pp. 100–110), and his 'After Abstract Expressionism,' *Art International*, vol. 6, no. 8, October 1962, revised reprint in *New York Painting and Sculpture: 1940–1970*, edited by Henry Geldzhaler, London, Pall Mall Press Ltd, and New York, Metropolitan Museum of Art, 1969, pp. 360–371. For a sympathetic intellectual biography see Donald B. Kuspit, *Clement Greenberg: Art Critic*, Madison and London, The University of Wisconsin Press, 1979.

4 Alfred H. Barr Jr: such works as *Cubism and Abstract Art*, New York, The Museum of Modern Art, 1936; *Picasso: Fifty Years of His Art*, New York, The Museum of Modern Art, 1946; *Matisse: His Art and His Public*, New York, The Museum of Modern Art, 1951. John Rewald: such works as *The History of Impressionism*, New York, The Museum of Modern Art, 1946, and subsequent revised editions; *Post-Impressionism – From Van Gogh to Gauguin*, New York, The Museum of Modern Art, 1956, and subsequent revised editions.

5 Greenberg's criticism is paradigmatic, for example: 'Jackson Pollock was at first almost as much a late Cubist and a hard and fast easel-painter as any of the abstract expressionists I have mentioned . . . Pollock has an instinct for bold oppositions of dark and light, and the capacity to bind the canvas rectangle and assert its ambiguous flatness and quite unambiguous shape as a single and whole image concentrating into one the several images distributed over it. Going further in this direction, he went beyond late Cubism in the end.' ' "American-Type" Painting,' *Partisan Review*, vol. 22, no. 2, Spring 1955, pp. 186–187.

6 February 1967, pp. 14–22; March 1967, pp. 28–37; April 1967, pp. 18–31; May 1967, pp. 28–31.

7 Fogg Art Museum, Harvard University.

8 Ibid., pp. 4–5.

9 Ibid., p. 50, note 3.

10 Ibid., p. 14.

11 See Irving Sandler, *Abstract Expressionism: The Triumph of American Painting*, New York, Praeger, and London, Pall Mall Press, 1970; and his later *The New York School: The Painters and Sculptors of the Fifties*, New York and London, Harper & Row, 1978.

12 See Gabriel Kolko, *The Roots of American Foreign Policy*, Boston, Beacon Press, 1969, and his *Wealth and Power in America: An Analysis of Social Class and Income*

Distribution, New York, Praeger, 1969; Gabriel and Joyce Kolko, *The Politics of War, 1943–45*, New York, Random House, 1968, and *The Limits of Power: The World and United States Foreign Policy*, New York, Harper & Row, 1972; Christopher Lasch, 'The Cultural Cold War: A Short History of the Congress for Cultural Freedom' in *Towards a New Past: Dissenting Essays in American History*, edited by Barton J. Bernstein, New York, Pantheon Books, 1968, and his *The New Radicalism in America: The Intellectual as a Social Type*, New York, Knopf, 1965, and his *The Agony of the American Left*, New York, Random House, 1968; Richard M. Freeland, *The Truman Doctrine and the Origins of McCarthyism*, New York, Schocken, 1971; Noam Chomsky, *American Power and the New Mandarins*, New York, Pantheon Books, 1969, and his *Problems of Knowledge and Freedom*, New York, Pantheon Books, 1971, and his *For Reasons of State*, New York, Pantheon Books 1973.

13 See note 5.

14 See 'A Conversation with Greenberg' published in three parts in *Art Monthly*, February 1984, no. 73, pp. 3–9; March 1984, no. 74, pp. 10–14; April 1984, no. 75, pp. 4–6.

15 See the Kuhnian notion of paradigms in his *The Structure of Scientific Revolutions*, Chicago, The University of Chicago Press, 2nd edition, 1970, for a critique of such a view.

16 See, for example, the histories by: Daniel Aaron, *Writers on the Left*, Oxford, Oxford University Press, 1977, first published 1961; James Gilbert, *Writers and Partisans: A History of Literary Radicalism in America*, New York, John Wiley and Sons, 1968.

17 Annette Cox, op. cit., p. 142.

18 Given in the United States House of Representatives, 16 August 1949, *Congressional Record*, First Session, 81st Congress. On Dondero see Jane de Hart Mathews, op. cit., [Chapter 8] and William Hauptman, op. cit.

19 'The Cultural Cold War,' loc. cit., pp. 322–323.

20 From a letter sent to the newspapers, including *The New York Times*, by the Federation on the occasion of their third show at the Wildenstein Gallery, June 2–26, 1943. Quoted in Guilbaut, *How New York Stole the Idea of Modern Art*, op. cit., pp. 73–74.

21 Op. cit., p. 306 [212].

22 *Partisan Review*, vol. 15, no. 1, p. 83.

23 See earlier discussion, in the Introduction to Part One.

24 Trotsky, *Literature and Revolution*, translated by Rose Strunsky, Ann Arbor Paperbacks, The University of Michigan Press, 1960, first English translation, 1925; Benjamin, 'The Author as Producer,' address delivered at the Institute for the Study of Fascism, Paris, 27 April, 1934. First published in German in 1966, edited reprint of translation by Edmund Jephcott in Frascina and Harrison, op. cit., pp. 213–216.

25 Loc. cit., pp. 215–216.

26 See Guilbaut, *How New York Stole the Idea of Modern Art*, op. cit.

27 'The Present Prospects of American Painting and Sculpture,' *Horizon*, London, vol. 16, nos. 93–94, October 1947, pp. 25–26.

28 Ibid., p. 28.

29 Ibid., p. 30.

30 'Jane Street Group, Rufino Tamayo,' *Nation*, March 8, 1947, p. 284.

31 'The Situation at the Moment,' loc. cit., p. 82.

32 'New York Painting Only Yesterday,' *Art News*, vol. 56, Summer 1957, p. 58; material in parenthesis from the revised reprint titled 'The Late Thirties in New York,' *Art and Culture*, op. cit., p. 230.

33 *Partisan Review*, vol. 15, no. 3, March 1948, p. 369.

34 From a taped interview with William Wright, an East Hampton neighbour, who was planning a radio programme. Taped in 1950 it was broadcast for the first time on radio station WERI in Westerly, RI, in 1951. Quoted in Francis V. O'Connor and Eugene Victor Thaw (eds), *Jackson Pollock: A Catalogue Raisonné of Paintings, Drawings and Other Works, Vol. 4*, New Haven and London, Yale University Press, 1978, pp. 248–249.

35 Op. Cit., p. 43; see Chapter 6, p. 130.

36 Ibid., pp. 43–45; see Chapter 6, p. 131.

37 Ibid., p. 46; see Chapter 6, p. 135.

38 Catalogue by Greta Berman and Jeffrey Wechster published by Rutgers University, 1981.

39 See note 32.

40 See Guilbaut, Chapter 10.

41 Statement made in 1947 when applying for a Guggenheim Fellowship, quoted in O'Connor and Thaw, op. cit., p. 238.

42 *Partisan Review*, vol. 15, no. 4, April 1948, pp. 481–484, reprinted in *Art and Culture*, op. cit., pp. 154–157.

Max Kozloff

AMERICAN PAINTING DURING THE COLD WAR

MORE CELEBRATED THAN ITS counterparts in letters, architecture, and music, American postwar art has become a success story that begs, not to be retold, but told freshly for this decade. The most recent as well as most exhaustive book on Abstract Expressionism is Irving Sandler's *The Triumph of American Painting*, a title that sums up the self-congratulatory mood of many who participated in its career. Three years ago, the Metropolitan Museum enshrined 43 artists of the New York School, 1940–1970, as one pageant in the chapter of its own centennial. Though elevated as a cultural monument of an unassailable but also a fatiguing grandeur, the virtues of this painting and sculpture will survive the present period in which they are taken too much for granted. Yet, if we seem to have explored everything about this art technically, we have not yet asked sufficiently well what past interests have made it so official.

The reputation of the objects themselves has been taken out of the art world's hands by money and media. But this accolade reflects rather than explains a social allure that has been far more seductive overall than even the marvelous formal achievements of the work. I am convinced that this allure stems from an equivocal yet profound glorifying of American civilization. We are not so careless as to assume that such an ideal was consciously articulated by artists, or, always directly perceived by their audiences. [. . .] Their international reputations should not preclude our acknowledgment that a Clyfford Still or a Kenneth Noland, an Andy Warhol or a Roy Liechtenstein, among many others are quintessentially American artists, more meaningful here than anywhere else. It is less evident, though reasonable that they have acquired their present blue-chip status partly through elements in their work that affirm our most recognizable norms and mores. For all the comment on the

Source: 'American Painting During the Cold War', *Artforum* vol. 11 no. 9, May 1973, pp. 43–54. This article is a somewhat revised version of the introduction to the catalogue of the exhibition *Twenty-five Years of American Painting 1948–1973* at the Des Moines Art Center, March 6th–April 22nd, 1973. This text has been edited. The original article included sixteen illustrations, all of which have been omitted. Reprinted by permission of the author and *Artforum*.

'triumph of American painting,' this aspect of it has been the one least studied, a fact that in itself has historical interest.

If we are to account for this omission, and correct it, we are inevitably led to ask what, after all, can be said of American painting since 1945 in the context of American political ideology, national self-images, and even the history of the country? Such a question has not been seriously raised by our criticism, I think, for two reasons. One is the respectable but unproven suspicion that such an outlying context is too porous and nonexclusive for anything meaningful to be said. The other is the simplistic assumption that avant-garde art is in deep conflict with its social, predominantly middle-class setting. The liberal esthete otherwise variably critical of American attitudes, has been loathe to witness them celebrated in the art he admires, even though this is to subtract from its humanity as art. (The radical philistine correctly senses systems support in American art, but reads its coded signals far too crassly as direct statement.) Professional avant-garde ideology exhibits a great distaste for the mixing of political evaluations with artistic 'purity.' Yet modernist accolades dam up the continuing psychological resonance of American art and reinforce the outdated piety with which it is regarded.

Two facts immediately distinguish ambitious American painting from all predecessors in modern art. Before the Second World War, this country had exerted no earlier genuine leadership nor had it any significant cultural prestige in visual art. Distinguished painters were active – Georgia O'Keeffe, Mark Tobey, Edward Hopper, and Stuart Davis – but their example was considered too parochial in coloration, and thus too 'unmodern' to provide models for mainstream work. The complete transformation of this state of affairs, the switching of the art capital of the West from Paris to New York, coincided with the recognition that the United States was the most powerful country in the world. In 25 years, no one could doubt that this society was determined from the first to use that power, economic and military, to extend it everywhere so that there would be no corner of the earth free from its influence. The most concerted accomplishments of American art occurred during precisely the same period as the burgeoning claims of American world hegemony. It is impossible to imagine the esthetic advent without, among several internal factors, this political expansion. The two phenomena offer parallels we are forced to admit, but may find hard to specify. Just as the nations of Western Europe were reduced to the level of dependent client and colonized states, so too was their art understood here to be adjunct, at best, to our own. Everywhere in the New York art world there were such easy assumptions of self-importance and natural superiority as not to find their match in any of the Western democracies. Never for one moment did American art become a conscious mouthpiece for any agency as was, say, the Voice of America. But it did lend itself to be treated as a form of benevolent propaganda for foreign intelligentsia. Many critics, including this one, had a significant hand in that treatment. How fresh in memory even now is the belief that American art is the sole trustee of the avant-garde 'spirit,' a belief so reminiscent of the U.S. government's notion of itself as the lone guarantor of capitalist liberty. In these phenomena above all, our record ascribes to itself an incontrovertible 'modernity.' [. . .]

In 1945, the United States emerged intact and unbombed from a devastating world war that had left its allies traumatized and its enemies prostrate. We were a country, according to Dean Acheson, still at an adolescent stage of emotional

development, yet burdened with vast adult responsibilities of global reconstruction and leadership.[1] Compared to Soviet Russia's overwhelming armed might on the ground, America possessed a terrifyingly counterweighted superweapon, the atomic bomb. We had also a heavy war industry whose reconversion to peacetime needs was being urged by public opinion and economic good sense.

In the worldview of the untried president, Truman, the European civil war had removed a buffer that had hitherto stood against the eruptive forces of Euro-Asiatic communism. Comparable to Axis enslavement, these forces clearly had no legitimate aim in establishing for themselves a security zone in Eastern Europe. Here was a situation that called for the stepping up rather than the relaxation of the American militancy that had just proved itself with such effectiveness in actual combat. It was necessary to alert the idealist spirit of the Americans to a new danger when they were feeling their first relief from war weariness and pleading for widespread demobilization. At Truman's disposal, significantly, were two important psychological levers: the recent illusion of national omnipotence, and the conviction, no less illusory, that all the world's peoples wanted to be, indeed had a right to be, like Americans. 'We will lift Shanghai up and up, ever up, until it is just like Kansas City,' a U.S. Senator once remarked.[2]

To galvanize such attitudes, and to justify the allocation of funds that would contain the communist menace, Truman dramatized world politics as a series of perpetual crises instigated by a tightly coordinated, monolithic Red conspiracy. He made his point graphically in Iran, Greece, Berlin, and eventually Korea. 'It must be,' he said, 'the policy of the United States to support free peoples who are resisting subjugation by armed minorities or by outside pressures.'[3] The Marshall Plan, Truman Doctrine, the Atlantic Alliance and Point Four, and above all, National Security Council paper 68 were measures, infused sometimes with extraordinary generosity and always with extreme boldness, to strengthen economies whose weakness made them vulnerable to 'subjugation,' and not incidentally to invest in their resources and to improve their position to buy American products, the better to ensure our political dominance. Thus when these activities were countered by the Russians, was initiated the era of mounting interventions, 'atomic diplomacy,' the arms race, and increasing international scares – the era known to us as the Cold War.

The generation of painters that first came of age during this period – whose tension, in retrospect, was so favorable to the development of all the American arts – felt united on two issues. They knew what they had to reject in terms of past idioms and mentality. At the same time, they were aware that achievement depended on a new and pervasive creative principle. Pollock, Still, Rothko, de Kooning, Newman, Gottlieb, and Gorky were prideful, enormously knowledgeable men who had passed through the government-sponsored WPA phase of their careers and now knew themselves, no longer charity cases, to be cast out on their own. During and shortly after the war, they were still semi-underground personalities with first one-man shows ahead of them, although they were on the average forty years old. For them, regionalist painting, rigid geometric abstraction, and politically activist art were very infertile breeding grounds for new, breakthrough ideas. On the hostile American scene in general, they counted not at all.

In 1943 some of them contributed to a statement which, in part, reads:

> As a nation we are now being forced to outgrow our narrow political isolationism. Now that America is recognized as the center where art and artists of all the world meet, it is time for us to accept cultural values on a global scale.[4]

No doubt the remark reflects the personal and quite natural impact of the leaders of modern European art, temporarily present in New York as emigrés from the war. That their tradition had been blasted apart does not seem so much to have depressed as excited the Americans. Jealous understudies were preparing to take over the roles of those whom they considered failing stars. Above all, there was to be no convergence of immediate aims or repeating of European 'mistakes,' such as Surrealist illusionism or Neoplastic abstraction. Where artists like Léger and Mondrian deeply sympathized with the urban vitality of America, this was precisely the motif – especially in its accent on machined rhythms – that the Abstract Expressionists thought deadening to the human soul and had to escape.

It is remarkable that art searching to give form to emotional experience immediately after the most cataclysmic war in history should have been completely lacking in overt reference to the hopes or the absurdities of modern industrial power. These Americans were neither enthusiasts of the modern age nor nihilist victims of it. None of them had been physically involved in the great bloodletting. The violence and exalted, tragic spirit of their work internalized consciousness of the war and found a striking synthesis in expressive brushwork contained by increasingly generalized and reductive masses. Theirs came also to be a most spacious, enveloping art, its spontaneity or sheer willfulness writ large and innocent of the mockery and despair, the charnel elements in such Europeans of their own generation as Francis Bacon and Jean Dubuffet, whose works flared with atrocious memories.

The native rhetoric, rather, was an imperious toughness, a hardboiled aristocracy. In 1949, William Baziotes wrote: 'when the demagogues of art call on you to make the social art, the intelligible art, the good art – spit on them and go back to your dreams . . . '[5] All the ideas of the New York School were colored by antagonism to the practical mind, not as to some disembodied attitude, but as an inimically lowbrow and literalist obstacle to an authentic understanding of their work in America. Nothing was more irrelevant and foreign to their conception of terror in the world than American 'knowhow,' exactly at the moment when that 'knowhow' was to provide a backup in concerted U.S. tactics of saber-rattling.

On the contrary, in choosing primitive icons from many cultures, Southwest Indian or Imperial Roman, for example, they attempted to find 'universal' symbols for their own alienation. Their art was suffused with totems of atavistic faith raised in protection of man against unknowable, afflicting nature.

Yet, it was as if their relish for the absolute inextricably blended with the demands of the single ego, claiming solidarity with the pioneering modernism of European art, and compensating for the inability to establish contact with social experience. Robert Motherwell was the only one among them to express written regrets on this score. The modern artists 'value personal liberty because they do not find positive liberties in the concrete character of the modern state.'[6] Not being able to identify with debased social values, they paint only for their colleagues, even if this is to condemn them to formalism remote from

of Nabokov,

a social expression in all its public fullness . . . Modern art is related to the problem of the modern individual's freedom. For this reason the history of modern art tends at certain moments to become the history of modern freedom.[7]

In a very curious backhanded way, Motherwell was by implication honoring his own country. Here, at least, the artist was allowed, if only through indifference, to be at liberty and to pursue the inspired vagaries of his own conscience. Elsewhere in the world, where fascist or communist totalitarianism ruled, or where every energy had been spent in fighting them, the situation was otherwise. Modern American art, abandoning its erstwhile support for left-wing agitation during the '30s, now self-propagandized itself as champion of eternal humanist freedom. [. . .]

It is impossible to escape the impression that the simple latitude they enjoyed as artists became for this first generation, part of the necessary content of their work, a theme they reiterated with more intensity, purpose, and at greater length than in any other prior movement. Where Dadaism, a postwar art 30 years earlier, had utilized license for hilarious disdain, the New Yorkers charged 'freedom' with a new, sober responsibility, even with a grave sense of mission. Each of their creative decisions had to be supremely exemplary in the context of a spiritual privilege denied at present to most of their fellow men. 'The lone artist did not want the world to be different, he wanted his canvas to be a world.'[8] Here were radical artists who, at the very inception of their movement, purged themselves of the radical politics in their own background. They did this not because they perceived less domestic need for protest in the late '40s (on the contrary), but because serious politics would drain too much from the courage needed for their own artistic tasks. That they heroicized these tasks in a way suggestive of American Cold War rhetoric was a coincidence that must surely have gone unnoticed by rulers and ruled alike.

Information about these preceptors of American painting would be incomplete without dealing with their understanding of themselves as practitioners of the 'sublime.' 'The large format, at one blow, destroyed the century-long tendency of the French to domesticize modern painting, to make it intimate. We replaced the nude girl and the French door with a modern Stonehenge, with a sense of the sublime and the tragic that had not existed since Goya and Turner.'[9] Going further than even Motherwell here, stressing the need for an unqualified and boundless art, beyond beauty and myth, Newman, personally a very thoughtful anarchist, wrote 'We are reasserting men's natural desire for the exalted, for a concern with our relationship to the absolute emotions.'[10] Hence was revealed the positive value, an inevitably doomed quest for unlimited power, to which painters of high resources bent their backs. Nothing less would satisfy them than the imposition of a roughhewn grand manner. Avant-gardes are not strangers to self-righteousness. And the unusual feature here was not the assertion of sovereignty over the French tradition, the claim that art history was now definitively being made on these shores – correct, as it turned out. It was, rather, the declaration of total moral monopoly, the separation of the tiny minority in possession of the absolute from the unwashed materialist multitudes.

To be sure, the question for sublimity invariably emerged as a call *against*

institutional authoritarianism and was always considered to be a meaningful gesture of defiance against repression. 'There,' said Clyfford Still, speaking of his role in the '40s, 'I had made it clear that a single stroke of paint, backed by work and a mind that understood its potency and implications, could restore to man the freedom lost in twenty centuries of apologies and devices for subjugation.'[11] How one might relate such an overwrought mood to the prevailing fear of atomic destruction is a baffling and disturbing question.

Looking back on this issue, the art historian Robert Rosenblum saw it characteristically in art historical terms:

> . . . a quartet of the largest canvases by Newman, Still, Rothko, and Pollock might well be interpreted as a post-World War II myth of genesis. During the Romantic era, the sublimities of nature gave proof of the divine; today, such supernatural experiences are conveyed through the abstract medium of paint alone.[12]

Their affinity with, one would hesitate to call it a historical derivation from, the deserted, magniloquent, and awesome landscapes of Romantic painting obviously furthered nationalist overtones for these artists as well. By 1950, in none of the recently occupied and worn-out countries could there be painting of such naked, prepossessing self-confidence, such a metaphoric equation of the grandeur of one's homeland with religious veneration.

Still, it would misrepresent this art to call it internally assured. As the '50s wore on, it became evident that however original in pictorial style, American painters had emotional ties with the anxieties and dreads of French existentialism. It is true that they disengaged themselves from the typical Sartrean problem of the translation of personal to political liberty, but they showed great concern for his notion that one is condemned to freedom, that the very necessity to create oneself, to give oneself a distinguishable existence, was a desperate, fateful plight.

> The tension of the private myth is the content of every painting of this vanguard. The act on the canvas springs from an attempt to resurrect the saving moment in his 'story' when the painter first felt himself released from Value — myth of past selfrecognition. Or it attempts to initiate a new moment in which the painter will realize his total personality — myth of future self-recognition.[13]

From a quite famous essay, 'The American Action Painters,' Harold Rosenberg's sonorous remarks were designed to reveal the heights to which the gestural side of our art aspired by indicating the precipices off which the psychology of gesture might easily fall. One false step, one divergence from the 'real act,' and you produced merely 'apocalyptic wallpaper.'

> In terms of American tradition, the new painters stand somewhere between Christian Science and Whitman's 'gangs of cosmos.' That is, between a discipline of vagueness by which one protects oneself from disturbance while keeping one's eyes open for benefits; and the

discipline of the Open Road of risk that leads to the farther side of the object and the outer spaces of the consciousness.[14]

It is certain that however much they may have disagreed with these dialectics, painting, for the American vanguardists, was often an uncertain and obstacle-prone activity, rife with internal challenges to authentic feeling, in which, 'As you paint, changing and destroying, nothing can be assumed.'[15] Behind their bravado and machismo, a more authentically insecure note is sounded, a tingle of fear in the muscle, acknowledging the very real possibility of sudden failure, and with that, something far more serious indeed, loss of identity. False consciousness was a not so secret enemy within the artist's organism. Rosenberg's article itself ended with an attack on the taste bureaucracy, the enemy without, which was witlessly drawn to modern art for reasons of status, and could not grasp the morality of the quivering strokes for which his whole piece was a singular promotion.

During the '50s the world-policing United States experienced a series of checks and frustrations that made it both a more sobering and uneasy place in which to live. Washington launched policies on the basic assumption that a loss of face and U.S. backdown in any area of the globe, no matter how remote, would bring about an adverse shift in the balance of power. Even a local defeat would amplify our weakness, shake faith in our resolve, and leave countless nations exposed to our communist enemies. One tends to forget that the domino theory, with its paranoid vision, budded over 20 years ago. It was an era of confrontation. To meet trial and crisis, American bases hemmed in the Iron Curtain on every front, radar nets were extended at ever further remove from our boundaries, the nuclear arsenal was expanded, SAC B-52's flew stepped-up patrol missions, and the defense budget and the armaments industry grew at an accelerated pace. But American influence could not match American power, despite its offensive and defensive potential.

Events proved that we could no more cross the Yalu River with impunity than we could aid the Hungarians when they revolted against Soviet manipulation. Eisenhower's 'New Look' depended on the deterrence of 'massive retaliation,' consistent with the idea that the presence of hyperdestructive weaponry could resolve issues beyond the reach of inadequate manpower in the field. But this concept did not lend itself to flexibility. The discrepancy between commanding rhetoric and the control of actual affairs proved so evident that a noxious climate of suspicion, jingoism, apathy, and megalomania envenomed the American atmosphere. 'There are many depressing examples,' writes Charles Yost,

> of international conflicts in which leaders have first aroused their own people against a neighbor and then discovered to their chagrin that even when they judged the time had come to move toward peace, they were prisoners of the popular passions they had stimulated.[16]

Such was the situation that set the scattered American left in retreat and brought forth the full ire of right-wing criticism of government policy in the American '50s. This manifested itself in a fusillade of civil-rights suppressions, and quickly became exemplified by the choke of McCarthyism.

Liberal personalities in sensitive or influential positions were purged in an ever more promiscuous campaign to root out the cancer of supposed disloyalty. Super-patriots, in their intimidating cry, 'Twenty years of treason,' conceived that there was as much an internal danger to their ideal America as the foreign threat. A superiority complex began to impose upon American civilization a form of dema-gogic thought control, ever more sterile, rigid, and unreal, with particular animus against intellectuals of the Eastern variety, stigmatized as 'eggheads.' Ironically, Stevenson, the chief egghead, felt obliged when campaigning against Eisenhower, to accuse him of not doing enough to stop the communists.

It was in the interest of federal government to ward off the accusations that would undermine its credibility as a bona fide cold warrior.

> You have to take chances for peace, just as you must take chances in war. Of course we were brought to the verge of war. The ability to get to the verge without getting into war is the necessary art . . . If you try to run away from it, if you are scared to go to the brink, you are lost. We've had to look it square in the face. We took strong action.[17]

Thus, John Foster Dulles explaining his policy of brinksmanship. In this unwitting mockery of existential realism, such cliff-hanging willingness to gamble the fate of millions (as at Quemoy and Matsu), was naturally accompanied by a persistent negative pattern of action: the refusal to negotiate or instrument test-ban treaties and disarmament proceedings. Moreover, Dulles' ideology of risk, really a form of international 'chicken,' was steeped in the pieties of Christian faith, whose appli-cation, just the same, required 'the necessary art.' However, the atmosphere eventually became so nightmarish that the conservative Republican, Eisenhower, went to the summit with Krushchev, in tacit admission that a stalemate had been reached.

The 'haunted fifties,' as I. F. Stone called the decade, acted as a psychological depressant on the national consciousness. At Little Rock, the desperation of blacks became once more visible and stayed just as unrectified. Under the gospel of anti-colonialism and defense of freedom, the United States was supporting a multitude of corrupt and petty dictators. For all our energy, growth, affluence, and progressive-ness, the Pax Americana emerged as the chief banner of counter-revolution. Under the stupefying, stale impact of these contradictions, a whole college generation earned the title 'silent,' while others, no less conformist in their way, dropped out among the beats. Separated by only a very few years, there appeared William Whyte's The Organization Man and Paul Goodman's Growing Up Absurd. Mort Sahl could quip that the federal government lived in mortal fear of being cut off without a penny by General Motors, a mild enough acknowledgement, during the plethora of sick jokes, of who was really in charge.

> In 1958, Dwight Macdonald submitted an article to Encounter – 'America! America!' – in which he wondered whether the intellectuals' rush to rediscover their native land (one of the obsessive concerns of the fifties, at almost every level of cultural life) had not produced a some-what uncritical acquiescence in the American imperium.[18]

Encounter magazine, which rejected Macdonald's piece, was sponsored by the Congress for Cultural Freedom, all of whose branches were discovered, by the '60s, to be supported secretly by dummy foundations set up by the CIA. Here was a group of prominent Cold War intellectuals who

> had achieved both autonomy and affluence, as the social value of their services became apparent to the government, to corporations, and to foundations . . . The modern state, among other things, is an engine of propaganda, alternately manufacturing crises and claiming to be the only instrument which can effectively deal with them. This propaganda, in order to be successful, demands the cooperation of writers, teachers, and artists not as paid propagandists or as state censored time-servers but as free intellectuals.[19]

It signifies a new sophistication in bureaucratic circles that even dense and technical work of the intelligentsia, as long as it was self-censoring in its professional detachment from values, could be used ambassadorially as a commodity in the struggle for American dominance.

If this country was unrivaled in industrial capacity and military might, it must follow that we had a culture of our own, too. One ought not, therefore, be surprised to see the fading away during the late '50s of the official conviction that modern art, however incomprehensible, was subversive. While conquering all worthwhile critics and curators on its home territory, in the process being imitated a hundredfold in every art department in the country, Abstract Expressionism had also acquired fame in the media and riches in the support of culturally mobile middle-class collectors. A second and even third generation of followers, many of them trained on the G.I. Bill or on Fulbright scholarships, had testified to the virility of its original principles. But this onslaught of acceptance, that so vitiated its proud alienation and so undermined its concept of inhospitable life in America, went far to traumatize the movement. It was at the point of a stylistic hesitation that the work of the Abstract Expressionists was sent abroad by official agencies as evidence of America's coming of creative age. Where the USIA had earlier capitulated to furious reaction from right-wing groups when attempting exhibitions of nonrepresentational art or work by 'communist tinged' painters, it was now able to mount, without interference, a number of successful programs abetted and amplified by the International Council of The Museum of Modern Art. While the museum played a pivotal role in making our painting accessible across the seas, private dealers had already initiated the export process as early as 1950. But, now it was to be the austere and eruptive canvases of the early masters, those lordly things, that came to European attention through well organized and publicized traveling shows. This occurred during one of the repeated dips in America's image on the continent. Making much headway England and Germany, less in France and Italy, the *New American Painting*, as it was called in an important show of 1959, furnished out-of-date and over-simplified metaphors of the actual complexity of American experience.

At the risk of considerable schematization, I would say that the torments of the '50s had enervated and ground down the ideological faculty of the American artist. Never comfortable with manifestoes, he embarked now into an ironic, twisted, and

absurdist 'Neo-Dada,' as it was at first known, or a distinctly impersonal, highly engineered chromatic abstraction. Significantly, neither of these modes pretended any philosophical or moral claims at all – the better, as it turned out, to *specify* sensations and appearances in the immediate environment. Technology had shown, with dazzling conviction, that means were more important than ends, and that in the vacuum of a society that was losing a sense of its goals, professionalism and specialization had utmost value. Now that their mentors had shown that American art could be 'mainstream,' members of the younger generation could release their pent-up fascination for their surroundings without fear of being taken – or sometimes even delighting in being taken – for regionalists. In this flattened ethical landscape, public information, often of the most trivial, alarming, or contradictory character, held almost cabalistic sway for a huge percentage of artists. [. . .] Art thinking, that had been yoked to one field theory for several years, now gave evidence of breaking into many differing spheres of ephemeral, specialized interest. [. . .]

Whether they expanded or restricted the flow of available information, the younger artists tended to adopt a morally neutral stand except to the absorbing studio tasks at hand. Discredited for them were the he-man clichés that once magnified the would-be potentials of art and that bespoke of thorough refusal to accommodate the artistic enterprise to the tastes of the bourgeois audience. In place of Olympian but self-pitying humanism, they insisted on functional attitudes and a cool tone. No longer, for instance, was there any agonizing over personal identity or spiritual resources, the bugbears of crisis-oriented Action painters. Without undue pangs of conscience, work got done almost on a production-line basis.

To speed this mythless art, the '60s provided the tempi of enthusiasm. McNamara's 'cost effectiveness' and Kennedy's Youth Corps and Alliance for Progress seemed at the time a heady combination of objectives that would leave behind the embarrassment of Sputnik and the U-2 incident. A 'can-do' mentality promised momentum away from the stagnation of the Republican years. Pledging to end a fictional missile gap, the new president also engendered plans for flexible counter-insurgency, created the Green Berets, and masterminded the Bay of Pigs fiasco. Politics became a theater of charismatic hardsell. Science in the universities became a colony of the defense industry. Contingency plans, doomsday scenarios, think tanks, the Velvet Underground, Cape Canaveral, the drug culture: all this hard- and software, to use terms coined during the period, bobbled together in that indigestible stew of sinister, campy, solid-state effluvia with which the American '60s inundated the world. In retrospect, there is a moment when we can see that Herman Kahn, 'thinking the unthinkable,' and Andy Warhol, wishing that everyone were like a machine, participate in the same sensibility.

In the beginning, there was Jasper Johns and Robert Rauschenberg. The interest both these men had in the work of Marcel Duchamp and the composer John Cage, from the late '50s on, indicates a deflationary impulse, as far at least as serious, grand manner abstraction was concerned. But it is still a moot point whether the American flags of the one, or the images of Kennedy in the art of the other, were derisory in any social sense. These two artists took from Dada neither its scornful theater nor its lightsome subversions, but rather its malleability, even its ambivalence. The absence in their work of any hierarchical scheme, either of subject or formal relation, was, in any event, far less malign than in Dada. Part of the difference may be explained by

the fact that the American polity, unlike the sprawling chaos of the early European interregnum, maintained a high ratio of stability to prosperity. The possibilities of the sardonic were limited in a country whose youth, more and more during these years, was oriented to scientific careerism.

'What does he love, what does he hate?' asked Fairfield Porter of Johns. 'He manipulates paint strokes like cards in a patience game.'[20] Time and again, the note struck in his work, and that of Rauschenberg, is of a fascinated passivity. It fell to these brilliant Southerners to materialize the slippage of facts from one context to another, the possibilities inherent in the blurring of all definitions, the mutually enhancing collision of programmed chance and standard measurement. And all this was understood in the larger mental simulacrum of a game structure in which, not the potentials, but the deceits of form became the main issue. Theirs was an intellectual response that acknowledged pointlessness by making a subject out of it. They found in the numbness that afflicted any sensitive citizen agog before the disjunctive media stimuli of his world, a source of iconic energy. Instead of an arena of subjective human reflexes and editorialized sentiment, dominated with allusions to man and his space, they conjured a plane laden with neutralized objects or images of objects.

The commercial success of the Pop artists, legatees of Johns and Rauschenberg, is bound up for us, at its inception in 1962 as it is now, with their commercial subjects and styles. There was repeated all over again the controversy that Realist incursions into high art, like Courbet's, had originally provoked. The greatest heat was generated by the question: 'Is any of this material esthetically transformed?' However, this time there was no socialist creed to add fuel to the debate – only an objectivity that seemed a mask for the celebration of what everyone, even the artists themselves, admitted to be the most abrasive images in the American urbanscape. Pop symptomized, more than it contributed to, an age noted for visual diarrhea. In that charged atmosphere around the time of the Cuban missile crisis of 1962, the 'New Realist' show at the Sidney Janis Gallery deceived some into thinking that a political statement, in accord with their views or not, had been decreed in American art. If anything, however, its omission of any political *parti pris*, in contrast to its highly flagrant themes of crimes, sex, food, and violence gave Pop art the most insurrectionary value. Few people could speak coolly about it at all.

One of the exceptions over a long period, Lawrence Alloway, later wrote:

> As an alternative to an aesthetic that isolated visual art from life and from the other arts, there emerged a new willingness to treat our whole culture as if it were art . . . It was recognized in London for what it was ten years ago, a move towards an anthropological view of our society . . . the mass media were entering the work of art and the whole environment was being regarded, reciprocally, by the artists as art, too.[21]

In contrast, Ivan Karp, who dealt in their works, pleaded the case of Warhol, Rosenquist, and Lichtenstein under the banner 'Sensitivity is a bore.' 'Common Image Art,' as he called it,

> is downright hostile. Its characters and objects are unabashedly ego-tistical and self-reliant. They do not invite contemplation. The style is

happily retrograde and thrillingly insensitive . . . It is too much to endure, like a steel fist pressing in the face."[22]

The worship of brutality and the sociology of popular media as legitimate art folklore, both these attitudes, early and recent, add to rather than distort the record of the movement. For Pop art was simultaneously a tension-building and relieving phenomenon. It processed many of the most encroaching, extreme, and harsh experiences of American civilization into a mesh of grainy rotogravure or a phantasm taken from the dotted pulsations on the face of a cathode tube. Lichtenstein's *Torpedo Los*, cribbed from a comic about a Nazi sub commander, was placed with jokey topicality in the era of Polaris submarines. Here was an art that could shrewdly feed on the Second World War while keeping present, and yet assuaging, the fears of the Cold War.

On the national level, during those early years of the '60s, events were most confused. Under Kennedy the social scene had become relatively enlightened, style conscious, and permissive, with chic and fey undergrounds rivaling the White House court. [. . .] Meanwhile, Harvard professors were industriously planning strategy that would inaugurate ten years of mayhem in Vietnam. Culturally there ensued a kind of literate bad faith, the camp attitude, which was never so bitter as cynicism nor so unsophisticated as to allow for moral judgments. It became a necessary emotional veneer for audiences to feel removed from, yet assimilate with full indulgence of their hyped, insolent glamor, impulses, events and objects they knew to be hideous and depraved. For having discovered this formula in art, Pop was instantly acculturated and coopted by the mass media upon which it preyed.

The immense publicity and patronage these artists enjoyed was surely no put-on. The masses at large had at last found an avant-garde sensation which they could appreciate quite justifiably on extraesthetic grounds, while its esoteric origins lent piquancy to its appeal. If it had not already had rock music, a whole younger generation could have learned the disciplines of mod cool from Pop art alone. As could never be with Abstract Expressionism, Pop artists and their clients mutually manipulated each other. There were high dividends of communications feedback and product promotion that were difficult to overlook, especially during the epoch when consumership was based almost entirely on style, and packaging had tacitly nothing to do with the value of goods received. Yet the upper bourgeois collectors who boosted Pop art with such adventurism were genuine enthusiasts.

The stereotype that they were parvenu vulgarians on a taste level with the images they so vocally adored, has to be modified under analysis. It is true that some of them were self-made men of nouveau-riche status, but this does not distinguish them at all from the field of the postwar monied in America. Professional or in business, most of them had seriously collected the Abstract Expressionists a few short years before. Pop art, oddly enough, given its exaltation of the standardized, but also explainably, considering its glorification of success, flattered their sense of individualism. Moreover, 'Now middle-aged or older, they identify the pop movement with their children's generation. To own these works, they feel, is to stay young.'[23] Perhaps an even more telling consideration was the excitement this art suffused in them as an absolutely up-to-the minute visual phenomenon, a condition they often interpreted by crowding out even their furniture with a plethora of Pop

works that could no longer be looked at singly, but had to be taken in montage fashion, with that nonlinear, noncontemplative élan of the trendy Marshal McLuhan.

The Pop artist behaved with aplomb as a celebrity in the New York art world. Such an elevation to stardom, the while he was compelled to behave as a rising businessman, gave to the artist a recognizably new psychology. It was in a spirit of realism that Allan Kaprow, speaking generally of many different studio types, described what he thought were their relevant traits in a much-read article of 1964, 'Should the Artist Become a Man of the World?' Kaprow had discerned not only the collapse of Bohemia, and that 'the artist could no longer succeed by failing,' but that he was a college trained, white collar bourgeois himself, who resembled the 'personnel in other specialized disciplines and industries in America.'[4] Best then, to make a moral adjustment and engage in the politics of *culture*, for avoiding it is never to know whether one has proven onself in 'the presence of temptation or simply run away.'[5] Kaprow managed to make accommodation to the prevailing cultural powers sound still a heroic task (a very clever insinuation), though it was probably an involuntary *fait accompli*. An echo of Abstract Expressionist high-mindedness lurked in this argument. He admonished the new artists that 'Political awareness may be all men's duty, but political expertise belongs to the politician. As with art, only the full-time career can yield results' – a separatist line strikingly reminiscent of one taken by Rosenberg and Motherwell in 1948! And yet, as against this, Claes Oldenburg could draw very opposite conclusions three years later. 'You must realize cops are just you and I in uniform . . . Art as life is murder . . . Vulgar USA civilization now beginning to interfere my art.'[6]

The Kaprow article was published close in time to the Gulf of Tonkin resolution. In that same year, the dealer Leo Castelli printed an ad in *Art International* showing a map of Europe with little flags indicating shows by his artists in various cities, an unsubtle anticipation of victory at that summer's Venice Biennale. Earlier, Kennedy had come to see that domestic and third world liberties might not exactly flourish under a United States garrison mentality. He gave signs of lessening Cold War pressures, of curbing the CIA, and of ending racial discrimination in jobs. The August 1963 March on Washington, at which Martin Luther King spoke – 'I have a dream' – symbolized the unappeased punishing inequity of the blacks. It was to herald, along with the Free Speech movement and student rebellion at Berkeley, the eruptions of the gathering New Left, all the protests, war sit-ins, strikes, guerrilla politics and peace vigils to come. After Kennedy had been killed, the nostalgic flavor of Pop art and the entertainment media in general became particularly evident, as if depiction of the present had all the heart go out of it.

The Pop artists became sporadically active on the fringe of dissent. Sometimes supported by their elders, they contributed to CORE, to many peace causes and moratoria against the Vietnam war. Rosenquist's extraordinary *F-111* could be read [. . .] as an indictment of United States militarism. [. . .] Rauschenberg secretly financed much of the Artists' Peace Tower against the war in Los Angeles in 1965. But he also celebrated the triumph of American space flight technology, the trip to the moon, for NASA in 1969.

The truth was that Pop art, whatever the angered political sentiments of its creators, was a mode captured by its own ambiguities, and cranked up willy-nilly to express benign sentiments. It could not have been Pop art, that beguiling invention,

if its latencies of critique had not been sapped by its endorsement of business. Abroad, this flirtatious product of the 'Great Society' was framed with maximum panache. At our lavish installation at the 1967 São Paulo Biennial, Hilton Kramer reported that 'such a display of power cannot avoid carrying political implications in an international show . . . Some observers here, including the commissioners of the other national sections, have been quite vocal in condemning what they regard as an excessive display of wealth and chauvinism.'[7] Under the tutelage of the National Collection of Fine Arts, Pop art could symbolize a continuing American freedom, but one whose supermarkets and synthetics had roosted in a score of different economies, and had come to speak above all of glut and complacency.

An entirely different kind of freedom was prefigured by the ultracompetitive color-field and systemic abstractionists of the '60s. One sees in the art of Stella, late Louis, Noland, Kelly, Irwin, Poons, and Olitski, an institutionalized counterpart of Pop, polarized with regard to it more in idiom than the mechanized style they both shared. But where Pop was timely and expansive, these artists upheld the timeless and the reductive. The symbolic values latent in such abstraction aspired to a vision of limitless control and ultimate, inhuman perfectibility (which was also a particular aspect of '60s America). The computer and transistorized age of corporate technology achieved in its striped and serialized emblems, its blocks or spreads of radiant hues, an acrylic metaphor of unsettling power.

Never, in modern art, had such a 'purist' enterprise been deployed without recourse to utopian or 'futurist' justifications, and it was perhaps because of its very muteness on this point that color-field abstraction now seems to us, in terms of American self-imagery on the world scene, the stick behind the carrot.

The antiseptic surfacing, the compressed, two-dimensional designing, the optical brilliance, and the gigantism of this art's scale, invoke a far more mundane awe than the sublime. And yet, no one can categorize the sources that stimulated this openness of space, or say of such painting that it refers to a concrete experience. Nothing interferes with the efficient plotting of its structure – in fact, efficiency itself becomes its pervasive ideal. The strength, sometimes even the passion of this ideal, rescues the best of this work from the stigma of the decorative, but only to cause it all the more to seem the heraldry of managerial self-respect.

It would not be irrelevant that during this time, the conglomerate executives with their lobbyists and bankers, through the efforts of their technical elites, had achieved an unprecedented hold on the economy. 'While in the realm of pure logic, a Federal Power Commission in Washington might tell Standard Oil of California what it might or might not do, in actual fact such an agency is less powerful than the corporation . . . This is the politics of capitalism.'[8] It is fruitful to suppose that this diffused, invisible, but immensely consequential reality, with its subtle manipulations, would find some correspondence in the sensitized zone of capitalist art. As Pop art spoke best to the entrepreneurial collector, so expensive-looking color-field abstraction blazoned the walls of banks, boardrooms, and those corporate fiefs, the museums. Never as literally readable or cosmetic as Pop, this art had more appropriately chaste and hierarchical overtones whose stripped functioning materialized a code that was more intuitively grasped than rationally comprehended. No deciphering of the conventions of art was necessary for the corporate homage of this art to come across to its patrons. In that sense, though without subject in a strict

iconographical sense, it was self-sufficient expressively, and by 1964, no later, immediately meaningful as a consumed signifier.

There is another, larger dimension in which it made itself felt, as well. America had become ugly, fouled with industrial wastes, and split with divisive forces. As Norman Mailer put it:

> America was torn by the specter of civil war, and many a patriot and many a big industrialist – they were so often the same – saw the cities and the universities as a collective pit of Black heathen, Jewish revolutionaries, a minority polyglot hirsute scum of nihilists, hippies, sex maniacs, drug addicts, liberal apologists and freaks. Crime pushed the American public to give birth to dreams of order. Fantasies of order had to give way to lusts for new order. Order was restraint, but new order would call for a mighty vault, an exceptional effort, a unifying dream.[29]

Without so intending, American abstraction of the '60s strikes us as the visual anagram of these 'lusts for new order.' There is something understandable, very contemporary, and also chilling in the spectacle this new art offered. As a psychedelic poster for a whiz-bang at Fillmore East had its definite constituency, so chromatic abstraction would solace those in upper echelons who could not abide the inertial tugs and the irate spasms in the overheated ghettos of our national life.

None of this, however, can be assumed to have occupied the artists' conscious minds while at work. The gap between their own technical motives, the demiurge of form pursued for its own sake, and the rarefied prestige their art conferred upon its backers, does not seem to have occasioned any comment among them – nor did it have to. On the contrary, they had been socially insulated by a critical framework – an explanation of purpose and a means of analysis – called formalism. The ineffable criterion of this doctrine, the word 'quality,' was sparingly applied to those works which were considered to have advanced the possibilities of radical innovation in painting while maintaining vital contact with its tradition. The artists had to contend with professional standards – none outside formalism were allowable – that were at once more ambitious and yet more conservative than those in the business world. These standards were also nakedly authoritarian, but if nervous-making on that score, they at least assured a seemingly objective superiority to those that had met them.

It is curious that the word 'quality,' though more abstract in connotation than, say, 'risk,' is more onerous and arrogant in implication. One went through a rite of passage, a rigorously imposed set of limitations that took the place of any moral stance, and yet arrogated to itself a historical mission. The enemy here was not the defunct School of Paris, but upstart 'far-out' American competitors. Clement Greenberg, critic emeritus of formalism, was an intellectual Cold Warrior who traveled during the '60s under government sponsorship to foreign countries with the good news of color-field's ascendance. This message, however, proved to be less noteworthy abroad than in our university art departments, where the styles of Noland and Olitski were perpetuated with a less than becoming innocence.

Meanwhile, if political agitation on the left failed to stir these masters (Stella excepted), the more attenuated, parodistic elements of late Pop sidled into their

work. There had been finally less antagonism between them than hitherto supposed. But then, the determination of American art in general to draw nourishment from its environment has been one of its most natural yet underestimated features. Long after the war, our artists were still participating in the vitality of American experience, but they also had a taste of something darker and more demonic within it, the pathology of oppression. This was an awareness that has come increasingly to motivate their social unrest. Toward the end of this development, the time and space of the art of the '60s having run their course, as had the work of the two preceding decades, the Metropolitan Museum accorded it a giant retrospective, with all the honor that venerable establishment is capable of giving. But compared to the projections of fear and desire which underlies our art, that honor, a kind of imperial bearing in state, now looks insignificant indeed.

Notes

1 Dean Acheson, in a conversation with the author at the Aspen Institute for Humanistic Studies, Aspen, Colorado, Summer, 1966.

2 Quoted in Stephen Ambrose, *Rise to Globalism*, Baltimore, 1971, p. 118.

3 Quoted by Barton Bernstein, 'The Limitations of Pluck,' *The Nation*, January 8, 1973, p. 40.

4 Quoted by Edward Alden Jewell, *The New York Times*, June 6, 1943, in Irving Sandler, *The Triumph of American Painting*, New York, 1970, p. 33.

5 Quoted in *New York School, The First Generation*, Los Angeles County Museum of Art, 1965, p. 11.

6 Robert Motherwell, 'The Modern Painter's World,' *Dyn VI*, 1944, quoted in Barbara Rose, *Readings in American Art Since 1900*, New York, 1968, pp. 130–131.

7 Motherwell, ibid.

8 Harold Rosenberg, 'The American Action Painters,' *Art News*, September, 1952, p. 37.

9 Max Kozloff, 'An Interview with Robert Motherwell,' *Artforum*, September, 1965, p. 37.

10 Barnett Newman, 'The Ideas of Art,' *Tiger's Eye*, December 15, 1948, p. 53.

11 Clyfford Still, 'An Open Letter to an Art Critic,' *Artforum*, December, 1963, p. 32.

12 Robert Rosenblum, 'The Abstract Sublime,' *Art News*, February, 1961, p. 56.

13 Rosenberg, p. 48.

14 Rosenberg, ibid.

15 Philip Guston in 'Philadelphia Panel,' *It Is*, Spring, 1960, p. 34.

16 Charles Yost, *The Conduct and Misconduct of Foreign Affairs*, New York, 1972, quoted by James Reston in *The New York Times*, January 14, 1973.

17 John Foster Dulles, *Look* magazine, January, 1956, quoted in Ambrose, p. 225.

18 Christopher Lasch, 'The Cultural Cold War,' *Towards A New Past: Dissenting Essays in American History*, ed. Barton Bernstein, New York, 1969, p. 331.

19 Lasch, pp. 344–345.

20 Fairfield Porter, 'The Education of Jasper Johns,' *Art News*, February, 1964, p. 44.

21 Lawrence Alloway, 'Popular Culture and Pop Art,' *Studies in Popular Communication*, Panthe Record 7, 1969, p. 52.

22 Ivan Karp, 'Anti-Sensibility Painting,' *Artforum*, September, 1963, p. 26.

23 William Zinsser, *Pop Goes America*, New York, 1969, p. 24.
24 Allan Kaprow, 'Should the Artist Become a Man of the World?,' *Art News*, October, 1964.
25 Kaprow, ibid.
26 Claes Oldenburg, 'America: War & Sex, Etc.,' *Arts Magazine*, Summer, 1967.
27 Hilton Kramer, 'Art: United States' Exhibition Dominates São Paulo's 9th Biennial,' *The New York Times*, September 20, 1967.
28 Andrew Hacker, *The End of the American Era*, New York, 1970, p. 68.
29 Norman Mailer, *Of A Fire On The Moon*, New York, 1971, p. 65.

Eva Cockcroft

ABSTRACT EXPRESSIONISM, WEAPON
OF THE COLD WAR

TO UNDERSTAND WHY A particular art movement becomes successful under a given set of historical circumstances requires an examination of the specifics of patronage and the ideological needs of the powerful. During the Renaissance and earlier, patronage of the arts went hand in hand with official power. Art and artists occupied a clearly defined place in the social structure and served specific functions in society. After the Industrial Revolution, with the decline of the academies, development of the gallery system, and rise of the museums, the role of artists became less clearly defined, and the objects artists fashioned increasingly became part of a general flow of commodities in a market economy. Artists, no longer having direct contact with the patrons of the arts, retained little or no control over the disposition of their works.

In rejecting the materialistic values of bourgeois society and indulging in the myth that they could exist entirely outside the dominant culture in bohemian enclaves, avant-garde artists generally refused to recognize or accept their role as producers of a cultural commodity. As a result, especially in the United States, many artists abdicated responsibility both to their own economic interests and to the uses to which their artwork was put after it entered the marketplace.

Museums, for their part, enlarged their role to become more than mere repositories of past art, and began to exhibit and collect contemporary art. Particularly in the United States, museums became a dominant force on the art scene. In many ways, American museums came to fulfill the role of official patronage – but without accountability to anyone but themselves. The U.S. museum, unlike its European counterpart, developed primarily as a private institution. Founded and supported by the giants of industry and finance, American museums were set up on the model of their corporate parents. To this day they are governed largely by self-perpetuating boards of trustees composed primarily of rich donors. It is these

Source: 'Abstract Expressionism, Weapon of the Cold War', *Artforum*, vol. 12, no. 10, June 1974, pp. 39–41. Reprinted by permission of the author and *Artforum*.

boards of trustees – often the same 'prominent citizens' who control banks and corporations and help shape the formulation of foreign policy – which ultimately determine museum policy, hire and fire directors, and to which the professional staff is held accountable. Examination of the rising success of Abstract Expressionism in America after World War II, therefore, entails consideration of the role of the leading museum of contemporary art – The Museum of Modern Art (MOMA) – and the ideological needs of its officers during a period of virulent anticommunism and an intensifying 'cold war.'

In an article entitled 'American Painting During the Cold War,' published in the May, 1973 issue of *Artforum*, Max Kozloff pointed out the similarity between 'American cold war rhetoric' and the way many Abstract Expressionist artists phrased their existentialist-individualist credos. However, Kozloff failed to examine the full import of this seminal insight, claiming instead that 'this was a coincidence that must surely have gone unnoticed by rulers and ruled alike.' Not so.

Links between cultural cold war politics and the success of Abstract Expressionism are by no means coincidental, or unnoticeable. They were consciously forged at the time by some of the most influential figures controlling museum policies and advocating enlightened cold war tactics designed to woo European intellectuals.

The political relationship between Abstract Expressionism and the cold war can be clearly perceived through the international programs of MOMA. As a tastemaker in the sphere of contemporary American art, the impact of MOMA – a major supporter of the Abstract Expressionist movement – can hardly be overestimated. In this context, the fact that MOMA has always been a Rockefeller-dominated institution becomes particularly relevant (other families financing the museum, although to a lesser extent than the Rockefellers, include the Whitneys, Paleys, Blisses, Warburgs, and Lewisohns).

MOMA was founded in 1929, mainly through the efforts of Mrs. John D. Rockefeller, Jr. In 1939, Nelson Rockefeller became president of MOMA. Although Nelson vacated the MOMA presidency in 1940 to become President Roosevelt's coordinator of the Office of Inter-American Affairs and later assistant secretary of state for Latin American affairs, he dominated the museum throughout the 1940s and 1950s, returning to MOMA's presidency in 1946. In the 1960s and 1970s, David Rockefeller and Mrs. John D. Rockefeller, 3rd, assumed the responsibility of the museum for the family. At the same time, almost every secretary of state after the end of World War II, right up to the present, has been an individual trained and groomed by the various foundations and agencies controlled or managed by the Rockefellers. The development of American cold war politics was directly shaped by the Rockefellers in particular and by expanding corporations and banks in general (David Rockefeller is also chairman of the board of Chase Manhattan Bank, the financial center of the Rockefeller dynasty).

The involvement of The Museum of Modern Art in American foreign policy became unmistakably clear during World War II. In June, 1941, a Central Press wire story claimed MOMA as the 'latest and strangest recruit in Uncle Sam's defense line-up.' The story quoted the Chairman of the Museum's Board of Trustees, John Hay Whitney, on how the Museum could serve as a weapon for national defense to 'educate, inspire, and strengthen the hearts and wills of free men in defense of their own freedom.'' Whitney spent the war years working for the Office of Strategic

Services (OSS, predecessor of CIA), as did many another notable cold warrior (e.g., Walt Whitman Rostow). In 1967, Whitney's charity trust was exposed as a CIA conduit (*New York Times*, February 25, 1967). Throughout the early 1940s MOMA engaged in a number of war-related programs which set the pattern for its later activities as a key institution in the cold war.

Primarily, MOMA became a minor war contractor, fulfilling 38 contracts for cultural materials totalling $1,590,234 for the Library of Congress, the Office of War Information, and especially Nelson Rockefeller's Office of the Coordinator of Inter-American Affairs. For Nelson's Inter-American Affairs Office, 'mother's museum' put together 19 exhibitions of contemporary American painting which were shipped around Latin America, an area in which Nelson Rockefeller had developed his most lucrative investments – e.g., Creole Petroleum, a subsidiary of Standard Oil of New Jersey, and the single most important economic interest in oil-rich Venezuela.

After the war, staff from the Inter-American Affairs Office were transferred to MOMA's foreign activities. René d'Harnoncourt, who had proven himself an expert in the organization and installation of art exhibits when he helped American Ambassador Dwight Morrow cultivate the Mexican muralists at the time Mexico's oil nationalism threatened Rockefeller oil interests, was appointed head of the art section of Nelson's Office of Inter-American Affairs in 1943. A year later, he was brought to MOMA as vice-president in charge of foreign activities. In 1949, d'Harnoncourt became MOMA's director. The man who was to direct MOMA's international programs in the 1950s, Porter A. McCray, also worked in the Office of Inter-American Affairs during the war.

McCray is a particularly powerful and effective man in the history of cultural imperialism. He was trained as an architect at Yale University and introduced to the Rockefeller orbit through Rockefeller's architect Wallace Harrison. After the war, Nelson Rockefeller brought McCray into MOMA as director of circulating exhibits. From 1946 to 1949, while the Museum was without a director, McCray served as a member of MOMA's coordinating committee. In 1951, McCray took a year's leave of absence from the Museum to work for the exhibitions section of the Marshall Plan in Paris. In 1952, when MOMA's international program was launched with a five-year grant of $625,000 from the Rockefeller Brothers Fund, McCray became its director. He continued in that job, going on to head the program's expanded version, the International Council of MOMA (1956), during some of the most crucial years of the cold war. According to Russell Lynes, in his comprehensive new book *Good Old Modern: An Intimate Portrait of the Museum of Modern Art*, the purpose of MOMA's international program was overtly political: 'to let it be known especially in Europe that America was not the cultural backwater that the Russians, during that tense period called "the cold war," were trying to demonstrate that it was.'

MOMA's international program, under McCray's directorship, provided exhibitions of contemporary American art – primarily the Abstract Expressionists – for international exhibitions in London, Paris, São Paulo, and Tokyo (it also brought foreign shows to the United States). It assumed a quasi-official character, providing the 'U.S. representation' in shows where most nations were represented by government-sponsored exhibits. The U.S. Government's difficulties in handling the delicate issues of free speech and free artistic expression, generated by the

McCarthyist hysteria of the early 1950s, made it necessary and convenient for MOMA to assume this role of international representation for the United States. For example, the State Department refused to take the responsibility for U.S. representation at the Venice Biennale, perhaps the most important of international-cultural-political art events, where all the European countries including the Soviet Union competed for cultural honors. MOMA bought the U.S. pavilion in Venice and took sole responsibility for the exhibitions from 1954 to 1962. This was the only case of a privately owned (instead of government-owned) pavilion at the Venice Biennale.

The CIA, primarily through the activities of Thomas W. Braden, also was active in the cold war cultural offensive. Braden, in fact, represents once again the important role of The Museum of Modern Art in the cold war. Before joining the CIA in 1950 to supervise its cultural activities from 1951 to 1954, Braden had been MOMA's executive secretary from April 1948 to November 1949. In defense of his political cultural activities, Braden published an article 'I'm Glad the CIA is "Immoral",' in the May 20, 1967 issue of *Saturday Evening Post*. According to Braden, enlightened members of the governmental bureaucracy recognized in the 1950s that 'dissenting opinions within the framework of agreement on cold-war fundamentals' could be an effective propaganda weapon abroad. However, rabid anticommunists in Congress and the nation as a whole made official sponsorship of many cultural projects impracticable. In Braden's words, ' . . . the idea that Congress would have approved of many of our projects was about as likely as the John Birch society's approving medicare.' As the 1967 exposés revealed, the CIA funded a host of cultural programs and intellectual endeavors, from the National Student Association (NSA) to *Encounter* magazine and innumerable lesser-known 'liberal and socialist' fronts.

In the cultural field, for example, CIA went so far as to fund a Paris tour of the Boston Symphony Orchestra in 1952. This was done, according to Braden, to avoid the severe security restrictions imposed by the U.S. Congress, which would have required security clearance for every last musician in order to procure official funds for the tour. 'Does anyone think that congressmen would foster a foreign tour by an artist who has or had had left-wing connections?' Braden asked in his article to explain the need for CIA funding. The money was well spent, Braden asserted, because 'the Boston Symphony Orchestra won more acclaim for the U.S. in Paris than John Foster Dulles or Dwight D. Eisenhower could have bought with a hundred speeches.' As this example suggests, CIA's purposes of supporting international intellectual and cultural activities were not limited to espionage or establishing contact with leading foreign intellectuals. More crucially, CIA sought to influence the foreign intellectual community and to present a strong propaganda image of the United States as a 'free' society as opposed to the 'regimented' communist bloc.

The functions of both CIA's undercover aid operations and the Modern Museum's international programs were similar. Freed from the kinds of pressure of unsubtle red-baiting and super-jingoism applied to official governmental agencies like the United States Information Agency (USIA), CIA and MOMA cultural projects could provide the well-funded and more persuasive arguments and exhibits needed to sell the rest of the world on the benefits of life and art under capitalism.

In the world of art, Abstract Expressionism constituted the ideal style for these

propaganda activities. It was the perfect contrast to 'the regimented, traditional, and narrow' nature of 'socialist realism.' It was new, fresh and creative. Artistically avant-garde and original, Abstract Expressionism could show the United States as culturally up-to-date in competition with Paris. This was possible because Pollock, as well as most of the other avant-garde American artists, had left behind his earlier interest in political activism.' This change was manifested in the organization of the Federation of Modern Painters and Sculptors in 1943, a group which included several of the Abstract Expressionists. Founded in opposition to the politically motivated Artists Congress, the new Federation was led by artists who, in Kozloff's words, were 'interested more in aesthetic values than in political action.' On the one hand, the earlier political activism of some of the Abstract Expressionists was a liability in terms of gaining congressional approval for government-sponsored cultural projects. On the other hand, from a cold warrior's point of view, such linkages to controversial political activities might actually heighten the value of these artists as a propaganda weapon in demonstrating the virtues of 'freedom of expression' in an 'open and free society.'

Heralded as the artistic 'coming of age' of America, Abstract Expressionist painting was exported abroad almost from the beginning. Willem de Kooning's work was included in the U.S. representation at the Venice Biennale as early as 1948. By 1950, he was joined by Arshile Gorky and Pollock. The U.S. representation at the Biennales in São Paulo beginning in 1951 averaged three Abstract Expressionists per show. They were also represented at international shows in Venezuela, India, Japan, etc. By 1956, a MOMA show called 'Modern Art in the U.S.,' including works by 12 Abstract Expressionists (Baziotes, Gorky, Guston, Hartigan, de Kooning, Kline, Motherwell, Pollock, Rothko, Stamos, Still, and Tomlin), toured eight European cities, including Vienna and Belgrade.

In terms of cultural propaganda, the functions of both the CIA cultural apparatus and MOMA's international programs were similar and, in fact, mutually supportive. As director of MOMA's international activities throughout the 1950s, Porter A. McCray in effect carried out governmental functions, even as Braden and the CIA served the interests of the Rockefellers and other corporate luminaries in the American ruling class. McCray served as one of the Rockefeller's main agents in furthering programs for the export of American culture to areas considered vital to Rockefeller interests: Latin America during the war, Europe immediately afterwards, most of the world during the 1950s, and – in the 1960s – Asia. In 1962–63, McCray undertook a year's travel in Asia and Africa under the joint auspices of the State Department and MOMA. In October, 1963, when Asia had become a particularly crucial area for the United States, McCray left MOMA to become director of the John D. Rockefeller 3rd Fund, a newly created cultural exchange program directed specifically toward Asia.

The U.S. Government simply could not handle the needs of cultural imperialism alone during the cold war, at least overtly. Illustrative of the government's problems were the 1956 art-show scandals of the USIA – and the solution provided by MOMA. In May, 1956, a show of paintings by American artists called *Sport in Art*, organized by *Sports Illustrated* for USIA, was scheduled to be shown in conjunction with the Olympic Games in Australia. This show had to be cancelled after strong protests in Dallas, Texas, where the show toured before being sent abroad. A

right-wing group in Dallas, the Patriotic Council, had objected to the exhibition on the grounds that four of the artists included had once belonged to communist-front groups.

In June, 1956, an even more serious case of thought censorship hit the press. The USIA abruptly cancelled a major show of American art, '100 American Artists.' According to the June 21 issue of the *New York Times*, this show had been planned as 'one of the most important exhibits of American painting ever sent abroad.' The show was organized for USIA by the American Federation of Arts, a nonprofit organization based in New York, which refused to cooperate with USIA's attempt to force it to exclude about ten artists considered by the information agency to be 'social hazards' and 'unacceptable' for political reasons. The Federation's trustees voted unanimously not to participate in the show if any paintings were barred by the Government, citing a 1954 resolution that art 'should be judged on its merits as a work of art and not by the political or social views of the artist.'

Objections against censorship were also raised by the American Committee for Cultural Freedom (which was revealed as receiving CIA funds in the 1967 exposés). Theodore Streibert, Director of USIA, testifying before Senator Fulbright's Foreign Relations Committee, acknowledged that USIA had a policy against the use of politically suspect works in foreign exhibitions. The USIA, as a government agency, was handcuffed by the noisy and virulent speeches of rightwing congressmen like Representative George A. Dondero (Michigan) who regularly denounced from the House floor abstract art and 'brainwashed artists in the uniform of the Red art brigade.' As reported on June 18, 1956, by the *New York Times*, Fulbright replied: 'unless the agency changes its policy it should not try to send any more exhibitions overseas.'[3]

The Rockefellers promptly arranged a solution to this dilemma. In 1956, the international program of The Museum of Modern Art was greatly expanded in both its financial base and in its aims. It was reconstituted as the International Council of MOMA and officially launched six months after the censorship scandal of USIA's '100 American Artists' show. MOMA's newly expanded role in representing the United States abroad was explained by a *New York Times* article of December 30, 1956. According to the *Times*,

> The government is leery of anything so controversial as art and hampered by the discreditable interference on the part of some politicians who are completely apathetic to art except when they encounter something really significant . . . Some of the immediate projects which the Council is taking over financially are United States participation in three major international art exhibitions and a show of modern painting to travel in Europe.

This major show of American painting was produced two years later by MOMA's International Council as 'The New American Painting,' an elaborate traveling exhibition of the Abstract Expressionists. The exhibition, which included a comprehensive catalogue by the prestigious Alfred H. Barr, Jr., toured eight European countries in 1958–59. Barr's introduction to the catalogue exemplified the cold war propaganda role of Abstract Expressionist art.

Indeed one often hears Existentialist echoes in their words, but their 'anxiety,' their commitment, their 'dreadful freedom' concern their work primarily. They defiantly reject the conventional values of the society which surrounds them, but they are not politically engagés even though their paintings have been praised and condemned as symbolic demonstrations of freedom in a world in which freedom connotes a political attitude.

As the director of MOMA from its inception until 1944, Barr was the single most important man in shaping the Museum's artistic character and determining the success or failure of individual American artists and art movements. Even after leaving MOMA's directorship, Barr continued to serve as the Museum's reigning tastemaker. His support of Abstract Expressionist artists played an influential role in their success. In addition to his role at MOMA, Barr was an artistic advisor to Peggy Guggenheim, whose Surrealist-oriented Art of This Century Gallery gave some of these artists their first important shows in the mid-1940s. For example, Peggy Guggenheim's gallery offered one-man shows to Jackson Pollock in 1943, 1945, 1947, Hans Hofmann in 1944, Robert Motherwell in 1944, and Mark Rothko in 1945. Barr was so enthusiastic about the work of the Abstract Expressionists that he often attended their informal meetings and even chaired some of their panel discussions at their meeting place, The Club, in New York City.

Barr's 'credentials' as a cultural cold warrior, and the political rationale behind the promotion and export of Abstract Expressionist art during the cold war years, are set forth in a *New York Times* Magazine article Barr wrote in 1952, 'Is Modern Art Communistic?,' a condemnation of 'social realism' in Nazi Germany and the Soviet Union. Barr argued in his article that totalitarianism and Realism go together. Abstract art, on the other hand, is feared and prohibited by the Hitlers and Stalins (as well as the Donderos of the world, who would equate abstraction with communism). In his battle against the ignorant right-wing McCarthyists at home, Barr reflected the attitudes of enlightened cold warriors like CIA's Braden and MOMA's McCray. However, in the case of MOMA's international policies, unlike those of CIA, it was not necessary to use subterfuge. Similar aims as those of CIA's cultural operations could be pursued openly with the support of Nelson Rockefeller's millions.

Especially important was the attempt to influence intellectuals and artists behind the 'iron curtain.' During the post-Stalin era in 1956, when the Polish government under Gomulka became more liberal, Tadeusz Kantor, an artist from Cracow, impressed by the work of Pollock and other abstractionists which he had seen during an earlier trip to Paris, began to lead the movement away from socialist realism in Poland. Irrespective of the role of this art movement within the internal artistic evolution of Polish art, this kind of development was seen as a triumph for 'our side.' In 1961, Kantor and 14 other nonobjective Polish painters were given an exhibition at MOMA. Examples like this one reflect the success of the political aims of the international programs of MOMA.

Having succeeded so handsomely through MOMA in supporting the cold war, Nelson Rockefeller moved on, in the 1960's, to launch the Council of the Americas and its cultural component, the Center for Inter-American Relations. Funded almost entirely by Rockefeller money and that of other American investors in Latin

America, the Council advises the U.S. Government on foreign policy, even as does the older and more influential Council on Foreign Relations (headed by David Rockefeller, the CFR is where Henry Kissinger began his rise to power). The Center for Inter-American Relations represents a thinly veiled cultural attempt to woo back respect from Latin America in the aftermath of the Cuban Revolution and the disgraceful Bay of Pigs and Missile Crisis incidents. In its Park Avenue offices of a former mansion donated by the Rockefeller family, the Center offers exhibits of Latin American art and guest lectures by leading Latin American painters and intellectuals. Like the John D. Rockefeller 3rd Fund for Asia, the Center is yet another link in a continuing and expanding chain of Rockefeller-dominated imperialism.

The alleged separation of art from politics proclaimed throughout the 'free world' with the resurgence of abstraction after World War II was part of a general tendency in intellectual circles towards 'objectivity.' So foreign to the newly developing apolitical milieu of the 1950s was the idea of political commitment – not only to artists but also to many other intellectuals – that one social historian, Daniel Bell, eventually was to proclaim the postwar period as 'the end of ideology.' Abstract Expressionism neatly fits the needs of this supposedly new historical epoch. By giving their painting an individualist emphasis and eliminating recognizable subject matter, the Abstract Expressionists succeeded in creating an important new art movement. They also contributed, whether they knew it or not, to a purely political phenomenon – the supposed divorce between art and politics which so perfectly served America's needs in the cold war.

Attempts to claim that styles of art are politically neutral when there is no overt political subject matter are as simplistic as Dondero-ish attacks on all abstract art as 'subversive.' Intelligent and sophisticated cold warriors like Braden and his fellows in the CIA recognized that dissenting intellectuals who believe themselves to be acting freely could be useful tools in the international propaganda war. Rich and powerful patrons of the arts, men like Rockefeller and Whitney, who control the museums and help oversee foreign policy, also recognize the value of culture in the political arena. The artist creates freely. But his work is promoted and used by others for their own purposes. Rockefeller, through Barr and others at the Museum his mother founded and the family controlled, consciously used Abstract Expressionism, 'the symbol of political freedom,' for political ends.

Notes

1 Cited in Russell Lynes, *Good Old Modern*, New York, 1973, p. 233.
2 For Pollock's connections with the Communist Party see Francis V. O'Connor, *Jackson Pollock*, New York, 1967, pp. 14, 21, 25, and Harold Rosenberg, 'The Search for Jackson Pollock,' *Art News*, February, 1961, p. 58. The question here is not whether or not Jackson Pollock was, in fact, affiliated with the Communist Party in the 1930s, but, simply, if there were enough 'left-wing' connections to make him 'politically suspect' in the eyes of right-wing congressmen.
3 For a more complete history of the right-wing offensive against art in the 1950s and the role of Dondero, see William Hauptman, 'The Suppression of Art in the McCarthy Decade,' *Artforum*, October, 1973, pp. 48–52.

Jane de Hart Mathews

ART AND POLITICS IN COLD WAR AMERICA

PUBLIC PATRONAGE OF THE ARTS, instituted during the depression as a New Deal measure to provide work for the unemployed, was revived in the Cold War years as part of America's struggle against communism. From this fusion of art and politics issued a form of 'free world' advertisement – the cultural exchange program. Ironically, however, the program that was intended to demonstrate that the United States was not a nation of materialists ran afoul of people who were themselves devoted opponents of Communist aggression, but who believed that this effort, in the visual arts especially, contained disturbing evidence of domestic subversion. Recognizing the power of art as a medium of influence and mode of communication, ardent anti-Communists in Congress, notably Michigan Congressman George Dondero, supported by local counterparts, inveighed against works reflecting social commentary that they deemed subversive, whether in an overseas embassy or a local post office, with a zeal scarcely matched since the thirties. Lambasting individual artists who allegedly had Communist associations, they demanded that works by such artists, no matter how innocuous the subject matter, be banned from publicly supported arts institutions and most especially from federally sponsored cultural exchanges. Finally, they attacked modern art itself as an instrument of Communist subversion in terms that blended fact with fantasy.

These three forms of expressing political discontent by focusing on art were really three stages of one process. The initial stage, opposition to social commentary in predominantly representational art, involved at first little more than an objection to the particular message conveyed by artists who used their work to communicate what they perceived as social injustice. The second stage, objection to the political affiliations of the artists, involved a more complicated response because it attempted to link ideology and art in the person of the artist irrespective of the content of specific works. The objection to modern art as Communist conspiracy, the final

Source: 'Art and Politics in Cold War America', *The American Historical Review*, vol. 81, February to December 1976, pp. 762–787. The original included one illustration which has been omitted.

stage, involved a yet more 'sophisticated' thought process, for the assumption was that rejection of traditional ways of seeing form and space inherent in vanguard style of painting implied rejection of traditional world views. Iconoclasm in art, in other words, was assumed to extend to the broader realms of the cultural and social order, threatening ultimately all established norms and values.

Most Americans, to be sure, probably did not like or understand modern or abstract art; but most of them, too, could simply 'take it or leave it.' And certainly most informed opponents of the form would never identify it as part of a Communist conspiracy. Indeed, most Americans would not confuse their esthetic judgment or preferences with political commitments; but some people would do so in a public and dramatic way. And they would demand that others follow their lead in making deviation from their own esthetic canon, not a matter of taste, but of deviation from their standard of 'Americanism.'

Although such a peculiar conflation of politics and esthetics was commonplace in the United States during the late forties and fifties, it would be a mistake to view the assault on modern art solely in political terms, for the inability to tolerate new esthetic values and modes of perception reveals much about the psychological sources of antiradicalism in this country as well as the symbolic significance of public patronage. Since congressional critics were aided by certain representational artists who feared the growing ascendancy of abstract expressionism, their attacks also illuminate the dynamics of the modernist-traditionalist controversy that flared up again in the fifties: politics not only became esthetics but esthetics became politics. To focus on those anti-Communists who made internal subversion a political issue and their alliance with disgruntled traditionalist painters and sculptors, however, is not to suggest a simplistic or invariable correlation between political and esthetic traditionalism – or conversely, political and esthetic radicalism. Rather it affords a unique opportunity to probe some of the pressure behind the impulse to prevent certain modes of art from being styled as 'American' – indeed, to label them as 'un-American.' More specifically, by focusing on this unique esthetic-political continuum, it is possible to show why modern art, which Communists themselves hated and feared no less than their American enemies, should have become emblematic of 'un-Americanism' – in short, cultural heresy.

While opposition to works of art never assumed the proportions in this nation that it did in totalitarian countries, where offending artists often suffered imprisonment as well as loss of official patronage, the impulse to censor was undeniably present in the United States in the Cold War years. The simplest and most direct expression of that impulse involved opposition on political rather than esthetic grounds. Critics objected to the message communicated through immediately perceptible images conveying the artist's convictions about past injustices and present wrongs. Predictably, therefore, criticism developed about the social commentary inherent in such works as Ben Shahn's *Hunger* and Robert Gwathmey's *Work Song* when, in 1946, the State Department purchased its first collection of art for exhibit abroad. But the paintings that drew sharpest attack were not part of that ill-fated collection; rather, they were a part of San Francisco's Rincon Post Office Annex murals.

The controversy, like the murals themselves, was reminiscent of the thirties. One of the last and most expensive ($26,000) of the mural projects initiated by the

Treasury Department's Section of Fine Arts, this 240-foot painting depicting the history of San Francisco was the work of Anton Refregier. An established muralist, whose sketches had been chosen from among those submitted by eighty-one competing artists, Refregier, like most socially conscious artists in that depression decade, believed that art must address itself to contemporary issues and that a mural painting in particular must not be 'banal, decorative embellishment,' but a 'meaningful, significant, . . . powerful plastic statement based on the history and lives of the people.'' His preliminary designs reflected that conviction. Although the jury approving the sketches praised the coherence of the historical element, federal officials were ever mindful that these were public buildings being decorated with public funds.² In such circumstances, the mood was one of caution: artistic freedom had to yield to public accountability. No artist, however distinguished, escaped the 'heavy, if well meaning, hand' of federal supervision.³

Refregier was no exception. There was the usual haggling with officials of the Public Buildings Administration about minor details in the murals as work was resumed after the war. A VFW cap had to be painted out since veterans' groups had protested the presence of a man with such a cap in a strike scene — newspaper pictures to the contrary notwithstanding. By the same token alteration had to be made in a scene that depicted a parade celebrating the winning of the eight-hour day. Officials also objected to the inclusion of a huge head of FDR in a panel on the Four Freedoms, despite the artist's protest that a portrait of the late president was not only historically appropriate but a necessary focal point.⁴ But such changes, while not uncommon on mural projects of the thirties, were insufficient to stifle criticism from civic groups, veterans' organizations, and patriotic and fraternal societies in a nation where concern about Communist subversion had been intensified by the Hiss trial and the 'fall' of China.⁵

When the completed project was finally unveiled in 1949, the L-shaped lobby of the Rincon Annex was panelled with a series of vibrantly colored, generally well-designed and executed paintings that carried San Francisco history from exploration and conquest, past the gold rush, the building of the Union Pacific, the disastrous earthquake and fire, and into the twentieth century and a second World War, culminating in the signing of the UN charter.⁶ Delighted with their artistic quality, the San Francisco Art Association called Refregier's work 'among the most distinguished mural paintings executed in this country in the past generation.'⁷ But other critics, perhaps accustomed to the noncontroversial character of most of California's New Deal art, found little to admire about the muralist or his murals.⁸ Refregier, a United States citizen since 1930, was naturally suspect because of his Russian background and myriad leftist activities.⁹ As for the murals, all twenty-nine panels were done in a kind of stylized realism that resulted in simple, elongated angular figures disturbing to many viewers — 'Frankenstein monsters' was the appellation of a disappointed legionnaire who lamented that such art could never be 'pleasing and uplifting.'¹⁰

If style was offensive, content was more so. Denouncing the paintings as 'artistically offensive,' 'historically inaccurate' and 'subversive,' opponents charged that they cast a 'derogatory and improper reflection' on the character of the great state of California.¹¹ Specifically critics objected to scenes dealing with the California fire and earthquake, vigilante activity, Chinese coolie labor, the Mooney case, and labor

difficulties on the water-front. Such subjects, they complained, placed disproportionate emphasis on violence, racial hatred, and class struggle. Detail was as subversive as the general theme. Making monks 'cadaverous' or 'potbellies' was anticlerical; putting the British flag above the American flag in a panel on World War II was unpatriotic; painting a hammer and sickle on the Soviet flag in the scene depicting the signing of the UN charter was subversive, and portraying the U.S. representative with 'mule's ears' was worse still. So the list went. With even San Francisco's Young Democrats insisting that the presence of such murals in a public building was 'little short of treason,' public officials responded accordingly.[12] In a letter to a California veteran, Representative Richard M. Nixon had previously stated that, while he realized that 'some very objectionable art of a subversive nature' had been allowed to go into federal buildings in many parts of the country, he believed that there was no remedy under the present administration. As [sic] such time as we may have a change in the administration and in the majority in Congress,' he wrote, 'I believe a Committee of Congress should make a thorough investigation of this type of art in Government buildings with a view to obtaining removal of all that is found to be inconsistent with American ideals and principles.'[13] Nixon's fellow California representative, Hubert B. Scudder, agreed.

By 1953, the conditions that Nixon believed necessary obtained: elections the previous fall had swept into office a Republican president and Congress. More important, the Chairman of the House Committee on Public Works was George Dondero. A Michigan Republican who frequently denounced Communism in the arts, Dondero promptly appointed a subcommittee of the Committee on Public Works to consider removal of murals that he considered 'an insult to every loyal American.'[14] Accordingly, Scudder introduced H.J. Resolution 211, which directed the Administrator of General Services to remove the twenty-nine murals on the grounds that: 1. they were derogatory to and an improper reflection on the character of California's pioneers; and 2. they contained Communist propaganda. In hearings before the House subcommittee, Scudder was supported in his effort by a colleague from the House Un-American Activities Committee who read at length from committee files of the many instances when Refregier had lent his name to publications, resolutions, congresses, and organizations listed by the Attorney General as subversive. The Commissioner of Public Buildings, who was responsible for awarding the contract to the Russian-born artist, explained that he personally had never liked the sketches. Most damning, however, were Scudder's own remarks. Charging that the murals were not only historically inaccurate, but 'slanderous' and 'subversive,' he inserted into the record supporting statements from critics charging that the murals failed to depict 'the romance and glory of the West' and tended instead to promote 'racial hatred and class warfare.' Other witnesses seconded his objections, agreeing that the murals did indeed project Communist propaganda.[15]

Opponents of removal had also come prepared. California Congressmen John Shelly, a liberal Democrat, and William Maillard, a moderate Republican, were both outspoken in opposing the resolution of their conservative colleague.[16] Attesting to the accuracy of the murals, Shelly readily admitted that a great deal of California's early history was not to his liking. The Chinese labor riots and the Mooney bombing were historical facts, he said. Moreover, this was not the USSR, where artists were judged on their political views. Representatives of the Bay Citizen's Committee to

Protect the Rincon Annex Murals and various allied groups such as the San Fran-
cisco Museum and the San Francisco Art Association, were also on hand to rebut
Scudder's charges. The Committee, consisting of what the San Francisco *Chronicle*
characterized as an 'imposing array' of leaders in business, finance, the arts, and
society, had been organized in part through the efforts of Grace McCann Morley,
Director of the San Francisco Museum of Art. She was convinced of the flimsy basis
of the arguments for removal and the alarming precedent that it would afford.[17]
Speaking first for the Committee, Attorney Chauncey McKeever submitted a nine-
page statement condemning the resolution. Citing testimony of authorities in the
California Historical Society, he argued that the murals were historically accurate as
well as esthetically sound and politically safe. Though certain minor changes might
be desirable in a few panels, such as the UN scene, to pass the resolution, he insisted,
would be to yield to the prejudice of uninformed pressure groups. Thomas Carr
Howe, Jr., Director of the California Palace of the Legion of Honor, agreed, as did
representatives of the American Federation of Art and Artists Equity. From these
and other nationally based artists' groups the message was the same: regardless of
style, subject matter, or the political beliefs of the artist, to destroy a work of art was
to destroy freedom of expression.[18]

 In the days that followed, supporters of the murals continued to plead their
case. In San Francisco, the *Chronicle* not only covered the controversy fully, devoting
substantial space to a detailed statement attesting to the historical veracity of the
episodes Refregier had chosen to portray, but also editorialized on behalf of preser-
vation, suggesting that the Scudder resolution was reminiscent of events in totali-
tarian societies.[19] And in Washington, the House subcommittee was inundated
with mail — some of it advocating the destruction of murals that functioned as 'an
instrument of Soviet psychological warfare,' but much of it arguing for preservation
of important works of art. Written not only by ordinary San Franciscans, but also by
museum directors and art experts across the country, the letters attacked removal as
'official cultural vandalism.' Arguing on behalf of artistic freedom, Lloyd Goodrich
of the Whitney pointed out that opposition to the murals had come from only 'a few
reactionary elements' in California politics and art. Julian Huxley, former Director-
General of UNESCO, deplored such 'witch-hunting' in the United States. The
murals' removal, he said, was an 'example of the growing tendency' in this country
'to exert political control over freedom of thought and expression.' And from
Artists Equity came the reminder that passage of the Scudder resolution might deal
an irreparable blow to America's cultural standing abroad at precisely the time
federal officials were trying to improve that standing through cultural exchanges.[20]

 The issue was clearly complicated, because Refregier, ever willing to use his art
as political commentary, had deliberately chosen to depict controversial issues such
as the Mooney case and the anti-Chinese riots in the conviction that the public must
be reminded of the 'unfortunate aspects' of its history if such events were not to be
repeated.[21] In the end, however, the subcommittee ruled that removal was an
administrative matter, and since the Commissioner of Public Buildings insisted that
the murals could not be taken down without explicit authorization from Congress,
they remained intact. Still, efforts at censorship persisted, and as late as 1956
California veterans continued to explore strategies for the removal of the murals.[22]
That they persisted was a measure of the intensity of feelings aroused when art was

used by social realists to express the artist's hatred of injustice. That they ultimately failed was a result, at least in part, of the effectiveness with which prominent San Franciscans mobilized themselves and their allies on behalf of artistic freedom, for without such action, anti-Communist crusades leading to patriotic excesses could fast gain momentum in the deteriorating political climate of the early fifties.

Fed by frustrations with a U.S. foreign policy that failed to 'win' diplomatic victories against the Soviet Union, these crusades became increasingly concerned with internal subversion. Predictably, this effort to ferret out the 'enemy within' led to persons who had participated in groups, activities, or causes sponsored by 'Communist-front' organizations during the thirties. Artists were naturally among these suspected subversives, not only because of the content of specific works, but also because of past personal or professional associations. Thus self-styled anti-Communists, operating at this second level of sophistication, attempted in the course of such attacks to unite ideology and art through the person of the artist. Events in Dallas, Texas provided a case in point. That this burgeoning center of new wealth should have become the scene of controversy is hardly surprising. The head-quarters of millionaire H. L. Hunt, the city had been exposed to his national radio and television broadcasts as well as numerous publications such as the *American National Research Report*, which 'named' Communists and 'Communist-front' organ-izations, describing their activities in detail.[23] Another Dallasite, Colonel Alvin Owsley, had begun compiling his own directory in 1921, which, with names from the annual reports of the House Un-American Activities Committee and congres-sional speeches, constituted a formidable list of 'subversives' against which local citizens could check the names of writers, composers, actors, and artists that appeared in local newspapers and museum catalogs.[24] Although certain names had involved the Dallas Museum in a variety of conflicts, the incident that brought the loudest reverberations was the showing of 'Sport in Art.'[25]

Assembled by the American Federation of Art for *Sports Illustrated*, the exhibit was to tour the United States during 1956 before going to Australia under USIA auspices for the Olympics. Two months before its arrival in Dallas, however, local anti-Communists demanded the exclusion of four paintings because of the alleged subversive associations of the artists involved. The four included Ben Shahn's drawing of a baseball game entitled 'National Pastime,' a skating scene by Yasuo Kuniyoshi, another winter scene with ice skaters by Leon Kroll, and a painting of an elderly fisherman by William Zorach.[26] Although Shahn's work, like that of other Social Realists, often served as a means of communicating the artist's political and social values, these particular paintings bore no 'message.' But however innocuous the works themselves, all four artists had been linked to 'front' organizations in the thirties. According to the House Un-American Activities Committee, Shahn, for example, had associated with numerous radical groups, publications, and causes, among them the John Reed Club, the American Artists Congress, the Spanish Refugee Relief Committee, *Masses and Mainstream*, and the National Council of American-Soviet Friendship.[27] Museum trustees nevertheless issued a statement saying that the museum acquired and exhibited works solely on the basis of merit.[28] Supporters also pointed out that the exhibit, which would be cosponsored by Neiman-Marcus, cost local taxpayers nothing.[29] But the museum's critics were in no way mollified. Convinced that the trustees were little better than Communist

'dupes,' and knowing that public funds were funneled through the Park Board to the museum for maintenance, they appealed to the Park Board to ban the exhibit.[30] In subsequent hearings both the identity of these self-styled patriots and the nature of their argument became apparent.

Opponents of the museum's policy were led by the Communism in Art Committee of the Dallas Patriotic Society. The society itself consisted of a federation of some sixteen clubs, principally veterans' groups, patriotic associations, and an assortment of local art clubs.[31] Their presence in the Patriotic Society owed much to the energetic efforts of Reveau Basset, a local resident and traditionalist artist, who frequently spoke to groups of women amateur painters about the dangerous modernist tendencies of the Dallas Museum.[32] By failing to remove the works of Communist artists, they charged, the Dallas Museum was aiding communism, inasmuch as exhibitions in a leading museum gave the artist standing that could be translated into monetary terms. And money, of course, could be contributed to Communist causes that in turn would harm America. There was, spokesmen for the Patriotic Council concluded, a 'well-organized apparatus operating to exhibit the works of Communists, however inferior, in preference to the works of others, however superior.'[33] Unconvinced, the Park Board rejected the request to withdraw 'Sport in Art' amidst mutterings about its members' having gone soft on communism.[34] The exhibit went on as scheduled, though critics stationed themselves beside the pictures in question to warn the public that these were the works of 'Reds.'[35] But any notion that artistic freedom had triumphed was shortlived.

The clamor of the Patriotic Council in Dallas had repercussions in Washington. Fearing congressional criticism, USIA Director Theodore Streibert reversed the decision to send 'Sport in Art' to the Olympics. Moreover, he promptly cancelled an important overseas exhibit of twentieth-century American painting after the American Federation of Art (AFA), which had assembled the exhibit, refused to remove the works of ten artists whom the Agency deemed 'social hazards' by virtue of their 'front' associations.[36] This cancellation, however, was simply the latest in a long line of aborted exhibitions. The State Department had called back an exhibition of American painting as early as 1947, fired the young man who had put it together, and sold off the paintings at auction amidst charges from Congress and the press that twenty of the forty-five artists represented 'various shades of Communism.'[37] Mindful of this history, the AFA had hoped to avert this latest cancellation by persuading the USIA director to refer the matter to the White House. Eisenhower had issued a declaration on artistic freedom two years earlier as a result of the efforts of Alfred Barr and trustees of the Museum of Modern Art, who had used the Museum's twenty-fifth birthday celebration to elicit a presidential statement.[38] The hope was that it might now become more than a paper proclamation. But the AFA was quickly disappointed. Sherman Adams, the president's chief assistant, supported Streibert's decision.[39] In discussing his action, the USIA director explained that if he regarded the artists' politics as irrelevant he would surely face congressional criticism and perhaps jeopardize appropriations for the entire agency.[40] Accordingly, he also cancelled an exhibit put together by the College Art Association because of the inclusion of a Picasso. And in a similar display of caution, the State Department revoked plans for an overseas tour of Toscanini's former NBC Symphony of the Air because 4 of the 101 members of the orchestra were allegedly pro-Communist.

Administration 'cowardice' was attacked on the Senate floor by Hubert H. Humphrey and on the editorial pages of the New York *Times* and the Washington *Post*.[41] In the context of the political climate of the fifties, however, such caution was perhaps understandable.

Though by 1954 Joseph McCarthy's fellow Senators had voted to censure their colleague, the crusade that bore his name had not yet abated. Fears over national security and internal subversion as well as frustrations over the cost and complexity of the Cold War persisted during the Eisenhower years, prompting the administration to extend the loyalty/security programs instituted in the Truman era. Thus preoccupied with the paraphernalia of those programs – the Attorney General's list, the loyalty oaths – a bureaucratic organization such as the USIA was not prepared to invite the suspicions of those congressmen who were ever ready to use appropriations as a coercive tool with which to enforce their own definition of loyalty.

Many ardent anti-Communists were bothered, however, by more than 'Marxist' social commentary in art and 'subversive' political associations of artists. Their *bête noire* was modernism, for the rejection of traditional forms and the commitment to abstraction that characterized vanguard art seemed to impart to their highly structured world the quality of chaos and the demonic that they so easily identified with communism. Thus the charges that the promotion of modern art was part of the Communist conspiracy represented the third and most 'sophisticated' stage of the argument of those who labeled any deviation from their own esthetic canon, not a matter of taste, but a deviation from their standard of 'Americanism.'

A number of congressmen were hostile to modern art, but the representative who most consistently and thoroughly emphasized its intrinsic un-American character was Michigan's George Dondero. A slender, erect man with regular features and thinning gray hair, Dondero inveighed for the better part of a decade against everything from State Department exhibits to artists' unions. The real enemy, however, was modern art and those 'misguided disciples who bore from within to destroy the high standards and priceless tradition of academic art.' With the closely reasoned rhetoric so characteristic of conspiratorial thinking, Dondero argued that modernism had been used against the Czarist government when Trotsky's friend, Wassily Kandinsky, had released on Russians 'the black knights of the isms': cubism, futurism, dadaism, expressionism, constructionism, surrealism, and abstractionism. Each was deadly. Cubism, according to Dondero, aimed to destroy 'by designed disorder'; futurism, 'by the machine myth'; dadaism, 'by ridicule'; expressionism, 'by aping the criminal and insane'; abstractionism, 'by the creation of brainstorms'; surrealism, 'by the denial of reason.' To be sure, socialist realism ultimately prevailed in Russia itself. But the art of the Revolution had been cleverly retained for subversion abroad. Thus from the 'pen-and-brush phalanx of the Communist conspiracy' had come the 'front' organizations of the thirties: the John Reed Clubs, the League of American Writers, the American Artists Congress, and their successors, such as Artists Equity.[42]

Current targets, according to Dondero, were America's cultural centers, which were being infiltrated by modernism with all its 'depravity, decadence, and destruction.' The Museum of Modern Art was a prime example since its origins went back to the Société Anonyme of which Kandinsky himself had been an officer. Nor had Kandinsky been the only revolutionary apostle of modernism invading American to

corrupt its art. A 'horde of foreign art manglers' had descended upon this country just before World War II, spreading their pernicious doctrines. Followers of these 'international art thugs' now included Americans such as Robert Motherwell, William Baziotes, and Jackson Pollock. Thus as followers increased and as American universities turned out museum directors sympathetic to modernism, the danger from foreign 'isms' increased proportionately. Harvard's Fogg Museum, Dondero charged, was one of the worst offenders. The 'effeminate elect' it sent out to run the nation's museums not only discriminated against traditionalists in juried shows, but also paid inflated prices for modern art that they jammed down the throat of an unwilling public. In sum, a 'sinister conspiracy conceived in the black heart of Russia' had become a threat to America's cultural institutions and to those loyal American artists who sought to protect their cultural heritage from the new forms that were the symbols of a foreign ideology. Only if the hard-working, right-thinking patriotic proponents of academic art followed the example of labor unions and ejected Communists, the Michigan Congressman argued, could traditional art be preserved and cultural institutions cleansed.[43]

Simplistic and uninformed, such an attack can be temptingly dismissed as yet another example of what Richard Hofstadter has called the 'paranoid style.' However labeled, Dondero's protest and, more important, the tensions and anxieties behind it cannot be discounted, for to do so would be to ignore the concerns and influence of a fearful and militant minority. For at least some Americans Dondero's was an appealing argument. As in most conspiracy theories, there were sufficient elements of truth to elicit belief from those people who seek to escape the complexity of causation by devising simplistic, face-saving formulas wherein fears can be assuaged and anger externalized. Such people may also have resonated to the anti-intellectual and frankly nativistic overtones of Dondero's address: the characterization of Harvard-produced museum directors as an 'effeminate elect,' the dubbing of this nation's newest emigrés as a 'polyglot rabble.' Certainly there was little question that Dondero's remarks struck a responsive note in people such as Wheeler Williams, the President of the National Sculpture Society and one of the 'real' American artists whom Dondero called to take up arms against this 'horde of foreign art manglers.' Indeed, Williams publicly lamented the fact that the USIA would send abroad works by a 'newly made American' such as Theodore Roszak, while ignoring such established sculptors as the late Daniel Chester French and Augustus Saint-Gaudens.[44]

Undeniably the ethnic and social character of the American art community had changed radically in the early decades of the twentieth century, as first generation Americans, many of them immigrants, flowed into the New York art world. These were the 'newly made' Americans – immigrant sons such as the social realist Jack Levine, who discovered art in a settlement house and fame on the WPA. And there were also the emigrés: the 'notorious' French surrealists, Tanguy, Masson, and Breton; the charismatic John Graham from Russia; Albers and Hofmann from Germany. On the eve of the Nazi invasion, others had followed, among them the great Dutch neoplastic painter and theoretician of abstract art, Piet Mondrian. Thus, by the mid-forties the emigré community virtually encompassed the leaders of every nonrealistic art movement of the twentieth century.[45] Modernist all, this 'polyglot rabble' would help to change the nation's artistic sensibilities far more radically than

had a few *avant-garde* paintings in a New York armory some forty years before. But whether social realist or surrealist, such names and the art they represented were understandingly threatening to the eminently respectable academicians who dominated the National Sculpture Society, the American Artists Professional League, and the National Academy of Design. These groups had long enjoyed a monopoly on official art, and they did not choose to relinquish it. Indeed, the American Artists Professional League issued a 'War Cry' against 'decadent isms,' echoing Dondero in their plaint about the 'sensationalists' who had 'infiltrated *our* large exhibitions, *our* art societies, and *our* museums.'[46] Thus the final perhaps most important appeal was to traditionalists to reassert their hegemony in an art world that was once again caught up in the modernist-traditionalist controversy.

That controversy was, in fact, at the heart of this whole attack on communism in the arts. Raging intensely in the aftermath of the Armory show, then relatively quiescent in the thirties, it flared with renewed vigor against the backdrop of the McCarthy era. While congressional critics of modernism held forth in Washington, Pope Pius XII denounced surrealist and abstract art as 'immoral' and 'enslaving to the spiritual powers of the soul.' In Boston, the Institute for Modern Art changed its name to the less offensive Institute for Contemporary Art, defining neither term precisely, but in the process calling artists to come forward with a 'strong, clear affirmation of humanity.' In New York, when the Metropolitan Museum included modernist work in a large retrospective of recent sculpture, conservative sculptors took the Museum to task for proving hospitable to a movement that 'by destroying an ideal of beauty, endeavor, and discipline in artistic expression' threatened not only art but 'the fundamental freedom of our American way of life.' At the White House, President Truman received assurances that hundreds of 'stifled' realists could be rallied to paint patriotic pictures of America free from the distortion and disharmony inherent in the works of Communist-inspired modernists.

On the defensive once again, the modernists tried to counter the attack. At the New School for Social Research, where a curtain was subsequently placed over an Orozco mural entitled 'Revolutionary Violence,' Stanley Hayter debated the whole modernist-traditionalist issue with fellow artist and social realist George Biddle. An advocate of socially conscious art and an ardent admirer of FDR, Biddle, like many traditionalists, was not conservative in either an esthetic or political sense. And he would never have equated modernism with communism. But he was adamant in his argument that nonobjective art would prove a short-lived fad. Its appeal, he insisted, was the product of 'war neurosis, a dealer-rigged market, and snobbism.' In the pages of the New York *Times* critics continued to explore the issue still further. Aline B. Louchheim had previously deplored the willingness of some traditionalists to make abstract moral judgments about work that was non-representational. Her colleague, Howard Devree, focused more precisely on charges of communism, pointing out that socialist realism, the objective style that dominated official art in the USSR, represented not modernism but its very antithesis. Moreover, he noted a dangerous parallel between the practices of totalitarian regimes under Hitler and Stalin and the current attacks on vanguard art as 'degenerate' stuff deserving suppression and censorship. Alfred Barr, former director of the Museum of Modern Art, elaborated on this theme in a long article, 'Is Modern Art Communist?' pointing out that, on the contrary, abstraction had been damned in Soviet Russia as

decadent formalism since the early twenties. He might also have added that modernism had been subsequently anathema to much of the Communist left, which demanded a didactic art the masses could immediately apprehend. But such defenses of modern art had little impact on its more irrational opponents; the New York *Times* continued to receive letters frequently so 'violent in their phraseology' that some were unprintable.[47]

Why Dondero, who had no training in art or art criticism, should have become the defender of these unhappy traditionalists is unclear. As a congressman, however, he had proved no friend of change; it was a measure of his legislative career that he would oppose Roosevelt's domestic and foreign policy with a rigor and rhetoric that earned him in 1942, after ten years in the House, a place on *The Nation's* list of 'Our Worst Congressmen'—a group distinguished not only by their 'bitterness to the New Deal' but by their 'essentially undemocratic outlook.'[48] Unscathed by this expression of liberal opposition, the Michigan Republican had held fast to his Congressional seat, emerging in the Truman years as an outspoken foe of communism well before he launched his first assault upon abstract artists as agents of the Kremlin. Whatever the element of political opportunism in such attacks, they reflected an intense aversion to nonobjective painting. Although Dondero explained to art critic Emily Genauer that he opposed modern art as 'Communist' because it bred 'dissatisfaction' by virtue of the fact that it was unintelligible to ordinary Americans whose 'beautiful country' it failed to 'glorify,' he also emphasized its distortion, grotesqueness, and meaninglessness, adding privately, 'modern art is a term that is nauseating to me.'[49] This reaction, moreover, was hardly unique if the thousands of letters that eventually poured into his office are an adequate measure of support.[50]

Precisely who Dondero's ideological constituents were is difficult to determine, but they extended far beyond the geographical confines of Michigan's Seventeenth Congressional District and the modest homes of Royal Oak. Dondero himself believed that he had become the spokesman for great numbers of Americans throughout the country who applauded his attacks on modern art as Communist conspiracy. After 1949, few would deny that he had become the single most important congressional 'authority' on communism in art.[51] Moreover, he played that role with the full cooperation of those politically conservative traditionalists who secretly plied him with damaging information about fellow artists,[52] reinforcing in the process the popular identification of modernism with the left.[53]

The potential strength of this alliance of esthetically and politically conservative artists and anti-Communist crusaders had been demonstrated as early as 1947, when the State Department purchased a collection of modern art for an exhibition called 'Advancing American Art,' to be circulated in Europe and Latin America. Although little attempt was made to recognize the struggling abstract expressionists of what would later become the New York School, the collection did include works by such established modernists as Marsden Hartley and Stuart Davis, along with other well-known artists of the period. Recognizing that these seventy-nine paintings had been accumulated within the limitations imposed by an exceedingly modest budget – only $49,000 – most critics agreed with Lloyd Goodrich of the Whitney, who, with few qualifications, called the collection a 'remarkably fine one.'[54] But not so the American Artists Professional League, an organization of 'modern classicists' who

deplored the increasing strength of 'revolutionaries' 'debauching' all that was 'noble in art.' In a letter to Secretary of State James F. Byrnes, they complained that this 'one-sided collection' was tainted with radical European trends 'not indigenous to our soil.' Similar charges came from other artist groups such as the National Academy of Design, Allied Artists, the Salmagundi Club, and the Society of Illustrators.

Echoing their objections, the Hearst press was especially vitriolic in its castigation of this latest federal 'folly.' While the Baltimore *American* complained about the inclusion of works by 'left-wing painters who are members of Red Fascist organizations,' the New York *Journal American* reserved its animus for the paintings themselves, which were described as 'incomprehensible, ugly and absurd,' a 'lunatic's delight.' *Look* magazine joined the fray, as did conservative radio commentator Fulton Lewis, Jr.[55]

Governmental critics were similarly outraged. Referring to this 'sinister' exhibit of modernists, Illinois' Fred Busbey deplored the 'weird,' 'unnatural' depiction of human forms. Georgia's Edward Cox (Democrat) agreed that no sane man could have painted such 'crazy' pictures, while Mississippi's John Rankin (Democrat) suggested that they were 'Communist caricatures . . . sent out to mislead the rest of the world as to what America is like.'[56] The president agreed, at least on the esthetic merits of the exhibit; of a Yasuo Kuniyoshi painting of a circus scene, Truman remarked that 'if that's art, I'm a Hottentot.'[57]

Not surprisingly, the State Department, riddled with charges of subversion and under severe scrutiny from congressional appropriation committees, capitulated, cancelling the exhibition, despite the protests of New York artists, museum officials, dealers, and art journal editors, who deplored the incident as a serious threat to artistic freedom.[58] With the future of the entire Office of International Information and Culture Affairs in doubt, Secretary of State George C. Marshall announced that there would be 'no more taxpayers' money for modern art.'[59] The USIA eventually followed suit. Arguing that the agency was interested in art exhibitions only in so far as they provided 'a means of interpreting American culture to other peoples,' its spokesman insisted that the government 'should not sponsor examples of our creative energy which are nonrepresentational.' Emphatically, he added: 'We are not interested in purely experimental art.'[60] The perception of *avant-garde* art as un-American had now been incorporated into official policy.

Although government officials subsequently modified their stand, hostility to modern art had by no means entirely dissipated when the USIA began plans to send abroad paintings and statuary for the American National Exhibition that Vice-President Richard M. Nixon, was to open in Moscow in the summer of 1959. With talk now of detente with Russia, the agency relaxed sufficiently to include in the four-man jury charged with assembling the exhibit Lloyd Goodrich, Director of the Whitney and a persistent proponent of artistic freedom. Charged with the task of selecting works that would reflect the vitality and variety of American art over the previous forty years, Goodrich and his colleagues naturally included examples of the early modernists and those of the New York School along with social realists, American scene painters, and a variety of others.[61] Anticipating objections, they sought to outmaneuver potential critics by withholding any announcement of the works selected until they were packed for shipping, thus presenting opponents with a kind of *fait accompli*.[62]

Four days after the list was released the sniping began.[63] Naturally, Jackson Pollock's *Cathedral* was critized, as were other 'meaningless abstractions.'[64] Wheeler Williams, appearing before the House Un-American Activities Committee, which was investigating several of the artists involved, called the painting a 'childish doodle.' Fortunately, President Eisenhower declined to act as censor even though he was far more unhappy with Jack Levine's unflattering depiction of a returning general in *Welcome Home*. When asked about the exhibit at a news conference, the president admitted that his favorite was an Andrew Wyeth painting. He went on to say that perhaps future selection committees might include 'one or two people that, like most of us here . . . are not too certain exactly what art is, . . . but know what we like and what America likes.' 'What America likes,' he insisted, 'is after all some of the things that might be shown.'[65] Although it was subsequently decided to send additional traditional works to Moscow, Jack Levine's *Welcome Home*, with its social commentary, and Jackson Pollock's *Cathedral* remained intact. For champions of artistic freedom, Eisenhower's decision, combined with the extensive criticism they were able to marshal against the investigation of the House Un-American Activities Committee, represented a major breakthrough.[66]

Although there would be future cancellations, the old relish for congressional intervention had clearly begun to wane. The USIA, fearful that more subtle pressure would be exerted through budget cuts, remained exceedingly wary through the early sixties, preferring exhibits that produced little publicity and no controversy. Gathering courage, the agency finally ventured into those international competitions, the biennials, but the news that an American artist had won the prize at the São Paulo Bienal in 1963 and again the following year at the Venice Biennale gave USIA officials an acute case of the jitters. The publicity was considerable, and with the top prize going in 1964 to Robert Rauschenberg for one of his painterly photographic collages, the agency was sure that budgetary repercussions would be forthcoming. Although their predictions were not fulfilled, the fears persisted until 1965, when the International Exhibits were moved out of the USIA and into the Smithsonian.[67]

By that time it was apparent that Dondero and his traditionalist allies had been fighting a rear-guard action in their battle against modernism. The esthetic leadership of these artists long since eroded, they ultimately lost political influence as well. Even their temporary victories proved hollow ones, for, in the final analysis, they had been outmaneuvered by more sophisticated individuals eager to capitalize on the fact that *avant-garde* art and culture exist only in a society that is liberal-democratic (politically) and bourgeois-capitalist (socioeconomically).[68] Thwarted by repeated interference in USIA and State Department exhibits throughout the fifties, more enlightened anti-Communists, among them Nelson Rockefeller, had naturally turned to 'mother's museum' and its newly expanded international program.[69] Accordingly, the Museum of Modern Art arranged for U.S. participation in a variety of international exhibits, putting together in the process a major show of abstract expressionist art for circulation in Europe in 1958–59. Entitled 'New American Painting,' the exhibition included a catalog with a comprehensive introduction by Alfred Barr, former Director of the Museum of Modern Art and a long-time advocate of the abstract expressionists. In an essay that subtly reflects the manner in which this self-consciously apolitical vanguard was becoming identified with the

cause of human freedom, their work used as a form of 'benevolent propaganda for foreign intelligentsia.'[70] Barr wrote: 'Indeed one often hears Existentialist echoes in their words, but their 'anxiety', their commitment, their 'dreadful freedom' concern their work primarily. They defiantly reject the conventional values of the society which surrounds them, but they are not politically engagés even though their paintings have been praised and condemned as symbolic demonstrations of freedom in a world in which freedom connotes a political attitude.'[71]

For Dondero and his allies there was irony indeed in that, as New York replaced Paris as the capital of the art world, the painting that earned for this nation unparalleled pre-eminence and prestige was the art of the abstract expressionists. And there was greater irony still in that, through the transmogrifying context of the Cold War, this new generation of New York painters ultimately came to be regarded as the embodiment of the kind of freedom denied their colleagues behind the iron curtain, their works celebrated as quintessentially American.[72] So rapid and complete was this identification that by the mid-sixties modern art itself had somehow become inextricably linked with the United States as if only in America could the *avant-garde* 'spirit' truly flourish. Governmental agencies could at last join private museums and dealers in sending abroad modernist evidence of our creative coming of age – and they did so with little fear of interference.

That such fears should have persisted as long as they did among intelligent public servants, however, is evidence of the zeal and commitment of people who were determined to keep American art recognizably 'American.' If they could not control the power of a militant Russia, then they would at least impose an ideological and esthetic conformity associated with their standard of Americanism on art and artists receiving any form of public patronage. A coalition of esthetically and politically conservative legislators and artists, veterans and patriotic groups, they were always a minority. But the events of the McCarthy era demonstrated with frightening force how much political leverage can be gained from the animosities and passions of a small, but articulate and effective minority. Deeply disturbed by the international domestic tensions that beset Cold War America, they sought security from without by searching for the enemy within. Scrutinizing the whole apparatus of government, education, religion, and the communications media, they focused on the 'front' affiliations of many of this nation's leading artists. What they saw was evidence not of youthful dedication to Marxist ideology or even a persisting affiliation with the Communist Party, but of contemptible collusion with a conspiratorial power that had reduced half of the world to chains. And when they examined the paintings themselves, they found in the works of socially conscious artists a commentary on society and politics that seemed to suggest not so much a personal protest against injustice as visual evidence of disloyalty. As individuals who sought security in a unified nation, they were unable to tolerate the evidence of social cleavage such paintings reflected. A Marxist concept – class conflict – seemed not only patently un-American but personally threatening.

Convinced that national unity and domestic security were jeopardized by art with 'subversive' social commentary and artists with 'front' associations, such people possessed little tolerance for new esthetic forms and values. The rejection of modern art and the argument that it was a weapon in the Communist arsenal, however strained the logic, must be carefully scrutinized for what it reveals about

the psychological character of antiradicalism as well as the symbolic significance of public patronage.

The identification of modern art with foreign influence, like the identification of political and cultural radicalism, is of long standing. When exhibitors displayed hundreds of postimpressionists, fauve, and cubist works before scandalized Americans at the Armory Show in 1913, some leading art critics had been quick to detect a foreign conspiracy in the invasion of 'Ellis Island art,' as one commentator termed the new styles.[73] Ridiculed by culturally sanctioned artists and critics, a small *avant-garde* community struggled in subsequent years to create what it conceived to be an indigeneous American art that would reflect contemporary life, but such efforts met with scant acceptance from the larger society. It was a measure of public intransigence to the new art that in the 1920s, Max Weber, one of the greatest American cubist painters, was so impoverished that he lacked money for paint and canvas.[74] A majority of Americans, literal-minded in their taste, continued to assume that American art must be representational.[75] Never had this identification been more firmly established than in the thirties when many artists, whether rurally oriented regionalists or the more radical urban social realists, sought to detach themselves from 'foreign influence' and immerse themselves in the 'spirit of the land,' capturing the texture of reality in a movement appropriately known as the 'American Scene.'[76] Like their counterparts in fiction, theater, and dance, they sought in a new genre of actuality to record and clarify the American experience in explicit, commonly recognizable images that would make possible immediate identification between picture and audience, artist and public.[77] This effort to capture reality by making art a vehicle for realistically recording places, events, and things, rather than exploring the vast inner landscape of the psyche, coincided, moreover, with a passionate desire of esthetic nationalists for an authetically American art that would rival the great national schools of Europe. It was a significant coincidence and one that would further strengthen the belief that American art was representational art – recognizably American in content, non-European (non-abstract) in style, and democratic in accessibility.[78] Such had been the case in the thirties and forties, and such would be the case in the fifties.

Traditionalists had a stake in seeing that this formula persisted. The hostility to modernism on the part of many traditionalist artists and sculptors had its origins in many sources, but most noticeably economic rivalry and status anxiety. Academic sculptors in organizations such as the National Sculpture Society had long enjoyed a lucrative monopoly on official art. As suppliers of statuary to public buildings and war memorials, they were responsible for those huge Victorias, Columbias, Giants of Trade and Industry, to say nothing of the muscle-bound horses, that abound in state capitals as well as Washington. Conceived in the classic pattern, it was precisely what was calculated to win approval from Washington's Fine Arts Commission.[79]

Though an attachment to recognizable subject matter persisted through the forties and fifties, abstract expressionist or 'action' paintings were exhibited in Peggy Guggenheim's gallery, The Art of This Century, as early as 1943. By 1945, when Jackson Pollock held his second one-man show, the Wyoming-born artist again received enthusiastic endorsement from both James Johnson Sweeney and Clement Greenberg, the latter critic praising him as the 'strongest painter of this generation, perhaps the greatest one to appear since Miró.' By the mid- to

late-forties, abstract expressionists were lauded not only in *Partisan Review, The Nation, Magazine of Art*, and *Art News*, but also in popular magazines such as *Life*. Critical acclaim was naturally followed by museum purchases. The Museum of Modern Art, which bought Pollock's *She Wolf* as early as 1944, picked up paintings by Arshile Gorky and Robert Motherwell two years later. In 1947, a William Baziotes canvas received the major prize at the show of the Chicago Art Institute following its exhibit at the Venice Biennale. Moreover, as the fifties progressed, abstract expressionist painting was bought, shown, lectured on, and talked about by an articulate and vocal generation of artists and critics in more and more museums, colleges, art centers, and magazines. Thus, behind the aggrieved cry of dispossessed traditionalists in the conservative art organizations was the impending reality of vanguard triumph. Understandably threatened economically and stylistically, they made common cause with other Americans to whom modernism in any guise was perceived as threatening.[80]

Although economic rivalry and partisan politics underlay much of the hostility to modern art, it would be a mistake to underestimate the intense hatred of abstraction that permeated the attacks of congressmen such as Dondero and the letter writers who provided them unsolicited support. Clearly, these people were threatened at a very basic level. And the reason why lies not only in their world view but also in the intrinsic characteristics of modern art and most especially abstract expressionism.

The abstract expressionists of the New York School were genuine esthetic revolutionaries – but revolutionaries who were steeped in the modern tradition. Having mastered the esthetic basis of modernism with the help of Hofmann, Albers, Mondrian, and the many surrealists who fled Europe during the war, they rejected existing realistic and geometric tendencies while borrowing the biomorphic shapes, mythic symbols, and automatist technique of the surrealists. The result was not merely an eclectic synthesis of European sources but a highly original style that quite literally extended the frontiers of art. Although landscape and figure elements can be discovered in many works, readily identifiable subject matter was rejected. Turning instead to private visions, insights, and most especially the subconscious, the abstract expressionists plumbed the depths of their own experience for metaphors and symbols that would somehow possess universal meaning. Content thus consisted of ambiguous forms with loosely defined, perhaps even subliminal, multivalent associations arrived at not through prior determination but in the actual process of painting. Gone were the pleasures of easy recognition and the enjoyment of technical dexterity in the imitation of material form and surface so evident in the painting of Andrew Wyeth. Appreciation of abstract expressionism, critic Harold Rosenberg noted, now required a consciousness of history since the art historical reference, especially in 'over-all' abstraction, was often the only content. 'The old pleasure of seeing "life" inside the frame must be augmented, if not replaced,' Rosenberg noted, 'by the stimulation of recognizing an inspired side glance to, say "Les Demoiselles d'Avignon."'[81]

Thus for the untutored viewer, the art of the abstract expressionists was not only subjectless in the traditional sense, but it seemed conspicuously foreign in terms of historical antecedents. And since public consciousness had no part in the work, it was perforce elitist.[82] While this characteristic was widely accepted by

abstract expressionists self-consciously alienated from the middle class, it was ana-thema to frustrated viewers whose very bafflement reminded them that esthetically they had not yet arrived after all – and, indeed, might never make it. Fed the predigested pap of mass culture, they were simply unprepared for the sheer effort required in the process of visual analysis.[83] Opposition, as André Malraux had predicted of any mass public confronting *avant-garde* art, derived not only from ignorance but from an obscure sense of 'betrayal.'[84] Thus rejected and rejecting, many people were no doubt further enraged by the implications of it all: the notion of a hierarchy of taste – the possibility of cultural classes in a democratic state.[85] And there were still other barriers. The art of the abstract expressionists was also perceived as functionless when function was a quality that Americans had traditionally demanded in the visual arts. Indeed their very legitimization in this country had been accom-plished through the attribution of didactic qualities. And perhaps worse still, these canvases with their static masses of color or tangled surfaces of dripped paint provided no indication of the artist's talent or index to his actual labor. Unlike an Andrew Wyeth painting with its photographic rendering of each blade of grass, a Mark Rothko or a Jackson Pollock communicated no evidence of hard work. And as one art critic has noted, respect for hard work amounts to an 'esthetic prejudice' in America.[86]

The elitist character of abstract expressionism, its nonrepresentational quality, its perceived lack of technical dexterity of function and even of meaning are thus but a few of the factors that would understandably make the art of the New York School inaccessible to many, if not indeed most, Americans in the late forties and fifties. But the vast majority of individuals who found such art unintelligible or unattractive might dismiss it simply as 'junk'; they would not respond by calling it decadent, degenerate stuff that was communist inspired. To understand why some Americans would respond in this fashion and do so with an intensity and passion that on occasion rendered their attacks unprintable requires further examination of the art itself and its psychological impact.

These were people, it must be remembered, who were already fearful that traditional American virtues had been undermined by cosmopolitans and intel-lectuals, the old competitive capitalism gradually eroded by Socialist and Commun-ist schemes, and national security compromised by treasonous plots. To compound matters, they were confronted in abstract expressionism by a form of vanguard art characterized by two dimensionality, fluid space, lack of closed shapes, a deliberately unfinished quality, and an 'overall' composition that diffused any notion of focus. Complex, cosmopolitan, and ever-changing, it was intrinsically at odds with the need for certitude and control. Control, moreover, was precisely what was threat-ened by the strong Freudian elements in abstract expressionism. *Avant-garde* Ameri-can painters, as has been previously noted, borrowed heavily from the surrealists, emphasizing the unconscious as a source of imagery and automatism as a technique whereby painting became spontaneous action – a gesture of 'liberation from value – political, esthetic, moral.'[87] Reality in art now embraced not only the outer, objec-tive world of nature and human activity, but also the inner, subjective, psychological world of self. Sophisticated critics such as Ben Shahn could recognize that this inner reality offered a 'rich, almost limitless panorama' – an unparalleled source of images and symbols – while simultaneously deploring the apparent abdication of intention on the part of the artist.[88]

For some of the less sophisticated, the free play of the unconscious could mean only irrationality in its most pejorative sense – the beast within. In a pamphlet significantly entitled *The Animal Stalks*, a realist artist argued that 'the insane and sensual animal aspects of "Modern" art must be as surely repressed as are obscene photographs and narcotics . . . and an art that "feeds" the mind encouraged [lest] the Western World . . . perish.'[89] Although the author would doubtless have resented the comparison, his were sentiments worthy of that notorious Stalinist censor and suppressor of creative thought, Andrei Zhdanov, whose own efforts to stifle modernism in the USSR reflect what one scholar has described as an almost pathological tendency toward repression of the sexual element in art.[90] Like their Soviet counterparts, these American opponents of modernism never underestimated the power of the artist to coerce the senses. Thus, when they lambasted abstract expressionism, they did so out of a compelling, if little understood, need to maintain a rigid view of reality characteristic of what might be called the 'cultural fundamentalist'[91] – a view wherein the irrational was repressed, causation simplified, change controlled, heterogeneity denied, loyalty affirmed, national unity and personal esteem preserved. Precisely how modernism in art, as in other aspects of life, threatened that reality was never fully and satisfactorily delineated by its opponents, but they correctly perceived that it did. The problem, then, was not just one of ignorance but of innate antipathy or, as Renato Poggioli would say, not of 'exegesis but of psychology' for, in the final analysis, the perception of art is essentially a psychophysiological process.[92]

The intensity of opposition becomes more understandable if it is recognized that public patronage, like Prohibition, was a cultural issue fraught with symbolic significance.[93] The fact that the USIA and State Department were sending abroad modern art under official auspices raised the question whether the power and the prestige of the government had been placed now on the side of the modernists. Inasmuch as abstract expressionism symbolized a whole set of cultural values associated with modernism, such patronage served to legitimate those values – to affirm their validity while simultaneously discrediting those associated with cultural fundamentalism. Thus in the contest for social dominance, many traditionalists no longer enjoyed the symbolic satisfaction of being exclusively identified with publicly affirmed values and norms. Confronted with this evidence of declining hegemony and control, some responded with the self-righteous passion of the dispossessed.

That they also responded with charges of communism is hardly surprising when we recognize that communism itself had become for many a symbolic issue that had less to do with a foreign ideology or even the realities of international politics than with the forces of change. For those who responded to the rhetoric of a Joseph R. McCarthy or George A. Dondero, anti-Communism became a call not only for political conservatism but for competitive capitalism, a nativistic nationalism, and religious orthodoxy. Antistatist, antibureaucratic, antiforeign, and anti-intellectual, it was also antimodernist. And in its gallery of 'enemies,' the Museum of Modern Art was as suspect as the National Council of Churches. Indeed, so dominant is this preservatist character that our understanding of an era may well be enhanced if we view the anti-Communist crusade of the fifties and early sixties not just as a political response to legitimate and highly disturbing Cold War problems but also as a revitalization movement designed to eliminate foreign influences and revive traditional values and beliefs in a period of societal stress.[94] In the process of revitalization,

countersubversives focused, as they did in the wake of World War I, on the familiar readily recognizable symbols of Americanism, emphasizing always the concrete, the definite, the unambiguous. And these, of course, were the very qualities that were antithetical to the modern art of the abstract expressionists, with its ambiguous forms, fluid space, open shapes, and multivalent associations. Thus it is hardly surprising that modern art became emblematic of the forces threatening the psychic equilibrium of the anti-Communist right.

Notes

1 Anton Refregier, *Government Sponsorship of the Arts* (New York, 1961), 7. Quoted in Gladys M. Kunkel, 'The Mural Painting of Anton Refregier in the Rincon Annex of the San Francisco Post Office, San Francisco, California' (master's thesis, Arizona State University, 1969), 27.

2 Kunkel, 'Rincon Annex Murals,' 33. Under terms of his contact, Refregier was to revise his preliminary designs until they met the requirements of the Commissioner of Public Buildings, and he was not to proceed with the execution of the murals until the commissioner or his duly authorized representative had given approval.

3 Richard D. McKinzie, *The New Deal for Artists* (Princeton, 1973), 60–61.

4 For details of the VFW controversy, see the San Francisco *Chronicle*, May 17, 1948, and the San Francisco *Examiner*, Oct. 27, 1948. The dispute over the eight-hour day celebration is discussed in William Hauptman, 'The Suppression of Art in the McCarthy Decade,' *Artforum*, 11 (1973): 52. For the Roosevelt portrait controversy, see the *Examiner*, Nov. 14, 1947, and also Refregier's letter to Gladys M. Kunkel quoted in her 'Rincon Annex Murals,' 166. For additional details see Matthew Josephson, 'The Vandals are Here: Art is Not for Burning,' *Nation*, 177 (1953): 244–48; and Amy Robertson. 'Refregier Paints a Mural,' *Art News*, 48 (1949): 32–34.

5 Opponents included the California Council of Republican Women, the DAR, the Native Sons of the Golden West, the American Legion, the VFW, the Sailors' Union, and the Society of Western Artists, a traditionalist group made up largely of commercial illustrators.

6 For a fuller description see Kunkel, 'Rincon Annex Murals.'

7 San Francisco *Chronicle*, Mar. 10, 1953.

8 With the exception of the Coit Tower murals that included certain radical symbols, most federally subsidized art in California during the thirties was 'overwhelmingly bland and noncontroversial,' according to Steven Gelber. See his 'New Deal Art in California' (paper presented at the Apr. 1976 meeting of the Organization of American Historians at St. Louis).

9 *Congressional Record*, 82nd Cong., 2nd Sess. (1952), A3765: San Francisco *Chronicle*, May 21, 1953.

10 Charles E. Plant to W. E. Reynolds, Aug. 28, 1950. George Dondero Papers, Archives of American Art (Washington, D. C.).

11 San Francisco *Chronicle*, May 2, 1953: San Francisco *Examiner*, May 23, 1953.

12 Accusations are detailed in Aline B. Louchheim's articles in the New York *Times*, May 2, 10, 21, 1953, and Alfred Frankenstein's in the San Francisco *Chronicle*, Mar. 10–13, Apr. 3, May 2, 1953.

13 Richard M. Nixon to Charles E. Plant, July 18, 1949, Hudson Walker Papers, Archives of American Art. Nixon appears to have reversed himself somewhat in 1955. When a lithograph called 'Dick McSmear' was removed from the San Francisco Art Festival, Nixon wired that city's Art Commission on behalf of the artist's freedom of expression. See *Art News*, 54 (1955): 7.

14 George Dondero to the Michigan American Legion, Dec. 1, 1956, Dondero Papers.

15 Hearings before the House Subcommittee on Public Buildings and Grounds of the Committee on Public Works on H. J. Res. 211, *Rincon Annex Murals, San Francisco*, 83rd Cong., 1st Sess. (Washington, 1953), 1–42.

16 See Congressional ratings, published in the *ADA World*, 1949–53.

17 San Francisco *Chronicle*, May 1, 1953; Grace Morley to Jane De Hart Mathews, Aug. 19, 1975. Indicative of the insubstantial character of the charges against the murals was the assertion that the artist had painted mule's ears emanating from the head of the U.S. representative in the UN panel. But when the painting was examined *in situ*, the forms in blue behind the figure of the American representative which might conceivably be construed as mule's ears in a photograph of the panel were quickly recognized as swags of the blue drapery that decorated the stage of the San Francisco Opera House, where the Plenary Sessions of the UN were held. Morley's efforts on behalf of the murals are documented in letters such as that of Morley to J. D. Zellerbach, Apr. 10, 1952, Hudson Walker Papers. Zellerbach, who was president of the Crown-Zellerbach Corporation, was only one of the many corporate leaders whose support she sought. For a complete listing of the supporters of the Citizen's Committee, see the *Chronicle*'s May 1 article.

18 *Rincon Annex Murals*, 43ff.

19 San Francisco *Chronicle*, May 1, 18, 1953.

20 I am especially indebted to the Chairman of the House Committee on Public Works for special arrangements to read at the Committee office all correspondence relating to the Scudder resolution. The material, 'Considerations of H. J. Res. 211, 83rd Cong., 1st Sess. (1953): "To direct the Administration of General Services to remove the mural paintings from the lobby of the Rincon Annex Post Office Building. San Francisco, California,"' although a part of Record Group 121 at the National Archives, is not otherwise available. 'The Rincon Annex Murals: A Psychological Warfare Criticism,' a ten-page typed manuscript, is contained in the files, as are the other arguments referred to above in letters from: Alfred H. Barr. Jr., Apr. 21, 1953; Lloyd Goodrich, Apr. 29, 1953; Julian Huxley, Apr. 9, 1953; Lincoln Rothschild, Apr. 22, 1953.

21 Interview with Anton Refregier, Jan. 2, 1975. I am grateful to Helen A. Harrison who conducted the interview for providing me with a transcript.

22 George Dondero to Charles E. Plant, June 29 and Nov. 19, 1956; Dondero to Arthur E. Summerfield. Nov. 19, 1956; Dondero to the Michigan American Legion, Dec. 1, 1956, Dondero Papers.

23 Charlotte Devree, 'The U.S. Government Vetoes Living Art,' *Art News*, 55 (1956), 35.

24 *Ibid.*

25 *Ibid.* According to Devree, the Public Affairs Luncheon Club, a women's group of some 400 members, had previously taken the Dallas Museum to task for its modernist tendencies and for its exhibitions of work by artists with 'known' Communist affiliations. Under the leadership of Stanley Marcus, owner of Neiman-Marcus, the museum's trustees initially resisted the demands of these critics, only to capitulate

when Marcus' successor was in charge. The latter called on Congressman Dondero for advice, circulated lists of 'subversive' artists among museum trustees who, in turn, issued a statement that it was not the museum's policy knowingly to acquire or exhibit works by persons known to be Communist or to have 'front' affiliations. Not surprisingly, two subsequent exhibitions came under attack: 'In Memorium' because twelve of the artists, all recently deceased, had 'leftist associations'; and 'Sculpture in Silver' because of William Zorach's participation. Neither exhibit was federally funded.

26 *Ibid*. The controversy was followed closely by the Dallas *Morning News*, Feb. 1, 3–5, 7, 23, 29, 1956, and the New York *Times*, Feb. 12 and Mar. 4, 1956, sec. 2.

27 Attacks on Shahn's leftist associations, which may be found in Dondero's early speeches, continued through the 'Sport in Art' controversy and culminated in an investigation by the House Un-American Activities Committee. See *Congressional Record*, 81st Cong., 1st Sess. (1949), 11586, and Hearings Before the House Un-American Activities Committee, *The National Exhibition, Moscow*, 86th Cong., 1st Sess. (Washington, 1959), 941–50. Cited hereafter as HUAC Hearings.

28 Dallas *Morning News*, Feb. 1, 1956.

29 *Ibid.*, Feb. 4, 23, 1956.

30 *Ibid.*, Feb. 7, 1956.

31 Included were the DAR, Daughters of 1812, American Legion, VFW, Public Affairs Luncheon Club, Pro-America, 1950 Study Club, Southern Memorial Association. Inwood Lions Club, Matheon Club, Reveau Basset Art Club and Reaugh Art Club.

32 Devree, 'The U.S. Government Vetoes Living Art,' 35.

33 Dallas *Morning News*, Feb. 3, 7, 23, 1956. The leading speech at the Park Board hearing was made by Colonel Alvin Owsley. Other speakers included Colonel John Mayo and B. I. F. McCain, also a Legionnaire and a past president of the Dallas Chamber of Commerce. There is evidence to suggest that Owsley's speech may have been written by a Dallas artist.

34 Dallas *Morning News*, Feb. 29, 1956.

35 Devree, 'The U.S. Government Vetoes Living Art,' 56.

36 Washington *Post and Times Herald*, June 22, 1956.

37 See below, footnotes 54 through 57.

38 Lloyd Goodrich interview, Archives of American Art. The American Federation of Arts, which assembled many of the exhibits circulated abroad by the federal government, had issued its statement that same month. See footnote 17.

39 Goodrich interview.

40 In one of his many speeches attacking government involvement with 'subversive' artists, Dondero praised Dallas citizens for their efforts to prevent the showing of 'Sport in Art.' He would certainly have taken to task the USIA had the exhibit been sent abroad as planned. See the *Cong. Rec.*, 84th Cong. 2nd Sess. (1956), 10419–25. 13774–849.

41 Humphrey was one of the first – and few – Senators to speak out against cancellations. See the *Cong. Rec.*, 84th Cong., 2nd Sess. (1956), 10918–20, 12305–6. Senator William Fulbright also inserted into the *Record* editorials criticizing the USIA from the *Times* and the *Post*. (See A 5602–3.) With the exception of Jacob Javits, most congressmen were silent throughout the decade, taking what Humphrey called in reference to his Senate colleagues a stand 'a little to the left of Grant or McKinley.'

42 *Cong. Rec.* 81st Cong., 1st Sess. (1949), 11584.

43 The traditionalist organizations that Dondero wanted to take action were the National Academy of Design, the American Artists Professional League, Allied Artists of America, the Illustrators' Society, the American Watercolor Society, and the National Sculpture Society. See *Cong. Rec.*, 81st Cong., 1st Sess. (1949), 6375. For a fuller exposition of his ideas on modern art, see *Cong. Rec.*, 81st Cong., 1st Sess. (1949), 11584–87; 84th Cong., 2nd Sess. (1956), 13774–79. See also his speech to the American Artists Professional League on March 30, 1957, 'Communism and Art,' Dondero Papers. According to American Federation of Arts representatives who spoke with Dondero, the Michigan congressman believed not only that museum juries were dominated by modernists, but that art journals and art critics of the metropolitan press were 'undermining the standards of American culture.' See Thomas Parker to [L.C.] Smith, memorandum, Hudson Walker Papers. In fairness, however, one must recognize the extent to which taste and esthetic criteria were and are affected by a few influential museum directors and critics.

44 HUAC Hearings, 916.

45 For a fuller assessment of the immigrants' impact, see Jo Ann Lewis, 'Immigrant artists: who they were and what they did,' *Smithsonian*, 7 (1976): 92–101. Visual evidence of their contribution is contained in the Hirshhorn's exhibition, 'The Golden Door: Artist-Immigrants of America, 1876–1976' (May 20–Oct. 20, 1976).

46 See 'War Cry,' a release of the American Artists Professional League. A copy is printed in HUAC Hearings, 906. Italics mine.

47 New York *Times*, Sept. 6, 1950; 'Boston Goes from "Modern" to "Contemporary",' *College Art Journal*, 7 (1948): 230; 'Contemporary Documents: American Sculpture 1951,' *College Art Journal*, 11 (1952): 280–89; Dale Nichols to Harry S. Truman, Dec. 15, 1950, Nichols File, National Collection of Fine Arts (Washington, D.C.); New York *Times*, May 22, 1953; Feb. 26, 1949. For Biddle's thinking on the issue, see his 'Modern Art and Muddled Thinking,' *Atlantic*, 180 (1947): 58–61. Aline B. Louchheim, '"Modern Art": Attack and Defense,' New York *Times*, Dec. 26, 1948, sec. 2; Howard Devree, 'Modernism Under Fire,' New York *Times*, Sept. 11, 1949, sec. 2; Alfred H. Barr, Jr., 'Is Modern Art Communist?' New York *Times Magazine* (Dec. 14, 1952), 22–23, 28–30; Howard Devree, 'State of the Art World,' New York *Times*, Sept. 17, 1950, sec. 2.

48 Will Chasan, 'Keep Them Out! Our Worst Congressmen,' *The Nation*, 155 (1942): 438–9. Dondero's connection with Father Charles Coughlin was of interest since both lived in Royal Oak. Chasan pointed out that Dondero had inserted material from *Social Justice* in the *Congressional Record* and had in turn been quoted in Coughlin's paper. More important, however, was the close friendship he developed with J. Edgar Hoover in the mid- to late forties. See Carey McWilliams, 'The White House Under Surveillance,' *The Nation*, 174 (1952): 150–1.

49 Emily Genauer, 'Still Life with Red Herring,' *Harper's Magazine*, 199 (1949): 89; Dondero to Charles E. Plant, June 29, Nov. 19, 1956; Dondero to Elizabeth Staples, Feb. 27, 1959, Dondero Papers.

50 Dondero asserted that he had communications from roughly 2,000 individuals and groups concerning his attack on modern art. See Dondero to Arthur B. McQueen, Jan. 7, 1957. The Washington *Evening Star* (Feb. 16, 1957) was less precise, referring simply to thousands of letters.

51 His role was accorded ample publicity upon his retirement from Congress when he was honored by such organizations as the International Fine Arts Council. In a ceremony Vice-President Nixon had agreed to attend, the gold Medal of Honor was

presented to Dondero by Major General U.S. Grant, 3rd. See Helen Bassel to Dondero, Oct. 7, 1965; also 'Dick' (Nixon) to 'George' (Dondero), telegram, Feb. 8, 1957, Dondero Papers. A full account of the ceremony is contained in the *Cong. Rec.*, 85th Cong., 1st Sess., A1172–3. Dondero was also honored by the American Artists Professional League and the Painters and Sculptors Club of Los Angeles.

52 Dorothy Drew, a New York City artist who painted Dondero's portrait when he became chairman of the House Committee on Public Works, provided him with material for his speeches attacking modern art and leftist artists. See Dondero to Dorothy Drew, June 21, Aug. 6, 1957; Jan. 12, 19, 1960; also Wheeler Williams to Dondero, Aug. 27, 1965, Dondero Papers. Dondero took great care to keep this fact from becoming public lest their opponents work their 'bitterness and revenge' on her. See Dondero to Drew, Feb. 5, 1964, Dondero papers.

53 While self-consciously apolitical in the late forties and the fifties, the abstract expressionists had, like most artists in New York in the thirties, been involved in leftist activities of one kind or another. See Harold Rosenberg, *The Anxious Object: Art Today and its Audience* (New York, 1966), 262. Edward Laning recalls a visit to the 8th Street Club, a favorite haunt of the abstract expressionists, where he discovered his former WPA colleagues complaining about representational painting and noted that 'Nelson Rockefeller's Museum of Modern Art took up where the John Reed Club left off.' See Edward Laning, 'The New Deal Mural Projects' in *The New Deal Art Projects: An Anthology of Memoirs*, edited by Francis V. O'Connor (Washington, D.C., 1972), 112. This association of political and esthetic radicalism is explored by Donald D. Egbert, *Socialism and American Art* (Princeton, 1967), and *Social Radicalism and the Arts: Western Europe* (New York, 1970). For the disastrous consequences of such linkage in Germany, see Barbara Miller Lane, *Architecture and Politics in Germany, 1918–1945* (Cambridge, Mass., 1968).

54 A complete listing of the paintings is contained in the *Cong. Rec.*, 80th Cong., 1st Sess. (1947), 5225. For critical opinions, see John D. Morse to William Benton, Oct. 10, 1946, Hudson Walker Papers; Alfred M. Frankfurter, 'American Art Abroad: The State Department's Collection,' *Art News*, 45 (1946): 21–30ff.; and Goodrich interview. Edward Alden Jewell, of the New York *Times*, predictably dissented. His view of the exhibit is of interest because of the tendency of conservatives to link modern art to the political left. See 'Eyes to the Left,' New York *Times*, Oct. 6, 1946, sec. 2.

55 'League Protests to the Department of State,' *Art Digest*, 21 (1946): 32–33; Ralph M. Pearson, 'Hearst, the A.A.P.L. and *Life*,' *Art Digest*, 21 (1946): 25; Peyton Boswell, 'Humor on the Right,' *Art Digest*, 21 (1946): 3; 'Government Tries Again,' *Art Digest*, 22 (1947): 32–33.

56 Hearings before the Subcommittee of the House Committee on Appropriations, *Department of State Appropriation Bill for 1948*, 80th Cong., 1st Sess. (Washington, 1947), 412 ff., and *Cong. Rec.*, 80th Cong., 1st Sess. (1947), 5187–5292.

57 As Robb observed, the Kuniyoshi *Circus Rider* that drew Truman's fire was not one of the more abstract paintings in the collection. See 'Art News from Chicago,' 39.

58 New York *Times*, May 6, 1947; also editorial comment in *Art News*, 46 (1947): 13 and *Art Digest*, 22 (1947): 7, as well as the May 1947 issue of the Artists Equity *Newsletter*. The collection, after being summarily recalled from abroad, was consigned for disposal as war surplus; Lloyd Goodrich arranged for a showing at the Whitney, however, so that prospective buyers from public institutions might see the paintings before purchasing them. Thus they happily escaped the fate of those WPA

oils that were sold by the government for the price of the canvas. See Aline B. Louchheim, 'The Government and Our Art Abroad,' New York *Times*, May 23, 1948, sec. 2. Even this action was criticized by Representative Busbey. See *Cong. Rec.*, 80th Cong., 2nd Sess. (1948), A4115–6.

59 New York *Times*, May 6, 1947.

60 A. H. Berding's statement of USIA policy was enunciated at a meeting of the AFA in October 1953. Although not stated in his original speech a second form of censorship was made public in an article in the Washington *Post and Times Herald* on March 6, 1955, quoting agency policy on the political associations of artists. The USIA refused to exhibit 'works of avowed Communists, persons convicted of crimes involving a threat to the security of the United States, or persons who publicly refuse to answer questions of congressional committees regarding connection with the Communist Movement.' As Alfred Barr ('Letters to the Editor') pointed out, this 1955 statement actually represented a relaxation of censorship as previously practiced by federal agencies that had banned or tried to ban the work of artists obviously less 'subversive' than those who were 'avowed Communists' or who had taken the Fifth Amendment. See 'Artistic Freedom,' *College Art Journal*, 15 (1956): 184–89.

61 For the complete listing of works initially included in the exhibit, the rationale behind their selection. and Senator Philip Hart's defense of the exhibit, see *Cong. Rec.*, 86th Cong., 1st Sess. (1959), 9812–14.

62 Goodrich interview.

63 Representative Francis E. Walter's attack on the exhibit and his charges that thirty-four of the sixty-seven artists represented had affiliations with Communist causes are contained in the *Cong. Rec.*, 86th Cong., 1st Sess (1959), 9746–48. For testimony before Walter and his House Un-American Activities Committee, see HUAC Hearings, 899–963.

64 For the discussion of the Pollock painting, see HUAC Hearings, 915.

65 A complete transcript of Eisenhower's press conference is contained in the New York *Times*, July 2, 1959. Jacob Javits made a far more eloquent speech on behalf of artistic freedom in the Senate where he argued that whether or not one likes modern art it was closely identified with the American scene and should not be removed from the exhibit. 'To send . . . officially dictated art,' he insisted, 'will only be to parrot the performance of their own government.' *Cong. Rec.*, 86th Cong., 1st Sess. (1959), 12548–9. Levine, incidentally, specifically excluded Eisenhower and Omar Bradley from attack, professing great respect for both generals, but not for the military establishment generally.

66 Interview with Lois Bingham, Feb. 17, 1969. Bingham, Chief of the Office for Exhibitions Abroad at the National Collection of Fine Arts, worked in that area during the fifties when International Exhibits were under USIA auspices.

67 *Ibid.*

68 Renato Poggioli has thoughtfully explored the political conditions under which *avant-garde* culture can flourish in *The Theory of the Avant-Garde* (Cambridge, Mass., 1968), 95–109.

69 For the role of the Rockefellers and the Museum of Modern Art, see Eva Cockcroft, 'Abstract Expressionism. Weapon of the Cold War,' *Artforum*, 12 (1974): 39–41. [Chapter 7.]

70 The phrase was used by Max Kozloff in his suggestive 'American Painting During the Cold War,' *Artforum*, 11 (1973): 43–54.[Chapter 6.]

71 Quoted in Cockroft, 'Abstract Expressionism,' 41.

72 Kozloff, 'American Painting During the Cold War.'

73 Barbara Rose, *American Painting Since 1900: A critical History* (New York, 1967), 13. The persistent charge that modern art was 'foreign' is evident in the response to the awarding of the first prize of the Chicago Art Institute to abstract expressionist William Baziotes in 1947. Wrote C. J. Bulliet of the *Daily News*: 'These 'isms' grown stale and sterile in the land of their origin, are further enfeebled crossing the Atlantic.' Bulliet's comment is quoted in Dore Ashton, *The New York School: A Cultural Reckoning* (New York, 1973), 147.

74 Rudi Blesh, *Modern Art U.S.A.: Men, Rebellion, Conquest, 1900–1956* (New York, 1956), 85–86.

75 Lionel Trilling noted a related tendency in American literature wherein liberal intellectuals have followed the Parrington tradition of associating 'reality' with democracy. See his 'Reality in America' in *The Liberal Imagination: Essays on Literature and Society* (New York, 1957), 1–19.

76 Matthew Baigell, *The American Scene: American Paintings of the 1930's* (New York, 1974), 18.

77 *Ibid.* See also William Stott, *Documentary Expression and Thirties America* (New York, 1973).

78 See my 'Art and the People: The New Deal Quest for a Cultural Democracy,' *Journal of American History*, 62 (1975), 334 ff; and Baigell, *The American Scene*, 13, *passim*, 45. That so much of the New Deal art was 'American Scene' in effect gave it an official imprimatur as Baigell has rightly observed.

79 Charlotte Devree, 'Is This Statuary Worth More Than a Million of Your Money?' *Art News*, 54 (1955): 34–37ff.

80 Irving Sandler. *The Triumph of American Painting: A History of Abstract Expressionism* (New York, 1970), 79, 211–12; Rosenberg. *Anxious Object*, 77. It is significant also that Pollock, de Kooning, and Gorky were included in the American exhibit at the 1950 Venice Biennale.

81 Rose, *American Painting Since 1900*, 61, 66, 70–73, 89; Sandler, *Triumph of American Painting*, 1, 3, 29, 62, 92–93; Rosenberg, *Anxious Object*, 77.

82 Gottlieb put the matter succinctly: 'The modern artist does not paint in relation to public needs or social needs – he paints only in relation to his own needs.' See Adolph Gottlieb, 'The Artist and Society,' *College Art Journal*, 14 (1955): 99.

83 The extent to which mass culture has rendered the general public less able to deal with high culture, especially modern art, is explored in a variety of essays in *Mass Culture: The Popular Arts in America*, eds Bernard Rosenberg and David Manning White (Glencoe, 1958). See especially, Irving Howe, 'Notes on Mass Culture,' 499.

84 Quoted in Poggioli, *The Theory of the Avant-Garde*, 180.

85 The hostile response of the 'middlebrow' to the possibility of cultural classes in a democratic state is suggested by Leslie Fiedler in 'The Middle Against Both Ends,' in *Mass Culture*, eds Rosenberg and White, 547.

86 Rose, *American Painting Since 1900*, 43.

87 Harold Rosenberg, *The Tradition of the New* (New York, 1959), 30.

88 Ben Shahn, *The Shape of Content* (Cambridge, Mass., 1957), 43ff. In these Charles Eliot Norton lectures at Harvard, Shahn provides a lucid and perceptive critique of abstract expressionism that belies the notion that such opposition issues only from the political right. His distress at the abdication of intention is shared by Jacques Barzun, who suggests that the progressive elimination of purpose culminating finally

in aleatory art has made it necessary to refer to older genres as 'intentional art.' See Barzun, *The Use and Abuse of Art* (Princeton, 1974), 55.

89 Dale Nichols, *The Animal Stalks* (n.p., 1953), 8. The pamphlet is available in the Nichols File, National Collection of Fine Arts.

90 Maynard Solomon, ed., *Marxism and Art* (New York, 1973), 238.

91 The term 'cultural fundamentalist' has reference to 'culture' in the anthropological sense rather than as a synonym for the fine arts and to 'fundamentalist' in a nonreligious as well as a religious context. The term is not meant to be perjorative. My conception of the term has been influenced by a number of studies, among them: Theodore W. Adorno *et al.*, *The Authoritarian Personality* (New York, 1950); Richard Christie and Marie Jahoda, eds, *Studies in the Scope and Method of the Authoritarian Personality* (Glencoe, Ill., 1954); M. Brewster Smith, Jerome S. Bruner, and Robert W. White, *Opinions and Personality* (New York, 1956); Neil J. Smelser, *The Theory of Collective Behavior* (New York, 1962); and Eric Hoffer's idiosyncratic but provocative *The True Believer* (New York, 1958).

92 Poggioli, *The Theory of the Avant-Garde*, 154. Arnold Hauser has noted in *The Philosophy of Art* that the mass public reacts 'not to what is artistically good or bad but to features that have a reassuring or disturbing effect upon their course of life; they are ready to accept what is artistically valuable provided that it supplies vital value for them by portraying their wishes, their fantasies, their day-dreams, provided that it calms their anxieties and increases their sense of security.' Quoted in Berel Lang and Forest Williams, eds, *Marxism and Art: Writings in Aesthetics and Criticism* (New York, 1972), 274. For an introduction to the psychology of visual perception, see the writings of Rudolf Arnheim, especially *Visual Thinking* (Berkeley, 1969). There is extensive literature documenting the ways in which perceptual behavior is affected by personality. See, for example, Jerome S. Bruner and Cecile C. Goodman, 'Value and Need as Organizing Factors in Perception,' *Journal of Abnormal Psychology*, 42 (1947): 33–44.

93 The analogy between Prohibition and public patronage was suggested by the reading of Joseph Gusfield's *Symbolic Crusade: Status Politics and the American Temperance Movement* (Urbana, Ill., 1963).

94 The most effective treatment of an anti-Communist crusade in terms of a revitalization movement is Stanley Coben's 'A Study in Nativism: The American Red Scare of 1919–1920,' *Political Science Quarterly*, 79 (1964): 52–57. Gregory Guroff of Grinnell College has called my attention to a comparable response in the Soviet Union where real international responsibilities acquired in the years following World War II seemed to engender a similar rejection of cosmopolitan culture and a furiously nationalistic campaign complete with renewed denunciations of nonrepresentational art, atonal music, and nonsocialist realist literature.

David and Cecile Shapiro

ABSTRACT EXPRESSIONISM
The politics of apolitical painting

Abstract art was the main issue among the painters I knew in the late thirties. Radical politics was on many people's minds, but for these particular artists Social Realism was as dead as the American Scene. (Though that is not all, by far, that there was to politics in those years: some day it will have to be told how 'anti-Stalinism,' which started out more or less as 'Trotskyism,' turned into art for art's sake, and thereby cleared the way, heroically, for what was to come.) – CLEMENT GREENBERG, 'The Late Thirties in New York,' 1957, 1960, *Art and Culture* (Boston: Beacon Press, 1961).

accepting the challenge

I

[. . .] in the 1930s a group of left-wing artists in the United States attempted to effect a radical change in artists' self-concepts and in the work they produced. As Marxists they argued that art could and should serve ideological ends, as it had in the past, and in order to discuss and promote ways of achieving political art – art with a 'message' – they organized themselves into groups such as the John Reed Clubs and the American Artists Congress.

The John Reed Clubs especially, led by members of the Communist Party, sought to change the entire structure of the art world, not solely the work produced; they wanted to revamp its goals, ideology, and patrons, with the medieval or Renaissance systems as the models. In the new case, of course, it was the worker organizations, rather than the Church, that were to be patrons. Their art was intended to inform, educate, and radicalize the worker – and it was to be paid for by the trade

Source: *Prospects* 3 (ed.) Jack Salzman, 1977, pp. 175–214. This text has been edited and footnotes have been renumbered. The original article included twelve illustrations, all of which have been omitted. Reprinted by permission of the authors. © David and Cecile Shapiro.

unions. The artist, indeed, was to be educated at art schools oriented toward these same unions. Art, then, was to be by and for the working class. Not only was its content to be proletarian; it was to be readily understood by its patron, the ordinary working man, a stance that immediately suggests an aesthetic. Museums and art schools, as they then existed, were to be shunned – at least in theory – since art was to be redirected along revised class lines. Instead of serving as a luxury product for the pleasure of the upper classes and the affluent bourgeoisie, as it had been and continues to be in industrial capitalism, art was to be at the service of the working class.

This movement, known as Social Realism, became one of the leading art movements of the 1930s, if not the most prominent. Among the artists subscribing to some or all of its tenets were Philip Evergood, William Gropper, and Ben Shahn.[1] Also important and influential during the 1930s were such regionalist painters as Thomas Hart Benton, John Steuart Curry, and Grant Wood, whose art expressed their belief that true American values resided in the Midwest and who hoped to attract their audience there.[2] Although the Regionalists, too, were critical of the art world – the museums, the gallery system, the critics, and European influences – they never called for the overthrow of the system under which the art world functioned. A third group, organized as the American Abstract Artists, which included such painters as George L. K. Morris, Burgoyne Diller, and Carl Holty, worked in the European mode developing from Matisse, Braque, and Picasso, and they attempted to secure greater acceptance for their aims and their art within the framework of the existing art-world system, even to the extent of picketing the infant Museum of Modern Art for neglect. Perhaps the largest single group among American artists during the 1930s were those subsumed under the name American Scene, artists like Reginald Marsh, Peter Hurd, Paul Sample, and Dale Nichols who painted landscapes and genre scenes representing all areas of the country in works that often aimed at bolstering their concept of American values, particularly those perceived as threatened by the struggle to survive the Great Depression. There were yet other painters, quite independent on the whole, of any of these groups – such as Arthur Dove, Georgia O'Keefe, and even Charles Burchfield and Edward Hopper – who continued during these years of economic and world crisis to paint on their own in individual and highly personal manners, less at odds with the art world than hopeful of change, struggling in the meantime to survive and work.

An astonishingly large percentage of the artists painting during the 1930s were at one time or another associated with the federal government's arts projects. As such, many of them joined the Artists Union, which, like any other union, was involved with such matters as working conditions, pay, and job security. For the first time in centuries large numbers of artists were active within an economic organization – the union – that immediately connected them with one another and with the larger society.[3] To this degree these outsiders became insiders like everyone else – the federal government was their patron-employer, their fellow employees the peers with whom they shared self-interest. This unique situation, born of the Depression, was also the stimulant for the art organizations sponsored by the Communist party. Each of the other groups – the Regionalists, the American Scene painters, and the Abstract Artists – polemicized as well, with the result that there was unprecedented political, social, and aesthetic ferment among artists.[4]

Government patronage helped to develop a new audience. Murals, for instance,

were painted in post offices and other public buildings, frequently on themes that deferred to the needs and history of the community. The WPA arts projects distributed large numbers of paintings, prints, and sculpture to such public organizations as schools and museums. (Many of these were so undervalued that they were destroyed or allowed to disappear, but renewed interest in the period has now uncovered important caches.) Adult education art classes, commonplace today, had their beginnings on the projects. Museums showing WPA work reached hitherto untapped audiences.[5] It might readily be argued that the growth of the art audience so widely noticed in the 1960s and 1970s had its origin in the activities of the 1930s.

This, in sum, was the state of the art world in 1939, when Clement Greenberg published his brilliant and prescient essays, 'Avant-Garde and Kitsch' in the *Partisan Review*, a magazine that had broken with its Stalinist, Communist party origins early on to become by the fall of 1939 the leading Marxist, Trotskyist intellectual journal in the United States. Scarcely noticed at the time of publication, but soon to be widely read and discussed, this essay can be considered the manifesto and program for the art movement known today as Abstract Expressionism. Moreover, although nowhere is American art of the 1930s specifically derogated, the essay in our view is a direct response to and attack on the then current schools of American art, particularly Social Realism, and it is an attack which arises as much from political considerations as aesthetic ones, albeit, in this case the two are indeed one. Greenberg, furthermore, as will be detailed below, may have arrived at the ideas expressed in this essay, from his understanding of Leon Trotsky's theories of culture,[6] in much the same way that the Social Realists arrived at their ideas from interpretations of cultural developments and ideology in the Soviet Union, from Lenin and Stalin, and from discussions among Communist writers and theoreticians elsewhere.

Greenberg's contention, in 'Avant-Garde and Kitsch,' is that artists in our Western culture, instead of academically repeating themselves in the decaying present, have produced something previously unheard of: 'avant-garde culture.'[7] [. . .]

The avant-garde represents the opposite of the kitsch; kitsch is the rear guard; it is debased. Kitsch is the 'product of the industrial revolution which urbanized the masses of Western Europe and America and established what is called universal literacy.' In the past, culture belonged to those who had leisure and literacy. 'But with the introduction of universal literacy the ability to read and write became a minor skill like driving a car,' making it more difficult to 'distinguish an individual's cultural inclinations, since it was no longer the concomitant of refined tastes.'

Kitsch is the devalued, watered-down version of high culture, repetitive and self-evidently academic, Greenberg writes. It takes different forms in different countries, so that it can be found in Soviet Russia, where the masses have been 'conditioned to shun "formalism" and to admire "socialist realism."' [. . .] Kitsch is synthetic; it imitates life. Avant-garde art, on the other hand, is a new creation. It adds new forms of life. It is by definition difficult. Its difficulty guarantees that the masses will shun it and the elite will support it. The reaction of the audience becomes a litmus test of the art. 'Avant-Garde and Kitsch,' then, denies as high art all the dominant forms and styles of American art in the 1930s and serves as a guide toward the forms for which it issues a call.

Whatever else is true of Greenberg's essay [. . .] by making the enjoyment of

recondite, hermetic art a cultural test, the avant-garde became attractive, a barrier to be overcome, for those with upwardly mobile aspirations. Who wants to be left standing outside the gardens of the elite? Who can admit to not understanding, if to do so were to cause one to be tagged 'uncultured'? Unlikely as this was to have been Greenberg's intentional effect, the 1939 essay, as well as subsequent ones expanding and reinforcing the argument, plus the presence and influence of the critic among the artists with whom he was acquainted and to whose work he responded person-ally and in print, led to Greenberg's position as the grand guru of Abstract Expres-sionism – one who frequently could make as well as break reputations by means of public discussions or private introductions.

Just a year before Greenberg's piece appeared, Leon Trotsky and André Breton had published an essay, also in the *Partisan Review*, that the younger writer is unlikely to have missed, although at the time he may not have known its true authorship, since this was not publicly revealed until much later. The portions Greenberg seems to have adopted and expanded include the argument against

> those who would regiment intellectual activity in the direction of ends foreign to itself, and prescribe, in the guise of so-called 'reasons of state,' the themes of art. The free choice of these themes and the absence of all restrictions on the range of his explorations – these are the possessions which the artist has a right to claim as inalienable. In the realm of artistic creation, the imagination must escape from all constraint and must, under no pretext, allow itself to be placed under bonds. To those who would urge us, whether for today or tomorrow, to consent that art should submit to a discipline which we hold to be radically incompatible with its nature, we give a flat refusal, and we repeat our deliberate intention of standing by the formula: *complete freedom for art*.[8]

If, Trotsky and Breton write, 'the revolution must build a *socialist* regime with centralized control, to develop intellectual creation an *anarchist* regime of individual liberty should from the first be established. No authority, no dictation, not the least trace of orders from above!'

Trotsky and Breton's lines against 'themes' in art can be seen as preliminary to Greenberg's suggestion that the avant-garde artist turn away from subject matter of common experience. His idea that art cannot be reduced to anything not itself, a commonplace in literary criticism, is another way of saying that art cannot be *reduced* to its theme. [. . .] His expression of the need of the avant-garde to create something 'new' in a sense quite different from Platonic mimesis – and radically different from anything that had existed before in American art – can also be interpreted as a way of escaping from constraint, as Trotsky advised. The meshing of these ideas can be read as the initial formulation of the theory of Abstract Expressionism.

If Greenberg expanded the germ of Trotsky's idea of 'complete freedom for art' into the basis for Abstract Expressionism, the second influential theoretician and spokesman was Harold Rosenberg. His seminal essay, 'American Action Painters,' appeared in *Art News* in 1952, when the movement was sweeping all before it.[9] It was in this article that Rosenberg made his now famous remark that 'what was to go on

canvas was not a picture but an event.' Although the line invites parody, such as Mary McCarthy's quip that you can't hang an event on the wall, its meaning is clear enough when one grants that Rosenberg is saying that it is the act – or the event – of making a picture that takes precedence over what lines or colors or images appear on the resulting object. [. . .]

If the picture is an act, however, 'it cannot be justified as an act of genius in a field whose whole measuring apparatus has been sent to the devil.' The work of art depends not on the 'psychologically given' but on the 'intentional,' which translates it into a '"World" – and thus transcends it.' The role the artist plays now is all important, as is the way he 'organizes his emotional and intellectual energy as if he were in a living situation.' The big moment came, Rosenberg says, when the artist 'decided to paint . . . Just to paint, the gesture on the canvas was a gesture of liberation, from Value – political, aesthetic, moral.'

It may be worth suggesting at this point that the act of repudiating political, moral, and aesthetic values becomes, willy-nilly, an aesthetic both political and moral. In the context of its time it is easy to read Rosenberg as aiming his fire at three specific targets: at the Social Realists, who were 'political'; at the Regionalists and American Scene painters, who were 'moral'; and at the American Abstract Artists, who were 'aesthetic.'

The artist was not, Rosenberg continued in 'American Action Painters,' to defy or condemn society. Such quotidian matters left him 'diffident.' Rather than change the world, the artist made the canvas into a world. By liberating himself from the reality outside the canvas, the artist liberated himself from 'nature, society, and art already there.' [. . .] Since the art cannot be communicated, and the painting 'is not an object nor the representation of an object nor the analysis or impression of it nor whatever else a painting has ever been,' what has it become? A trademark, Rosenberg answers. The artist 'has made himself into a commodity with a trademark,' and this commodity 'informs the populace that a supreme Value has emerged in our time, the Value of the NEW.'

From somewhat different approaches and in different terms, both Greenberg and Rosenberg seem to agree that the artist must be freed from discipline, from the past, and from the public world for subject or even connection. Most especially, both believe in the 'new.'

It is not difficult to posit a link between the cultivation of the perpetually new in art and Trotsky's theory of permanent revolution. This new art, too, is to overthrow that which has gone before. For Greenberg the new art must be difficult enough to shut out all but an elite; for Rosenberg the intention of self-exploration is what counts. To both the image is anathema – for Greenberg not in and of itself, but simply because it is 'easy'; for Rosenberg because it is a leash that yanks the artist out of his private world into the public one. Greenberg says that the cream of the rich, educated class will support the new art; Rosenberg implies something similar for an art with which, he says, even an elite cannot communicate, since the image itself has little significance, reduced as it is to a trademark evoking the artist's name and recording an adventure with paint. How the audience was to distinguish quality within these criteria is not explained – habitually in his essays Greenberg simply *feels* that one piece is superior to another, that the differences in quality are so immediately apparent that there is not much point in discussing them with anyone who does

not instantaneously perceive them as he does. Rosenberg grants at the outset that questions of quality do not enter into the matter because they are irrelevant to the intentions and execution of this new kind of painting, since all standards have been programmatically thrown out of the studio. 'Beauty' and 'truth,' and other such discarded mistresses, have never even been invited to sit on the studio couch.

Yet despite their restricted philosophic and aesthetic baggage – and despite certain leaps out of logic – the two essays became programs for the artists whom they championed, so much so that those artists explaining themselves and their works frequently sounded like quotations from one or another of the two critics. Curiously, however, within this symbiotic relationship between the artists and the critics, there was a constant whine that nobody loves us but us. Or to be more precise, both the artists who were working in the Abstract Expressionist mode and the critics who supported them complained early and late about their neglect, their lack of recognition and support in the art world. But the real case was quite the contrary: not only were the Abstract Expressionists recognized early and widely; they were so strongly promoted and dispersed by the art establishment that to an unprecedented degree, and for more than a decade, they effectively routed other stylistic and philosophic expressions in American painting.

II

As early as 1948, when few of the first generation of Abstract Expressionists had yet had the opportunity for more than one or two solo shows in the new mode, when reviews of this kind of art were thought to merit little more than the standard couple of inches in serious journals or the art magazines, *Life* magazine, then in its heyday with probably the largest circulation in America, devoted pages of text and pictures to a symposium held in the penthouse of the Museum of Modern Art.[10] The participants were fifteen internationally known critics, connoisseurs, museum curators, and directors, among them Clement Greenberg, Meyer Schapiro (associate professor of art at Columbia University), Francis Henry Taylor (then head of the Metropolitan Museum of Art), Raymond Mortimer (a British art critic), George Duthuit (editor of *Transition* and a French critic), H. W. Janson (professor of art at Washington University in St. Louis), Alfred Frankfurter (editor and publisher of *Art News*), A. Hyatt Mayor (curator of prints at the Metropolitan Museum), James Thrall Soby (curator of paintings at the Museum of Modern Art), and James Johnson Sweeney (who directed many exhibitions at the Museum of Modern Art and elsewhere, and in the same year became an advisory editor of the *Partisan Review*). (All of the identifying titles above refer to 1948.)

The participants discussed modern art in general and works by Picasso, Braque, Matisse, and Rouault in particular, but they especially focused on the new paintings by Jackson Pollock, Willem de Kooning, Adolph Gottlieb, and William Baziotes. A long report of their by no means unanimous views, simplified for the unsophisticated reader, was interspersed among generous color reproductions of the works under discussion, most of them owned by the Museum of Modern Art. No movement given this kind of mass-media coverage within less than a decade of its birth can make too great a case for neglect, for even if the magazine was read largely by

those whom Greenberg, as well as more latitudinarian observers, might dub 'uncultured,' the willingness of these top-level art people to devote time to a public consideration of Abstract Expressionism suggests that the movement was taken seriously in high places.

Earlier, a number of 'little' magazines friendly to Abstract Expressionism – among them *Possibilities* (edited by Robert Motherwell with John Cage and Harold Rosenberg and lasting for only one highly influential issue), *Tiger's Eye*, and *Modern Artists in America* – had begun to publish articles and reproductions of work in the new style. The first large-circulation art magazine to become sympathetic to Abstract Expressionism was the *Magazine of Art* (now defunct but then under the powerful auspices of the American Federation of Art), which, between 1948 and 1951, 'ran features on de Kooning, Still, Motherwell, Rothko, Pollock, and Gorky . . . During the 1950s, *Art News* was more sympathetic toward Abstract Expressionism than any other publication. In 1948 a monograph on Hans Hofmann was published, the first on an Abstract Expressionist. It accompanied a retrospective of his painting held at the Addison Gallery of American Art in Andover, Massachusetts (the first major one-man show given by a museum to an Abstract Expressionist) . . . Other books that dealt seriously with the Abstract Expressionist were James Thrall Soby's *Contemporary Painters* (1948); John I. H. Baur's *Revolution and Tradition in Modern American Art*, and Andrew C. Ritchie's *Abstract Painting and Sculpture in America*, both published in 1951. In that year also there appeared the first general book to feature the Abstract Expressionists, [Thomas B.] Hess's *Abstract Painting.*'[11]

In 1949 Denys Sutton wrote a major piece, 'The Challenge of American Art,' for *Horizon* (the English magazine published in London). Sutton, then visiting professor at Yale University, introduced the European community to some of the concepts of the new mode, supported many of its claims, and suggested that it was 'a symbol of youth, adventure, and liberation.'[12]

As to exhibitions, neither in galleries offering work for sale nor in museums did the Abstract Expressionists languish. Between 1946 and 1951 the Betty Parsons, the Samuel Kootz, the Charles Egan, and the Peggy Guggenheim Art of this Century Gallery 'exhibited the Abstract Expressionists in show after show. During the six seasons, for example, Pollock had seven one-man exhibitions; Rothko and Hofmann six; Gottlieb, Baziotes, Reinhardt, and Motherwell, five; Still, four; de Kooning, three; Newman and Franz Kline, two. Taken together, these shows made a strong impression on fellow artists and the art conscious public.'[13]

The catalogue for Pollock's first solo show at Art of this Century in 1943 was written by a man of no less importance than James Johnson Sweeney, who was also one of the members of the jury that year – along with Alfred H. Barr, Jr. (then director of the Museum of Modern Art), James Thrall Soby, Max Ernst, Piet Mondrian, and Marcel Duchamp – for an exhibition called 'Spring Salon for Young Artists' at Art of this Century, in which Pollock was included. Pollock also participated in a 1944 show at the Sidney Janis Gallery featuring abstract and surrealist art, and in 1945 the David Porter Gallery in Washington, D. C., included him, along with most of the first generation Abstract Expressionists, in a group show. In the same year the Arts Club of Chicago gave Pollock a one-man show, again with a catalogue by Sweeney. (For an artist to have this kind of establishment support for his first exhibitions is exceedingly rare.) In fact, Sweeney, always a prolific author on

many phases of modern art, had also published 'Five American Painters' in the April 1944 issue of the fashion magazine *Harper's Bazaar*, commenting on Pollock, Gorky, Matta, and others.

Museums were quick to notice Abstract Expressionism. The Museum of Modern Art bought Pollock's 'She-Wolf' in 1944. In that year the artist was included in the exhibition, selected by Janis, that circulated from the Cincinnati Art Museum to the San Francisco Museum of Art, and from there to museums in Denver, Seattle, and Santa Barbara. In 1944 the Museum of Modern Art's circulating exhibit, 'Twelve Contemporary American Painters,' included Pollock, and Gorky and Motherwell were represented in the 1946 'Fourteen Americans.' By 1947, when Baziotes won a major prize at the Annual of the Art Institute of Chicago, Pollock's works were being shown in a loan exhibition in Winchester, England. In 1948 Pollock was exhibiting at the Venice Biennale, as he was again in 1950 along with de Kooning and Gorky, the Abstract Expressionist portion of the United States Pavilion's show having been selected by Alfred Barr of the Modern under the auspices of the American Federation of Art. All this, and only a partial list at that, occurred in the years *before* Abstract Expressionism is acknowledged to have become important!

The Venice Biennale, in which Pollock and other Abstract Expressionists were exhibited so soon after inventing the new mode, held a special niche in the art world in the years after the war. The Biennale was the international exhibit that attempted to show representative works by the best artists from the largest number of participating nations. It was the exhibit with the greatest panache and prestige, and was well covered by art publications throughout the world. Visits to these exhibitions, furthermore, were among the first opportunities Europeans had after World War II to see the work of contemporary Americans. Artists from countries that had been living under fascism, like Italy and Germany, had not even been permitted to see modern art, American or otherwise, in decades. Their response to whatever was shown by the Western democracies, especially what was shown from a vivid and lusty America, was immense. Indeed, their needs tended to make them sympathetic with whatever new art they saw and to do their utmost to identify with it. It is worth noting, however, that these Venice Biennales were not representative of American art in the sense of constituting a cross-section of what was being done here, or even representative of the 'best' art as most established curatorial or critical opinion might then have selected it. That is, the choices made in 1950 by Barr (and by Alfred M. Frankfurter of the non-Abstract Expressionist painters Lee Gatch, Hyman Bloom, and Rico Lebrun) would have been totally different if made, say, by Francis Henry Taylor or Daniel Catton Rich. This is not the same as saying that tastes differ, which of course is true. It is to say, though, that if a literary Venice Biennale had been held in 1950, American critics of every taste probably would have felt impelled to include Faulkner and Hemingway, even if it meant excluding newer writers. To omit them would have been as arbitrary as were the American art choices.

By the early 1950s the bibliography on Abstract Expressionism and its individual practitioners was growing by geometric progression, and the galleries showing their work were increasing annually [. . .]

By 1954 a visiting English critic could write that

at the start of last season I counted eighty-one New York galleries, showing contemporary art, of which only seven were exhibiting painting that could be called realist in the loosest sense. What happens? Trained by their abstract teachers, and confronted with a market-place hostile to anything outside abstract distortion, the young students excusably turn into model exempla of run-of-the-mill abstraction. What is more, the national salons and fellowship donors sedulously encourage abstract distortion and ugliness. Very few prizes are won by realist works at leading annuals, while beautiful paintings are severely handicapped . . . And then a sincerely concerned museum director, like Mr. Herman More of the Whitney, comes along, surveys the field, and tells the *Times* art editor that he sees very little realism around, and so cannot in all conscience represent much of it in his annual.'[4] [. . .]

Large numbers of artists swung over to Abstract Expressionism during the 1950s, thus contributing to the force of the movement they were joining because they could not beat it.

By 1959, John Canaday noted in the *New York Times*,

Abstract Expressionism was at the zenith of its popularity, to such an extent that an unknown artist trying to exhibit in New York couldn't find a gallery unless he was painting in a mode derived from one or another member of the New York School . . .

But still, at that time, a critic not entrenched in the New York scene could find himself in a painful situation when he suggested that Abstract Expressionism was abusing its own success and that the monopolistic orgy had gone on long enough. It is painful for anyone to be declared a pariah by his colleagues whose opinions, even if they contradict his own, he respects; it is unpleasant when an anonymous voice tells you to watch out because 'we're laying for you when you leave the office.' Anonymous letters are always nasty. But in 1959, for a critic to question the validity of Abstract Expressionism as the ultimate art form was to inspire obscene mail, threatening phone calls, and outraged letters to the editor signed by eminent artists, curators, collectors, and critics demanding his discharge as a Neanderthal throwback.'[5]

III

The most surprising fact about American art in the 1950s is the dearth of well-written published material critical of or hostile to Abstract Expressionism. Since a conspiracy is entirely unlikely – even Senator Joe McCarthy never claimed to have uncovered any in the art world – more likely possibilities must be examined [. . .]

Abstract Expressionism, of course, can in no way be equated with McCarthyism, although the conformism that pervaded the decade goes a long way toward explaining the power of each. But while McCarthyism was the expression of a vicious political authoritarianism, Abstract Expressionism might better be described as

anarchist or nihilist, both antipodes of authoritarianism, in its drive to jettison rules, tradition, order, and values. 'Things fall apart; the center cannot hold; mere anarchy is loosed upon the world,' Yeats prophetically wrote. Anarchist Abstract Expressionism and neofascist McCarthyism ruled in their separate spheres during the same period, and the fact that their control was almost complete for a time makes it fair to suggest certain parallels.

If the atmosphere of the times and the support of the leading critics, museums, and art publications helped Abstract Expressionism to reach an unprecedented vogue that stifled other forms during the 1950s, there were other stimulants to its success as well. The GI Bill for veterans and a new prosperity meant that schools, in this case mainly college art departments, were expanding and thus catching as young faculty the first wave of artists trained as Abstract Expressionists. They, in turn, taught the next generation of art students, a group substantially larger than ever before in our history. The varied modes of art noticeable during the 1930s and 1940s were virtually untaught and unrepresented during the 1950s for more reasons than that they seemed tired and perhaps old-fashioned in a postwar world. Unlike earlier periods, all art seemed to be funneled toward one type of expression [. . .] the lever that lifted Abstract Expressionism to the peak it achieved as the quasi-official art of the decade, suppressing other kinds of painting to a degree not heretofore conceivable in our society, was an arm of the United States government. [. . .]

The United States Information Agency, which as time went on was to sponsor a great deal of American art, worked within an official censorship policy which ruled that our government was not to support nonrepresentational examples of our creative energy nor circulate exhibitions that included the work of 'avowed communists, persons convicted of crimes involving a threat to the security of the United States, or persons who publicly refuse to answer questions of Congressional committees regarding connection with the communist movement.'[16]

Among the artists and organizations attacked at some point by one congressional committee or another were the Los Angeles City Council, the Dallas Museum, the Metropolitan Museum, the American Federation of Art circulating exhibit called '100 American Artists of the Twentieth Century,' the Orozco murals at the New School for Social Research, the Diego Rivera murals in Detroit, and the Anton Refregier mural created with federal funds for the Rincon Annex Post Office in San Francisco.[17]

Almost any style, then, was a potential target for congressional pot-shots, ranging from that which was explicitly political and/or executed by artists involved with sociopolitical affairs, to art that categorically denied any possibility of ideological communication. Yet despite the problems, Abstract Expressionism became the style most heavily dispensed by our government, for reasons that were in part explained by Thomas W. Braden in a 1967 article that appeared under the title 'I'm Glad the C.I.A. Is Immoral' in the *Saturday Evening Post*.[18]

Braden, executive secretary of the Museum of Modern Art for a short period in the late 1940s, joined the Central Intelligence Agency as supervisor of cultural activities in 1951, and remained as director of this branch until 1954. Recognizing that congressional approval of many of their projects was 'as likely as the John Birch Society's approving Medicare,' he became involved with using such organizations as the Institute of Labor Research and the National Council of Churches as fronts in the

American cold war against communism here and abroad. The rules that guided the CIA allowed them to 'use legitimate existing organizations; disguise the extent of American interest; protect the integrity [*sic*] of the organization by not requiring it to support every aspect of official American policy.'[19] Braden said that 'we placed one agent in a Europe-based organization of intellectuals called the Congress for Cultural Freedom.'[20] The agent remained for many years as executive director, another CIA agent became editor of *Encounter*. When money was needed to finance these projects it was supplied by the CIA via paper organizations devised for that purpose. Commenting on these activities years later, Conor Cruise O'Brien said that the 'beauty of the operation . . . was that writers of the first rank, who had no interest in serving the power structure, were induced to do so unwittingly.'[21] The same might be said of the Abstract Expressionists, and perhaps of the critics and museum personnel supporting them. In any case, Braden, possibly taking his aesthetic cue from his Museum of Modern Art years, supported the export of Abstract Expressionism in the propaganda war. It appears likely that he agreed with Greenberg's 1949 remark, the purport of which became for a time the American twentieth-century version of the discredited 'white man's burden,' which held – apropos art – that this country, 'here, as elsewhere . . . has an international burden to carry.'[22] Backed by money available to the CIA and supportive of Abstract Expressionism, Braden's branch became a means of circumventing Congress and sending abroad art-as-propaganda without federal intervention.

In his study of one of the organizations infiltrated by the CIA, the Congress for Cultural Freedom, Christopher Lasch wrote that

> especially in the fifties American intellectuals, on a scale that is only beginning to be understood, lent themselves to purposes having nothing to do with the values they professed – purposes, indeed, that were diametrically opposed to them.
>
> The defection of intellectuals from their true calling – critical thought – goes a long way toward explaining not only the poverty of political discussion but the intellectual bankruptcy of much historical scholarship. The infatuation with consensus; the vogue of disembodied 'history of ideas' divorced from considerations of class or other determinants of social organization; the obsession with 'American Studies' which perpetuates a nationalistic myth of American uniqueness – these things reflect the degree to which historians have become apologists, in effect, for American national power in the holy war against communism . . .
>
> The prototype of the anti-communist intellectual in the fifties was the disillusioned ex-Communist, obsessed by the corruption of Western politics and culture by the pervasive influence of Stalinism and by a need to exorcise the evil and expiate his own past.[23]

Lasch's description fits both Greenberg and Rosenberg, who wrote articles supporting Abstract Expressionism for CIA-subsidized journals as well as others. (*Partisan Review*, according to Lasch, was one of those journals that for a time was sponsored by the CIA.) Their published material had a great deal to do with the

acceptance of the style by other intellectuals in the 1950s. It is also worth remarking in this connection that the word 'American' drums repeatedly in the titles of essays sympathetic to Abstract Expressionism: 'The Present Prospects of American Painting and Sculpture,' 'American Action Painting,' 'American Type Painting,' 'The New American Painting,' 'Is Abstraction Un-American?' – the last a peculiarly 1950s-type question. It is not surprising, Lasch says, that these cold war intellectuals became affluent as well as powerful as their usefulness to the government, corporations, and foundations became apparent, 'partly because the Cold War seemed to demand that the United States compete with communism in the cultural sphere as well as in every other.'[24]

The Abstract Expressionists were used in the 1950s in a series of international exhibitions, sponsored by the International Council of MOMA, whose purpose appears to have coincided with the aims of government bodies.[25] (This may be a good place to note that from 1954 to 1962 the U.S. Pavilion in Venice was the property of the Museum of Modern Art, the only such national pavilion privately owned.) 'The functions of both the CIA's undercover operations and the Modern Museum's international programs were similar,'[26] [. . .]

Although the artists who made this art were generally no longer political (including those who had been at some time in the past), they were on the whole in accord with official policy, not only in its fixation on the Communist menace but also in their disdain for figurative art; especially the left-wing political art of the Social Realists in America. If these factors did not entirely allay qualms about their employment as part of the establishment propaganda apparatus, they could take comfort, as artists inevitably do, in the exhibition record. Few are ever likely to argue about the purposes for which their paintings are exhibited just so long as they are in fact widely and regularly shown.

A vocal portion of the art world, moreover, was cockily triumphant about the splash American art was making abroad for the first time. As the Luce publications proclaimed, this was to be the American century. We had emerged from the war unscathed; we had the biggest and best of everything. We wanted the rest of the world to know it, and to know that it was all due to our true-blue goodness, our planning, and our form of government. The new world had invented a new art which lay claim to epitomizing a new freedom.

Yet another reason suggests itself for the speed with which government and museums cooperated in arranging exhibitions of Abstract Expressionism abroad. Social Realism, widely exhibited until World War II, is programmatically critical of capitalism. Its stated aim, in fact, is to serve as an instrument in the social change that will disestablish capitalism. The Museum of Modern Art had on occasion exhibited and purchased works of certain Social Realists and continued to do so for a time after the emergence of Abstract Expressionism. Indeed, in 1946 MOMA had shown Social Realist Ben Shahn's work in a retrospective that established his reputation. But they may now have been relieved to be helped off a hot spot, for it should not be forgotten that MOMA, like most American museums, was founded and funded by extremely rich private collectors, and MOMA was still actively supported by the Rockefellers, a clan as refulgent with money and power as American capitalism has produced.

These people, to paraphrase Churchill, had no wish to preside over the

dismantling of the economic system that had served them so well. It is likely that related reasons influenced other museums, which, after varying periods of hesitation, joined in support of Abstract Expressionist art. (Many other elements, of course, were operative as well.) Museums backed up exhibitions of the new mode with massive purchases of work by living artists on a scale that had never before been approached. 'It was a kind of instant history, and quickly a sampling of their works was to be found in most museums,' wrote Joshua Taylor, director of the National Collection, Smithsonian Institution.[27] Earlier the rule had been for museums to be extremely chary of acquiring work by living artists. Now museums not only splurged on canvases sold to them at ever-augmenting prices; the trustees who had authorized the acquisitions became collectors of the new art. 'Trustees often urged the museum to acquire works by the very artists they were collecting, thus helping to bolster their own taste,' Daniel Catton Rich has observed.[28] Even curators – giving rise to ethical problems – functioned as public taste makers and private clients.

Thus it came about that the critics and their theories, the art publications as well as the general press, the museums led by the Museum of Modern Art, the avant-garde art galleries, the clandestine functions of the CIA supported by the taxpayer, the need of artists to show and sell their work, the leveling of dissent encouraged by McCarthyism and a conformist era, the convergence of all varieties of anti-Communists and anti-Stalinists on a neutral cultural point, the cold war and the cultural weapons employed in its behalf, American postwar economic vigor and its sense of moral leadership, plus the explosion of a totally new kind of American-born painting that seemed the objective correlative of Greenberg's early announcement that 'the main premises of Western art have at last migrated to the United States'[29] – all these combined to make Abstract Expressionism the only art acceptable on a wide scale during the conforming 1950s.

The rise of Abstract Expressionism to its leadership of the avant-garde, and from there to its position of official art, is replete with irony. First, because the very term 'avant-garde,' as proudly vaunted as Baudelaire's 'modernism,' was first used in art by *socialist* artists in the nineteenth century, and its meaning then was very close to what we have come to call Social Realism. 'Avant-garde' as cultural vanguard was used in an 1845 essay in the following way:

> Art, the expression of Society, reveals in its highest forms the most advanced *social* tendencies; it is a precursor and herald. Now, to know whether an art worthily fulfills its proper mission as initiator, if an artist is really at the *avant-garde*, one must know where humanity is heading, what is the destiny of the species . . . *strip nude with a brutal brush all the ugliness, all the garbage that is at the base of our society.*[30]

Or, as the French socialist philosopher Henri de Saint-Simon wrote twenty years earlier,

> It is we, artists, who will serve you as *avant-garde* [in the struggle toward socialism]: the power of the arts is in fact most immediate and most rapid: when we wish to spread new ideas among men, we inscribe them on marble or canvas.[31]

The paradox is here [handwritten margin note]

It is ironic, too, that an apolitical art that arose at least in part as a reaction to didactic art, as an 'art-for-art's-sake' antidote to 'art-as-a-weapon,' should have become a prime political weapon. As Max Kozloff wrote in 1973, in the 1950s the art establishment saw this kind of art as the 'sole trustee of the avant-garde spirit, a belief so reminiscent of the U.S. Government's notion of itself as the lone guarantor of capitalist liberty.'[32] It is also an irony that an art indifferent to morality became the prime example of the morality of free expression, and that an art foreswearing aesthetics came to be used as the originator of a new aesthetic.

And perhaps the final irony is that instead of reigning for a thousand years, as Adolph Gottlieb had predicted,[33] it lasted as king for a decade, with pop art – the epitome of the banal and the glorification of kitsch – its immediate successor. Jack had killed the giant, but the giant arose again, deformed, stronger, with greater pretensions, and flexing muscles never dared before. Pop, as everyone knows, has been succeeded by op, minimal, conceptual, photorealism, and more yet – but each of these in one way or another either derives from Abstract Expressionism or is a violent reaction against it, so that the disruption caused by the dominance of Abstract Expressionism for its decade will be felt not only in American art but all over the world throughout this century.

Notes

1 David Shapiro, 'Social Realism Reconsidered,' in *Social Realism: Art as a Weapon*, ed., David Shapiro (New York: Ungar, 1973), pp. 3–35.

2 Thomas Hart Benton, 'Answers to Ten Questions,' in Shapiro, *Social Realism*, pp. 100–101. Originally this essay appeared in *Art Digest*, March 15, 1935, in response to an attack made by Stuart Davis in *The Art Front* on nationalism in art and the Regionalists in particular. *The Art Front* was the journal of the Artists' Union.

3 Stuart Davis, 'The Artist Today: The Standpoint of the Artists' Union,' in Shapiro, *Social Realism*, pp. 111–17. Reprinted from the *American Magazine of Art*, August 1935. Davis said that 'this article deals with the artistic, social, and the economic situation of the American artist in the field of fine arts, regarding the situation in the broadest possible way, and does not intend to stigmatize individuals except as they are the name-symbols of certain group tendencies.' He ends the essay by saying that 'an artist does not join the Union merely to get a job: he joins it to fight for his right to economic stability on a decent level and to develop as an artist through development as a social human being.'

4 Irving Sandler, *The Triumph of American Painting* (New York: Harper & Row, 1970), p. 7.

5 Holger Cahill, *New Horizons in American Art* (New York: Museum of Modern Art, 1936), pp. 9–41. A catalogue of an exhibition surveying one year's activity of the Federal Art Project of the Works Progress Administration, this book is a valuable source for the ideas and intent of the Federal Art Project as seen by Cahill, its national director.

6 André Breton and Diego Rivera, 'Manifesto Towards a Free Revolutionary Art,' *Partisan Review*, 6 (Fall 1938), 49–53. Translated by Dwight MacDonald. Republished in *Theories of Modern Art*, ed., Herschel B. Chipp (Berkeley: Univ. of California, 1968), pp. 483–97. Although when originally published the essay was

signed by Breton and Diego Rivera, its authorship was clarified by Breton in a letter to Peter Selz dated February 12, 1962[. . .] 'This text, in its entirety, was drawn up by Leon Trotsky and me, and it was for tactical reasons that Trotsky wanted Rivera's signature substituted for his own. On page 40 of my work, La Clé des champs [Paris: Sagittarie, 1953], I have shown a facsimile page of the original manuscript in additional support of this rectification.' Chipp, Theories, pp. 457–58.

7 Clement Greenberg, 'Avant-Garde and Kitsch,' Art and Culture (Boston: Beacon Press, 1965), pp. 3–21 [see Chapter 1]. All quotations in this essay are from the 1965 collection. The original essay appeared in the Partisan Review in 1939. There were many changes in the text published in the Partisan Reader (New York: Dial Press, 1946), pp. 378–89, among them the omission of the final paragraph [. . .]

8 Breton and Rivera (i.e., Trotsky), 'Manifesto,' in Chipp, Theories, p. 485. Trotsky's view of culture in this essay differs from that presented in his earlier 'Literature and Revolution,' first published in Russian in 1923, and in English in 1925. Portions of this English translation are excerpted in Chipp's Theories.

9 Harold Rosenberg, 'American Action Painters,' Art News, December 1952, pp. 22–23, 48–49 [. . .]

 The content of this essay accounts in part for the intense rivalry between Rosenberg and Greenberg. In response to 'American Action Painting' Greenberg published 'American Type Painting' (Partisan Review, 22 [Spring, 1955], 179–96). Rosenberg brought their differences into the open in 'Action Painting: A Decade of Distortion' (Art News, December 1961, rpt. in Encounter, May 1963). Greenberg answered with 'How Art Writing Earns Its Bad Name' (Encounter, December 1962) and 'After Abstract Expressionism' (Art International, October 1962). Rosenberg's reply was 'After Next, What?' (Art in America, April 1964).

10 Life (October 11, 1948), pp. 56 ff.

11 Sandler, Triumph of American Painting, pp. 211–12.

12 Denys Sutton, 'The Challenge of American Art,' Horizon (London) October 1949, pp. 268–84 [. . .]

13 Sandler, Triumph of American Painting, p. 211. 'I have really had amazing success for the first year of showing a color reproduction in the April Harpers Bazaar – and reproductions in the Arts and Architecture,' Pollock wrote in a letter to his brother Charles. Quoted by Francis V. O'Connor, Jackson Pollock (The Museum of Modern Art, New York: 1967), p. 33.

14 Geoffrey Wagner, 'The New American Painting,' Antioch Review (March–June 1954). Both Greenberg and Rosenberg responded to this article with anger and contempt in letters published in the following issue of the Antioch Review.

15 John Canaday, 'A Critic's Valedictory: The Americanization of Modern Art and Other Upheavals,' New York Times, August 8, 1976. Some of the letters referred to were published in the New York Times, September 6, 1959, and more were reprinted along with them in Canaday's Embattled Critic (New York: Farrar, Straus, 1962).

16 William Hauptman, 'The Suppression of Art in the McCarthy Decade,' Artforum, October 1973, p. 49.

17 Ibid., pp. 50–51.

18 Thomas W. Braden, 'I'm Glad the C.I.A. Is Immoral,' Saturday Evening Post, May 20, 1967, pp. 10 ff.

19 Ibid., p. 11.

20 Ibid.

21 Christopher Lasch, 'The Cultural Cold War,' in *Towards a New Past, Dissenting Essays in American History*, ed., Barton J. Bernstein (New York: Pantheon, 1968), p. 353.

22 Clement Greenberg, 'Art Chronicle: A Season of Art,' *Partisan Review* (July–August 1949), 414.

23 Lasch, 'Cultural Cold War,' pp. 323, 336.

24 Ibid., p. 344. His statement about the CIA and the *Partisan Review* is on p. 335.

25 Russell Lynes, *Good Old Modern: An Intimate Portrait of the Museum of Modern Art* (New York: Atheneum, 1973), p. 384. MOMA's international exhibition program, Lynes said, was 'to let it be known especially in Europe that America was not a cultural backwater that the Russians, during the tense period called "the cold war," were trying to demonstrate that it was.'

26 Eva Cockcroft, 'Abstract Expressionism, Weapon of the Cold War,' *Artforum*, June 1974, p. 40 [see Chapter 7, p. 150].

27 Joshua C. Taylor, 'The Art Museum in the United States,' in *On Understanding Art Museums*, ed., Sherman E. Lee (Englewood Cliffs, N.J.: Prentice-Hall, 1975), p. 60.

28 Daniel Catton Rich, 'Management, Power, and Integrity,' in Lee, *On Understanding Art Museums*, p. 137.

29 Clement Greenberg, 'Art Chronicle: The Decline of Cubism,' *Partisan Review* (March 1948), p. 369.

30 James S. Ackerman, 'The Demise of the Avant-Garde: Notes on the Sociology of Recent American Art,' *Comparative Studies in Society and History* 2 (October 1969), 375n. (Italics added.) Ackerman quotes from Renato Poggioli, *Theory of the Avant-Garde* (Cambridge, Mass.: 1968). The original lines were written by Gabriel-Desiré Laverdant, a follower of the socialist Fourier.

31 Ackerman, 'Demise of the Avant-Garde,' p. 375n. Ackerman is quoting from Donald Egbert, 'The Idea of the Avant-Garde in Art and Politics,' *American Historical Review*, 70 (1967). (Italics added.)

32 Max Kozloff, 'American Painting During the Cold War,' *Artforum*, May 1973, p. 44 [see Chapter 6, p. 131].

33 Selden Rodman, *Conversations with Artists* (New York: Capricorn Books, 1961), p. 87.

Chapter 10

Focal role of Greenberg, Haacment (any minimal counterparts?)

Serge Guilbaut

THE NEW ADVENTURES OF THE AVANT-GARDE IN AMERICA

Greenberg, Pollock, or from Trotskyism to the New Liberalism of the 'Vital Center'

translated by Thomas Repensek

WE NOW KNOW THAT the traditional make-up of the avant-garde was revitalized in the United States after the Second World War. In the unprecedented economic boom of the war years, the same strategies that had become familiar to a jaded Parisian bourgeoisie were skillfully deployed, confronted as they were with a new bourgeois public recently instructed in the principles of modern art.

Between 1939 and 1948 Clement Greenberg developed a formalist theory of modern art which he would juxtapose with the notion of the avant-garde, in order to create a structure which, like that of Baudelaire or Apollinaire, would play an aggressive, dominant role on the international scene.

The evolution of Greenbergian formalism during its formative period from 1939 to 1948 cannot be understood without analyzing the circumstances in which Greenberg attempted to extract from the various ideological and aesthetic positions existing at the end of the war an analytical system that would create a specifically American art, distinct from other contemporary tendencies, and international in import.

When we speak about Greenbergian formalism, we are speaking about a theory that was somewhat flexible as it began clearly to define its position within the new social and aesthetic order that was taking shape during and after the war; only later would it solidify into dogma. We are also speaking about its relationship to the powerful Marxist movement of the 1930s, to the crisis of Marxism, and finally to the

Source: 'The New Adventures of the Avant-Garde in America', *October* 15, Winter 1980, pp. 61–78. Reprinted by permission of the author and M.I.T. Press, Cambridge, Mass. This article is a revised and expanded version of a paper delivered at the *Conference on Art History and Theory; Aspects of American Formalism*, Montreal, October 1979. This text has been edited, and footnotes have been renumbered.

complete disintegration of Marxism in the 1940s – a close relationship clearly visible from the writings and ideological positions of Greenberg and the abstract expressionists during the movement's development. Greenbergian formalism was born from those Stalinist-Trotskyite ideological battles, the disillusionment of the American Left, and the de-Marxification of the New York intelligentsia. [. . .]

De-Marxification really began in 1937 when a large number of intellectuals, confronted with the mediocrity of the political and aesthetic options offered by the Popular Front, became Trotskyites. Greenberg, allied for a time with Dwight MacDonald and *Partisan Review* in its Trotskyite period (1937–1939), located the origin of the American avant-garde venture in a Trotskyite context: 'Some day it will have to be told how anti-Stalinism which started out more or less as Trotskyism turned into art for art's sake, and thereby cleared the way heroically for what was to come.'' When the importance of the Popular Front, its voraciousness and success are taken into account, it is hardly surprising that Trotskyism attracted a certain number of intellectuals. The American Communist party's alliance with liberalism disillusioned those who sought a radical change of the political system that had been responsible for the Depression. This alliance prepared the stage for revolution. [. . .]

It was the art historian Meyer Schapiro who initiated the shift. In 1937, abandoning the rhetoric of the Popular Front as well as the revolutionary language used in his article 'Social Bases of Art,' in which he emphasized the importance of the alliance between the artist and the proletariat,' he crossed over to the Trotskyite opposition. He published in *Marxist Quarterly* his celebrated article 'Nature of Abstract Art,''' important not only for its intelligent refutation of Alfred Barr's formalist essay 'Cubism and Abstract Art,''' but also for the displacement of the ideology of his earlier writing, a displacement that would subsequently enable the Left to accept artistic experimentation, which the Communist Popular Front vigorously opposed.

If in 1936, in 'Social Bases of Art,' Schapiro guaranteed the artist's place in the revolutionary process through his alliance with the proletariat, in 1937, in 'Nature of Abstract Art,' he became pessimistic, cutting the artist off from any revolutionary hope whatsoever. For Schapiro, even abstract art, which Alfred Barr and others persistently segregated from social reality in a closed, independent system, had its roots in its own conditions of production. The abstract artist, he claimed, believing in the illusion of liberty, was unable to understand the complexity and precariousness of his own position, nor could he grasp the implications of what he was doing. By attacking abstract art in this way, by destroying the illusory notion of the artist's independence, and by insisting on the relationships that link abstract art with the society that produces it, Schapiro implied that abstraction had a larger signification than that attributed to it by the formalists.

Schapiro's was a two-edged sword: while it destroyed Alfred Barr's illusion of independence, it also shattered the Communist critique of abstract art as an ivory tower isolated from society. The notion of the nonindependence of abstract art totally disarmed both camps. Leftist painters who rejected 'pure art' but who were also disheartened by the Communist aesthetic, saw the 'negative' ideological formulation provided by abstract art as a positive force, a way out. It was easy for the Communists to reject art that was cut off from reality, isolated in its ivory tower. But if, as Schapiro claimed, abstract art was part of the social fabric, if it reacted to

conflicts and contradictions, then it was theoretically possible to use an abstract language to express a critical social consciousness. In this way, the use of abstraction as critical language answered a pressing need articulated by *Partisan Review* and *Marxist Quarterly*: the independence of the artist vis-à-vis political parties and totalitarian ideologies. An opening had been made that would develop (in 1938 with Breton-Trotsky, in 1939 with Greenberg, in 1944 with Motherwell)[5] into the concept of a critical, avant-garde abstract art. The 'Nature of Abstract Art' relaxed the rigid opposition of idealist formalism and social realism, allowing for the reevaluation of abstraction. For American painters tired of their role as propagandizing illustrators, this article was a deliverance, and it conferred unassailable prestige on the author in anti-Stalinist artistic circles. Schapiro remained in the minority, however, in spite of his alignment with J. T. Farrell, who also attacked the vulgar Marxism and the aesthetic of the Popular Front in his 'Note on Literary Criticism.'[6]

In December 1937, *Partisan Review* published a letter from Trotsky in which he analyzed the catastrophic position of the American artist who, he claimed, could better himself, caught as he was in the bourgeois stranglehold of mediocrity, only through a thorough political analysis of society. He continued:

> Art, which is the most complex part of culture, the most sensitive and at the same time the least protected, suffers most from the decline and decay of Bourgeois society. To find a solution to this impasse through art itself is impossible. It is a crisis which concerns all culture, beginning at its economic base and ending in the highest spheres of ideology. Art can neither escape the crisis nor partition itself off. Art cannot save itself. It will rot away inevitably — as Grecian art rotted beneath the ruins of a culture founded on slavery — unless present day society is able to rebuild itself. This task is essentially revolutionary in character. For these reasons the function of art in our epoch is determined by its relation to the revolution.[7] [. . .]

Trotsky and Breton's analysis, like Greenberg's, blamed cultural crisis on the decadence of the aristocracy and the bourgeoisie, and placed its solution in the hands of the independent artist; yet they maintained a revolutionary optimism that Greenberg lacked. For Trotsky, the artist should be free of partisanship but not politics. Greenberg's solution, however, abandoned this critical position, as well as what Trotsky called eclectic action, in favor of a unique solution: the modernist avant-garde.[8] In fact, in making the transition from the political to the artistic avant-garde, Greenberg believed that only the latter could preserve the quality of culture against the overwhelming influence of kitsch by enabling culture to continue to progress. Greenberg did not conceive of this cultural crisis as a conclusion, as had been the case during the preceding decade, that is, as the death of a bourgeois culture being replaced by a proletarian one, but as the beginning of a new era contingent on the death of a proletarian culture destroyed in its infancy by the Communist alliance with the Popular Front, which *Partisan Review* had documented. As this crisis swiftly took on larger proportions, absorbing the ideals of the modern artist, the formation of an avant-garde seemed to be the only solution, the only thing able to prevent complete disintegration. Yet it ignored the revolutionary aspirations that had burned

so brightly only a few years before. After the moral failure of the Communist party and the incompetence of the Trotskyites, many artists recognized the need for a frankly realistic, nonrevolutionary solution. Appealing to a concept of the avant-garde, with which Greenberg was certainly familiar, allowed for a defense of 'quality,' throwing back into gear the progressive process brought to a standstill in academic immobility – even if it meant abandoning the political struggle in order to create a conservative force to rescue a foundering bourgeois culture.

Greenberg believed that the most serious threat to culture came from academic immobility, the Alexandrianism characteristic of kitsch. During that period the power structure was able to use kitsch easily for propaganda purposes. According to Greenberg, modern avant-garde art was less susceptible to absorbtion, not, as Trotsky believed, because it was too critical, but on the contrary because it was 'innocent,' therefore less likely to allow a propagandistic message to be implanted in its folds. Continuing Trotsky's defense of a critical art 'remaining faithful to itself,' Greenberg insisted on the critical endeavor of the avant-garde, but a critique that was directed inward, to the work itself, its medium, as the determining condition of quality. Against the menacing background of the Second World War, it seemed unrealistic to Greenberg to attempt to act simultaneously on both a political and cultural front. Protecting Western culture meant saving the furniture.

'Avant-Garde and Kitsch' was thus an important step in the process of de-Marxification of the American intelligentsia that had begun around 1936. The article appeared in the nick of time to rescue the intellectual wandering in the dark. After passing through a Trotskyite period of its own, *Partisan Review* emphasized the importance of the intellectual at the expense of the working class. It became preoccupied with the formation of an international intellectual elite to the extent that it sometimes became oblivious to politics itself. [. . .]

Greenberg's article should be understood in this context. The delicate balance between art and politics which Trotsky, Breton, and Schapiro tried to preserve in their writings, is absent in Greenberg. Although preserving certain analytical procedures and a Marxist vocabulary, Greenberg established a theoretical basis for an elitist modernism, which certain artists had been thinking about since 1936, especially those associated with the American Abstract Artists group, who were also interested in Trotskyism and European culture.[9]

'Avant Garde and Kitsch' formalized, defined, and rationalized an intellectual position that was adopted by many artists who failed fully to understand it. Extremely disappointing as it was to anyone seeking a revolutionary solution to the crisis, the article gave renewed hope to artists. By using kitsch as a target, as a symbol of the totalitarian authority to which it was allied and by which it was exploited, Greenberg made it possible for the artist to act. By opposing mass culture on an artistic level, the artist was able to have the illusion of battling the degraded structures of power with elitist weapons. Greenberg's position was rooted in Trotskyism, but it resulted in a total withdrawal from the political strategies adopted during the Depression: he appealed to socialism to rescue a dying culture by continuing tradition. 'Today we no longer look towards socialism for a new culture – as inevitably as one will appear, once we do have socialism. Today we look to socialism *simply* for the preservation of whatever living culture we have right now.'[10] The transformation functioned perfectly, and for many years Greenberg's article was

used to mark the beginning of the American pictorial renaissance, restored to a preeminent position. The old formula for the avant-garde, as was expected, was a complete success.

The appearance of 'Avant-Garde and Kitsch' coincided with two events that threw into question the integrity of the Soviet Union – the German–Soviet alliance and the invasion of Finland by the Soviet Union – and which produced a radical shift in alliances among Greenberg's literary friends and the contributors to *Partisan Review*. After the pact, many intellectuals attempted to return to politics. But the optimism which some maintained even after the alliance was announced evaporated with the Soviet invasion of Finland. Meyer Schapiro could not have chosen a better time to interrupt the self-satisfied purrings of the Communist-dominated American Artist's Congress and create a split in the movement. He and some thirty artist colleagues, in the minority because of their attempt to censure the Soviet Union, realized the importance of distancing themselves from an organization so closely linked not only to Stalinism, but also the social aesthetic of the Popular Front.

And so the Federation of American Painters and Sculptors was born, a non-political association that would play an important part in the creation of the avant-garde after the war, and from which would come many of the first-generation painters of abstract expressionism (Gottlieb, Rothko, Pousette-Dart). After the disillusion of 1939 and in spite of a slight rise in the fortunes of the Popular Front after Germany attacked Russia in June of 1941, the relationship of the artist to the masses was no longer the central concern of major painters and intellectuals, as it had been during the 1930s. With the disappearance of the structures of political action and the dismantling of the Works Progress Administration programs, there was a shift in interest away from society back to the individual. As the private sector reemerged from the long years of the Depression, the artist was faced with the unhappy task of finding a public and convincing them of the value of his work. After 1940 artists employed an individual idiom whose roots were nevertheless thoroughly embedded in social appearance. The relationship of the artist to the public was still central, but the object had changed. Whereas the artist had previously addressed himself to the masses through social programs like the WPA, with the reopening of the private sector he addressed an elite through the 'universal.' By rediscovering alienation, the artist began to see an end to his anonymity, as Ad Reinhardt explained, 'Toward the late '30s a real fear of anonymity developed and most painters were reluctant to join a group for fear of being labeled or submerged.'" [. . .]

Nineteen forty-three was a particularly crucial year, for quietly, without shock, the United States passed from complete isolationism to the most utopian internationalism of that year's best-seller, *One World* by Wendell Wilkie.'" Prospects for the internationalization of American culture generated a sense of optimism that silenced the anticapitalist criticism of some of its foremost artists. In fact, artists who, in the best tradition of the avant-garde, organized an exhibition of rejected work in January 1943, clearly expressed this new point of view. In his catalogue introduction Barnett Newman revealed a new notion of the modern American artist:

> We have come together as American modern artists because we feel the
> need to present to the public a body of art that will adequately reflect the

new America that is taking place today and the kind of America that will, it is hoped, become the cultural center of the world. This exhibition is a first step to free the artist from the stifling control of an outmoded politics. For art in America is still the plaything of politicians. Isolationist art still dominates the American scene. Regionalism still holds the reins of America's artistic future. It is high time we cleared the cultural atmosphere of America. We artists, therefore, conscious of the dangers that beset our country and our art can no longer remain silent.'³

This rejection of politics, which had been reassimilated by the propagandistic art of the 1930s, was, according to Newman, necessary to the realization of international modernism. His manifest interest in internationalism thus aligned him – in spite of the illusory antagonism he maintained in order to preserve the adversary image of the avant-garde – with the majority of the public and of political institutions.

The United States emerged from the war a victorious, powerful, and confident country. The American public's infatuation with art steadily increased under the influence of the media. Artists strengthened by contact with European colleagues, yet relieved by their departures, possessed new confidence, and art historians and museums were ready to devote themselves to a new national art. All that was needed was a network of galleries to promote and profit from this new awareness. By 1943 the movement had begun; in March of that year the Mortimer Brandt Gallery, which dealt in old masters, opened a wing for experimental art, headed by Betty Parsons, to satisfy the market's demand for modernity.'⁴ In April 1945, Sam Kootz opened his gallery. And in February 1946, Charles Egan, who had been at Ferargil, opened a gallery of modern art, followed in September by Parsons, who opened her own gallery with the artists Peggy Guggenheim left behind when she returned to Europe (Rothko, Hofmann, Pollock, Reinhardt, Stamos, Still, Newman). Everything was prepared to enter the postwar years confidently.

The optimism of the art world contrasted sharply with the difficulties of the Left in identifying itself in the nation that emerged from the war. In fact, as the newly powerful middle-class worked to safeguard the privileges it had won during the economic boom, expectations of revolution, even dissidence, began to fade among the Communist party Left. And the disillusions of the postwar period (the international conferences, the Truman administration, the Iron Curtain) did nothing to ease their anxiety. What began as a de-Marxification of the extreme Left during the war, turned into a total de-politicization when the alternatives became clear: Truman's America or the Soviet Union. Dwight MacDonald accurately summarized the desperate position of the radical Left: 'In terms of "practical" political politics we are living in an age which consistently presents us with impossible alternatives . . . It is no longer possible for the individual to relate himself to world politics . . . Now the clearer one's insight, the more numbed one becomes.''⁵

Rejected by traditional political structures, the radical intellectual after 1939 drifted from the usual channels of political discourse into isolation, and, utterly powerless, surrendered, refused to speak. Between 1946 and 1948, while political discussion grew heated in the debate over the Marshall Plan, the Soviet threat, and the presidential election in which Henry Wallace and the Communists again played

an important part, a humanist abstract art began to appear that imitated the art of Paris and soon began to appear in all the galleries. Greenberg considered this new academicism[16] a serious threat, saying in 1945:

> We are in danger of having a new kind of official art foisted on us – official 'modern' art. It is being done by well intentioned people like the Pepsi-cola company who fail to realize that to be for something uncritic- ally does more harm in the end than being against it. For while official art, when it was thoroughly academic, furnished at least a sort of chal- lenge, official 'modern' art of this type will confuse, discourage and dissuade the true creator.[17]

During that period of anxious renewal, art and American society needed an infusion of new life, not the static pessimism of academicism. Toward that end Greenberg began to formulate in his weekly articles for the *Nation* a critical system based on characteristics which he defined as typically American, and which were supposed to differentiate American from French art. This system was to revive modern American art, infuse it with a new life by identifying an essential formalism that could not be applied to the pale imitations of the School of Paris turned out by the American Abstract Artists. Greenberg's first attempt at differentiation occurred in an article about Pollock and Dubuffet[18] [. . .]

Greenberg emphasized the greater vitality, virility, and brutality of the American artist. He was developing an ideology that would transform the provin- cialism of American art into internationalism by replacing the Parisian standards that had until then defined the notion of quality in art (grace, craft, finish) with American ones (violence, spontaneity, incompleteness).[19] Brutality and vulgarity were signs of the direct, uncorrupted communication that contemporary life demanded. American art became the trustee of this new age.

On March 8, 1947, Greenberg stated that new American painting ought to be modern, urbane, casual, and detached, in order to achieve control and composure. It should not allow itself to become enmeshed in the absurdity of daily political and social events. That was the fault of American art, he said, for it had never been able to restrain itself from articulating some sort of message, describing, speaking, telling a story:

> In the face of current events painting feels, apparently, that it must be epic poetry, it must be theatre, it must be an atomic bomb, it must be the rights of man. But the greatest painter of our time, Matisse, pre- eminently demonstrated the sincerity and penetration that go with the kind of greatness particular to twentieth century painting by saying that he wanted his art to be an armchair for the tired business man.[20]

For Greenberg, painting could be important only if it made up its mind to return to its ivory tower, which the previous decade had so avidly attempted to destroy. This position of detachment followed naturally from his earlier critical works (1939), and from many artists' fears of participating in the virulent political propaganda of the early years of the Cold War. It was this integration that Greenberg

attempted to circumvent through a reinterpretation of modernist detachment – a difficult undertaking for artists rooted in the tradition of the 1930s who had so ruthlessly been made a part of the social fabric. The central concern of avantgarde artists like Rothko and Still was to save their pictorial message from distortion: 'The familiar identity of things had to be pulverized in order to destroy the finite associations with which our society increasingly enshrouds every aspect of our environment.'[21]

Rothko tried to purge his art of any sign that could convey a precise image, for fear of being assimilated by society. Still went so far as to refuse at various times to exhibit his paintings publicly because he was afraid critics would deform or obliterate the content embedded in his abstract forms. In a particularly violent letter to Betty Parsons in 1948, he said:

> Please – and this is important, show them [my paintings] only to those who may have some insight into the values involves, and allow no one to write about them. NO ONE. My contempt for the intelligence of the scribblers I have read is so complete that I cannot tolerate their imbecilities, particularly when they attempt to deal with my canvases. Men like Soby, Greenberg, Barr, etc. . . . are to be categorically rejected. And I no longer want them shown to the public at large, either singly or in group.[22]

The work of many avant-garde artists, in particular Pollock, de Kooning, Rothko, and Still, seemed to become a kind of un-writing, an art of effacement, of erasure, a discourse which in its articulation tried to negate itself, to be reabsorbed. There was a morbid fear of the expressive image that threatened to regiment, to petrify painting once again. Confronted with the atomic terror in 1946, Dwight MacDonald analyzed in the same way the impossibility of expression that characterizes the modern age, thus imputing meaning to the avant-garde's silence. 'Naturalism is no longer adequate,' he wrote, 'either esthetically or morally, to cope with the modern horror.'[23]

Description of nuclear destruction had become an obscenity, for to describe it was to accept it, to make a show of it, to represent it. The modern artist therefore had to avoid two dangers: assimilation of the message by political propaganda, and the terrible representation of a world that was beyond reach, unrepresentable. Abstraction, individualism, and originality seemed to be the best weapons against society's voracious assimilative appetite.

In March 1948, when none of the work being shown in New York reflected in any way Greenberg's position, he announced in his article 'The Decline of Cubism,' published in *Partisan Review*, that American art had definitively broken with Paris and that it had finally become essential to the vitality of Western culture. This declaration of faith assumed the decline of Parisian cubism, he said, because the forces that had given it birth had emigrated to the United States.

The fact that Greenberg launched his attack when he did was not unrelated to certain political events and to the prewar atmosphere that had existed in New York since January of that year.[24] The threat of a Third World War was openly discussed in the press; and the importance accorded by the government to the passage of the

European Recovery Plan reinforced the idea that Europe – France and Italy – was about to topple into the Soviet camp. What would become of Western civilization? Under these circumstances, Greenberg's article seemed to rescue the cultural future of the West:[25]

> If artists as great as Picasso, Braque and Léger have declined so griev-ously, it can only be because the general social premises that used to guarantee their functioning have disappeared in Europe. And when one sees, on the other hand, how much the level of American art has risen in the last five years, with the emergence of new talents so full of energy and content as Arshile Gorky, Jackson Pollock, David Smith – then the conclusion forces itself, much to our own surprise, that the main prem-ises of Western art have at last migrated to the United States, along with the center of gravity of industrial production and political power.[26]

New York's independence from an enfeebled, faction-ridden Paris, threatened by communism from within and without, was in Greenberg's eyes necessary if modern culture was to survive. Softened by many struggles and too much success, the Parisian avant-garde survived only with difficulty. Only the virility of an art like Pollock's, its brutality, ruggedness, and individualism, could revitalize modern cul-ture, traditionally represented by Paris, and effeminized by too much praise. By dealing only with abstract-expressionist art, Greenberg's formal analysis offered a theory of art that finally brought 'international' over to the American side.

For the first time an important critic had been aggressive, confident, and devoted enough to American art to openly defy the supremacy of Parisian art and to replace it on an international scale with the art of Pollock and the New York School. Greenberg dispensed with the Parisian avant-garde and placed New York at the center of world culture. From then on the United States held all the winning cards in its struggle with communism: the atomic bomb, a powerful economy, a strong army, and now artistic supremacy – the cultural superiority that had been missing.

After 1949 and Truman's victory, the proclamation of the Fair Deal, and the publication of Schlesinger's *Vital Center*, traditional liberal democratic pluralism was a thing of the past. Henry Wallace disappeared from the political scene, the Communist party lost its momentum and even at times ventured outside the law. Victorious liberalism, ideologically refashioned by Schlesinger, barricaded itself behind an elementary anticommunism, centered on the notion of freedom. Aes-thetic pluralism was also rejected in favor of a unique, powerful, abstract, purely American modern art, as demonstrated by Sam Kootz's refusal to show the French-influenced modern painters Brown and Holty.[27] Individualism would become the basis for all American art that wanted to represent the new era – confident and uneasy at the same time. Artistic freedom and experimentation became central to abstract-expressionist art.[28]

In May 1948, René d'Harnoncourt presented a paper before the annual meeting of the American Federation of Art in which he explored the notion of individuality, explaining why – his words were carefully chosen for May 1948 – no collective art could come to terms with the age. Freedom of individual expression, independent of any other consideration, was the basis of our culture and deserved protection and

even encouragement when confronted with cultures that were collectivist and authoritarian.

> The art of the twentieth century has no collective style, not because it has divorced itself from contemporary society but because it is part of it. And here we are with our hard-earned new freedom. Walls are crumbling all around us and we are terrified by the endless vistas and the responsibility of an infinite choice. It is this terror of the new freedom which removed the familiar signposts from the roads that makes many of us wish to turn the clock back and recover the security of yesterday's dogma. The totalitarian state established in the image of the past is one reflection of this terror of the new freedom.[29]

The solution to the problems created by such alienation was, according to d'Harnoncourt, an abstract accord between society and the individual:

> It can be solved only by an order which reconciles the freedom of the individual with the welfare of society and replaces yesterday's image of one unified civilization by a pattern in which many elements, while retaining their own individual qualities, join to form a new entity. . . .
> The perfecting of this new order would unquestionably tax our abilities to the very limit, but would give us a society enriched beyond belief by the full development of the individual for the sake of the whole. I believe a good name for such a society is democracy, and I also believe that modern art in its infinite variety and ceaseless exploration is its foremost symbol.[30]

In this text we have, perhaps for the first time, the ideology of the avant-garde aligned with postwar liberalism – the reconciliation of the ideology forged by Rothko and Newman, Greenberg and Rosenberg (individuality, risk, the new frontier) with the liberal ideology as Schlesinger defined it in *Vital Center*: a new radicalism. [. . .]

The new liberalism was identified with the avant-garde not only because that kind of painting was identifiable in modern internationalist terms (also perceived as uniquely American), but also because the values represented in the pictorial work were especially cherished during the Cold War (the notion of individualism and risk essential to the artist to achieve complete freedom of expression). The element of risk that was central to the ideology of the avant-garde, was also central to the ideology of *Vital Center*.[31] Risk, as defined by the avant-garde and formulated in their work as a necessary condition for freedom of expression, was what distinguished a free society from a totalitarian one, according to Schlesinger: 'The eternal awareness of choice can drive the weak to the point where the simplest decision becomes a nightmare. Most men prefer to flee choice, to flee anxiety, to flee freedom.'[32] In the modern world, which brutally stifles the individual, the artist becomes a rampart, an example of will against the uniformity of totalitarian society. In this way the individualism of abstract expressionism allowed the avant-garde to define and occupy a unique position on the artistic front. The avant-garde appropriated a coherent,

definable, consumable image that reflected rather accurately the objectives and aspirations of a newly powerful, liberal, internationalist America. This juxtaposition of political and artistic images was possible because both groups consciously or unconsciously repressed aspects of their ideology in order to ally themselves with the ideology of the other. Contradictions were passed over in silence.

It was ironic but not contradictory that in a society as fixed in a right-of-center position as the United States, and where intellectual repression was strongly felt,[33] abstract expressionism was for many people an expression of freedom: freedom to create controversial works, freedom symbolized by action and gesture, by the expression of the artist apparently freed from all restraints. It was an essential existential liberty that was defended by the moderns (Barr, Soby, Greenberg, Rosenberg) against the attacks of the humanist liberals (Devree, Jewell) and the conservatives (Dondero, Taylor), serving to present the internal struggle to those outside as proof of the inherent liberty of the American system, as opposed to the restrictions imposed on the artist by the Soviet system. Freedom was the symbol most enthusiastically promoted by the new liberalism during the Cold War.[34]

Expressionism became the expression of the difference between a free society and totalitarianism; it represented an essential aspect of liberal society: its aggressiveness and ability to generate controversy that in the final analysis posed no threat. Once again Schlesinger leads us through the labyrinth of liberal ideology:

> It is threatening to turn us all into frightened conformists; and conformity can lead only to stagnation. We need courageous men to help us recapture a sense of the indispensability of dissent, and we need dissent if we are to make up our minds equably and intelligently.[35]

While Pollock's drip paintings offended both the Left and the Right as well as the middle class, they revitalized and strengthened the new liberalism.[36] Pollock became its hero and around him a sort of school developed, for which he became the catalyst, the one who, as de Kooning put it, broke the ice. He became its symbol. But his success and the success of the other abstract-expressionist artists was also the bitter defeat of being powerless to prevent their art from being assimilated into the political struggle.

The trap that the modern American artist wanted to avoid, as we've seen, was the image, the 'statement.' Distrusting the traditional idiom, he wanted to warp the trace of what he wanted to express, consciously attempt to erase, to void the readable, to censure himself. In a certain way he wanted to write about the impossibility of description. In doing this, he rejected two things, the aesthetic of the Popular Front and the traditional American aesthetic, which reflected the political isolationism of an earlier era. The access to modernism that Greenberg had theoretically achieved elevated the art of the avant-garde to a position of international importance, but in so doing integrated it into the imperialist machine of the Museum of Modern Art.[37]

So it was that the progressively disillusioned avant-garde, although theoretically in opposition to the Truman administration, aligned itself, often unconsciously, with the majority, which after 1948 moved dangerously toward the right. Greenberg followed this development with the painters, and was its catalyst. By analyzing the

political aspect of American art, he defined the ideological, formal vantage point from which the avant-garde would have to assert itself if it intended to survive the ascendancy of the new American middle class. To do so it was forced to suppress what many first generation artists had defended against the sterility of American abstract art: emotional content, social commentary, the discourse that avant-garde artists intended in their work, and which Meyer Schapiro had articulated.

Ironically, it was that constant rebellion against political exploitation and the stubborn determination to save Western culture by Americanizing it that led the avant-garde, after killing the father (Paris), to topple into the once disgraced arms of the mother country.

Notes

1 Clement Greenberg, 'The Late 30's in New York,' *Art and Culture*, Boston, Beacon Press, 1961, p. 230.

2 Meyer Schapiro, 'Social Bases of Art,' *First American Artist's Congress*, New York, 1936, pp. 31–37.

3 Meyer Schapiro, 'Nature of Abstract Art,' *Marxist Quarterly*, January/February 1937, pp. 77–98; comment by Delmore Schwartz in *Marxist Quarterly*, April/June 1937, pp. 305–310, and Schapiro's reply, pp. 310–314.

4 Alfred Barr, *Cubism and Abstract Art*, New York, Museum of Modern Art, 1936.

5 Leon Trotsky, 'Art and Politics,' *Partisan Review*, August/September, 1938, p. 310; Diego Rivera and André Breton, 'Manifesto: Towards a Free Revolutionary Art,' *Partisan Review*, Fall 1938, pp. 49–53; Robert Motherwell, 'The Modern Painter's World,' *Dyn*, November 1944, pp. 9–14.

6 J. T. Farrell, *A Note on Literary Criticism*, New York, Vanguard, 1936.

7 Trotsky, 'Art and Politics,' p. 4. In spite of Trotsky's article, which was translated by Dwight MacDonald, the magazine's relationship with the movement remained unencumbered. In fact, Trotsky distrusted the avant-garde publication which he accused of timidity in its attack on Stalinism and turned down several invitations to write for the magazine (Gilbert, *Writers and Partisans: A History of Literary Radicalism in America*, New York, John Wiley and Sons, p. 200).

8 Trotsky agreed with Breton that any artistic school was valid (his 'eclecticism') that recognized a revolutionary imperative; see Trotsky's letter to Breton, October 27, 1938, quoted in Arturo Schwartz, *Breton/Trotsky*, Paris, 10/18, 1977, p. 129.

9 Many members of American Abstract Artists were sympathetic to Trotskyism but looked to Paris for an aesthetic standard; Rosalind Bengelsdorf interviewed by the author, February 12, 1978, New York.

10 Greenberg, 'Avant-Garde and Kitsch', *Partisan Review*, Fall 1939, p. 49 [see Chapter 1, p. 58].

11 Ad Reinhardt, interviewed by F. Celentano, September 2, 1955, for *The Origins and Development of Abstract Expressionism in the U.S.*, unpublished thesis, New York, 1957, p. xi.

12 Nineteen forty-three was the year of internationalism in the United States. Although occurring slowly, the change was a radical one. The entire political spectrum supported United States involvement in world affairs. Henry Luce, speaking for the right, published his celebrated article 'The American Century' in *Life*

magazine in 1941, in which he called on the American people vigorously to seize world leadership. The century to come, he said, could be the American century as the nineteenth had been that of England and France. Conservatives approved this new direction in the MacKinac resolution. See Wendell Wilkie's best-seller, *One World*, New York, 1943.

13 Catalogue introduction to the First Exhibition of Modern American Artists at Riverside Museum, January 1943. This exhibition was intended as an alternative to the gigantic one organized by the Communist-dominated Artists for Victory. New-man's appeal for an apolitical art was in fact a political act since it attacked the involvement of the Communist artist in the war effort. Newman was joined by M. Avery, B. Brown, G. Constant, A. Gottlieb, B. Green, G. Green, J. Graham, L. Krasner, B. Margo, M. Rothko, and others.

14 Betty Parsons, interviewed by the author, New York, February 16, 1978.

15 Dwight MacDonald, 'Truman's Doctrine, Abroad and at Home,' May 1947, published in *Memoirs of a Revolutionist*, New York, World Publishing, 1963, p. 191.

16 The abstract art fashionable at the time (R. Gwathmey, P. Burlin, J. de Martini) borrowed classical themes and modernized or 'Picassoized' them.

17 Greenberg, *Nation*, April 1947.

18 Greenberg, 'Art,' *Nation*, February 1, 1947, pp. 138–139.

19 For an analysis of the ideology of this position see S. Guilbaut, 'Création et développement d'une Avant-Garde: New York 1946–1951,' *Histoire et critique des arts*, 'Les Avant-Gardes,' July 1978, pp. 29–48.

20 Greenberg, 'Art,' *Nation*, March 8, 1947, p. 284.

21 M. Rothko, *Possibilities*, No. 1, Winter 1947/48, p. 84.

22 Clifford Still, letter to Betty Parsons, March 20, 1948, Archives of American Art, Betty Parsons papers, N 68–72.

23 Dwight MacDonald, October 1946, published in *Memoirs*, 'Looking at the War,' p. 180.

24 His article had an explosive effect since it was the first time an American art critic had given pride of place to American art. There were some who were shocked and angered by it. G.L.K. Morris, a modern painter of the cubist school, former Trotskyite and Communist party supporter, violently attacked Greenberg's position in the pages of his magazine. He went on to accuse American critics in general of being unable to interpret the secrets of modern art: 'This approach – completely irresponsible as to accuracy or taste – has been with us so long that we might say that it amounts to a tradition.' He ironically attacked Greenberg's thesis for being unfounded: 'It would have been rewarding if Greenberg had indicated in *what ways* the works of our losers have declined since the 30's.' Working in the tradition of Picasso, Morris was unable to accept the untimely, surprising demise of cubism ('Morris on Critics and Greenberg: A Communication,' *Partisan Review*, pp. 681–684; Greenberg's reply, 686–687).

25 For a more detailed analysis of how events in Europe were understood by the American public, see Richard M. Freeland, *The Truman Doctrine and the Origins of McCarthyism*, New York, Schocken Books, 1974, pp. 293–306.

26 Greenberg, 'The Decline of Cubism,' *Partisan Review*, March 1948, p. 369.

27 When Kootz reopened his gallery in 1949 with a show entitled 'The Intrasubjectives,' Brown and Holty were no longer with him. The artists shown included Baziotes, de Kooning, Gorky, Gottlieb, Graves, Hofmann, Motherwell, Pollock, Reinhardt, Rothko, Tobey, and Tomlin. It was clear what had happened: artists who

worked in the tradition of the School of Paris were no longer welcome. In 1950 and 1951, Kootz disposed of Holty and Brown's work, making a killing by selling the paintings at discount prices in the Bargain Basement of the Gimbels department store chain. It was the end of a certain way of thinking about painting. The avant-garde jettisoned its past once and for all.

28 The ideology of individualism would be codified in 1952 by Harold Rosenberg in his well-known article 'The American Action Painters,' *Art News*, December 1952.

29 René d'Harnoncourt, 'Challenge and Promise: Modern Art and Society,' *Art News*, November 1949, p. 252.

30 Ibid.

31 See discussion in 'Artist's Session at Studio 35' in *Modern Artists in America*, ed. Motherwell, Reinhardt, Wittenborn, Schultz, New York, 1951, pp. 9–23.

32 Arthur Schlesinger, *The Vital Center, Our Purposes and Perils on the Tightrope of American Liberalism*, Cambridge, Riverside Press, 1949, p. 52.

33 We should recall that at that time the power of the various anticommunist committees was on the rise (HUAC, the Attorney General's list) and that attempts were made to bar persons with Marxist leanings from university positions. Sidney Hook, himself a former Marxist, was one of the most vocal critics; see 'Communism and the Intellectuals,' *The American Mercury*, Vol. LXVIII, No. 302 (February 1949), 133–144.

34 See Max Kozloff, 'American Painting during the Cold War,' *Artforum*, May 1973, pp. 42–54 [Chapter 6].

35 Schlesinger, *Vital Center*, p. 208.

36 The new liberalism accepted and even welcomed the revitalizing influence of a certain level of nonconformity and rebellion. This was the system's strength, which Schlesinger clearly explains in his book. Political ideology and the ideology of the avant-garde were united: 'And there is a "clear and present danger" that anti-communist feeling will boil over into a vicious and unconstitutional attack on nonconformists in general and thereby endanger the sources of our democratic strength' (p. 210).

37 See Eva Cockcroft, 'Abstract Expressionism: Weapon of the Cold War,' *Artforum*, XII (June 1974), 39–41 [Chapter 7].

Another "telling"

Fred Orton and Griselda Pollock

AVANT-GARDES AND PARTISANS REVIEWED

A N *AVANT-GARDE* DOES not simply emerge 'readymade' from virgin soil to be attributed *à la mode*. It is actively formed and fulfils a particular function. It is the product of self-consciousness on the part of those who identify themselves as, and with, a special social and artistic grouping within the intelligentsia at a specific historical conjuncture. It is not a process inherent in the evolution of art in modern times: it is not the motor of spiritual renovation and artistic innovation; and it is more than an ideological concept, one part of a complex pattern of imagery and belief. An *avant-garde* is a concrete cultural phenomenon that is realised in terms of identifiable (though never predetermined) practices and representations through which it constitutes for itself a relationship to, and a distance from, the overall cultural patterns of the time. Moreover, its construction and the definition of its function results from a broader discursive formation that provides the terms of reference by which artists can see themselves in this illusory but effective mode of difference, and by which others can validate what they are producing as somehow fulfilling an *avant-garde*'s function. [. . .]

the language of manifestos

the language of bullshit

Modernist art history has evacuated the term's historical meanings, using it to signify an idea about the way art develops and artists function in relation to society. *Avant-garde* is now a catch-all label to celebrate most twentieth-century art and artists. '*Avant-gardism*' has become the pervasive, dominant ideology of artistic production and scholarship.' It instates and reproduces the appearance of a succession of styles and movements often in competition and each one seemingly unique and different in its turn. And like all ideologies, '*avant-gardism*' has its own structures of closure and disclosure, its own way of allowing certain perceptions and rendering others impossible. The illusion of constant change and innovation disguises a more profound level of consistency, a consistency of meaning for the

But this is right on

Source: 'Avant-Gardes and Partisans Reviewed', *Art History*, vol. 4, no. 3, September 1981, pp. 305–327. This text has been edited and footnotes have been renumbered. Reprinted by permission of Routledge & Kegan Paul PLC.

avant-garde that results from the concrete history of real practices and postures which were first designated as a cultural *avant-garde* in Paris in the 1850s–1870s. [. . .]

Art, it was claimed, should have no aim but itself: art should use its own techniques to bring itself into question. This set of artistic practices and its aesthetic ideology can rightly be characterised as *avant-garde*. But the *avant-garde* means more than this. *Avant-garde* must also signify, as it did at its inception in the second half of the nineteenth century, a range of social postures and strategies for artists by which they could differentiate themselves from current social and cultural structure while also intervening in them. To be of the *avant-garde* was to participate in complex and contradictory tactics of involvement with, and evasion of, immediate forms of metropolitan social and economic life. That transitory period of engagement and disengagement can be called the *avant-garde* moment.

In this century there has been only one other, successful *avant-garde* moment when the *avant-garde* and the definition of appropriate *avant-garde* practices had to be, and was, revivified and re-articulated. This occurred in New York in the late 1930s and early 1940s when a new discursive framework was established that enabled some of the artists and intellectuals who gathered there to construct an identity for themselves which was simultaneously an opposition to, and an extension of, available American and European traditions. It provided them with the consciousness of a role and function through which they could engage with, and disengage from, the current social turmoil and ideological crisis. What concerns us here as historians of modern American art is the failure of art history to recognise this formation. Most historians of American art since the Second World War make no distinction between the influences – artistic or otherwise – on the development of Abstract Expressionism as a style of painting, and those decisive forces which shaped the consciousness of the artists and apologists involved in its production and ratification. Until these forces are mapped we shall not understand what it was that allowed those artists and intellectuals to regard themselves as an *avant-garde* and to be recognised as such in America and eventually in Europe.

In the celebratory histories of the American phase in the history of Modern Art the term *avant-garde* or vanguard is taken for granted. The opening sentences of Irving Sandler's introduction to his book on *The New York School: The Painters and Sculptors of the Fifties* (New York, 1978) are paradigmatic.

> From 1947 to 1951, more than a dozen Abstract Expressionists achieved 'breakthroughs' to independent styles. During the following years, these painters, the first generation of the New York School, received growing recognition nationally and globally, to the extent that American vanguard art came to be considered the primary source of creative ideas and energies in the world, and a few masters, notably Pollock, de Kooning, and Rothko, were elevated to art history's pantheon.[2] [. . .]

Sandler's conception of artistic production is a simple, threefold process. First, there is the creation of a new style in art. Thereafter, critical acclaim at home and abroad recognises the advancedness of those styles. Finally, those advances are situated in the history of art as a school with certain masters.

of Rosen

Sandler's art historical method is common enough. It is intentionalist and formalist, a history of style which is based on notions of individualism and multiple discovery. It manifests all the symptoms of '*avant-gardism*' in its inability to account for the *avant-garde*. In Sandler's history the *avant-garde* becomes commonplace, matter of fact, eternal rather than something specific or disputable. It is not surprising, therefore, that his major full-length study of New York painting ca. 1942–52, *Abstract Expressionism: The Triumph of American Painting* (New York, 1970)[3] fails to identify the twentieth-century *avant-garde* moment, and does not consider how the *avant-garde* was formed and what it was formed for. Sandler's narrative of 'broader attributes of [this] process of stylistic change'[4] conceals the fact that a section of the New York intelligentsia was intensely preoccupied with the *avant-garde* in the late 1930s and early 1940s. No mention is made of the intervention which one member of that group, Clement Greenberg, made at that time in *avant-garde* theory and American intellectual – and, importantly with regard to Abstract Expressionism – artistic strategies. Greenberg has to be accounted for. Yet he is virtually absent from Sandler's discussion of the 1930s and he is misrepresented in the chapter wherein Sandler describes how 'A New Vanguard Emerges' in the early 1940s.[5] [. . .] Greenberg is never acknowledged as having been a part of the *avant-garde*, and his contribution to its formation in writings which were published prior to the appearance of Abstract Expressionism as a recognisable style is ignored. 'Avant-Garde and Kitsch', 1939, Greenberg's major article on the *avant-garde* is neither referred to in Sandler's text nor cited in his bibliography.[6] Sandler draws his notion of *avant-gardeness* from Greenberg's essay 'Towards a Newer Laocoon' which was published in 1940.[7] It is an important text but it is not about the *avant-garde*. [. . .]

Greenberg's first essay on the *avant-garde*, 'Avant-Garde and Kitsch', was published in *Partisan Review* in the Fall of 1939.[8] The article – an essay not on painting or sculpture but on culture – was Greenberg's considered contribution to a debate about the role and nature of revolutionary literature and art which was undertaken in this magazine between 1936 and 1940. *Partisan Review* was a literary magazine which had been founded in 1934 by William Phillips and Philip Rahv. The intention was for the magazine to publish the best writings of the New York John Reed Clubs,[9] to publish creative and critical literature from the viewpoint of the revolutionary working class. From the outset, however, the editors thought that it was wrong to make literature the vehicle for currently expedient political ideas. Literature should not just promote class struggle. Literary history had to be preserved even if it was largely the history of bourgeois authors writing for a bourgeois audience. As far as Phillips and Rahv were concerned, a literary theory derived from Marxism was an intellectual tool to be used to understand and preserve the best literature of the past while creating the basis for a new culture.

In July 1935 the Seventh World Congress of the Third Communist International defined the new Soviet policy of the Popular Front, an attempt to unite a broad spectrum of intellectuals in a common campaign against fascism which would, moreover, favourably dispose non-aligned Marxists and liberals towards the Soviet Union. The John Reed Clubs were one of the first casualties of this redefinition of Soviet policy with its move away from revolutionary class struggle. They were disbanded and replaced by the League of American Writers, an organisation that was

formed to provide the necessary framework to accommodate sympathetic intel-
lectuals and a more flexible approach to literature.'° Most of the radical little
magazines who relied on the John Reed Clubs for literary and financial support
were forced to cease publication. *Partisan Review* was critical of the Popular Front
and remained committed to a revolutionary new literature. It managed to continue
publication without becoming affiliated to the League but toward the end of 1936 it,
too, folded. In December 1937 *Partisan Review* resumed publication, but with a
different orientation.

To *Partisan Review* the 'death' of proletarian literature left the problem of the
modern writer and intellectual with no adequate solution. How could revolutionary
writers forge a new sensibility out of a reconciliation of Marxist ideology with
formal or artistic experimentation? The events of 1935 (Popular Front) and 1936
(Stalin's purge of independent intellectuals and political enemies, the Moscow
Trials) cast fundamental doubts on the integrity of Soviet communism. It seemed
imperative to recognise and resist the degeneration of the Communist movement
which had been responsible for the misdirection of revolutionary culture towards
the policy of the Popular Front. This process is most evident in the magazine's
reassertion of the theoretical purity of Marxism by a temporary identification with
Trotskyism – a form of Marxism which appealed to the editors' highly intellectual-
ised radicalism and clarified their objection to Communism. When *Partisan Review*
resumed publication it did so independent and critical of the Communist movement.
There were four new editors. Phillips and Rahv were joined by G. L. K. Morris (the
painter and member of the American Abstract Artists) who provided much of the
financing of the magazine until 1943 but had little to do with literary or political
issues, and Fred Dupee (formerly an editor of the *New Masses*), Mary McCarthy (the
novelist and poet), and Dwight MacDonald (who had been on the staff of *Fortune*
magazine), who were all sympathetic towards Trotskyism. It was MacDonald who in
late 1937 wrote to Trotsky – in exile in Mexico – on behalf of the editors outlining
the policy of the magazine and requesting a contribution to a symposium on the
theme 'What is Alive and What is Dead in Marxism?' [Trotsky replied doubting] the
strength of *Partisan Review*'s conviction to rid itself of Stalinist influence. Towards
the end of his letter, dated 20 January 1938, Trotsky wrote:

> A world war is approaching. The inner political struggle in all countries
> tends to become transformed into civil war. Currents of the highest
> tension are active in all fields of culture and ideology. You evidently wish
> to create a small cultural monastery, guarding itself from the outside
> world by skepticism, agnosticism and respectability. Such an endeavour
> does not open up any kind of perspective.'' [. . .]

However, another, later request to Trotsky met with a positive response. His
doubts about *Partisan Review* eased, he expanded his arguments in a letter dated 18
June 1938 which was published in August under the title 'Art and Politics'.'' Much
of 'Art and Politics' is devoted to an attack on the conception of art's function
and the bureaucratic constraints on artistic practice in Stalinist Russia. Trotsky also
addressed American artists for whom the immediate crisis of capitalism and the
imminence of war, which might either produce or foreclose the potential for revolu-

tion, were pressing realities. Trotsky offered some ideas on the revolutionary role which artists and their art could play. [. . .] History had set a trap for the artist. Trotsky gave the October Revolution as an example. The October Revolution gave a magnificent impetus to all kinds of Soviet art. After the Revolution, however, a massive bureaucracy was formed which stifled artistic creation. According to Trotsky, art was basically a function of the nerves and demanded complete sincerity. This genuine art was impossible in Soviet Russia where art – official art – was based on lies, deceits and subservience.

For Trotsky, art, culture and politics needed a new perspective without which humanity would not develop. But, he maintained, this new perspective should not begin with or be addressed to, a mass base. A progressive idea only found its masses in its last stage. Trotsky maintained that all great movements had begun as 'splinters' of older movements. Protestantism, for example, had been a splinter of Catholicism and the group of Marx and Engels had come into being as a splinter of the Hegelian left. Movements in art occurred in the same way, and the more daring the pioneers showed in their ideas and actions, the more bitterly they opposed themselves to established authority which rested on a conservative mass base.

Trotsky regarded it as vital that art should remain independent of any authority other than its own rules and principles.

> Art, like science, not only does not seek orders, but by its very essence, cannot tolerate them. Artistic creation has its own laws – even when it consciously serves a social movement. Truly intellectual creation is incompatible with lies, hypocrisy and the spirit of conformity. Art can become a strong ally of the revolution only in so far as it remains faithful to itself.[13]

This view, which Trotsky had first put forward in *Literature and Revolution*[14] – wherein he had argued that a work of art should in the first place be judged by its own law, that is, the law of art[15] – was restated in the 'Manifesto: Towards a Free Revolutionary Art' in *Partisan Review*, Fall 1938.[16] The 'Manifesto' was published under the signatures of André Breton and Diego Rivera but it is generally agreed that the text is substantially Trotsky's. Here it was pointed out that certain conditions were required if art was to play a revolutionary role. Foremost among these was the need for a complete opposition to any restriction on artistic creation. The imagination had to escape from all constraint. However, the practice of art had to be undertaken in concert with political practice.

> It should be clear by now that in defending freedom of thought we have no intention of justifying political indifference, and that it is far from our wish to revive a so-called 'pure' art which generally serves the extremely impure ends of reaction. No, our conception of the role of art is too high to refuse it an influence on the fate of society. We believe that the supreme task of art in our epoch is to take part actively and consciously in the preparation of the revolution. But the artist cannot serve the struggle for freedom unless he subjectively assimilates its social content, unless he feels in his very nerves its meaning and

drama and freely seeks to give his own inner world incarnation in his art.[17]

In February 1939 *Partisan Review* published an enthusiastic letter from Trotsky which was written in support of the 'Manifesto.'[18] Trotsky explicitly located the demand for artistic freedom in relation to Stalinist corruption: 'The struggle for revolutionary ideas in art must begin once again with the struggle for artistic truth.'[19] In relation to the current world crisis, reaction and cultural decline 'truly independent creation cannot but be revolutionary by its very nature, for it cannot but seek an outlet from intolerable social suffocation.'[20]

Thus Trotsky proposed a particular and historical relationship between art and bourgeois society in its state of aggravated contradictions and of art to social authority in general. Art requires a social base. Currently it depends on bourgeois society. At the same time it plays a liberating role in relation to it. Art cannot escape the present crisis or save itself. Art will wither if society withers. It is historically tied to those forces which will rebuild society – revolution. Art has to be considered in a dialectical relationship to historical forces and social forms, autonomous in pursuing its role but not independent of the society which sustains it. Art is a force through which humanity advances. It liberates by contributing progressive ideas and new perspectives on the world. But artistic progress cannot be prescribed in advance: it is not subject to bureaucratic contract or mass opinion. Art is therefore presented as a kind of 'advanced guard' on the level of culture and consciousness. In order to fulfil its function art must be free from external constraints. It may be dependent but it serves only by pursuing its own trajectory – specifically, not arbitrarily. Art's participation in revolution will not be accomplished by subservience to political bureaucracies, to fabricating and supporting party lines, but by its concern for its own human integrity.

During 1939 *Partisan Review* became increasingly concerned about conditions in Europe. In addition to the need to take a political stance opposing fascism and the imminent war, *Partisan Review* discussed the fate of Western culture under this dual threat. The unsigned editorial, 'The Crisis in France', Winter 1939, described the special significance which Paris had as the 'eye' of modern European civilisation.[21] For a century the history of Paris had been the history of European politics, art and literature. It was there that 'the expression of the best integrated culture in modern times, the *avant-garde* . . . in art and literature' was born and survived.[22] Now that was threatened. The eye of Western culture was dimming. If France went fascist, as seemed likely under the Daladier government,[23] the West could say goodbye to culture in all seriousness for a long time to come.

In the editorial of the Spring 1939 issue of *Partisan Review* titled 'War and the Intellectuals: Act Two', Dwight MacDonald appealed to intellectuals to resist the drive towards a second war.[24] Spuriously presented as a crusade for democracy the war was, in fact, a war in the interests of the capitalist ruling class and itself a product of capitalism. MacDonald insisted that support for the war under the banner of opposition to fascism abroad meant 'political and cultural submission to the ruling class at home'.[25] He restated opposition to the Stalinist policy of a united front against European fascism. American intellectuals seemed to have forgotten that there was a genuine alternative to capitalism and its wars – social revolution.

> The great objection to the war programme of the intellectuals is not so
> much that it will get us into the war – the bourgeoisie will decide that
> question for themselves . . . but that it is diverting us from our main
> task: to work with the masses for socialism, which alone can save our
> civilisation.[26]

Intellectuals who support the war claim to be concerned with the future of civilisa-
tion; they think themselves to be on the side of the people. In effect, they are
aligning themselves with the bourgeoisie, with capitalism, in supporting the war, in
identifying the enemy as foreign fascism. According to MacDonald this paradox
results from the 'peculiar relationship of the intelligentsia to the class struggle'.[27] By
virtue of their not having a direct economic interest in one side or another they can
pose as 'disinterested', free from class loyalties, addressing themselves to 'society in
general'. However, like the small bourgeoisie from which most intellectuals come,
the intelligentsia does adopt class alignments. In times of severe capitalist crisis they
may side with the workers but more often they follow the big bourgeoisie – which is
now leading them into war. In this virulently anti-war piece MacDonald calls on
American intellectuals to ally themselves with socialism to defend civilisation and to
reoccupy their position which involves the 'privilege – and duty – of criticising
ruling class values'.[28]

The role and place of the intellectuals, the intelligentsia, was taken up by Philip
Rahv in his editorial 'Twilight of the Thirties' in the next issue of *Partisan Review*,
Summer 1939.[29] [. . .] Rahv argues that there are lessons to be learned from the
relationship of politics to literature, especially in the abuse of talent which results
when writers serve party machines and follow party lines. Politics *qua* politics is
neither good nor bad for literature which is none the less subject to general
processes of social determination. Literature cannot escape the influence of its
society, its history. At the present time politics is shaping its destiny. This impact
can be seen in the prevalence of a reactionary *Zeitgeist* which reflects the two great
catastrophes of the epoch, the victory of fascism and the defeat of the Bolshevik
Revolution. In America Rahv sees symptoms of this decline in the emergence of a
new gentility in literature, a cowardly and hypocritical pandering to official public
opinion, a patriotic regionalism celebrating America's bourgeois history. In point-
ing to the ebb of creative energy and rapid decline in standards, Rahv identifies an
absence:

> This is the one period in many decades which is not being enlivened by
> the feats and excesses of that attractive artistic animal known as 'the
> younger generation'. With very few exceptions, the younger writers of
> today, instead of defying, instead of going beyond, are in fact imitating
> and falling behind their elders. There still are remnants, but no *avant-
> garde* movement to speak of exists any longer . . . Everywhere the
> academicians, the time-servers, the experts in accommodation, the
> vulgarizers and the big money adepts are ruling the literary roost; . . .
> For more than a hundred years literature, . . . was in the throes of a
> constant inner revolution, was the arena of uninterrupted rebellions and
> counter rebellions, was incessantly renewing itself both in substance and

in form. But at present it seems as if this magnificent process is drawing to a close.[30]

To speak of modern literature, Rahv argues, is to speak of a particular social group created by the drastic division of labour which prevails under capitalism, namely, the intelligentsia. [. . .] The intelligentsia is materially and politically dependent on society and its classes, but the illusion of self-determination has enabled it to act and think independently of both masses and ruling strata and to produce moral and aesthetic values which oppose and criticise the bourgeois spirit. Thus Rahv proposes that the most typically modern literary tendencies have become articulate because of the supportive social framework provided by the relative detachment of intellectuals from a society basically hostile and indifferent to human or creative – i.e. non-commercial – values.

Modern artists have been criticised by socially minded critics of the right and left for their introversion and privacy, their aesthetic mysticism, their tendency to the obscure and morbid. Without these qualities – which are not derived from limitless self-confidence but from the group ethos, the self-imposed isolation of a cultivated minority – the modern artist could not have survived in bourgeois society. It is this isolation, ideologically translated into various doctrines – Rahv gives the theory of 'art for art's sake' as an example – which prevented the art object being drawn entirely into the web of commodity relations. The modern artist preferred alienation from society to alienation from herself or himself.

The effect of the crisis of the 1930s has been to undermine this. Weakened, the capitalist system withdrew the privilege of limited self-determination which it had previously allowed the intelligentsia. It could not afford an independent or even semi-independent class of intellectuals, and the intelligentsia could no longer make light of or disregard political beliefs or actions. It was drawn back into alliances with the ruling class. But which class was the ruling class – the decrepit bourgeoisie or the contending proletariat? The question momentarily posed by the events of 1917 had been elided by Stalinism with its political prescriptions for literature [. . .]

Rahv doubted whether a new *avant-garde* movement 'in the proper historical sense of the term' could be founded in the pre-war situation, but he was not prepared to write an obituary. This is hardly surprising. At its reappearance *Partisan Review* was conceived as a kind of 'international' of intellectuals who were devoted not to writing off the *avant-garde* but to redefining it, preserving it, and reproducing it. The editors, including Rahv, believed that cultural change could only be initiated by an international community of intellectuals and that the cultural epicentre – the *avant-garde* – of that community would be the Trotskyist intellectuals whose best work was being published in *Partisan Review*.

Partisan Review's discussion of the *avant-garde* was continued and developed in the next issue by Clement Greenberg in his essay 'Avant-Garde and Kitsch' [. . .] his first major piece of writing. It is strategically complex both in terms of why it was written and in what it argued. On one level it can be read as a contribution to the discourse within *Partisan Review* on art and revolution and cultural change, and on another level it can be seen as an attempt by a young writer to situate himself, or to have himself accepted within, the Marxist intelligentsia of New York. 'Avant-Garde and Kitsch' was both a discussion of the nature and function of the *avant-garde* and

the author's means of access to it. It was his way of claiming space within an *avant-garde* at that formative moment. Greenberg was successful on both counts. In 1940 *Partisan Review* published another extended essay by him entitled 'Towards a Newer Laocoon' which, with 'Avant-Garde and Kitsch', provides the premises of his subsequent art writing, his apology for Abstract Expressionism and after. In 1941 he also became an editor of the magazine. He was brought on to the board by MacDonald – with whom he agreed on most important political and cultural issues – and stayed until 1943. In the same year that he became an editor of *Partisan Review* he also became the first art critic of *The Nation*, a position of considerable influence which he held throughout the decade. Within a very short period then Greenberg moved from the relative obscurity of his job in the customs service in the Port of New York, spare time writer and painter, and sometime attender at Hans Hofmann's School, to occupy a central position within the radical intellectual movement and cultural intelligentsia.

'Avant-Garde and Kitsch' was written for the specific historical context of the debates in *Partisan Review*. In 1939 it had tactical implications. However, it was able to transcend that immediate context. Although 'Avant-Garde and Kitsch' accords with *Partisan Review*'s Trotskyism it does not proselytise a self-evident Trotskyist position. At that time Greenberg thought that it was 'necessary to quote Marx word for word' not Trotsky.³¹ Greenberg's address was to the diversity amongst the young New York and East Coast left intellectuals and to the much larger body of liberals and radicals of various shades of opinion who made up the readership of the magazine.³² After the war its status and credibility changed. In the 1940s and 1950s America's anti-Communism made the work of those intellectuals and institutions who had been, like Greenberg and *Partisan Review*, anti-Stalinist and against Communism before the war acceptable and important. Greenberg and his work could be, and were mobilised for other projects. 'Avant-Garde and Kitsch', in particular, gained a currency and accessibility beyond that afforded it at the *avant-garde* moment. Moreover, Greenberg offered something novel in his discussion of the *avant-garde*. He considered not only what it was but what it was not. [. . .]

The article operates on two axes. It provides a particular historical perspective on Western bourgeois culture since the mid-nineteenth century, and, critically, it addresses the contemporary condition of that culture. [. . .]

Greenberg provides a profile of the *avant-garde* not as an idea or as an artistic development. The *avant-garde* is a special socio-artistic intellectual *agency* through which culture can be advanced. Greenberg's characterisation implies a particular relationship between the artists who constitute the *avant-garde* and society which has need of such a special cultural instrument. Greenberg also writes of *avant-garde* culture. This was produced at a historical moment ca. 1850 in and against a network of particular ideological, social and economic conditions. Thus, *avant-garde* refers to a novel *form* of culture produced in bourgeois society in the mid-nineteenth century and a novel *force* which advances and keeps culture at a high level. [. . .]

The *avant-garde* withdrew from both bourgeois and anti-bourgeois politics in order to keep culture alive and developing independent of extraneous directives from external masters. This does not imply a non-political position or political indifference but a necessary distance, a distinct function which the *avant-garde* accomplished by disengagement. The *avant-garde* was formed by that from which it

became separated. Politics gave it consciousness and courage but culture has its own spheres of activity and processes which are distinct from those of politics. Although revolutionary impetus provided notions of change and progress, and the impulse to move forwards and reject stasis, the form of cultural revolution was not to be dictated by it.

The aim of the *avant-garde* was to preserve, direct and advance culture, but this could not be achieved by arbitrary experimentation. The *avant-garde* functions by defining and pursuing the proper concerns of art. 'Art for art's sake' was one result of this impetus: subject matter or content were dissolved completely into form so that to all intents and purposes the processes and disciplines of art became the subject matter of art. Abstract or non-representational art followed on from this. [. . .]

The *avant-garde*'s methods are fully justified because they are the only means by which to keep culture progressing, to create the genuinely new, and to maintain high standards in literature and art. However, 'art for art's sake' – the *avant-garde*'s specialisation of itself – is a necessity which is not without its disadvantages. Many of those who traditionally supported and appreciated ambitious literature and art have been alienated because of the difficulty which the *avant-garde*'s preoccupation with art's own means and materials presents. Culture in the process of its development has never been a mass phenomenon. The *avant-garde* was never *economically* independent of bourgeois society but was tied to a fraction of its ruling class by an 'umbilical cord of gold'.[33] Now, *avant-garde* culture has begun to estrange some of that cultural élite on whose support it depended. The existence of the *avant-garde* is currently threatened by the erosion of its limited and inevitably select social and economic base; this undermines its confidence and courage and tempts it into Academicism.

There is also another threat to culture. Greenberg calls this *kitsch*, which is the popular, commercial art or literature that appeared at the same time as the *avant-garde*. *Kitsch* is a product of the industrial revolution which urbanised the masses of Western Europe and America and established what is called universal literacy. *Kitsch* is a commodity produced to satisfy urban populations that have become dislocated from traditional rural folk cultures and now enjoy leisure sufficient to be bored. The masses need entertainment and diversion. *Kitsch*, which is mechanical, formulaeistic and profitable, provides it. *Kitsch* offers vicarious experience and faked sensations. It does not demand of its audience the hard work which is required for the enjoyment of high culture. [. . .]

Kitsch is ersatz culture; it uses the debased and academicised simulacra of the mature cultural tradition as a reservoir for its tricks and strategems. It provides a short cut to what is inevitably difficult and demanding in living culture, in art and literature of a high order.

As a mass-produced commodity of Western industrialism *kitsch* has been exported to the whole world. It is a cultural form for the masses. *Kitsch* has been adopted as the official culture of totalitarian régimes in Nazi Germany and Soviet Russia where it is used to win the political support of the masses. [. . .] *Kitsch*, the cultural rearguard, has become a tool of political reaction.

'Avant-Garde and Kitsch's is a manifesto for the *avant-garde* in which Greenberg plays off a description of the reasons for the historical formation of these two

cultural products against the circumstances of culture and society in 1939. The *avant-garde* was originally a product of bourgeois society, but, in decline, capitalism is threatened by whatever of quality and progressiveness it is still capable of producing. Accordingly, in the current crisis of capitalism, the dialectic by which the *avant-garde* was formed in and against bourgeois society as a product of it and challenge to it, is resolved in a different manner. Now, Greenberg argues, the *avant-garde* must look to revolutionary politics, to socialism, not only for a new culture but for the preservation of living culture, of itself. The *avant-garde* can, in this way, be aligned with revolution.

In 'Avant-Garde and Kitsch' Greenberg drew a map of the forces and relations of cultural production in Western bourgeois society since the mid-nineteenth century in order to describe the constellation of those forces and relations in the present. Like Rahv, Greenberg could not point to the existence of an active *avant-garde* but he did indicate the necessity for it and describe how it might be formed.

'Towards a Newer Laocoon' which was published in July–August 1940 is in many ways the corollary to the arguments advanced in 'Avant-Garde and Kitsch'. In it Greenberg takes up issues which were summarily treated in the earlier piece such as imitation, the importance of the medium, and the historical significance of Cubism with reference to *avant-garde* painting. [. . .]

The article is presented primarily as a defence of abstract purism, abstract and non-objective painting, which rejects literature as a model for the plastic arts and therefore eschews overt subject matter. The purists had been dismissed as merely symptomatic of a cultist attitude towards art. Greenberg justifies their dogmatism and intransigence because it represents an extreme concern for the fate of art and a desire to conserve painting's identity. However, Greenberg argues that the claims made for abstract purism by its supporters and practitioners can be questioned on the grounds that they are unhistorical. He writes:

> It is quite easy to show that abstract art like every other cultural phenomenon reflects the social and other circumstances of the age in which its creators live, and that there is nothing inside art itself, disconnected from history, which compels it to go in one direction or another. But it is not so easy to reject the purist's assertion that the best of contemporary plastic art is abstract.[34]

Greenberg proposes an historical answer to the problem of the present supremacy of abstract purism. It can be seen as 'the terminus of a salutory reaction against the mistakes of painting and sculpture in the past several centuries' which resulted from a confusion, a tendency for the arts to imitate each other and their respective effects.[35] [. . .]

Visual artists had attained such technical facility and virtuosity that they could annihilate the mediums they worked in in favour of illusion. They could achieve not only illusionism but the effects attained in other arts, and they were especially tempted to become the stooges of literature, sacrificing the medium to literary subject matter and to the creation of poetic effects in the interpretation of that subject matter. [. . .]

The Romantic Revolution coincided with the triumph of the bourgeoisie and as

a result a fresh current of creative energy was released into every field. In the visual arts frivolous literary subject matter was replaced by more sincere and powerful themes which necessitated new and bolder pictorial means. Temporarily the medium was brought back into the limelight but the exploration of it soon deteriorated into virtuosity and talent was perverted in the service of realistic imitation. [. . .] The legacy of Romanticism was a novel cultural phenomenon, Academicism, a stasis in which talented artists serviced bourgeois society with an art of realistic illusion required by sentimental or sensational literature.

Here Greenberg situates the formation of *avant-garde* culture, the successor to and negation of Romanticism, a product of bourgeois society but also a challenge to it. [. . .] In its Bohemian retreat the *avant-garde* strives to find 'adequate cultural forms for the expression' of bourgeois society.[36] This it does without succumbing to the ideological divisions within that society, its class conflicts and political struggles. The *avant-garde* also demands that the arts should be recognised as their own justification and not as vehicles or servants of society or politics. The major concern of the *avant-garde* is the preservation of art, and its exclusive responsibility is to the values of art. The *avant-garde* attempts to liberate painting and sculpture from ideas through which they are affected by current political struggles. It also tries to escape from the domination of literature, from the idea of art as communication, from subject matter in general, and from the concomitant disregard for the medium.

In an important aside Greenberg makes a distinction between subject matter and content. All art has content – it is neither empty nor meaningless – but subject matter is something extraneous which the artist has in mind whilst working. Content is a result, an effect of the work of art. Subject matter is a prior programme for it, something to be communicated to which the medium must be subservient. In place of subject matter the *avant-garde* strives to emphasise form and to insist on each art as an independent vocation, as craft and discipline, as something which deserves respect for itself not as a servant of social or literary communication.

In the subsequent paragraphs of this third section of 'Towards a Newer Laocoon' and in the whole of Section IV Greenberg's focus narrows to the internal history of *avant-garde* painting. He discusses the project of the *avant-garde* since the mid-nineteenth century and identifies two variants in it. The first variant is represented by Courbet – 'the first real *avant-garde* painter'[37] – Manet, and the Impressionists who stressed sensations as the basis for painting and who, with materialist objectivity, attempted to emphasise the medium of their craft. [. . .] Within this first variant of *avant-garde* practice the redemption of painting was accomplished by the erosion of subject matter through parody, indifference, detachment, or the inversion of the relative status of subject matter and medium. It also demonstrated the materialist emphasis on medium, visual experience and effect in painting.

The second variant of the *avant-garde* was also preoccupied with medium but investigated it for its expressive resources. It intended to express not ideas but sensations, the 'irreduceable elements of experience'.[38] This tendency held several dangers, one of which was to tempt painting back into imitation. In this case it was not emulation of literature and its effects which was the danger but rather the emulation of music and to a lesser extent poetry. [. . .] The *avant-garde* in painting, learning from music, had to pursue the particular identity of the medium of painting. Painting had to attend to its own pure form; it had to identify the sensations by

which its medium appealed and by which it was to be known and responded to as a distinct art. Its emphasis, therefore, was found to be on the physical, the 'sensory'. Music had appealed to the *avant-garde* because, in opposition to literature which was concerned with the communication of conceptual messages, it was pure, sensuous, abstract. In order to liberate painting once again from the imitation of effects it was necessary for the *avant-garde* to realise that music was not (or need not be) the only pure, sensuous, and abstract art form. [. . .]

According to Greenberg there has been an historical process taking place by which the confusion between several arts has been increasingly clarified. Each art has been defined in its particularity in terms of the discipline which its medium imposes on it and the effects that medium produces. It is the *avant-garde* which functions to preserve the specific identity of each art. In the visual arts the medium is physical: it produces visual sensations and such emotion as it conveys may be called, in the words of Valéry, an emotion of 'plastic sight'. But there is yet one more distinction to be made within the plastic arts. Painting must be differentiated from sculpture. Greenberg maintains that much of the history of the *avant-garde* in painting hangs upon the programme of excluding the sculptural and other related means of realistic imitation from painting. Chiaroscuro and modelling are abandoned. Line no longer delineates shape, contour or volume; it is treated as colour. Space and depth or fictive three-dimensional illusion are reduced as the planes become flattened, pressed together to meet on the real plane of the canvas surface. These moves constituted a decisive surrender to the problems and character of the medium particular to painting. The most crucial of these is the flatness of the picture plane which had, since the Renaissance, been consistently evaded by attempts to create the illusion of realistic space and the illusion of three-dimensional objects located in that space. The destruction of this pictorial space and with it the object 'was accomplished by means of the travesty that was cubism'.[39] Cubism represents the culmination of *avant-garde* moves to date and represents a decisive break with the past. But painting was not fully brought to abstraction by the Cubists. That was accomplished by subsequent artists, by the Germans, by the Dutch, and by the English and the Americans. Paris, hitherto the home of *avant-garde* culture, is not the centre of abstract art. Abstract art has now emigrated to London, and Paris is now the home of a regressive tendency in the arts towards literature and subject matter. This reaction, Surrealism, has to be omitted from Greenberg's notion of the *avant-garde*. It is here that his strategy becomes clear. Greenberg uses the phrase 'development of Modern painting',[40] which is a collective term for art produced within the various strands of the historical *avant-garde* in painting. But not all Modern painting is *avant-garde* – Modern painting and the *avant-garde* are not synonymous. In this penultimate section of the essay, Greenberg identifies what, within the category of Modern art practices, is still, in 1940, of the *avant-garde* and capable of advancing culture.

In the concluding part of 'Towards a Newer Laocoon', Section VI, Greenberg clearly states that he has 'offered no other explanation for the present superiority of abstract art than its historical justification'.[41] He is adamant that abstract art is a justifiable product of the *avant-garde*'s necessary procedures for identifying and preserving the specific identity of painting as an art. There can be both *avant-garde* and reactionary tendencies in the arts; which is which is determined by the history of the *avant-garde* and the present condition of each art with regard to its traditions

and conventions. Abstraction is only one of several contemporary tendencies in Modern art. It is historically the most significant and potentially the vanguard of *avant-garde* culture in painting [. . .] In 'Avant-Garde and Kitsch' Greenberg appealed to history, especially to an historical moment in the mid-nineteenth century in order to identify a comparable moment and recognise a parallel need for a special agency, the *avant-garde*. In 'Towards a Newer Laocoon' he traces the internal history of the art produced by the *avant-garde*. Greenberg not only contributes to the reconstruction of an *avant-garde* consciousness, a need for the force, but he also specifies the form of *avant-garde* culture in painting. The two essays, in conjunction, point to a new moment, a rupture, and indicate a consistency that enables Greenberg to identify the course in painting which the *avant-garde* might take.

The polemic of 'Towards a Newer Laocoon' is directed at contemporary critics and artists who, favouring a return to the imitation of nature in art, oppose and repudiate abstraction. Greenberg was addressing a specific constituency in the cultural intelligentsia, the practitioners and apologists of visual art. His essay represents a strategic manoeuvre within the coterie of *Partisan Review*'s editors and readership. The debates in the magazine had hitherto been pursued either in general cultural terms or with exclusive reference to literature and cinema. In 'Towards a Newer Laocoon' Greenberg was attempting to define a special place for himself within the artistic community and to reconstruct an *avant-garde* position for painting.

Greenberg reminisced about the late 1930s in New York in an article published in 1957, 'New York Painting Only Yesterday'.[42] He wrote:

> Abstract art was the main issue among the artists I knew then; radical politics was on many people's minds but for them Social Realism was as dead as the American Scene.[43]

When this was republished in 1961 in the edition of his selected writings, *Art and Culture*, a parenthesis was added in which Greenberg made an oblique but crucial reference to the political climate and debates on art, revolution and the *avant-garde* in *Partisan Review* between 1937 and 1940.

> (Though that is not all, by far, that there was to politics in art in those years; some day it will have to be told how 'anti-Stalinism', which started out more or less as 'Trotskyism', turned into art for art's sake, and thereby cleared the way, heroically, for what has to come.)[44]

On to a Trotskyist claim for a special freedom for art, and for art as a form of cognition of the world and as a necessary precondition for the building of a new consciousness, Greenberg mapped one of the strategies of the historic *avant-garde*, 'art for art's sake', the steeping of painting in its own cause. In this transaction the momentary specificity of Trotsky's revolutionary perspective and Marxist vocabulary — some might say Trotsky's millenarianism — was erased. Opposition to prescribed subjects or functions for art — anti-Stalinism — was matched by a claim for the relative autonomy of artistic practices. This was then overlaid by the concept of a cultural *avant-garde* which, of necessity, fulfilled its social purposes at a distance from

party politics and political organisation. Greenberg's participation in, and man-
oeuvres upon, that ideological terrain had the effect of clearing a space. He contrib-
uted to that moment by offering a special sense of group identity for some painters
and by defining a function for a specific kind of painting.

Notes

1 N. Hadjinicolaou, 'Sur l'idéologie de l'avant-gardisme', *Histoire et Critique d'Art*, 1976, vol. 2, pp. 49–76.
2 I. Sandler, *The New York School: The Painters and Sculptors of the Fifties*, New York, 1978, p. ix.
3 Republished in paperback as *The Triumph of American Painting: A History of Abstract Expressionism*, New York, 1976.
4 I. Sandler, *Abstract Expressionism: The Triumph of American Painting*, New York, 1970, p. 1.
5 Sandler, op. cit. (1970), ch. 6, pp. 78–89. In Chapter I, 'The Great Depression', pp. 5–28, Sandler discusses New York art and artists in the 1930s. He quotes from Greenberg's later writings, using them only as a document or source of informa-tion, pp. 20, 23, 24. Greenberg is not discussed as a participant or formative figure in the intellectual and cultural milieu.
6 C. Greenberg, 'Avant-Garde and Kitsch', *Partisan Review*, Fall 1939, vol. VI, no. 6, pp. 34–49 [see Chapter 1]. Hereafter noted as *A–G & K*.
7 C. Greenberg, 'Towards a Newer Laocoon', *Partisan Review*, July–August 1940, vol. VII, no. 4, pp. 296–310 [see Chapter 2]. Hereafter noted as *TANL*.
8 See note 6.
9 The John Reed Clubs were founded in 1929 in memory of the American literary Bolshevik John Reed. For information on the Clubs see J. B. Gilbert, *Writers and Partisans: A History of Literary Radicalism in America*, New York, 1968, pp. 91–2, 108–9; and D. Aaron, *Writers on the Left*, Oxford and New York, 1977, pp. 221–30, 271–3, 280–3.
10 On the League of American Writers see Gilbert, op. cit., pp. 134, 138–40; and Aaron, op. cit., pp. 283–4.
11 Leon Trotsky, 'Letter to Dwight MacDonald', 20 January 1938, republished in *Leon Trotsky on Literature and Art*, ed. by P. N. Siegel, New York, 1970, p. 103.
12 Leon Trotsky, 'Art and Politics', *Partisan Review*, August–September, 1938, vol. V, no. 3, pp. 3–10.
13 Ibid., p. 10.
14 Leon Trotsky, *Literature and Revolution*, 1923, first translated into English by Rose Strunsky and published in 1925.
15 Leon Trotsky, 'The Social Roots and Social Function of Literature' in *Literature and Revolution* (1923) reprinted in *Leon Trotsky on Literature and Art*, ed. P. N. Siegel, p. 37.
16 André Breton and Diego Rivera, 'Manifesto: Towards a Free Revolutionary Art' (translated by Dwight MacDonald), *Partisan Review*, Fall 1938, vol. VI, no. 1, pp. 49–53.
17 Ibid., pp. 51–2.
18 'Leon Trotsky to André Breton', 22 December 1938, *Partisan Review*, Winter 1939, vol. VI, no. 2, pp. 126–7.
19 Ibid., p. 127.

20 Ibid.

21 'This Quarter – The Crisis in France', *Partisan Review*, Winter 1939, vol. VI, no. 2, pp. 3–4.

22 Ibid., p. 3.

23 S. Niall, 'Paris Letter Christmas Day 1938', *Partisan Review*, Winter 1939, vol. VI, no. 2, pp. 103–7. For instance, Niall wrote (pp. 103–4): 'A spectre is haunting France – not, alas, the spectre of Communism, but that of internal fascism and external war . . . for politically conscious artists are already sufficiently distressed by the conviction that Daladier bears a more sinister resemblance to one Heinrich Brüning than to the Napoleon Bonaparte he apparently fancies himself to be, without having a quiet art weekly suddenly burst into reactionary howls against artistic progress which are unnervingly reminiscent of that "Anti-Kultur-Bolshewismus" movement which, similarly born in 1932 Berlin, grew like a rank weed till, with Hitler's accession to power, it finally succeeded in entirely strangling German culture.'

24 D[wight] M[acDonald], 'This Quarter – War and the Intellectuals: Act Two', *Partisan Review*, Spring 1939, vol. VI, no. 3, pp. 3–20.

25 Ibid., p. 10.

26 Ibid.

27 Ibid., p. 19.

28 Ibid., p. 10.

29 P. Rahv, 'This Quarter – Twilight of the Thirties', *Partisan Review*, Summer 1939, vol. VI, no. 4, pp. 3–15.

30 Ibid., p. 5.

31 Greenberg, *A–G & K*, p. 49 *[58]*.

32 See Gilbert, op. cit. pp. 195–7 for discussion of the results of a questionnaire sent out to subscribers and readers in 1941:35 per cent were found to live in New York and 50 per cent were spread out over the East Coast. 'But in general the magazine was directed to the radical intellectual community of New York' (p. 197). See also L. Fiedler, 'Partisan Review' – Phoenix or Dodo? – The Life History of America's Most Influential Cultural Magazine', *Perspectives*, Spring 1956, vol. 15, p. 84.

33 Greenberg, *A–G & K*, p. 38 *[51]*. The notion stems from a text by Joseph Freeman, *Proletarian Literature in the United States*, New York, 1935, p. 20.

34 Greenberg, *TANL*, p. 296 *[60]*.

35 Ibid.

36 Ibid., p. 301 *[63]*.

37 Ibid., p. 302 *[64]*.

38 Ibid., p. 303 *[65]*.

39 Ibid., p. 308 *[68]*.

40 Ibid., p. 309 *[69]*.

41 Ibid., p. 310 *[69]*.

42 C. Greenberg, 'New York Painting Only Yesterday', *Art News*, Summer 1957, vol. 56, no. 4, pp. 58–9, 84–6.

43 Ibid., p. 58.

44 Reprinted as 'The Late Thirties in New York' in *Art and Culture: Critical Essays*, 1961, p. 230.

Revisionism revisited

Introduction (1999)

As I explained in 'Looking Forward, Looking Back: 1985–1999,' Part Three has been totally revised from the first edition of *Pollock and After*. The main reason is to create space for examples of publications, since 1985, that have developed, expanded and critiqued texts and debates in the previous two parts: those addressing the relationships between art, art criticism, and the Cold War in the United States. I have already drawn attention to many publications, related to debates represented in the first edition of *Pollock and After*, which have appeared since the mid 1980s. A major criterion in selecting from this large terrain of texts has been to further discussion of themes evident, explicitly or implicitly, in the concerns of revisionist texts of the 1970s and early 1980s.[1] These are: the role of writers, other than Greenberg, whose publications reveal the paradoxes and contradictions of attempts by members of the 'Old Left' to maintain a political practice during the McCarthy period; the relationship between critical and institutional responses to art in the 1940s and 1950s in the context of the art market, exhibitions and perceptions of cultural value; the construction of the 'post-war American artist,' as encoded for example in Nina Leen's photograph of the 'Irascible Group of Advanced Arts,' 1951,[2] in terms of unquestioned assumptions about ethnicity, gender and sexuality; the relationships between constructions of masculinity, power relations and the social utterances of value in the period from the late 1940s to the 1960s.

The Chapters contained in this revised part are presented in a thematic order. The first two Chapters discuss the writings of Meyer Schapiro (by David Craven) and Harold Rosenberg (by Fred Orton). Craven considers Schapiro's 'The Liberating Quality of Abstract Art,' 1957, as an argument for reading Abstract Expressionism as a critique of an ascendant multinational capitalism. Implicit in his discussion is a further consideration of the consistencies and transformations in Schapiro's writings between

those of the 1930s, 'The Social Bases of Art' (1936) and 'Nature of Abstract Art' (1937), and the McCarthy period.[3] For an example of a response to Craven's reading, in the context of 1950s discourses, see Nancy Jachec's 'The Space Between Art and Political Action: Abstract Expressionism and Ethical Choice in Post War America.'[4] Orton's discussion of Rosenberg is intended to place his writings within a politics that has often been obscured by an institutionalised Modernist legacy. Rosenberg's essay 'The American Action Painters,' 1952, is considered in terms of what he regarded as the most viable legacy of 1930s Marxist debates about the dialectic and revolution. Orton's text should be considered alongside another of his essays 'Footnote One: The Idea of the Cold War.'[5]

The next two chapters consider aspects of the art market and institutions, particularly MoMA, in relation to the arguments put forward by revisionist historians. The first is by A. Deirdre Robson on the time lag between art market and critical responses to the Abstract Expressionists. Robson's work brings to the period a doubly important perspective: a close attention to patronage, the art market and the growth of the entrepreneurial dealer all of which have been crucial to social historians of the art and culture of other periods;[6] and the relationships between art criticism, institutional validation through purchase, and the cultural capital of art collecting within the consumerist boom of post-war America. Here other publications by Robson are important including *Prestige, Profit, and Pleasure: The Market for Modern Art in New York in the 1940s and 1950s*, 1995.[7] Such discussion assists to locate the role and status of articles such as Greenberg's 'The Jackson Pollock Market Soars,' 1961, and 'America Takes the Lead 1945–1965,' 1965.[8] The second article is by Michael Kimmelman on MoMA, its critics and the Cold War. His is one of a number of essays published in two volumes in the Museum's 'Studies in Modern Art Series,' which attempt to rebut criticism of its activities.[9] Besides Kimmelman's essay, there are, for example, Lynn Zelevansky, 'Dorothy Miller's "Americans," 1942–1963' and Helen M. Franc, 'The Early Years of the International Program and Council' in 'Studies in Modern Art 4' and Carol Morgan, 'From Modernist Utopia to Cold War Reality: A Critical Moment in Museum Education' in 'Studies in Modern Art 5.'

Fundamental issues of ethnicity, gender and sexuality in relation to Abstract Expressionism are addressed in the next pair of texts. Anne Eden Gibson's *Abstract Expressionism: Other Politics* was published in 1997. The 'Introduction' to this important discussion is included and should be considered in relation to publications by Gibson and others on histories still in the making.[10] On this, too, see my discussion of, for example, *To Conserve a Legacy*[11] in 'Looking Forward, Looking Back: 1985–1999.' Anna C. Chave's article on Jackson Pollock and Lee Krasner is an example of feminist historians' analyses of the conditions of the production and reception of 'Abstract Expressionist' art with respect to the construction of artistic identities in the 1940s and 1950s. Her text follows in the history of approaches that can be indexed to texts ranging from Linda Nochlin's important essay of 1971 'Why Have There Been No Great Women Artists?'[12] to Anne Wagner's highly influential 'Lee Krasner as L.K.' published in 1989.[13] My reason for not including the latter here is because it has already rightly gained wide spread currency and has been reprinted in Norma Broude and Mary Garrard's anthology *The Expanding Discourse*, 1992.[14]

Lastly, I have included two texts that address, in different ways, masculinity and the authorial voice: extracts from larger works by Michael Leja and Rosalind E. Krauss both of whom are concerned with identity and Abstract Expressionism. Leja's extensive *Reframing Abstract Expressionism: Subjectivity and Painting in the 1940s,* 1993, argues for a consideration of the practices of art and of art criticism produced in/by a 'modern man discourse' of the 1940s and 1950s.[15] In this extract he considers the 'structural constitution' of gendering subjectivity in the relationships between representations of the 'artists' studio' and the 'conflict within the modern man subject: *film noir.*' Here, other relevant texts are by, for example, T. J. Clark, Daniel Belgrad, Caroline Jones, Andrew Perchuk, and Amelia Jones.[16] The final text is an extract from a long chapter in Rosalind Krauss's *The Optical Unconscious.*[17] In it 'Clement Greenberg' and 'Jackson Pollock' are presented and represented from a number of perspectives all starting and returning to a paragraph in which Krauss is remembering Greenberg through images both on 'film' and in her memory of his personality, physical being and agency. As I discuss in 'Looking Forward, Looking Back: 1985–1999' there are a number of issues to consider in the Greenberg/Krauss relationship. Here, the process of Krauss remembering the 'implacably final' character of Greenberg's 'pronouncements' are, it seems to me, to be implicitly about the legacy of the 'authoritarian personality,' whether 'on the left' or 'on the right,' within post-war American cultural life.[18]

Notes

1 I wish to draw readers' attention to texts by T. J. Clark that in both length and texture of argument could not be included within the parameters of this revised anthology. It seems to me that to include one of them necessitates including them all. They are: T. J. Clark, 'Jackson Pollock's Abstraction,' in Serge Guilbaut (ed.) *Reconstructing Modernism: Art in New York, Paris and Montreal,* Cambridge and London, The MIT Press, 1990, pp. 172–238; T. J. Clark, 'In Defense of Abstract Expressionism,' *October* 69, Summer 1994, pp. 23–48; T. J. Clark, 'The Unhappy Consciousness' and 'In Defense of Abstract Expressionism' Chapters 6 and 7 of his *Farewell to an Idea: Episodes from a History of Modernism,* New Haven and London, Yale University Press, 1999.

2 This famous photograph by Nina Leen, as famous as Hans Namuth's photographs of Jackson Pollock and Lee Krasner, was published in *Life,* 15 January 1951, p.34. Out of fourteen artists in the photograph (basically the 'Abstract Expressionists') only Hedda Sterne disrupts the white masculinity, though significantly Leen places Sterne at an off-centre apex. Sterne, along with artists ranging from Grace Hartigan to Norman Lewis, subsequently became erased in the official histories. For example, Sterne does not even appear in the index of Irving Sandler's *Abstract Expressionism: the Triumph of American Painting,* New York, Praeger, 1970, yet the photo of the 'Irascibles,' with Sterne, fills a whole page at the start of the book.

3 For earlier discussion of Schapiro and references see my 'Introduction' to Part One The Critical Debate and its Origins. Importantly, too, see Alan Wald, *The New York Intellectuals: The Rise and Fall of the Anti-Stalinist Left from the 1930s to the 1980s,* Chapel Hill and London, University of North Carolina Press, 1987; the special issue of

the *Oxford Art Journal*, vol. 17, no. 1, 1994 on Schapiro; David Craven, *Abstract Expressionism as Cultural Critique: Dissent During the McCarthy Period*, Cambridge, Cambridge University Press, 1999; Francis Frascina, 'My Lai, *Guernica*, MoMA and the Art Left, New York, 1969–70', *Art, Politics and Dissent: Aspects of the Art Left in Sixties America*, Manchester and New York, Manchester University Press, 1999, pp. 160–208.

4 *The Oxford Art Journal*, vol. 14, no. 2, 1991, pp. 18–29.

5 In David Thistlewood (ed.) *American Abstract Expressionism*, Liverpool, Liverpool University Press and the Tate Gallery Liverpool, pp. 179–192. See, too, essays by Craven, Harris, and Jachec in the same volume.

6 Within the modern period studies such as Raymond Moulin, *Le Marché de la peinture en France*, Paris, Les Editions de Minuit, 1967; Judith Zilczer, 'The Noble Buyer': John Quinn, Patron of the Avant-Garde, Washington DC., Smithsonian Institution Press, 1978; Karl. E. Meyer, *The Art Museum: Power, Money, Ethics*, New York, William Morrow and Company, 1979; Malcolm Gee, *Dealers, Critics and Collectors of Modern Painting: Aspects of the Parisian Art Market Between 1910 and 1930*, New York and London, Garland, 1981; Isabel Monod-Fontaine (ed.) *Daniel-Henry Kahnweiler: marchand, éditeur, écrivan*, Paris, center Georges Pompidou, 1984; Diane Crane, *The Transformation of the Avant-Garde: The New York Art World, 1940–1985*, Chicago and London, The University of Chicago Press, 1987. Generally, the work of Pierre Bourdieu is crucial. For example, Pierre Bourdieu and Alain Darbel with Dominique Schnapper, *The Love of Art: European Museums and their Public*, Cambridge, Polity Press, 1991 (first published in French in 1969).

7 A. Deirdre Robson, 'The Avant-Garde and the On-Guard: Some Influences of the Potential Market for the First Generation Abstract Expressionists in the 1940s and 1950s,' *Art Journal*, vol. 47, no. 3, Fall 1988, pp. 215–21; A. Deirdre Robson, *Prestige, Profit, and Pleasure: The Market for Modern Art in New York in the 1940s and 1950s*, New York and London, Garland Publishing, 1995.

8 Greenberg, 'The Jackson Pollock Market Soars,' *The New York Times Magazines*, 16 April 1961, pp. 42–43, 132 and 135; Greenberg, 'America Takes the Lead 1945–1965,' *Art in America*, August–September 1965, pp. 108–129.

9 *The Museum of Modern Art at Mid-Century, At Home and Abroad*, 'Studies in Modern Art 4,' New York, MoMA, 1994; *The Museum of Modern Art at Mid-Century, Continuity and Change*, 'Studies in Modern Art 5,' New York, MoMA, 1995.

10 Ann Eden Gibson, 'Norman Lewis in the Forties,' *Norman Lewis: From the Harlem Renaissance to Abstraction*, New York, Kenkeleba Gallery, 1989, slightly modified in Thistlewood (ed.) op.cit., pp. 53–76; and the important publication Ann Eden Gibson et al., *The Search For Freedom: African American Abstract Painting, 1945–1975*, New York, Kenkeleba Gallery, 1991; David Craven, 'Myth-Making in the McCarthy Period,' in Penelope Curtis (ed.) *Myth-Making: Abstract Expressionist Painting from the United States*, Liverpool, Tate Gallery Liverpool, 1992; Judith Wilson, '"Go Back and Retrieve It": Hale Woodruff, Afro-American Modernist' in *Selected Essays: Art and Artists from the Harlem Renaissance to the 1980s*, Atlanta, National Black Arts Festival, 1988, pp. 41–49; Mary Schmidt Campbell (ed.) *Tradition and Conflict: Images of a Turbulent Decade, 1963–73*, New York, The Studio Museum in Harlem, 1985; David Craven, 'Abstract Expressionism and Third World Art: A Post-Colonial Approach to "American Art",' *The Oxford Art Journal*, 14:7, 1991, 44–66; David Craven, 'Clement Greenberg and

the "Triumph" of Western Art' *Third Text*, 25, Winter 1993–4, pp. 3–9; W. Jackson Rushing, *Native American Art and the New York Avant-Garde, A History of Cultural Primitivism*, Austin, University of Texas Press, 1995; Lisa Bloom, 'Ghosts of Ethnicity: Rethinking Art Discourses of the 1940s and 1980s,' *Socialist Review*, vol. 24, nos 1–2, 1995, pp. 129–63; David Belgrad, *The Culture of Spontaneity: Improvisation and the Arts in American Society, 1940–1960*, Chicago and London, University of Chicago Press, 1998.

11 Richard J. Powell and Jock Reynolds (eds) *To Conserve a Legacy: American Art from Historically Black Colleges and Universities*, Cambridge, The MIT Press, 1999.

12 *Art News*, vol. 69, no. 9, 1971, pp. 23–39.

13 Anne Wagner, 'Lee Krasner as L.K.' *Representations* 25, Winter 1989, pp. 42–57. See too: Anne Wagner, 'Krasner's Presence, Pollock's Absence,' in Whitney Chadwick, and Isabelle de Courtivon (eds) *Significant Others: Creativity and Intimate Partnership*, London and New York, Thames and Hudson, 1993, pp. 223–43; Anne Wagner, *Three Artists (Three Women): Modernism and the Art of Hesse, Krasner and O'Keeffe*, Los Angeles and London, University of California Press, 1996; Griselda Pollock, 'Killing Men and Dying Women' in Fred Orton and Griselda Pollock, *Avant-Gardes and Partisans Reviewed*, Manchester, Manchester University Press, 1996, pp. 219–94; Ellen G. Landau, *Lee Krasner: a Catalogue Raisonné*, New York, Abrams, 1995.

14 Norma Broude and Mary Garrard's (eds) *The Expanding Discourse*, New York, HarperCollins, 1992, pp. 425–36.

15 Michael Leja, *Reframing Abstract Expressionism: Subjectivity and Painting in the 1940s*, New Haven and Yale, Yale University Press, 1993. See, too, Leja's conference paper 'Slow Learners: The Challenges of Using Art for Cold War Cultural Diplomacy,' 1998, forthcoming as part of the proceedings of a conference on Cold War Culture, Zagreb, 1998, and his earlier related paper given at the 'Cold War Culture' conference, University College London, October 1994.

16 T. J. Clark, 'Jackson Pollock's Abstraction,' Serge Guilbaut (ed.) *Reconstructing Modernism*, op.cit., pp. 172–238; Daniel Belgrad, *The Culture of Spontaneity: Improvisation and the Arts in American Society, 1940–1960*, op. cit., Caroline Jones, 'Finishing School: John Cage and the Abstract Expressionist Ego,' *Critical Inquiry*, vol. 19, no. 4, Summer 1993, pp. 628–625; Andrew Perchuk, 'Pollock and Postwar Masculinity,' Andrew Perchuk and Helaine Posner (eds) *The Masculine Masquerade; Masculinity and Representation*, Cambridge and London, The MIT Press, 1995, pp. 31–42; Michael Leja, 'Barnett Newman's Solo Tango,' *Critical Inquiry*, vol. 21, no. 3, Spring 1995, pp. 556–80; Caroline Jones, *Machine in the Studio: Constructing the Postwar American Artist*, Chicago, 1996; Amelia Jones, *Body Art/Performing in the Subject*, Minneapolis and London, University of Minnesota Press, 1998.

17 *The Optical Unconscious*, An October Book, Cambridge and London, The MIT Press, 1993. See, too: Rosalind E. Krauss, 'A View of Modernism,' *Artforum*, vol. 11, no. 1, 1972, pp. 48–51; Rosalind E. Krauss, *The Originality of the Avant-Garde and Other Modernist Myths*, Cambridge and London, The MIT Press, 1985.

18 Theodor Adorno et al., *The Authoritarian Personality*, New York, Harper, 1950.

David Craven

ABSTRACT EXPRESSIONISM, AUTOMATISM AND THE AGE OF AUTOMATION

[. . .] During the 1950s, Meyer Schapiro defended Abstract Expressionism not only for its progressive use of non-Western cultural practices but also for its critical counter to the contemporary definition of labour. As was true of his focus on the way Abstract Expressionism assimilated Third World art forms, Schapiro's discussion of this North American movement both as a form of labour 'opposed to the characteristics of industrial production' and as a new visual language 'opposed to communication as it is understood now' is also found in his exemplary essay of 1957, 'The Liberating Quality of Avant-Garde Art'.[1] Owing to the way he illuminated these three fundamental attributes, Schapiro could further observe that this post-war avant-garde within the US helped 'maintain the critical spirit' in the face of an ever ascendant multinational capitalism.[2]

Of notable theoretical import is how Schapiro simultaneously analyzed Abstract Expressionism as a form of labour *and* as a new visual language, each of which was seen in relation to human self-realization *and* in light of a dialogical aesthetic necessitating viewer engagement. Recent critiques of language have much advanced this nexus of relationships by demonstrating that humanity shapes itself as much through language as through labour.[3] In acting as a formative force, not simply as a reproductive one, languages do not passively reflect society but rather actively function as material components whereby a society *variously* defines and produces what it is. Indeed, language (spoken and written) provides the basic network of ideological and communicative bonds which are both a *pre*-condition for and a result of the social relations of production in the workplace. In a word, without language there simply would be no collective labour.[4] [. . .]

My aim in this study will be to outline and to extend Schapiro's contention that Abstract Expressionism at its best affirmed an historical concept of humanity 'in opposition to the contemporary qualities of the ordinary experience of working'

Source: 'Abstract Expressionism, Automatism and the Age of Automation', *Art History*, vol. 13, no. 1, March 1990, pp. 72–103. This text has been edited and footnotes renumbered.

within late capitalism.[5] I will then further explain how Abstract Expressionism was intended to embody a political critique of instrumental thinking in conjunction with an ideological critique of technologism. As such, my article will involve four parts: (1) an explication of Schapiro's original critique; (2) an outline of the period developments in political economy that form the context for his position; (3) a sustained examination of statements by the Abstract Expressionists themselves, which show clearly that their methods for producing art were *intentionally* at odds with the capitalist mode of production in the post-war period; and (4) a consideration of the unresolved difficulties that characterized this position of the Abstract Expressionists, thus allowing the temporary appropriation of this art for different ideological ends.

Once this assessment has been achieved, it will be possible, for example, to understand why Abstract Expressionism was neither an escapist flight into 'pure art' nor a misguided retreat to mysticism. Rather, this art signified a profound form of romantic anti-capitalism with substantial strengths and considerable weaknesses. Not surprisingly, in contradicting the society from which it arose this art was itself also deeply contradictory, yet in ways that often seem historically unavoidable and that were certainly not always politically reprehensible.

Abstract expressionism as anti-capitalism

Since Schapiro's discussion of Abstract Expressionism's contravention of post-war wage labour has been largely ignored both by mainstream art historians and by their opponents on the left, I shall begin by outlining his position before seeking corroboration from political economy, as well as from statements by the Abstract Expressionists themselves. In contending that the radical changes in post-war US art were 'related to a broader and deeper reaction to basic elements of common experience', Schapiro contended that a consideration of this art should address 'new problems, situations, and experiences' that had arisen in society as a whole.[6] Among these issues, he listed the challenge of social conflict, the problem of the subject, and concomitant developments in science as well as in technology. His critical focus was mostly on painting in the post-war US (and his article was accompanied by a reproduction of Jackson Pollock's water-colour *No. 7, 1951*) because at that moment, painting was 'the domain in culture in which the contradiction between the professed ideals and the actuality' of society was most painfully clear.[7]

While eloquently adumbrating the historical context for the paradoxical relation of Abstract Expressionism to US society, Schapiro stated:

> In a number of respects, painting and sculpture today may seem to be opposed to the general trend of life. Yet, in such opposition, these arts declare their humanity and importance. Painting and sculptures, let us observe, are the last handmade, personal objects within our culture. Almost everything else is produced industrially, in mass, and through a high division of labor. Few people are fortunate enough to make something that represents themselves, that issues entirely from their hands and minds . . .

Most work, even much scientific work, requires a division of labour, a separation between the individual and the final result . . . Standardized objects produced impersonally and in quantity establish no bond between maker and user. They are mechanical products with only a passing and *instrumental value* [my italics] . . . What is most important is that the practical activity by which we live is not satisfying: we cannot give it full loyalty, and its rewards do not compensate enough for the frustration and emptiness that arise from the lack of spontaneity and personal identifications in work.[8]

In response to these alienating conditions within the post-war US, Abstract Expressionism emerged as a way of producing art that was fundamentally at odds with the capitalist mode of production. According to Schapiro, this new art work symbolized above all a deep engagement of the self within work. And in a moving passage which deftly defined what most distinguished Abstract Expressionism from all earlier art, Schapiro stated that this new art work was more 'passionately than ever before, the occasion of spontaneity or intense feeling'.[9] He then enumerated the resulting formal traits, the visual idiom, unique to Abstract Expressionism, particularly in the paintings by Pollock and de Kooning from 1947 to 1950.

The consciousness of the personal and spontaneous in the painting and sculpture stimulates the artist to invent devices of handling, processing, surfacing, which confer to the utmost degree the aspect of the freely made. Hence the great importance of the mark, the stroke, the brush, the drip, the quality of the substance of the paint itself, and the surface of the canvas as a texture and field of operation – all are signs of the artist's active presence.

All these qualities may be regarded as means of affirming the individual in opposition to the contrary qualities of the ordinary experience of working . . . [contrary] characteristics of industrial production, may be found also in the different sense of the words 'automatic' and 'accidental' as applied in painting, technology and the everyday world.

Modern painting is the first complex style in history which proceeds from elements that are not pre-ordered as closed articulated shapes. The artist today creates an order out of unordered variable elements to a greater degree than the artist of the past . . . While in industry accident is that event which destroys an order . . . in painting the random or accidental is the beginning of an order . . . a kind of order that in the end retains the aspect of the original disorder as a manifestation of freedom.

This art is deeply rooted, I believe, in the self and its relation to the surrounding world. And the pathos of the reduction or fragility of the self within a culture that becomes increasingly organized through industry, economy, and the state intensifies the desire of the artist to create forms that will manifest his liberty in a striking way . . . to reach out

into common life. It becomes then a possession of everyone and is related to everyday experience.

If the painter cannot celebrate many current values, it may be that these values are not worth celebrating.[10]

Just as Abstract Expressionism was seen by Schapiro as a repudiation of capitalist wage labour and the particular division of labour on which it was predicated, so this art was also discussed as a rejection of the instrumental thinking orchestrated by this new technocracy's means of communication. In Schapiro's view, another aspect of Abstract Expressionism 'which is opposed to our actual world and yet is related to it' was the contradiction between this painting and 'what are called the "arts of communication"'.[11] The hegemonic mode of communication in the US was one of streamlined exclusions – 'a world of social relationships which is impersonal, calculated and controlled in its elements, aiming always at efficiency'.[12] Yet, conversely, what 'makes painting and sculpture so interesting in our times is their high degree of non-communication'.[13] As such, this new art failed to signify in conventional codes. It had no 'practical' message, 'no clear code or fixed vocabulary'.[14]

Abstract Expressionism thus signified a visual language 'in which communication seems to be deliberately prevented'.[15] Consequently, the reception of this art, like its production, was 'a process ultimately opposed to communication as it is understood now'.[16] This was true, Schapiro observed, because these artists did not wish simply to transmit an 'already prepared and complete message to a relatively indifferent and impersonal receiver'.[17] In abrogating the normal function of language by affirming values that went beyond mere instrumental or technocratic concerns, the Abstract Expressionists wished to trigger a different and more critical thought process in the spectator. Rather than the prescribed message passively consumed, this art work depended on active 'contemplativeness and communication with the work of another human being'.[18] As a result, Schapiro maintained that Abstract Expressionism at its most politically engaged and socially effective helped 'to maintain the critical spirit . . . indispensable to the life of our culture'.[19]

Aside from the impediments posed by the anti-democratic organization of the workplace within capitalism and the control by multi-national corporations over the means of communication within society at large, realization of the oppositional intentions of Abstract Expressionism was also thwarted by the institutions *within* the US art world. Precisely because of the fact that the visual arts produced objects, Schapiro said, they were exposed 'more than the other arts to dangerous corruption'.[20] Even while advancing certain dimensions of human existence in material form, this art work could also succumb to the humanly negating logic of commodity fetishism as 'a unique commodity of high market value'.[21] On the other hand, though, Schapiro noted that as of the mid-1950s 'no profession is as poor as the painter's . . . *The painter cannot live by his art*' [my italics].[22]

The institutional mediation of how paintings were coming to be viewed as the most costly human-made objects in the world could none the less lead to appropriation or evisceration by the very existing order these painters criticized. For in the ascendant US art world, the perception of success 'stamped the painting as an object of speculation, confusing the values of art'.[23] Furthermore, the reception of art

work could generate ideological legitimacy for its owner, instead of publicly challenging the whole process whereby this redefinition of art occurred. Having located the Abstract Expressionists in this paradoxical, even debilitating position, Schapiro then ended by reminding the reader that Abstract Expressionism had yet to garner the type of monetary success that would have effected a transvaluation of its contumacious aims.

With this unresolved conflict between the institutional framing of art and the individual intentions of artists, Schapiro's analysis reached an impasse concerning the broader signification of Abstract Expressionism. Subsequently, the paintings of Abstract Expressionism, which arose as an assimilation of non-Western cultural traditions and as a repudiation of commodity production in the US, would become quite precious commodities supposedly exalting the 'American Way'. (It is of note here that formalist critics such as Clement Greenberg, ever concerned with bowdlerizing this art politically, would label it 'American' and in the 1960s would celebrate how the 'Jackson Pollock Market Soars'.[24] This later state of affairs, however, neither invalidates Schapiro's observation about the artistic intent motivating the work's conception nor forecloses a progressive disappropriation of Abstract Expressionism along these lines.

The frequent signification of this art work within the US art world at present (Latin America is another matter) as mere disengaged private expression does point to some serious limitations of this art. Such a situation does not demonstrate the uselessness of Abstract Expressionism for posing critical alternatives, however. Rather, we are reminded of the ongoing pertinence of such an alternative reading of Abstract Expressionism, however marginalized and incomplete this interpretation might be at present in the US. There is little doubt that Willem de Kooning encapsulated both the original intent of this art, as well as its early reception, when he stated: 'I think we are craftsmen . . . but we have no position in this world.'[25] Similarly, Mark Rothko recognized well the process of appropriation threatening the Abstract Expressionists when he observed in 1947:

> A picture lives by companionship, expanding and quickening in the eyes of the sensitive observer. It dies by the same token. It is therefore a risky and unfeeling act to send it out into the world.[26]

The age of automation and 'scientific management'

Far from simply reflecting ideological and industrial developments both in the US and Europe, Abstract Expressionist paintings at first contested and only later seemed to confirm fundamental structural developments in other spheres, because of the way this art was partially appropriated through art-world institutions. A summary of the historical context in the post-war US will clearly demonstrate how the above-mentioned process of making Abstract Expressionist paintings – as well as the distinctive objects resulting from this process – originally signified a critique of what occurred in the work place during this period.

Along with the enormous new accumulation of wealth in the post-war US, which saw per capita living standards rise substantially, there were some regressive

developments concomitant with the wholesale consolidation of what has been called the third great revolution in technology, namely, the 'Age of Automation'.[27] While the early nineteenth century saw a transition from handicraft-made steam engines to machine-made steam engines, and the early twentieth century ushered in a change to electric or combustion engines, *the post-1945 period was dominated by the generalized control of machines through electronic apparatuses.*[28] The principle behind this impetus towards fully automated mass production that resulted even in machine-made raw materials and synthetic food stuffs was, as political economist Earnest Mandel has noted, that of ' "emancipating" industry from the human hand'.[29]

The post-war drive by Western capital 'to eliminate living labour from the process of production'[30] involved an effort to reduce wages while simultaneously reconstituting the industrial reserve army. Predicated as it was on private property and commodity production, this process of capitalist 'modernization' was based on the generation of surplus value for capital by lowering wages in relative terms. Such a diminution in wages was achieved by an expansion of the labour force, through the use of more automated technology to accomplish a new level of global unemployment, or what apologists for this system term a heightening of 'competition' among workers. (Needless to say, the use of automation by and on behalf of the workers will be consistently possible only in a post-capitalist society based on workplace democracy.[31])

The new job insecurity of the post-war US resulting from the growing threat of displacement through automation was permitted by several changes: by political repression in the 1950s of the left, by a demobilization of the labour organizations so powerful and progressive in the 1930s (through such legislation as the Taft–Hartley Act of 1947), and by an unprecedented succession of US military interventions abroad (both to expand the source of cheap labour and to deny democratic self-determination by foreign workers). All of this dramatically lowered relative wages in the Third World, as multinational US capital penetrated into economic regions characterized by a low organic composition of capital. The key doctrine for this military intervention in the periphery of the world economic order was the Truman Doctrine of 1947, which endorsed a global campaign by the US against 'Communism' (or, as its opponents countered, against the right of non-Western workers to resist being reduced to cheap labour by 'free' enterprise) and resulted in the systematic support of a remarkable number of ultra-right-wing military dictatorships that dutifully guaranteed 'economic stability' for US capital.[32]

The substantial success enjoyed by US capital in the 'Age of Automation', particularly from the mid-1940s through to the early 1960s, has been amply documented by official US statistics. From 1946 to 1961, the domestic working class increased by 35 per cent and its total physical output rose by 70 per cent while workers' real wages rose only 29 per cent, all of which translated into a notable rise in the rate of surplus value expropriated by capital from 1940 to 1966.[33] This same period saw investment in automation reach 18 per cent of all new investments by 1963, while 21,000 of the 32,000 major US manufacturing establishments had become largely automated by the early 1960s. This 'modernization' through automation occurred in four basic ways: (1) through a transfer of parts between successive productive processes based on automatic devices, as in Detroit automobile plants; (2) through continuous flow processes with automatic controls over the flow, as in

chemical, oil, gas and electric utilities; (3) through computer-controlled processes, as in the communication industries; and (4) through a combination of the above.[34]

In US society as a whole, the post-war age of automation, or what is now known as the 'hi-tech' era, has produced two main ideological tendencies to legitimate such inequitable developments. These are the ideologies of technologism and of 'scientific management', or what the Frankfurt School has aptly labelled the 'instrumental reasoning' of scientism.[35] [. . .]

Significantly, it was in 1944 that T.W. Adorno and Max Horkheimer published their now classic critique of technology, scientism and instrumental thinking, *Dialectic of Enlightenment*.[36] Their analysis of the paradoxical role of 'reason' in modern Western society underscored how it has signified on the one hand 'the idea of a free, humane, and social life' and has meant on the other hand 'the court of judgment of calculation' subordinate to the 'ratio of capital'.[37] In this way, the development of reason in modern Western society has been deeply contradictory. From being a necessary means both of societal self-preservation and general human self-realization, reason has also become the opposite, namely, a narrowly circumscribed instrument of domination, rather than general liberation, whereby a minority has protected its privileges against the majority.

In league with capitalist modernization, instrumental thinking hardened first into a technologist view for the domination of nature and then into a technocratic view for the domination of people (labour). Early on in this process, nature was stripped of all integrative qualities and instead became a phenomenon to be controlled for quantitative gain. Human reason itself also became constrictively redefined as part of this system's 'pragmatic' logic. From being a fundamental mode of self-realization interdependent with the progress of humanity in general, synthetic reason has been reduced to a narrow technique for instrumental thought and self-interested thinking. While the progression of human reason in a rational society is inextricably connected to the end of all exploitation, instrumental thinking conversely operates in exploited and exploitative circumstances. This reification of reason, into what Marcuse incisively called 'one-dimensional thought', was based on a fetishism of science.[38] While modern science at its best is a way of empirically describing natural phenomena in quantitative terms, scientism (the ideological form of fetishized science) is the unjustified transposition of this technique for quantification into historical situations and political circumstances that are necessarily qualitative, never merely natural, and certainly not neutral.

Nowhere was the attendant human abuse of applied scientism more obvious than in the work place of post-1945 US society. It was there, in tandem with the Age of Automation, that F.W. Taylor's principles of 'scientific management' were first used in a sustained way on the work force.[39] Unlike Adam Smith's discussion of the new division of labour during the early phase of the industrial revolution (when it was assumed that this development in specialization would *not* lead to the intellectual disengagement of ordinary workers), Taylor's view was that further 'progress' depended on just such an elimination of all intellectual involvement by wage labour. According to Taylor's principles, which although conceived in the early twentieth century were consolidated systematically only after 1945, all intellectual engagement must henceforth become the exclusive prerogative of management and the factory owners.[40]

F.W. Taylor's three basic concepts of 'scientific management' involved undisguised ways to cheapen labour, thus reducing overheads and enlarging output. First, management should dissociate the labour process from any need for skills on the part of workers. Second, management should orchestrate a thorough separation of conception from execution within the work place, thus eradicating any intellectual decision-making by workers. Third, management should exercise complete control over *all* knowledge necessary for production, so as to ensure itself *total* authority in the labour process.[41]

The human alienation fostered by such work conditions in post-war society is quite self-evident. [. . .]

Nor is it surprising that 'scientific management' would have an equally implausible counterpart in formalist criticism which, as Greenberg has acknowledged, is based on positivism – the analogue in philosophy of technologism and scientism.[42] As Casey Blake has noted, the desire to reconcile post-war US art, such as Abstract Expressionism, with contemporary industrial developments expressed itself in Greenberg's transformation of vanguard cultural radicalism into 'the administration of a self-referential cultural idiom by a cultural elite – in short, into aesthetic engineering'.[43] In this way, a concept of artist progress arose that was characterized by a linear, technocratic variant of modernism, which generally corresponded to the technologist modernization of post-war capitalism. In accordance with his managerial role, Greenberg redefined the relationship between the critic and the artist 'along lines parallel to the industrial division of labour between administrator and worker', so that Greenberg himself could function as the chief quality controller for the supposed line of luxurious objects produced by the US art world.[44]

Revealingly, the entirely different conceptual framework used by Meyer Schapiro to discuss Abstract Expressionism finds much more ready corroboration both in the paintings of these artists and in the Abstract Expressionists' own unequivocal opposition to scientism, technologism, and wage labour alienation (on which we will focus in part three of this article). Far from being the consequence of predetermined formal problems, as formalist versions of modernism maintain, these artistic innovations occurred at the juncture of diverse historical developments that Schapiro aptly disclosed. Abstract Expressionism was, he said, 'a break with the kind of painting that was important in the 1920s' because 'the experiences of the last twenty-five years have made such confidence in the values of technology less interesting and even distasteful.'[45]

The military rise of fascism in the 1930s, the unparalleled holocaust of the Second World War, and finally the invention as well as use of the atomic bomb in 1945 accounts for the way that progressive forces in the West, including Meyer Schapiro and the Abstract Expressionists, repudiated the unqualified adulation of technology by the early avant-garde (particularly the machinalotry of Futurism and the 'machine aesthetic' of the 1920s). This new position did not entail a neo-Luddite rejection of technology *per se* but rather a critical appraisal of how technology was not an end in itself, as is assumed by the ideology of technologism. Thus, technology was seen by post-war progressives as an awesome force no better or worse than the system of political economy that used it. As Schapiro indicated, after the 1930s the left had increasingly recognized that, instead of automatically producing new social relations, technology is itself often reproductive of the social relations manufactured

by the established order controlling the design, use and deployment of this technology. [. . .]

Critiques by the abstract expressionists of technologism and scientism

Even a cursory consideration of the statements by the Abstract Expressionists them-selves is sufficient to demonstrate that they intended their 'automatic' hand-made works as a commentary on the dehumanizing developments intrinsic to the Age of Automation after 1945. This not only involved a reclamation of 'outdated' non-European art forms from the North-West Coast or Latin America, but also a recourse to non-Western techniques such as that of the Navajos for painting on the floor. Both of these manoeuvres were allied to a redefinition of Western oil painting through the assimilation of a mural-sized format from Mexican art. In turn, all of these traits were related to a new vocabulary of improvised visual forms, which accented the artisanal and inalienably human quality of this process of artistic production.

As Jackson Pollock noted, 'Craftsmanship is essential to the artist' for respond-ing to 'the aims of the age we're living in'.[46] The hand-inflected, manual traces of these paintings in turn inter-related with the non-mimetic character of Abstract Expressionism, because, as Pollock observed, 'the modern artist is living in a mech-anical age and we have mechanical means of representing objects.'[47] Willem de Kooning was no less insistent on the interventionary role of artisanal labour in the production of art. In the well-known discussions at Studio 35 in 1950, de Kooning prefaced his remarks on the necessity of craftsmanship and his need to 'force my attitude upon this world' with the view that in making art 'there is no such thing as being anonymous'.[48]

Significantly, much of the discussion among the artists at Studio 35 involved whether or not an art work should look or be 'finished'. De Kooning himself said: 'I refrain from "finishing" it. I paint myself out of the picture.'[49] He then criticized contemporary French paintings for evincing a certain 'touch' that 'makes them look like a "finished" painting'.[50] Other Abstract Expressionists and the artists associated with them generally voiced a comparable view. Barnett Newman declared: 'I think the idea of a "finished" picture is a fiction.'[51] He subsequently said: 'The artist's intention is what gives a specific thing form.'[52] (Both of these concepts utterly contradict the concern of formalists with 'resolved' art that is important not because of artistic intent, but because of the finished *object* that results whether intentionally or otherwise.) Reinhardt added a statement analogous to that of Newman when he stated that 'the emphasis with us is upon a painting experi-ence'.[53] This position moved Reinhardt to ask. 'Is there anyone here who considers himself a producer of beautiful objects?' (to which no one responded affirmatively).[54]

Elsewhere, Robert Motherwell specifically identified this new concept of painting as a signifier of improvised, non-regulated human labour and thus as a critique of the standardization and instrumentalism endemic to the capitalist mode of production in the post-war US:

If a painting does not make human contact, it is nothing . . . Pictures are
vehicles of passion, of all kinds and orders, not pretty luxuries like sports
cars . . . For this reason, *the act of painting is a deep human necessity, not the
production of a hand-made commodity.* [my italics][55]

In elaborating on the making of art, Motherwell explained that 'painting and
sculpture are not skills that can be taught in reference to pre-established criteria',
but entail 'a process, whose content is found, subtle, and deeply felt'.[56] He extended
this line of reasoning by contending:

I don't exploit so-called accidents in painting. I accept them if they seem
appropriate . . . *One doesn't want a picture to look 'made' like an automobile
or loaf of bread in waxed paper.* Precision belongs to the world of
machinery – which has its own forms of the beautiful. One admires
Léger. But machinery created with brush and paint is ridiculous, all the
same . . . I agree with Renoir, who loved everything hand-made.[57]

The profoundly avant-garde nature of the Abstract Expressionist movement,
with its commitment to a type of human engagement at odds with the existing order,
was a theme that clearly surfaced in the Studio 35 symposium as well as elsewhere:

Newman: The thing that binds us together is that we consider painting to
be a profession in an 'ideal society' . . . We go into normal society and
insist on acting on our own terms.
Motherwell (to Newman): You mean that we are not acting in relation to
the goals that most people in our society accept?
Newman: Yes.

. . .

Motherwell: What distinguishes these people is that they are trying to act
ideally in a non-ideal society.
Reinhardt: Does not one have to remove oneself from the business world
in order to create 'fine' art or to exist as a 'fine artist'?[58]

With two contemporary papers – 'The Renaissance and Order' (1950) and
'What Abstract Art Means to Me' (1951) – Willem de Kooning reinterpreted
classic art as well as modernist art in such a way as to emphasize the improvisatory
human engagement of art production and to repudiate the ideologies of technolo-
gism and scientism. In the first of these, de Kooning specifically rejected the idea
that what was most important to the Renaissance artist was the science of perspec-
tive (a misguided view he ascribes to 'philosophers and educators of commercial
art').[59] Far from being a matter of mechanical rules, he said, 'Painting was more
intellectual than that'.[60] Instead, the Renaissance painter made works, in order 'to
be, so to speak, on the inside of his picture'.[61]

But this use of art that both artisanally and conceptually affirmed human
self-realization (the real subject of art to him) became increasingly uncommon,
according to de Kooning, because of the demands placed on artists by practical-
minded bourgeois patrons. Concerning the ever more mechanical, ever less humanly

meaningful production of paintings, de Kooning declared: 'That's what happened when the burghers got hold of art, and got hold of man, too, for that matter.'[62]

In discussing the growing use of paintings to celebrate objects *per se*, rather than the human acts that went into producing them (all of which increasingly occurred in the mercantile phase of capitalism to which he was referring), de Kooning added: 'although I, myself, don't care for all the pots and pans in the paintings of burghers . . . I do like the idea that they – the pots and pans I mean – are always in relation to man'.[63] Significantly, the legacy of Renaissance art for ordering nature effectively was equated by de Kooning with the desire to quantify nature as well as society – a view that directly recalls the famous critique of instrumental reasoning by Adorno and Horkheimer. These Frankfurt philosophers observed, for example, in 1944, that today 'Bourgeois society is ruled by equivalence',[64] while de Kooning ended his essay of 1950 with a delightful anecdote that ridiculed the pervasive quantification of nature and humanity in Western society:

> There was the village idiot. His name was Plank and he measured every-
> thing. He measured roads, toads, and his own feet; fences, his nose and
> windows, trees, saws, and caterpillars. Everything was there already to be
> measured by him . . . He had no nostalgia, neither a memory nor a sense
> of time. All that he noticed about himself was that his length changed.[65]

In a slightly later commentary on the 'machine aesthetic' of the avant-garde before the Second World War, de Kooning both admired and rejected this type of art, in addition to the scientism it presupposed. As he explained the historical link between scientism and the machine aesthetic, de Kooning also said that the ultimate and unwanted results of this *Weltanschauung* based on a reification of science were twofold, namely, (1) military conflict and (2) 'purely' formalist art. As such, he declared:

> These latter-day artists were bothered by their apparent uselessness . . .
> these estheticians proposed that people up to now understood painting
> in terms of their own private misery. Their own sentiment of form
> instead was one of comfort. The beauty of comfort . . . *That millions of
> people have died in war since then, because of the idea of comfort, is something
> else* [my italics].
>
> *This pure form of comfort became the comfort of 'pure form'* [my italics]. The
> 'nothing' part in a painting until then . . . they generalized with their
> book-keeping minds, into circles and squares . . . But this idea made
> them go backward in spite of the fact that they wanted to go forward.
> That 'something' which was not measurable, they lost by trying to
> make it measurable . . . The sentiments of the Futurists were simpler
> . . . Either a man was a machine or else a sacrifice to make machines
> with.[66]

From here de Kooning went on to attack sharply the fetishism of science within post-war US society, particularly on the part of Cold War liberals. In so doing, he caustically referred to the new technocratic romance with atomic weaponry.

> The argument often used that science is really abstract and that painting could be like music . . . is utterly ridiculous. That space of science – the space of the physicists – I am truly bored with now . . . There seems to be no end to the misery of the scientists' space . . .

> Today, some people think that the light of the atom bomb will change the concept of painting once and for all. The eyes that actually saw the light melted out of sheer ecstasy. For one instant, everybody was the same color . . .[67]

In his critique of the prevailing values responsible for instrumental thought, scientism and formalism, de Kooning underscored the dissident position of himself and of other Abstract Expressionists. By the way he defended this group, de Kooning presented it as avant-garde in the deepest sense, namely as a movement not simply on behalf of a new style for art, but rather in favour of an alternative concept of life through art. As Peter Bürger has observed, what was negated by an avant-garde group was not an earlier form of art so much as 'Art' institutionally disconnected from praxis.[68] Thus, for the avant-garde, the demand was not raised simply at the level of the content of individual works. Instead, Bürger stated, the avant-garde directed itself to the way art functions in society. De Kooning attested to this strategy when he rejected formalism (although clearly not formal values *per se*) by observing, 'I never was interested in how to make a good painting.'[69] He then further repudiated Greenberg's contention in 1947 that Matisse's greatness resulted from his escapist desire to produce art that functioned as an armchair for the tired businessman. To the contrary, de Kooning said:

> Art never seems to me peaceful or pure. I always seem to be wrapped in the melodrama of society . . . Some painters, including myself, do not care what chair they are sitting on . . . They do not want to 'sit in style'. Rather they have found that *painting . . . is a way of living today, a style of living* [my italics]. That is where the form of it lies. Those artists do not want to conform.[70]

In 1963 de Kooning recapitulated these ideas, if at times elliptically, when he again opposed Greenberg's variety of formalism, while also expressing a sense of alienation from the hegemonic values of the post-war US. About being an artist in the US, de Kooning remarked: 'America never really cared much for people who do those things.'[71] He then concluded, at a time when he was becoming a public opponent of the Vietnam War, 'it is a certain burden, this American-ness . . . I feel much more in common with artists in London or Paris.'[72] Similarly, in looking back on his work from the 1950s, de Kooning expressed surprise at the depth of alienation conveyed by his *Women* series: 'I look at them now and they seem vociferous and ferocious.'[73]

None of the Abstract Expressionists, however, was more systematic in his critique of post-war culture than was Barnett Newman. Contrary to what most art historians have maintained (Annette Cox and Ann Gibson are exceptions here), Newman's principled position on behalf of being *engagé* did not collapse into an

'apolitical' 'art for art's sake' stance.[74] From the early 1930s to his death in 1970, Newman developed an increasingly nuanced defence of anarchist ideals that he consistently, indeed insistently, related to his own art work throughout this entire period.

Although he was unusual among the Abstract Expressionists in two respects — he did not work with the WPA Federal Art Project and was never a fellow traveller of the Communist Party (he was also one of the few Abstract Expressionists not from the working class) — Barnett Newman was, like several of the rest, a long-time anarchist (Gottlieb, Rothko and Still arrived at this position somewhat later). As early as 1933, Newman ran for mayor of New York City as an anarchist. Among his proposals were the city or community ownership of banks, business and housing; a system of municipal galleries and orchestra halls providing free services to the public; the closing of streets to private automobiles so as to reinvigorate public space for pedestrians as well as cafés; and, more whimsically, playgrounds for adults.[75] All of these views were clearly predicated on the anarchist contention — from Bakunin and Tolstoy through Kropotkin and Emma Goldman — that the decentralized Russian peasant communes (MIR) had already demonstrated the superiority of communal forms of social development over those dominated by private property (as in the US) or directed by a centralized national state (as in the USSR).[76]

From the mid-1940s through to the late 1960s, Newman published a series of articles on the history of art, in which he used anarchist terminology and made clear his opposition to the system of corporate capitalism. Only a few years before Cold War liberals were celebrating the 'American century' in clearly technologist terms and McCarthyists were denouncing modernist art as subversive of the 'American Way', Newman wrote in 1942 that art which glorified US life, particularly in regionalist guise, resembled 'fascist ideology' by using 'intensified nationalism, false patriotism, the appeal to race, the re-emphasis on the home and homey senti-ments'.[77] Similarly, in 1946, when both liberals and conservatives were euphoric about the new superpower status of the US, Barnett Newman was of a different mind. Instead, he noted that 'we are living in times of the greatest terror the world has known.'[78]

Against this post-war historical backdrop in 1947, Newman published an essay, 'The Ideographic Picture', for an exhibition of work at the Betty Parsons Gallery of recent work by Hans Hofmann, Boris Margo, Barnett Newman, Ad Reinhardt, Mark Rothko, Theodoros Stamos and Clyfford Still. He remarked in his essay that it was time 'to make clear the community of intention' motivating this group of artists, 'who are not abstract painters although working in what is known as the abstract style'.[79] True to his own anarchist concept of human nature, and its belief in the superiority of unordered 'spontaneity' (with all that this implies about the 'natural goodness' of people, as opposed to the Marxist view that humanity has a natural *potential* for goodness), Newman claimed that, 'spontaneous and emerging from several points', there had arisen 'a new force in American painting that is the modern counterpart of the primitive art impulse'.[80] As did all the other Abstract Expressionists on various occasions, Newman specifically underlined three aspects of this art, each of which contradicted precepts of formalist criticism: (1) that their aim was *not* 'to renounce the living world for the meaningless materialism of

design'; (2) that they were not concerned with 'pure art' along with 'its overload of pseudo-scientific truths'; and (3) that this art was not about pleasing form, but rather about 'the hard, black chaos that is death, or the grayer, softer chaos that is tragedy'.[81]

Later in 1947, Newman published an eloquent essay, entitled 'The First Man was an Artist,' in which he penned the most lengthy rejoinder by any Abstract Expressionist to the ideology of scientism. Significantly, this critique of scientism was done in the name of modern science, as well as on behalf of human progress, so that it would be erroneous to argue that Newman was simply promoting a species of irrationalism. Rather, he was pointing out, as did Adorno and Hork- heimer in 1944, that science – for all its immense potential to contribute to human advances – was in fact currently being reified in such a way as to aid the exploitation of humanity. Similarly, Newman was not rejecting reason, but rather arguing for a genuine redefinition of it in terms that went beyond mere instru- mentality to encompass human self-realization through disalienated labour and aesthetic acts:

> Shall we artists quarrel with those who need to wait for the weights of scientific proof to believe in poetry? . . . In the last sixty years, we have seen mushroom a vast cloud of 'sciences' in the fields of culture . . . Why the invasion? . . . Has science, in its attempt to dominate all realms of thought, been driven willy nilly to act politically? . . . To accomplish this expansion, the scientist abandoned the revolutionary act . . .

> So intense is the reverence for this symbol, scientific method, that it has become the new theology . . . it has overwhelmed the original ecstasy of scientific quest, scientific inquiry . . . [which] was validity because the question is basic for the attainment of descriptive knowledge and per- mits a proper integration between its quest, the question *what* constantly maintained, and its tool, mathematics or logic, for the discovery of its answer.[82]

From this excellent discussion of the reification of science (which so clearly relates to Herbert Marcuse's explication in 1964 of how 'one-dimensional thought' had gained ascendancy in the West),[83] Newman went on to defend the impulse toward aesthetic development as an elemental realization of human nature that had become unjustly suppressed in late capitalism. Just as the supposedly 'ideal' order and rules of Classical art came to signify alienation through scientism, so Newman's deep sympathy for 'primitive art' unquestionably disclosed the avant-garde char- acter of Abstract Expressionism. For, as Poggioli has noted, avant-garde alienation insistently features the call for a 'clean cultural slate' whereby human history can be placed on a new foundation for future development that more justly accommodates humanity's intellectual potential as well as its material needs.[84] Post-war US society, then, was considered culpable because it structurally denied the aesthetic realization intrinsic to disalienated human development. Thus, art could never be reducible to the instrumental uses or practical concerns then overdetermining all values within the US. To this, Newman said:

the job of the artist is not to discover truth, but to fashion it . . . What was the first man? . . . undoubtedly he was an artist . . . the aesthetic act always precedes the social one . . . the necessity for dream is stronger than any utilitarian need . . . The human in language is literature, not communication . . . Even the animal makes a futile attempt at poetry . . . *His [humanity's] behavior had its origin in his artistic nature* . . .

In our inability to live the life of a creator can be found the meaning of the fall of man [my italics]. It was a fall from the good, rather than the abundant life. And it is precisely here that the artist today is striving for a closer approach to the truth concerning original man . . . What is the explanation of the seemingly insane drive of man to be painter and poet if it is not an act of defiance against man's fall and an assertion that he return to the Adam of the Garden of Eden.[85]

In this passage and elsewhere, Newman gave a distinctly anarchist account of art history. For him, the artistic process was both independent of social labour and inherent to human nature (while for Marx, on the other hand, aesthetic acts were interdependent with labour and sociality, as well as grounded in human potentiality).[86] Precisely because Newman placed art in a dichotomous relation with social developments, he sometimes transvalued alienation from society into an alienation from sociality as such (which is why some of his pronouncements were existentialist in tone). This conflation of discontent at a certain moment in history with the rejection of history in any progressive sense is a common failing of anarchist thought, which in turn leads to an apocalyptic view of change rather than to a concept for the revolutionary transformation of the existing order. It is this total opposition of anarchists to the established system that surfaced in Newman's denunciation of existing politics *per se* – a position which some art historians have erroneously interpreted as an 'apolitical' attitude towards the post-war developments.[87]

Nowhere were Newman's anarchist views of 'spontaneous' art, in addition to his apocalyptic belief in the end of history, more clearly present than in his famous text of 1948, 'The Sublime is Now'. Classical beauty, because of its demand for rational precision along with its dependence on a set of rules first codified in Greece, was seen as a barrier to 'man's natural desire in the arts' for self-realization.[88] Hegel and Kant, whom Newman said discussed the sublime less successfully than Edmund Burke, subordinated artistic production to Classical beauty, 'thus creating a range of hierarchies in a set of relationships to reality that is completely formal'.[89] In rejecting the 'fetish of quality' resulting from the restriction of art to 'perfect form', Newman asserted, 'The impulse of modern art was the desire to destroy beauty.'[90] Yet all earlier European avant-garde movements, according to Newman, had failed to achieve a definitive rupture with this classical reification of form, because the Cubists, Dadaists, et al., were caught in 'the grip of the *rhetoric* of exaltation'.[91] As such, they accomplished only a 'transfer of values instead of creating a new 'vision'.[92] (Implicit in Newman's critique, however, is the implausible belief in a 'natural' form of aesthetic communication unmediated by 'artificial' rhetoric.)

What radically distinguished the Abstract Expressionists' concern with the

sublime, Newman claimed, was that for them Classical beauty was not an issue either to affirm or negate. Instead of becoming another chapter within art history, these new artists supposedly left art history by 'reasserting man's natural desire for the exalted' in opposition to 'the tawdry, the picayune, the brutish'.[93] In this way, the painters of the sublime emptied painting of formal problems and technical issues, because 'The image we produce is the self-evident one of revelation, real and concrete, that can be understood by anyone who will look at it without the nostalgic glasses of history.'[94]

Statements by five other artists – Kurt Seligman, Robert Motherwell, A. D. B. Sylvester, Nicolas Calas and John Stephan – also appeared with the one by Newman, in the journal called *Tiger's Eye*. All of these other essays correlated a use of the sublime with a deep alienation from the present. The closest complement to Newman's position, though, can be found in Robert Motherwell's essay, 'A Tour of the Sublime'. It is here in 1948 that Motherwell, though a democratic socialist or perhaps social-democrat, most approached the radical tone of Newman's anarchism. As Motherwell observed:

> A true history of modern art will take account of its innumerable con-
> crete rejections . . . Suppose we assume that, despite defaults and confu-
> sions, modern art succeeded in *ridding us of the glory of conquerors and
> politicos, that it became, though 'understood' only by a minority, a people's art, a
> peculiarly modern humanism,* that its tactics in relation to the general
> human situation were those of gentle, strong, humane men *defending their
> values with intelligence and ingenuity against the property-loving world.* [my
> italics]

> One might say that it is only the most inhuman professions in modern
> society that permit the agent to behave nicely in everyday life and to
> regard the world with a merry and well-glassed eye . . . [yet] painting
> becomes Sublime when the artist transcends his personal anguish, when
> he projects in the midst of a shrieking world an expression of living and
> its end that is silent and ordered . . . *all of us must reject the Sublime in the
> social sense, in its association with institutional authority.* [my italics][95]

In 1962, Newman further affirmed the anarchist intent of his art in conjunction with his political ideals. He spoke of his own painting as being 'spontaneous' and 'anti-anecdotal'.[96] The implications of these traits for his painting were its presumed negation of conventional ways of seeing, and its 'denial of dogmatic principles, its repudiation of all dogmatic life'.[97] He then observed that in the late 1940s, Harold Rosenberg had challenged him to explain what one of his paintings could possibly mean to the world. Newman's response was that if Rosenberg and others 'could read it properly it would mean the end of all state capitalism and totalitarianism. That answer still goes.'[98]

Nowhere else in his written oeuvre, however, did Barnett Newman so exten-sively interrelate his political views, social ideals and artistic concerns than in his exemplary Foreword to the 1968 edition of Peter Kropotkin's autobiography, *Memoirs of a Revolutionist*. Newman left no doubt that from the 1930s through the

1960s, the anarchist ideals and political activism of Kropotkin were of central import-
ance to his own life and art. Newman began this Foreword by complimenting the
book's reissue 'at this moment of revolutionary ferment' and praised it at the expense
of all other alternatives on the left (including Marxism), which he considered 'dog-
matic'.[99] In declaring that it was no longer enough to voice opposition to the establish-
ment, Newman stressed what he deemed the signal importance of Kropotkin's ideas
for authentic revolutionary change. According to Newman, Kropotkin's indispens-
ability came especially from his commitment to 'the autonomy of the Individual' and
from his resolute opposition to 'all forms of domination'.[100] This meant that:

> For him [Kropotkin] only spontaneous, self-organized communes, now
> fashionably known as participatory democracy, based on mutual aid
> and respect for each person's individuality and person, are practical and
> realistic . . . He saw that all dogmatic systems, no matter how radical,
> are as much a tyranny as the State and he took a stand against all
> Establishments.

> Kropotkin was deeply concerned with the *dehumanization which was hap-*
> *pening as a result of the industrial revolution and the division of labour* [my
> italics]. His ideas on the problems of integrating rural and urban life, his
> opposition to the division of labor, make him the precursor of all those
> who have theorized on the subject . . . and would make possible the
> leisure for a creative life.[101]

In adding his own views to those of Kropotkin, Newman made some note-
worthy points. He approved of ideas in the 1960s among student radicals, who
believed that 'the pursuit of science' had become transformed into a 'trap set by the
Establishment to submerge them in the technocracy that can only end in total
war'.[102] Newman related how in the 1940s he felt 'destroyed by established institu-
tions'.[103] He acutely noted that 'only those people practise destruction and betrayal
who hunger to accept completely the values of the Establishment.'[104] In positing that
'It's the Establishment that makes people predatory,' Newman further declared
'only those are free who are free from the values of the Establishment. And that's
what Anarchism is all about.'[105]

Concerning the relation of his anarchist ideas to his production of art, Newman
summed it up well by outlining the views of his adversaries:

> they cannot understand how anybody is able to make anything, particu-
> larly a work of art, spontaneously or directly − *a prima.* The idea
> that someone can make anything without planning, without making
> sketches upon sketches from which one renders a finished product, is
> incomprehensible to them. By the same token, the same intellectuals
> cannot understand the Anarchist idea of social spontaneity or the direct
> formation of social communities.[106]

Two concepts are particularly notable in this passage, especially in so far as they
intersect with the views of other Abstract Expressionists. First, this declaration by

Newman reaffirmed the artistic tendency within anarchist thought represented by Kropotkin (and at odds with the competing line put forth by Proudhon) that the anarchist was not concerned with a particular style of art, but with a specific mode of artistic production that was 'disalienated'.[107] Second, this new means of producing art drew in turn on a concept of human nature that involved both the belief in a human 'spontaneity' unregulated by repressive social institutions and the view (defended eloquently by Kropotkin in his famous biological concept of mutualism)[108] that a 'natural' consequence of allowing autonomous individualism would *not* be selfishness. Rather, the mutual creation of interdependent and egalitarian communities capable of accommodating individual spontaneity would 'naturally' emerge. In all of these respects, Newman's theory of art was in the tradition of nineteenth-century artists such as Pissarro, Seurat and Signac, all of whom were influenced by Kropotkin's particular definition of artistic autonomy. As Signac stated in a lecture from 1902 that was deeply grounded in Kropotkin's views:

> The anarchist painter is not one who will show anarchist paintings, but one who without regard for lucre, without desire for reward, will struggle with all his individuality, with personal effort, against bourgeois and official conventions . . . The subject is nothing, or at least only one part of the work of art . . . when the eye is educated, the people will see something other than the subject in pictures. When the society we dream of exists, the workers freed from the exploiters who brutalize them, we will have time to think and to learn. They will appreciate the different qualities of the work of art.[109]

Contradictions of anarchism and abstract expressionism

Abstract Expressionism at its best signifies not only the social wholeness and improvisation embodied in artisanal traditions, both Western and non-Western, but also an implicit affirmation of what Newman explicitly advocated – the anarchist belief in natural 'spontaneity'. To the extent that it is based on a faith in socially unmediated, or 'direct', art, Abstract Expressionism raises questions about the degree to which this art, for all its reputed 'elitism', is in fact based on backward-looking populist assumptions that constitute impediments to a realization of their otherwise genuinely progressive aims. Although Motherwell said of this art that 'it became, though "understood" only by a minority, a people's art',[110] an altogether different reception has more often been the fate of Abstract Expressionism. For while the formal sophistication of Abstract Expressionism along with its egalitarian intent clearly exempt this art from the charge of populism, some of the theoretical views on which Abstract Expressionism was based do not escape this criticism. Indeed, it was precisely the populist assumptions intrinsic to the theories of the Abstract Expressionists that ultimately led to a certain naïveté about the way society at large would 'naturally' interpret these hardly naïve art works. [. . .]

By endorsing the anarchist view that people are naturally good, hence are most creative when they act as 'spontaneous' and heroic 'individuals', Newman, Rothko

and Still increasingly transformed an alienation from modern society into an alienation from sociality as such. Since people freed from society's prejudices could 'naturally' understand sublime art, then modern Western society – and indeed all other hierarchical State-run societies that had developed beyond the stage of communal organization – precluded the presumed elemental understanding conveyed by their art works. This position is intrinsic to Newman's claim on behalf of his art and that of the other Abstract Expressionists that it 'can be understood by anyone who will look at it without the nostalgic glasses of history'.[111]

What further followed from their confusion of alienation from a certain moment in history with an alienation from all advanced historical progress was a paradoxical *need* for alienation *per se*.[112] As such, the demand for immediate freedom from alienation became paradoxically inverted into a feeling of freedom *through* alienation, because this alienation appeared to demonstrate how the Abstract Expressionists themselves were 'free' of the values of an unfree society. Consequently, the call of these artists for profound change was undermined by the nature of the change that they proposed – a change which went from seeming unlikely to being undesired. Contrary to Tolstoy, Newman and the others did not of course dismiss the Western fine arts as 'incomprehensible' to the populace. Yet very much like Tolstoy, the Abstract Expressionists became enamoured with their own alienation to the point of embracing the 'natural' conditions that necessitated sublime art. This understandable but self-contradictory view was eloquently conveyed by Mark Rothko when in 1947 he wrote:

> The unfriendliness of society to his activity is difficult for the artist to accept. Yet this very hostility can act as a lever for true liberation.[113]

Nowhere does this paradoxical state of affairs (resulting from the perceived impasse between 'naturally' good people and an 'inherently' perverting society) find more extreme expression than in the ultra-anarchist judgments of Clyfford Still. These pronouncements are at one and the same time imminently apocalyptic and remotely possible. The primary reason for Still's increasingly bitter as well as isolating assessment was less personal misanthropy than the anarchist ideal of 'naturally' free behaviour – behaviour that he found ever more difficult to achieve as the years went by. It should perhaps be noted here that this viewpoint is opposed both to the capitalist faith in 'natural' selfishness and to the Marxist belief in human potentiality capable of realization in various directions, depending on the social structure encountered. For Marxists, then, further appreciation of the merits of Abstract Expressionism would be based on progress *through* history, not on Still's implausible ideas of 'transcending' history altogether.

There are few if any parallels within Western art for the degree of alienation expressed by Clyfford Still both from the contemporary US and from Western history in general. Still's alienation was of such intensity that it permitted no solution, thus becoming what Brecht once labelled an alienation from which one does not return. Simultaneously, Still spoke of an *inescapably totalitarian system* in the US and also implied that somehow a few good people could escape its institutional reach, not to overturn the system but to avoid its otherwise unchecked authority. Post-war society, then, was deemed without hope, except for a few individuals who

could flourish on its margins by means of 'natural' virtues. It was in the bleakest terms that Still outlined the coordinates of contemporary life:

> In the few directions we were able to look during the 1920s, whether to past cultures or the scientific, aesthetic, and social myths of our own, it was amply evident that in them lay few answers valid for insight or imagination . . .
>
> Self-appointed spokesmen . . . dumped upon us the combined and sterile conclusions of Western European decadence. For nearly a quarter of a century we stumbled and groped through the nightmare of its labyrinthine evasions . . . No one was permitted to escape its fatalistic rituals – yet I, for one, refused to accept its ultimatums . . . The omnivorousness of the totalitarian mind, however, demands a rigor of purpose and subtlety of insight from anyone who would escape incorporation . . . semantically and ethically the corruption is complete.[14]

According to Still, the totalitarian system of the post-war US was maintained by a network of institutions (such as the regulatory strictures of museums as well as other 'authoritarian devices for social control')[15] and by pervasive ideologies (such as 'shouting about individualism', formalist aesthetics with its 'superficial value of material', and the 'morbidity of the "objective position"').[16] A consequence of these institutions and ideologies was the reactionary reception of art they fostered. This situation was summarized by Still in strongly anti-hierarchical terms:

> . . . behind these reactions is a body of history matured into dogma, authority, tradition. The totalitarian hegemony of this tradition I despise, its presumptions I reject. Its security is an illusion.[17]

From here, Still went on to despair of how 'spontaneous' or unmediated reactions to his paintings would never be common, even as he maintained that such reactions were possible. Thus, in the name of pristine and natural values which he himself claimed had no hope of ascendancy in US society, Still denounced the ideology of narcissistic individualism as a corollary of totalitarianism. None the less, he observed that to 'achieve a purpose beyond vanity, ambition, and remembrance' artists must do it alone and in solitude.[18] The contradictory relationship of individual to society, as described by Still, was sometimes one of almost complete predetermination by hegemonic values and at other times one of sublime autonomy in the face of impossible odds. The very impossibility of one set of circumstances thus capsized into its converse, which in turn became all the more exalted because of its own presumedly immitigable state.

Caught in an impossible bind, the sublime artist simultaneously refused to propagandize for any position that advanced hierarchical values and yet had his or her position overwhelmed by these very same conventional, even totalitarian, values, because the public for the art was enmeshed in the system. Here, as elsewhere, Still's reliance on an anarchist position – with all that this implies about the belief in dichotomous relationships and monolithic structures, such as 'the

State' — means that he (along with the other painters of the sublime) overlooked both internal contradictions within progressive art that allow for dialogical inter-change, and intrinsic fissures within reactionary societies that always present pro-gressive possibilities. The result is the untenable belief in an art without faults (it is not by chance that Still used the word 'Absolute' to praise his own paintings)[19] versus a society without virtues — a society that cannot be changed, but only renounced. As such, Still's position recalls less Kropotkin's critique of society, than Bakunin's demand for its annihilation, with complete destruction being seen as the highest form of creation.[20]

The impossibly paradoxical position in which Still located his art is clear enough when one examines his characterization of museums, technology, science and viewer reception. In neo-Bakunist terms, Still proclaimed a faith in isolated autonomy that was extremist even by the standards of nineteenth-century anarchists:

> By 1941, space and the figure in my canvases had been resolved into a total psychic entity . . . My feeling of freedom was now absolute and infinitely exhilarating . . . I'm not interested in illustrating my time . . . Our age — it is of science — of mechanism — of power and death. I see no point in adding to its mammoth arrogance the compliment of graphic homage . . .

> The sublime? A paramount consideration in my studies and work from my earliest student days. In essence it is most elusive of capture or definition . . . The values involved, however, permit no peace, and mutual resentment is deep when it is discovered that salvation cannot be bought.

> Demands for communication are both presumptuous and irrelevant. The observer usually will see what his fears and hopes and learning teach him to see. But if he can escape these demands that hold up a mirror to himself, then perhaps some of the implications of the work may be felt . . . *It is the price one has to pay for clarity when one's means are honored only as an instrument of seduction or assault.* [my italics][21]

Not only did Still claim that the very clarity of his paintings would render them unclear to the dogmatic, but also that this incomprehension would unfortunately aid the appropriation of his paintings. In addition, Still admitted of his works that their 'power for life' was hardly capable of overturning art world institutions, from existing museums to established criticism.[22] When writing about the appearance of his own paintings in an important exhibition at a leading museum, the Albright-Knox Art Gallery, Still again resorted to a rigid binary classification to describe the relationship between his work and the museum:

> The paradox manifest by the appearance of this work in an institution whose meaning and function must point in a direction opposite to that implied in the paintings — and my own life — was accepted. I believe it will not be resolved, but instead will be sharpened and clarified.[23]

Similarly, Still was resigned to a dissident status within society, as opposed to any role in its transformation. This position emerged clearly enough in his dismissive attitude towards contemporary art criticism. Instead of engaging in a debate both about what was wrong *and* also right about the mainstream interpretation of his works, Still attempted rather implausibly to sequester his art works from a public discourse that he deemed unrelievedly totalitarian in nature. At one and the same time, his 'subversive' paintings were supposed to be on behalf of all humanity, yet needed to be guarded from most encounters with society while being discussed not at all in print. A letter of 1948 to Betty Parsons from Still demonstrated well the self-contradictory ideals following from an ultra-anarchist faith in the inherent autonomy of *engagé* art:

> Please – and this is important, show them [my paintings] only to those who have some insight into the values involved, and allow no one to write about them. NO ONE . . . Men like Soby, Greenberg, Barr, etc . . . are to be categorically rejected. And I no longer want them shown to the public at large, either singly or in a group.[124]

Far from being either an endorsement of Cold War liberalism or an embodiment of the 'vital centre', Still's position here – like that of all the other Abstract Expressionists whom Still represented in an extreme form – is indicative both of an opposition to post-war Western society and of a desire for an ideological position on the far margins of it. As such, the 'autonomous' position of Still and the other Abstract Expressionists reminds us of what E. J. Hobsbawm has observed about the inception of anarchism during the period after the revolutions of 1848. With its populist hatred of all governments as well as hierarchies, along with its ideal of 'naturally' autonomous communes, anarchism simultaneously represented a revolt of the pre-industrial past against the present and a distinctive manifestation of the present in its unwitting convergence with *laissez-faire* individualism.[125] (It is precisely this latter and only partial convergence which has led some scholars to confuse the position of the Abstract Expressionists with that of Cold War liberalism.)[126] [. . .]

While the consistent efforts of Newman and other Abstract Expressionists to be *engagé* through their art is undeniable, some of their claims on behalf of the nature of this engagement are obviously untenable. It was hardly plausible, for example, when Newman contended that many of the Abstract Expressionists had transcended all conventional artistic rhetoric as well as traditional visual imagery to arrive at 'spontaneous', hence 'self-evident' and 'natural' revelations of the sublime. Just as few if any viewers have experienced the sublime before these paintings without first knowing what the concept means historically, so Newman, Rothko, Motherwell, Still and Gottlieb all drew substantially if also very subtly on the formal values associated with nineteenth-century European paintings that dealt with the sublime.[127]

This assimilation of previous visual rhetoric and concomitant use of an established medium – as opposed to any 'spontaneous' images entirely disconnected from previous conventions in art – has been conclusively demonstrated by several art historians. Since the visual language of the Abstract Expressionists was culturally mediated by earlier visual languages and the ideological values that emerged with them, the art of the sublime painters hardly originated in 'natural' utterances

outside history or society. Consequently, we cannot stop with Newman's explanation of how this anti-capitalist, socially alienated and humanly affirmative art arose as the 'spontaneous' outpouring of 'autonomous individuals'. Instead, we must subject these latter views to a sustained critique. Only then can we understand the process whereby art opposed to multi-national capitalism could sometimes be used to promote ideological tendencies interrelated with this very same system.

Notes

1 Meyer Schapiro, 'The Liberating Quality of Avant-Garde Art', *Art News*, vol. 56, no. 4, Summer 1957, pp. 36–42. This essay has been reproduced in its entirety in Meyer Schapiro, *Modern Art, 19th and 20th Centuries: Selected Papers*, New York, 1978, as 'Recent Abstract Painting', pp. 213–26. Because this latter book contains exactly the same text, albeit in a more accessible form, I shall cite the page numbers of the book when referring to Schapiro's 1957 text.

2 Schapiro, op. cit., p. 226. Schapiro's ongoing engagement with Marxist political economy is clear enough. In 1983, for example, Helen Epstein wrote, after interviewing Schapiro extensively, that 'Meyer Schapiro still considers himself a sort of Marxist – an unorthodox one' (*Art News*, vol. 82, no. 6, Summer 1983, p. 84). [. . .]

3 See, for example, Mikhail Bakhtin and P. N. Medvedev, *The Formal Method in Literary Scholarship*, Cambridge, Massachusetts, 1985.

4 This fact was scientifically established by Charles Darwin's work on evolution. See Charles Darwin, *The Descent of Man*, in *Darwin*, Philip Appleman (ed.), New York, 1979, pp. 161ff.

5 Schapiro, op. cit., p. 218.

6 ibid., p. 217.

7 ibid., p. 224.

8 ibid., pp. 217–18.

9 ibid., p. 218.

10 ibid., pp. 218, 220, 221, 222, 226.

11 ibid., p. 222.

12 ibid., p. 223.

13 ibid.

14 ibid.

15 ibid.

16 ibid.

17 ibid.

18 ibid., p. 224.

19 ibid., p. 226.

20 ibid., p. 224.

21 ibid.

22 ibid. For recent confirmation of Schapiro's statement, see the careful examination of primary documents in this regard by Deidre Robson, 'The Market for Abstract Expressionism', *Archives of American Art Journal*, vol. 25, no. 3, 1985, pp. 19–23. [Chapter 14]

23 ibid.

24 Clement Greenberg, 'The Jackson Pollock Market Soars', *New York Times Magazine*, 16 April 1961, pp. 42ff.

25 'Artists' Session at Studio 35', (1950), edited by Robert Goodnough, in *Modern Artists in America*, edited by Robert Motherwell and Ad Reinhardt, New York, 1951, p. 16.

26 Mark Rothko, 'The Ides of Art', in *Tiger's Eye*, no. 1, December 1947, p. 41.

27 Ernest Mandel, *Late Capitalism* (1972) Joris De Bres (trans.), London, 1975, p. 191. See also, Friedrich Pollock, *Automation*, Frankfurt, 1964 and Julius Rezler, *Automation and Industrial Labor*, New York, 1969.

28 Mandel, op. cit., p. 120.

29 ibid., p. 193.

30 ibid.

31 ibid., pp. 206–16.

32 For a well documented look at US military intervention on behalf of multi-national corporations, see the following: Noam Chomsky and Edward Herman, *The Washington Connection and Third World Fascism*, Boston, 1980; Richard Barnet, *Intervention and Revolution: The US and the Third World*, New York, 1969; and Roger Burbach and Patricia Flynn, (eds), *The Politics of Intervention: The United States in Central America*, New York, 1984. In particular, see, for example, Norma Stoltz Chincilla and Nora Hamilton, 'Prelude to Revolution: US Investment in Central America', in Burbach and Flynn, op. cit., pp. 213–49.

33 For these statistics and others, see *The Economic Report of the President to the US Congress*, Washington DC, January 1962. See also, Mandel, op. cit., pp. 176–9.

34 For the statistics on investment, see Joseph Froomkin, 'Automation', *International Encyclopedia of Social Sciences*, vol. 1, New York, 1968, p. 180. Also, see Mandel, op. cit., pp. 194–8. For the discussion of the whole process of automation, see Julius Rezler, *Automation and Industrial Labor*, New York, 1964.

35 See, for example T. W. Adorno and Max Horkheimer, *Dialectic of Enlightenment* (1944), John Cumming (trans.), New York, 1972 or Herbert Marcuse, *One-Dimensional Man*, Boston, 1964.

36 Adorno and Horkheimer, op. cit.

37 ibid., pp. 7, 83–4.

38 Marcuse, op. cit., pp. 146ff.

39 Harry Braverman, *Labor and Monopoly Capital*, New York, 1974, pp. 113–33, 231–42.

40 See, for example, Frederick W. Taylor, *Principles of Scientific Management* (1911), reprint, New York, 1967, p. 36. For the very different position of Adam Smith, see *The Wealth of Nations* (1776), introduced by Max Lerner, New York, 1937, p. 9. Smith associated the division of labour with increasing numbers of inventions *by* workers.

41 Taylor, op. cit., pp. 22, 36–8, 62. Also see Braverman, op. cit., pp. 112–21.

42 Clement Greenberg, *Art and Culture*, Boston, 1961, pp. 120, 139. For a critique of Greenberg's positivism, see David Craven, 'Towards a Newer Virgil – Mondrian Demythologized', *Journal of Fine Arts* (University of North Carolina, Chapel Hill), vol. 1, no. 1, Spring 1977, pp. 14–31.

43 Casey Blake, 'Aesthetic Engineering', *Democracy*, vol. 1, no. 4, October 1981, p. 41. For an excellent critique of Greenberg's early criticism, see François-Marc Gagnon, 'The Work and Its Grip; Greenberg's First Critical Approach to Pollock', in *Jackson Pollock: Questions*, Montréal, Musée d'art contemporain, 1979, pp. 16–42.

44 ibid., p. 42.

45 Schapiro, op. cit., p. 219.

46 Jackson Pollock, Response to Questionnaire, *Arts and Architecture* (February 1944), reprinted in *American Artists on Art*, edited by Ellen Johnson, New York, 1982, p. 2.

47 Jackson Pollock, 'My Painting', *Possibilities No. 1*, Winter 1947–8, reprinted in *American Artists on Art*, p. 6.

48 'Artists' Session at Studio 35', p. 15.

49 ibid., p. 12.

50 ibid., p. 13.

51 ibid., p. 12.

52 ibid., p. 18.

53 ibid., p. 14.

54 ibid., p. 18.

55 Robert Motherwell, Statement in *The New Decade* (1955), reprinted in *American Artists on Art*, p. 29.

56 Robert Motherwell, Statement (1951), in *Artists on Art*, Dore Ashton (ed.), New York, 1985, p. 235.

57 Robert Motherwell, Statement (1963), in *Artists on Art*, p. 236.

58 'Artists' Session at Studio 35', p. 21.

59 Willem de Kooning, 'The Renaissance and Order', *Transformation*, vol. 1, no. 2, 1951, reprinted in Thomas Hess, *Willem de Kooning*, New York, 1968, p. 141.

60 ibid.

61 ibid.

62 ibid. p. 142.

63 ibid. p. 143.

64 Adorno and Horkheimer, op. cit., p. 7.

65 Willem de Kooning, op. cit., p. 143.

66 Wilem de Kooning, 'What Abstract Art Means to Me', *The Museum of Modern Art Bulletin*, vol. 18, no. 3, Spring 1951, reprinted in Thomas Hess, op. cit., pp. 144–5.

67 ibid., p. 146.

68 Peter Bürger, *Theory of the Avant-Garde* (1974), Michael Shaw (trans.), Minneapolis, 1984, p. 22.

69 Willem de Kooning, An Interview with David Sylvester for the BBC (Spring 1963), reprinted in Hess, op. cit., p. 149.

70 Willem de Kooning, 'Abstract Art', p. 145.

71 An Interview with David Sylvester, p. 147.

72 ibid.

73 ibid., p. 149.

74 Thomas Hess, a close friend of Newman, also underscored Newman's political convictions. See Thomas Hess, *Barnett Newman*, New York, 1971, p. 18. Also, see Annette Cox, *Art-as-Politics*, Ann Arbor, 1982, pp. 67–82, and Ann Gibson, 'Barnett Newman and Tiger's Eye', *Art International*, no. 5, Winter 1988, pp. 14–22.

75 A. J. Liebling, 'Two Aesthetes Offer Selves as Candidates', *New York World-Telegram*, 4 November 1933, cited in Hess, *Newman*, pp. 24–5.

76 Cox, op. cit., p. 77. For a more general discussion of anarchism, including its diverse tendencies, see the following: James Joll, *The Anarchists*, Cambridge, Masachusetts, 1980 and Daniel Guérin, *Anarchism*, Noam Chomsky (introd.) and Mary Klopper (trans.), New York, 1979.

77 Barnett Newman 'What About Isolationist Art?' (1942), unpublished essay in Hess, *Newman*, p. 35.

78 Barnett Newman, 'Art of the South Seas' (1946), first published in English in *Studio International*, no. 179, February 1970, p. 70.

79 Barnett Newman, 'The Ideographic Picture' (1947), reprinted in *Theories of Modern Art*, Hershel Chipp (ed.), Berkeley, 1968, pp. 550–1.
80 ibid.
81 ibid.
82 Barnett Newman, 'The First Man was an Artist', *The Tiger's Eye*, no. 1, October 1947, pp. 57–8.
83 Marcuse, *One-Dimensional Man*, pp. 146ff.
84 Renato Poggioli, *The Theory of the Avant-Garde* (1962), Gerald Fitzgerald (trans.), Cambridge, Massachusetts, 1982, pp. 54–5.
85 Newman, 'The First Man', pp. 59–60.
86 See, for example, Karl Marx and Frederick Engels, *The German Ideology* (1846), C. J. Arthur (ed. and introd.), New York, 1977, pp. 108–9. See also Norman Geras, *Marx and Human Nature*, London, 1983, pp. 59ff.
87 As is the case in Serge Guilbaut, *How New York Stole the Idea of Modern Art*, Chicago, 1983, p. 70.
88 Barnett Newman, 'The Sublime Is Now', *The Tiger's Eye*, no. 6, December 1948, pp. 51.
89 ibid.
90 ibid., p. 52.
91 ibid.
92 ibid.
93 ibid., pp. 53, 57.
94 ibid., p. 53.
95 Robert Motherwell, 'A Tour of the Sublime', *The Tiger's Eye*, no. 6, December 1948, pp. 47–8.
96 Newman, 'Frontiers of Space' (An interview with Dorothy Seckler), *Art in America*, vol. 50, no. 2, Summer 1962, p. 87.
97 ibid.
98 ibid.
99 Barnett Newman, Foreword, *Memoirs of a Revolutionist* (1899) by Peter Kropotkin, New York, 1968, p. ix.
100 ibid., p. xi.
101 ibid., pp. xi, xviii.
102 ibid., p. xvi.
103 ibid., p. xix.
104 ibid.
105 ibid.
106 ibid.
107 James Joll, op. cit., pp. 149–51.
108 Peter Kropotkin, 'Mutual Aid' (1902), abridged reprinting in *Darwin*, Philip Appleman (ed.), New York, 1979, pp. 405–15.
109 Robert and Eugenia Herbert, 'Artists and Anarchism: Unpublished Letters of Pissarro, Signac, and Others', Part I, *The Burlington Magazine*, vol. 102, no. 692, November 1960, p. 479. See also, Eugenia Herbert, *The Artist and Social Reform: France and Belgium, 1885–1898*, New Haven, 1961.
110 Motherwell, 'A Tour of the Sublime', p. 47.
111 Newman, 'The Sublime Is Now', p. 53.
112 Barbara Braun, 'Freedom's Just Another Work . . .', *The Village Voice*, 29 May 1984, pp. 49–50.

113 Mark Rothko, 'The Romantics Were Prompted', *Possibilities*, no. 2 Winter 1947–48, p. 84.

114 Clyfford Still, Statement (1959), reprinted in *Theories of Modern Art*, pp. 574–5.

115 ibid., p. 515.

116 ibid.

117 Clyfford Still, Statement (1952), in *15 Americans*, Dorothy C. Miller (ed.), New York, Museum of Modern Art, 1952, p. 21.

118 Still, Statement (1959), pp. 575–6.

119 Clyfford Still, Statement (1963), in *Clyfford Still*, University of Pennsylvania, Institute of Contemporary Art, 1963, p. 9.

120 James Joll, op. cit., pp. 75–80.

121 Still, Statement (1963), pp. 9–10, and Still, Statement (1952), pp. 21–2.

122 Still, Statement (1952), pp. 22.

123 Still, Statement (1959), p. 574.

124 Clyfford Still, Letter to Betty Parsons, March 20, 1948, Archives of American Art, Betty Parsons Papers, N: 68–72.

125 E. J. Hobsbawm, *The Age of Capital: 1848–1975*, London, 1975, pp. 175–7.

126 Serge Guilbaut, op. cit.

127 The formal tradition of Abstract Expressionism has been clarified by Robert Rosenblum and Lawrence Alloway, while the rhetorical conventions of Abstract Expressionism have been discussed by Ann Gibson and Richard Shiff. See, for example, Robert Rosenblum, *Modern Painting and the Northern Romantic Tradition*, New York, 1975, pp. 195ff, and Ann Gibson, 'The Rhetoric of Abstract Expressionism', in *Abstract Expressionism: The Critical Developments*, New York, 1987, pp. 64–93.

Fred Orton

ACTION, REVOLUTION AND PAINTING

A raised arm has many meanings.
Convictions falter with desire; the arm remains.
<div style="text-align:right">(Harold Rosenberg, 'The Men on the Wall')</div>

THERE WAS A TIME, in the late 1950s and early 1960s, when explainers of Abstract Expressionism valued Harold Rosenberg's writings and took them into account. After that, he was increasingly marginalised, overlooked, or uncited. One reason for this was the increasing and what came to be almost exclusive attention which was given to the writings of Clement Greenberg. This is not to say that the focus was misdirected, for Greenberg is a necessary if insufficient text. Critical art history needs him, but if it is not to rehearse its histories of Abstract Expressionism exclusively with reference to his ideas of the triumph of a depoliticised art practice, apolitical painting and art for art's sake, Greenberg's cannot be taken as the only story. This is precisely where Rosenberg takes on importance. Rosenberg's writings on art and culture provide us with another necessary but insufficient corpus producing a knowledge of Abstract Expressionism, a corpus which is indispensable if we want to explain the politics of the production of Abstract Expressionism. Many of the Abstract Expressionists – most of the Irascibles and others – regarded their work as having a social and political content which Rosenberg, as close as anyone to the studio talk and closer than more or less anyone to its politics, was committed to explaining. This he did consistently and more vividly than any other explainer of Abstract Expressionism – not as an apologist or as an opponent but as someone keeping his preoccupations up to date and well oiled.

One of the aims of this essay is to bring Rosenberg in from the margins he is so often made to occupy, and to begin writing against the grain of those bits of conventional wisdom which represent his ideas as naïve, romantic,

Source: 'Action, Revolution and Painting', *Oxford Art Journal*, vol. 14, no. 2, 1992, pp. 3–17. Material in the footnotes has been edited.

quasi-philosophical, theatrical, and as reconciling an avant-garde ideology with the ideology of post-war liberalism. It sets out to situate Rosenberg with respect to the changes in New York leftism in the 1930s and 1940s, and then to use his writings on drama and the proletariat, which focus on issues of action and agency, as relevant to understanding his characterisation of action painting in the 1952 essay, 'The American Action Painters' – one of the first published attempts to endow Abstract Expressionism with meaning.¹ My concern is to offer a political reading of this essay in order to replace the lazy existentialist-humanist reading which has become paradigmatic.

Part of the significance of 'The American Action Painters' has to be located in the way Rosenberg shows that the political impasse which many on the left currently regard as uniquely 'postmodern' was already inscribed within the modernism which emerged in the United States circa 1940, and that this sense of impasse was international and not narrowly American. Action painting, for Rosenberg, was painting about the possibility of a radical change that had not happened in the 1930s and 1940s – far from it – and could not happen in the 1950s. It was a possibility that neither he nor his 'American Action Painters' could afford to abandon. No more can we.

The politics of action painting were determined by the failure of the proletarian revolution and its continuing regeneration within the dialectical dynamism of capitalism, with acting out the possibility of radically transforming the situation, while forever failing to do so. It will become clear as this essay proceeds that the negation of the negation played out in action painting could never produce the redefinition of identity that would negate the negative identity given to the proletariat in capitalism. The action painters could not succeed in culture where the proletariat had failed in politics. Action painting could not compensate at the symbolic level for the fact that the political action which would redefine the proletariat did not, at that moment, seem to be available to it as a class. Instead, action painting was caught up in the failure of the proletariat, but the action painters glimpsed that that failure was not total.

In this reading of Rosenberg's 'The American Action Painters', the action painter was not a middle-class artist playing with symbolic or surrogate revolutionary gestures, acting out, in art, a drama of political agency and identity that no social class is able to do. Action painting was not revolutionary gesturing. It was painting concerned with the dialectical possibility of a revolution whose outlines can neither be defined nor denied.

I

who thrust his fist into cities
arriving by many ways
watching the pavements, the factory yards,
the cops on beat
walked out on the platform
raised his right arm, showing the fist clenched
'comrades, I bring news'

came back then skies and silhouettes,
facing the bay, of sailors
who no longer take the sea
because of strikes, pay-cuts and class-unity

'comrades, I bring news'

of the resistance of farmers
in Oneida county on a road
near a small white cottage
looking like a Xmas card,
4 shot, the road was blocked
glass to blow their tires

there was one guy we grabbed
some bastard of a business man
learning to play State Trooper
one of the boys tackled him neat as he ran

Behold my American images get it straight
a montage of old residences bridges shops freights
Xmas, the millions walking up and down
the tables where applications are received
the arguments that will yet get down to something

in the center of this a union-hall
and on the platform he
with right arm crooked, fist clenched
'comrades, I bring news'

That poem by Rosenberg appeared in the *Partisan Review* for January–February 1935.[2] Titled 'The Front', it refers to the life circumstances of millions of Americans around Christmas 1934, some five months into the sixth year of the Great Depression: to capitalism in crisis, mass unemployment and applications for benefit, strikes, organised labour and class unity, and the class struggle in town and country. At the centre is a union hall, and out on to its platform walks someone who raises his right arm, fist clenched, and addresses the assembly: 'comrades, I bring news'. I cannot describe the specific circumstances of the poem's making or limit the excess of meaning available for its strikes, pay cuts, and so on, nor extend the particularity of that event in Oneida County. What can be said – leaving aside a discussion of its structure and the momentum of its syntax – is that Rosenberg's poem, dedicated by its title to the United Front, was meant to participate in winning the workers' support for revolutionary organisations and for an agreement on action of some kind – insurrection, if not revolution.

Aged twenty-eight when he wrote 'The Front' Rosenberg had already earned himself something of a reputation as a poet and intellectual. *The Symposium*, edited by James Burnham and Philip Wheelwright and described as a journal of philosophical discussion, had published several of his essays, including, in 1932, the seminal 'Character Change and the Drama'.[3] He had also edited with H. R. Hays an

'experimental quarterly' called *The New Act*.[4] And Harriet Moore's *Poetry: A Magazine of Verse*, which published all kinds of verse, conventional and innovative, had regularly printed his poetry and commissioned book reviews from him, and would continue to do so throughout the 1930s and 1940s.[5]

In 1936 he was considered, by William Phillips and Philip Rahv, to be one of the poets who had achieved 'the much desired integration of the poet's conception with the leading ideas of the time'. This 'desired integration' was achieved by way of an awareness that the necessary revolt was aesthetic as well as social, and that as such it was 'a revolt within the tradition of poetry rather than against it'.[6]

'The Men on the Wall', published a year earlier in 1934, may well be one of Rosenberg's first poems to make reference to the historical and social circumstances of its writing.[7] It uses some stereotypical metaphors of state, worker and capitalist power:

> [. . .] a sword
>
> in the hand of the arm
> flowers from a sleeve of gold brocade
>
> [. . .] and that arm's fist,
>
> whose khaki cuff is stained with grease,
> is yours, and clasps the hammer of your resolve.
> And whose contending tendons flex with threat
> against the background factories and glass?
>
> [. . .] the wind still affirms
>
> the faces of ruminants with folded arms,
> the men below, divining peace before their doors,
> the azure casings of whose blood are torn
> by no quick hemorrhage of indissoluble event;
> whose ecstasy, despair and rage
> are hidden escapades that lift no arms.[8]

But at the end of the poem, the men on the wall stay there, 'entranced somnambulists', on the night shift. It is a poem which seems more symptom than criticism of the moment that inscribes it, a social poem with a tendency to leave its workers working and only half-awake. By the end of the year when Rosenberg wrote 'The Front', that tendency had changed, or been clarified; the workers were unemployed, less dreamy, and politicised.

'The Front' is a socialist poem, and as the editors of *Partisan Review*, the year-old journal of the John Reed Club of New York, were keen to point out it was the first poem that Rosenberg had published in a 'proletarian magazine'.[9] The John Reed Club was founded in 1929, the year the Great Depression began and the year when Stalin's first Five Year Plan was adopted. Initiated by and affiliated to the International Union of Revolutionary Writers, the Club was, from the outset, influenced by the Proletcult movement, led by members of the Communist Party, and dedicated to the belief that art was a weapon in informing, educating and radicalising the worker. It had branches in most large cities and many of them published their own

periodical of literature and art, the best known being that of the New York branch, *Partisan Review*.[10]

The Rosenberg of 'The Front' is a Marxist and probably a fellow traveller of the C.P.U.S.A., a poet and critic committed to the artist's capacity to participate in the class struggle.[11] But he was short lived. The authorial 'I' which 'The Front' and *Partisan Review* had inaugurated was put in the position of having to manoeuvre itself when in July–August 1935 the Seventh Congress of the Comintern promoted the 'broadest united front [. . .] the establishment of a unity front with social democratic and reformist organisations . . . with mass national liberation, religious-democratic and pacifist organisations, and their adherents [. . .] for the struggle against war and its fascist instigators'.[12] Unlike the United Front this 'Popular Front' was not a strategy of class struggle but of class co-operation. One almost immediate result of the Popular Front was that the Proletcult movement was abandoned.

The Popular Front had been written on the wall for some time. The writing was there, for example, in January 1935 in the call put out by the National Committee of the John Reed Club, under instructions from the C.P.U.S.A., for an American Writers' Congress to undertake an 'exposition of all phases of a writer's participation in the struggle against war, the preservation of civil liberties, and the destruction of fascist tendencies everywhere'.[13]

The American Writers' Congress met at the end of April and Rosenberg reported its proceedings in the July issue of *Poetry*.[14] He was obviously impressed by the representative of a group of Pennsylvania miners who were prepared to print and circulate 10,000 copies of any poem that they could recite or sing together and by an appeal on behalf of 300 workers' theatres for works to perform.[15] He thought that here 'it became possible to see how poetry might step forth from the little magazines [. . .] and walk once more upon the stage and street'.[16] How, in other words, art might achieve a valid constituency and a valid agency. However, it was clear to him that, faced with the dangers to society of fascism and war, the writer was forced to play his part not in revolution, but in society's effort to protect its peace, freedom, and progress.[17] The questions were: what was the role of the writer in the social movement, and what was the best mode of performance?[18] The answers were provided by Earl Browder in his opening address: one could not be converted automatically into a literary genius just by calling himself 'Marxist'; revolutionary art could succeed only 'through achieving superiority as art, not through politics'; 'the socially conscious writer need not engage in organisational activity at the expense of writing'. The attitude of his party was: 'better a good writer than a bad organizer'.[19] Browder's party was the C.P.U.S.A. Indeed, he was its General Secretary and national spokesman, a familiar figure on a wide variety of platforms.

After quoting Browder, Rosenberg made a point of mentioning Waldo Frank who 'also attacked "leftism"' and who 'would not capitulate easily to dogma, outside control'.[20] Frank, an editor of the C.P. Journal *New Masses*, would go on to represent the League of American Writers, the organisation which came out of the American Writers' Congress, at the Popular Frontist First International Congress of Writers for the Defense of Culture which met at Paris in June. Rosenberg, the revolutionary poet and critic writing in the liberal-democratic *Poetry*, pointed out, reassuringly, and following Browder's line, that though 'the Congress turned its face left, it donned no red uniform'.[21]

Later that year Rosenberg became active in Popular Front art politics and art theory through his involvement with *Art Front*. *Art Front* was the official publication of the Artists Union, the militant trade union that had emerged from the Unemployed Artists Group set up by the John Reed Club of New York in 1933 and which, in 1935, came to represent the interests of the artists employed on the Federal Art Projects. *Art Front's* political orientation was, of course, never in doubt. It was dominated by the Communist Party, committed to art as propaganda, and to guiding its members in their role as revolutionary artists. However it was always prepared to debate whether the art they were to produce should be social realist or modernist, expressionist, surrealist, abstractionist, etc. – there was, after all, no Party-line on art at the time, even in the Soviet Union. In a sense, *Art Front* was the New York communist and left art community's public conversation about art and politics. Moreover, it was at that time the only periodical in the United States which was primarily concerned with art and politics. At the end of 1935, the editors signified *Art Front's* sympathetic attitude to modernist art by bringing on to the board Joseph Solman, Max Spivak and the assistant who had been assigned to him by the W.P.A., Harold Rosenberg.[22]

Rosenberg's 'beginnings' as a practicing art critic can be located in the work he produced for *Art Front*:[23] a translation of Fernand Léger's Museum of Modern Art lecture 'The New Realism';[24] reviews of the Museum of Modern Art's Van Gogh and Cubism and Abstract Art shows;[25] several book reviews, including one of Salvador Dali's *Conquest of the Irrational*;[26] and a review of an exhibition of William Gropper's paintings at the A.C.A. gallery in which he stated that 'the revolutionary painter, far from being a grim specialist of a world seen in contracted focus, is precisely the major discoverer of new pictorial possibilities as well as of new uses for the old [. . .] by his easy and graceful mastery of the materials of social struggle, by his presentation of it, as it were, *from the inside*, without strain, [the revolutionary painter] carried forward the possibility of technical discovery in revolutionary art'.[27]

Recent art history has produced several versions of how the American left was affected by the Russian–French Non Aggression Pact of 1935 and the inception of the Popular Front, by the three show trials in Moscow of August 1936, January 1937 and March 1938 of prominent intellectuals and party leaders and activists (including, in his absence, Leon Trotsky), by the signing of the Russian–German Non-Aggression Pact in August 1939 and the collapse of the Popular Front.[28] Large numbers of intellectuals who began the decade in support of the Communist Party lost faith at certain points – abruptly, reluctantly, with such disillusion that they could not be reconciled to it. As we have seen, Rosenberg's support for the Party survived the shift from the United Front to the Popular Front. It also survived the Moscow Trials of 1936 and 1937 but was abandoned before the signing of the Russian–German Pact in 1939.[29] The moment of the move away, early or late, is important as an indicator of the intensity of his commitment to and subsequent disillusion with the Party line and Soviet communism.

For Marxists like Rosenberg, who were disillusioned with the Communist Party but who remained committed to Marxist politics and the revolutionary function of the artist and intellectual, one place to go was to the personality and writings of Trotsky – not to the Trotsky of the Civil War and the Red Army, but to the

outlawed peripatetic Trotsky of the 1930s, analysing fascism and Stalinism and still committed to keeping a radical Marxist project going.

For Trotksy, theorist and exile in Mexico, revolution and art became in certain respects alike as forms of human activity. As he made clear in his letter of 1 June 1938 to the founding conference on the Fourth International, they were inseparable and he approached both in the same way.

> I have always forced myself to depict the sufferings, the hopes and struggles of the working classes because that is how I approach life, and therefore art, which is an inseparable part of it. The present unresolved crisis of capitalism carries with it a crisis of all human culture, including art [. . .]
>
> Only a new upsurge of the revolutionary movement can enrich art with new perspectives and possibilities. The Fourth International obviously cannot take on the task of directing art [. . .] give orders or prescribe methods. Such an attitude towards art could only enter the skulls of Moscow bureaucrats drunk with omnipotence. Art and science do not find their fundamental nature through patrons; art, by its very existence, rejects them [. . .] Poets; artists, sculptors, musicians will themselves find their paths and methods, if the revolutionary movement of the masses dissipates the clouds of skepticism and pessimism which darken humanity's horizon today . . .[30]

Trotsky wrote another letter two weeks later, this time to the editors of *Partisan Review* who published it in the August–September issue under the title 'Art and Politics'.[31] This expanded what he'd written to the Fourth International. 'Art and Politics' got Trotsky inside the still Marxist but by then anti-Stalinist *Partisan Review*. He reappeared in the next issue when the journal made its relationship with him more secure by publishing the Manifesto of his International Federation of Revolutionary Writers and Artists.[32]

Rosenberg reconnected with *Partisan Review* at just this moment, when it was beginning to identify with Trotskyism. He re-entered it in the winter issue with a long critical discussion of Thomas Mann's idealistic, anti-radical anti-fascism.[33] To the summer issue he contributed replies to a questionnaire-symposium on 'The Situation in American Writing',[34] and a commentary on Arthur Rosenberg's *Democracy and Socialism*: 'By his sly shift in historical meanings', this author converted the 'principle of "permanent revolution" into that of coalition governments and the Popular Front.'[35] He also signed the statement issued by the Trotskyist League of Cultural Freedom and Socialism with its demand: 'COMPLETE FREEDOM FOR ART AND SCIENCE. NO DICTATION BY PARTY OR GOVERNMENT.'[36] A year later, in December 1940, the journal published his essay, thoroughly Trotskyist in its art and politics, on the fall of Paris.[37]

The foregoing describes part of the historical matrix which produced 'Harold Rosenberg'. It serves its purpose by enabling a reading of 'The American Action Painters' as a text situated in and inscribed by a particular Marxist tradition, by the

mutation and modification of New York Marxism related to the C.P.U.S.A., by the set backs of the late 1930s, and by the espousal of international Trotskyism with its notion of agency and of the freedom of art. Rosenberg's Marxist 'beginnings' were in the early and mid 1930s, in the art and politics of the Great Depression and the New Deal, the union movement, public protests, federal agencies, resistance and strikes, the United Front and Popular Front. The encounter with Marxism and Marxist politics was significantly different for him, and for many of his comrades, than it was for those persons who began with Marx around 1939, disenchanted with Russia and the C.P.

The 'Harold Rosenberg' I've produced from 'The Front' and a little bit of history and biography was not the kind of critic of art and culture who in the late 1930s and early 1940s quoted Marx word for word to get noticed by New York's left intelligentsia only to jettison that Marxism once it had served its purpose. In the 1950s, he was scathing about those persons of the 'turning generation' who adapted to 'Couch Liberalism'.[38] There was, it seems to me, nothing superficial or opportunistic about his Marxism; and his commitment to it was long lasting.

II

Another clenched fist, a 'rapping of the soldier's fist', begins 'The Fall of Paris' where it announces the German army's entry into the city on 14 June 1940. In this essay Rosenberg was not particularly interested in the demise of Paris as the French capital. It was more important to him as 'the laboratory of the twentieth century': the place that had drawn artists from all over Europe and America and which had become the site of their collective practice producing new ways of seeing and representing. Rosenberg, like Trotsky, thought that the continuity of culture mattered, even through revolutions and periods of social upheaval; but with the fall of Paris that continuity had been terminated. As far as Rosenberg was concerned, the cultural laboratory had not been working very effectively for ten years or so, but 'the rapping of the soldier's fist' announced its closure (TN, 209).

Rosenberg considered that twentieth-century Paris was to the intellectual what America had been in the nineteenth to the pioneer. It was, he thought, a place where no one class was able to impose its purpose and representations on artistic creation, and where individual nationalities and cultures were blended; and yet where what was alive in various national cultures might be discovered. What Paris stood for was thus the opposite of individualism and nationalism in culture because in it and through it the art of every individual and nation was increased. It was, in effect, the International of culture. At the end of the 1930s and the beginning of the 1940s, with civil war in Europe, and when cultural production was being directed by state bureaucracies in the United States and the Soviet Union, what had been achieved by Paris provided evidence for him that cultural internationalism was possible as a creative communion which could sweep across boundaries (TN, 209–210).

Rosenberg's Paris was a material place with a particular physiognomy and a lot of ideology. It was the French capital at a certain moment, say 1907–1929, and the artists who gathered there. It was also the style which was produced there: 'the Paris

style', 'the Paris Modern', 'Modernism' or 'the Modern' (TN, 210–211). However, Rosenberg realised that the Internationalism of Paris was not 'the actual getting together of the peoples of different countries'. And he also realised that the Modern 'was an inverted mental image . . . with all the transitoriness and freedom form necessity of imagined things. A dream living-in-the-present and a dream world citizenship – resting not upon a real triumph, but upon a willingness to go as far as was necessary into nothingness in order to shake off what was dead in the real. A negation of the negative' (TN, 212–213). This negation was not the practice of merely saying 'no'. It was not a practice of pure negativity. Following Marx and Engels following Hegel, Rosenberg took the 'negation of the negative' as an immanent dialectical moment of development, 'becoming', mediation and transition. The negation of the negation is a dynamic for change.[39]

Rosenberg saw the Modern as 'the style of today' – 'the contemporary as beginning in 1789' (TN, 214) – and by reference to it as 'a negation of the negative' he pointed to its critical, resistive and emancipatory potential in the development of an advanced, liberating, revolutionary consciousness. Paris had been central to it as the site of the International of culture but not to the modern as a temporality because 'the social, economic and cultural workings which define the modern epoch are active everywhere' (TN, 215).

And just as the International of culture had a capital, Paris, so in the 1920s the political International – the Third International – had a capital, Moscow. 'It is a tragic irony of our epoch,' writes Rosenberg, 'that those world centres were not brought together until the signing of the Franco-Soviet pact in 1935 when both were already dead. Then the two cadavers of hope embraced farcically, with mutual suspicion and under the mutually exclusive provincial slogans: DEFENSE OF THE USSR and FRANCE FOR FRENCHMEN' (TN, 215).

And what happened to the modern formulae perfected by Paris and Moscow and discarded with the Russian–French Non-Aggression Pact and the inauguration of the Popular Front? They were taken over by Germany and adapted to its particular aims. 'In that country politics became a "pure (i.e., inhuman)" art, independent of everything but the laws of its medium . . . Against this advanced technique, which in itself has nothing to do with revolutionary change, the Paris of the Popular Front compromise was helpless' (TN, 218). The demise of the Modern was inseparable from revolutionary defeat and the defeat of the revolutionary idea, i.e., from the rise of Stalinism and fascism and the rehegemonisation of nationalism and individualism, and the working class's loss of political independence. The fall of Paris merely made it definitive.

Despite this, 'The Fall of Paris' manages to end optimistically – just. Against the Fascist modernist mysticism 'dreaming of an absolute power to rearrange life according to any pattern of its choice', Rosenberg glimpsed the possibility of 'other forms of contemporary consciousness, another Modernism' (TN, 220). But he found it impossible to predict where the centre of this new phase of the Modern would be located.

III

By the late 1940s–early 1950s, it had become possible for Rosenberg to identify the new International of culture – if not the International of politics – and to discuss the significance of the movement or style produced by it. He does this in 'The American Action Painters' which was published in the issue of *Art News* for December 1952. Like 'The Front' and 'The Fall of Paris', 'The American Action Painters' begins with a gesture; this time it is taken from Apollinaire, and set epigrammatically with a fragment from Wallace Stevens: ' "*J'a fait des gestes blancs parmi les solitudes.*" APOLLINAIRE "The American will be easily satisfied in its efforts to realise itself in knowing itself." WALLACE STEVENS.'

One thing which needs to be immediately established is what it is that Rosenberg thought was 'American' about 'American action painting'. He was obviously trying to write something about a kind of collective identity, but there is nothing nationalistic, patriotic or chauvinistic about his use of 'American' or his idea of what kind of person the 'American' action painter might be. 'American' has to be understood as meaning a kind of ethnic diversity and cosmopolitanism.[40] You only have to read his 1959 essay, 'Tenth Street: A Geography of Modern Art', to see how clearly the material and ideological space of the American action painters was, in Rosenberg's scheme of things, related to the International of culture he'd described nineteen years before in 'The Fall of Paris'.[41] Here, in this essay, 'the new American "abstract" art' is the kind of painting made around 10th Street, New York, by displaced persons, immigrants, the sons and daughters of immigrants, and by Americans who have 'moved' there (DP, 102) maybe for reasons similar to those of the artists, writers, etc., who travelled from all over the world to Paris and produced the Modern.

In 'The American Action Painters' the artist is figuratively and literally a pioneer and an immigrant. And just as the earlier International of culture was determined partly by the physical character of its place of production and by the qualifying and the blending of nationalities and class positions which was possible there, so 'Tenth Street' was determined not only by its geography – Rosenberg writes that it 'has not even the picturesqueness of a slum' (DP, 103), it is 'devoid of local colour', it's a 'neutral zone' (DP, 104) – but also by the unfixing and mixing of nationalities, races, classes, and ideologies which happened there (DP, 106). In 1940 Rosenberg had described the Paris 'International' as a 'No-Place'; in 1959 he described the area around 10th Street as a 'no-environment' (DP, 104), it was all places and none of them.[42] As the new site of cultural internationalism, 'Tenth Street' transcended the internationalism of the moribund Paris 'International' of the 1930s. Its 'ethnic openness' – its 'Americanness' – went beyond the 1930s fighting talk of 'internationalism' (DP, 104). And its 'American' action painting went beyond the dogma of 1930s 'modernism' (DP, 104). I will consider this double 'going beyond' later, but for the moment I want to stay with Rosenberg's notion of 'American' and 'Americanness' and consider how it relates to his thinking about identity and action.

One of Rosenberg's most interesting considerations of 'Americanness' occurs in his 1949 essay 'The Pathos of the Proletariat'.[43] This was the second of two essays on class and class struggle – the first was 'The Resurrected Romans' of

1948[44] — which he wrote at a time when he was concerned with 'the drama of modern history as conceived by Marx — a drama in which individual identity and action are replaced by collective actions formed out of historical processes and myths' (AA, 206). Both essays, but particularly 'The Pathos of the Proletariat', are significantly inscribed by what he had written in 1932 in 'Character Change and the Drama'. We need to look into 'Character Change and the Drama' before we consider 'Americanness' in 'The Pathos of the Proletariat' and start rereading 'The American Action Painters' because it's in this early essay that he develops most fully those ideas on the making of an 'identity' and the relation of this to individuality which are so central to his politics.

What Rosenberg wrote in 'Character Change and the Drama' was informed as much by his studies in law school as by his interest in the theatre and the mechanics of tragedy.[45] Legal definitions were important for his argument. He explained that the law totally defines an individual by his 'overt acts', by what he did in particular circumstances. The law does not recognise 'personality', a person with a biography, a life pictured as fully and precisely as possible. It is only interested in a person's actions, an 'identity' to which its judgements are applied (TN, 138).

Rosenberg goes on to argue that in *Hamlet* the Prince is transformed from a 'personality' (a thoroughly naturalistic, psycho-biographical character) into a dramatic 'identity' (a character relevant to and able to perform the role required by the plot in which he is located) (TN, 146–149).

Hamlet has all the qualities required for action; what he lacks is the identity structure which would fit him to be a character in the drama, a oneness with his role originating in and responding to the laws of his dramatic world. The change occurs when he acquires a certainty with regard to his feelings, and when his capacity for action is no longer the expression of his 'personality' but accords with the dramatic rules of the situation in which he finds himself. He breaks with one character and '*becomes*' another: 'This is I, Hamlet the Dane.' From that moment, 'his action hustles the play to its tragic close and the apparently accidental character of his revenge serves to emphasise that he is controlled at the end not by the conflicting intentions of a self but by the impulsions of the plot. Transformed from the image of a personality into that of a dramatic identity, he has found at last his place in the play' (TN, 149).

Here, in Rosenberg's legalistic thinking about character change in *Hamlet*, we find a key for understanding his reading not only of Marx on class and class struggle, but also of the American action painters and American action painting. This paragraph near the end of 'Character Change and the Drama' is crucial:

> Individuals are conceived as identities in systems whose subject matter is action and the judgment of actions. In this realm the multiple incidents in the life of an individual may be synthesized, by the choice of the individual himself or by the decision of others, into a scheme that pivots on a single fact central to the individual's existence and which, controlling his behavior and deciding his fate, becomes his visible definition. Here unity of the 'plot' becomes one with unity of being and through the fixity of identity change becomes synonymous with revolution (TN, 152).[46]

Fifteen years later, in 'The Pathos of the Proletariat', the identity change which becomes synonymous with revolution is that made by the 'hero of Marx's drama of history' whose 'action is to resolve the tragic conflict and introduce the quiet order of desired happenings' (AA, 14). The hero was not to be an individual but a particular kind of collective identity, a social class: the proletariat (AA, 15). But for an American radical like Rosenberg, four or five years after World War II, the social revolution seemed unlikely: capitalism was secure; its internationalisation well advanced; Soviet communism was discredited. The revolutionary processes of capitalism had not genuinely illuminated the worker about himself nor united him with other workers. Existence had not yet determined a revolutionary consciousness. Instead, it had determined a revolutionary politics and propaganda, a collective 'I' defined and confirmed by the Party and its bureaucracy (AA, 47). But unlike many Marxists, Rosenberg was not claiming or complaining that the proletariat had not lived up to its appointed form of consciousness or had failed in the role imagined and written for it. Rather, the problem of the agency of revolutionary change which had previously thought of in terms of the individual had now become a central preoccupation, and one which he puzzled in terms of class. The question which concerned him in 'The Pathos of the Proletariat' was how the proletariat's character and consciousness might be transformed into a revolutionary consciousness and identity.

The proletariat had been on stage since the industrial and bourgeois revolutions, but if it had only the social character and function assigned to it by the process of production, what did it mean to speak of it as revolutionary? (AA, 17–18).

Rosenberg finds answers, or partial answers, to this question in Marx's *The Class Struggles in France*, *The Civil War in France*, and especially in *The Eighteenth Brumaire of Louis Bonaparte*. In these 'historical-literary' writings, the class transcends its given form and its economic function and 'expresses its collective personality and acts with an intelligence and spirit peculiar to itself' (AA, 19). It is apparent to Rosenberg that, in these texts, 'the essence of class definition consisted for Marx in this active character-shaping spirit' (AA, 19). He finds this implicit in the statement: 'The working class is revolutionary or it is nothing.' In terms of 'Character Change and the Drama', the class would be defined 'by the coherence of its acts and with the fact in which they terminated'. Without this 'identity' or 'character' the proletariat would merely be a 'personification' (AA, 21), and as a personification it would be nothing. Since Rosenberg believes that dialectically and by definition the proletariat must be more than a personification, that its existence presupposes a revolutionary consciousness and will, and that its own direct decisions and acts – and not decisions or actions taken on its behalf – must be the basis of any change considered to be socialist, he argues that the self-consciousness which converts it from 'social character' to 'character' or historical actor is an aspect of revolution and of revolutionary practice (AA, 22). The proletariat must come to consciousness through its own action, its own response to the structural contradictions of capitalism. 'Both class awareness and class identity rise out of class action' (AA, 22).

To the question of how the proletariat's 'social character' might be transformed, Rosenberg finds an answer in that part of *The Eighteenth Brumaire*, where Marx writes that the proletarian revolution will be characterised by its total abandonment of the past:

> The social revolution cannot draw its poetry from the past but only from the future. It cannot begin with itself before it has stripped off all superstitions in regard to the past. Earlier revolutions required world-historical recollections in order to drug themselves concerning their own content; the revolution of the nineteenth century must let the dead bury the dead. There the phrase went beyond the content; here content goes beyond the phrase (AA, 23).

Whereas the bourgeois revolutions had been performed in costumes borrowed from the past, with ghosts of dead heroes presiding over events – like the ghost of Hamlet's father – the social revolution has to be without recourse to myth, and must be clear concerning its content. The proletariat, called into existence by the bourgeoisie and a product of modern industry, is without a past. Its revolution 'is to owe nothing to that repertory of forms out of which history has supplied earlier revolutions with the subjective means for meeting their situation' (AA, 23). Pastless, the proletariat must begin its revolution, become one with the drama of history, with a profound asceticisation of mind and imagination realising itself for what it is, the personification of wage labour (AA, 23).

In other words, there will come a moment when the proletariat, as the first condition of historical action, must surrender its given character and function under capitalism. It will then act to fulfil its historical role, develop a form of revolutionary consciousness and 'identity', and come to exist at the level of political struggle.

Rosenberg regarded the pastlessness of the proletariat as the key to its 'character' and its revolutionary role. Here, in 'The Pathos of the Proletariat', he developed the idea that the proletariat and the American are 'similar' or analogous with regard to their pastlessness and their capacity for action. As an immigrant, or the descendant of immigrants, the American is regarded as detached or estranged from his or her origins – the culture, traditions, places, things, even the human relations of Europe – and this constitutes a kind of pastlessness; 'the American exists without the time dimension' (AA, 27).[47] Also, he does not meditate, he acts; and his 'self-consciousness arises through the "practical movement" [AA, 28] [. . .] For the American action is but a natural response [Rosenberg makes it sound like a species characteristic] to need or desire (whether his action can satisfy that need is another question)' (AA, 31).

This *similarity* might seem a bit flim-flam now but it would have seemed less so in the 1940s when Lenin's and Trotsky's views on American agriculture and industry were more part of left conventional wisdom than they are today.[48] That's to say, the assimilation of the values attaching to 'American' with those attaching to proletarian in 1949 worked because of the job it was doing and the context in which it was uttered.

> Many of the attributes of the proletariat as the potential embodiment of the spirit of the modern are, inescapably, attributes of the American,[49] unquestionably the best available model of the new-fangled; from Marx to Lenin to Trotsky, American practices have been cited to illustrate qualities needed under socialism (AA, 29).

However, the American is no revolutionary: 'his history has been one of setting limits to his revolutionising' (AA, 30).

But how does the simile work? What is it supposed to illustrate with reference to the proletariat's character change and the drama of history?

> Speaking half-figuratively,[50] to become a human being the proletarian must *Americanize* himself, that is, overcome the void of his past by making a new self through his actions (AA, 32).[51]

IV

It should be clear from the foregoing that Rosenberg's idea of 'action' – 'American-action' – came out of the very particular way he read Marx's writings. As far as his thinking about 'action' in 'action-painting' is concerned, I doubt that he found much of use for what he wanted to write in Hans Namuth's photographs of Jackson Pollock painting which appeared in the *Art News* for May 1951.[52] Some persons think they were important for him, but the point is that he did not need to see – or see photographs of – any of the artists at work – Pollock, Willem de Kooning, Barnett Newman, whoever – to write what he *saw* their painting *as* or *as of*.[53] On the other hand, I can see why, in 1947, some passages in Richard Huelsenback's 'En Avant Dada' caught his eye amongst the proofs of Robert Motherwell's Dada anthology.[54] In one passage, which he and Motherwell included in *Possibilities*, you can read: 'The Dadaist should be a man who has fully understood that one is entitled to have ideas only if one can transform them into life – the completely active type, who lives only through action, because it holds the possibility of achieving knowledge.'[55] That seems compatible with how he read Marx. Motherwell has said that Rosenberg's notion of 'action' derives from Huelsenbeck.[56] There was more to it than that, indeed more to it than I have written here. But then, beginnings are over-determined.

We can now start reading 'The American Action Painters' and answer the question posed about action painting in its first section: 'Modern Art? Or an Art of the Modern?' For Rosenberg, writing in 1952, Modern Art is painting which has caught up with, or is catching up with, what was produced by the 'School of Paris', the academic, moribund Modern of the late 1920s–30s. It is painting secure in the knowledge of what art is, practicing its immediate past, enabled and supported by a stable structure. This Modern Art is what has to be negated in and by any radical art practice: an Art of the Modern will be that negation (TN, 23–24).

But Modern Art is not only painting. As Rosenberg points out, the category could also include architecture, furniture, household appliances, advertising 'mobiles', a three-thousand year old mask from the South Pacific, even a piece of wood found on a park bench (TN, 35–36). Modern Art has nothing to do with style, with when it was produced, why, by whom, for whom, etc., and more or less everything to do with the social power and pedagogy of those persons who designate it as 'psychologically', aesthetically or ideologically relevant to our epoch' (TN, 36). It is a 'revolution of taste' conducted by those persons who value it and contested by those who do not. Responses to it represent 'claims to social leadership' (TN, 36).

Rosenberg was alluding to that aspect of the struggle for leadership within the ruling class which, during the Cold War, was fought with claims about Modern Art. On one side, there was that fraction (the internationalist–multinationalist 'business liberals') which valued it, collected it, and made it available to the public in those bits of the cultural apparatus owned and controlled by it – the Museum of Modern Art, New York, was a prime site – and for whom Modern Art had 'a supreme Value [. . .] the Value of the New' (TN, 37). On the other side there was that fraction (the isolationist–nationalist 'practical conservatives') which regarded Modern Art as un-American, subversive, 'snobbish, Red, immoral, etc.' (TN, 36), and whose views were represented publicly by the likes of Congressman George A. Dondero. Rosenberg, who understood how Modernism – or those aspects of Modern Art which were synonymous with his Art of the Modern – put the politics of both class fractions at risk,[57] regarded this struggle, restricted to 'weapons of taste' and at the same time addressed to the masses, as a 'comedy of a revolution' (TN, 36), i.e., a farce.

The professional enlighteners of Modern Art use action-painting in their struggle and for their pedagogic and profit-making purposes (TN, 37), but they do not understand it. Their judgement is a matter of taste, of identifying 'resemblances of surface', and of perpetuating beliefs about what painting is and what is to be valued as 'modish' (TN, 38). So they failed to grasp 'the new creative principle' which set action painting apart from twentieth-century picture making (TN, 39).

Rosenberg's action painting has nothing to do with taste or with 'the all too clearly rationalised' 'previous mode of production of modern masterpieces' (TN, 24). It was a different kind of practice to that of the earlier abstractionists of the International of culture or, as it was called in 'The American Action Painters', the Great Vanguard (TN, 24). The Modern, or the Great Vanguard, was historically and culturally specific to Paris, 1907–29. Action painting was historically and culturally specific to an art community associated with 10th Street, New York, 1945–52. It was that community's response in relation to the unevenness of history and to what Rosenberg regarded as a break in the Modern. Not surprisingly – nor illogically according to his order of things – Rosenberg's action painters regarded the style of the Great Vanguard as dead or as something to be transcended. Though it is possible to see a cutaneous similarity between their work and previous abstract painting, the two kinds of painting are crucially different with regard to their functions. Rosenberg said that what the action painter produces 'has separated from' the Great Vanguard and from what the taste bureaucracies and formalism have designated Modern Art because it is determined by and produced with an awareness of a new function for painting (TN, 24). Rosenberg's use of 'the Modern' remained consistent since 'The Fall of Paris' and continued to mean – as it did in 'The Pathos of the Proletariat', where he talked about 'the spirit of the modern' (AA, 29) – the style of the progressive consciousness of the epoch. Action Painting then, is not Modern Art but an Art of the Modern.

Rosenberg points out that most of the artists he has in mind were over forty years old when they became action painters. Before then, many of them had been '"Marxists" (WPA unions, artists' congresses) [. . .] trying to paint Society. Others had been trying to paint Art (Cubism, Post-Impressionism)'. It amounted to the same thing. They had been trying to paint the Modern. By 1940 both the Society and

the Art Modern were dead. 'The Fall of Paris' had written their obituaries. It is in this double demise, not in 'the war and the decline of radicalism in America', that Rosenberg locates the beginnings of action painting. 'At its center the movement was away from, rather than towards. The Great Works of the Past and the Good Life of the Future became equally nil' (TN, 30).

It was at this moment of 'grand crisis' (TN, 30) when the two Moderns of Art and Society became nothing, and were recognised as having failed, that it became possible to make an Art of the Modern again. However, the ideas, beliefs, theories, practices, materials and methods of Art and Society which survived were useless to those artists who were concerned to deal with the crisis and work it out in practice. 'Value – political, aesthetic, moral' had to be rejected.[58] But this rejection did not, as it had done with Dada and Surrealism after the First World War, take the form of condemnation or defiance. This time the reaction was, not surprisingly, 'diffident' (TN, 30), distrustful of Society and uncertain about 'Art', 'creation', 'creativity', 'individuality' and the 'identity' of the artist.

In coming to nothing the two Moderns provided artists with a major resource for any vanguard practice: *nothingness*. With the idea of nothingness and with severely reduced material equipment the action painter 'decided to paint . . . just TO PAINT' (TN, 30). There was no intention 'to reproduce, re-design, analyse or "express" an object, actual or imagined. What was to go on the canvas was not a picture but an event. The painter no longer approached his easel with an image in his mind; he went up to it with material in his hand to do something to that other piece of material in front of him' (TN, 25). The image that was produced by 'staining' the canvas or by 'spontaneously putting forms into motion upon it' (TN, 25) was the indexical – and occasionally the iconic – mark or trace of those actions.[59] Initially that was all there was to it. But then the painter began to take stock of the way the surface was marked, started to attend to the 'act of painting', to what might be learned about painting and art and about himself as an artist: 'What matters always is the revelation contained in the act' (TN, 26–27). Action painting is, in Rosenberg's account of it, painting at the point of formation, when everything has to be redone; it is Ur-painting at the moment of thematisation; but it is not yet, and may never become, painting as art.[60]

We are now near to understanding this new painting which Rosenberg regards 'as an act that is inseparable from the biography of the artist', that is 'a "moment" in the adulterated mixture of his life', that is 'of the same metaphysical substance as the artist's existence', and that has 'broken down every distinction between art and life' (TN, 27–28). But we will not understand it if we see it as Modern Art, i.e., in relation to 'the works of the past, rightness of colour, texture, balance, etc.', or as expressing or representing some aspect of the artist's existence, for example, his 'sexual preferences or debilities' (TN, 29). Taking the hint from the reference to 'the critic who goes on judging' (TN, 28) (and recalling what he had written previously in 'Character Change and the Drama' about the way the law defines a person by his acts), it seems clear that Rosenberg understands action painting as a given sequence of acts which enable a judgement by the painter and the critic, a judgement which is an inseparable part of recognising the painter's 'identity'. 'The law is not a recogniser of persons; its judgements are applied at the end of a series of acts.'[61] With regard to individuals the law thus creates a fiction, that of a person who

is identified by the coherence of his acts with a fact in which they have terminated (the crime or the contract), and by nothing else. The judgement is the resolution of these acts. The law visualises the individual as a kind of actor with a role whom the court has located in the situational system of the legal code' (TN, 136).

In understanding an action painting or the 'actpainting' as an act which is 'inseparable from the biography of the artist', Rosenberg doesn't see it as a mere attribute of or clue to the painter's 'psychology, philosophy, history, mythology, hero worship' (TN, 28). Nor, if the action painter is to be understood in terms of the commonly ascertainable elements of his acts – his action paintings – should he ever be made to be more than he could have possibly performed. 'In contrast with the person who is recognised by the continuity of his being, we may designate the character defined by the coherence of his acts as an "identity"' (TN, 136). This, if we follow Rosenberg, is how we are to understand the action painter: as an 'identity'. The action painter's activity is intended to define his 'identity' at a moment of 'grand crisis':

> With the American, heir of the pioneer and the immigrant, the founder-
> ing of Art and Society was not experienced as a loss. On the contrary,
> the end of Art marked the beginning [. . .] of an optimism regarding
> himself as an artist [. . .] On the one hand, a desperate recognition of
> moral and intellectual exhaustion; on the other, the exhilaration of an
> adventure over depths in which he might find reflected the true image of
> his identity . . . Guided by visual and somatic memories of paintings he
> had seen or made – memories which he did his best to keep from intrud-
> ing into his consciousness – he gesticulated upon the canvas and watched
> for what each novelty would declare him and his art to be (TN, 31).

Aware that their ideological and material conditions were thoroughly immiser-
ated and freed from, or wanting to be free from, past ideas and beliefs, the action painters acted according to their historical circumstances and entirely in their own interests. The 'saving moment' occurred 'when the painter first felt himself released from Value – myth of past self-recognition' and 'attempted to initiate a new moment' in which he would 'realise his total personality – myth of future self-recognition' (TN, 31). It was here that the painter's character change became, like Hamlet's or like the *Americanised* proletariat, synonymous with revolution. This is Rosenberg on revolutionary action in 'The Pathos of the Proletariat'.

> For the worker action is but a possibility, the anguishing possibility of
> transforming himself into an individual. Hemmed in on the bare, func-
> tional stage of industrial production, altogether '*there*', without past or
> vision of paradise, he is, except for this possibility of acting, a mere prop,
> a thing that personifies. Speaking half-figuratively, to become a human
> being the proletarian must '*Americanize*' himself, that is, overcome the
> void of his past by making a new self through his actions.
>
> Yet all the relations of capitalist society forbid the working class to act
> except as a tool. Hence its free act must be a revolutionary act, one that

must subdue 'all existing conditions' and can set itself no limits. The proletarian victim of the modern cannot enter the historical drama as an actor without becoming its hero. In 'the indefinite prodigiousness of their aims', as Marx described them in *The Eighteenth Brumaire*, the workers signify that with them revolution is a need of the spirit, a means of redemption. Before Marx's internal pioneer opens a frontier without end (AA, 31–32).

This is what he wrote, or rewrote, in the 'American Action Painters'.

The revolution against the given, in the self and the world, which since Hegel has provided European vanguard art with theories of a New Reality, has re-entered America in the form of personal revolts. Art as action rests on the enormous assumption that the artist accepts as real only that which he is in the process of creating. 'Except the soul has divested itself of the love of created things . . . ' The artist works in a condition of open possibility, risking, to follow Kierkegaard, the anguish of the esthetic, which accompanies possibility lacking in reality. To maintain the force to refrain from settling anything, he must exercise in himself a constant No (TN, 32).

The action painter can only produce effectively if he is in relation to the dominant culture as a proletarian, an alienated proletarian, a proletarian within a class. Action is the prerequisite of class 'identity'. For the proletariat, which is held in an alienated, exploited fixed-relation, any free act, any action made spontaneously and without recourse to myths of the past or to a Utopian future, will be, by definition, revolutionary and will begin the revolution in permanence. Action is also the prerequisite of the vanguard painter's 'identity'. In the crisis period of 1940 and after, the painter could either remain inactive and continue to paint Art and Society, or he could rid himself of all considerations except those demanded by his historical situation, directly encountered, and . . . just PAINT. He could produce Modern Art or an Art of the Modern, make art or 'original work demonstrating what art is about to become' (TN, 24).

As I read them, 'The Pathos of the Proletariat' and 'The American Action Painters' are the essays of a Marxist who *refused* to be forced into a pessimism which would be quite alien to the Marxist tradition.[62] The Harold Rosenberg who wrote 'The Front' was still here, residually, in these essays of the late 1940s and 1950s. The proletariat still had the potential for revolution: '*So long as the category exists*, the possibility cannot be excluded that it will recognise itself as a separate human community and revolutionise everything by asserting its needs and its traditionless interests' (AA, 56–57). And the American action painters provided evidence that there was still some potential for personal revolt and for insurrection. For Rosenberg, 'good' action painting left 'no doubt concerning its reality as an action and its relation to a transforming process in the artist' (TN, 33). Weak or 'easy' action painting lacked 'the dialectical tension of a genuine act, associated with risk and will' (TN, 34). The painter seemed to be able to act out an 'identity' – 'Dramas Of As If' (TN, 27) – which the proletariat, at that moment, could not.

Maybe the action painter's action was always, at some level, a failure – unless, as seems unlikely, it was part of a 'revolution' whose outlines were not perceptible in political terms, but whose potential could only be denied at the cost of an entire loss of self.

Rosenberg was able to remain optimistic because his analyses incorporated the dialectic. When it appeared, the dialectical method, which combines the negativity of man's social experience with the need for change, introduced an essential, confident movement into his writing. Remember: the Paris Modern represented 'a dream living-in-the-present and a dream world citizenship – resting not upon a real triumph, but upon a willingness to go as far as was necessary into nothingness in order to shake off what was dead in the real. A negation of the negative'. For Rosenberg, that was what the work of American action painters was. If action painting had any meaning, it was about revolutionary political agency arising from the contradictions of capitalism, the reality of which could not be totally excluded if the prospect of radical change was to be kept open . . . sometime . . . somewhere . . . Action painting was the sign that the possibility of revolution was not totally closed down, that the dynamic of revolution was still there.[63] Action painting was that, or it was nothing.

'I am nothing and I should be everything.' Karl Marx, *Critique of Hegel's Philosophy of Right* Introduction (1844)

Abbreviations

AA Harold Rosenberg, *Act and the Actor, Making the Self* (N.Y.: World Publishing Co., 1970, The University of Chicago, 1983).

DP Harold Rosenberg, *Discovering the Present/Three Decades in Art, Culture, and Politics* (Chicago: The University of Chicago, 1973, Phoenix Edition, 1976).

TN Harold Rosenberg, *The Tradition of the New* (N.Y.: Horizon Press, 1959, The University of Chicago, Phoenix Edition, 1982).

Notes

1 Harold Rosenberg, 'The American Action Painters', *Art News*, vol. 51, no. 8, December 1952, pp. 22–23, 48–50, reprinted in *The Tradition of the New*, 1982, pp. 23–39.

2 Harold Rosenberg, 'The Front', *Partisan Review*, vol. 11, no. 6, January–February 1935, p. 74.

3 Harold Rosenberg, 'Character Change and the Drama', *The Symposium*, vol. III, no. 3, July 1932, pp. 348–369, reprinted in *The Tradition of the New*, 1982, pp. 135–53. See also his other work for *The Symposium*: 'Myth and Poem', vol. II, no. 2, April 1931, pp. 179–91; a review of William Empson's *Seven Types of Ambiguity*, vol. II, no. 3, July 1931, pp. 412–18; a review of Kenneth Burke's *Counter-Statement* and Montgomery Belgion's *The Human Parrot and Other Essays*, vol. III, no. 1, January

1932, pp. 116–18; and a review of Jules Romains' *Men of Good Will*, vol. IV, no. 4, October 1933, pp. 511–14.

4 Rosenberg and Hays published three issues of *The New Act*, Number One, January 1933, Number Two, June 1933, and Number Three, April 1934. *Poetry, a Magazine of Verse*, vol. 45, no. 6, March 1935, p. 357, referred to it as an 'experimental quarterly'. *The New Act* published articles by René Daumal, Paul van Ostayen, Henry Bamford Parkes, George Plekhanov, Ezra Pound, Samuel Putman, and Parker Tyler. For Rosenberg's contributions see 'Note on Class Conflict and Literature', *The New Act*, Number One, January 1933, pp. 3–10, and 'Sanity, Individuality and Poetry', *The New Act*, Number Two, June 1933, pp. 59–75, two essays in which he developed the ideas on class conflict and individuality that he had first written in 'Character Change and the Drama', 1932.

5 Rosenberg's contributions are indexed in *Thirty Years of Poetry: A Magazine of Verse. Index to Volumes 1–60, October 1912–September 1942* (inclusive) and *Index to Fifty Years of Poetry, A Magazine of Verse, Volumes 1–100, 1912–1962* (N.Y.: AMS Reprint Company, 1963).

6 William Phillips and Philip Rahv, 'Private Experience and Public Philosophy', *Poetry*, vol. 48, no. 2, May 1936, p. 104.

7 Harold Rosenberg, 'The Men on the Wall', *Poetry*, vol. 44, no. 1, April 1934, pp. 3–4.

8 *Ibid.*

9 'Contributors', *Partisan Review*, vol. II, no. 6, January–February, 1935, p. 2.

10 On the John Reed Club and *Partisan Review* see Daniel Aaron, *Writers on the Left: Episodes in American Literary Communism* (N.Y.: Harcourt, Brace & World, Inc., 1961); James Burkhart Gilbert, *Writers and Partisans: A History of Literary Radicalism in America* (N.Y.: Wiley, 1968); Richard H. Pells, *Radical Visions and American Dreams: Culture and Social Thought in the Depression Years* (Wesleyan University Press, 1973); Alan Wald, 'Revolutionary Intellectuals: *Partisan Review* in the 1930s', *Occident*, n.s. viii, Spring 1974, pp. 118–33; Eric Homberger, *American Writers and Radical Politics, 1900–1939: Equivocal Commitments* (N.Y.: St. Martin's Press, 1986).

11 Considering the secrecy which continues to surround membership and which was deliberately fostered by the C.P., it's very difficult to know who was and who was not a member of the C.P.U.S.A. And there are conflicting reports. It seems that being a member demanded a kind of discipline that most writers and artists would not be able to accept. One has to remember that the C.P.U.S.A. was partly committed to democratic centralism and to the strategic use of writers and artists. Because it could not accommodate any criticism from members at local levels of organisation, it would not accept into its ranks any really independent figures, and they, in turn, would not accept its dictates. My guess is that Harold Rosenberg was a fellow-traveller.

12 'The Coming Writers Congress', *Partisan Review*, vol. ii, no. 6, January–February 1935, pp. 94–6, see p. 95. The Congress, it was announced, would also 'develop the possibilities for wider distribution of revolutionary books and the improvement of the revolutionary press, as well as relations between revolutionary writers and bourgeois publishers and editors'. It was clear from this that when the Congress met at the end of April it was to be less concerned with revolution than with establishing good relations with the literary bourgeoisie and with fighting fascism.

13 Jane [Tabrisky] Degras, *The Communist International 1919–1943: Documents Vol. 3* (London and New York: Oxford University Press, 1965), p. 375, quoted in Duncan

Halas, *The Comintern* (London: Bookmarks, 1985), p. 143, an excellent discussion of the Comintern's revolutionary period.

14 Harold Rosenberg, 'The American Writers Congress', *Poetry*, vol. 46, no. 4, July 1935, pp. 222–7.

15 *Ibid.*, p. 226.

16 *Ibid.*, pp. 226–7.

17 *Ibid.*, p. 225.

18 *Ibid.*

19 *Ibid.*

20 *Ibid.*

21 Rosenberg is using Browder's speech to the Congress which was intended to reassure the non-communist writers that the C.P. had no intention of putting them into 'uniforms'. This mention of 'uniforms' was clearly a reference to Max Eastman's *Artists in Uniform* (N.Y., 1934).

22 Here I've relied on Gerald M. Monroe's essay 'Art Front' in *Archives of American Art Journal*, vol. 13, no. 3, 1973, pp. 13–19. The editorial board's shift towards modernism was made partly as a result of pressure which had been brought to bear by some modernist members of the Union – Solman, Ilya Bolotowsky, Balcomb Greene, Mark Rothkowitz, Byron Browne, George McNeil, and others – and partly because the Popular Front made it necessary to open up the editorial board to modernism. The move did not go uncontested. Rosenberg's place was secured at the expense of Solman's and Spivak's and several others, and then only on the advice of a visiting official of the French Communist Party who sat in on a crucial board meeting.

 In *Poetry*, vol. 5, no. 4, January 1938, p. 234, Rosenberg is referred to as a 'poet, critic, and painter of murals'.

23 Rosenberg's first piece for *Art Front* was a report on an Artists Union demonstration outside the C.A.A. on August 15, 1935, at which 83 W.P.A. artists and art teachers were arrested, see 'Artists Increase their Understanding of Public Buildings', *Art Front*, November 1935, pp. 3, 6.

24 Harold Rosenberg, translator, Fernand Léger, 'The New Realism', *Art Front*, December 1935, p. 10.

25 Harold Rosenberg, 'Peasants and Pure Art', January 1936, pp. 5–6, and 'Cubism and Abstract Art', *Art Front*, June 1936, p. 15.

26 Harold Rosenberg, 'Book Reviews', *Art Front*, March 1936, pp. 13–14, see p. 14.

27 Harold Rosenberg, 'The Wit of William Gropper', *Art Front*, March 1936, pp. 7–8.

28 The most complete and still the best account can be found in the rich detail of Chapter One 'New York, 1935–1941: The De-Marxization [sic] of the Intelligentsia' in Serge Guilbaut's *How New York Stole the Idea of Modern Art: Abstract Expressionism, Freedom, and the Cold War* (The University of Chicago Press, 1983).

29 In 1937 Rosenberg published several things in *New Masses*, the cultural magazine of the C.P.U.S.A. which always affirmed the validity of the Moscow Trials and the communist line. 'Portrait of a Predicament', his very hostile review – in the context of *New Masses* it couldn't have been anything but hostile – of William Saroyan's *3 Times 3* appeared in the same issue as 'The Moscow Trials: An Editorial', *New Masses*, February 9, 1937, see p. 24. Other writings are: 'What We May Demand', *New Masses*, March 23, 1937, pp. 17–18, an article on literature and major political writings (i.e. 'But the least we may demand from literature is that it equal the best political and historical writings of our time in the consciousness of its own subject matter. Only thus can it probe the wound of humanity which the act of thinking and

of political combination is part of the effort to cure [. . .] no poem or novel of the past few years can equal as a literary expression of modern human consciousness the Communist Manifesto or Marx's Eighteenth Brumaire.'); 'Aesthetic Assault', a review of Jules Romains' *The Boys in the Back Room, New Masses*, March 30, 1937, p. 25; and 'The Melancholy Railings', a poem, *New Masses*, July 20, 1937, p. 20. However, he did not publish in *New Masses* after July 1937, and he did not put his name to 'The Moscow Trials: A Statement by American Progressives' endorsing the trials, *New Masses*, May 3, 1938, p. 19. This break with *New Masses* helps date his move away from the C.P.

30 Leon Trotsky, *Writings of Leon Trotsky [1937–38]* (N.Y.: Pathfinder Press, 1970), pp. 351–2.

31 Leon Trotsky, 'Art and Politics', *Partisan Review*, August–September 1938, vol. V, no. 3, pp. 3–10.

32 See André Breton and Diego Rivera, 'Manifesto: Towards a Free Revolutionary Art', *Partisan Review*, Fall 1938, vol. VI, no. 1, pp. 49–53. It is generally agreed that this text is substantially Trotsky's.

33 Harold Rosenberg, 'Myth and History', *Partisan Review*, vol. VI, no. 2, Winter, 1939, pp. 19–39.

34 'The Situation in American Writing', *Partisan Review*, vol. VI, no. 4, Summer 1939, see pp. 47–9.

35 Harold Rosenberg, 'Marx and "The People"', *Partisan Review*, vol. VI, no. 4, Summer 1939, pp. 121–5, see p. 124.

36 'Statement of the L.C.F.S.', *Partisan Review*, vol. VI, no. 4, Summer 1939, pp. 125–7, see p. 127. He also signed the League's Manifesto 'War Is The Issue!', in the next issue of *Partisan Review*, vol. VI, no. 5, Fall, 1939, pp. 125–7. See Rosenberg on the L.C.F.S. in 'Couch Liberalism and the Guilty Past', *Dissent; a quarterly of socialist opinion*, vol. II, Autumn 1955, pp. 317ff., reprinted in *The Tradition of the New*, 1982, pp. 238–9.

37 Harold Rosenberg, 'On the Fall of Paris', *Partisan Review*, vol. VII, no. 6, December 1940, pp. 440–8 reprinted under the title 'The Fall of Paris' in *The Tradition of the New* (1982), pp. 209–220.

38 See Harold Rosenberg, 'Couch Liberalism and the Guilty Past' (1955), TN. 221–40.

39 In the dialectical process of development 'The old quality is negated by its opposite [. . .] thus constituting the first negation. However, the superceded quality does not remain in its original form but, by another process of negation, develops into the next stage, the negation of the negation. Marx, Engels and other classical Marxist philosophers developed the concept from Hegel, but gave it a materialist content and stressed its dynamic aspect of development. However, as Engels and Lenin insisted, neither negation nor the negation of the negation in dialectics amounts to the total denial or rejection of the old. Thus socialism is basically a negation of capitalism, yet the former also embodies the best elements of the latter . . . ' (J. Wilczynski, *Encyclopedic Dictionary of Marxism, Socialism and Communism* (Berlin and New York: De Gruyter, 1981), p. 382.

In 'The Pathos of the Proletariat', AA, 35, Rosenberg quotes this fragment from *Capital* with reference to the Hegelian dialectic as summarised by Marx: 'it includes in its comprehension an affirmative recognition of the existing state of things, at the same time also, the recognition of the negation of that state, of its inevitable breaking up'. For the classic formulation of the negation of the negation

see Karl Marx, *Capital I*, trans. Ben Fowkes (Harmondsworth and London: Penguin/New Left Review, 1976), p. 929: 'The capitalist mode of appropriation, the result of the capitalist mode of production, produces capitalist private property. This is the first negation of individual private property, as founded on the labour of the proprietor. But capitalist production begets, with the inexorability of a law of Nature, its own negation. It is the negation of the negation. This does not re-establish private property for the producer, but gives him individual property based on co-operation and the possession in common of the land and the means of production.'

However, the negation of the negation cannot produce a self-sustaining positivity. Accordingly the positive value of the social revolution must be constituted through successive stages of development and transition. The social revolution prevents the dialectical movement coming to an end; the proletariat will continually remake society and itself.

Slavoj Žižek, *The Sublime Object of Ideology* (London: Verso, 1989), pp. 176–7, provides this useful gloss on the negation of the negation and identity (which is also helpful with regard to reading what Rosenberg writes, TN, 32, about the American action painters' 'revolution against the given, in the self and in the world'): 'This is also, in a nutshell, the logic of the "negation of the negation"; this double, self-referential negation does not entail any kind of return to positive identity, any kind of abolition, of cancellation of the disruptive force of negativity, of reducing it to a passing moment in the self-mediating process of identity; in the "negation of the negation", the negativity preserves all its disruptive power; the whole point is just that we come to experience how this negative, disruptive power, menacing our identity is simultaneously a positive condition of it. The "negation of the negation" does not in any way abolish the antagonism, it consists only in the experience of the fact that this immanent limit which is preventing me from achieving my full identity with myself simultaneously enables me to achieve a minimum of positive consistency, however mutilated it is.

'This, then, is the "negation of the negation": not a kind of "superseding" of negativity but the experience of the fact that *the negativity as such has a positive function*, enables and structures our positive consistency. In simple negation, there is still the pre-given positive identity which is being negated, the movement of negativity is still conceived as the limitation of some pre-given positivity; while in the "negation of the negation", negativity is in a way *prior to what is being negated*, it is a negative movement which opens the very place where every positive identity can be situated.'

40 See David A. Hollinger, 'Ethnic Diversity, Comosopolitanism and the Emergence of the American Liberal Intelligentsia', *American Quarterly*, vol. XXVII, no. 2, May 1975, pp. 133–51, especially with reference to Rosenberg pp. 146–7. [. . .]

41 Harold Rosenberg, 'Tenth Street: A Geography of Modern Art', *Art News Annual*, XXVIII, 1959, pp. 120–37, 184, 186, 190, 192 reprinted with slight modifications in *Discovering the Present: Three Decades in Art, Culture, and Politics* (1973), pp. 100–9.

42 See DP, 104, 'Identical with rotting side streets in Chicago, Detroit, and Boston, Tenth Street is differentiated only by its encampment of artists. Here de Kooning's conception of "no environment" for the figures of his *Women* has been realised to the maximum with regard to himself.' According to Thomas B. Hess, *Willem de Kooning* (N.Y.: The Museum of Modern Art, 1968), pp. 78–9, the idea of 'no environment' was developed by de Kooning while he worked on *Woman I* (1950–52) to refer to

'the American urban scene and its lack of specificity . . . Everything has its own character, but its character has nothing to do with any particular place'. Rosenberg in *Willem de Kooning* (N.Y.: Abrams, 1973), p. 15, refers to de Kooning arriving 'at his concept of "no style"' as an aspect of 'the act of painting': 'Transient and imperfect as an episode in daily life, the act of painting achieves its form outside the patternings of style. It cuts across the history of art modes and appropriates to painting whatever images it attracts into its orbit. "No Style" painting is neither dependent upon forms of the past nor indifferent to them. It is transformal . . . ' Given that in 'The Fall of Paris', 1940, Rosenberg had discussed the Paris Modern as a 'No-Time' and the Paris 'International' as a 'No-Place' it seems likely that de Kooning developed the idea of 'no environment' from Rosenberg. That's to say, the idea was probably a resource which Rosenberg and de Kooning shared, and shared with other persons in their bit of the New York avant-garde artistic community, with John Cage, for example. As Richard Shiff points out in 'Performing an Appearance: On the Surface of Abstract Expressionism', *Abstract Expressionism, The Critical Developments*, edited by Michael Auping (Harry N. Abrams Inc. in association with the Albright-Knox Art Gallery, 1987), p. 121: n. 77, 'The concept "no style", indicating both emptiness and plentitude, might also be related to the teachings of Zen' – as, indeed, it was for Cage. [. . .]

43 Harold Rosenberg, 'The Pathos of the Proletariat', *The Kenyon Review*, vol. XI, no. 4, Autumn 1949, pp. 595–629, reprinted in *Act and the Actor* (1983), pp. 2–57.

44 Harold Rosenberg, 'The Resurrected Romans', *The Kenyon Review*, vol. XI, no. 4, Autumn 1948, pp. 602–20, reprinted in *The Tradition of the New* (1982), pp. 154–77.

45 Born in New York City in 1906, Rosenberg attended City College, 1923–24, Brooklyn Law School and graduated with a law degree from St Lawrence University in 1927.

46 Rosenberg is here rewriting that bit of Marx's third thesis on Feuerbach which goes: 'The coincidence of the changing of circumstances and of human activity or self-changing can be achieved and rationally understood only as revolutionary practice.' By 1933 the *political* reading would have become unavoidable.

47 Rosenberg has a note here: '*One effect of American indignation is to play down the difference in spiritual form of a nation with a past of immigration, pioneering and democratic revolts. The official American view is that America has culture, too; in other words, an inheritance like any other country. Yet American writers and artists know through experience that they cannot hope to define themselves as individuals so long as they follow European models in respect to the past, even a past of their own. *Moi, je suis barbare*, defiantly declared a character in one of Dostoyevsky's stories. It would be a gain for American consciousness if it, too, boldly accepted its predicament as a nation (aging) of "new men".'

48 On the place the United States held in Lenin's thinking, see *Lenin on the United States: Selected Writings by V. I. Lenin* (N.Y.: International Publishers, 1970). Trotsky's most extended discussion of the economy – and politics – of U.S. monopoly capitalism is to be found in the introduction to his book *The Living Thoughts of Karl Marx* (Philadelphia: D. M. McKay Co., 1939) which was published separately as *Marxism in the United States* (N.Y.: Workers Party Publications, 1947).

49 Rosenberg has a note here '*: In comparing the American and the proletariat we are thinking of them, of course, not as categories, where they overlap (since many Americans are wage workers), but as collective entities or types – the first actual, the second hypothetical.'

50 Rosenberg has a note here: '*Only "*half*" figuratively, since becoming Americans has been the actual salvation chosen by millions of workingmen from older nations. With the proletariat there is more to the impulse to become an American than the desire for economic opportunity, flight from oppression, etc. Primarily, it is a will to enter a world where the past no longer dominates, and where therefore that creature of the present, the workingman, can merge himself into the human whole. Thus proletarians immigrate to America in a different spirit from middle-class people or peasants, who from the moment they enter "American time" experience it is as something disconcerting and even immoral, and whose nostalgia for their homelands and customs is often communicated from one generation to the next. But America's thin time crust, that seems so desolate to immigrants of other classes, is precisely what satisfies the proletariat and has provided so many workers with the energy to become leaders of industry. Becoming an American is a kind of revolution for foreign proletarians, though it is a magical revolution rather than a revolutionary act. It alters the workingman's consciousness of himself; like a religious conversion it supplies him with a new identity. But this change does not extinguish his previous situation as a character in the capitalist drama; he is still in the realm of economic personifications. As an American, too, a social-economic role will be assigned to him: worker, farmer, capitalist. The elimination of these abstract types continues to call for a transformation of the historical "plot".'

51 James P. Cannon, 'Trotsky on the United States', *Internationalist Socialist Review*, Fall 1960, reprinted in *Leon Trotsky: The Man and His Work* (N.Y.: Merit Publishers, 1969), pp. 87–88, quotes this fragment from Trotsky's 'Europe and America', 1926, which is useful with regard to what I'm arguing here: 'In this "revolutionary Marxist critique of Americanism . . . we do not at all mean thereby to condemn Americanism, lock, stock, and barrel. We do not mean that we abjure to learn from Americans and Americanism whatever one can and should learn from them. We lack the technique of the Americans and their labor proficiency . . . to have Bolshevism shod in the American way – there is our task! . . . If we can get shod with mathematics, technology, if we Americanise our frail socialist industry, then we can with tenfold confidence say that the future is completely and decisively working in our favor. Americanised Bolshevism will crush and conquer imperialist Americanism".'

52 Robert Goodnough, 'Pollock paints a picture', photographs by Hans Namuth, *Art News*, vol. 50, no. 3, May 1951, pp. 38–41, 60–1.

53 See what Rosenberg wrote in his review of Bryan Robertson's *Jackson Pollock*, N.Y.: Abrams, 1961, with regard to Pollock or something Pollock may have said to him, 'The Search for Jackson Pollock', *Art News*, vol. 59, no. 10, February 1961, pp. 59–60: 'according to Robertson . . . "During a conversation in 1949 with Harold Rosenberg, Pollock talked of the supremacy of *the act of painting* as in itself a source of magic. An observer with extreme intelligence, Rosenberg immediately coined the new phrase: action painting". (Robertson's italics). The aim of this statement is obviously, to present Pollock as the originator of Action Painting in theory and in practice, if not in name . . . The statement is, of course, entirely false, and whoever informed Mr. Robertson that this conversation took place knew it was false. Pollock never spoke to Rosenberg about the "act of painting", of its "supremacy" (to what?) or of any "source of magic" in it. This can easily be demonstrated. The concept of Action Painting was first presented in the December, 1952, *ARTNews*, so that if the conversation described by Robertson had taken place in 1949 Rosenberg did not produce the phrase "immediately" but waited three years. It may have required that

much time for him to penetrate the depths of Pollock's observation, but in that case one would be justified in questioning his "extreme intelligence". On the other hand, Rosenberg had *published* writings on the subject of action as constitutive of identity as far back as 1932; in 1948, a year before the alleged tip-off, he further elaborated the topic in an essay in *The Kenyon Review* entitled "The Resurrected Romans", which may have had something to do with "magic" but nothing to do with Pollock or with painting. A conversation between Pollock and Rosenberg did occur in 1952, immediately preceding the composition of 'The American Action Painters' but in this talk Pollock said nothing about action. He spoke of identifying himself with a tree, a mode of self-stimulation not unknown in the tradition of which we have been speaking and more relevant to the paintings for which he is famous. He also attacked a fellow artist for working from sketches, which in Pollock's opinion, made the artist "Renaissance" and backward (this point was reported in the "Action Painters" essay, though without mentioning names). In the last years, Robertson informs us, Pollock liked to refer to the canvas he was working on as "the arena" – this term was garnered from "The American Action Painters", which says: "At a certain point the canvas began to appear to one American painter after another as an arena in which to act." Apparently, Pollock, or someone presently speaking for him, wished to acquire this thought for himself exclusively, although Rosenberg told Pollock, in the presence of a witness, that the article was not "about" him, even if he had played a part in it . . . '

Despite this the idea that Pollock was somehow the model for 'action painting' or provided Rosenberg with the idea, or that Namuth's photographs of Pollock at work did, persists. See, for example, the letters exchanged between Rosenberg and William Rubin in *Artforum*, April 1967, pp. 6–7 and, especially, May 1967, p. 4, correspondence concerning Rubin's 'Jackson Pollock and the Modern Tradition, Part I', *Artforum*, February 1967, pp. 14–22. See also Barbara Rose, 'Hans Namuth's Photographs and the Jackson Pollock Myth: Part One: Media Impact and the Failure of Criticism', *Arts Magazine*, vol. 53, no. 7, March 1979, pp. 112–19, especially pp. 112–13; and more recently Deborah Solomon, *Jackson Pollock: A Biography* (N.Y.: Simon and Schuster, 1987), p. 210, Ellen G. Landau, *Jackson Pollock* (N.Y.: Abrams, 1989), pp. 85–6, and Steven Naifeh and Gregory White Smith, *Jackson Pollock, An American Saga* (N.Y.: Clarkson N. Potter, 1989), pp. 703–7.

54　'An Interview with Robert Motherwell', *Artforum*, vol. IV, September 1965, p. 37: 'At that time, I was editing "Dada" proofs of Hulsenbeck's which ultimately appeared in the Dada anthology [*The Dada Painters and Poets: An Anthology*, edited by Robert Motherwell (N.Y.: Wittenborn, Schultz, Inc., 1951), pp. 22–48.] as 'En Avant Dada' . . . Harold came across the passage in proofs in which Hulsenbeck violently attacks literary esthetes, and says that literature should be action, should be made with a gun in the hand, etc.'

55　*Possibilities*, No. 1, Winter 1947–48, pp. 41–3. *The Dada Painters and Poets: An Anthology*, 1951, p. 28.

56　'An Interview with Robert Motherwell', *Artforum*, vol. IV, September 1965, p. 37.

57　On the internationalist 'business-liberals' and the old guard, 'America First', isolationists as fractions of the U.S. ruling class, see the books of G. William Domhoff, for example, *Who Rules America?* (Englewood Cliffs, N.J.: Prentice Hall, 1967), and *The Powers That Be: Processes of Ruling Class Domination in America* (N.Y.: Random House, 1978). In 'Revolution and the Idea of Beauty', *Encounter*, vol. I, no. 3, December 1953, pp. 65–8 (reprinted and revised as 'Revolution and the Concept

of Beauty' in *The Tradition of the New* (1982), pp. 74–83) Rosenberg discusses the use made of Modern Art by the likes of Representative George A. Dondero (Michigan) and Alfred H. Barr Jr. in 'Is Modern Art Communistic?', *New York Times Magazine*, December 14, 1952, pp. 22–3, 28–30. [. . .]

58 Which is not to say that there is not a political, aesthetic and moral purport to Action Painting as 'painting in the medium of difficulties'. See the note provided by Rosenberg. *The Tradition of the New* (McGraw-Hill paperback, 1965), and the subsequent reprints, TN, 33–34: 'As other art movements of our time have extracted from painting the element of structure or the element of tone and elevated it into their essence, Action Painting has extracted the element of decision inherent in all art in that the work is not finished at its beginning but has to be carried forward by an accumulation of 'right' gestures. In a word, Action Painting is the abstraction of the moral element in art; its mark is moral tension in detachment from moral or aesthetic certainties; and it judges itself morally in declaring that picture to be worthless which is not the incorporation of a genuine struggle, one which could at any point have been lost.'

59 For an interesting discussion of the indexical and iconical in Abstract Expressionism, see Richard Shiff, 'Performing an Appearance: On the Surface of Abstract Expressionism', *Abstract Expressionism, The Critical Developments* (1987), pp. 94–123.

60 See Richard Wollheim's account of Ur-painting in *Painting as an Art* (Princeton University Press, 1987), pp. 19–25, p. 359, n. 9.

61 Rosenberg has a note here: '*Razkolnikov, for example, in *Crime and Punishment* sought judgement so that his act would be completed and he could take on a new existence.'

62 Here I had in mind something of what Alasdair MacIntyre writes in his conclusion to *After Virtue, a study in moral theory* (University of Notre Dame Press, 1981), pp. 243–4. [. . .]

63 N. B. Harold Rosenberg and Robert Motherwell, 'Possibilities', *Possibilities*, no. 1, Winter 1947–48, p. 1: 'If one is to continue to paint or write as the political trap seems to close upon him He must perhaps have the extremist faith in sheer possibility.'

A. Deirdre Robson

THE MARKET FOR ABSTRACT
EXPRESSIONISM
The time lag between critical and commercial acceptance

THE IMMEDIATE POST-WORLD WAR II years are taken to be those that mark the emergence not only of the United States as a major world power but also of a new American artistic avant-garde, aggressively different in style and aesthetic from previous European modernism. Recently some attention has focused on how Abstract Expressionism came to critical prominence and on the political and cultural implications of this new avant-garde, due to the apparent congruence between an aesthetic that stressed individuality and vigour and the Cold War liberal ideology of the postwar Truman era, which equated these two characteristics with Western (American) democracy. However, within the context of this reappraisal of Abstract Expressionism and its increasing prominence, little attention has been focused upon this group's performance within the marketplace. Where this subject has been broached, there has been a tendency to equate critical and commercial acceptance. If this equation were true, then it would suggest that Abstract Expressionism achieved commercial success in the late 1940s. My contention is that this reading of the situation creates a distortion, predating such success by a number of years, and that only in the mid-1950s did one see any measurable public willingness to buy the work of Abstract Expressionists.

Such a misapprehension could be based upon a misunderstanding or incomplete reading of economic and cultural factors that indicate that the Abstract Expressionist artists could achieve market success in the 1940s. The early to mid-1940s were years of remarkable war-induced prosperity, with concomitant high levels of liquidity. Between 1942 and 1946, the Gross National Product of the United States rose sixty-six percent, the stock market was newly bouyant with share prices rising by eighty percent, personal income levels doubled for most sections of the population, and

Source: Archives of American Art Journal, vol. 25, no. 3, 1985, pp. 19–23. The original included five illustrations all of which have been omitted.

despite the introduction of a widely-based income tax system in 1942, levels of disposable income were exceptionally high.[1] This liquidity was accompanied, as a result of years of Depression and war-induced shortages, by a public hunger for consumer durables and luxury goods, and in the mid-1940s one sees a dramatic increase in spending on luxury goods (consumer durables still being unobtainable because of wartime controls on industry). This spending activity was reflected in the art world. In 1943 one auction house, Parke-Bernet, reported a gross for the previous season of $6.15 million – a considerable increase from the $2.5 million spent in 1940 – and the total annual value of such sales remained between $6 million and $6.5 million until 1946.[2] The year 1943 also saw the start of a reported boom for the commercial galleries on Fifty-Seventh Street with large increases in sales in successive seasons until, in 1946, they were three hundred percent higher than in 1940.[3] Also present at the time was a belief, propounded by sections of the media (and more particularly the art press), that there was a new, more widely-based middle-class public for contemporary art. This public was thought to be newly willing to concede respectability to American art and artists, largely as a result of the federal New Deal patronage of the 1930s, which had for the first time legitimized the fine arts as a profession in America. It was thought to have been familiarized with modern art by institutions such as the Museum of Modern Art (in New York) and to have overcome its prejudices against new expressions in art (a conclusion that was deemed to be proved by greatly increased museum attendance – at the Museum of Modern Art attendance rose from two hundred-nine thousand in 1936 to five hundred-eighty-five thousand in 1940).[4] This public was also encouraged to see that the purchase of art works was no longer the province solely of the very wealthy, particularly via national events such as the federally-sponsored 'Art Weeks' of 1940 and 1941 and through the efforts of commercial dealers who encouraged sales of modestly priced work both in their own galleries and in non-conventional venues such as department stores.[5]

The years 1943 to 1947, during which the future Abstract Expressionist artists (among them Baziotes, Hofmann, Motherwell, Pollock, and Rothko) were given their first exposure at Peggy Guggenheim's Art of This Century gallery, would seem to be auspicious for them, coinciding as they did with the war-induced boom. Prices fetched by major contemporary artists appeared healthy when one compares them to a national mean income of $2,800[6] – a major Picasso could cost $5,000, School of Paris painters such as Modigliani and Soutine generally fetched $1,000 to $5,000, while an established American such as Kuniyoshi was asking $3,000 for large works in the mid-1940s. Theoretically, there should have been another advantage for the proto-Abstract Expressionists in exhibiting at Art of This Century, shown as they were alongside major names in European modernism in the most discussed gallery in New York, something that should have favorably affected their sales. Indeed, their prices, ranging on average from $50 to $750, do seem higher than one might expect for new American artists – during the same period, and at the same stage in his career, Jack Levine was asking $100 to $500 at the Downtown Gallery, while in 1944 Stuart Davis could only get an average of $500 to $700 for large works, though his prices doubled in the following two years.[7]

But a closer examination of sales of proto-Abstract Expressionist work at Art of This Century shows that they were slow and that only rarely did any of these artists get anything close to the maximum asking price for any of their works. Only one

painting was sold from Pollock's first exhibition in 1943, *She Wolf* for $400, and during the time he was under contract to Guggenheim (from 1943 to 1947), Pollock's sales never equalled the value of his stipend. Baziotes's sales amounted to nearly $1,430 in the few years after his show in 1944, but only three Rothkos, totalling $265 in value, were sold after his exhibition in 1945. The highest price paid for a Pollock before 1947 was $740 in 1945, while the most paid for a Baziotes was $275 in 1946, for a Motherwell $225 in 1944, and for a Rothko, $120 in 1946.[8] In this situation Art of This Century was no different from the market for modern art as a whole, for despite increased museum attendance and the high total figures of art sales annually in the mid-1940s, sales of contemporary art accounted for only fifteen percent of all Fifty-Seventh Street profits.[9]

In the immediate postwar years, new galleries concerned with avant-garde American art (Betty Parsons, Samuel Kootz, and Charles Egan) opened, and the Abstract Expressionist artists began to receive wider exposure, increased critical coverage, and attention from museums. At the same time, their asking price levels rose gradually. At Samuel Kootz's gallery, from 1946 to 1948 the general price range for work by his Abstract Expressionist gallery artists (Baziotes, Hofmann, and Motherwell) was $100 to $950.[10] At Betty Parsons's gallery, Pollock's prices rose to $250–$3,000 by 1950, while Rothko's asking prices rose from $75–$400 in 1947 to $600–$3,000 in 1951.[11] It is this rise in prices that has led to the suggestion that the Abstract Expressionists were becoming commercially successful in the late 1940s, for it has been taken as indicative of an increased demand for their work on the part of collectors. But in arriving at this conclusion, two factors have been overlooked. First, there was a general inflation in art prices in the immediate postwar years. The increase mirrors the state of the general economy, for in the three years after the end of the war and with the deregulation of the wartime economy the cost of living in the United States rose by sixty percent. Among the Americans, Kuniyoshi's sale prices rose to $6,000 for large canvases, and Stuart Davis's to $1,000–$4,500 for similar works, while paintings by major School of Paris painters could fetch up to $15,000. Second, there has been an apparent failure to distinguish between *asking price* and *selling price* in noting rising prices for Abstract Expressionist work – and in practice the two can be quite dissimilar, particularly in the case of a new artist. In fact, Pollock rarely got more than $900 for any work he sold in the years he was with the Parsons Gallery (1947 to 1951). Among these were *Number 5*, 1948, for which he got $1,500, and *Number 1*, 1948, which sold for $2,350.[12] The highest price paid for a Rothko in the same period was $1,250, for *Number 10*, 1950 in 1951.[13]

The importance of inflation as a factor in the rise in asking price is reinforced by the knowledge that the art market as a whole was depressed during the late 1940s, with auction sales dropping below $6 million per annum, though the real fall was far greater because of the high inflation. Several dealers, including Edith Halpert of the Downtown Gallery and Betty Parsons, complain about how slow business was in these years.[14] Other galleries fared no better. For instance, the closure of the Kootz Gallery in 1948 was due to financial difficulties caused by commitments to gallery artists far outweighing the amount made in sales.[15] The sluggishness of the art market can be seen as part of the generally uncertain state of the economy (which went into a mild recession in 1948) and widespread lack of confidence about its

future. Matters did not markedly improve, either in a general economic sense or within the market for modern art, until after the Korean War (1951–1953), for though this conflict stimulated a boom, anticipation of it also generated the highest-ever single rise in the rate of inflation in late 1950. But the cessation of hostilities and the lifting of economic controls in 1953 was not followed by the inflationary spiral that characterized 1946. Instead, a short boom and recession sequence was followed in the mid-1950s by the first period of economic stability and business confidence, not distorted by war, for several decades. This change in economic climate and, more important, the increase in confidence that it generated eventually had a profound effect on the art market, and particularly for postwar American painting.

The first signs of Abstract Expressionist market success came soon after Pollock's death in 1956. Until the mid-1950s the market for modern art continued to be dominated by major European artists and some more established, older American painters. By 1955, a work by a modern 'old master' such as Matisse had been known to fetch $75,000, up to $45,000 was being asked for major examples by School of Paris painters, while artists such as Kandinsky, Klee, and Léger fetched $8,000 to $10,000. In the same year, Stuart Davis was asking $7,500 for large paintings, Ben Shahn had a waiting list on works at $3,500, while more established names such as Kuniyoshi and Hopper had active markets in the $4,500 to $7,500 price range. By 1955, only Pollock among the Abstract Expressionists had gotten more than $5,000 for any work: $6,000 in 1954 for One (Number 31, 1950) and $8,000 in 1955 for Blue Poles (Number 11, 1952).[16] Generally, until this date, top prices for any Abstract Expressionist work seem to have been no more than $2,000 to $3,000. In 1957, however, Pollock's Autumn Rhythm was sold to the Metropolitan Museum of Art for $30,000 – a painting that the Museum of Modern Art had been reluctant to buy for $8,000 before the artist's death.[17] This sale served as an important validation of Abstract Expressionism, for it was the first time that a major museum had bought a painting in this style for a price commensurate with what it might pay for a work by a major European artist. Although the sum paid was influenced by Pollock's death and thus was not directly applicable to the other artists working within this style, this sale set the ceiling price for Abstract Expressionist work for some years and helped to boost prices for the other artists. Where in 1953 $2,000 to $2,500 was being asked for a large de Kooning, in 1956 a similar work cost $7,500 to $8,500 and had nearly doubled again in price by 1959.[18] Between 1956 and 1958, Rothko's top prices rose to the region of $5,000, Hofmann's to $7,500, and those of Baziotes to $3,500. This rise in prices was accompanied by a sharp increase in the volume of sales, with a number of the Abstract Expressionist artists managing to sell out their exhibitions from 1956 onward, something that none had managed before this date.

In addition to the general economic circumstances already discussed that had some bearing on the market for modern art as a whole and for Abstract Expressionism in particular in the immediate postwar period, there are still other considerations that provide some clue as to why commercial success came to these artists in the mid-1950s and no sooner. On a financial level, where in the early to mid-1940s hopes were pinned on a newly-prosperous middle class as a prospective market for modern, and in particular American, art, those concerned overlooked the fact that in reality less than one percent of the population had sufficiently high incomes (at least $10,000 per annum in the latter half of the 1940s)[19] to enable them to buy more than

the occasional minor work of art. Thus, such purchases remained the province of if not solely the very wealthy then at least the most prosperous. This situation was exacerbated by the postwar economic uncertainties. It was not until 1956 that the purchasing power of income recovered to 1944 levels with the help of cuts in personal taxation in 1954. But of more significance were the attitudes of the newly prosperous toward the purchase of art. It remained a low priority and was, as a rule, bought only to satisfy purely decorative needs. There was a general reluctance to view such spending as an investment. In this the monied of the United States displayed a marked dissimilarity to their European counterparts, who, over many years of economic uncertainties, had come to regard art as an investment. For many years in the United States, only a few very wealthy collectors, concerned primarily with the established names of European modernism, were willing to spend large sums of money on art. Also of importance was the generation factor: collectors tend to be much of an age with the artists they collect. Few older collectors, including those known for their support of the more radical European modernism in the 1930s and early 1940s, were able to make the transition to the new American art. Only in the mid-1950s does one see a younger generation of collectors, seemingly better able to empathize with Abstract Expressionism, reach economic maturity.

It is these attitudes that have been overlooked when the ideological and nationalistic links between a new generation of entrepreneurs and Abstract Expressionism have been stressed, creating the mistaken presumption of the former's early appreciation of the latter. Instead, those entrepreneurs most interested in collecting American art per se, at least until the early to mid-1950s, appear to have been more concerned with earlier or more conservative work. A shift in attitudes on the part both of those already collecting and those with the money to do so had to be accomplished before Abstract Expressionism could become commercially successful. On one hand, collectors had to be reassured about the status of this new art by its linkage to European modernism – first by museum exhibitions and purchases that served to validate the new style; second by the juxtaposition of European and American Abstract Expressionist work in the same galleries (in this process Sidney Janis and Samuel Kootz were particularly important). On the other hand, to appeal to a new generation the style had to be strongly identified with the future and with American aspirations. The first process inevitably took some years to accomplish; the requisite shifts in prosperity and confidence that gave a stimulus to the second only occurred in the years immediately after the Korean War. Then, and only then, was Abstract Expressionism in a position to achieve commercial success.

Notes

This article is based on a paper delivered at the 'New Myths for Old: Redefining Abstract Expressionism' seminar, College Art Association Conference, New York, N.Y., February 1986.

1 For information about the postwar economy, see: Lester Chandler, *Inflation in the United States 1940–1948* (New York: Da Capo Press, Inc., 1976); Joseph P. Crockett, *The Federal Tax System in the United States* (Westport, Conn.: Greenwood Press,

1955); Herman P. Miller, *Income of the American People* (New York: Wiley, 1955); Harold G. Vatter, *The United States Economy in the 1950s* (Chicago: University of Chicago Press, 1985).

2 'Report on Auction Season,' *Art News* XLIII, 10: 21; 'Fifty-Seventh Street – a tight bottleneck for art . . . ' *Fortune* (September 1946): 145.

3 A. B. Louchheim, 'Who Buys What in the Picture Boom,' *Art News* XLIII, 9: 12–14, 23, 24; Louchheim, 'Second Season of the Picture Boom,' *Art News* XLIV, 10: 9–11, 26.

4 D. MacDonald, 'Profiles – Action on West Fifty-Third Street – II,' *The New Yorker* (12/19/53): 39, 42.

5 'Week of Weeks,' *Time* (9/12/40): 59: 'Art Week Commentary.' *Magazine of Art* 34.1; 42, 50–56; 'Art Week II,' *Magazine of Art* 34, 10: 534–535; *American Art Annual* XXXV (1938–1941): 17–18; Eugenia L. Whitridge, 'Trends in the Selling of Art,' *College Art Journal* III, 2:58–64.

6 Miller, p. 111.

7 Prices quoted in this article for European painters are from a variety of sources, including contemporary art periodicals, published auction prices, and various gallery and collectors' papers held by the Archives of American Art. Prices quoted for artists belonging to the Downtown Gallery were obtained from the Downtown Gallery Papers, microfilm rolls ND1–ND71, and unfilmed correspondence, Archives of American Art, Washington, D.C.

8 These figures are taken from the annual balance sheets of Art of This Century, 1942–1946. Photocopies of these are in the Bernard J. Reis Papers, Archives of American Art, Washington, D.C.

9 *Fortune*, p. 148.

10 Samuel Kootz Gallery Papers, microfilm rolls 1318–1321, Archives of American Art; Kootz to Alfred H. Barr, January 17, 1949, Alfred H. Barr Papers, Museum of Modern Art Archives, New York.

11 For Pollock records, see Betty Parsons Gallery Papers, Archives of American Art, Washington, D.C.; for Rothko, Betty Parsons Gallery Papers, microfilm rolls N68–62 to N68–74.

12 Barbara Harper Friedman in *Jackson Pollock: Energy Made Visible* (New York: McGraw-Hill, 1972) claims that *Lavender Mist (Number 1*, 1950) was sold for $1,500 on its exhibition in 1950, but no record of this sale appears in the Parsons Gallery Papers.

13 Betty Parsons Gallery Papers.

14 Edith Halpert in speeches given at Chicago (11/9/48) and Boston (n.d.), Edith Gregor Halpert Papers, microfilm roll 1883, Archives of American Art: Betty Parsons to F. C. Bartlett, October 10, 1947, and in typescript, November 30, 1965, both Betty Parsons Gallery Papers.

15 L. Levine. 'The Spring of '55,' *Arts Magazine* (April 1947): 34: Rosalind Bengelsdorf Browne, tape-recorded monologue on the relationship between Byron Browne and dealer Samuel Kootz, n.d.: Archives of American Art, Washington, D.C.

16 Sidney Janis interviewed by Paul Cummings, March 21–September 9, 1972, Archives of American Art: Friedman, pp. 198–199.

17 Janis, *ibid.*

18 *Ibid.*

19 Miller, pp. 16–26; Edith Gregor Halpert, 'Function of a Dealer,' *College Art Journal* (Fall 1949): 56.

Michael Kimmelman

REVISITING THE REVISIONISTS
The modern, its critics, and the Cold War

[. . .] Since the late 1960s, revisionist historians and critics have worked to shift the discussion of postwar American art away from the formalism of Alfred H. Barr, Jr., Michael Fried, Clement Greenberg, William Rubin, and others.' Critical of the notion of art as a hermetic practice, the revisionists have directed attention to the political, economic, and social circumstances in which this art was produced. In so doing, they have linked the critical reception and promotion of postwar American art to political ideology, relating the promotion of American art abroad to the Marshall Plan, for instance, or Greenberg's writings on Abstract Expressionism to Arthur Schlesinger, Jr.'s manifesto of anti-Communist and antifascist liberalism, *The Vital Center* (1949).[2]

If a single text signaled this shift in critical practice it was Max Kozloff's 'American Painting During the Cold War,' originally an introduction to an exhibition catalogue,[3] and published in a revised version in the May 1973 issue of *Artforum*, of which Kozloff was an editor [Chapter 6]. What, Kozloff asked, 'can be said of American painting since 1945 in the context of American political ideology, national self-images, and even the history of the country? Such a question has not been seriously raised by our criticism . . . '[4] Kozloff supplied his own answer, in the form of a mea culpa: 'Never for one moment did American art become a conscious mouthpiece for any agency as was, say, the Voice of America. But it did lend itself to be treated as a form of benevolent propaganda for foreign intelligentsia. Many critics, including this one, had a significant hand in that treatment. How fresh in memory even now is the belief that American art is the sole trustee of the avant-garde "spirit," a belief so reminiscent of the U.S. government's notion of itself as the lone guarantor of capitalist liberty.'[5]

After Kozloff's article, *Artforum* published other articles that addressed his

Source: *The Museum of Modern Art at Mid-Century, At Home and Abroad*, 'Studies in Modern Art 4', New York, MoMA, 1994, pp. 38–55. This text has been edited and footnotes renumbered. The original included ten illustrations all of which have been omitted.

question in different ways. The first was William Hauptman's 'The Suppression of Art in the McCarthy Decade,' in October 1973.[6] The second was Eva Cockroft's 'Abstract Expressionism, Weapon of the Cold War,' in June 1974 [Chapter 7].[7] [. . .]

Kozloff prepared the way for an analysis of the Modern's activities during the fifties, but it was Cockroft who did the job. In 'Abstract Expressionism, Weapon of the Cold War' she focused particularly on the International Council and on Nelson A. Rockefeller, concluding that 'Rockefeller, through Barr and others at the Museum his mother founded and family controlled, consciously used Abstract Expressionism, "the symbol of political freedom," for political ends.'[8]

'Throughout the early 1940's,' Cockroft wrote, 'MOMA engaged in a number of war-related programs which set the pattern for its later activities as a key institution in the cold war.'[9] Several high-placed officials at the Modern were, in Cockroft's view, government operatives who used the Museum to further their own agendas: They included Thomas W. Braden, who had served as Executive Secretary of the Modern in the late forties, before joining the Central Intelligence Agency (CIA) in 1950 to direct its cultural activities; René d'Harnoncourt, who had been head of the art section of Nelson Rockefeller's Office of the Coordinator of Inter-American Affairs (CIAA) in 1943, before joining the Museum in 1944; Porter McCray, who also had worked in the Coordinator's office, before becoming the Museum's Director of Circulating Exhibitions in 1947, and subsequently, its International Program; and, of course, Rockefeller himself.

'Freed from the kinds of pressure of unsubtle red-baiting and super-jingoism [that were] applied to official governmental agencies like the United States Information Agency,' Cockroft argues, 'CIA and MOMA cultural projects could provide the well-funded and more persuasive arguments and exhibits needed to sell the rest of the world on the benefits of life and art under capitalism. In the world of art, Abstract Expressionism constituted the ideal style for these propaganda activities.'[10] To this end, 'Willem de Kooning's work was included in the U.S. representation at the Venice Biennale as early as 1948. By 1950, he was joined by Arshile Gorky and Pollock. The U.S. representation at the Biennales [sic] in São Paulo beginning in 1951 averaged three Abstract Expressionists per show. They were also represented at international shows in Venezuela, India, Japan, etc. By 1956, a MOMA show called "Modern Art in the U.S.," including works by 12 Abstract Expressionists (Baziotes, Gorky, Guston, Hartigan, de Kooning, Kline, Motherwell, Pollock, Rothko, Stamos, Still, and Walker Tomlin) toured eight European cities, including Vienna and Belgrade.'[11] And so on, she wrote, culminating in the International Council's 'The New American Painting' of 1958–59, directed by Dorothy C. Miller and with a catalogue essay by Barr. An 'enlightened cold warrior,' like Braden and McCray, Barr became an enthusiast for the Abstract Expressionists, Cockroft proposes, because he grasped their political value (or, more precisely, the value of their apolitical stance, which she feels allowed their work to be more easily molded to fit a Cold War cause).[12]

Revisionist historians after Cockroft have essentially accepted her conclusion about the Modern and restated it in one form or another. David and Cecile Shapiro were among the first to follow her lead, in 'Abstract Expressionism: The Politics of Apolitical Painting,' published in the journal Prospects in 1977 [Chapter 9].[13] The rise of Abstract Expressionism, they hypothesize, must have come as a kind of salvation

to officials at the Modern: The Museum 'may now have been relieved to be helped off a hot spot, for it should not be forgotten that MOMA, like most American museums, was founded and funded by extremely rich private collectors, and MOMA was still actively supported by the Rockefellers, a clan as refulgent with money and power as American capitalism has produced.'[14] Thus, they contend, the Modern early on supported Abstract Expressionism: Witness its acquisition of Jackson Pollock's *She-Wolf* (1943) in 1944; its inclusion of Pollock in the 1944 national circulating show 'Twelve Contemporary American Painters,' and of Gorky and Robert Motherwell in the 1946 'Fourteen Americans.'[15] True, the Shapiros concede, the Modern also organized a retrospective of Ben Shahn in 1946 (the exhibition actually took place in 1947–48), but they imagine it did so reluctantly: The Museum never felt comfortable with Social Realism because that movement was 'programmatically critical of capitalism.'[16]

Serge Guilbaut has taken a similar tack in several of his writings. He delivered a first, glancing blow to the Museum in 1980, in an article for the journal *October*, 'The New Adventures of the Avant-Garde in America,' [Chapter 10] in which he blasts 'the imperialist machine of the Museum of Modern Art.'[17] Next came Guilbaut's book, *How New York Stole the Idea of Modern Art* (1983), which acknowledges Kozloff, Cockroft, and the Shapiros. Here, Guilbaut addressed the connections between Cold War rhetoric and the rhetoric surrounding the Abstract Expressionists in the years leading up to 1952. He contradicts himself in his descriptions of precisely what role the artists themselves played in making these connections, at one point writing that the Abstract Expressionist group 'forged an "American" image for itself, something that was becoming increasingly necessary for selling art in the United States.'[18] At other points he implies that the artists were passive and that the sheer ambiguity of Abstract Expressionist art allowed it to be easily appropriated by powerful forces: 'the avant-garde artist who categorically refused to participate in political discourse and tried to isolate himself by accentuating his individuality was coopted by liberalism, which viewed the artist's individualism as an excellent weapon with which to combat Soviet authoritarianism.'[19]

About the Modern itself, he reasserts the alliance Kozloff and others had drawn between the Museum and the USIA, and he points out, as did Cockroft, that during World War II the Modern 'served as a recreation center for soldiers, a symbol of free expression and a place to mount military exhibitions for propaganda purposes.'[20]

That is the extent of it for the Modern in *How New York Stole the Idea of Modern Art*. But in 'Postwar Painting Games: The Rough and the Slick,' an article he published in the 1990 anthology *Reconstructing Modernism*, which he also edited, Guilbaut elaborates.[21] He maintains that there was an 'important and successful push by the Museum of Modern Art between 1948 and 1950 to impose Abstract Expressionism as the most advanced and significant modern art in America . . .'[22] And he cites Barr's appeal in a letter to *Life* magazine's Henry Luce that Luce embrace Abstract Expressionism (Barr called the movement 'artistic free enterprise'), as well as Barr's 1952 article 'Is Modern Art Communistic?' in *The New York Times Magazine*.[23] Guilbaut connects Barr with Nelson Rockefeller, to whom he pays a compliment of sorts: He points out that Rockefeller, like Barr, objected to attacks against modernism from the right wing and compared them to those by the Nazis.[24]

Guilbaut concludes: 'Since 1950, one knew, thanks to the strenuous efforts of Alfred Barr, Nelson Rockefeller, and Thomas Hess, director [sic] of *Art News*, that modern art was in no way a Communist plot to destroy Western values. They had also done well in convincing most Americans that it was, in fact, a sign of freedom.'[25]

Guilbaut's assessment has become the standard view, recapitulated often. It appears, for example, in a catalogue for 'Constructing American Identity,' a 1991 exhibition organized by the Whitney Museum of American Art's Independent Study Program. The catalogue refers to the coordinated 'propaganda effort' involving 'The International Council at the Museum of Modern Art and the United States Information Agency's sponsorship of traveling exhibitions of Abstract Expressionism. The most notable [example] was "The New American Painting" . . . '[26] The introduction to the Whitney catalogue claims that the show was 'organized by The International Council . . . and sent abroad under the auspices of the . . . USIA.'[27] [. . .]

Were critics such as Cockroft accurate in their accounts of the Museum's activities? Contrary to what she wrote, de Kooning was not included in the 1948 Venice Biennale.[28] In 1950, he was represented in the Biennale by four works in a show of six artists that was ancillary to a John Marin retrospective comprising eighty-one works. Four years later, de Kooning was given a retrospective at the Biennale, as was Shahn.[29] The Modern did not, as Cockroft contended, take sole responsibility for the U.S. representation at the Biennales from 1954 through 1962: It ceded that task twice – to The Art Institute of Chicago (in 1956) and to The Baltimore Museum of Art (1960).[30] As for the São Paulo Bienal, the Modern put together only three of the U.S. exhibitions between 1953 and 1965 (in 1953, 1957, and 1961); others were organized by the San Francisco Museum of Modern Art (1955), the Walker Art Center (1963), the Minneapolis Institute (1959), and the Pasadena Art Museum (1965).[31] Abstract Expressionists were represented in the Bienal exhibitions organized by the Modern, but it is not at all self-evident that they were dominant. At the 1953 Bienal, for example, Alexander Calder was the main representative. And the 1955–56 'Modern Art in the United States,' which Cockroft claimed included a dozen Abstract Expressionists, had works by 112 artists in all.[32]

How is one to judge the meaning of such statistics, in any case? Is the number of participants or pictures a reliable guide to the character of an exhibition? What about the placement and size of the pictures? What about the language of the exhibition's promotional and educational materials? What about the extent to which the art may, or may not, have been selected and analyzed in ways indebted to Abstract Expressionist values?

One needs to know more about the big survey of 112 artists organized by Dorothy Miller, for example, which Cockroft cited. Did the Abstract Expressionists culminate a chronological progression, or did they constitute a critical mass that outnumbered any other cluster of artists? The evidence is ambiguous. In the catalogue for the exhibition's presentation in London, ten of the twenty-nine plates reproducing paintings are devoted to Abstract Expressionist works. Holger Cahill's text for the painting section is organized according to the following sequence of categories: The Eight; Early Moderns; The Armory Show; Americans Abroad; The

Return to the Object; Precisionism and the Industrial Theme; Painters of Social Content; The Second Wave of Abstraction; Realists, Romantics and Pure Painters; Geometric Abstraction; Abstract Expressionism (which included not twelve but fourteen artists – those mentioned by Cockroft, plus Richard Pousette-Dart and Mark Tobey); and as the culminating category, Folk Art (which included Patrocino Barela, Louis Michel Eilshemius, Morris Hirshfield, John Kane, José Dolores Lopez, Joseph Pickett, and Clara McDonald Williamson).

But photographs of the installation in London tell a somewhat different story from the catalogue. The painting section was divided into five parts, with modern 'primitives,' meaning folk artists, first, and contemporary abstraction last. It was succeeded by sections devoted to sculpture and then prints (which consisted mostly of works by now-forgotten figures like Walter Rogalski, Leona Pierce, and Misch Kohn). And the show's overall effect was to stress diversity in twentieth-century American art.

The reception of the show in London was described in an analysis by the Modern of the press reaction: 'Although abstract expressionism was certainly the most frequently discussed and controversial section of the exhibition, there was an overwhelming preference for the more realistic canvases.'[33] The analysis goes on: '"Christina's World" was undoubtedly the most popular painting in the exhibition among critics and public alike,' and there was considerable response, according to the Modern's analysis, to the social commentary in such major works in the show as Shahn's *Bartolomeo Vanzetti and Nicola Sacco* (1931–32), Blume's *The Eternal City* (1934–37), Levine's *The Feast of Pure Reason* (1937), and several of Hopper's paintings.

The reception of the inaugural version of the show in Paris, which had included works in even more mediums than would London's, was very different. Critics focused above all on the architecture section, which was regarded as 'the most original and esthetically satisfying form of art produced by the United States, and the one which dominated the other mediums'.[34] It was also the opening section of the exhibition. Photography and film were picked out for praise, too, and to a lesser degree, industrial design. Prints were written about more favorably than was either painting or sculpture, which were treated most dismissively. Some critics noted, unfavorably, that the painting section was weighted toward abstraction. Clearly, this exhibition did not have the effect of elevating American abstraction in the eyes of French critics. To the contrary: The 'primitives' were given sympathetic treatment among the painters, and between painting and sculpture, the latter was preferred. The spirit of the coverage was altogether against Abstract Expressionism and toward other forms of American culture. André Chastel summed it up in his review in *Le Monde* (January 17, 1959): 'It becomes apparent that the two arts in which the United States reveals itself most forcefully are architecture and photography, and after that, of course, film.'[35]

How, then, is one to judge, from the evidence of this exhibition, the extent to which the Modern pushed Abstract Expressionism?

And who were the Abstract Expressionists? Not all of those listed as Abstract Expressionists in the Miller show would now be regarded as such. Would the inclusion of Bradley Walker Tomlin make Calder or Stuart Davis look more like one of them? Throughout the forties, there was little agreement about whether a new

school of painting had come into existence, much less what constituted membership in it. As Michael Leja has pointed out, the problem for critics and dealers was 'to articulate for the purported group a platform that was powerful and specific and yet managed to conceal ideological and aesthetic diversity. For their part, the artists refused to accept the distortions involved in the process of producing a common denominator.'[36] A consensus began to form by the fifties, but it remained contested by artists and critics alike, and it would not have been obvious to everyone precisely who was an Abstract Expressionist.[37]

Finally, there is the issue of the institutional character of a museum which, like every such big organization, has multiple, often competing viewpoints among its curators. How were individual choices politically and bureaucratically conditioned? What is clear is that the artists selected for the Modern's circulating shows varied with the curator in charge: Ritchie and Miller – along with Robert Beverly Hale of the Metropolitan, Lloyd Goodrich of the Whitney, and John I. H. Baur of The Brooklyn Museum – selected the works for the painting and sculpture section of the first Bienal in São Paulo in 1951; their list included thirty-two painters and sixteen sculptors (of whom six painters and three sculptors are today widely considered to be Abstract Expressionists[38]). Ritchie's 1955 'International Exhibition of Painters Under 35,' which toured Europe, included Richard Diebenkorn, Seymour Drumlevitch, Joseph Glasco, John Hultberg, Irving Kreisberg, and Theodoros Stamos. Frank O'Hara's choice for the 1957 São Paulo Bienal comprised paintings by James Brooks, Philip Guston, Grace Hartigan, Franz Kline, and Larry Rivers; sculpture by David Hare, Ibram Lassaw, and Seymour Lipton; and a Pollock retrospective.

The story of the inspiration for 'The New American Painting,' of 1958–59, needs elucidating. The International Program was established in 1952; the next year it sent to Europe '12 Modern American Painters and Sculptors,' which included a mix of artists (chosen by Ritchie): Ivan Le Lorraine Albright, Calder, Davis, Gorky, Morris Graves, Hopper, Kane, Marin, Pollock, Theodore Roszak, Shahn, and David Smith. Along with 'Modern Art in the United States,' it prompted museum officials in Amsterdam, Berlin, Brussels, and Milan to request that the Modern organize a show specifically devoted to 'our most avant-garde American painters and sculptors,' as Porter McCray wrote in a 1956 confidential memorandum to René d'Harnoncourt.[39] McCray continues: 'Especially in view of the USIA's present orientation and the probability that exhibitions assembled under its auspices may become increasingly conservative, it seems that The Museum of Modern Art is the only institution likely to organize this kind of representation for showing abroad and our obligation to do so is thereby all the greater.' D'Harnoncourt's foreword to the American catalogue reiterates McCray's memorandum: '*The New American Painting* was organized at the request of European institutions . . .'[40]

Whether or not individuals at the USIA privately wanted to push Abstract Expressionism, the reality of the McCarthy era was that the agency could not coorganize an exhibition of such vanguard art, although in certain European cities the offices of the United States Information Service (USIS, a division of the USIA) could assist with local publicity and transportation costs. In fact, the only time the USIS is mentioned in a catalogue for 'The New American Painting' is in that for the London showing, where it is credited with a donation towards British catalogue costs. Shows like 'The Family of Man' and 'Built in the U.S.A. – Postwar

Architecture' were something else: The USIA shared responsibility for the circula-
tion of these exhibitions abroad. But to link as one the USIA and the International
Council, as some have done, is a generalization that simplifies the byzantine cultural
politics of the era.

Clearly, exhibitions sent abroad, like 'The New American Painting,' partici-
pated in a cultural campaign to fight Communism. D'Harnoncourt was entirely
open about aiding this campaign, as were virtually all museum directors at the time.
From the perspective of the early seventies, in the midst of the Vietnam War, such a
campaign may have seemed to critics like Kozloff and Cockroft to be as objection-
able as the covert bombing of Cambodia. But during the fifties, d'Harnoncourt was
one museum official among dozens who openly lobbied Congress to finance this
campaign.

During the late forties, requests by foreign institutions for shows of contempor-
ary American art and architecture were regularly presented to the Modern via the
State Department.[41] D'Harnoncourt, Ritchie, and others served on a committee in
1948 that recommended more government involvement to promote shows abroad,
a plan endorsed by numerous U.S. museums. In 1951, officials from The Brooklyn
Museum, The Cooper Union for the Advancement of Science and Art, the Morgan
Library, the New-York Historical Society, the American Museum of Natural
History, and other New York institutions convened at the Modern to discuss joint
projects with the United Nations Educational, Scientific, and Cultural Organization
(UNESCO).[42]

A series of bills was presented to Congress during the fifties, like the one that
Representative Frank Thompson of New Jersey proposed in 1955 'to establish a
program of cultural interchanges with foreign countries to meet the challenge of
competitive coexistence with communism.'[43] Thompson wrote to d'Harnoncourt:
'The ultimate outcome of the struggle between the totalitarian and free worlds will
be decided by ideas.'[44] D'Harnoncourt's abiding concern, however, was that in
undertaking cultural interchanges, the U.S. government not censor its own artists,
as it had been doing to suspected Communist sympathizers, under pressure from
redbaiting representatives like Representative George A. Dondero of Michigan[45] and
others. (D'Harnoncourt joined the Advisory Panel of the National Council on
Freedom from Censorship in 1956 to protest the exclusion of Yasuo Kuniyoshi,
Shahn, and others from the USIA exhibition 'Sport in Art' because of the supposed
political leanings of these artists.[46])

The leap that The Museum of Modern Art's critics have taken is to link the anti-
Communist cultural campaign with an embrace by the Museum of Abstract Expres-
sionism. The Museum's acquisitions and roster of exhibitions during the fifties
suggest at the least a more complex story. In fact, the Modern would seem to have
been slow to take up Abstract Expressionism's cause. Its circulating shows stressed
European masters, as did shows at the Museum. Take, for example, 1950. The
Modern presented nine loan exhibitions of painting and sculpture: one on the
Percival Goodman War Memorial Model; others on Charles Demuth, Edvard
Munch, Chaim Soutine, and Franklin C. Watkins; two New Talent surveys in the
penthouse that included the work of Louis Bunce, Drumlevitch, Ynez Johnston,
William D. King, Ernest Mundt, and Raymond Parker; and two group shows, one a
historical survey of works from Art Nouveau through organic abstraction, the other

a selection of recent sculpture that included eleven artists, of whom only three – Hare, Roszak, and Smith – could even distantly be linked with Abstract Expressionism. In 1954, the exhibition roster was 'Ancient Arts of the Andes,' 'Japanese Calligraphy,' and exhibitions of works by Jacques Lipchitz, Niles Spencer, and Edouard Vuillard.[47]

Occasionally, there were exhibitions that included Abstract Expressionists, like Ritchie's 1951 show and Miller's 1952 '15 Americans,' which included Pollock. But not until 1956–57 did the Modern organize in New York a one-person retrospective of an Abstract Expressionist, a posthumous one for Pollock, organized by Sam Hunter. With the exception of this and another show organized by Hunter in 1957, devoted to David Smith, the only other specifically New York School exhibition in New York was 'The New American Painting' (subtitled 'As Shown in 8 European Countries 1958–59) in 1959. This raises a point that historians and critics have minimized: The Modern's exhibitions of Abstract Expressionism, more so at home but also abroad, came on the whole only during the later fifties, by which time the movement's first generation had already been followed by a second (by 1958, Jasper Johns was in the Venice Biennale). The Museum's promotion of its 1958–59 touring Pollock retrospective and 'The New American Painting' was skillful and effective, though hardly flawless, in persuading Europeans to take the Abstract Expressionists seriously. But these were relatively isolated shows and late undertakings in a wide-ranging program of exhibitions that had been conspicuous, if for anything, for its reticence toward the New York School.

So it seemed at the time, at least. Thomas Hess complained in a 1954 editorial in Art News, where he was executive editor, about the Museum's 'baffling lack of recognition of postwar American abstract painting and sculpture,' a failing 'prevented from becoming a scandal' only by 'Dorothy Miller's exhibitions of American artists in 1946 and 1952.'[48] In a 1957 editorial in the magazine's fifty-fifth anniversary issue, he wrote that matters had improved, but only somewhat since 1952,[49] provoking a response from Barr in the form of a letter to the editor.[50] Barr took issue with Art News's own record of support for the Abstract Expressionists. He pointed out that before 1952 the Modern had exhibited examples of Gorky's art in 1930, 1936, 1938, and 1946 (ten works in 'Fourteen Americans'), and had bought paintings of his in 1941, 1942, and 1950. He noted that an Art News critic had dismissed the works in 'Fourteen Americans' as 'decorative meanderings.' By 1952, 'at least sixteen paintings by Tomlin, Motherwell, Pollock, Baziotes, Gorky and de Kooning had been acquired by four trustees of the Museum,' Barr wrote. He cited a 1949 show of the Modern's American painting collection that grouped William Baziotes, Gorky, de Kooning, Motherwell, Pollock, and several others 'as the climax of the exhibition, a gesture made with enthusiasm and conviction . . . '[51] Again taking a swipe at Art News, Barr added that the magazine had failed to mention Pollock's Number 1, 1948 and Gorky's Agony (1947), both owned by the Modern, in its deliberations on the most important modern American paintings acquired by an American public collection in 1950. Instead, it cited a Shahn. That same year, the magazine had named Shahn, Balthus, Blume, Lee Gatch, and Jean Arp as the five artists with the best one-person shows of the year.

He concluded: 'The Museum's record is far from perfect. Sometimes it was handicapped by lack of money, always by lack of time and space; occasionally it was

retarded by differences of opinion, more often, I know, by lack of vision. Further-more – *pace* the partisans – the Museum has not, and I hope will not, commit it-self entirely to one faction . . . Some of the Museum's friends have questioned this policy, urging that the Museum align itself exclusively with the current avant-garde. Its bitterest enemies insist that the Museum has already done exactly that.'[51] Clearly, the Modern's record regarding the Abstract Expressionists was a matter of lively debate during the fifties. The figures regarding acquisitions and exhibitions do not, in any case, simply speak for themselves, as Barr implied. If the Modern was early in buying works of Pollock, and if it did buy a de Kooning as early as 1948 – which Barr pointed out – and if it did show Baziotes, Gorky, de Kooning, Motherwell, and Pollock, in 1949, a perusal of the dates of acquisition in Barr's *Painting and Sculpture in The Museum of Modern Art, 1929–1967* reveals that it acquired as many works by Lucian Freud as by de Kooning throughout the fifties; as many by Eduardo Paolozzi as by Smith; and as many by Reg Butler as by Baziotes, Kline, Barnett Newman, and Tobey combined. [. . .]

About the eventual embrace of Abstract Expressionism by the Modern, self-evident by the time the revisionists began to write, there can be no doubt. In the general sense that there developed a link between the fortunes of that art and those of the institution, the revisionist argument is clear. But many of the particulars of that argument – and the statistical and historical assumptions underlying it – simply do not bear up under the weight of the historical evidence.[53]

Notes

I am indebted to Amy Zorn for collaborating with me on the research and preparation of this article, and to the anonymous reader. I hope to have addressed, and in some cases incorporated, a few of his or her concerns.

1 The publication in 1970 of Irving Sandler's *The Triumph of American Painting: A History of Abstract Expressionism* (New York: Harper & Row; Praeger, 1970) was perhaps the single publishing event that most galvanized the revisionists.

2 Arthur Schlesinger, Jr., *The Vital Center: The Politics of Freedom* (1949; Cambridge, Mass.: Riverside Press, 1962; rpt. New York: Da Capo Press, 1988).

3 'Twenty-five Years of American Painting 1948–1973,' organized by James T. Demetrion for the Des Moines Art Center, March 6–April 22, 1973.

4 Max Kozloff, 'American Painting During the Cold War,' *Artforum* 11 (May 1973), pp. 43–54. The quotation appears on p. 43. Reprinted in Francis Frascina, ed., *Pollock and After: The Critical Debate* (New York: Harper & Row, 1985), pp. 107–23.

5 Ibid., p. 44.

6 William Hauptman, 'The Suppression of Art in the McCarthy Decade,' *Artforum* 12 (October 1973), pp. 48–52.

7 Eva Cockroft, 'Abstract Expressionism, Weapon of the Cold War,' *Artforum* 12 (June 1974), pp. 39–41. Reprinted in Frascina, ed., *Pollock and After*, pp. 125–33.

8 Cockroft, 'Abstract Expressionism, Weapon of the Cold War,' p. 41.

9 Ibid., p. 39.

10 Ibid., p. 40.

11 Ibid. An extended discussion of 'Modern Art in the United States,' organized by Dorothy C. Miller, follows in the body of this article.

12 Ibid., p. 41.

13 David and Cecile Shapiro, 'Abstract Expressionism: The Politics of Apolitical Painting,' *Prospects*, no. 3 (1977), pp. 175–214. Reprinted in Frascina, ed., *Pollock and After*, pp. 135–51. Frascina provides an excellent, sanguine introduction (pp. 91–106) to this as well as to Kozloffs and Cockroft's articles, and to the entire shift in critical practice that occurred around 1970.

14 Frascina, ed., *Pollock and After*, p. 147. The 'hot spot' the Shapiros referred to was evidently the necessity of supporting openly left-wing artists like Ben Shahn in order to endorse leading-edge art.

15 Ibid., p. 142.

16 Ibid., p. 147.

17 Serge Guilbaut, 'The New Adventures of the Avant-Garde in America,' *October*, no. 15 (Winter 1980), pp. 61–78. The quotation appears on p. 77.

18 Serge Guilbaut, *How New York Stole the Idea of Modern Art: Abstract Expressionism, Freedom, and the Cold War* (Chicago and London: University of Chicago Press, 1983), p. 121.

19 Ibid., p. 143.

20 Ibid., p. 88. The Modern held a poster competition, 'Posters for National Defense,' in the spring of 1941, around the same time it presented an exhibition called 'Britain at War.' After the bombing of Pearl Harbor in December 1941, the Museum stepped up its war-related activities considerably. It began, under the leadership of James Thrall Soby, the Armed Services Program, which Russell Lynes described as 'partly therapy, partly exhibitions, partly morale-sustaining, and partly making the Museum's facilities and talents available to Nelson Rockefeller and his Office of Inter-American Affairs.' In addition to organizing numerous exhibitions related to the war (many sent by Rockefeller's office to Latin America), the Museum supplied art materials to military camps. It held garden parties for soldiers and sailors, and a canteen was installed in the garden, where, under the aegis of the Salvation Army, women from the Junior League sold coffee, sandwiches, and doughnuts to service-men and their friends (the canteen was not open to the public). See Russell Lynes, *Good Old Modern: An Intimate Portrait of the Museum of Modern Art* (New York: Atheneum, 1973), pp. 233–38.

21 Serge Guilbaut, 'Postwar Painting Games: The Rough and the Slick,' in Guilbaut, ed., *Reconstructing Modernism: Art in New York, Paris, and Montreal 1945–1964* (London and Cambridge, Mass.: MIT Press, 1990), pp. 30–84.

22 Ibid., p. 32.

23 Ibid., p. 35. Barr's article (published in *The New York Times Magazine* of December 14, 1952) is mentioned on p. 75, n. 8. It is reprinted in *Defining Modern Art: Selected Writings of Alfred H. Barr, Jr.*, ed. Irving Sandler and Amy Newman (New York: Abrams, 1986), pp. 214–19. The article was written in response to an assertion by Harry S. Truman that modern art was, in fact, 'Communistic.' See also Lynn Zelevansky, 'Dorothy Miller's "Americans," 1942–1963,' *The Museum of Modern Art at Mid-Century: At Home and Abroad* (New York: MoMA, 1994) pp. 86–91.

24 Ibid., p. 34.

25 Ibid., p. 67.

26 Elizabeth Bigham and Andrew Perchuk, 'American Identity/American Art,' in

Constructing American Identity (New York: Whitney Museum of American Art, 1991), p. 11.

27 Eric Miles, Introduction to *Constructing American Identity*, p. 2. A clarification of the USIS's involvement in 'The New American Painting' follows in the body of this article.

28 Cockroft, 'Abstract Expressionism, Weapon of the Cold War,' p. 40. Cockroft may have made this mistake by copying it from the Modern's catalogue for 'The New American Painting.' The exhibition history for de Kooning (p. 92 of the catalogue for the version of the show installed at the Modern, a reprint of the catalogue used for The Tate Gallery's presentation) lists the 1948 Venice Biennale under group shows. For the correct information, see Philip Rylands and Enzo di Martino, *Flying the Flag for Art: The United States and The Venice Biennale, 1895–1991* (Richmond, Va.: Wyldbore Wolferstan, 1993), pp. 277–79. See also Paolo Rizzi and Enzo di Martino, *Storia della Biennale: 1895–1982* (Milan: Electa, 1982), p. 97.

29 See Frances K. Pohl, 'An American in Venice: Ben Shahn and United States Foreign Policy at the 1954 Venice Biennale,' *Art History* 4 (March 1981), pp. 80–113.

30 In 1954, the Modern, with the support of the International Program and a grant from the Rockefeller Brothers Fund, bought the U.S. Pavilion from the Grand Central Art Galleries, which had built it in 1930. It was the only pavilion not owned by its nation's government. While it meant that the Modern paid the bills for upkeep, it did not mean that the Museum took control of all the shows installed in the pavilion. Beforehand, the Modern had been involved in the 1950 show, jointly organizing it with The Cleveland Museum of Art. In 1952, David E. Finley, Director of the National Gallery of Art and Chairman of the National Commission of Fine Arts, asked the American Federation of Arts to select the artists and arrange the exhibition. In 1954, the first year of the Modern's ownership, the Museum took sole responsibility and organized the Shahn and de Kooning twin bill. In 1956, The Art Institute of Chicago assumed control of the exhibition. In 1958, control reverted to the Modern. In 1960, it was Baltimore. In 1962, it was again the Modern. And after that, the Museum gave over responsibility to the USIA, which in 1964 asked The Jewish Museum to organize the show featuring Robert Rauschenberg that would become perhaps the most famous American presentation ever at the Biennale. See Rylands and di Martino, *Flying the Flag for Art*, pp. 101–45.

31 In November 1950, the Modern signed an agreement of cooperation with the Museu de Art Moderna of São Paulo, under which the Modern organized the United States' entries to the Bienal in 1951, 1953, and 1957 and helped provide support for the other museums that oversaw the U.S. representation at the Bienal during the mid- and late fifties. Ibid., p. 109. The selection of the U.S. representation at the 1951 and 1957 Bienals is discussed later in this essay.

32 Cockroft, 'Abstract Expressionism, Weapon of the Cold War,' p. 40 (writing about 'Modern Art in the United States'). Cockroft does not provide sources for any of her figures. The show began at the Musée National d'Art Moderne, Paris, in 1955, as '50 Ans d'Art aux Etats-Unis: Collections du Museum of Modern Art de New York,' a survey of several hundred paintings, sculptures, prints, photographs, films, industrial design objects, and architectural models. The painting and sculpture sections (selected by Dorothy Miller) and the print section (selected by William S. Lieberman) were shown in seven other European cities in 1955–56 as 'Modern Art in the United States: A Selection from the Collections of the Museum of Modern Art,' and consisted of a total of 112 artists, including Charles Burchfield, Charles

Demuth, Arthur Dove, Lyonel Feininger, Marsden Hartley, Edward Hopper, Jack Levine, Maurice Prendergast, Ben Shahn, Joseph Stella, Florine Stettheimer, Max Weber, and Andrew Wyeth, among many others. At several of these venues, one or more additional curatorial departments were represented as well. A more detailed discussion of the show immediately follows in the body of this essay.

33 'Press Analysis' of 'Modern Art in the United States: London,' May 1, 1956, p. 10. The Museum of Modern Art Archives: International Council/International Program Exhibition Records (ICE-F-24–54; London): Box II.1. The analysis, like the accompanying one for the showing in Paris (*see* n. 34 below), contains numerous and extended excerpts from many articles written about the exhibition.

34 'Press Analysis' of '50 Ans d'Art aux Etats-Unis,' May 1, 1956, p. 11. The Museum of Modern Art Archives: IC/IP Exh. Records (ICE-F-24–54; Paris): Box II.1.

35 Ibid., p. 10.

36 Michael Leja, *Reframing Abstract Expressionism: Subjectivity and Painting in the 1940s* (New Haven, Conn.: Yale University Press, 1993), p. 47.

37 As with all of the questions posed in these paragraphs, the point is not to rebut specifically the revisionist argument – in this case the membership of certain artists in this school as Cockroft and others might have defined it – but to suggest that an analysis of the school's identity more subtle than any that has yet been put forward may yield a more complex understanding of the Modern's role in promoting that school.

38 The painters were William Baziotes, Willem de Kooning, Jackson Pollock, Mark Rorhko, Mark Tobey, and Bradley Walker Tomlin. Sculptors were David Hare, Theodore Roszak, and David Smith. MoMA press release no. 21, March 25, 1955. Department of Public Information, The Museum of Modern Art.

39 McCray's June 11, 1956, memorandum cites specific requests 'from Berlin, . . . the Stedelijk Museum at Amsterdam, . . . the Palais des Beaux Arts at Brussels, . . . and the Galleria d'Arte Moderna at Milan . . . ' The Museum of Modern Art Archives: Dorothy C. Miller Papers, I.14.f.

In 1957, Arnold Rüdlinger, of the Kunsthalle, Basel, traveled to the United States with a proposal for a similar exhibition, which he had previously discussed with directors of various European museums, including the Palais des Beaux-Arts, Brussels. On learning of the Modern's plans, he deferred to its initiative. See Robert Giron, letter to McCray, April 2, 1957. The Museum of Modern Art Archives: IC/IP Exh. Records (ICE-F-36–57; Brussels): Box 23.II.

40 *The New American Painting: As Shown in 8 European Countries, 1958–1959* (New York: The Museum of Modern Art, 1959), p. 5.

41 The Museum of Modern Art Archives: René d'Harnoncourt Papers [AAA: 2928, 250f; 2928, 147f].

42 The Museum of Modern Art Archives: D'Harnoncourt Papers [AAA: 2924; 1107].

43 House of Representatives Bill No. 6874; see also bills regarding cultural freedom of expression and foreign competitiveness through cultural programs: H. R. Bill Nos. 4913, 5756, 6713, 5040.

44 Thompson to d'Harnoncourt, November 7, 1955. The Museum of Modern Art Archives: D'Harnoncourt Papers [AAA: 2924; 974].

45 Representative George A. Dondero of Michigan in a speech before the House of Representatives, August 16, 1949: 'Modern Art Shackled to Communism,' in *Congressional Record: Proceedings and Debates of the 81st Congress, First Session* (4 pp.)

46 The Museum of Modern Art Archives: D'Harnoncourt Papers [AAA: 2924;

234–36]. D'Harnoncourt's support of Shahn and Kuniyoshi on political grounds, like the sponsorship of Shahn at the 1954 Venice Biennale, is obviously contrary to the assertion by the Shapiros that the Modern was reluctant to throw its weight behind such artists. If anything, it suggests, as Barr often contended, that the Museum wished above all to be an institution of catholic taste, unallied to any one particular school of art. A press release concerning the 1956 Venice Biennale refers to the 1954 show in a way that implies this posture of equanimity: 'At the XXVII Biennale in 1954, the Museum presented an exhibition of work by 2 painters of widely contrasting tendencies, Willem de Kooning and Ben Shahn. Three sculptors, Gaston Lachaise, Ibram Lassaw and David Smith, were each represented by a major work. Ben Shahn won the hightest purchase prize awarded by the international jury' (July 8, 1956).

47 One more example: In 1955, the loan shows of painting and sculpture included an exhibition of nineteenth-century paintings from France; a New Talent show featuring Tom Benrimo, Hugh Townley, and Richard O. Tyler; 'The New Decade: 22 European Painters and Sculptors,' a show of paintings from private collections; exhibitions of Giorgio de Chirico and Yves Tanguy; and a second New Talent show, with works by Martin Craig, Leander Fornas, and Nora Speyer.

48 Thomas B. Hess, 'Eros and Agape Midtown,' *Art News 53* (November 1954), p. 17. This quotation appears in Barr's letter to the editor, *Art News 56* (September 1957), p. 6 (see n. 50 below).

49 Thomas B. Hess, 'Fifty-fifth Anniversary,' *Art News 56* (Summer 1957), p. 27.

50 Alfred H. Barr, Jr., letter to the editor, *Art News 56* (September 1957), p. 6, 57. Reprinted as 'The Museum of Modern Art's Record on American Artists,' in *Defining Modern Art*, ed. Sandler and Newman, pp. 226–29.

51 Ibid., p. 228.

52 Ibid., p. 229.

53 This is to take issue with T. J. Clark's remark in a recent issue of *October* about the certitude of the revisionist argument, if not with the gist of his feeling about 'an impasse': 'There has been a feeling in the air for some time now that writing on Abstract Expressionism has reached an impasse. The various research programs that only yesterday seemed on the verge of delivering new and strong accounts of it, and speaking to its place (maybe even its function) in the world fiction called America, have run into the sand. Those who believed that the answer to the latter kind of question would emerge from a history of Abstract Expressionism's belonging to a certain Cold War polity, with patrons and art world institutions to match, have proved their point and offended all the right people. But the story, though good and necessary, [has] turned out not to have the sort of upshot for interpretation that the storytellers had been hoping for' (Clark, 'In Defense of Abstract Expressionism,' *October*, no. 69 [Summer 1994], pp. 23–48; the quotation appears on p. 26).

Ann Eden Gibson

ABSTRACT EXPRESSIONISM
Other Politics

A S THE MYTH of Abstract Expressionism developed from the late forties through the fifties, it established the reputations of artists such as Jackson Pollock, Willem de Kooning, Robert Motherwell, Mark Rothko, and others. A rebellious movement, it aimed not only to revolutionize representation by superceding America's regionalism, realism, and recognizably national styles like French Cubism, but in doing so also to oppose America's isolationism, imperialism, and ethnocentrism.[1] In its redefinition of styles and themes, however, Abstract Expressionism also neatly invalidated the products of those who were not among America's most powerful persons: white heterosexual males. Artists who were thus privileged discredited or appropriated aesthetic strategies that paralleled experiences (such as masking, maternalism, and social invisibility) more familiar to blacks, to women, to gays, and to lesbians. As an 'other' to more academically naturalistic styles (regionalism, social realism) or abstract but 'foreign' modes of art (French Cubism, German Expressionism, French and Spanish Surrealism, Dutch Neoplasticism), however, Abstract Expressionism claimed for itself the mantle of marginality, mustering social strategies and aesthetic procedures that might otherwise have been used by blacks, women, and other disenfranchised groups to affirm their difference. The story of Abstract Expressionism as it has been written is a classic American tale of the triumph of the outsider: Conventionally, the narrative recounts the personal, economic, and professional trials of a small group of resolute bohemians and intellectuals as they struggled against impressive odds to occupy a central position in the international art world.[2]

By 1980, art historians had begun to broaden this picture, stressing the breadth and historical context of Abstract Expressionist subject matter and emphasizing the canonical Abstract Expressionists' interest in and identification with the feminine

Source: 'Introduction', *Abstract Expressionism: Other Politics*, New Haven and London, Yale University Press, 1997, pp. xix-xxxviii, 192–97. This text has been edited and footnotes renumbered. The original included one illustration, which has been omitted.

and with Native American and non-Western cultures.³ Still, few historians have written about the *effect* these artists' incorporation of 'others' into their own work and personas had on the definition of who could produce 'Abstract Expressionism' or how that definition deflected attention from contemporary artistic production by those of other cultures and their descendants in the United States. The Abstract Expressionist rhetoric of presence was defined through resistance to language, methods designed to convey that the art they made corresponded to the thoroughness of their convictions, redemption of the decorative through monumentalization, the employment of feminine sexuality as transgressive, and the polyphony of multiple meanings. Formalism, connoisseurship, and existentialism shaped these practices, defining the structure of works and ways of thinking about them. Yet, at the same time, the success of these strategies and themes in affirming values that supported an aesthetic elite of white heterosexual males distorted the potential of those same strategies and themes to empower work that affirmed other identities, other experiences, and other relations to power.

In the years immediately following World War II, mechanisms that defined the movement we have known as Abstract Expressionism included a selection and exclusion based on the belief that high quality backed by dogged individualism always wins out. This process narrowed Abstract Expressionism's roster. Until the eighties only the work of what could be called the 'essential eight' – Adolph Gottlieb, Willem de Kooning, Motherwell, Barnett Newman, Pollock, Ad Reinhardt, Rothko, and Clyfford Still – seemed central. Sometimes William Baziotes, Arshile Gorky, Philip Guston, Hans Hofmann, and Fritz Kline were added to this key group, and, less frequently, Richard Pousette-Dart, Mark Tobey, and Bradley Walker Tomlin.

But the 'quality' that is understood to have determined this hierarchy is itself a period concept favoring characteristics prized by those who defined it in the first place. Throughout the 1930s, the term *quality* was increasingly identified with abstraction and was denied to art with narrative and even symbolic meanings, particularly with specific political content. By the mid- to late forties, this definition of quality was identified with universality, freedom, and individualism and was found in Abstract Expressionism, where it was understood as the product of hard-won artistic integrity, blessedly free of collective needs or programs. As intellectuals in New York came increasingly to distrust the programs of both right and left, the 'unassailable' artistic standards of the avant-garde were linked to its political innocence.

The eviction of artists' personal histories from the historical development of the meaning of the art they produced was an important part of Clement Greenberg's influential criticism, as outlined, for instance, in his 1939 essay 'Avant-Garde and Kitsch.' Greenberg believed that the difference between good and bad art rested on a distinction between 'those values to be found only in art and the values which can be found elsewhere.'⁴ In the following decades, he played out this belief in his widely read essays, declaring the centrality of optical values (the delimitation of flatness, color in painting, and form in sculpture) and railing against the literary (associations with history, politics, biography). Many influential tastemakers in the art world found this approach congenial and considered optical values superior to literary approaches for decades. More interesting and important now is the relation

between the two levels of analysis, in order to consider works of art as places where different meanings become lodged. The reading of diverse meanings in the same work frequently comes from makers' and viewers' different circumstances in society; and they may, moreover, be used by persons in various situations to reinforce or oppose these positions.[5]

Although some art historians accept the relativity of this approach, they have seldom factored race and gender into the equation. Rarer still are art historical models for a culturally or theoretically oriented practice that still accounts for the specificity of the individual works.[6] Even writers who have treated cultural production as being historically grounded have often failed to demystify the production of art because most of them have continued to accept the art historical canon.[7] [. . .]

A key determinant in artists' choices of methods was the relation of their artistic identity to power. How does one achieve economic and psychological control of the production of meaning in the art world and in the greater community? The question of power in this era, as in earlier and later periods, was buttressed by relative definitions of the self and the other. The powerful personal assets of whiteness and heterosexual masculinity in postwar New York had meaning chiefly in relation to their difference from color, homosexuality, and femininity, differences usually presented in either negative or fetishized terms (as in Gottlieb's primitivizing pictographs or de Kooning's *Women* series).

For Abstract Expressionism, a style whose definition was intimately related to the identity of the artist, personal identity linked meaning to power. Prejudice and social sanctions involving sexuality and race were both internal and external. Those who were the most 'different' from the white male norm (black female artists, for instance), had great difficulty establishing their ability to produce what Abstract Expressionist circles would see as meaning of consequence.

[. . .] Abstract Expressionism as it has most often been defined incorporates a stylistic stretch from Barnett Newman's scholarly persona and linear restraint to Willem de Kooning's bohemian painterliness. As Lawrence Alloway observed by the 1960s, 'the unity of Action Painting and Abstract Expressionism was purely verbal, a product of generalization from incomplete data.'[8] But the themes and styles of abstraction in the work of African Americans such as Thelma Johnson Streat and Rose Piper, in some ways the least like standard Abstract Expressionism, make it necessary either to pull 'Abstract Expressionism' into a different shape or to admit that its 'universality' stops short at the boundaries of race and gender.

The work of Piper and Streat [. . .] was flat and abstract, as was Abstract Expressionist work. Piper ranged eclectically in style from Expressionism to Cubism, illustrating social issues drawn from black work songs. Streat's work, inspired by African and Northwest Coast Native American art and dance, was more hieratic and less narrative, but retained, as did Piper's, readily recognizable figurative references. Does their presence in Streat's and Piper's painting mean that these artists cannot be considered Abstract Expressionists? It's hard to hold that this is the case when, in the late forties, the years on which this book centers, representational images could be found in Gottlieb and Kline's works, and, in the early fifties, figuration returned to the work of Pollock and de Kooning. One could say that Streat's and Piper's work does not look like what has been culled from the years 1948–1950 from the careers of the essential eight to stand as canonical Abstract

Expressionism for most exhibitions and books; but it does fit comfortably into the full range of pre- and post-fifties Abstract Expressionist production.

The areas in which Streat's and Piper's painting are actually least 'like' Abstract Expressionism are the relations between their social identities and their subject matter. Their themes, some of which revolved around the 'primitive' and included images of women, were also important to more familiar artists, such as Pollock, de Kooning, Gottlieb, and Newman. But Piper's 'woman' was Bessie Smith, bleeding to death because a segregated emergency room in the South wouldn't treat her. Streat echoed the patterns and rhythms stressed by Katherine Dunham's Haitian-inspired dancers. Their relation to their sources was one of both distance *and* social identity.

Piper's and Streat's relationship to Abstract Expressionism is telling. If Abstract Expressionism is only the movement as it has until now been defined, then their work is *not* Abstract Expressionist. But if this is the case, it has a lot to teach us about what the movement we (think we) know, is. All the artists around whom this book revolves, the famous and the lesser-known, questioned existing modes of figuration. If Abstract Expressionism is art whose formal and thematic qualities have an American European and heterosexual male charge determined by the gender and race stereotypes of the forties, the essential eight win. But, from another point of view, those not in the usual group have a crucial relation to Abstract Expressionism. They do belong to its history, although they have not entirely belonged to the 'Abstract Expressionism' that history has so far established. It's a relationship of negotiation – a mixture of affirmation and opposition. [. . .]

To fix the meaning of the 'other' is to place oneself in control, to define oneself as the standard. A system that has defined who is empowered and who is not can succeed without changing the sources of power only if it excludes the disempowered altogether (making them appear to be absent), or exoticizes, assimilates, or even emulates selected aspects of them – which in this case meant emphasizing aspects of their identities and work that were not-European, not-male, and not-heterosexual. In a postwar society whose standards were racist, misogynist, and homophobic, these mechanisms functioned to reinforce the power of European, male, and heterosexual identity.

From this point of view, the myths embodied in an insistence on Abstract Expressionism's anti-narrative and visual character are at an important level claims to authority. The conventions of Abstract Expressionist painting – large brushstrokes, for instance, whose appearance indicates that they were laid on the canvas rapidly – have come to stand for spontaneity and even masculine force. The canvases' large sizes have come to embody Abstract Expressionism's control of its environment. They are signs of its authority. Where does this leave the modest size and precision of Alice Trumbull Mason's works and the gentle, practiced linearity of Norman Lewis? Rather than understanding the brushstroke in its fullest historical complexity, which would include its parallels with weaving and African American music, we limit it by seeing only what it has come to stand for: the myth of Abstract Expressionism's creative vigor, originality, force. The connections between art, culture, and ideas represented by both of these extremes cannot be understood without recognizing that they constitute configurations of power. Those configurations established by that rebel movement, Abstract Expressionism, were as rigid and disabling for some as those it sought to dismantle.

At its core, Abstract Expressionism was a modernist art movement, dedicated to transcendence, to progress, and to the repression of anything that threatened the autonomy of art. Most of the artists involved believed that meaning was not dependent on mimesis or even associative thought. Yet they also argued that the meanings of their art were determined by its context. Sculptor Herbert Ferber claimed, 'What we are concerned with is a relationship to the world. Truth and validity cannot be determined by the shape of the elements of the picture.' Motherwell concurred: 'I cannot imagine a structure being defined as if it had only internal meaning.'[9] Such a distinction between the art's interior and exterior associations with the world reveals in the aesthetic terms of Abstract Expressionism the ethical schizophrenia that Ralph Ellison discerned in American life in general. But it suggests that in the end these artists did see their works in a broad cultural and social context rather than a narrowly stylistic one. This holds true; but only if one understands that this broad context had its limits.

In American intellectual circles after the war, pluralist ideals warred with right-wing paranoia of Communism; visual artists often reacted by confining their stated concerns to purely aesthetic issues, and even then narrowing the range of acceptable interests and subjects. In particular, these artists' withdrawal of their art from the instrumental political arena – which many saw as offering only forced choice between the equally unacceptable terms of Communism and McCarthyism – was stimulated by the rise of individualism in postwar America. The idea of not letting a group (such as corporate managers, Communists, or McCarthyites) determine one's decisions was to a large degree responsible for the stylistic diversity of Abstract Expressionism. As Willem de Kooning put it in 1951, Abstract Expressionism 'implies that every artist can do what he thinks he ought to – a movement for each person and open for everybody . . . It is exactly in its uselessness that it is free.'[10] Most Abstract Expressionist artists shared the conviction that any sense of community should be avoided, including the communal imagery of realism. Only when the artist was free of the security of recognizable images, Rothko maintained, was transcendental experience possible.[11] What counted was the artist's ability to shuck what Barnett Newman called 'the impediments of memory, association, nostalgia, legend, myth, or what have you, that have been the devices of Western European painting.' That accomplished, the artists would then be free to make paintings 'out of ourselves, out of our own feelings.'[12] Inevitably their intensity and honesty would infuse the work and be transmitted directly to the viewer.

A number of these artists claimed that meaning was determined in their work not by external factors but by a kind of transcendental transfer of emotional power from the artist to the art. For this transfer to take place unimpeded, it was necessary to establish a kind of cultural vacuum around the work. Social function and historical necessity had to be ignored so that meaning could be determined by the artist's intentions alone. Thus, Rothko wrote in 1949 that memory, history, and geometry (for example, Mondrian and the constructivists – painting's recent, European past, to say nothing of the horrors of the recent past of Europe itself) were 'obstacles between the idea and the observer.'[13] As Ad Reinhardt said, 'We have cut out a great deal. We have eliminated the naturalistic, and among other things, the supernaturalistic and the immediately political . . . You're putting in everything about yourself, but not everything outside yourself.'[14] This assumption of a relatively unmediated

translation from intention to matter was the subject of much Abstract Expressionist art.

The decontextualizing 'freedom' deemed so necessary for the production of Abstract Expressionist art works was hardly intended by these artists as an escape from all aspects of culture. They were acutely aware not only of the recent history of art but also – often going deeper than the popular level – of contemporary developments in literature, physics, biology, philosophy, anthropology, and psychology. They did not fear contamination by these fields; in fact, they repeatedly avowed their indebtedness to such sources. What they consciously feared were those aspects of culture that marked their work as things for sale and those that regarded art as a vehicle for politics. These were crucial points for the Abstract Expressionists and constituted the limits within which they confined their intended subject matter and its formal expression. They refused to ally themselves with known styles (for example, social realism, Surrealism, geometric abstraction) in order to make their work sell or to explore political dilemmas. To do so, they felt, was to renounce the possibility of constructing new aesthetic forms through which real breakthroughs in human thought were possible. Thus, the Abstract Expressionists' mythology of the new was formed from the belief that significant art was by definition apolitical, unappealing to the general public, and unfamiliar even to art world habitués. As Ad Reinhardt and Robert Motherwell wrote in 1947, 'Political commitment in our times means logically – no art, no literature.'[15]

Writing in the *Nation* in that same year, Clement Greenberg described 'a new indigenous school of symbolism' that included Gottlieb, Rothko, Still, and Newman. He questioned, however, the use of the symbolic, or metaphysical, content claimed by the artists, saying that what counted was that the painting was good. This being the case, Greenberg said, 'differences of ideology may be left aside for the time being.'[16] A statement like this – one that maintains that a separation between art and politics is even possible, let alone desirable – would have been suspect in an artistic culture of New Deal programs such as the WPA (which stood for Works Progress Administration from 1935 to 1939 and for Work Projects Administration from 1939 to 1943), imbued with Popular Front ideals in the mid-thirties. But by the late forties, in a cultural atmosphere informed by anti-Communist hysteria that made many artists' former socialist associations suspect, it was safer to believe that the proper function of art was the invention of codes to transpose universal, rather than local, meaning into visual form (and that the critic's job was to identify and explicate that code).[17]

Although Greenberg admitted that there could be 'differences in ideology,' he dismissed them in dealing with art. Nowadays the word *ideology* often refers simply to a set of social and philosophical concepts. But Greenberg's understanding that there are multiple ideologies *and* his dismissal of them all recalls Marx's more negative description of morality, religion, and metaphysics as *forms* of ideology and therefore of mystified, or false, consciousness. Greenberg's belief that it is possible to dispense with ideology when considering works of art should come as no surprise, considering his immersion in the Marxist circle around the early *Partisan Review*. His mention of 'differences in ideology' reflects a humanist-Marxist view that ideology is a distortion that prevents the establishment of true knowledge. From the beginning, however, nearly all the Abstract Expressionist artists disagreed

with Greenberg about the limits of ideology. While they agreed with him that popular and political culture – including sexual, racial, and class differences – had no place in art, other aspects of ideology that Greenberg believed could be left aside were the very ones that the artists wished to reassert.[18] These included the artists' intended subject matter: chaos and death, love and rebirth, the inhumanity of atomic power and the Holocaust, freedom, connections between the world of visible matter and the unseen worlds of psychic and electric force, and the creative act itself.[19]

Barnett Newman, for instance, argued with Greenberg that metaphysics, far from being immaterial, was at the core of Abstract Expressionism. A complete discussion of a work's significance, Newman estimated, would entail an exposition of the kind of reality it created, its subject matter, the nature of its abstraction, and its plastic imagery. Willem de Kooning also emphasized the importance of a multi-level approach to works of art: 'There's no way of looking at a work of art by itself; it's not self-evident – it needs a lot of talking about; it's part of a whole man's life.' Yet, it is here that the myth of Abstract Expressionism needs to be reexamined. For, despite the broad-minded sound of such statements, to artists such as de Kooning and Newman, 'a whole man's life' excluded more than one might think. In the original charter for the Club, for instance, the members stipulated that the meetings should exclude the world of commerce and politics: no dealers, no critics, no Communists. Ibram Lassaw recalled that the Club's original intention was to exclude women as well, nor were homosexuals to be admitted, Ruth Abrams reported. Did they also exclude blacks? They didn't have to, according to painter Pat Passlof: the possibility of a black artist presenting himself or herself for membership was considered remote.[20]

[. . .] ideologies cannot be left aside. They are at work in every aspect of social relations (including aesthetic criteria), determining how people see themselves in relation to society and defining how even the most abstract statements are shaped and understood. Thus, the restricted context these Abstract Expressionist artists defined for themselves was not only relevant to but also depended on a hidden requirement: the apparent absence in their work of the bases of certain aspects of ideology, namely, the sexuality, gender, or race of the artist or the audience, the politics of right and left, and the artwork's commercial position as an object for sale.

The Abstract Expressionists and their proponents rarely admitted that the various 'subjects of the artist' (that is, those drawn from such disciplines as psychology, philosophy, literature, biology, and anthropology) that they so freely allowed into their art were in any way political. In fact, the political inflection of these subjects, particularly with regard to the invisible politics of race and gender, was further distorted by Abstract Expressionism's mythic universalism. The apparent difference of the work of the essential eight (or twelve, or fifteen) from some of the other artists whose work I discuss in conjunction with theirs, is principally in the degree of universalism the first group was successful in claiming.

This universalism was delivered by men who aspired to be artistic heroes. This claim, to which sympathetic contemporary viewers readily responded and which subsequent historians have made specific, was not seen as the movement's implicit story about itself, that is, as literary, but simply as a wondrous fact. The idea that such an iconic art as Abstract Expressionism was built on such narratives and the suggestion that 'narrative and its complicities play an unusual and important role

behind the scenes' in that art may come as somewhat of a surprise.'' This notion established grounds for the distinction that, in segregated America, only white heterosexual males could attain: generating a universal product that could speak for everyone, Women, African Americans, and avowed homosexuals could not do that because their audiences would not accept their work as universal. Even if they *wanted* to be universal and said so, as did Romare Bearden, the dominant society did not read the work that way. This hidden requirement was based on biography, or, more precisely, identity.

There was, then, a triple avoidance of politics. It consisted of (1) a refusal to adopt conventional political positions or to identify with the left or the right (already a radical break from avant-garde practice, which had typically been highly politicized and mostly leftist, in its rhetoric, at least); (2) an insistence that the meaning of the work had no relation to its interpretation and distribution (the politics of the market); and (3) an uncritical acceptance of the racial and sexual biases of the humanities and the sciences. [. . .] In the internationalist climate of the postwar years, appropriating forms and procedures from other cultures and evaluating art by the progressive logic of science was regarded as politically neutral. In fact, it was precisely this omission of direct or specific reference to political practices that made Abstract Expressionism useful to the U.S. State Department as Cold War propaganda for the equation of freedom with American democracy.'' Roughly, freedom was translated in regard to Abstract Expressionism as liberation from the 'objective' requirements of mimetic representation.

This belief in the apoliticization of Abstract Expressionism is clear in much of the early criticism, which limited the defining criteria of the new movement to such formal qualities as abstraction, unity, spatial ambiguity or flatness, and allover composition. In time, these aesthetic characteristics came to stand as the visual component of a universalized Western humanism. But critics cannot be held solely accountable for these formalistic and apoliticized definitions. Many artists also emphasized the formal aspects of their work to the exclusion of its social or political significance. De Kooning's 'one objective professional standard,' according to his friend Edwin Denby, was to ensure that 'everything in the picture [was] out of equilibrium except spontaneously all of it . . . That was form the way the standard masterpieces had form – a miraculous force and weight of presence moving from all over the canvas at once.' This 'presence' was the result of 'the action of the visual paradoxes of painting'; it was not supposed to be due to any reference to the outside world.''

Throughout the 1950s and 1960s, critics continued to valorize Abstract Expressionism's nonobjective 'presence.' Despite their resistance to formal characterizations of their endeavor, the Abstract Expressionists found that certain morphological qualities their works shared, such as flatness and a high degree of abstraction, were also the aspects of their art most often discussed by certain critics. The authority accorded to these qualities was said to emanate from the work either by ambiguous formal tensions, as theorized by Clement Greenberg,'' or by the aura of the act, as described by Harold Rosenberg. For Rosenberg, the real significance of Action Painting was not the work itself, but the sum total of the decisions and actions made by the artist. The painting was only a ghost. As Rosenberg saw it, 'the gesture on the canvas was a gesture of liberation, from Value – political, aesthetic, moral.''' Rosenberg's conception, which has become one of the most durable popular

versions of Abstract Expressionism, demanded the kind of spontaneity of action propounded by such existentialists as Hannah Arendt, Albert Camus, Maurice Merleau-Ponty, and Jean-Paul Sartre. In such widely read parables as 'The Wall,' Sartre, for instance, emphasized that integrity consisted of unpremeditated, disinterested choices, rather than in making decisions based on what happened when they were played out in life situations. To escape the bad faith of programmatic decisions – that is, to be sincere – one must make each decision based on present needs, according to a kind of situational morality, not to meet the demands of a preordained system or to ensure a certain result in the future. So pervasive was the respect for this definition of authenticity that even Abstract Expressionists like Barnett Newman, whose paintings reveal divisions based on the mathematical formulas of dynamic symmetry, nevertheless insisted that his decisions were made instinctively.[26]

Greenberg's formalism and Rosenberg's existentialism encouraged a view of art as without history and free of all but the most remote social utility.[27] Although many of these artists had embraced overtly political themes in their work during the twenties and thirties, the belief in art's political efficacy lost credence in the United States as the thirties drew to a close. In appearance, though frequently not in intention, Abstract Expressionism represented a striking turnabout for many of these artists. Rejecting the instrumentalism of political advocacy, Action Painting as described by Rosenberg favored Sartre's existential position in which the individual refused to occupy programmatic positions.[28]

Critical and curatorial acceptance of Abstract Expressionism on its own terms – especially the vaunted notions of individuality and freedom – established rather limited standards for evaluating these works. The standards promoted by critics like Greenberg and Rosenberg were based on the assumption that meaning in these works was intrinsic and universal. If historical referents and political effectiveness – much less race, gender, or sexuality – could not be used openly as criteria, other grounds were necessary for artists to know how to proceed, for critics to decide what was good, and for museums and collectors to choose what to buy.

So, to individuality, freedom, and universality was added another crucial guarantor of quality: originality. This attribute was wielded like a critical club. The work of African Americans and women was often denigrated for its lack of originality. But what was originality? Greenberg traced it in those works that departed usefully from the work of someone else, most impressively from an acknowledged master, by taking precedence and in turn influencing others. His use of the word *original* in his reviews was most frequently in comparative situations. This made it a sort of family affair; Gorky was original in returning Matta's biomorphism to 'serious' painting, Morris Graves and Mark Tobey in their departures from Paul Klee, and Pollock in superceding John Marin as the greatest American painter of the twentieth century.[29] In addition, the originality that was valued was stylistic (positivistic), not ideological (or literary).[30]

But if the conflict of ideologies is readmitted as a criterion for originality, works that question the binary exclusivity of racial and sexual spheres (such as those of Beauford Delaney and Sonia Sekula) seem even more 'original' in some ways than the formal innovations of de Kooning or Newman. As literary critic Valerie Smith has noted, to believe that technical experimentation is the only innovation that counts is to construct a false dichotomy between form and content.[31]

By the same token, to argue that formal innovation constitutes the crucial limit of Abstract Expressionism is to imply that meaning resides principally *in the work itself*, rather than in, say, the interaction between the work and the viewer or in the work's relation to society.[32] This view is becoming increasingly difficult to support. Innovation is only one way of understanding originality. By insisting that 'important' art adopt the qualities of some mythical 'first,' Abstract Expressionists attempted to sever themselves from their own history. Original art was by definition art that put distance between itself and the specificities of immediate cultural influences. In the case of Abstract Expressionism this gap was enhanced by the conviction that art that addressed such issues as oppression, wages, or the separation of the domestic from the public sphere, or that expressed the (subjective) view of any modern ethnic identity or sexual identity other than the straight and male, was necessarily doomed by its 'literary' premises to 'minor' status. Abstract Expressionism seemed the fulfillment of a dream of producing works that escaped ideology; works that were free of politics, convention, history. This strategy allowed the Abstract Expressionists to identify themselves as modern-day primitives, producing art that was untouched by the vagaries of contemporary life, except in that it served as an escape.[33] In other words, their originality, like abstraction, was in an important way predicated on the denial of politics.[34]

The early definition of Abstract Expressionism as an abstract 'presence' gradually was amplified by the insistence of the artists themselves and historian-critics close to them (including William Seitz, Lawrence Alloway, Irving Sandler, and Dore Ashton) that there was subject matter in Abstract Expressionism. They claimed that Abstract Expressionism's 'presence' was deeply informed by its subject matter, and that the artists' attitudes toward their themes directed their attitudes toward form and process. By investigating the artists' insistence that their work had subject matter – the result of an intercourse between content and form – these writers reopened the possibility of social and historical as well as philosophical and psychological themes. The discovery of 'hidden' subject matter, which has been the goal of much recent scholarship [. . .] is not my goal here.[35] In fact, many of the subjects these scholars have uncovered have become a part of the aesthetic through which the Abstract Expressionist rhetoric of presence – premised on the absences it concealed – has continued to be defined. This presence has been understood as the ground – the basis – of what could be called the discourse of Abstract Expressionism. But one can also see this ground – the assumption that Abstract Expressionism iconically projects a presence – as part of its subject matter. When this presumption of presence with all its implicit and symbolic prerequisites, can be the *object* of an examination rather than a given, it is possible to see some of its mechanics.

[. . .] Lawrence Alloway's articles in the 1960s on Newman and Pollock, and his essays on 'The American Sublime' and 'The Biomorphic '40s,' later gathered in his *Topics in American Art since 1945*, not only established the idea that there was subject matter to be found in Abstract Expressionism, but also set a standard for the imaginative and responsible use of historical investigation. Irving Sandler's richly informative *Triumph of American Painting* (1970) defined Abstract Expressionism for a generation of scholars. Like William C. Seitz's ground-breaking *Abstract Expressionist Painting in America* (submitted as his Princeton dissertation in 1955 but not published until 1983) and Dore Ashton's later but even more emphatically cultural *The Life and*

Times of the New York School that followed in 1972, Sandler suggested a wealth of approaches to Abstract Expressionism. These four historians, all of whom knew and worked with the artists, emphasized the personal context of the work, in addition to its broader cultural and art historical precedents. Although it is instructive that the earliest (Seitz) gives the most consideration to formal (Greenberg) and procedural (Rosenberg) considerations, it is also important to note that in choosing Abstract Expressionism's primary artists (de Kooning, Gorky, Hofmann, Motherwell, Rothko, Tobey, but not Pollock and Newman), Seitz had already deleted from consideration artists of color, 'out' gays and lesbians, and white women. Sandler established a historical context by linking the development of Abstract Expressionism to certain effects of the Depression and to the more immediate ambience of the Second World War. In addition he offered considerable insight into the artists' elusive subject matter. However, like Seitz, Sandler devoted his chapters only to white male artists: Baziotes, Pollock, de Kooning, Still, Rothko, Newman, Gottlieb, Motherwell, and Reinhardt. Hedda Sterne, at the top of the heap, so to speak, in the photograph of the 'Irascibles' that has come to stand as a roll call of first-generation Abstract Expressionism, was not even in Sandler's index. Of these early studies, Ashton's is the most culturally inclusive in terms of race, gender, and medium. She mentions Romare Bearden, Aaron Douglas, Lee Krasner, Elaine de Kooning, Hedda Sterne, and Isamu Noguchi, and gives more than casual attention to dancer Martha Graham. But in giving the most attention to the 'exceptional individuals' who anchored the established canon of Abstract Expressionism, she shared with Seitz and Sandler – and the rest of American culture – a nearly exclusive focus on the production of the most privileged members of that society; heterosexual white men.

The fact that for these critics and their followers Abstract Expressionism was an art of subject matter and attitude, however, instead of a primarily visual or self-referential experience, opened a fissure in the movement's heretofore impervious roster. For as long as critics had permitted their understanding of art to be determined by the art in isolation, their analyses stopped short of questioning the exclusivity of its art historical and critical definition. But when Abstract Expressionism was defined more broadly as art that took abstraction and realism as relative terms, and that employed concepts such as war, the self, reality, and humanity as its subject matter,[36] then it became possible to consider the movement from other cultural perspectives. Even surveys of Abstract Expressionism that aimed to rectify earlier omissions preserved the idea of a canon at its base. E. A. Carmean and Eliza Rathbone's *American Art at Mid-Century: The Subjects of the Artist* (1978) added sculptor David Smith to the canon, and Phyllis Rosenzweig gave an unusual degree of consideration to the work of women in her catalogue *The Fifties: Aspects of Painting in New York* (1980), but neither book mounted a critique of the canon. Even Serge Guilbaut, in his much-debated *How New York Stole the Idea of Modern Art* (1983), the controversial crescendo of a decade of writing that reconsidered Abstract Expressionism from the perspective of its reception and its political uses during the Cold War, generally followed the existing canon.[37]

One might claim, as the authors of these works surely believed, that such analyses were focused on the mainstream of American painting and were not meant to give much coverage to sculptors, to photographers, or to the double-voiced

discourse (see below) of marginalized artists. But their omission of identities that were not male, white, or heterosexual has become more obvious and more problematic as Abstract Expressionism has come to stand for the important aesthetic achievement of the 1940s and 1950s, not only in the United States but in the world. To define Abstract Expressionism through only one media and one kind of subjectivity narrows and impoverishes it.[38]

In order to move beyond questions of Abstract Expressionism's visual style and its subject matter to how we define the movement in general, it is necessary to challenge yet another fundamental assumption of art history: the belief that discovering or inventing the meaning of art is the principal goal of art historical study. Although I address meanings [. . .] I am not primarily concerned with meanings per se, but with what they reveal about how, and upon what bases, aesthetic values were established in mid-century New York.[39] A project such as this will be considered by some to be outside the realm of proper art historical practice, especially as it incorporates insights derived from a number of adjacent fields. Or, even more disturbingly, it may be received as a sort of mugging of Abstract Expressionism that robs it of its hard-won magisterial presence. To look *behind* the canonical view of Abstract Expressionism is to refuse to follow instructions. It means asking questions that interrupt or contradict the story through which we have become used to participating in Abstract Expressionism's transcendence.

Despite the tremendous thematic flexibility produced by the active scholarship since the mid-1980s, few have ventured, except in monographic arguments, to expand the number of Abstract Expressionism's most significant participants beyond eight, twelve, or even fifteen artists. And the movement's determining characteristic is still visual style (despite its latitude from geometric abstraction to fluid Cubistic figuration), with all the value judgments that implies for maintaining the canon whose bases I am questioning. To the extent that the work of an artist who is not in the canon looks like that of one who is, the noncanonical artist's work is derivative. To the extent that the noncanonical work does not resemble that in the canon, the contending work is not Abstract Expressionist [. . .] the values that keep the essential eight where they are and place even the satellite five and three at a noticeable distance from the center, elevating visual likeness to the already chosen to a decisive value, are inflected by racializing and gendered interpretations that have excluded many visually and thematically rich and challenging works from extended consideration.

Should works by artists not now considered important Abstract Expressionists – or not Abstract Expressionists at all – simply be inserted into the canon? If this means leaving the values as they are, they can only fit in positions pretty far from the central positions accorded the essential eight. Even among these there is an order of dominance – currently, Pollock and de Kooning are on the top. I prefer to think of Abstract Expressionism as art whose degree of abstraction was extreme enough that debate about the appropriate range of its representational modes in itself became a part of its subject matter in the late forties. This would permit the consideration of art by artists as different as Forrest Bess, Charmion von Wiegand, and Ronald Joseph, along with Pollock, Rothko, and the others, in a net of interwoven influences with many fascinating nodes of great significance for other audiences. [. . .]

To simply add artists would also be to gravitate toward biographically based

criticism as an axis. This is tempting when treating an era in which intellectuals' resistance (pace Clement Greenberg) to the 'intentional fallacy' – using the artist's announced or presumed goals as a work's meaning – greatly reduced the cachet of biographical criticism. Such resistance caused repressed biographical elements to function more subversively but no less powerfully than ever as elements that participated in establishing the value of a body of work. These elements prevented persons with certain identities from succeeding as 'major' artists by driving underground the fact that an awareness of the identity and goals of the artist did still play a part in interpretation and judgment. This permitted judgments based on race and gender prejudice to operate undiscussed and unacknowledged. It contributed to the creation of a dominant realm in which biography and politics played no admitted part, but in whose preferred subjects and subject matter the continuing exclusionary function of these factors is evident. Structuring around issues is necessary to avoid simply reversing Abstract Expressionism's politics of identity (putting people of color, lesbians and gays, and straight women on top) in favor of opening space for exploration and debate about the place of identity in a politics of meaning.[40]

In New York's abstract milieu, for example, some artists retained forms openly suggestive of Expressionism, Cubism, Purism, and Surrealism, either in the same work or in series. In the work of artists usually excluded from the canon of Abstract Expressionism, including Louise Bourgeois, Perle Fine, Charles Alston, Charmion von Wiegand, Norman Lewis, and Hedda Sterne, this was considered regressive. But some of these artists chose to acknowledge the conflicts between their social positions and their aspirations by foregrounding a play of styles, including still-denigrated ones like mimesis, in a kind of doubled vision. Just after the turn of the century, W. E. B. Du Bois used the term *double consciousness* to describe the social situation of African Americans, always living in a state of contradiction between their appearance in the eyes of white people and their own self-perceptions.[41] In the 1980s cultural critics Theresa de Lauretis, Robert K. Martin, and others have used this idea to describe the position of women and gays, respectively, as subjects at the same time inside and outside the ideology of gender, and conscious of being so. 'We see heterosexually because we have been taught to and because our survival depends on it,' observes Martin. 'There is an obvious analogy with the situation of blacks, who must learn the signals of a white community without expecting whites to learn even the most elementary black semiotics.'[42]

Formal elements such as shape, line, and color, as well as images, had their iconographies in Abstract Expressionism. And as with images, the meaning of forms could differ according to the position of the producer and/or viewer. According to the aesthetic standards of the day, the methodical angularity of some of Lee Krasner's paintings and collages of the late 1940s and early 1950s would have been deemed less 'feminine' than the soft edges of William Baziotes's primeval biomorphic forms. One may argue, however, that in her sharp forms Krasner was consciously evading the connotations of the primitive and the feminine, which she saw as oppressive, in contrast to Baziotes, who in his softer contours and subtly muted colors courted the feminine qualities he saw as mysterious and primordial.[43] Similarly, both Adolph Gottlieb and Hale Woodruff attentively pursued the forms and meaning of African art and repeated them in their paintings. But while each looked for universality in the arts of Africa, Woodruff's assiduous examination of

African forms and traditions was also a search for a heritage specific to himself, whereas Gottlieb's intention was to find a heritage different from his own (which he could then claim by virtue of his appreciation of its fundamental humanity).[44] The crucial distinction lay in the claimants' understandings of the politics of gendered and 'racial' status, relative to their assumption of universality. When Baziotes adopted the feminine, and Gottlieb produced African signs, their work was read as universal; for Krasner or Woodruff to do likewise would, in the eyes of audiences of the forties, simply cement their feminine or 'race' identities: their singularity, their otherness, and therefore the impossibility of their producing anything that could claim universality. Their responses to their situations were different; Krasner generally withdrew from the stereotypically feminine, whereas Woodruff synthesized varieties of African and European styles. Critics have often stressed the alienation that the principal Abstract Expressionist artists experienced, for many of the artists were immigrants, sons of immigrants, Jews, or Westerners.[45] Few writers on artists in Abstract Expressionist circles, however, mention the distance between the kitchen and the studio, however, or the psychological and social chasm dividing Harlem from Fifty-seventh Street.[46]

As the canonical version of the Abstract Expressionist movement was for the most part based in New York, I focus on art in that city. For New Yorkers, the necessity of accommodating – or, alternately, defining themselves against – a strong African American presence in the city was especially intense during the final years of World War II. The Harlem riots of 1943[47] had dislodged Manhattan's archaic image of the affable, accommodating Negro, and the war furnished the irony of black soldiers fighting Nazi racism when their own government placed Japanese citizens in internment camps and irrationally segregated white from 'colored' blood transfusions for GIs. But what were the effects of these events in the art world? Was there a relation between a changed perception of the Negro and the hiring of Hale Woodruff to teach art at New York University in 1945? Did this new awareness (or perceptions of it) influence the induction of Norman Lewis into Marian Willard's gallery in 1946, or of Romare Bearden into Samuel Kootz's in 1947?

Similarly, the movements of large parts of the American populace according to gender and race – men to the military, women and, when they could, African Americans and other minorities to the defense industries – also had profound ramifications within cultural circles. For one thing, it created a nationwide 'woman problem.' Even before the end of the war, educators and legislators began to worry that Rosie the Riveter would balk at exchanging her overalls for an apron. How did the national preoccupation with restoring women to their roles as wives, homemakers, and mothers affect the critical and economic fortunes of such female artists as Ruth Abrams, Louise Bourgeois, Lee Krasner, Rose Piper, and Hedda Sterne? And, if white ex-G.I.'s had trouble supporting themselves after the war, what difficulties faced black soldiers like Ronald Joseph when he mustered out?

At the same time, thousands of gays and lesbians were purged from the armed forces after the war. Many found it impossible to return home and preferred to settle in cities like New York. Their post-war presence was made more prominent by public pressures to identify and evict them from government and civil-service positions. What effect did these pressures have on lesbians and gay men in the art world, such as gallerists Betty Parsons and Michael Frelich (who ran the RoKo

gallery) or for gay artists like Beauford Delaney and Alfonso Ossorio, and lesbians Sonia Sekula and Nell Blaine?

The contemporaneous work of African Americans and women, both straight and lesbian, and gay male artists provides powerful correctives to the restrictiveness of the original canon of Abstract Expressionism. But it is not just a question of the canon versus some monolithic 'other.' The position of African Americans and other people of color, as well as that of other Caucasian nationalities in regard to Abstract Expressionism, for instance, is a vexed one. The relation of art by Americans of Chinese, Native American, and Japanese descent to Abstract Expressionism deserves careful reevaluation, especially on the West Coast, as does the influence of their Jewish heritage on some of its practitioners and critics. [. . .]

On the whole, black women (recalling that the postwar histories of Chinese, South American, Japanese, Native American, and many other nationalities of abstractionists in New York remain to be explored) were the persons most thoroughly ostracized by the white male character of the Abstract Expressionist circle. Sometimes sanctions overlapped and sometimes they conflicted. Straight women's and lesbians' goals could be the same (as in demanding equal pay for equal work) or different (as in defining what constitutes sexual expression). Although lesbians and gays shared the oppression of a number of legal and medical judgments, some felt that lesbian women (as being both female and same-sex oriented) often faced deeper hostilities in the art world than did gay men.[48]

I raise the issue of the permeability of these boundaries of gender and race because the stereotypes for these categories were more rigid than the reality of lived experience. The contradictions between stereotypes and real life affect not only the iconography of Abstract Expressionist art but its style as well. To paint as if you were someone else (with a split subjectivity) was to the Abstract Expressionists to paint 'inauthentically'; to paint decoratively was to make art that was not forceful, original, virile, or properly male; to paint 'primitively' was to escape conscious control and become 'authentic,' closer to nature. These presumptions colored a day-to-day existence for most Abstract Expressionist artists, a context in which African American, gay, lesbian, and straight women artists were seen – at least in part – as standing for stereotypes that may have been quite alien to them as educated, determined, and cosmopolitan New Yorkers. White Abstract Expressionists, for instance, could strip themselves in the eyes of others of adopted alliances with the so-called 'primitives.' African Americans could not. Even if, like so many whites, African Americans had been brought up with an awareness of Western art and culture (Piper, Alston, and Bearden come to mind) – and may have similarly yearned for an escape into immediacy, represented by 'the primitive' to so many of the intelligentsia of their era – they could hardly escape noticing that in the eyes of most of American society, they *were* the 'primitive.' And as Lowery Sims has noted, in most eyes, it has been impossible both to be and to represent the 'primitive.'[49] Nevertheless, if they were to gain a place in the avant-garde, these artists had to position their art carefully in relation to such stereotypes.

Links between gender and race, in the construction of its roster or in interpreting its works, have never been the subject of a sustained analysis of Abstract Expressionism, although such links have received attention in other social contexts, where the similarities and differences between the everyday oppression suffered by blacks

and that experienced by women and by homosexual men in America have been noted.⁵⁰ Am I suggesting that there is a gay, a lesbian, a feminine, or a black aesthetic at the margins of Abstract Expressionism? No, although it could be argued this way. But [. . .] it is important to ask *who* did the speaking in the 1940s; to note the viewpoints and positions from which they spoke, and to identify and analyze the goals of the institutions that enshrined their opinions and their works.⁵¹ At the same time, I am not trying to dismantle the regard in which what is considered Abstract Expressionism is held or to discredit its most familiar figures. Rather, I want to demonstrate that it is no longer appropriate to use the term without an awareness that in its status as the acme of value for mid-century abstraction, it exhibits the racist and sexist exclusivity that characterized its era. This approach, which could be broadly characterized as postmodern in its insistence on the complicity of knowledge and power, insists that abstract art, like writing, speech, and more naturalistic art, is a sign whose meaning is determined by its use.

Broadening the understanding of the artistic milieu in which Abstract Expressionism existed in order to include the subtexts of race and gender, then, does more than expand the meanings of works of the 'major' figures or elevate the work of 'minor' artists. It demonstrates a way of thinking about the purposes and methods of art history that addresses the multiple levels – economic and sociological, as well as aesthetic – on which questions of value are determined. [. . .] Addressing abstract art that is currently *outside* the canon of art in New York at mid-century, but that bears many of its stylistic marks, is a way of inserting a wedge into the canon, one that breaks it, right at the seams of racism and sexism.

Viewing, or re-viewing, Abstract Expressionism in relation to the politics of race and gender places it in the context of power relations in mid-century America. It does not characterize abstract art in postwar New York as a visual experience relevant only to an elite of heterosexual white males, but positions it in relation to the cultural experience of being black and/or female and/or lesbian, or gay. And it places the work of people in these groups in both the rich intellectual milieu of Abstract Expressionism and in the context of the historical pressures under which these different groups operated. [. . .]

Notes

1 David Craven, 'Abstract Expressionism and Third World Art: A Post-Colonial Approach to "American Art,"' *Oxford Art Journal* 14 (1990): 1.

2 The factors that valorized the qualities of this outsider art, contributing to its success, have been under investigation by recent scholars. A number of explanations for its critical, curatorial, and market success have been advanced in publications such as Serge Guilbaut, *How New York Stole the Idea of Modern Art* (Chicago: University of Chicago Press, 1983); Ellen Lawrence, Nancy R. Versaci, and Judith E. Tolnick, *Flying Tigers: Painting and Sculpture in New York, 1936–1946* (Providence, R.I.: Bell Gallery, Brown University, 1985); *Abstract Expressionism: The Critical Developments*, ed. Michael Auping (New York: Harry N. Abrams, 1987); Ann Gibson and Stephen Polcari, guest eds, 'New Myths for Old: Revising Abstract Expressionism' issue of *Art Journal* 47 (Fall 1988).

3 Most art historians until the 1990s have stressed the Abstract Expressionists' sympathy with non-establishment identities and modes of production as proof of the breadth of their intellectual pursuits and the sincerity of their oppositional stances. See Craven, 'Abstract Expressionism and Third World Art'; W. Jackson Rushing, 'The Impact of Nietzsche and Northwest Coast Indian Art on Barnett Newman's Idea of Redemption in the Abstract Sublime,' *Art Journal* 47 (Fall 1988): 189–192; and Stephen Polcari, 'Adolph Gottlieb's Allegorical Epic of World War II,' *Art Journal* 47 (Fall 1988): 203. More recent exceptions to this pattern include Michael Leja, ch. 2, 'The Mythmakers and the Primitive: Gott-lieb, Newman, and Still,' in *Reframing Abstract Expressionism: Subjectivity and Paint-ing in the 1940s* (New Haven: Yale University Press, 1993), and W. Jackson Rushing, ch. 1, 'The Idea of the Indian: Collection Native America,' in *Native American Art and the New York Avant-Garde* (Austin: University of Texas Press, 1995).

4 Clement Greenberg, 'Avant-Garde and Kitsch,' [Chapter 1] reprinted in *Clement Greenberg: The Collected Essays and Criticism*, ed. John O'Brian (Chicago: University of Chicago Press, 1986), 1: 15.

5 This is an extension of Jane Gallop's discussion of the idea that peoples' bodies may be thought in history by understanding them as places where apparently contradict-ory concepts interact. Jane Gallop, *Thinking Through the Body* (New York: Columbia University Press, 1988), esp. 132.

6 Janet Wolff remarks on this in *Feminine Sentences* (Berkeley: University of Califor-nia Press, 1990), ch. 7, 'Texts and Institutions, Problems of Feminist Criticism.' There are exceptions, though. See, for instance, Michael Baxandall, 'Intentional Visual Interest; Picasso's *Portrait of Kahnweller*,' in *Patterns of Intention* (New Haven: Yale University Press, 1985), and Lowery Stokes Sims's work on Wifredo Lam, such as 'Myths and Primitivism: The Work of Lam in the Context of the New York School and the School of Paris, 1942–1952,' in *Wifredo Lam and His Con-temporaries, 1938–1952* (New York: The Studio Museum in Harlem, 1992), 71–88.

7 For a discussion of the canonicity of even most attempts to describe art as an historically locatable activity as opposed to the transcendent production of inspired heroes, see Tom Gretton, 'New Lamps for Old,' in *The New Art History* (Atlantic Highlands, N.J.: Humanities Press, 1988), 68–69.

8 Lawrence Alloway, 'Systemic Painting' (1966), in *Topics in American Art Since 1945* (New York: W.W. Norton, 1975), 77.

9 Herbert Ferber and Robert Motherwell in 'Artists' Sessions at Studio 35 (1950),' in *Modern Artists in America* (New York: Wittenborn Schultz, 1951), 19.

10 Willem de Kooning, 'What Abstract Art Means to Me,' *Bulletin of the Museum of Modern Art* 18 (Spring 1951); repr. in Herschel Chipp, *Theories of Modern Art* (Berkeley: University of California Press, 1968), 556.

11 Mark Rothko, 'The Romantics Were Prompted,' *Possibilities* 1 (1947–48): 84.

12 Barnett Newman, 'The Sublime Is Now,' in 'The Ides of Art: Six Opinions on What Is Sublime in Art?' *Tiger's Eye* 6 (December 1948): 53.

13 Mark Rothko, 'Statement on His Attitude in Painting,' *Tiger's Eye* 9 (October 1949): 114.

14 Ad Reinhardt, 'Artists' Sessions at Studio 35 (1950),' 21.

15 See Robert Motherwell and Ad Reinhardt, 'The Question of What Will Emerge Is Left Open,' *Possibilities* 1 (1947–48): 1. While this was true in general, some

Abstract Expressionists – Barnett Newman, for instance – *did* hold that their work was political. For the paradoxes of this situation, see Serge Guilbaut, 'Postwar Painting Games: The Rough and the Slick,' 30–47, in *Reconstructing Modernism: Art in New York, Paris, and Montreal, 1945–1964* (Cambridge: MIT Press, 1992).

16 Clement Greenberg, review of exhibitions of Hedda Sterne and Adolph Gottlieb, *Nation*, 6 December 1947; repr. in *Collected Essays and Criticism*, 2: 191.

17 Some artists were under government surveillance. See David Craven, 'New Documents: The Unpublished FBI Files on Ad Reinhardt, Mark Rothko, and Adolph Gottlieb,' in *American Abstract Expressionism*, ed. David Thistlewood (Liverpool: Liverpool Press and the Tate Gallery, 1993), 41–52. On the WPA, Francis V. O'Connor, *Federal Support for the Visual Arts: The New Deal and Now* (Greenwich, Conn., New York Graphic Society, 1971), viii.

18 Given Greenberg's stress on issues of class in his crucial early essay 'Avant-Garde and Kitsch,' it is surprising that there has not been more investigation of taste as an historical issue in the criticism of Abstract Expressionism. See T. J. Clark, 'In Defense of Abstract Expressionism,' *October* 69 (Summer 1994): 22–48, as an exception to this paucity.

19 Karl Marx, *The German Ideology* (New York: International Publishers, 1947), 14. The view of ideology as mystifying but fundamentally multiple was contested by Louis Althusser, who saw the particulars of certain ideologies evident in certain social practices (i.e., religion) as funneling into 'an omni-historical reality,' whose structure and functioning was 'immutable' (*Lenin and Philosophy* [New York: Monthly Review Press, 1971], 161). As Greenberg saw the history of painting in terms of its struggle to separate its material practice from (the ideology of) its confusion with literature and other art forms, it is tempting to see his use of ideology as totalizing in Althusserian terms. The conflicted and by no means uniform attitude of both the Abstract Expressionists and the artists whom I am arguing in this book should be considered as a part of our historical understanding of that group, interestingly fits neither the humanist-Marxist nor the Althusserian description, but rather, supports recent critiques of Althusser's insistence on a monolithic and inescapable ideology as the basis of human action. Paul Smith and Diane Macdonnell, for instance, have contested Althusser's ideas in favor of multiple, conflicting belief systems that humans hold in contradiction and struggle, and that form the arenas in which human subjectivities are formed. For this latter view, see Paul Smith, *Discerning the Subject* (Minneapolis: University of Minnesota Press, 1984), and Diane Macdonnell, *Theories of Discourse: An Introduction* (Oxford: Basil Blackwell, 1986). For the intended subject matter of these artists, see William C. Seitz, *Abstract Expressionist Painting in America* (Cambridge: Harvard University Press, 1983), and Stephen Polcari, *Abstract Expressionism and the Modern Experience* (New York: Cambridge University Press, 1991).

20 Thomas Hess, *Barnett Newman* (New York: Walker and Company, 1969), 36. Willem de Kooning, in *Sketchbook I, Three Americans* (New York: Time Magazine, 1960), n.p. For Lassaw, see Marilyn Brown, introduction to *Alice Trumbull Mason, Emily Mason: Two Generations of Abstract Painting* (New York: Eaton House, 1982), 11; Ruth Abrams in Thomas Livesay, 'Essay,' *Ruth Abrams: Paintings, 1940 to 1985* (New York: Grey Art Gallery and Study Center, New York University, 1986), 12. Patricia Passlof, public interview at SoHo 20, New York City, 19 January 1990.

21 David Anfam, 'Interrupted Stories: Reflections on Abstract Expressionism and Narrative,' in *American Abstract Expressionism*, 21–39.

22 Serge Guilbaut, 'Postwar Painting Games,' in *Reconstructing Modernism*, and 'The Frightening Freedom of the Brush,' in *Dissent: The Issue of Modern Art in Boston* (Boston: Institute of Contemporary Art, 1985), 83–86.

23 Edwin Denby, 'The Thirties – Painting in New York' (New York: Poindexter, 1956), n.p. At the Museum of Modern Art Library, in the Willem de Kooning scrapbook, now published as 'The Thirties' in *Willem de Kooning* (New York: Hanuman Books, 1988), 51. These visual paradoxes registered in de Kooning's work, according to Denby, as 'the opposition of interchangeable centers, or a volume continued as a space, or a value balancing a color.'

24 As with Cubism, Greenberg wrote, 'It is the tension inherent in the constructed, re-created flatness of the surface that produces the strength of . . . art.' 'Art,' *Nation* 164 (1 February 1947): 137. See Donald Kuspit, *Clement Greenberg* (Madison: University of Wisconsin Press, 1979), 32, 44–45. This insistence was steered toward an emphasis on form alone by the appreciation of critics like Donald Judd for the work of Ad Reinhardt and Barnett Newman.

25 Harold Rosenberg, 'American Action Painters,' *Art News* 51 (December 1952): 23. For an important exception to the standard view that Rosenberg's interpretation of Abstract Expressionism was solely a kind of Americanized existentialism, see Fred Orton, 'Action, Revolution and Painting,' *Oxford Art Journal* 14, no. 2 (1991): 3–17. [Chapter 13.]

26 Barbara Cavaliere, 'Barnett Newman's "Vir Heroicus Sublimis"; Building the Idea Complex,' *Arts* 55 (January 1981): 144–152.

27 See Fred Orton, 'Footnote One: The Idea of the Cold War,' in Thistlewood, ed., *American Abstract Expressionism*, 179–192.

28 It surely is no coincidence that Sartre and Rosenberg were close friends; Sartre, who published Rosenberg's writing in *Les Temps Moderne*, would stay with the Rosenbergs when he was in New York in the forties. Author's interview with May Natalie Tabak, 19 April 1982, New York City. Michael Leja usefully cautions that existentialism's self-determined but pessimistic individualism was tempered in Abstract Expressionism by the fragmented but optimistic and essentialized self of Modern Man discourse. See *Reframing Abstract Expressionism*, 247. [Chapter 18.]

29 See, for instance, Greenberg in *Collected Essays and Criticism*, 2: 14, 75, 90, 123, 125, 127, 165–166, 170, 202–203.

30 See, for instance, Clement Greenberg, 'Review of an Exhibition of School of Paris Painters' (1946), in *Collected Essays and Criticism*, 2: 87–90.

31 Valerie Smith, 'Reconstituting the Image: The Emergent Black Woman Director,' in *Callaloo*, 34 (Fall 1988): 708–716.

32 Yet some of the work by noncanonical artists is as innovative on a formal level as that of their better-known peers. Janet Sobel, for instance, as Anna Chave has noted, was one of those who poured before Pollock. 'Pollock and Krasner: Script and Postscript,' *Res* 24 (Autumn 1993): 108–110. [Chapter 17.]

33 Emulating the 'primitive' as an escape from evils of modern society was by mid-twentieth century a staple in the avant-garde cupboard. See, for instance, Gill Perry, 'Primitivism and the "Modern,"' in Charles Harrison, Francis Frascina, and Gill Perry, *Primitivism, Cubism, Abstraction* (New Haven: Yale University Press, in association with the Open University, 1993), and Griselda Pollock, *Avant-Garde Gambits, 1888–1893: Gender and the Color of Art History* (New York: Thames and Hudson, 1992), esp. 8–12, 45–49, 70–73.

34 On the historical connections between literary assessments of originality and such

loss see Edward Said, 'On Originality,' 113–114, in *The World, the Text, and the Critic* (Cambridge: Harvard University Press, 1983).

35 A discussion of the literature on Abstract Expressionism's subject matter is beyond the scope of this chapter, but the topic has been influentially explored by a number of scholars. A selected list would include Rosalind Krauss, *Terminal Iron Works: The Sculpture of David Smith* (Cambridge: MIT Press, 1971); Judith Wolfe, 'Jungian Aspects of Jackson Pollock's Imagery,' *Artforum* 11 (November 1972): 65–73; Wayne Andersen, *American Sculpture in Process: 1930/1970* (Boston: New York Graphic Society, 1975); Barbara Cavaliere and Robert Hobbs, 'Against a Newer Laocoon,' *Arts* 51 (April 1977): 110–117; Mary Davis, 'The Pictographs of Adolph Gottlieb,' *Arts* 52 (March 1977): 141–147; Cavaliere and Mona Hadler in essays on William Baziotes in *William Baziotes: A Retrospective Exhibition* (Newport Beach, Calif.: Newport Harbor Art Museum, 1978); Robert Hobbs and Gail Levin, *Abstract Expressionism: The Formative Years* (New York: Whitney Museum of American Art, 1978); E.A Carmean and Eliza E. Rathbone, with Thomas Hess, *American Art at Mid-Century* (Washington, D.C.: National Gallery of Art, 1978); Elizabeth Langhorne, 'Jackson Pollock's *Moon Woman Cuts the Circle*,' *Arts* 53 (March 1979); 128–137; Donald Gordon, 'Pollock's "Bird,"' *Art in America* 68 (October 1980): 43–53; Harry Rand, *Arshile Gorky: The Implications of Symbols* (Montclair, N.J.: Allenheld, Osmun, 1980); Evan Firestone, 'James Joyce and the First Generation New York School,' *Arts* 56 (June 1982): 116–121; Robert S. Mattison, 'The Emperor of China: Symbols of Power and Vulnerability in the Art of Robert Motherwell in the 1940s,' *Art International* 25 (November–December 1982): 8–14; Anna Chave, *Mark Rothko's Subjects* (Atlanta: High Museum of Art, 1983); David Anfam, 'Clyfford Still' (Ph.D. diss., Courtauld Institute, 1984); Bonnie Clearwater, *Mark Rothko: Works on Paper* (New York: Hudson Hills Press, 1984); Bradford Collins, 'The Fundamental Tragedy of the *Elegies to the Spanish Republic*, or Robert Motherwell's Dilemma,' *Arts* 59 (September 1984): 94–97; Robert Lubar, 'Metaphor and Meaning in David Smith's *Jurassic Bird*,' *Arts* 59 (September 1984): 76–86; Donald Kuspit, 'Arshile Gorky: Images in Support of the Invented Self,' in *Abstract Expression: The Critical Developments* (Buffalo: Albright-Knox Art Gallery, 1987), 49–63; Robert Saltonstall Mattison, *Robert Motherwell: The Formative Years* (Ann Arbor: UMI Research Press, 1987); Mona Hadler, 'David Hare: A Magician's Game in Context,' Stephen Polcari, 'Adolph Gottlieb's Allegorical Epic of World War II,' and W. Jackson Rushing, 'The Impact of Nietzsche and Northwest Coast on Barnett Newman's Idea of Redemption in the Abstract Sublime,' *Art Journal* 47 (Fall 1988): 196–201, 202–207, and 187–195, respectively; Anna Chave, *Mark Rothko: Subjects in Abstraction* (New Haven: Yale University Press, 1989); Ellen Landau, *Jackson Pollock* (New York: Harry N. Abrams, 1989), Ann Gibson, 'Norman Lewis in the Forties,' *Norman Lewis: From the Harlem Renaissance to Abstraction* (New York: Kenkeleba Gallery, 1989); Cécile Whiting, ch. 6, 'Antinationalist Myths,' in *Antifascism in American Art* (New Haven: Yale University Press, 1989), 160–201; Matthew Wittkovsky, 'Experience vs. Theory: Romare Bearden and Abstract Expressionism,' *Black American Literature Forum* 23 (Summer 1989): 257–282; Michael Leja, 'Jackson Pollock: Representing the Unconscious,' *Art History* 13 (December 1990): 542–565; and Leja, *Reframing Abstract Expressionism*; Stephen Polcari, *Abstract Expressionism: A Critical Record* (New York: Cambridge University Press, 1990); David Craven, 'Myth-Making in the McCarthy Period,' in *Myth-Making: Abstract Expressionist Painting from the United States* (Liverpool: Tate Gallery, 1992), 7–45.

36 William C. Seitz, *Abstract Expressionist Painting in America* (Cambridge: Harvard University Press, 1983), 135–138, 130–135, 115–120, respectively. Seitz had discussed these points in 1955 in his Princeton doctoral dissertation, which was known and respected by a small audience of artists and scholars. Not until 1970, with the publication of Irving Sandler's *The Triumph of American Painting*, did a survey of these issues become available to a broader public.

37 Serge Guilbaut, *How New York Stole the Idea of Modern Art* (Chicago: University of Chicago Press, 1983). Some of Guilbaut's predecessors include Max Kozloff, 'American Painting During the Cold War,' *Artforum* 11 (May 1973): 43–54; William Hauptman, 'The Suppression of Art in the McCarthy Decade,' *Artforum* 12 (October 1973): 48–52; and Eva Cockroft, 'Abstract Expressionism, Weapon of the Cold War,' *Artforum* 12 (June 1974): 39–41. Also relevant are Jane de Hart Mathews, 'Art and Politics in Cold War America,' *American Historical Review* 81 (October 1976): 762–787; John Tagg, 'American Power and American Painting: The Development of Vanguard Painting in the United States since 1945,' *Praxis* 1: 2 (Winter 1976): 59–79; and David and Cécile Schapiro, 'Abstract Expressionism: The Politics of Apolitical Painting,' *Prospects* 3 (1977): 175–214. See also Annette Cox, *Art-as-Politics: The Abstract Expressionist Avant-Garde and Society* (Ann Arbor, Mich.: UMI Research Press, 1983). [See Chapters 6–11.]

38 More recent publications have exhibited some concessions, however; Michael Auping's exhibition and catalogue *Abstract Expressionism: The Critical Developments* (1987) included Lee Krasner among an otherwise all-male cast. David Anfam in his *Abstract Expressionism* also took Krasner into account, granting that by 1946 her allover composition was more audacious than Pollock's; he also accorded unaccustomed prominence to photographer Aaron Siskind and to sculptor David Smith (*Abstract Expressionism* [London: Thames and Hudson], 122–125). Stephen Polcari's full-dress examination of the historical and cultural sources of the subjects of Abstract Expressionist painting pays overdue attention to Lee Krasner and especially to dancer Martha Graham (*Abstract Expressionism and the Modern Experience* [Cambridge: Cambridge University Press, 1991]). David Craven's *Myth-Making: Abstract Expressionism from the United States* is the first survey exhibition of Abstract Expressionism to include the work and viewpoint of Norman Lewis (20). Michael Leja, in *Reframing Abstract Expressionism*, has not only considered Elaine de Kooning's work and artistic persona in relation to those of her husband, Willem, but also contextualized and critiqued a number of the concepts such as Abstract Expressionist individualism, heroism, and self-revelation, that I treat here. While our emphases and some of our purposes are different (I see aesthetic value as more relative than does Leja, and I am more concerned with the production of artists currently outside the canon), he engages in many of the same critical revisions that I attempt here.

39 For a discussion of the interpretation of meaning as a harmfully limited parameter for critical activity, see Barbara Herrnstein Smith, 'Contingencies of Value,' 5–39, in *Canons*, ed. Robert von Hallberg (Chicago: University of Chicago Press, 1984).

40 Some will recognize this as the approach suggested by Jacques Derrida, who felt that to be effective, one must aim not only to 'put into practice a reversal of the classical opposition' but also to effect 'a general displacement of the system.' 'Signature Event Context,' *Glyph* 1 (Baltimore: Johns Hopkins University Press, 1977), 195.

41 W.E.B. Du Bois, *The Souls of Black Folk* (Greenwich, Conn.: Fawcett Publications [1903], 1961), 16–17.

42 Robert K. Martin, 'Reclaiming Our Lives,' in *The Christopher Street Reader*, ed. Michael Denney (New York: Putnam, 1983), 249; see also Theresa de Lauretis, *Technologies of Gender* (Bloomington: Indiana University Press, 1987), 10.

43 Anne Wagner, 'Lee Krasner as L. K.,' *Representations* 25 (Winter 1989): 42–57; Mona Hadler, 'The Art of William Baziotes' (Ph.D. diss., Columbia University, 1977), 143–154.

44 Judith Wilson, 'Hale Woodruff: "Go Back and Retrieve it,"' in *Selected Essays: Art and Artists from the Harlem Renaissance to the 1980s* (Atlanta: National Black Arts Festival, 1988), 41–52. Sanford Hirsch, 'Adolph Gottlieb's Pictographs,' in *Adolph Gottlieb: The Pictographs, 1942–1951* (Los Angeles: Manny Silverman Gallery, 1992), 13, n. 2.

45 Arshile Gorky, Hans Hofmann, Willem de Kooning, and Philip Guston were born outside the United States; William Baziotes and Ad Reinhardt were sons of immigrants; Adolph Gottlieb, Philip Guston (originally Goldstein), Barnett Newman, and Mark Rothko were Jewish; and Robert Motherwell, Jackson Pollock, and Clyfford Still were all from the West Coast.

46 Exceptions to this include Ellen Landau, 'Sie waren der gleichen Auffassung,' in *Lee Krasner–Jackson Pollock: Dialogues d'artistes resonances* (Berne: Künstmuseum Berne/Musée des Beaux Arts de Berne, 1989–90), 71–92, and Romare Bearden and Harry Henderson, *A History of African–American Artists* (New York: Pantheon Books, 1993).

47 Crowds, infuriated by rumors that a white policeman had killed a black soldier who was defending his mother, broke windows and looted and burned stores on Seventh and Lenox Avenues. See Dominic J. Capeci, Jr., *The Harlem Riot of 1943* (Philadelphia: Temple University Press, 1977), 100–102.

48 Both Gertrude Barrer (15 December 1988), Roxbury, Conn., and poet-painter Elise Asher (18 June 1988), New York City, made such observations in interviews with the author.

49 Lowery Sims, 'In Search of Wifredo Lam,' *Arts* 63 (December 1988): 54.

50 See, for instance, Patricia Hill Collins, 'The Social Construction of Black Feminist Thought,' *Signs* 14: 4 (1989), 745–771, esp. 757–758, and bell hooks, *Talking Back* (Boston: South End Press, 1989), chs. 7 and 8. Donald Webster Cory extended the observation to 'the homosexual problem' in *The Homosexual in America* (New York: Greenberg, 1951), 39. For a discussion of the impact of such observations, see Toby Marotta, *The Politics of Homosexuality* (Boston: Houghton Mifflin, 1981), 6.

51 I hasten to add that this book is not an institutional history of Abstract Expressionism, though institutional histories in general are long overdue in the field of art history. The best book in this area for Abstract Expressionism is A. Deirdre Robson, *Prestige, Profit, and Pleasure: The Market for Modern Art in New York in the 1940s and 1950s* (New York: Garland, 1995). [See Chapter 14.]

Anna C. Chave

POLLOCK AND KRASNER
Script and postscript

THE VENERABLE LEGEND OF Jackson Pollock, that oft-told American tale, is the story of a taciturn, 'hard-drinkin' . . . farmer's son from Cody, Wyoming' who 'rode out of the Mid-West to put citified art to rights' with his sweeping lariats of paint.' This tough 'bronco-buster of the art world' has lately suffered some slights to his manhood, however.² With the closer scrutiny of Pollock afforded by a rash of recent biographies, the maker of the famed and defamed poured and dripped paintings has unexpectedly emerged as a vulnerable and even sexually confused figure.³ As for his spouse, Lee Krasner, her image also has been subject to revision. Once dismissed as an inconsequential figure, dwarfed by Pollock's formidable stature, she has since been touted both as a worthy artist and as the mastermind behind her husband's immense success. No less an authority than Clement Greenberg (who himself could have laid claim to engineering Pollock's rise) has declared that 'for his art she was all-important, absolutely,' while the dealer John Bernard Myers asserted, 'There would never have been a Jackson Pollock without Lee Pollock and I put this on *every level*.'⁴ Such assessments of Krasner's influence often carry a derisive edge, however, as when the painter Fritz Bultman referred to Pollock as Krasner's 'creation, her Frankenstein,' adding 'Lee was in control toward the end and very manipulative.'⁵

This matter of control – the fact that, by all accounts, Krasner was a deeply controlling person while Pollock was chronically veering out of control – is a crucial factor in the work as in the lives of both these artists. The way Barbara Rose narrated the story of the couple's 'working relationship' (as she was first to do), he was her creation from the outset: when Krasner and Pollock met in 1942, she was a smart, well-connected New Yorker whose intensive studies at Hans Hofmann's school had brought her au courant with events in the Paris vanguard, while he was a misfit hick who – having separated himself with difficulty from his mentor, that self-styled

Source: *Res* 24, Autumn 1993, pp. 95–111. The original included eight illustrations all of which have been omitted.

hillbilly painter and archenemy of modernism, Thomas Hart Benton – was adrift and consumed by doubt. Pollock's engagement with the work of such comparatively marginal figures as Benton and the Mexican muralists had left him groping for a language to articulate the social content and the mythic dimension of art. Krasner's training had brought her, by contrast, a sure command of the idioms of cubism and the School of Paris. As Rose portrayed it, then, Krasner had to catechize Pollock in the dominant tenets of modernism.[6]

If Krasner enjoyed some initial advantage in the studio, it proved evanescent, for her encounter with Pollock caused her to question so severely what she knew about making art that between 1942 and 1945 she did not complete a single painting.[7] Subsequently, she developed a convincing facility with various New York School idioms, beginning with that of Pollock, as she created a group of her own poured and dripped 'all over' pictures between 1946 and 1949. It followed that Krasner was reflexively identified as Pollock's wife and described by the press in solicitous but inaccurate terms as 'an artist in her own right.' In fact, she never could nor would decouple herself from Pollock. Whereas he prevailed in the studio, however, it appears that there were ways in which she prevailed at home: visitors describe how the more urbane and cultivated Krasner was forever 'educating' or improving her spouse, the uncouth high school dropout.[8]

To hear his biographers tell it, the cause of Jackson Pollock's deep feelings of inadequacy was less his limited formal education than the immense difficulty he had in mastering his craft. The consensus about Pollock within his family is that he never really did learn how to draw – not like his eldest brother, Charles, a wondrously adept draughtsman. Classmates from the Art Students League likewise remember that no matter how diligently he applied himself to drawing, Pollock never really measured up. This trouble with drawing impeded his progress in painting and caused him terrible frustration. A psychoanalyst he consulted during his early years in New York related that 'at first his main preoccupation and sorrow was not being able to paint and paint as he wanted to.'[9]

Pollock did eventually learn to draw: his sketchbooks from the late 1930s, when he was engrossed with the art of Michelangelo and El Greco, then of the Mexican muralists, and then of the Picasso who painted *Guernica*, are often riveting. But what is of interest here is his peers' estimation; and even after Pollock emerged as a leader of the New York School, they remained skeptical of his basic abilities. Robert Motherwell reportedly 'was always bragging that Pollock couldn't draw,' and Franz Kline went around at the reception following Pollock's funeral (in 1956) telling anyone who would listen, 'Say what you want, he couldn't paint' (ibid., pp. 127, 260). According to his family and friends, Pollock was inept not only at drawing but at practically everything he undertook: he couldn't dance or play an instrument; he didn't read easily; he had great difficulty speaking, unless he had had too much to drink (in which case he wasn't always lucid); and he plainly couldn't hold his liquor. So pathetic was Pollock in the conduct of his daily affairs that 'he felt he couldn't go to the station and buy a ticket for himself,' as Greenberg described it.[10]

What is at issue here is not Pollock's troubles at the ticket office but his difficult relation to languages, both visual and verbal: his perceived and self-perceived ineptitude with a pencil and brush and his no less remarked infacility with words. The small body of letters and writings that Pollock left behind is riddled with incomplete

and ungrammatical sentences made up of misspelled and misformed words. 'It is of the utmost difficulty that I am able to write – and then only miles from my want and feeling,' a distressed Pollock once lamented to his mother.[11] And a psychoanalyst who treated the artist has revealed that she was hindered by his being an intractably 'inarticulate personality.'[12] Even his wife found him ' . . . very closed mouth. I practically had to hit him to make him say anything at all.'[13] This silence was to become an indelible part of the Pollock melodrama: 'He left silent as he came,' pronounced a friend, 'It was phenomenal, that silence.'[14]

If Pollock was as tongue-tied and as ham-fisted as legend has it, then the question must be asked: How did he succeed in making his presence felt at all, let alone to the remarkable extent that he did? What his biographers now tell us is that his wife contrived to speak for him, that she 'became Jackson's voice, corresponding with his relatives, making his phone calls, even speaking his thoughts.'[15] His close friend, the painter Alfonso Ossorio, observed 'Someone had to speak,' so she did the talking.[16] And while Krasner was busy putting words in Pollock's mouth, others reportedly helped him put words on paper, ghostwriting some of his few public statements.[17] Pollock once protested to his dealer, Sidney Janis, that 'to attempt explanation' of his art 'could only destroy it'; but Janis pressed him anyway to title rather than number his pictures.[18] Knowing that titles facilitated marketing his difficult paintings, Krasner and others regularly helped to title them.[19] Not only did Pollock resist naming his most radically abstract pictures, he also hesitated signing them. But signatures also aided picture sales, so Krasner not only urged the artist to sign his work but allegedly had his signature forged on some unsigned work after his death to enhance the value of the estate, of which she was the sole beneficiary.[20]

If Pollock was such a hapless figure and Krasner was such a crafty woman as one is led to believe, then another question begs to be asked: Why couldn't Krasner do for her own career what she evidently did for Pollock's; or what can account for the huge discrepancy in their reputations? Some feminist critics would argue that the best answers to this question lie with the discriminatory behavior of critics, dealers, and collectors toward women artists in general, and with the sexism rampant in the precincts of the New York School. Krasner's art probably would have been taken more seriously had she been a man; what undid Lee Krasner was perhaps not merely her sex but her success at painting like a man – or rather like a succession of men, from Matisse and Picasso to Pollock and Motherwell. By contrast, what finally made Pollock such a compelling figure was in a sense his success at painting like a woman – or, more precisely, at assuming what might be called a 'transsexuating' role as an artist. The contrast, in other words, is that between a female artist who, over the course of a long career, demonstrated her knowledge of a range of modernist languages, with their difficult, hermetic parts of speech, and a male artist who is persistently associated (as women more typically are) with a state of nonknowledge, wordlessness, and incoherence. To her feminist partisans, Krasner's command was all to her credit, but others reacted more skeptically to the specter of that oxymoronic being, a female master. Said Greenberg dismissively, 'I don't think Lee was much of a painter – all brass and accomplishment' – as if accomplishment were some sort of liability; and Le Corbusier snidely adjudged of Pollock and Krasner: 'This man is like a hunter who shoots without aiming. But his wife, she has talent – women always have too much talent' (ibid., pp. 139, 200).

Whether Pollock aimed when he shot, the extent to which he exerted control, has always been a matter of some dispute. The painter was highly sensitive about this matter – sensitive in part, no doubt, because unloading a brush, like shooting a gun, has sexual connotations. That Pollock made his art through a series of 'explosions' is a standard locution in descriptions of his technique, with all its sexual implications. The photographer Hans Namuth recalled 'the flame of explosion when the paint hit the canvas; . . . the tension; then the explosion again.'[21] The critic William Feaver less euphemistically envisioned the artist 'casting paint like seed . . . onto the canvas spread at his feet. This was no sissy. . . . It was, demonstrably, the real thing . . . painting composed of . . . manly ejaculatory splat.'[22] And *Time* magazine suggestively related that his friends had seen Pollock 'emerge from the studio limp as a wet dishrag' with 'a cigarette smoldering on his lip.'[23]

Pollock's own account of his working process was likewise sexually imbued. When he began the poured paintings, he reported happily: 'I'm just now getting into painting again, and the stuff is really beginning to flow. Grand feeling when it happens.'[24] He talked also of experiencing a kind of ecstasy or loss of the boundaries of self when he worked: 'I can . . . literally be *in* the painting. . . . When I am *in* my painting, I'm not aware of what I'm doing.'[25] The image this evinces, of a painter ejaculating in the body of his picture, is suggested in a particularly graphic way by the painting called *The Deep* of 1953, with its abstractly vaginal slit; but a rhetoric of potency and virility is rife in discussions of all of Pollock's art – surely fostered in part by the famous film footage that shows the intensely rhythmic movements of his body, and of his flowing sticks and syringes, over the canvas spread beneath him on the floor.

That implements of painting, drawing, and writing are phallic symbols, one may take, of course, from Freud, or from less exalted sources.[26] And the masculinist ideal of the great painter as one who, as Renoir is supposed to have coarsely put it, 'paints with his prick' helped reinforce the legend of Jackson Pollock in a way it could never do for his wife: although Lee Krasner also poured paint for a time, the critics would never think to credit her with the potency to have ejaculated it. And what flows from a woman's body – with its lack of that putatively crucial, anatomical equivalent to the brush or pen – is tacitly understood to be less subject to control, more vulnerable to happenstance or accident, than the flows of the male body. The key question for critics in Pollock's case, then – a question that became tantamount to a test of manhood – was whether, or to what extent, he could control the flow of paint on the canvas, and so control the image. *Life* magazine sneered that Pollock 'drools' and 'dribbl[es]' paint, evoking the involuntary flows of the body of an infant or moron; and the association of his painting practice with basic bodily functions was underlined more recently by Steven Naifeh and Gregory White Smith, whose celebrated biography makes much of the artist's engrossment with urination.[27] For years, the most repeated anecdote about Pollock was of his urinating in a fireplace at a party. And some have described him as being chronically out of control of all that flowed into and out of his body: when Jackson got drunk, one friend remembered, 'All he did was spit, drool, sneeze, cough, snot and piss. He was a mess, a real pain in the ass.'[28]

The years when Pollock made most of his greatest paintings, from 1947 to 1950, are in fact the years when he had his alcoholism most in check; and he

reportedly made it a rule not to paint when drunk in any case. But hostile critics have all along insinuated that Pollock's poured pictures are merely the damning evidence of his lawless behavior. Declared an Italian critic: 'It is easy to detect the following things in all of [Pollock's] paintings: Chaos. Absolute lack of harmony. Complete lack of structural organization. Total absence of technique, however rudimentary. Once again, chaos.'²⁹

Not only Pollock's poured paintings but even his prior, technically more conventional work, such as *Stenographic Figure* of 1942, looked to critics like, to take a representative phrase, 'a chaotic tangle of broad lines, wiry lines, threads and speckles . . . What it means, or intends, I've no idea.'³⁰*Stenographic Figure* could be seen as bearing a loose relation to Picasso's *Painter and Model* of 1928, replete with its palette of primary colors, black, white, and gray. But while Picasso's rigidly outlined artist neatly limns a naturalistic profile of his sitter's face, Pollock's artist is like a comical clerk spewing a ream of numbers, letters, and cryptic marks that careen off his paper and settle like flies all over the surface of the picture. Something about those garbled, frenzied marks began to attract a sensitive viewing public, however; and buoyed by the positive response to this picture – from such well-placed figures as Piet Mondrian, Peggy Guggenheim, and the reviewer for the *New Yorker* magazine – Pollock kept on writing. After 1942, his pictures increasingly looked like tablets inscribed, in whole or in part, with obsessive jottings and marks, until he finally lifted his paintbrush from the canvas, unrolled the fabric on the floor, and let his script flow freely with the movements of his hand, arm, and body.

Jackson Pollock's classic poured and dripped paintings evince complex manuscripts or palimpsests covered by a snarled, alien script. That script also may recall the physicalized and sprawling scribbles of the preliterate child who tries to produce handwriting by furiously willing a legible text onto a page. For that matter, Pollock generally felt as small children often do: excluded from language and ill-served by speech. Although many critics read his vigorous script as a manly affirmation of potency, that same script could be read instead as an aggrieved and urgent admission of impotence. In Jacques Lacan's rewriting of Freud, where language is identified with the almighty phallus, feelings of inadequacy in relation to language are symptoms of castration – a state that men and women necessarily, although unequally, share insofar as we are all 'inevitably bereft of any masterful understanding of language, and can only signify ourselves in a symbolic system that we do not command, that, rather, commands us.'³¹

The notion that Pollock's distinctive scrawl was merely childlike and random was something that always rankled the artist. 'I can control the flow of the paint,' he insisted, 'there is no accident.'³² When, in 1950, *Time* magazine headlined an article on Pollock 'Chaos, Damn It,' the painter testily cabled back: 'NO CHAOS DAMN IT. DAMNED BUSY PAINTING.'³³ Yet drips are an index of accidents in Western culture; and the space that Pollock unremittingly left between the end of his brush or stick and the surface of his canvas was ineluctably the space of accident, of a loss or surrender of control. (This space is what decisively separates Pollock from the Surrealists, moreover, whose concept of automatic writing and the controlled accident had helped encourage him to liberate his line, and what separates him also from artists like Mark Tobey, Cy Twombly – or Krasner, for the most part – who retained the role of, and the control of, the renderer in creating their calligraphic pictures.)

To a significant extent, refusing control, as Pollock did, meant refusing the authority of craft – refusing mastery.

That the poured paintings are never purely random or chaotic, that they could never have been done blindfolded, for instance, is plain enough to an attentive viewer. What attests to the pictures' manipulated character is the range of gestures, from broad to tight, lilting to tense; the measured degree of density to the webs of lines; the varied ordering or layering of the (however limited) palette of colors; the nuances in the viscosity and refractive properties of the diverse types of paint; and, in many cases, the artist's attention to keeping the majority of his meandering paint skeins within the borders of the canvas. For Pollock, then, the pressing question was not whether he could maintain any control but how much control he ought to exert, or whether the real test of his mettle might be the extent to which he permitted himself to let go in spite of the critics' taunts.

Jackson Pollock's radical painting practice might be said to represent a freedom, the taking of a freedom, which was practically political in its dimensions.[34] The lawlessness these pictures evince becomes especially pronounced, however, when we contrast Pollock's full-bodied and expansive script with the cramped and involuted script produced by Krasner in the late 1940s. Krasner produced her postscript to Pollock's script – the diminutive 'Little Image' series – in the small upstairs bedroom of the couple's farmhouse while Pollock was making monumental pictures in the capacious barn in the back.[35] Rose insists that 'the decision to work small and retain maximum control was her own,' but she adds that Krasner was not 'psychologically free enough to let go.'[36] What helped to keep her enchained was no doubt her self-appointed role of serving as Pollock's voice, a role that must have impeded her developing a distinct voice of her own. Commented Arthur Danto, 'There is no recurrent touch, or whatever may be the pictorial equivalent of voice, in Krasner's canvases'; there is only 'the echo of other voices' – chiefly, while he lived, that of Pollock.[37]

In endeavoring to empower Pollock, then, Krasner wound up disempowering herself. Presumably, she would not have endured that sacrifice for just anyone: there was something about Pollock's art that she deeply identified with, something that seemed to stymie and even to displace her own production, almost as if, while she was busy talking for Pollock, Pollock was painting for her. 'I had a conviction, when I met Jackson, that he had something important to say,' she explained after his death. 'When we began going together, my own work became irrelevant. *He* was the important thing.'[38] Naifeh and Smith detect an insidious pattern in the couple's relationship: as long as his work went well, hers tended to go badly, and vice versa – the exception being this moment between 1946 and 1949 when she succumbed to his influence and began to make something like 'Pollocks.'[39] But Krasner's Pollocks were Pollocks with a difference: where his script was free and fluid, hers was constricted, congested, obsessive. To deride a picture like *Continuum* of 1947–1949 [CR 236] as 'derivative,' in the usual way, then, is to ignore its distinct charge and to miss its intense affectivity. Although she was using Pollock's language, Krasner was making something other than Pollocks: an image less of rampant lawlessness than of rampant order – an order, like that of cancer cells, turned in on, replicating, and consuming itself.

Pollock liked to talk about how well a painting was going in terms of the ease of

the 'flow': 'When I'm working, working right, I'm in my work so outside things don't matter – if they do, then I've lost it. That happens sometimes, I guess because things get in the way of the flow' (Potter, *To a Violent Grave*, p. 129). But if flow and freedom were what counted most to Pollock, 'flow' is important to everyone else, too. 'Human beings live in, and on, flows,' Klaus Theweleit observes. 'They die when streams dry up.'[40] In his pioneering study of *Male Fantasies*, Theweleit dwells on the significance of the flow; and although he focuses on a population remote from the New York School – namely, professional soldiers in Germany between the wars (including some who went on to help form the core of Hitler's *Schutzstaffe*) – many of the discursive and symbolic formations he describes plainly overreach their immediate context. Freud's writing was rife with the imagery of fluid mechanics. He visualized the libido, more specifically, as 'a flow that must be regulated' – so notes N. Katherine Hayles in her insightful study of gender encoding in the science of hydraulics with its paradigmatically 'masculine channels and feminine flows' and its longstanding difficulty in accounting for the dynamics of turbulent flow.[41] In the population Theweleit studied, flows likewise were associated predominantly with the female body and, as such, considered repugnant and even dangerous; for what flows may escalate into a flood.[42] The dissident Lacanian theorist Luce Irigaray observed that the most dangerous floods identified with women are those related to childbirth and the body of the mother: fluids 'threaten to deform, propagate, evaporate, consume him [the male subject], to flow out of him and into another . . . The "subject" . . . finds everything flowing abhorrent. And even in the mother, it is the cohesion of a "body" (subject) that he seeks . . . Not those things in the mother that recall the woman – the flowing things.'[43]

In the early 1930s, Pollock conjured a nightmarish image of a kind of devouring mother dominating a row of five cowering, emaciated men (Pollock, *Woman*, ca. 1930–33). This picture begs to be examined in a biographical light in view of the fact that Pollock, the fifth of five sons, had a dreadful birth, during which he was nearly strangled to death by his own umbilical cord.[44] As an adult, Pollock is said to have had a very disturbed relation to the forceful woman he occasionally referred to as 'that old womb with a built-in tomb.'[45] He told Krasner that he sometimes 'had trouble working because the idea, or the image, of his mother came over him so strongly that he'd see her,' and his pictorial flows became dammed (as related by Cile Downs, in Potter, *To a Violent Grave*, p. 204). Alluding to a productive period of painting he enjoyed in 1950, Pollock once told a friend: 'Last year I thought at last I'm above water from now on in – but things don't work out that easily I guess.'[46]

Critics typically associate Pollock's flows not with the engulfing floods of the female body but with masculine streams of urine and semen. Semen attests to the presence of desire; and the Freudian image of desire as a flow has lately been reshaped by Gilles Deleuze and Félix Guattari, for whom 'the unconscious is a flow and a desiring machine' (Theweleit, *Male Fantasies*, vol. 1, p. 255). Because sexuality and love 'dream . . . of wide-open spaces and cause strange flows to circulate that do not let themselves be stocked within an established order,' further, that machine is implicitly revolutionary.[47] Under patriarchy, 'the work of domination has consisted in subjugating, damming in . . . [while the] desiring-production of the unconscious has been encoded as the subjugated gender, or femaleness,' Theweleit suggests. As he describes it, then, the subversive errand of Deleuze and Guattari is to take

Freud's mandate for human development – 'Where id was, there shall ego be' – and reverse it, demanding: 'Where dams were, flowing shall be.' Concludes Theweleit, rather than sublimation, 'a different process is applauded here: dive right in, be dissolved, become nameless – and not just in a regressive sense. What is seen here is a breaking out, a crossing of boundaries to discover . . . new streams, . . . [and] deterritorializations' (ibid., pp. 432, 270).

Jackson Pollock's impossible aim was to paint 'out of [the] unconscious,' as he famously put it.[48] Many critics have sensed that the artist's rawest feelings flowed through his streams of paint – the feelings of a man who confessed he sometimes felt as if he were 'skinned alive'; felt like 'a clam without its shell.'[49] Pollock tried to assuage that pain with the 'grand feeling' he got when 'the stuff is really beginning to flow'; tried, in effect, to dissolve himself in his work – work he wished to leave unnamed and unsigned. Pollock had some dephallicizing impulses, in other words, toward abnegating the role of the author. (As for Krasner, she did not enjoy the prerogative of renouncing the position of authority that she was largely precluded from assuming in the first place, both due to her gender and because she was not the originator of the language she used.)[50] For Pollock, it followed that becoming a public name or figure, even *the* public face of contemporary art, proved a deeply troubling experience. After being featured in a story in *Life* magazine in 1949, he reflected that once *Life* had finished with one of its subjects, 'You're not your own anymore – maybe more, maybe less. But whatever the hell you are after that, you're not your you.' And as for the film of Pollock made by Namuth in 1950, it made him think that 'maybe those natives who figure they're being robbed of their souls by having their images taken have something';[51] and it also triggered his return to drink in a violent break from several years of sobriety.

Jackson Pollock hated being objectified, in short, and that aversion was in a meaningful way continuous with his distinctive mode of painting. What distinguishes Pollock's work from almost all other art before it is not merely that he poured paint on canvas but that he kept those streams of paint from forming pools or bodying shapes or objects, and so configuring a composition. Theweleit observes that 'flows have no *specific* object. The first goal of flowing is simply that it happen (and only later that it seek something out).'[52] What Pollock's flows generated might be termed a kind of decomposition, with streams of paint running more or less evenly all over the picture surface; there is no center in his paintings, no one area pre-dominating over others. This refusal to allow discrete pictorial territories to develop on his complex road maps, a resistance to borders or outlines, might be said to render Pollock's pictures exercises in 'deterritorialization,' in a process of destruc-turing and dehierarchization. This is, in a sense, what critics alluded to when they remarked on the 'complete lack of structural organization' in Pollock's art and its 'abnegation of all composition in the traditional sense.'[53] Critics generally refer to this radical painting mode as 'all-over painting,' yet no one has noted that idiom's double meaning: 'all over' means not only 'everywhere' but 'finished,' which is precisely what Pollock's art would signify to many: that European modernism was finished – or even that painting itself was all over. As de Kooning bluntly put it: 'Every so often a painter has to destroy painting. Cézanne did it. Picasso did it with cubism. Then Pollock did it. He busted our idea of a picture all to hell.'[54]

Pollock created pictures that many viewers could not recognize as pictures at

all; pictures substituting chaos – albeit a painstakingly manufactured chaos – for composition. Remarked the sculptor Constantine Nivola: 'The French would say of de Kooning, "As painting, we can recognize this." Of Pollock, "*This* is not painting! Only in America could it happen"' (Potter, *To a Violent Grave*, p. 221). Through the nonsensical graffiti with which he covered his pictures, Pollock perpetrated a kind of willful defacement or erasure of established pictorial languages. At first he had hoped to master those languages; but the established canon admitted no American masters, and Pollock wished to be a great American artist, the first to paint on, or to paint, the tabula rasa of American culture. Less drawn to the Metropolitan Museum than to the Cedar Bar, Pollock was 'very mad at civilization,' observed a friend who witnessed some of his drunken sieges;[55] and that roiling anger finally placed him in a different relation to the canon from his wife, who would never shed the role of acolyte in the church of high culture. While Krasner endeavored from the first to insinuate both herself and Pollock into a high cultural frame, Pollock was toiling away in Krasner's own backyard at leveling that very frame and projecting in its stead an image of the unframed or the void.[56]

The effect of Pollock's classic poured and dripped paintings is often cosmic or oceanic, like the infinity of the universe as inscribed by the constellations and the seeming infinity of the ocean as marked by the repetitive patterns of the waves – an effect underscored by some of the titles he approved, such as *Galaxy, Comet, Reflection of the Big Dipper, Full Fathom Five*, and *Sea Change*. The extreme open-endedness of Pollock's paintings – not only the fact that the most impressive of them cover a relatively vast expanse but the way there seems to be no end to the patterns that form the pictures – was a feature that troubled some critics, but that the artist himself especially valued.[57] The sense that Pollock's predominantly horizontal paintings give, of going on and on while going nowhere in particular (as they lack any notable landmarks), may well relate to his intense feeling for the American landscape, especially the boundless, open spaces of the West – the memory of which he managed to recapture in the East in the presence of the ocean.[58] 'There is in Pollock some fundamentally American quality,' declared the cultural historian Leslie Fiedler, 'so that I think of him along with Huckleberry Finn and Jay Gatsby; a "heart-of-the-heart-of-the-country" American. This is because of the contempt he had for boundaries.'[59]

Pollock was often asked if, as an artist, he didn't need or want to go to Europe. He replied impudently, 'Hell no. Those Europeans can come look at us' (Landau, *Jackson Pollock*, p. 266), knowing full well that the proverbial New World was widely regarded by Europeans as a gaping cultural hole. Before World War II, 'absolutely no one thought American painting could rival French painting, then or ever,' recalled Lee Krasner.[60] If Europe represented the center of cultural authority and knowledge – the Father, metaphorically speaking – the New World represented the Mother, in all her nonknowledge and relative lack of authority or presence.[61] Pollock's painting, in its attempt to describe 'unframed space' (as Krasner phrased it), and in its act of destructuring and decentering, may in a sense be seen as an attempt to visualize the void, the hole, the Mother.[62]

Alice Jardine has suggested that 'we might say that what is generally referred to as modernity, is precisely the acutely interior, unabashedly incestuous exploration of these new female spaces: the . . . exploration of the female, differently maternal

body.'[63] Further, 'Over the past century, those master (European) narratives – history, philosophy, religion – which have determined our sense of legitimacy in the West have undergone a series of crises in legitimation'; and that crisis has propelled a radical rethinking, marked by a rejection of

> Anthropomorphism, Humanism, and Truth. . . . In France such rethink-ing has involved, above all, a reincorporation and reconceptualization of that which has been the master narratives' own 'nonknowledge,' what has eluded them, what has engulfed them. This other-than-themselves is almost always a 'space' of some kind (over which the narrative has lost control) and this space has been coded as *feminine*, as woman.
>
> Jardine, pp. 24–25

The task undertaken by some contemporary theorists, as Jardine describes it, then, is 'the putting into discourse of "woman",' that is, of the master narratives' absent term (ibid., p. 25). But feminist critics are not completely sanguine about these new roles that male theoreticians have been positing for women. Gayatri Spivak observes that throughout Jacques Derrida's critique of phallocentrism, he 'asks us to notice that *all* human beings are irreducibly displaced although, in a discourse that privileges the center, women alone have been diagnosed as such; correspondingly, he attempts to displace all centrisms' while using woman as 'the "model" for deconstructive discourse.' Spivak criticizes Derrida's 'desire to usurp "the place of displacement"' thereby, in effect, doubly displacing women; and she writes insinuatingly of 'the male appropriation of woman's voice.'[64]

Returning to Pollock: one might see how, in his tacit assumption of the position of the woman – the decentered and the voiceless, the one who flows uncontrollably, the one who figures the void and the unconscious – he remained, on some level, a man using his masculine authority to appropriate a feminine space.[65] In fact, one woman had tried to articulate that space before Pollock did, in a similar way – not Krasner but Janet Sobel, who made poured, all-over compositions that unmistakably made an impact on Pollock (Sobel, *Untitled*, ca. 1946). Greenberg recalls that 'Pollock (and I myself) admired [Sobel's] pictures rather furtively' at the Art of This Century gallery in 1944; 'The effect – and it was the first really "all-over" one that I had ever seen . . . – was strangely pleasing. Later on, Pollock admitted that these pictures had made an impression on him.'[66] When Sobel is mentioned at all in accounts of Pollock's development, however, she is generally described and so discredited as a 'housewife,' or amateur, a stratagem that preserves Pollock's status as the legitimate and unique progenitor, both mother and father of his art, a figure overflowing not only with semen but with amniotic fluid.[67]

What separates Pollock's work definitively from Sobel's is the heroic scale his pictures sometimes assumed and the relatively free flow of his paint. As for Krasner's all-over pictures, her postscript to Pollock's script looked less like Pollock than like something else: like the compressed and chilling record of one woman's strangled speech. If, in some sense, Pollock and Krasner both were struggling to get 'Out of the Web' (to take the title of a painting of 1949 by Pollock), he alone managed to leave his webs open enough on occasion to offer glimpses of escape. Krasner's sense of being bound or trapped emerged not only in her tightly closed

webs, however, but in her career-long practice of obsessively reworking, cannibal-izing, and demolishing her work: 'Jackson never destroyed his work the way I do,' she noted. 'If he had things that didn't come off, he'd put them aside for later consideration.'[68] Observed another artist and artist's wife, Elaine de Kooning, Krasner became 'kind of the opposite of competitive with Jackson. She wiped herself out.'[69]

Jackson Pollock's pictures are often described as exalting the freedom of indi-vidual action and expression and, by comparison with Krasner's constricted pic-tures, they surely appear to. Yet the freedom in question in Pollock's art was, in a sense, a freedom to express frustration. As the painter George McNeil put it, 'The freedom with which Pollock painted then, that was great. Everybody was changed by his work . . . he was able to project his frustrations – his work came from this' (ibid., 100). Pollock's script had better be read not simply as an affirmation of freedom, then, but also as an image of the frustration that triggered that affirmation. Observed a doctor friend of Pollock's: 'I think Jackson was trying to utter some-thing . . . There's an utterance there, but it's a lot like trying to understand brain-damaged people or those with an autistic or dyslexic factor, or psychotics' (ibid., 177). Although Pollock wrote and wrote in his art, his script was never lucid, never legible. But that Pollock's art would 'stop making sense' may be construed not as the babbling of a helpless fool, but as an artist's ingenious way of testifying to the failure of writing, or painting and drawing, to represent experience; or as a material protest against the poverty of received modes of communication.

'The threads of communication between artist and spectator are so very tenu-ous' in Pollock's work, one critic commented, that 'there are times when com-munications break down entirely, and, with the best will in the world I can say of such pieces as "Lucifer," "Reflection of the Big Dipper," and "Cathedral" only that they seem mere unorganized explosions of random energy, and therefore meaning-less.'[70] The significance of Pollock's tangled script lay elsewhere, however – not in its communicativeness but in the act of writing itself. 'What is at stake in writing,' the critic Barbara Johnson observes, 'is the very structure of authority itself,' as writing is a form of control. And whereas the graphocentric, logocentric logic of Western society 'has been coded as "male", the "other" logics of spacing, ambiguity, figuration, and indirection are often coded as "female",' such that a critique of graphocentrism and logocentrism 'can enable a critique of "phallocentrism" as well.' In the history of modern literature, the writer who is credited with introducing space or spacing into reading is Stéphane Mallarmé, who gave 'a signifying function to the materiality – the blanks, the typefaces, the placement on the page, the punctuation – of writing.'[71] In the history of art, Jackson Pollock, the vaunted 'action painter,' achieved something comparable, not only in forgoing the represen-tational function of drawing but in letting the action of and the spacing of lines on canvas alone be his image.

'To act . . . to produce upon many a movement that gives you back the feeling that you originated it, and therefore exist: something no one is sure of,' wrote Mallarmé in a text called 'Action Restrained':

> . . . to send a force in some direction, any direction, which, when countered, gives you immunity from having no result . . .

Your act is always applied to paper; for meditating without a trace is evanescent, nor is the exalting of an instinct in some vehement, lost gesture what you were seeking.

To write—

The inkwell, crystalline like consciousness . . .

You noted, one does not write, luminously, on a dark field; the alphabet of stars alone does that, sketched or interrupted; man pursues black upon white.

This fold of dark lace, which retains the infinite, woven by thousands, each according to the thread or extension unknowing a secret, assembles distant spacings in which riches yet to be inventoried sleep.[72]

Remarks Johnson, 'Mallarmé is here suggesting that action cannot be defined otherwise than as the capacity to leave a trace – a written trace, a trace not of clarity but of darkness. It is with his obscurity, his nonknowledge, that man writes, and the poet's duty is to stand as guardian of an ignorance that does not know itself, an ignorance that would otherwise be lost' (ibid., 30).

If Pollock's unraveling script is still mesmerizing more than forty years after he wrote it, it may be for a related reason: because Pollock's writing is writing that unwrites itself, that deauthorizes language, where language is identified with the phallus, the word of God the Father, and the constraints of law. Johnson observes that 'what enslaves is not writing per se but *control* of writing, and writing as control' (Johnson, 'Writing,' p. 48). Pollock offers a spectacle of writing that does not control or order but *dis*orders; writing degenerated into lawlessness, anarchy, chaos. Critics described his art in terms of 'the absurdity of sheer scribble'; as 'formless, repetitious, empty'; and as 'a loose, shapeless mess of paint without any apparent will to form.'[73] But the primal chaos suggested by Pollock's art – an art of deterritorialization, full of lines, but no boundaries or borders; an art of dedifferentiation, spilling with flows, neither and both male and female – spells a perversion or a reversal of values, of the logic of the biblical universe that moves purposively from chaos or 'indistinctness to separation and demarcation'; division, order and control.[74] In a world where order is, ipso facto, patriarchal order – the world as we know it – Pollock's perverse spectacles of chaos and formlessness may serve as a vision of a reality, a material reality, other than that of the paternal universe.

Notes

1 William Feaver, 'The Kid from Cody,' review of the *Jackson Pollock: Drawing into Painting* exhibition in its Oxford, England, Museum of Modern Art venue, 1979. A copy of this review is in the artist's file on Pollock at the library of the Museum of Modern Art, New York.

2 Dorothy Seiberling, 'Baffling U.S. Art: What It Is About,' pt. 1, *Life* (9 Nov. 1959): 79.

3 The biography that focuses most on Pollock's sexual instability, going so far as to make, to my mind, unconvincing insinuations about his engaging (willingly or

otherwise) in homosexual activity, is Steven Naifeh and Gregory White Smith, *Jackson Pollock: An American Saga* (New York: Clarkson N. Potter, 1989).

4 Jeffrey Potter, *To a Violent Grave: An Oral Biography of Jackson Pollock* (Wainscott, N.Y.: Pushcart, 1987), p. 139. Also, in a lecture in 1980, Greenberg described Krasner as the 'greatest influence' on Pollock (Ellen G. Landau, *Jackson Pollock* [New York: Harry N. Abrams, 1989], p. 253, n. 10). Myers made his statement in an undated, unpublished interview with Barbara Rose (ibid., p. 253, n. 2).

5 Potter, *To a Violent Grave*, p. 115. And in the words of Isamu Noguchi, 'Jackson was guided by a definite apparition, meaning Lee. She was the agent, be it angel or witch' (ibid., p. 79).

6 Barbara Rose, *Lee Krasner/Jackson Pollock: A Working Relationship* (East Hampton, N.Y.: Guild Hall Museum, 1981), p. 8. Rose's account exaggerated the degree of Pollock's ingenuousness in 1942 and diminished the role John Graham played in his formation before he even met Krasner, as Naifeh and Smith point out (*Jackson Pollock*, p. 406).

7 'Later, she would refer to this as her "blackout" period' (ibid., p. 402). 'The effect of Pollock's art on Krasner was to cause her to question everything she was doing,' noted Rose in a slightly later account (Barbara Rose, *Lee Krasner: A Retrospective* [New York: Museum of Modern Art, 1983], p. 50).

8 Potter, *To a Violent Grave*, p. 174. For comparable observations by Fritz Bultman and B. H. Friedman, see ibid., pp. 65, 78. Further: ' "She was much brighter than he was and she ran his career," says Lionel Abel. "She carried the ball for the enterprise. She thought the whole thing out from the beginning: how to put him over and make him a big success. How to attack rival painters and rival movements" ' (Naifeh and Smith, *Jackson Pollock*, p. 404).

9 Violet Staub de Laszlo, cited in Potter, *To a Violent Grave*, p. 66.

10 Ibid., p. 102. For Pollock's self-description of his sense of helplessness, see *Jackson Pollock: A Catalogue Raisonné of Paintings Drawings and Other Works*, ed. Francis V. O'Connor and Eugene Victor Thaw [hereafter cited as 'CR'] (New Haven: Yale Univ. Press, 1978), vol. 4, doc. 6, p. 208, and doc. 12, p. 212.

11 Ibid., vol. 4, doc. 19, p. 216. What prompted the poignant phrase cited was the news of his father's death, news that might make anyone feel at a loss for words; but Pollock expressed comparable feelings on other, less momentous occasions: 'I'm usually in such a turmoil that I haven't any thing to write about and when I do after I've written it – it looks like all bunk,' he wrote to his father in 1932 (ibid., vol. 4, doc. 12, p. 212). Thomas Hart Benton recalled how the young artist

> developed some kind of language block and became almost completely inarticulate. I have sometimes seen him struggle, to red-faced embarrassment, while trying to formulate ideas boiling up in his disturbed consciousness, ideas he could never get beyond a 'God damn, Tom, you know what I mean!' I rarely did know.
> (Naifeh and Smith, *Jackson Pollock*, p. 167)

For additional testimonies to Pollock's inarticulateness, see Potter, *To a Violent Grave*, pp. 45, 65, 93.

12 The phrase is Violet Staub de Laszlo's, cited in Landau, *Jackson Pollock*, p. 254, n. 12. The same source is cited in Potter, *To a Violent Grave*, p. 67.

13 Flora Lewis, 'Two Paris Shows à la Pollock,' *New York Times* (3 Oct. 1979); C21

(bylined Paris). In an earlier interview, Krasner used more decorous phrasing: 'Jackson had a mistrust of the word,' she explained. 'Words were never his thing. They made him uncomfortable' (John Gruen, 'A Turbulent Life With Jackson Pollock,' *New York/World Journal Tribune Magazine* [26 March 1967]: 15).

14 Douglass M. Howell, cited in Potter, *To a Violent Grave*, p. 179. Pollock's parents are also invariably described as exceedingly laconic people: 'There was no conversation at all around the Pollock family dinner table,' remembered Marie Pollock. 'Our parents . . . didn't need talk in the house,' recalled Charles Pollock (ibid., pp. 43, 168).

15 Naifeh and Smith, *Jackson Pollock*, p. 402. The painter Cora Cohen pointed out, in conversation, that there was a cultural factor in Krasner's taking charge of Pollock's career and daily affairs: it is customary in Orthodox Jewish homes for the wife to assume as many as possible of the mundane responsibilities to leave the husband free to pursue religious study – a pattern that fits the household where Krasner was raised, according to Naifeh and Smith, *Jackson Pollock*, p. 373.

16 Landau, *Jackson Pollock*, p. 253, n. 2. On Krasner's role as Pollock's mouthpiece, see also Potter, *To a Violent Grave*, p. 78, and Naifeh and Smith, *Jackson Pollock*, p. 612.

17 According to Krasner, Howard Putzel helped Pollock answer the questionnaire that formed the basis for his first full-length interview, published in *Arts and Architecture* in Feb. 1944 (Francis V. O'Connor, *Jackson Pollock* [New York: Museum of Modern Art, 1967], p. 31). Other accounts have Motherwell helping to answer those questions instead (Deborah Solomon, *Jackson Pollock: A Biography* [New York: Simon and Schuster, 1987], p. 146, and Naifeh and Smith, *Jackson Pollock*, p. 472). Naifeh and Smith detect Krasner's hand in many of Pollock's letters (see, for instance, *Jackson Pollock*, p. 467), although the authors err in part in their analysis of the letter in question by misreading 'he' as 'we,' as can be seen from careful study of the facsimile of the letter published in *CR*, vol. 4, p. 230, fig. 25; O'Connor and Thaw made the same error in transcribing the letter in their doc. 50, ibid.).

18 Ibid., vol. 4, doc. 60, p. 234. The statement in question was made in 1944 with reference to *She-Wolf*, but that Janis urged Pollock to title his mature paintings emerges in Potter, *To a Violent Grave*, p. 187, although the dealer there insists that Pollock readily agreed to do so.

19 Among the many accounts of this practice, see ibid., pp. 187–188, and Landau, *Jackson Pollock*, p. 172.

20 The allegation is made by Nicholas Carone in Potter, *To a Violent Grave*, p. 268. (Regarding Pollock's will, see Naifeh and Smith, *Jackson Pollock*, p. 661.) For Krasner's account of Pollock's chronic difficulties with signing his work, see *CR*, vol. 4, doc. 102d, p. 264. Pollock himself is cited on this subject in Potter, *To a Violent Grave*, p. 187.

21 B. H. Friedman, *Jackson Pollock: Energy Made Visible* (New York: McGraw-Hill, 1972), p. 162.

22 Feaver, 'The Kid.' Today, such descriptive phrases evoke Andres Serrano's *Ejaculate in Trajectory* photographs of 1989, as Michael Leja pointed out to me.

23 'Beyond the Pasteboard Mask,' *Time* (17 Jan. 1964): 69.

24 Letter to Louis Bunce, 29 Aug. 1947, cited in Landau, *Jackson Pollock*, p. 166.

25 This statement continues: 'It is only after a sort of "get acquainted" period that I see what I have been about . . . It is only when I lose contact with the painting that the result is a mess' – a description of a kind of coitus interruptus – 'Otherwise there is

pure harmony, an easy give and take, and the painting comes out well' (CR, vol. 4, doc. 71, p. 241).

26 See Sigmund Freud, *The Psychopathology of Everyday Life*, trans. Alan Tyson (New York: W. W. Norton, 1960), p. 197, and Freud, *Introductory Lectures on Psychoanalysis*, trans. James Strachey (New York: W. W. Norton, 1966), p. 155. Also, 'Jacques Derrida describes the literary process in terms of the identification of the pen with the penis, the hymen with the page . . . This model of the pen-penis writing on the virgin page participates in a long tradition identifying the author as a male who is primary and the female as his passive creation' (Sandra Gubar, ' "The Blank Page" and the issues of Female Creativity,' in *New Feminist Criticism*, ed. Elaine Showalter [New York: Pantheon, 1985], p. 295).

27 'Jackson Pollock: Is He the Greatest Living Painter in the United States?' *Life* (8 Aug. 1949), 44; and 'The Metropolitan and Modern Art,' *Life* (15 Jan. 1951): 34. Naifeh and Smith twice tell of Pollock's relating his method of painting to a childhood memory of watching his father urinate on a rock (*Jackson Pollock*, pp. 101, 541), and they describe repeatedly his making a public spectacle of his urination, and his wetting his own and others' beds as an adult (ibid., pp. 491, 760, 770, 541, 612, 671, 762).

28 John Cole, cited in Potter, *To a Violent Grave*, pp. 166–167. Nor was it only bodily fluids Pollock reportedly lost control of: de Kooning gleefully related a story told him by Franz Kline of Pollock pouring wine at a restaurant and becoming 'so involved in watching the wine pour out of the bottle that he emptied the whole bottle. It covered the food, the table, everything . . . Like a child he thought it was a terrific idea – all that wine going all over' (James T. Valliere, 'De Kooning on Pollock: An Interview,' *Partisan Review* vol. 34, no. 4 [Fall 1967]; repr. in *Abstract Expressionism: A Critical Record*, ed. David Shapiro and Cecile Shapiro [Cambridge: Cambridge Univ. Press, 1990], p. 374).

29 As cited in O'Connor, *Jackson Pollock*, p. 55. Also, Harold Rosenberg reportedly taunted Pollock that 'you paint like that monkey,' referring to a laboratory animal that had been set to work making paintings for reasons that are now obscure (Potter, *To a Violent Grave*, p. 182).

30 Maude Riley, 'Review,' *Art Digest* (1 April 1945): 59.

31 Jane Gallop, *Reading Lacan* (Ithaca, N.Y.: Cornell Univ. Press, 1985), p. 20.

32 *CR*, vol 4, doc. 100, p. 262; see also ibid., doc. 87, p. 251 ('I deny the accident'). Krasner, too, affirmed: 'His control was amazing' (ibid., doc. 102d, p. 264).

33 'Chaos, Damn It,' *Time* (20 Nov. 1950): 70–71 (the headline referred to Alfieri's description of Pollock's work as total 'chaos'); Pollock, 'Letters to the Editor,' *Time* (11 Dec. 1950): 10. In a letter written to his father in 1932, Pollock spoke of 'doing every thing with a definite purpose – with out a purpose for each move – thers chaos [sic]' (*CR*, vol. 4, doc. 12, p. 212).

34 Of interest in this regard is the impression that Pollock's work made on the painter Gerhard Richter when he encountered it at the Documenta exhibition in Kassel in 1958 and determined that it was 'not a Formalist gag, but rather the bitter truth, liberation.' Mused Richter, 'I might almost say that these pictures were the real reason for my leaving East Germany' (Benjamin H. D. Buchloh, 'Interview with Gerhard Richter,' trans. Stephen P. Duffy, in Roald Nasgaard, *Gerhard Richter: Paintings* [London: Thames and Hudson, 1988], p. 15).

35 Pollock made small paintings, too, of course: in fact, the preponderance of his work was relatively modest in scale, but the pictures his heroic reputation was built on were those heroic in scale.

36 Rose, *Lee Krasner*, p. 56. Although Rose argued that the difference in their studios was not a determining factor in their work, pointing out that Pollock had made a large canvas in the same bedroom before he converted the barn into his workspace, Krasner told Lawrence Alloway in bitter terms that she resented the discrepancy in the scale of their studios (Naifeh and Smith, *Jackson Pollock*, p. 638).

37 Added Danto, 'The whole [Krasner retrospective] exhibition is a series of surrenders to artistic personalities stronger than her own, and those surrenders are what enabled her to paint. Even though huge and bold, Krasner's work has something of the art school exercise about it' (Arthur Danto, 'Lee Krasner: A Retrospective,' in *The State of the Art* [New York: Prentice-Hall, 1987], p. 36).

38 Gruen, 'A Turbulent Life,' p. 14. Pollock's work 'opened a new channel, a new avenue for me,' Krasner also recalled. 'I started to break away from what I had learned' (Grace Glueck, 'Scenes from a Marriage: Krasner and Pollock,' *Art News* [Dec. 1981]: 59).

39 Regarding the couple's destructive symbiosis (which Rose was the first to remark), see Naifeh and Smith, *Jackson Pollock*, pp. 483, 571, 672. Of the 'Little Image' paintings, Pollock reportedly said, 'Lee keeps copying me and I wish she'd stop' (ibid., p. 640). His attitude toward Krasner's painting is said to have been mildly encouraging, at best; brutally dismissive, at worst (ibid., pp. 571, 751).

40 Klaus Theweleit, *Male Fantasies, Volume One: Women, Floods, Bodies, History*, trans. Stephen Conway (Minneapolis: Univ. of Minnesota Press, 1987), pp. 266–267.

41 N. Katherine Hayles, 'Gender Encoding in Fluid Mechanics: Masculine Channels and Feminine Flows,' *Differences*, 4, no. 2 (Summer 1992): 30. 'In hydraulics as in Freudian psychology, intuitions about flow come together with laws of conservation to posit equivalence between regulating fluids and regulating behavior,' adds Hayles; and 'It is significant . . . that Freud chose "sublimation" to describe the process of converting libido into a socially constructive force, for in its technical meaning sublimation denotes the transformation of a solid into a gas without going through the liquid phase. Better to bypass liquidity altogether than to risk being caught up in the vagaries of turbulent flows' (ibid., pp. 31, 32).

42 Theweleit acknowledges that male bodies also generate flows, but in the fantasies of the population he studied, those flows remained deeply associated with the fearsome floods of the female body: 'Fear of the flood has a decided effect . . . on the structuring of their [the soldiers'] bodily feelings,' as they suffered from sustained erections they could not or would not relieve; also, in the military, 'Fluid fell under the heading of dirt . . . [and] unmanliness' (Theweleit, *Male Fantasies*, pp. 249, 410).

43 Luce Irigaray, *Speculum of the Other Woman*, trans. Gillian C. Gill (Ithaca, N.Y.: Cornell Univ. Press, 1985), p. 237. In Irigaray's analysis, as Hayles notes, 'The privileging of solid over fluid mechanics, and indeed the inability of science to deal with turbulent flow at all,' is attributed to 'the association of fluidity with femininity. Whereas men have sex organs that protrude and become rigid, women have openings that leak menstrual blood and vaginal fluids. Although men, too, flow on occasion . . . this aspect of their sexuality is not emphasized. It is the rigidity of the male organ that counts, not its complicity in fluid flow' (Hayles, 'Gender Encoding,' p. 17).

44 The brush with mortality that Stella and Jackson Pollock both suffered during his birth was evidently a subject of family discussion and family lore (see *CR*, vol. 4, doc. 1, p. 203). Following the birth, Stella was told she could have no more children and, interestingly and atypically, Jackson grew up knowing that his parents had both desperately wanted their fifth son and final child to be a girl (Naifeh and Smith,

Jackson Pollock, pp. 42–43, 69). That Pollock's reading and developmental difficulties may well have stemmed in part from his traumatic birth has been suggested to me by numerous interlocutors.

45 Potter, *To a Violent Grave*, p. 203. Stella Pollock and Lee Krasner both are habitually assigned the role of the 'terrible mother' to Pollock's 'bad son' in their friends' reminiscences and in the literature (see, for instance, ibid., pp. 209, 275). Tellingly, Pollock's father, LeRoy, who all but abandoned the family when Jackson was a child, and whose youngest son believed that his father 'thinks I'm a bum' (letter of 1931, *CR*, vol. 4, doc. 11, p. 211), generally gets portrayed as a pitiable, not a censurable, figure – and never as an important source of Pollock's problems.

46 Letter to Alfonso Ossorio (*CR*, vol. 4, doc. 94, p. 257).

47 Deleuze and Guattari, *Anti-Oedipus*, as cited in Theweleit, *Male Fantasies*, vol. 1, pp. 269–270. Within the capitalist system, 'under no circumstances could desires be allowed to flow in their inherently *undirected* manner . . . desires had to be channelled . . . [to] bolster the flow of currency. Streams of desire were encoded as streams of money' (ibid., pp. 270–271).

48 *CR*, vol. 4, doc. 113, p. 275. See also ibid., vol. 4, doc. 72, p. 241 ('The source of my painting is the unconscious').

49 Ibid., vol. 4, doc. 103, p. 267 (misspelled as 'skined' in the original); and Potter, *To a Violent Grave*, p. 156.

50 'The female subject can participate in this fantasy of sexual and discursive divestiture only in a displaced and mediated way. She can assist the male subject in removing his mantle of privileges, but she herself has nothing to take off' (Kaja Silverman, 'The Female Authorial Voice,' in *The Acoustic Mirror: The Female Voice in Psychoanalysis and Cinema* [Bloomington: Indiana Univ. Press, 1988], p. 192).

51 Potter, *To a Violent Grave*, pp. 114, 129. Pollock said he allowed Namuth to film him because Krasner 'kept at me' (ibid., p. 129).

52 Theweleit, *Male Fantasies*, vol. 1, p. 268.

53 Alfieri, cited in O'Connor, *Jackson Pollock*, p. 55; and Edith Hoffman, 'Current and Forthcoming Exhibitions,' *Burlington* (Feb. 1957): 68. Pollock did have to reckon with the actual, physical borders of his canvases, of course, and sometimes he looped most of the paint skeins back at the pictures' edges, tacitly acknowledging the limitations of the space, whereas at other times he poured paint on a canvas and then cropped a picture out of it after the fact, in which case the trajectories of the paint skeins were necessarily interrupted by the picture's edge.

54 Rudi Blesh, *Modern Art U.S.A.: Men, Rebellion, Conquest, 1900–56* (New York: Knopf, 1956), pp. 253–254. De Kooning usually is described as Pollock's chief rival for leadership of the New York School; but de Kooning was unquestionably the figure most emulated by other painters in the circle because, as Al Held aptly remarked, 'de Kooning provided a language you could write your own sentences with. Pollock didn't do that' (Naifeh and Smith, *Jackson Pollock*, p. 714).

55 Manuel Tolegian, cited in Potter, *To a Violent Grave*, p. 47. Tolegian recalled Pollock's having smashed a Catholic altar in a church, ripped his (Tolegian's) paintings off the wall of a gallery, and smashed the windows in a building (ibid., pp. 47–48, 57).

56 It bears noting, as an aside, that Lenore Krassner deliberately took the 'Krass' out of Krassner (besides adopting the gender-neutral name 'Lee' in preference to her given first name).

57 In 1948, Aldous Huxley said of Pollock's work: 'It raises a question of why it stops when it does. The artist could go on forever. I don't know. It seems to me like a

panel for a wallpaper which is repeated indefinitely around the wall' (from a roundtable discussion on modern art in *Life* [18 Oct. 1948], as cited in Landau, *Jackson Pollock*, p. 179). Recalled Pollock some time later: 'There was a reviewer who wrote that my pictures didn't have any beginning or end. He didn't mean it as a compliment, but it was. It was a fine compliment' (Berton Roueché, 'Unframed Space,' *New Yorker* [5 Aug. 1950]: 16). And 'there is no accident, just as there is no beginning and no end,' Pollock once declared (*CR*, vol. 4, doc. 100, p. 262).

58 'I have a definite feeling for the West: the vast horizontality of the land, for instance; here only the Atlantic ocean gives you that,' observed Pollock (ibid., vol. 4, doc. 52, p. 232). '"Jackson's art is full of the West", [Krasner] said. "That's what gives it that feeling of spaciousness. It's what makes it so American"' (Roueché, 'Unframed Space,' p. 16). Horizontality is conventionally coded feminine, verticality masculine, the former connoting passivity or inertia, the latter activity and erectness. It bears noting in this context that Krasner explicitly stressed the predominant verticality of her own work (Cindy Nemser, *Art Talk: Conversations with Twelve Women Artists* [New York: Charles Scribner's Sons, 1975], p. 94).

59 Leslie Fiedler, 'Was Jackson Pollock Any Good?' *Art and Antiques* (Oct. 1984): 85. Contended the dealer Holly Solomon, 'Pollock invented a new language for us, for Americans . . . He taught us how to breathe' (ibid., p. 85).

60 Naifeh and Smith, *Jackson Pollock*, p. 341. This situation was not entirely altered after the war. To Hilton Kramer, Pollock's art would be 'dim indeed' compared to that of the European masters: 'It is only the poverty of our own artistic values that has elevated his accomplishment into something higher' (Kramer, 'Art: Looking Back at Jackson Pollock,' *New York Times* [5 April 1967]: 44).

61 In a sense, the United States had, like Pollock, only a distant or remote father – Europe, that is – with whom it maintained strained relations, longing for approval, but bent on independence.

62 Interestingly enough, Pollock was named for Jackson Hole in his birthplace of Wyoming (Naifeh and Smith, *Jackson Pollock*, p. 43), and was subject to being teased about 'Jackson's Hole' when he mused aloud philosophically, as he sometimes was prone to do, on the subject of the 'hole' or the 'void' (Potter, *To a Violent Grave*, pp. 203, 192).

63 Alice A. Jardine, *Gynesis: Configurations of Woman and Modernity* (Ithaca, N.Y.: Cornell Univ. Press, 1985), pp. 33–34.

64 Gayatri Chakravorty Spivak, 'Displacement and the Discourse of Woman,' in *Displacement, Derrida and After*, ed. Mark Krupnick (Bloomington: Indiana Univ. Press, 1983), pp. 170, 173, 190.

65 'It has also become clear that the imaginary femininity of male authors, which often grounds their oppositional stance vis-à-vis bourgeois society, can easily go hand in hand with the misogyny of bourgeois patriarchy itself' (Andreas Huyssen, *After the Great Divide: Modernism, Mass Culture, Postmodernism* [Bloomington: Indiana Univ. Press, 1986], p. 45). 'Society often tolerates and even encourages the femininity of male artists,' observes Mira Schor; 'Catherine Elwes . . . writes that "their role is often to provide the opportunity for other men vicariously to experience their buried femininity. The power and prestige of the artist's biological masculinity is *reinforced* rather than undermined by artistic forays into the feminine. His status as an artist partly depends on this poetic femininity"' (Schor, 'Representations of the Penis,' *M/E/A/N/I/N/G* [Nov. 1988]: 8).

66 Greenberg's next sentence quickly retreats from the suggestion that Sobel – whom

he describes as 'a "primitive" painter . . . who was, and still is, a housewife living in Brooklyn' – may have been a significant source for Pollock: 'But he had really anticipated his own "all-overness" in a mural he did for Peggy Guggenheim at the beginning of 1944' (Clement Greenberg, '"American-Type" Painting,' in *Art and Culture: Critical Essays* [Boston: Beacon, 1961], p. 218).

67 Luce Irigaray has suggested that men have conspired to keep naming, representing, and cultural production generally a masculine prerogative, thus in a compensatory way usurping the biological status of women as the site of reproduction or pro-creation (in *Speculum*, pp. 23, 33, 41–43). As for Sobel, her work is nowhere to be seen, on a regular basis, in any major museum (although the Museum of Modern Art owns two paintings), nor is there any monograph on her.

68 Glueck, 'Scenes from a Marriage,' p. 61. In the years after she first met Pollock, Krasner painted what she called her 'gray slabs': canvases (eventually thrown out) that she covered over and over with paint 'until they'd get like stone and it was always just a gray mess' (Nemser, *Art Talk*, p. 87). In 1953 she began a series of collages made up of her own old drawings, torn into shreds; many of those drawings came from her years in Hans Hoffman's school, where, interestingly, she once suffered the insult of having Hoffman tear up and rearrange a newly completed (and admired) drawing in front of the class (Naifeh and Smith, *Jackson Pollock*, p. 386). Krasner proceeded to 'slashing' and collaging her own old oil paintings: 'it is dangerous for me to have any of my early work around because I tend to always want to go back into it . . . – so the less around the better,' she told an interviewer, while explicitly expressing feelings of hatred for her own old work (Nemser, *Art Talk*, pp. 93–94).

69 In Potter, *To a Violent Grave*, p. 175. 'Lee was his victim in the end,' pronounced Greenberg (ibid., p. 174). Observed Potter, Krasner was 'trading on the trajectory of his fame, although not admitting to herself how much she was putting her own work and self aside from his' (ibid., p. 226). The increased visibility Krasner's art found in the decades following her husband's death was tacitly viewed more as an insidious index of Pollock's stature than as a positive measure of her own, as it was known that she controlled the holdings of the Pollock estate and so was a figure to be indulged.

70 Robert M. Coates, review, *New Yorker* (17 Jan. 1948): 57.

71 Barbara Johnson, 'Writing,' in *Critical Terms for Literary Study*, ed. Frank Lentricchia and Thomas McLaughlin (Chicago: Univ. of Chicago Press, 1990) pp. 46–48.

72 As cited in Barbara Johnson, 'Is Writerliness Conservative?' in *A World of Difference* (Baltimore: The Johns Hopkins Univ. Press, 1987), pp. 29–30.

73 'Beyond the Pasteboard,' p. 69; Emily Genauer, 'Sad Art of Pollock in Museum Show,' *Herald Tribune Book Review* (23 Dec. 1956); Victor Willing, 'Thoughts After a Car Crash,' *Encounter* (Oct. 1956): 66.

74 Not only the specific phrase cited but this notion of chaos and perversion generally is taken from Janine Chasseguet-Smergil, 'Perversion and the Universal Law,' in *Creativity and Perversion* (New York: W. W. Norton, 1984), p. 10 and passim. It bears noting that science since Pollock's day has come to evaluate chaos in more positive terms, reconceptualizing it as 'the progenitor of order rather than its opposite,' but in her analysis of contemporary chaos theory, Hayles has shown that the feminine-ness or 'otherness that chaos represents, while immensely attractive, is also always a threat, arousing the desire to control it, or even more extremely to annihilate it' (Hayles, 'Gender Encoding,' pp. 32, 33; see also Hayles, *Chaos Bound: Orderly Disorder in Contemporary Literature and Science* [Ithaca, N.Y.: Cornell Univ. Press, 1990]).

Michael Leja

REFRAMING ABSTRACT EXPRESSIONISM
Gender and subjectivity

[. . .] The word *modern* functioned to distinguish the new subjectivity from that of earlier humans, principally 'primitives,' although, conversely, authors often emphasized similarity and continuity between them and modern man. *Modern* designated a status implicitly denied to all African-Americans and Native Americans merely by virtue of their racial identity, which was assumed to entail a fixed core of unreconstructed – and unreconstructable – 'primitive' human nature. The term *man* was equally loaded, as it served to distinguish humanity from animal, nature, and god, even as some of those boundaries were being erased.' It also opposed the human individual to culture, society, and community, aggressively asserting the priority of individuality over collectivity. *Man* was generally used in a seemingly nondiscriminatory way, apparently designating all humanity. In fact, it was not nearly so comprehensive. While the exclusion of certain classes of humans (for example, men of African-American, Native American, Asian-American, or Latin American ancestry, to speak only of the U.S. population) was not revealed in the term *modern man*, the subtextual exclusion of women did find expression there.

[. . .] African-Americans, Native Americans, women, and other excluded groups served principally as foils in opposition to which a subjectivity for white, heterosexual, middle-class males was reconstituted. The gendering of this subjectivity is to be explored in this section. Beginning with an analysis of gender identity within the New York School, the discussion will open out to address Modern Man discourse broadly and reveal gendering as another mark of congruence and connection.

Two mid-1950s portraits of Willem and Elaine Fried de Kooning offer a useful point of departure (Hans Namuth, *Elaine and Willem de Kooning*, 1953, photograph, and René Bouché, *Bill and Elaine de Kooning*, 1955, oil on canvas). They suggest that

Source: Michael Leja, *Reframing Abstract Expressionism: Subjectivity and Painting in the 1940s*, New Haven and Yale, Yale University Press, 1993, pp. 253–268, 363–4. This text has been edited and footnotes renumbered. The original included eight illustrations all of which have been omitted

while both male and female artists occupied the Abstract Expressionist studio, their hold on that space was not equally secure. Male and female artists are portrayed here in bohemian variants of highly clichéd postures: man standing, woman seated; male attention outer-directed, female absorbed within; man commanding space, woman contained. In both cases there is reason to believe that we are in the man's studio: Willem is more proprietary in each, closer to action, while Elaine stares absently, cigarette elegantly poised. (I will turn to using first names here, not intending disrespect or familiarity but to distinguish efficiently between artists who share a last name.) In the painting by René Bouché, Willem seems to be contemplating a picture off to the left; in the Hans Namuth photograph, taken at Leo Castelli's East Hampton house, one of Willem's unfinished paintings is tacked to the wall behind.[2]

There are photographs of Elaine in her own studio from this time, but Willem is not included in them. This same asymmetry holds for contemporary studio photographs of Pollock and Krasner. We might wonder, in passing, how the men would have presented themselves had they appeared in the women's work areas. Merely asking the question sharpens our awareness of the intransitivity of the positions occupied. For the men to appear upstaged, idle, or doting was unthinkable; while for the women to appear so could serve valuable signifying purposes, some of which are evident here. First, the women stand as essential accessories of bohemia, their casual dress and posture helping to fill out a cultural image (or fantasy) of the male artist. They also keep that image within certain limits by confirming the heterosexuality or 'masculinity' of their partners. Thomas Hart Benton's contemporary ravings about the ill effects of the high proportion of homosexuals in the art world seemed to verify widespread popular suspicions. Such photos as these situated Jackson Pollock and Willem de Kooning in a normalized, domesticated bohemia. In a different vein: sometimes the women enact a form of attention – toward the work of art or the male artist – that the photograph posits as paradigmatic. Their relaxed and distracted but deep contemplation, and even occasionally loving admiration, provided models for viewers to emulate. And there is also the marketing convention that attaches a pretty girl to the commodity, whether car or refrigerator or painting. For the male viewer especially, she lends, in the variations illustrated here, sex appeal to the paintings and simultaneously displaces attention from the sexiness of the male artist, which might otherwise be susceptible to appreciation or questioning.

What makes the Namuth photo of the de Koonings an especially dense and revealing image is the fact that center stage has been given over to that larger than life-size image of woman looming over Elaine. Even without her legs, which are obscured by a plywood board resting against the bottom of the picture, the painted woman is an imposing, intrusive figure. The photograph juxtaposes the two kinds of female presence that occupied the space of Abstract Expressionism; it begins to establish parameters for a treatment of gender in the New York School (and, by extension, Modern Man discourse).

Abstract Expressionism has been recognized, from its first accounts, as a male domain, ruled by a familiar social construction of 'masculine' as tough, aggressive, sweeping, bold. The features of this art most appreciated in the critical and historical literature – scale, action, energy, space, and so on – are, as T. J. Clark has noted, 'operators of sexual difference,' part of an 'informing metaphorics of masculinity.'[3] As we have gained distance from the Abstract Expressionist milieu, the diverse

ethnic and class backgrounds of the principal male New York School artists have come to seem less significant, and the art's complicity in processes of cold war cultural imperialism has become more important for scholarship. As a result, Abstract Expressionism has come to appear more and more a homogenous white male art, an apt artistic counterpart to the cold war politics of the contemporary white male U.S. political establishment.

The functions served by Abstract Expressionism's aura of masculinity have also come into clearer focus: it was a crucial component of cold war U.S. national identity, differentiating the nation politically and culturally from a Europe portrayed as weakened and effeminate. In some contemporary aesthetic theory it served to distinguish avant-garde painting from kitsch, also strongly gendered as feminine.

Lately the difficulties of women artists affiliated with Abstract Expressionism have begun to be acknowledged and studied. Lee Krasner's struggle to forge an artistic identity within this aesthetic (one distinct from that of her husband, Jackson Pollock) has attracted much attention, and the bepedestaled Hedda Sterne in the famous Irascibles photo published in *Life* in 1951 has become perhaps the best symbol of the marginal presence women have been accorded in Abstract Expressionism.[4] Until recently most of the sparse critical and art historical attention directed to these women was condescending, and recent efforts to enlarge the canon to include their work have been very slow to gather momentum.

Perhaps most revealing of the 'masculinity' apparently inherent in Abstract Expressionist art is the fact that so few women attempted to align themselves with it during the crucial formative years, the 1940s and early 1950s. Other dominant contemporary visual modes – realisms, Surrealism, and geometric abstraction, for example – drew somewhat higher proportions of women to the ranks, and in those other ranks, women were occasionally able to command positions of considerable prestige. Around 1940, Lee Krasner herself was acknowledged by Greenberg and others in-the-know to be one of the most talented and promising younger painters in New York. But once School of Paris aesthetics was overshadowed by an aggressively 'American' and virile abstract idiom, that sort of promise was not so easily accorded to women. Those who did attempt to work within the evolving parameters of Abstract Expressionism often devised strategies to mask their gender: Lenore Krasner Pollock's preference for the name Lee, for example, or her use of her initials as a professional signature; or Grace Hartigan's adoption of the name George (after George Sand) for a while in the early 1950s.[5] There is also the preference for subject matter calculated to signify masculinity in one way or another: Elaine de Kooning's sports subjects led at least one critic to note that the artist had been a 'tomboy' in her youth.[6] A few works take the concealment of identity as thematic, for example, Hartigan's *Masquerade* and *The Masker*, both from 1954.

My intention here is not to document the exclusion of women from Abstract Expressionism, but rather to examine the processes and mechanisms by which that exclusion was effected then and now. What made Abstract Expressionism so inhospitable to artists who were women, and why has it been so difficult for critics and historians of both sexes to attribute much of the characteristic content and meaning of Abstract Expressionism to work by female artists? The answer centers, I believe, on the subjectivity inscribed in Abstract Expressionist art: the particular beliefs about and experiences of self, individuality, identity, human nature, and

mental process that both inform and take form in this art. This was, I have been arguing, an art that thematized subjectivity – it claimed to issue from and represent mind and experience, as these were revealed in mythic and unconscious materials and structures held to constitute the submerged foundations of human nature and being. I wish to propose now that the specific model of the human subject it inscribed was profoundly gendered.

In New York School painting as in Modern Man discourse, the emerging model of the subject was articulated through the male individual. That the focus of the discourse was the new, complicated 'modern *man*' was not simply a matter of linguistic convenience. The specifically male individual became the locus of the interaction of complex forces and drives, the site of the conflicts at the source of modern tragedies. Although the work of various female scholars figured prominently in the construction of this new subject – Ruth Benedict, Margaret Mead, and Susanne Langer, to name just a few – the model they helped to shape seems not to have been easily extended to women.

The exclusion of women from this new subjectivity was effected largely through its structural constitution. The internal divisions that distinguish the subject – between conscious and unconscious, modern and primitive, control and uncontrol – were commonly represented as gendered. In a broad range of cultural productions from this time – in popular psychology, *film noir*, cultural criticism, and popular philosophy, as well as in Abstract Expressionism – an 'other within' modern man was given female personification and objectification, whether that other was primarily the unconscious, primitive instincts and residues, vague irresistible forces, or all of these. Women often symbolized the powerful force fields that had to be negotiated by the conscious, rational part of the subject – gendered as masculine – in his quest for balance, harmony, and resolution of conflict. Before drawing out the implications of this gendered internal division, I will illustrate it with a few examples.

One of the most obvious examples of such gendering is the Jungian treatment of the anima – the feminine unconscious in the male subject – developed in detail by authors and analysts associated with the Analytical Psychology Club of New York. M. Esther Harding's *Woman's Mysteries* was one of the most comprehensive analyses of the topic. Since I treated this material in some detail in chapter 3 ['Jackson Pollock and the Unconscious'], I will focus here on another, by now rather familiar, set of representations that was especially heavy-handed in its employment of gendering to structure the conflict within the modern man–subject: *film noir*. *Noir* protagonists are typically sympathetic male characters who commit crimes or act violently, brutally, and irrationally for reasons they do not understand and cannot control. They are extreme cases of modern men: their personas are 'deep, dark, mysterious, and agitated,' as one character snappily phrased it in the film *D.O.A.* (1950); their minds and beings are overheated circuits of primitive impulses and unconscious drives.

Only very rarely are female characters in these films accorded this sort of subjectivity: ordinarily it is understood to be a distinctly male phenomenon. *Noir* dialogue is punctuated with remarks such as 'you're just like every other man, only more so: you feel restless, trapped, confused.' Or 'a man can be like that, Paula' – meaning confused, dissatisfied, driven by unknown desires, haunted by memories

and past actions. Women are generally less complex creatures in these films; though the devious webs they often weave may be stunningly intricate, their motivations are generally less conflicted. They seem congenitally good or evil: if they represent evil, that evil is largely uncompromised by contradictory inclinations. One common narrative theme posits a male protagonist who is incapable of returning a good woman's love until he has played out his powerful, irresistible attraction to a dangerous, destructive woman. His attraction to the latter is patently symbolic of his susceptibility to internal drives toward danger, evil, and self-destruction. The *noir* hero often laments his utter inability to resist the tragic forces personified by the dangerous woman. For example, in the film *Criss Cross* (1949), Burt Lancaster, lying alone on his cot, staring up at the ceiling, speaks in a voiceover about the irresistibility of his desire for his ex-wife, who will bring about his destruction, as he knows only too well.

> A man eats an apple. He gets a piece of the core stuck between his teeth, you know. He tries to work it out with some cellophane off a cigarette pack. What happens? The cellophane gets stuck in there too, Anna. What was the use. I knew one way or the other somehow I'd wind up seeing her that night.

In this quintessentially *noir* recasting of Garden of Eden imagery, the inevitability of Lancaster's demise is foretold. Happy endings are uncommon in *noir* films; more often than not, the protagonist's playing out of his attraction to evil proves fatal.

It is important to distinguish between these films and traditional femme fatale imagery. Here the focus is on the psychological dynamics of the male protagonist and the causes for his behavior. The films' particular emphases imply that simple assignment of blame to the woman will not carry much weight anymore, it will not suffice as explanation for evil. The *noir* male must recognize that the source of the problem is within him, and it is the character and framework of that internal dynamic – the impulses and desires that the *noir* woman merely activates and personifies – that is at issue in these films. One *noir* film, *Gilda* (1946), features Rita Hayworth singing the song 'Put the blame on Mame,' a parody of the femme fatale cliché. The song is a clear statement of the inadequacy of simply blaming the woman in the *noir* world.

Yet, projecting onto the women in *noir* films the same heroic, conflicted struggles enacted by men is virtually impossible. Though the cool, tough female types ubiquitous in these movies had strong appeal for women as well as men, they displayed less complexity and centrality in the narratives.[7] The women were denied the same capacity for internal conflict, nor could they have control of the narrative of self-exploration; they were required to play rather closely circumscribed roles. The barrier between men and women was sharp: in *Out of the Past*, one male character, using the lingo that refers to guns as 'rods,' observed that 'a dame with a rod is like a guy with a knitting needle.' Such remarks amount to more than assertions of separate male and female spheres; they conjure the authentic phallus (one that shoots) as passkey to full-bodied subjectivity. The female characters in these films are usually ancillary and contingent; they serve primarily as objectifications of the obstacles and force fields, both good and evil, that modern men have to negotiate

in their struggle to resolve the conflicts at the center of their subjectivity. As Janey Place puts it: '*Film noir* is a male fantasy . . . women are defined *in relation* to men.'[8] This gendered structuring of modern man subjectivity represents an extension of a familiar prior convention portraying a less radically sundered human nature comprising masculine intellect and feminine heart or emotion.

A similar structural use of gender operates in much New York School painting. The self-conception and presentation of many of the male artists as masculine *noir* characters is one indication of a linkage of this sort, as I have already argued. Such linkages played a part in generating public interest in these artists by channeling their characters, artistic commitments, and careers into territory made familiar by *noir* dramas. The identification was reinforced by the language some of them used. Pollock is the most striking case: his public pronouncements enacted masculinity through clipped, direct sentences; firm statements of positions; spare use of adjectives; tough-guy idiom ('I've knocked around some in California'); and reticence. His preference for the interview format over straightforward statement of purpose may also be relevant: it provided him an opportunity to enact both his reticence and his tough directness. Such devices brought his speech strikingly close to that of *noir* characters.

More important, however, in Abstract Expressionism, too, women serve as symbols of the powerful force fields constitute and definitive of modern man's subjectivity. One need only return to Pollock's imagery of the unconscious for a demonstration of this. In his early work, informed by the structural principle 'moon-female-unconscious' derived from Jungian theory, he often gave the unconscious a feminine gendering and even used an explicit feminine symbol for the 'anima' – the moon woman. Vestiges of this earlier gendering survived in the abstract work, insofar as the notion of the anima as source of the mind's 'dancing, flowing circuit of emotional energy' was counterposed in the paintings to the 'ravaging, aggressive virility' of Pollock's line.[9] Pollock's linear webs, in other words, were susceptible to interpretation as both (either) masculine and (or) feminine. And in some of his works, obvious metaphors for the unconscious are explicitly assimilated to imagery of female sexuality, for example in *Vortex* (1947) and *The Deep* (1953). The mysteries of the unconscious are metaphorically equated with the mysteries presumed to reside in the interior spaces of the female body.

Gendering enabled so-called unconscious and primitive materials to assume the place in artistic practice formerly occupied by that difficult, resistant, sexually charged other: the female nude. This substitution positioned the male artist/subject in a familiar relation to his artistic object; and simultaneously, women were presented with a new situation in which to be uncomfortable. The gendering of the Abstract Expressionist intrasubjective drama rendered difficult and necessarily incomplete both a woman's occupation of the place of conscious (masculine) protagonist and her disidentification with the (feminized) 'other within.' The woman who tried to constitute herself as split subject found gender identification an obstacle rather than a vehicle for focusing and structuring the opposition. She found herself precast as the other within the self, deprived of a basis for imagining and experiencing the division between that other and the self crucial to Abstract Expressionist subjectivity. The poles of self and other were blurred, if not fully inverted. Consequently, for female artists, the radicality of the split within the subject was

necessarily compromised. This difficulty conditioned both the production and reception of Abstract Expressionist paintings by women artists.

The great irony is that women might seem – as symbols of the unconscious and the primitive, and their nexus in uncontrollable sexuality – to have privileged relations to these spheres and be, therefore, in a better position to represent or express them. And indeed, this had been the case just a generation earlier, as the critical reception of Georgia O'Keeffe's painting reveals. O'Keeffe's rise to prominence in the 1920s rested on a reading of her work as shaped and infused by a woman's special access to the natural, the primitive, the subconscious. Her exceptionally unmediated relation to the realm of feeling, emotion, intuition, elementary being was 'discovered' as the source of meaning and significance in her work by friends and colleagues as well as critics; it was the basis of Stieglitz's promotion of her work, as Barbara Buhler Lynes has shown. 'He understood O'Keeffe's art as the pure expression of her unconscious,'[10] and partly through his influence this view came to dominate critical reaction to her work. The male modernist artists of Stieglitz's circle, themselves trying to tap an inner subconscious, emotional core of self, could envy O'Keeffe's gender advantage. As Arthur Dove put it to Stieglitz: 'This girl is doing naturally what many of us fellows are trying to do, and failing.'[11] For the male artist, the conscious mind and reason operated as a barrier blocking access to the subconscious. O'Keeffe's seeming advantage entailed profound disadvantages, among which was a blindness to the conscious, rational, skillful, controlled process that produced her work. Stieglitz's early description of O'Keeffe – 'The Great Child pouring out some more of her Woman self on paper' – reveals just how little room there was for a deliberate, professional artist in her artistic persona.[12] In this respect, despite the seeming advantages early modernist aesthetics in the U.S. offered to the woman artist, she remained excluded from full-fledged (male) subjectivity.

For women artists of the 1940s, the situation had changed as an effect of changes in the dominant cultural forms and functions of the unconscious. As the unconscious became more articulated and came to acquire a more ominous – barbaric and explosive – cast, came to serve fully in the explanation of evil and to be a source of intrapsychic conflict, woman's close association with it became a thoroughgoing liability. The increasing emphasis on division within the self exacerbated woman's disqualification from subjectivity. Being made into anima, earth mother, and locus of sexual desire made woman an object, not a subject, of Abstract Expressionist painting, even when the Abstract Expressionist painter was a woman. The pictures interpellate male viewers within the dominant ideology's evolving model of self, and what holds for viewers holds as well for producers. A dame with an Abstract Expressionist brush is no less a misfit than a *noir* heroine with a rod.

Joy Kasson has argued, in her study of neoclassical sculpture in the U.S., that in the mid-nineteenth century it was often the (white, middle-class) female subject who was represented as the locus of internal conflict.[13] She quotes the influential art critic Henry Tuckerman who, in writing about Erastus Dow Palmer's *White Captive* (1859), appreciated the enactment of internal conflict, of struggle for self-mastery, for Christian resignation in the face of profound fear and anguish, which he saw embodied in the face and gesture of this female youth held captive by Indians. Kasson relates this theme, which recurs frequently in the critical reception of the

various sculpted female captives and victims she studies, to anxiety over the nature of woman specifically; she sees it principally as an expression of a cultural desire to reaffirm the ideal of submissiveness in women. What is not clear is the extent to which the white, middle-class, female subject was, in this case, understood to represent humanity generally, and the affirmation of self-control she articulated interpreted as applying to every subject. The story of the transition from female to male subject as preferred site for staging of the drama of self-control, the morality play so crucial to bourgeois ideology and its social order, would be a fascinating and revealing tale. The gender shift would be accompanied by the relocation of evil from the alien cultural other (the Indian kidnapper) to the interior of the white self, formerly believed to be naturally good. It would also involve a profound loss of confidence in the ability of reason to overcome its antagonists without assistance from specialized and esoteric bodies of knowledge.

Examining a pair of paintings by the de Koonings in the context of the paradigm I have sketched may help to clarify the implications of my argument for our readings of Abstract Expressionist art. Elaine's *High Man* (1954) from 1954 and Willem's *Woman with a Bicycle* (1952–3) from 1953 are contemporaneous and in some ways analogous: each artist has presented in a loosely brushed field a figure or figures of the opposite sex in an athletic situation.

Elaine's basketball players are threads in the web of dynamic pictorial forces that constitutes the picture; there is considerable harmony and continuity between figurative and nonfigurative passages in the painting. Often in Abstract Expressionist work, the divided subject is evoked in the dialectic of abstraction and figuration, signifying control and uncontrol, structure and disruption; but here as elsewhere Elaine favors a comparatively symbiotic relation. The figures are not psychological presences at all, but rather dematerialized bodies rematerialized as paint. They do not register as others and are not made the source or site of uncontrol, rupture, or division in the picture.

Willem's woman, by contrast, is a resistant, intrusive, disruptive presence, refusing to dissolve into the paint surface. She assumes only enough detail to signify two crucial things: her gender (her preposterous breasts leave no question of that), and her deranged, mocking expression, underscored by the presence of two loony grins; these latter features make her materialization in the picture a taunt to painter and viewer, a taunt made worse by her evanescent bicycle, which frames her like an enormous article of jewelry – its wheels rhyming with her breasts – but which gracefully blends into the paint surface to a degree she herself resists.[14] She seems to will her own emergence from the abstract painted field, her presence and expression challenging de Kooning's authority. I may be going too far in attributing to her a ferocious determination to insinuate herself at the center of de Kooning's canvas, in apparent defiance of his effort to compose a modernist, abstract painting; but one could back down this road quite some way and still retain the point that the female figure personifies the forces against which the act of painting – the securing of pictorial unity – is performed. William Seitz wrote of de Kooning's women that they 'struggle against recession, flatness, and structure.' And in a contemporary review, Leo Steinberg made a related observation: he noted that the woman 'remains an impediment to the free flow of energy through the pictorial space.'[15] For some critics, conflict in these paintings was principally a matter of de Kooning's

'wrestling match with the materials of art' (as Michel Seuphor put it); but for many others the materials of art were only the vehicle for signifying 'struggle' of a different, more primal order, sometimes articulated as occurring within the author as subject.[16] To James Fitzsimmons, de Kooning was engaged in 'a terrible struggle with a female force . . . this is a bloody hand to hand combat.' Rudi Blesh and Harriet Janis similarly portrayed the woman paintings as a war between artist and image.

> Van Gogh and Soutine painted violently but their paintings were momentary releases from the battle they waged with themselves. De Kooning, attacking the canvas, attacked himself. Though the ikon seemed to be *Woman*, it was her creator smothering in the nascent paint. Finished, it is the tragic litter of a battlefield. No other artist ever left such paintings. The *Woman* would not be destroyed. Battered and wounded, hideous yet inexpressibly sad, she still sits implacable within a storm that will never cease.[17]

At times the woman was described in terms even closer to those I have outlined above; she was seen as the embodiment of primitive and unconscious elements that had intruded into the present, into consciousness and representation.

> Rising from the darkness of the past or the atavistic depths of consciousness, she stands, like the ancient Cybele who drove her lover Attis to madness and castration, a cult image of the eternal female.[18]

> It is to the unconscious (and to the American unconscious in particular, I fear) that The Woman appeals.

> . . . this female personification of all that is unacceptable, perverse and infantile in ourselves, also personifies all that is still undeveloped. I can't explain her horrid fascination otherwise.

> . . . though she belongs to the dawn of our history, she is still very much with us, and we must not be misled if she chooses to ride a bicycle and wear a boater instead of a crown.[19]

> She is a first emergence, unsteeped from a tangle of desire and fear, with some millenia of civilizing evolution still ahead of her . . . de Kooning has described a familiar shape, a form that even Adam would have recognized as from an ancient knowledge.[20]

For some viewers, apparently, the physical attributes of de Kooning's woman were evocative and legible. Her depravity and mockery worked to situate her within the domain of the irrational; her exaggerated breasts and hips and her frontal, hieratic pose identified her as 'primitive,' a relative of archaic fertility goddesses; her physical threat operated as a metaphor for the threat to the psyche and to personal and social well-being posed by unconscious and primitive components in human nature.[21] Fitzsimmons' words bear repeating: she was a 'female personification of all that is unacceptable, perverse and infantile in ourselves.' De Kooning himself made a related suggestion in 1956: he told an interviewer that 'maybe . . . I was painting the woman in me.'[22] (He felt compelled to follow up this revelation with a stern

defense of his heterosexuality; acknowledging some feminine component of the male self was not to be taken as any surrender of virility.) One critic, writing in *Time* magazine, explicitly related de Kooning's women to a character notorious in Modern Man literature: 'Mom,' the protective, possessive matriarch, the rapacious loving mother made famous by Philip Wylie's *Generation of Vipers*.[23] Wylie had based his caricature loosely on Freudian theory and modeled her to bear principal responsibility for oedipal distress; she became a popular cultural symbol encompassing every sort of feminized threat.[24] To see de Kooning's *Woman* as Mom was to construe her both as embodiment and cause of (male) psychic torment.

Could a female artist give such valencies to the figure, and if so, the figure gendered how? We have the example of one woman who worked on the female figure, for a while in a manner quite clearly indebted to de Kooning's example. When Grace Hartigan endeavored to introduce recognizable forms into her own largely abstract work – specifically, figures reminiscent of de Kooning's women – she found herself alienated from the imagery. She articulated the difficulty in a retrospective comment made in 1974, seeing the problem not simply as a product of her new imagery but of her various borrowings from the more established male artists. 'I began to get guilty for walking in and freely taking their [Pollock's and de Kooning's] form . . . [without] having gone through their struggle for content, or having any context except an understanding of formal qualities.'[25] Hartigan assumed that what she needed to do was to confront for herself the old masters – Velásquez, Rubens, Goya, et al., to engage in a personal struggle with their example, and to 'paint my way through art history'; in this way, she believed, she could devise a form of painting with which she could more closely identify. I suspect that the real problem was somewhat different: that her difficulty with identification stemmed rather from her inability to occupy the subject position inscribed in her sources unless she somehow disidentified herself with 'woman.' Arguably, the same difficulty provoked a later generation of woman artists, including Cindy Sherman, Barbara Kruger, and Laurie Anderson, to deconstruct the subjectivity that excluded and marginalized them.

If we return now to the point of departure for this section – the Namuth studio portrait of the de Koonings – the painted woman's upstaging of Elaine in the photo may have acquired some added poignancy. In part because of her and what she represents, Elaine and other female Abstract Expressionists were structurally excluded from the construction of subjectivity embedded in the full experience and production of Abstract Expressionist art. Anne Wagner has written that Lee Krasner's art is characterized by its refusal to produce a self in painting. She contends that Krasner declined to let her self emerge in her art for fear that it would betray her femaleness and undermine her necessary masquerade as male. In Wagner's view, Krasner effected this refusal by resisting certain components of Pollock's art – in particular, his evocations of mythic and primitivizing imagery and his involvement in psychologically loaded symbolics and figuration. This refusal, she proposes, became a means of establishing an otherness to Pollock that was not – or could not be easily dismissed as – the otherness of woman.[26] The reasons why this argument interests me are no doubt obvious by now, as are the sorts of amendments to it that I feel necessary. In my view, the frame Wagner posits for Krasner's resistance – principally, the dynamics of her relationship with Pollock (and to some

extent general gender dynamics in the New York art world of the 1940s) — is a bit too localized; while it sensitizes us to the special difficulty of Krasner's situation, it overpersonalizes her problem. Other women working in an Abstract Expressionist mode shared that problem, regardless of their proximity to Pollock. Furthermore, I think it crucially important to insist on the historically constituted character of the subjectivity that Krasner was both disinclined and disempowered to produce. In other words, I am proposing to recast Wagner's insights in this way: Krasner's work thematizes a situation that faced all aspiring Abstract Expressionists who were women — exclusion from the experience of and the power to represent the self of Modern Man discourse, as that self was embodied in Abstract Expressionist painting and aesthetics.

To conclude this consideration of the place of woman in Modern Man discourse, I wish to juxtapose briefly the Namuth photo with a *film noir* image — a publicity still from *Woman in the Window*, a 1945 film directed by Fritz Lang. In this shot, Edward G. Robinson is gazing at a portrait of Joan Bennett on display in a gallery window, a portrait whose dark allure leads him to sexual fantasy. Pausing in front of this painting and indulging his fantasy cause him to meet the real woman; this is the moment shown in the photo, when she is about to ask him for a light. It is a quintessential *noir* trope that contact between man and woman — especially their initial contact — is mediated by a flame. Bennett will escort Robinson into a nightmare of murder, deceit, paranoia, destruction of family and professional life, and finally suicide. It turns out to be literally a nightmare — a dream — in the end, but the moral of the story is unchanged. In this image, Bennett watches Robinson gaze at her own painted likeness; she is able for a moment to be simultaneously object and unseen observer of the male gaze. But positing too close an identification between Bennett and her portrait would be ill-advised. The portrait here may bear a closer resemblance to Bennett than Willem de Kooning's painting does to any conceivable woman, but neither painting has anything much to do with the character, psychology, or subjectivity of the woman portrayed. They are meant rather to reveal something important about the *male* figures in these photographs. It is their psychology and subjectivity that is being represented. The narrative frame of the movie makes Bennett's portrait stand as a material symbol of the repressed, dangerous desires lurking in Robinson's character. It is everything against which he must struggle if he is to retain the comfortable, orderly bourgeois life as a university professor that he cherishes. Likewise de Kooning's painted woman is a symbol that enables the staging of his subjectivity as a combat between opposing drives. He does not have a filmic narrative to situate and encode the painted image, as the painter of Bennett's portrait did; as a consequence de Kooning must work the full conflict into the forms and handling of the imagery.

Both forms — New York School painting and *film noir* — thematize the sensations of loss of control and autonomy for the male subject. Both reveal this preoccupation in a shrill insistence on the continuing, pivotal importance and transcendence of the subject and in an emphasis on figuring its vulnerability and division. The reliance upon gender in the conception and representation of this historical subjectivity consigned women artists to the sizable ranks of Abstract Expressionism's others, and it predetermined their marginality in practice and in critical and art historical discourse.

Notes

1 Donna Haraway has shown how the calamities of advanced industrialism, particularly the bomb, had led to an effort to 'renaturalize "man"' in the post-World War II era. See *Primate Visions: Gender and Nature in the World of Modern Science* (New York: Routledge, 1989), p. 156.
2 I wish to thank Mary Maggini for calling my attention to the Bouché painting.
3 'Jackson Pollock's Abstraction,' In Serge Guilbaut (ed) *Reconstructing Modernism: Art in New York, Paris and Montreal, 1954–1964* (Cambridge: MIT, 1990) p. 229.
4 See Anne Wagner, 'Lee Krasner as L. K.' *Representations* 25 (Winter 1989): 42–57.
5 See Anne Wagner, 'Lee Krasner as L. K.'; and Ann Schoenfeld, 'Grace Hartigan in the Early 1950s: Some Sources, Influences, and the Avant-Garde,' *Arts* (September 1985): 85–86.
6 Hubert Crehan, 'Elaine de Kooning,' *Art Digest*, 15 April 1954, p. 23.
7 In the late 1940s, Simone de Beauvoir was struck by the extent to which American women modeled themselves after the heroines of detective novels and Hollywood movies. See her *America Day By Day*, 254. (Quoted in Lynne Cooke, 'Willem de Kooning: "A Slipping Glimpser,"' PhD. diss. Courtauld Institute, 1988, p. 254.)
8 Janey Place, 'Women in Film Noir,' in Ann E. Kaplan, ed. *Women in Film Noir* (London: British Film Institute, 1978) p. 35.
9 See H. G. Baynes, *Mythology of the Soul* (London: Baillière, Tindal and Cox, 1940) 613; and Hunter, 'Among the New Shows,' *The New York Times*, 30 Jan. 1949, sec. 2, p. 9.
10 Barbara Buhler Lynes, *O'Keeffe, Stieglitz and the Critics, 1916–1929* (Chicago: University of Chicago Press, 1989) p. 16. My discussion of O'Keeffe draws principally upon Lynes and upon Anna Chave, 'O'Keeffe and the Masculine Gaze,' *Art in America* (Jan. 1990).
11 Quoted in Lynes, *O'Keeffe, Stieglitz and the Critics*, 16.
12 Quoted in ibid., 7.
13 Joy Kasson, *Marble Queens and Captives* (New Haven: Yale University Press, 1990) p. 81.
14 The subject – woman with bicycle – may have been inspired by Léger's *Big Julie*, purchased by the Museum of Modern Art in 1945.
15 William C. Seitz, *Abstract Expressionist Painting in America*, 1955 (Cambridge: Harvard University Press, 1983) p. 126; Leo Steinberg, 'Month in Review,' *Arts* (Nov. 1955): 46.
16 Michel Seuphor, *Abstract Painting* (New York: Abrams, 1961), 244. A related and characteristic reading of conflict in Willem de Kooning's paintings is articulated by Irving Sandler in *Triumph of American Painting*, 131.

> Painting that manifested the signs of his creative struggle – and they are everywhere in De Kooning's pictures – was of far greater value to him than painting that exhibited qualities identified with the French regard for *métier* . . . Indeed, De Kooning's pictures more than anything else are metaphors for his own and modern man's existential condition, capturing the anxious, rootless, and violent reality of a swiftly paced urban life.

A more recent response to 'Woman and Bicycle' is Michael Brenson, 'Iconoclastic Figures by De Kooning and Dubuffet,' *New York Times*, 7 Dec. 1990, B10 ('the great daubs, swabs and slashes of paint seem to relate to the figure like demons in a painting of the Temptation of St. Anthony').

17 James Fitzsimmons, 'Art,' *Arts and Architecture* (May 1953), p. 8; Hariet Janis and Rudi Blesh, *De Kooning* (New York: Grove Press, 1960) p. 61.

18 Seitz, *Abstract Expressionist Painting in America*, 126.

19 Fitzsimmons, 'Art,' 4, 6.

20 Steinberg, 'Month in Review,' *Arts* (Nov. 1955): 46.

21 A historian looking for a foothold for a feminist critique of Willem de Kooning's women or Jackson Pollock's moon women will look in vain to contemporary criticism by such women as Dore Ashton, Maude Riley, Emily Genauer, Margaret Breuning, and Mary Cole. Ashton, for example, minimizes the significance of the woman imagery in de Kooning's pictures in favor of appraisal of his formal and expressive achievement. One senses in fact some denial of the problems raised by the pictures in passages such as

> To me the expressive value of this painting goes beyond the fact of the two fleshy women. It is an expression of turbulent worldly emotion fixed in the carcasses of these two.
>
> I think their real importance went beyond problems of theme . . . The ladies, however prepossessing they were, were instrumental works leading to this apogee of abstract power ('Art,' *Arts and Architecture* [Dec. 1955]: 34).

The only subject positions available to aspiring critics who were women, like their counterparts among the painters, were those of the male artist/critic or the female object ('Other') of the picture. Neither alternative being attractive, women were forced to make an unpleasant choice or try to forge a double or other identity.

22 De Kooning to Selden Rodman, *Conversations with Artists* (New York: Delvin Adair Company) 1957, p. 102.

23 See Alexander Eliot, 'Under the Four Winds,' *Time*, 28 June 1954, 77.

24 Wylie, *Generation of Vipers*, 203:

> I give you mom. I give you the destroying mother. I give you her justice – from which we have never removed the eye bandage. I give you the angel – and point to the sword in her hand. I give you death – the hundred million deaths that are muttered under Yggdrasill's ash. I give you Medusa and Stheno and Euryale. I give you the harpies and the witches, and the Fates. I give you the woman in pants, and the new religion: she-popery. I give you Pandora. I give you Proserpine, the Queen of Hell. The five-and-ten-cent-store Lilith, the mother of Cain, the black widow who is poisonous and eats her mate, and I designate at the bottom of your program the grand finale of all the soap operas: the mother of America's Cinderella.

Cinderella is another of Wylie's vicious caricatural stereotypes; male variants include 'the scientist,' 'the businessman,' and 'the statesman.' [. . .]

25 Quoted in Irving Sandler, *New York School* (New York: Praeger, 1970) p. 113.

26 Wagner, 'Lee Krasner as L. K.'

Rosalind E. Krauss

GREENBERG ON POLLOCK

HE'S SITTING THERE JUST as I remember him, next to the neat little marble-topped table, with its prim lamp in gilt bronze mounted by a simple white shade, and behind him a painting that might be by Kenneth Noland but is hard to identify in the tightly held shot that frames him. His face is much the same, flabby and slack, although time has pinched it sadistically, and reddened it. Whenever I would try to picture that face, my memory would produce two seemingly mismatched fragments: the domed shape of the head, bald, rigid, unforgiving; and the flaccid quality of the mouth and lips, which I remember as always slightly ajar, in the logically impossible gesture of both relaxing and grinning. Looking at him now I search for the same effect. As always I am held by the arrogance of the mouth – fleshy, toothy, aggressive – and its pronouncements, which though voiced in a kind of hesitant, stumbling drawl are, as always, implacably final.

'I first met Jackson Pollock in '42,' he's telling the interviewer. 'Came down the sidewalk and there was Lee Krasner whom I'd known of old and she was with a very respectable gentleman.'

He hesitates so we can let it sink in, the coupling of Pollock's name with the words *respectable* and *gentleman*.

He begins again. 'And I saw this rather nice-lookin' guy. Lee said to me, "This guy's gonna be a great painter."' Pause.

Then the singsong of his own reply: 'Well. Uh. O-kay.'

As the film cuts away from Clement Greenberg to the notorious photographs of Pollock painting, one of us is unable to hold back the question, 'How many times has he told that story? One hundred? Two hundred? Three? How completely bored he sounds!'

But Clem is not bored, I think. If he's willing to broadcast the story over so many retellings, no matter how routinized and compressed, it's because he has a

Source: Rosalind E. Krauss, *The Optical Unconscious*, An October Book, Cambridge and London, The MIT Press, 1993, pp. 244–48, 321–322.

project, a mission. Lee had always said she introduced Pollock to him at a party, with dancing. Pollock, however, was never at his best at gatherings, alternately frozen with shyness and blustering with drink. So Clem's account labors to relocate their meeting: outside the customs house where he worked; therefore during the daytime; and thus the encounter with a sober Pollock – 'respectable,' a gentleman.

This, I think, is the process of sublimating Pollock. Of raising him up from that dissolute squat, in his James Dean dungarees and black tee-shirt, slouched over his paintings in the disarray of his studio or hunkered down on the running board of his old Ford. This is the posture, in all its lowness, projected by so many famous photographs, images recording the athletic abandon of the painting gesture but also the dark brooding silence of the stilled body, with its determined isolation from everything urban, everything 'cultured.' The photographs had placed him on the road, like Kerouac, clenching his face into the tight fist of beat refusal, making an art of violence, of 'howl.' Clem's mission was to lift him above those pictures, just as it was to lift the paintings Pollock made from off the ground where he'd made them, and onto the wall. Because it was only on the wall that they joined themselves to tradition, to culture, to convention. It was in that location and at that angle to gravity that they became 'painting.'

'He wasn't this wild, heedless genius,' Clem continues. 'No. He wasn't that. He looked. He looked hard; and he was very sophisticated about painting.' His voice trails off, as though he were remembering.

And it's right there, in that brief paragraph, in that little clutch of sentences, that you have the whole thing, the full redemptive gesture, the raising of the work from off its knees and onto the grace of the wall in one unbroken benediction, the denial of wild heedlessness in order to clear a space for the look, the look that will (in its very act of looking) create order, and thus create painting – 'sophisticated' painting.

This trajectory, moving ineluctably from disorder to order, can be tracked through the statements made by journeyman critics at the turn of the decade, as one after another they reversed themselves on the subject of Pollock's work. Before, they confessed, they could only see the wild heedlessness. Now, they say, they see the order. After the 1949 show, Henry McBride admits that previous works had looked to him 'as though the paint had been flung at the canvas from a distance, not all of it making happy landings.'

That's the language of *before*.

But now, he writes, 'The spattering is handsome and organized and therefore I like it.'

Which is to say that *before*, it was on the floor: 'a child's contour map,' 'a flat, war-shattered city, possibly Hiroshima, as seen from a great height,' 'dribblings,' 'drooling,' 'a mass of tangled hair.' And *now*, it's on the wall. Where it takes on order, and the sophistication of tradition: 'elegant as a Chinese character,' said the *Times*, while in *Art News* Pollock's use of metallic paint joins his work to Byzantium, to Siena, to all those sacred walls glittering with the illusioned light of transcendence: 'Pollock uses metallic paint in much the same sense that earlier painters applied gold leaf, to add a feeling of mystery and adornment.'

The welling up of this tide of benediction has a momentum of its own, carrying everything before it, even Greenberg. *Before*, the wall – the wall that was the

guarantor for him of the work's condition as painting – the wall had signaled compression, concreteness, flatness; it had meant the transformation from the easel picture to the mural painting, the movement from illusioned depth to a declaration of the wall's impermeable surface in all the 'positivity,' as he said, of its observable fact. The wall, the mural, was about *thisness*. It was a vertical, bounded plane, an object that stood before the viewer's own vertical body, facing off against it. This object, he reasoned, this continuous, planar object could function as an analogue for another continuous object, namely positivist science's 'space,' the continuum of neutral observation, the space everywhere open to examination, everywhere absolutely equal before the (scientific) law. 'The picture plane as a total object,' he had written, 'represents space as a total object.' And the extended plane of the mural-sized painting, he thought, will make this analogy into solid, pictorial fact.

But *now* the very verticality of that wall seemed to carry the force of transcendence.

Greenberg's first word for this was 'hallucinated,' as he began to search for a term that would capture the way this expansive vertical surface seemed to outrun the very world of facts, and the wall itself appeared to give way: 'object' now rewritten as 'field.' 'Hallucinated literalness,' he first decided, would set up just the right kind of tension between the pictorial wall's flatness and the optical illusions it nonetheless released. He tried to characterize these illusions. The wall seemed to breathe, he thought, to exhale color. It took on a kind of radiance, a luminous openness, volatilizing substance. By the mid-1950s he was reading Pollock's drip paintings as a matter of creating the 'counter-illusion of light alone.'

The stolid neutrality of 'space as an object,' materialist and literal, would cede its place to the idea of the pictorial field as 'mirage,' which is to say a zone enveloped by the subjective possibility of error. But as such this weightless, hovering, exhaling plenum would now stand, Greenberg thought, as the analogue of 'vision itself.' It would be the matrix of a gaze that, cut loose from the viewer's body, was free to explore the dimensions of its own projective movement buoyed by nothing else but subjective reflection on its own form of consciousness. 'To render substance entirely optical,' he wrote, 'and form as an integral part of ambient space – this brings anti-illusionism full circle. Instead of the illusion of things, we are now offered the illusion of modalities: namely, that matter is incorporeal, weightless and exists only optically like a mirage.'

The vertical is not, then, just a neutral axis, a dimension. It is a pledge, a promise, a momentum, a narrative. To stand upright is to attain to a peculiar form of vision: the optical; and to gain this vision is to sublimate, to raise up, to purify.

Freud had told that story years before, had he not? 'Man's erect posture,' he had written, could in and of itself be seen to 'represent the beginning of the momentous process of cultural evolution.' The very move to the vertical, he reasoned, is a reorientation away from the animal senses of sniffing and pawing. Sight alone, enlarging the scope of attention, allows for a diversion of focus. Sight alone displaces excited humanoid attention away from its partner's genitals and onto 'the shape of the body as a whole.' Sight alone opens the possibility of a distanced, formal pleasure to which Freud was content to give the name *beauty*; this passage from the sexual to the visual he christened *sublimation*.

'Sight alone' was very much the province of gestalt psychology, which in those

years was running fullback for Freud's fancy speculative passing plays in this matter of a psychohistory of the senses. The animal can see, the psychologists wrote, but only man can 'behold.' Its connection to the ground always ties the animal's seeing to touching, its vision predicated on the horizontal, on the physical intersection of viewer and viewed. Man's upright posture, they argued, brings with it the possibility of distance, of contemplation, of domination. 'We are able to behold things in a plane perpendicular to the direction of our gaze,' they wrote, 'i.e., in the plane of fronto-parallel *Prägnanz* and of transparent distance.' *Prägnanz* was the gestalt psychologists' term for the clarity of a structure due to its simplicity, its ability to cohere as shape. Beheld shape, they made clear, depended on being 'fronto-parallel,' which is to say, vertical.

The afterlife of the drip pictures continued to be conducted within this sublimatory, formal plane of the vertical. To that we have the testimony of the procession of artists who claimed themselves as Pollock's heirs: Helen Frankenthaler, Morris Louis, Kenneth Noland, Jules Olitski, Larry Poons. And the accounts of critics and historians – Michael Fried, William Rubin, T. J. Clark – do nothing if not concur. The drive of sublimation moves the paintings steadily away from the material, the tactile, the objective. By 1965 this drive had already reached a kind of climax when the next logical conclusion was drawn from Greenberg's claim that the volatilizing abstractness of Pollock's line 'bounds and delimits' – in Michael Fried's paraphrase – 'nothing – except, in a sense, eyesight.' Turning his attention to those few paintings in 1949 where Pollock has removed figurative shapes from the optical web of the drip pictures by knifing out sections of canvas, Michael describes the result. It is a break, he says, although it is not experienced as a rupture in the physical surface of the painting so much as it is felt as a lacuna – a kind of 'blind spot' – in the viewer's own field of vision. 'It is like part of our retina that is destroyed,' he urges, a part that 'for some reason is not registering the visual field over a certain area.' Evacuating the work altogether from the domain of the object and installing it within the consciousness of the subject, this reading brings the sublimatory movement to its climax. 'In the end,' Michael adds, 'the relation between the field and the figure is simply not spatial at all: it is purely and wholly optical: so that the figure created by removing part of the painted field and backing it with canvas-board seems to lie somewhere within our own eyes, as strange as this may sound.'

To Michael's good friend Frank Stella, however, it rang not only strange but false. The sublimated Pollock – the volatilized pigment, the patches of aluminum paint read out as a silver analogue for the gold grounds of Siena and Byzantium – raised a kind of skepticism in him. What he liked, instead, about Pollock's metallic paint, he told the interviewer in the film *Painters Painting*, was that it was 'repellent.' It repels the eye, as does much of the surface quality of the drip pictures seen up close, the coagulation of the paint in the areas where it had puddled and then shriveled in the process of drying, forming a disgusting film, like the skin on the surface of scalded milk. But Frank's objection went in large part unnoticed; and his own use of metallic paint would itself be gathered into the sublimatory embrace of 'opticality.'

Only three demurrals register within the afterhistory of the works that cannot be so assimilated, three refusals of the verticalization of Pollock, three reminders of the time when the drip pictures could still be thought of as having been 'painted

with a broom,' a floorbound condition that elicited the comment that 'a dog or cat could do better,' the polite version of what both Thomas Craven and Tom Benton accused Pollock of in 1950: making the drip pictures by peeing on them. The three dissenting voices came from the practices of Cy Twombly, Andy Warhol, and Robert Morris. None of these was interested in the sublimated Pollock.[. . .]

Bibliographical Note

Greenberg's account of his meeting with Pollock is part of his contribution to the PBS/BBC-IV television series 'Art of the Western World (Part 9),' made in 1989. He gave the same account to Steven Naifeh and Gregory White Smith for their book *Jackson Pollock: An American Saga* (New York: Clarkson Potter, 1989), p. 398, although Lee Krasner provided them with her own, different version (p. 857).

The monographs on Pollock I have consulted are the Naifeh and Smith book; *Jackson Pollock: Catalogue Raisonné of Paintings, Drawings, and Other Works*, ed. Francis V. O'Connor and Eugene Thaw (New Haven: Yale University Press, 1978); Francis V. O'Connor, *Jackson Pollock* (New York: Museum of Modern Art, 1967); B. H. Friedman, *Jackson Pollock: Energy Made Visible* (New York: McGraw-Hill, 1972); Ellen Landau, *Jackson Pollock* (New York: Abrams, 1989); Elizabeth Frank, *Jackson Pollock* (New York: Abbeville Press, 1983); Matthew L. Rohn, *Visual Dynamics in Jackson Pollock's Abstractions* (Ann Arbor: UMI Research Press, 1987).

Greenberg on Pollock

Clement Greenberg's analyses of Pollock's work have been drawn both from his published criticism and from interviews with him as cited in Naifeh and Smith. In the first connection his statement about painting and positivist space is found in his 'On the Role of Nature in Modernist Painting,' 1949 (reprinted in Greenberg, *Art and Culture* [Boston: Beacon Press, 1961]); 'hallucinated literalness' is from 'The Later Monet,' 1956 (*Art and Culture*, p. 42); 'the counter-illusion of light alone' is from 'Byzantine Parallels,' 1958 (*Art and Culture*, p. 169); 'optically like a mirage' is from the revised version of 'The New Sculpture,' 1958 (*Art and Culture*, p. 144); the flexibility of Pollock's idiom was discussed in Greenberg's review in *The Nation* (April 13, 1946) (reprinted in *Clement Greenberg: The Collected Essays and Criticism*, vol. 2, ed. John O'Brian [Chicago: University of Chicago Press, 1989, p. 75]); the variety 'beneath the apparent monotony' is from his February 1949 review of Pollock's show at the Parsons Gallery in *The Nation* (reprinted in *Clement Greenberg: Collected Essays*, vol. 2, pp. 285–286); his first assessment of the black and white pictures was 'Art Chronicle,' *Partisan Review*, 1952 (reprinted in *Art and Culture*, p. 152); his second view is from '"American Type" Painting,' 1955 (*Art and Culture*, p. 228); for the violence, paranoia, and Gothic-ness of Pollock's art, see 'The Present Prospects of American Painting and Sculpture,' *Horizon*, October 1947, (reprinted in *Greenberg: Collected Essays*, p. 166).

A useful close reading of Greenberg's evolving interpretation of Pollock's work is François-Marc Gagnon, 'The Work and Its Grip,' *Jackson Pollock: Questions* (Montreal: Musée d'art contemporain, 1979), pp. 15–42. Gagnon convincingly demonstrates that Greenberg continued to analyze Pollock's work in terms of the relatively traditional value of organic structure (variety within unity) and to be hostile to the idea of all-over composition, calling it 'monotonous,' until relatively

late (1948). He also argues that when in 1948 Greenberg related Pollock's com-position to synthetic cubism, this was a slip and he really meant analytic cubism, as he stated in his criticism from 1955 on. Yve-Alain Bois contests this latter point in his 'The Limit of Almost,' in *Ad Reinhardt* (New York: Rizzoli, 1991), pp. 16–17.

Naifeh and Smith report on Greenberg's telling either them or other interview-ers about: Pollock's having 'lost his stuff' (pp. 698, 731, 895); his contemptuous characterizations of others (p. 632), which my own experience of Greenberg throughout the 1960s confirms; his discussion with Pollock about Pollock's night-mare (pp. 628–629); on Pollock 'drawing like an angel' (p. 678); on Pollock's drip line made to avoid cutting into deep space (p. 535); on Pollock's view that *Blue Poles* wasn't a success (p. 698).

Index